D1637223

PICASSO

Also by Pierre Daix

Picasso: The Blue and Rose Periods
(with Georges Boudaille;
translated by Phoebe Pool), 1967

Picasso: The Cubist Years, 1907–1916
(with Joan Rosselet;
translated by Dorothy S. Blair), 1979

PICASSO

LIFE AND ART

PIERRE DAIX

Translated by Olivia Emmet

THAMES AND HUDSON

Picasso: Life and Art was originally published in French
under the title *Picasso Créateur* by Editions du Seuil in 1987

First published in Great Britain in 1993
by Thames and Hudson Ltd, London

Published by arrangement with
HarperCollins Publishers, Inc.,
New York, New York U.S.A.

British Library Cataloguing-in-Publication Data

A catalogue record for this book is available from the British Library

ISBN 0-500-09235-4

Designed by Abigail Sturges

Diagrammatic maps on pages 18, 28, 38 and 290 drawn by Paul Pugliese

Printed and bound in the USA

CONTENTS

Photographs and illustrations follow page 210.

ACKNOWLEDGMENTS

I could never have undertaken this book if Picasso had not honored me with his friendship from the end of 1945 until his death. He gave me free access to his personal collection, particularly after it was installed at the *mas* of Notre-Dame-de-Vie at Mougins. What he gave me far exceeds the generous clarifications and explanations he readily produced for me, and the close attention with which he followed my work on the *catalogues raisonnés*. The cumulative experience for me was one of unforgettable human richness, with which I also associate Jacqueline. It would not have been the same without her.

Subsequently, I was able to complete my personal knowledge of Picasso's work by participating in the commission which chose from his estate the works kept by the French nation in payment of death duties. I owe a great deal to my collaboration with the original organization of the Musée Picasso in Paris, to Michèle Richet, Dominique Bozo, Hélène Seckel, Marie-Laure Bernadac, Laurence Marcillac. And, because he allowed me to share his research for the Museum of Modern Art exhibitions "The Late Cézanne," "Pablo Picasso: a Retrospective," and "Primitivism and Twentieth-Century Art," William Rubin has provided unparalleled stimulation.

Among the exhibitions in which I participated, "Der Junge Picasso" at the Kunstmuseum in Berne with the late Jürgen Glaesemer, "Picasso 1905–1906" at the museums of Barcelona and Berne with Maria-Teresa Ocaña and Jean-Christophe Von Tavel, and "Picassos Klassizismus" and "Picassos Surrealismus" at Bielefeld with Ulrich Weisner provided opportunities for fruitful review. But my work with William Rubin, Hélène Seckel, and Judith Cousins on the *Demoiselles d'Avignon* exhibition of 1988 at the Musée Picasso in Paris and my participation in organizing "Picasso and Braque: Pioneering Cubism" at the Museum of Modern Art in New York are among the principal sources for this edition as opposed to the original French edition of 1987. Together with Judith Cousins, William Rubin, and the late Edward Fry, to whom I wish to give particular recognition, and with the acquisition of fresh information, I participated in the complete revision of the previously accepted chronology for the years 1905–1914.

Hanging the Modern's show provided opportunities for decisive confrontations and comparisons with which to refine our understanding of the relationship between Braque and Picasso. I cannot overstate the sense of enrichment I received from contributions by members of symposia subsequent to the show, and the revision of my efforts undertaken with Lynn Zelevansky.

Like everyone who has worked on Picasso, I am profoundly indebted to Christian Zervos, Alfred H. Barr, and John Golding. I owe a debt of a somewhat different character to James Johnson Sweeney and Robert Goldwater, pioneers of scientific study. And this edition has clearly benefited from Josep Palau i Fabre's work on Picasso's Cubism; from the first in-depth study of Picasso's works in the Soviet Union, by the late Anatoly Podoksik; and, above all, from the references to the period 1881–1906 in John Richardson's magisterial biography, which constitutes the most complete enquiry to date on relationships between Picasso and the various circles he frequented in his youth, and on his personal development.

This book in its present form owes a great debt to conversations with Jaume Sabartès, Daniel-Henry Kahnweiler, Siegfried Rosengart, Louis Aragon, Jean Cassou, Jean Cocteau, Paul Éluard, Tristan Tzara, Jean Laude, Louise and Michel Leiris, Roland Penrose, Douglas Cooper, and Gert Schiff, all of whom have since died. Also, with Brigitte Baer, Hélène Parmelin, Christian Gelhaar, Jean Leymarie, Édouard Pignon, Ted Reff, Robert Rosenblum, Gary Tinterow, and Kirk Varnedoe. I also thank Brigitte Leal, Caroline Lanchner, Isabelle Monod-Fontaine, Maurice Jardot, Heinz Berggruen, Ernst Beyeler, Jan Krugier, Gérard Régnier, Reinhold Hohl, Pierre Schneider, and Werner Spies.

I can never forget that the original French edition of this book was launched by an initiative of Milton Esterow, editor of *ARTnews,* and once again express my gratitude.

Paris, 1992

INTRODUCTION

T his edition differs considerably from the French edition of 1986. It was inspired by two events of primary importance which I was fortunate enough to experience personally: the *Demoiselles d'Avignon* exhibition at the Musée Picasso in Paris and "Picasso and Braque: Pioneering Cubism" at the Museum of Modern Art in New York. These led to the revision of many previously accepted ideas and considerably modified our understanding of Picasso's youthful work. In addition, record prices at public sales inspired many collectors to put previously unavailable pictures on the market. Study of these dispelled several mysteries, for example, Picasso's part in the Venice Biennale of 1905. The number of serious publications on the subject of Picasso also increased dramatically, disclosing gaps and errors previously enshrined by tradition.

In 1986 I was the first to establish that the separation of Fernande and Picasso coincided with the painting of *Les Demoiselles d'Avignon*. No one at that time knew that she had written an intimate memoir, which—confirming some of my hypotheses—modified our understanding of their private life and its effect on Picasso's art. In addition, the publication of Patricia Leighton's book *Re-ordering the Universe: Picasso and Anarchism, 1897–1914*[1] showed me that the political and social history of Spain and Europe was far less familiar to the American public than to the French. I have tried to bear this in mind while writing this book, benefiting from some twenty-five years of political conversation with Picasso.

In 1977 I attempted a first reconstruction of his creative itinerary, made necessary by access after his death to his notebooks and to work in his studio. Now, with this book, I have tried to make a synthesis between that itinerary—once again, considerably altered, even deepened—and the facts not only of his private life but of the intellectual life of the twentieth century, in which Picasso was simultaneously actor, witness, and didactic explorer.

As Gertrude Stein observed: "Matisse and all the others saw the twentieth century with their eyes, but they saw the reality of the nineteenth century. Picasso was the only one in painting who saw the twentieth century

with his eyes and saw its reality, and consequently his struggle was terrifying, terrifying for himself and for the others, because he had nothing to help him . . . He had to do it alone."[2] The principal difficulty for a biographer is linking these forward plunges of creativity to the curious mental equipment they activated. The operations of this equipment could, perhaps, be inferred, deduced, from conversations with Matisse, Derain, Gertrude Stein, Apollinaire, or Kahnweiler; but these have vanished without a trace. We are in the twentieth century, but in the archaeology of modernity. I had the good fortune of working with Picasso for twenty-five years; of personal acquaintance with some of his friends and some of the witnesses to his life; but in many instances I learned only too late how to put the proper questions.

On the other hand, Picasso, who until his eighties took very little interest in scrutinizing or auditing the works of his past, was attracted by the mirrors I held out to him with my first book in 1964 and then by work on the catalogue raisonné of his early works and of Cubism. Reproductions took him·back to important stages of his formation, to which he gave fresh and serious consideration. His work at that time was concerned with reevaluation, with the balance sheets of long experience. There was nothing in all this of nostalgia or self-congratulation. Rather, fresh attention was brought to bear on rediscoveries, which allowed him to compare finished results with original conceptions. I was a beneficiary of these multiple revisions, revisions not only of successes but also of uncertainties and doubts, as he weighed and measured his reasons for diverging from earlier intentions. Because he was involved with new work and new methods, he needed to understand what he had done up to that point. One might cite, as an example of this, the revelatory character of the 302 sculptures included in the 1966 exhibition "Hommage à Pablo Picasso" at the Petit Palais.

In *A Painter's Life* (1977) I had already struggled with a rather common tendency to regard Picasso as some kind of extraterrestrial. Certainly the circles in which he moved are beyond the habitual turf of the cultural establishment, but the rebirth of Spanish intellectual history after the death of Franco has helped to measure our neglect of the context in which Picasso's French trajectory occurred. I have collected all those from whom, as he put it, he drew his "sap": the poets who were always indispensable to him—Max Jacob, Apollinaire, Reverdy, Cocteau, Breton, Éluard; and the painters who joined him at various times in linked groups, like mountain climbers assaulting the heights: Matisse, throughout his life, Braque, Derain (before 1914), Miró, and the sculptors Gonzalez and Giacometti. There was also Gertrude Stein, who opened up the avant-garde for him; Kahnweiler, who provided a European horizon; and, of course, Diaghilev's Ballets Russes, and the encounter with Stravinski. Later, too, there was Zervos and the *Cahiers d'Art*. We shall note as well people like Mme Errazuriz, who introduced him to the king of Spain, the comte de Beau-

mont, the American painter Gerald Murphy, and his beautiful wife, Sara—acquaintances who were items of worldly calculation.

There were as well, long before his adherence to Communism, various political antecedents on the extreme left. I have, wherever possible, hunted down any kind of reduction of Picasso's idiosyncrasy to more common twentieth-century behavior, for example as regards his Communism, which was idealistic and never implied the least submission of his art or of his thinking to party politics; or as regards his strictly Mediterranean culture, his way of life deriving from the extreme south of Europe, and the deep roots of Spanish Catholic tradition, even though in his case the result was anticlerical atheism.

His sensuality and sexuality and, in the end, his art remain incomprehensible if one begins with anything other than an Andalusian born in the nineteenth century. For him time did not enter the twentieth century until he discovered Barcelona. He was not so much a collector as an explorer of women, making honey from both sensual pleasure and the dangers it could harbor—dangers in which sin or the clap did not figure nearly as strongly as calculations of expenditure: the distraction and diversion of creative capacity, in short, the loss of "sap."[3]

The greatest change in relation to both my earlier books—and to respectable tradition—derives from my sense that the most satisfactory and coherent "periodizing" of Picasso's output must be based on the stages of his private life. This can be seen from the first woman of any real importance to him—Germaine, for whom his friend Casagemas killed himself and who reappeared in 1906 and in 1925 and continues with the unknown woman whom Picasso called "la Madeleine." The critical years 1906 to 1908 were filled by the well-hidden complications of life with Fernande and emphasize the importance of Éva in 1912, in the history of *papiers collés* and of painting. The role of Marie-Thérèse must be reconsidered in the light of letters from Picasso revealed by her daughter, Maya. And—now that the final works can be seen in their true dimension—the figure of Jacqueline assumes its real importance. Each of these women was associated by him with projects previously unknown in art. He loved them for the new dimensions of imagination which were opened for him, and knew how to transcend, through art, slamming doors, disappointments, and failure.

If my work in various ways refuses limitation to a simple question of painting—which is how the celebrated articles by Leo Steinberg, Theodore Reff, and William Rubin approach the matter—it will be seen as well that I sometimes dissociate myself from their interpretations, aiming for a nuance which will avoid the details. A familiar framework—like the art of predecessors—functions as a springboard. For Picasso art meant making "something new," as he modestly put it. Therefore the "present" of art is always its summit. Picasso always "made something new" of his emotions, the woman he loved, his children, friends. And even more strongly of his

self-portraits. In taking all these risks, he was like "a tenor who reaches a note which is higher than anything written in the part. Me!" A cry from the summer of 1906 when he dared break with the classic successes which had dazzled Leo Stein.

With the aid of hindsight I have treated a number of received views with a freer critical spirit. Picasso loved to pull your leg if you asked ill-considered questions or to thrust you even deeper into error. This was his way of bringing to an end conversations he considered pointless. I myself now understand that at the time I didn't always grasp his drift.

The granting of access to certain archives has clearly been helpful in judging the testimony of various witnesses, even if, at times, I have run into refusals of information about events at the beginning of the century which I would not have expected at its end. Clearly I am in no position to prejudge what may evolve from these researches; perhaps they will have a provocative effect. That these things should be discussed is precisely what has inspired me. It is this, too, which has driven me to correct, rewrite, modify, and sometimes even contradict previously held views, a process which I hope will continue, for it contains not only the health of history but the life of this biography.

I am increasingly persuaded that we are, as it were, in the quattrocento of the modern revolution in the arts and that Picasso is indispensable to any cultural comprehension of this mutation. This is why I have always made a deliberate effort to note each instance of displacement and have been the first critic to make a point of it: to note each shift or lapse between the inventions and interventions of Picasso and their diffusion, their entry into the public domain of exhibitions and art history—often by a process akin to housebreaking, and after a lapse of sixty or more years. To be sure, this displacement was sometimes his own doing: not simply to protect his private life but because he did not wish his creative effort to be distorted by the refusals of commerce. In the last years of the 1920s, for example, he sold almost nothing. More probably he understood as well that this incomprehension of his boldest thrusts was an integral part of the times. There is also the suspicion—even today, an almost palpable substance—with which various French institutions regard modernity, treating it as an unpleasant—and parenthetical—commodity. That the vast continent of Picasso's output is only now beginning to lose its many blank zones is in itself news of the first order.

It is news which reveals that in regard to its most representative artist, the twentieth century in the West has been a period of ignorance and accumulated misunderstanding. This in turn has had consequences for other contemporary artists. We are the first to be able to measure not only the extent of ignorance and error but its implications for ideas which successive generations of critics and historians have formed about the art of their time.

For the rest, I have given much thought to a remark by my master and friend, the historian Fernand Braudel that "a danger of large enterprises is getting lost in them; sometimes, with great pleasure." In the course of his very long life, Picasso never got lost. If my readers gain the opposite impression, the fault is mine and will be all the heavier for that.

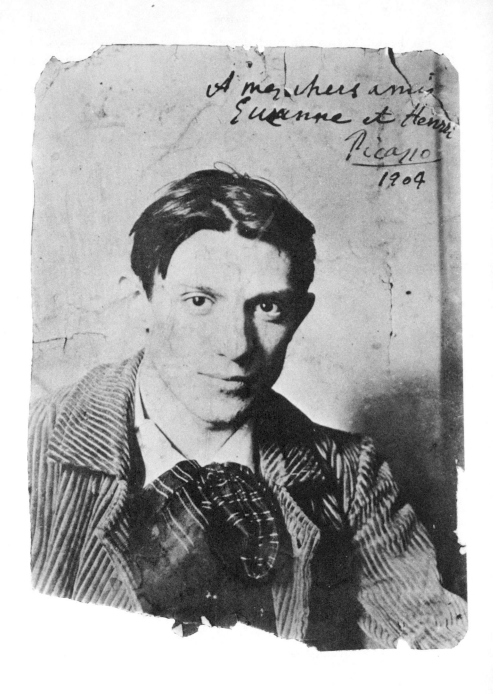

Pablo Picasso photographed by his friend Ricardo Canals in the latter's studio on rue
Girardon, Paris, 1904. Musée Picasso; © Photo R.M.N.—SPADEM.

THE FORMATION OF GENIUS

With him, there was never any hesitation: he came into the world with a painter's mission, and paint is what he would do, whatever the cost, without regard to anything else. By "paint," I mean explaining himself through signs; expressing himself through plastic media; manifesting himself by communicating those things which had caught his attention, on which he had reflected with his brain: the manner of doing this counted for little.

—*Jaume* Sabartès*

*With the exception of Ramón Pichot, as he is known in France, I refer to Picasso's Catalan friends by their Catalan names.

1

YO, PICASSO

1881–1897

A return to the birth of Pablo Picasso on 25 October 1881, under the sign of Scorpio, takes us to Andalusia, a province in which "Restoration" Spain—after the 1875 coup of General Martinez Campos—was tying itself to the past with even greater determination than elsewhere. The contrast with Catalonia was striking. There, in Barcelona, the adolescent Picasso would confront the stimulating shock of a triumphant industrial revolution and make the leap, with one bound, into the twentieth century. Behind him he would leave an ancien régime whose outlook, scarcely touched by the Enlightenment, was closer to the seventeenth century than to modern times; and the port of Málaga, oriented more to the Maghreb than to Europe. The rolling stock of the railroad, put through some fifteen years earlier, resembled that of Hollywood westerns; the young Picasso almost always traveled by sea.

Although Pablo's father, Don José Ruiz Blasco, had forebears of Castillian stock, his grandfather was born at Córdova in 1799. A glovemaker by trade, this grandfather married in Málaga in 1830, creating a solid Andalusian establishment, which on the mother's side went back another generation. She was a cousin of Don José's and the source of the name Picasso, unusual because of its double s. Family tradition—reported by Fernande, as well as by Maya, Picasso's elder daughter—spoke of Genoese forebears. The child, therefore, was born into a specifically Mediterranean environment, in formerly Arab-Andalusian territory.

Don José did not end his bachelor days until he was forty. Perhaps his single state was prolonged by some amorous disappointment, but his marriage, no doubt arranged, was entirely consistent with convention, and the structure of his life, which relied on three poorly paid jobs—teacher of drawing at the art school, curator of the municipal museum, and restorer of paintings—remained unchanged. While he spent his leisure time with friends at the café, the group of women his wife had brought into the family home—her two unmarried sisters and their mother—ruled over the comfortable apartment on the Plaza de la Merced.

The preponderance of Picassos—four of them, as opposed to one

Ruiz—was not a matter solely of arithmetic. Borne by the women, this name colored all of family life, as well as the domestic setting in which Don José reigned only by appearing on grand occasions. The infant Pablo opened his eyes in a female tribe, dominated, and undoubtedly subjugated, by his grandmother. We should not forget that Málaga was Moslem from 711 to 1487, and that as late as the sixteenth century the local Moriscos were still in a state of rebellion.

Don José was characterized by an air of apparent detachment, which derived—at least in part—from the insecure and scarcely brilliant nature of his work. And then, there was his physical appearance, of the type known as "English," with blond hair and blue eyes. Pablo, on the other hand, was a typical Andalusian. One can be sure that throughout his childhood female relatives repeated to him like a refrain that he was "a real Picasso." As the eldest child, and male, Picasso was prince of the household, idolized by the women, who in this way took their revenge for the subjection required by society.

His status was confirmed by the fact that he remained an only son. There were also two sisters: Lola and then Concepción, also called Conchita. Later he chose to call himself Picasso, not Ruiz, a choice made possible by the Spanish custom of linking maternal and paternal family names. Picasso, of course, was as rare a name as Ruiz was common; nonetheless, with this choice, Picasso was emphasizing the family structure of his childhood.

In that atmosphere, as soon as the boy manifested a passion for drawing—even, he said, before he began to speak—it was noticed, because of his father's profession. We can safely assume that this gift was encouraged—indeed exalted—receiving every possible support from a band of female relatives who hoped that the son would surpass the father. Even though his talent derived from his paternal heritage, its extraordinary quality must have seemed like a compensation by fortune, almost a kind of revenge. Sabartès, who knew Don José's relatives, has noted:

> The grandfather, Diego Ruiz y Almoguera, would have liked to be a painter, but this was impossible. Necessity, imposing on him the duties of family breadwinner, clipped his wings. . . . Diego, his eldest son, heir to the baptismal name of Pablo's grandfather, also enjoyed palette and brush. So, they say, did one of his sisters. . . . The first, however, who had the chance to employ this family taste in the matter of profession was Don José.*

But no one could fail to remark that in addition to his gifts—already employed in paper cutouts, to amuse his little cousins ("You'd like a horse? Here's one!")—Pablo was already entirely consumed by his passion. "Tran-

*Jaume Sabartès (1882–1968), Catalan writer, friend, and first biographer of Picasso.

quillity," Sabartès notes, "was possible if Pablo was free to draw when and as he chose—the head of a cane his father had left for him or a paint brush or the dove Don José intended to use as a model." Pablo had a passionate interest in visual things and, from the first, an unusual strength of will. He agreed to go to school only on condition that once there he could draw as much as he liked. Further, he insisted that Don José hand over those things the child considered essential: "which is to say," Sabartès translates, "things whose absence could be paralyzing: brushes, for instance."

The father, therefore, sacrificed his own painting to the whims of a child.

> From that first concession, Pablo gained the upper hand. Don José's desires could not stand up to the will of his son. . . .
>
> One can imagine what Don José must have felt as he understood that—insofar as Pablo managed to impose his personality—to that extent, his own importance diminished. He must have felt the shadow of his son gradually robbing him of light. His decision to abandon painting flowed from this knowledge.[1]

To be precise, the closing of the Málaga municipal museum had just forced Don José into exile—to La Coruña and the cold fogs of Galicia at the other end of Spain.

"That," says Picasso, "was when he gave me his paints and brushes. He never painted again."

The explosion of oil paintings which follows portraits of his father holding his palette dates this episode to the end of their stay at La Coruña: to the autumn of 1894, when Pablo was thirteen. But we are getting ahead of ourselves.

In Málaga Pablo rarely left the family cocoon—a tribe of women attentive to his every whim, and a dazzled, subject father. There was very little school. We know, on the other hand, that he went to the bullring with various members of the family. The subject of his earliest surviving picture (and soon every scrap from his hand would be jealously preserved) is a *Picador*,[2] probably from 1890. The youngest of his paternal uncles, Don Salvador, a doctor who married earlier than Don José, was the true head of the Ruiz clan. He, too, sheltered two maiden aunts; but these were his own sisters. Later Pablo was to paint the portrait of Aunt Pepa.[3] It was Don Salvador who threatened to forbid Pablo the bullring if he refused to make his first communion, an event dating their return to Málaga from La Coruña in 1895.

At La Coruña, when he was eleven, the young Pablo left his home circle of women to enter the drawing and ornament class at the School of Fine Arts. The family had moved from Málaga by sea through the Straits of Gibraltar and down the Atlantic coast, a journey which revealed to the child a radically different world—another Spain, whose wild shores were

pounded by the ocean. In this part of the country the language was Gali-
cian—closer to Portuguese than to Castilian and even closer to Andalusian.
The status of women was different there as well—less repressed and sepa-
rate.

Several schoolbooks from Pablo's tenth year have been found: a gram-
mar, a book of literary analysis, a French book—all embellished with
drawings whose vivacity and assurance are far from naive. One of these
shows a male donkey mounting a female, with a comment which leaves no
doubt as to the child's interest in sexuality. The following year, his first
classes confirmed the young prodigy's academic mastery. Fifty years later,
visiting an exhibition of children's drawings with Antonina Vallentin,
Picasso told her that at twelve he could not have entered the show, because
by then he already "drew like Raphael." Today we have the proof of that
remark. In 1893–94 he studied figure drawing, and the following year,
drawing from plaster casts of classical antiquities. In September he pro-
duced his first manuscript journal, with text and drawings—*La Coruña*—
which on 28 October, three days after his thirteenth birthday, was given the
title *Azul y Blanco* (Blue and White).[4] The sense of movement and carica-
ture in these drawings is staggering. We should remember that at the time,
the teaching of drawing confined the child to plaster casts from the antique.
The move to a living model would not occur for Pablo until the following
year, in Barcelona.

In these drawings the young adolescent—one can no longer say child—
created an entire world. They are, of course, a young person's means of
escape, but already they seize hold of life and are filled with power that
transcends the capacity to observe and copy. In 1971, more than seventy-
five years later, when Picasso gave me the facsimile of the last of these La
Coruña notebooks, he said, "At La Coruña, I didn't stop. You will say,
'Later you didn't either' . . . but at La Coruña, that's what saved me." Saved
from the discouragement of his father? Probably. Picasso summarized the
depression of those days in lapidary terms: "No Málaga, no friends, no
bulls: nothing." And: "He stared out the window at the falling rain." For
the father it was well and truly exile. For Pablo, too.

When Don José, in a symbolic gesture, gave his brushes to his son, he
also granted the rights of understudy, like a master of the bullring granting
a novice appearances as a substitute for himself. We know now that this
substitution was definitive; the triumph of the family circle, of the female
relatives—real enough, albeit discreet. Is an oil painting dated to the latter
part of 1894 and dedicated to cousin Carmen an instance of this triumph?
Pablo signed his earliest pictures with his full name: Pablo Ruiz Picasso. As
his confidence grew, the name became shorter: P. Ruiz, his father's heir.
This was the turning point, at which the young boy took possession of his
gifts. He painted his sister Lola on 1 December, and on 1 January 1895 drew
his father's reclining torso. In almost clinical fashion, he consigns to the
passage of time the sadness and defeat of his father. The portrait of his

sister, on the other hand, is a declaration of decisiveness: The strength and audacity of its workmanship is breathtaking.

There is a succession of portraits—bravura displays: *Man in a Cap; Old Galician;* several bearded men; all combine qualities of diabolic precision and assertive liberty. Immediately following these, *Girl with Bare Feet*[5] attests skill mastered to the point of trickery, placing the seated figure full face while concealing the spatial relationship of chair to ground. However, what interested Pablo in this instance was not simply a matter of technique. He wished, as well, to analyze the life of this model, who was his own age, to penetrate at any price her future as a woman, to capture it in advance with his brush. The precocity is already alarming, all the more so as this is the thought which seven years later would strike critics in Paris.

At the beginning of the year—10 January, to be precise—an event occurred which we can, perhaps, see reflected in this portrait of a little girl. Concepción, Picasso's youngest sister, born in 1887, was carried off by diphtheria, at that time an illness without mercy. The extraordinary maturing, therefore, which one senses in this painting occurred after this death. Can one fail to link this trauma at the beginning of adolescence with the phobic reaction to illness which Picasso was to display for the rest of his life? Perhaps, too, in the realm of life companions, the shock of his little sister's death was renewed and intensified by the illness which killed his mistress Éva in 1915. Certainly after that he could no longer bear illness in his inner circle—neither in his children nor in his friends. This was not a simple fear of death. Evidence suggests that for Picasso illness meant an intolerable disordering of existence, the shattering disappearance of his little sister.

Manifestations of this trauma in the paintings of Picasso's adolescence are evident. First there is the *Portrait of Ramón Perez-Costales*. A comparison done by the Musée Picasso of this painting with an academic portrait of the same person reveals Picasso's astonishing audacity. A former minister of fine arts, Perez-Costales dominated the social life of La Coruña. Pablo, dazzled, had done a painting of his house. During Conchita's illness, the doctor became a family friend. The portrait reveals a strong and vigorous personality treated with a respect the young painter did not display when the model was his father. Don José, in fact, had posed as a doctor in Pablo's first piece of academic bravura—*Science and Charity*—in which illness is a dominant theme.[6]

In April Don José exchanged jobs with a teacher in Barcelona and left immediately for that city. The family waited until the end of the school year and then joined him in Madrid, a trip which allowed the father to take his son through the Prado, where Pablo copied two Velasquez heads. They spent the holidays with their uncle, Salvador, in Málaga; there Pablo was able to see paintings by friends of his father, like Muñoz Degrain. To this man, born in 1840 of French parents, Pablo would dedicate at Christmas an astonishingly brilliant watercolor of his father, wrapped to the ears in a

muffler.[7] "Perfectly ordinary painting," Pablo said to me, "but still, a painting," from which I infer that he was aware of a gulf between the landscapes of sensibility produced by Degrain and the laborious awkwardness produced by his father. It seems that the latter had given up only his "public" painting, and still, from time to time, produced his landscapes and dining-room paintings—his *bodegones*.

Since railroads at that time were still pitiably bad, Pablo traveled to Barcelona by sea, a trip which inspired a series of small marine pictures. He immediately passed the entrance exams to La Lonja (in Catalan, Llotja: the Barcelona School of Fine Arts). There he made a friend for life—Manuel Pallarés, who was five years his senior.

The two drawings done for this exam at the end of September, one month before Pablo's fourteenth birthday—of a clothed and a nude model—are in line of descent from the La Coruña oils. There is the extraordinary psychological stripping down of the male model: a man in no way Apollonian, whose crabbed, bored spirit is made apparent by the subtle disequilibrium of his posture. Picasso observes him with the same adult gaze at work in the *Barefoot Girl* or *Ramón Perez-Costales* or the growing number of portraits of his friend, Manuel Pallarés. And when he copies a painting by his teacher, Arcadio Mas y Fontdevila, he focuses remorselessly on a nude seen from behind, with head turned, an interpretation whose freedom and expressiveness are perfectly anti-academic. The small religious paintings, *Altar to the Virgin* and *Flight into Egypt*,[8] demonstrate the same easy freedom.

The contrast with academic drawings, including his own—*First Communion*[9] and *Science and Charity* of his fifteenth year—is total. These are both virtuoso pieces—perfectly finished, rigorously controlled—in which the hypergifted pupil plays with the difficulties of a communicant's clothes or an overgilded frame. The realism of these portraits is perfectly handled. One can observe here an instance of Picasso's instinctive manipulation of perspective, organizing the picture's content so that its spatial reference points are disguised.

Science and Charity, which dates from the beginning of 1897, is far less "distanced" than *First Communion*. In the first place, as I've said, because Don José was his model for the doctor, who is taking the pulse of an ailing mother; secondly, because the sickbed of the young sister who died must have been superimposed on this scene. Thus in this piece of mechanical display done to impress Don José (and the family), there are intimate echoes.[10] Pablo won. The picture received honorable mention at the national Beaux-Arts exhibition of 1897, and, which is most important, a gold medal at Málaga.

Mary Matthews Gedo has recently stressed the father's role in this formative period of Picasso's life, a view which runs counter to other observations, notably those of Sabartès.[11] Don José rented a little studio for his son when the latter finished *Science and Charity*, but the initiative,

surely, came from Pablo. At this point in his development, the young man had undoubtedly learned more from his father than from his teachers. But learned what? To finish a picture within the academic rules. And if one considers everything Picasso had painted up to that point, the academic element is reduced to the minimum. For the two portraits conforming to the rules—*Father of the Artist* and *Mother of the Artist* (the second of these signed with his full name: P. Ruiz Picasso), one also finds a whole sequence of self-portraits: *With Short Hair; With a Gentleman's Wig; Coffee-Color; With Wild Hair.*[12] *Wild Hair*—an affirmation of Romanticism—displays a dazzling technique of feverish mastery. The adolescent is trying to find himself; but at each step of the way, feels free to thumb his nose, both at school and at his father's lessons. He had an extraordinary ability to change his age, as it were, passing from the child he had been to the adult he might be or to a young man the age of Pallarès. His *Portrait of Lola with a Doll on Her Lap*[13] reveals that the first portrait painted at La Coruña had deliberately aged her, anticipating the woman she would become.

This is a breakthrough of genius. From his fourteenth year Picasso used painting as a means of transformation, the transformation of everything—self, family, world. Painting is a language capable of changing life, of prefiguring (or exorcizing?) what might come; but it risks escaping from happiness as well as from danger. One can judge, from that moment, all the errors of "realistic" interpretation in the journal of paintings and drawings he was to keep for three quarters of a century. None of the 1896 self-portraits is signed. The proud autograph *Yo, Picasso* (I, Picasso) is still four years away. But it is surely in the subconscious of a pupil who devotes to official art only the crumbs of his extraordinary gifts.

During the holidays of 1896, in Málaga, Sabartès tells us, the family "seriously discussed the possibilities of keeping Picasso on the right route to his future." They "indulged some new illusions, thinking, perhaps, to orient Pablo's destiny through marriage. They had thought he might be in love with a cousin. And if he wasn't, never mind. What was certain was that the charms of a tender beauty from his native soil should not distract him from his future in Art." But already, at fifteen, Picasso belonged to no one but himself.

The *Portrait of Aunt Pepa* is his most mature work of that genre and that time. "The presence of his aunt," notes Sabartès, "did not blunt any of the nephew's faculties. Pablo looked at her without familial circumspection; and thereby managed to subordinate all the other senses to vision."

We can translate this to mean that Picasso did not hesitate for an instant to penetrate with his brushes the spirit and life of this old maid.

2

FROM PRODIGY TO ARTIST

1897–1900

For the rest of his life, resisting an almost diabolic facility presented his greatest difficulty. Forty years later—in 1936—Christian Zervos heard Picasso declare: "With me, a painting is a sum of destructions," which means a refusal of too much success, too much improvised perfection. Thanks to Don Salvador, even before the official approval of *Science and Charity*, Don José had saved enough money by October 1896 to send his son to Madrid, the only place, in his eyes, suitable for serious academic study. Muñoz Degrain had just been made a professor at the Academy of San Fernando and would act as "godfather" to the boy. Tradition asserts that once again, in the entrance exams, Picasso scored a triumphant success.

Little, in fact, is known about this period, which lasted until a bout of scarlet fever in the spring of 1898. Assumptions—like that of Mary Matthews Gedo—that Picasso was lost without his father and too vulnerable to master new material alone are not supported by the facts. On the contrary, everything seems to confirm Sabartès' view that Picasso went off to Madrid "without convictions," and that "he was to draw a conclusion entirely at variance with the importance his family attached to this move, and with objectives quite separate and distinct from theirs. Madrid—for him—meant escape and adventure; departure from the ordinary, discovery of the unforeseen." Had he complied with their wishes and followed the course they envisaged, "he would surely have become a recognized Pablo Ruiz, a figure with official distinctions and a steady income."

Sabartès, who met Picasso less than a year later, remembers specifically:

> The entrance exam to the San Fernando School, his third spectacular triumph, was enough to make him lose any desire to attend class, which was far too easy for him. He found the Prado much more attractive. . . . Then he fell ill and decided to leave Madrid, thereby destroying the plans his family had made for him.

By chance a document survives which sheds light on Pablo's state of mind and spirit at this time—a letter he sent to Bas, a friend from La Lonja, about whom we know nothing else. He is describing his teacher, the Malagueño Moreno Carbonero (1858–1941), then, it seems, also known as Degrain:

> He told me that the figure I was drawing was well proportioned, and well drawn, but that I should use straight lines, which would be better, and that I should pay more attention to the frame [*encaje*].* . . . By which he meant that one should draw a frame [*caja*] to hold the figure! It's almost beyond belief that anyone should utter such idiocies, right? But all the same, and more or less in spite of his thinking, he knows better than that, and doesn't draw at all badly. And I'll tell you why he draws the best: it's because he's been to Paris, to several schools there. Don't kid yourself: in Spain—as we've always shown—we're not stupid. We're just very badly educated. That's why—as I've told you—if I had a son who wanted to be a painter, I wouldn't keep him in Spain, even for a moment.

Already this boy of sixteen wasn't taking any nonsense about painting from anyone. He had his heroes: for painting, Velasquez; for sculpture, Michelangelo; his knowledge of the Prado dates from this visit. But he also had some distinctly old-fashioned ideas on the painting of his own day. Bas, for instance, should not think that he would send his son to Paris, "where I myself would certainly like to be." No, he would send him

> to Munik (I'm not sure that's how it's spelled). That's a place where painting is studied seriously, without blind deadends like pointillism and so on. . . . I'm against following the line of any particular school, because that produces only a particular set of mannerisms.

There are also some crisp judgments of the old masters:

> Velasquez is first class; and Greco does magnificent heads. Murillo, with all his tableaux, doesn't convince me. Titian has a fine *Dolorosa;* and Van Dyke, some stunning portraits and a marvelous crucifixion. There's an amazing Rubens (*The Serpent of Fire*); and Teniers has some very good little pictures of drunks.

Picasso asks his friend to take one of his (Picasso's) drawings to *Barcelona Comica* to see if the paper will buy it. The drawing would have

Encaje: socket, cavity, frame into which objects can be fitted, or inserted. *Caja*: box, chest, case. The teacher, apparently, was insufficiently subtle (and, it would seem, insufficiently attuned to verbal niceties) to distinguish between the two.

to be "modernist," as it was intended for a journal in that mode. Picasso adds, ". . . neither Nonell . . . nor Pichot[1] nor anyone else achieves the degree of extravagance I shall have in my drawing." In the end the drawing wasn't ready, but Picasso nonetheless didn't hesitate to compare himself to his elders. We should also note that this is the first appearance of the signature P. R. Picasso, with its reduction of the paternal name.

The rather sparse production of this Madrid period is imbued with independence and precocity. There is a copy of Velasquez's *Philip IV;* some small landscapes done with great assurance (including a *Salon del Prado* in the rain); and, above all, a transformative advance in drawing. Already the notebooks of spring 1898 bear an unmistakable stamp.

In fact, it was at Horta—Pallarès' village, where Picasso convalesced after a bout of scarlatina—that everything he had been storing internally since Madrid was first applied. As for the illness, we have no idea of its severity—he never spoke of it. "Everything I know," he said, "I learned at Pallarès' village." "Taught myself" would have been more accurate. On his return from Madrid, Pablo paid his parents the briefest possible visit, which suggests, perhaps, a sense of disquiet at having disappointed a father's dreams of academic glory for his son. His notebooks reveal that Horta was, first and foremost, an experience of foreignness: the first rural visit of a born and bred city dweller. Horta is a large agricultural town south of the Ebro, where Catalan is still spoken. With its moderate altitude and wooded slopes, the landscapes of this northern border of Aragon are very different from the sierras of Málaga or the wild countryside of Galicia.

Pablo noted local scenes of peasant life: the farms, with their wagons and oil presses, their setting in the terrain. Santa Bárbara is a high, isolated peak opposite the hillside on which the village is perched. He painted it and would do so again, eleven years later, after reflecting on Cézanne's *Montagne Sainte-Victoire*. His notebooks attest to the new assurance he had gained in Madrid, with studies of effects; contrasts and values, elisions and simplifications, which are increasingly decisive. Everything suggests health and vitality. Pablo was to keep for the rest of his life a small painting of *Santa Bárbara Mountain* by Pallarès, a memento of that free and happy time. On his return to Barcelona, a note—a teacher's comment perhaps— brought him this message: "That's how you always are: you never want to be like anybody else."

February 1899 found Pablo filled with a sharp desire for independence and, simultaneously, with good resolutions. He did not reenroll at La Lonja but nonetheless produced a series of academically perfect drawings. Sabartès has emphasized his accessibility at this moment in his adolescence: "With his inner spirit still somewhat uncertain, he was ready to respond to almost any sensuous demand." We know that he worked on a painting for the annual Beaux-Arts Exhibition—*Patio in an Aragon House* (today either lost or painted over), which Palau i Fabre thought was influenced by Pallarès.[2] The subject was intended to please Don José; but Pablo already

had his own studio, on the calle de Escudéllers Blancs. He worked at the house of the Cardona brothers, a painter and a sculptor respectively. Above all, he became a regular at Els 4 Gats (The 4 Cats). This artist's cabaret was launched in the spring of 1897 by Pere Romeu, a painter, poet, and dreamer. Inspired by Bruant's Chat Noir, the Paris club immortalized by Lautrec, the new cabaret became the instant headquarters of modernism in Catalonia. Translated by Picasso, this meant anti-Madrid. Barcelona was as open to Europe as Madrid was enclosed in Castillian conservatism.

Els 4 Gats was a center of this opening out, which was expressed by painters immersed in Impressionism—that extraordinary revolution in Parisian painting which triumphed after the death of Manet. Among them was Santiago Rusiñol, the poet who together with Joan Maragall—in the words of Sabartès—"waved the Catalan language like a flag." He was also a painter, who had made the rehabilitation of Greco a self-imposed task. In 1887, at the age of twenty-six, he had studied in Paris with Puvis de Chavannes and Carrière, bringing back from that experience a few Montmartre landscapes and a portrait of Erik Satie. His style is a symbol-laden realism reminiscent of Whistler. Ramón Casas, another pillar of Els 4 Gats, born in 1866, had arrived in Paris for his sixteenth birthday. At the Carolus-Duran school he was to discover "Velasquez and what Manet got from him."[3] An inspired portraitist whose drawing was influenced by Steinlen and Lautrec, Casas transmitted to Picasso the essentials of Parisian novelty and, simultaneously, embodied an objective to attain—or surpass. Pablo also encountered at Els 4 Gats Ricardo Canals and Nonell, whose exhibition in 1898 at the Barc de Boutteville in Paris was characterized by critics as that of two Impressionists in the grand Spanish tradition. "It was already Montmartre/Place de Catalogne," Picasso told me many years later.

There were, as well, the Gonzalez brothers—both sculptors still to make names for themselves; and Manuel Hugué, who signed himself Manolo; and Ramón Pichot, as long as a day without bread. With all of these Picasso experienced the intense intellectual effervescence released by the United States' defeat of Spain in the Philippines, feelings which were all the more passionate for him because he was the youngest and the last to join the group.

He absorbed every fresh influence with the voracity of one who wishes to rise to the level of his betters in order to supplant them. Barcelona was open to innovations not only from Paris but also England (works deriving from the Pre-Raphaelites and William Morris), Munich, and Vienna. Picasso listened to talk of Nietzsche, Ibsen, Maeterlinck, Munch, and *la Revue blanche* and benefited from an atmosphere of receptivity to Europe more eager and open than any Parisian equivalent. His letter to Bas provides an early indication of this; later he would be perfectly at ease with Kahnweiler, the Italian futurists, the Czech Kramar, or the Russian Tchukhin. At eighteen he was able to perceive—through Gaudí, the visionary Catalan architect—the cultural crisis which in Germany took the form of

Expressionism and in France provoked Gauguin's flight from civilization to Oceania: a perception as clear as any which might have derived from contact with "advanced" French circles. Rusiñol, after all, was proclaiming the right to "live by the abnormal, the unheard-of." Barcelona, to a greater degree even than Paris, was open and attentive to the twentieth century, for all the French city's self-definition as world capital of art and taste. We must dismiss all misapprehensions about Barcelona's provincialism.

The true astonishment, however, is not that Picasso, driven by extraordinary curiosity and the enthusiasm of youth, should fling himself into this seething brew of ideas and experiences. It is how quickly he was able to absorb, classify, and then dominate them. From the outset he was on equal footing with his seniors—"masters" like Rusiñol, Casas, and Miguel Utrillo, the painter, writer, and regular denizen of Montmartre, who gave his name to Suzanne Valadon's son. And with astonishing speed his work became better than theirs, developed a larger vision. We should not be surprised that he subjugated immediate elders like Pallarès or the photographer Juan Vidal y Ventosa; or that he was the ruler of his intimate circle, comprising people like the de Soto brothers, Reventos, Sabartès, Carlos Casagemas, and Sebastián Junyer-Vidal. Picasso's first *bande* formed even before he publicly chose to be "Picasso."[4] He was, simultaneously, a solitary, entirely possessed by his art, and a group leader, obliged to calm the anguish of his peers—an anguish which his genius provoked. He elaborated with the most intense concentration the intellectual sap he extracted wherever he found it. At the same time, he was warmly affectionate to those who helped him locate and collect it, as would be the case with Guillaume Apollinaire, Gertrude Stein, and Kahnweiler, before his surrealist period.

Els 4 Gats was above all a launchpad, the first of many. However, it would be a mistake to see it as nothing more than a means of widening the breach with his father, a father who, in the future, would paint only through the hand of his son. Each of his son's successes was for Don José a kind of compensation for what he himself had not been able to achieve. Although Picasso would no longer tolerate any kind of pressure to conform to his father's dreams, he was not so drunk with modernism that he forgot them. On the contrary, the fulfillment of those dreams was a point of family honor, a payment of debt for financial sacrifices which had been far from modest.

In 1971 when I remarked to Picasso that he must have attached very little importance to his academic work in those early days, he instantly disabused me. "On the contrary, it was very important for me." This should be understood in terms of money. Picasso realized from the first that the independence he needed in order to create obliged him to earn his living. Most of his friends had families comfortably established, either in commerce or in light industry. It is clear that his relatively straitened circumstances hastened his remarkable precocity.

There is no longer anything academic about the drawings of April

1899; for example, the drawing of an amorous couple in which the encounter of faces is simply left blank.[5] This abbreviation was not accidental. Picasso used it again in the portraits of his father, producing—among others—a little canvas of romantic rhythms outlining the older man against the sea. Don José thereafter was one model among many. So was Pablo's sister, Lola, still at that time a young girl. One can see in these pictures the development of new preoccupations, which epitomize this period. First there was the habit of composing in long, vertical strokes, and in his drawing this style gives his portraits a "Greco" quality.[6] Then there was his obsession with windows: either a window for its own sake, as, for instance, in *The Closed Window*—a view of the house opposite his studio—or because the window in question was his studio window, and he needed to take possession through painting of his workplace. Sometimes he placed Lola or another young girl in front of a window to produce a *contre-jour*, against which he abstracted the face[7] or through which he revealed a snowy landscape.[8] This concentration on lighting rules the most ambitious picture of that period: the *Portrait of Josep Cardona,* in which the subject is working by lamplight.[9]

When Picasso is working on the elongation of faces and figures, the rhythm provided by brush strokes and line is fundamental. In a watercolor in the Guggenheim Museum, for instance, a briskly sketched street scene with prostitutes features two long processions advancing toward the Angel of Death. This theme of death will be the subject of his final academic exploit: *Last Moments.*[10]

Why did Picasso return to this subject three years after *Science and Charity?* He was not in the habit of leaning on past successes. It would be more like him, in fact, to measure how much he had changed since the winter of 1896–97. It is striking that one of his first reengagements with this theme depicts a mother praying beside her child's bed. Is this a more or less conscious return to the death of his little sister, Concepción? I think so. He felt that in setting out to conquer life, one must look death in the face and dominate it through painting. We know today that Picasso used a 120-centimeter canvas, the largest ready-made size. We know, too, that he was staking everything on this academic exercise. The work was shown initially at Els 4 Gats—at his first exhibition there. But to confront the modernists on their own terrain, he would do their portraits. And would do as well portraits of all the café's regulars. These were very "free," with charcoal and watercolor; so many pieces of bravura. Some actually verged on caricature, like the head of Pere Romeu—viewed *from behind!* Everything had been done in the wink of an eye, like lightning, disregarding all the rules. There were portraits by the dozen, among them Ramón Pichot and a new friend, Carlos Casagemas. The three-quarter-face self-portrait is extremely romantic (and painted to look older). It is signed with a simple *Yo!* (I!).[11]

An attack on two fronts, demonstrating at once his capacity for brilliance in these two opposing modes. In the early months of 1900, the young

man, who had just turned eighteen, had no doubts about his gifts. Doing
the portraits of celebrated figures like Rusiñol or Casas amounted to pro-
claiming himself their peer. It seems, according to Palau i Fabre, that
Picasso's boldness provoked jealousy. In any case, Alfred Opisso, director
of *La Vanguardia,* allowed himself to "discover" the talent of Casagemas
in March and to be "unaware" of Picasso's in February. By then, however,
Picasso knew he had made his breakthrough. His *Last Moments* would be
chosen to represent Spain in the decennial retrospective of the Universal
Exhibition in Paris.

To prepare for the journey to Paris he worked overtime. It is impossi-
ble to know for certain whether all the "alimentary" works were part of
this effort. One assumes that they were done primarily for sale because of
their subjects, not their workmanship. Picasso's menus for Els 4 Gats—as
modernist as anyone could wish—transformed Pere Romeu's cabaret into
a luxury establishment for elegant ladies and gentlemen of fashion, in which
the "modern" style had become resplendent. And his bullfighting scenes—
charcoal drawings with highlights, or pastels—although demonstratively
"typical," were also occasions for experimentation and new methods.
Picasso had already tried his hand at engraving with the help of Ricardo
Canals, who had seen a great many Degases in Paris. The result was a
picador with the title *el Zurdo* (A Left-handed Fellow) because Picasso had
not realized that engraving would reverse his drawing.

He was doing an increasing number of illustrations for literary maga-
zines and had grown close to Casagemas,[12] accompanying the latter on
visits to his family houses: at Sitgès, where Rusiñol was staying; the Cau
Ferrat, a veritable museum of modernism; and Badalona. But all his oil
portraits or drawings emphasize his friend's dark side.[13] Sabartès clearly
saw Picasso's inner nature, even though the latter, as a joke, had sketched
him as a decadent poet.[14] But he was astounded when he heard of the
projected trip to Paris: "An adventure we simply couldn't understand. He
gave up his studio, left his family, said good-bye to all of us." The pastels
done for sale in Paris are all signed P. R. Picasso.[15] His father now existed
only as an initial.

PARIS, HERE I COME!

1900–1901

T he first Universal Exposition in Spain took place in Barcelona in 1888, a symbol of that city's separatism, industrial strength, and will to be the equal of London or Paris. One year later the defiant thrust of the new Eiffel Tower would crown the Paris Exposition of 1889. The Paris Exposition of 1900 was a statement of cosmopolitan culture by a colonial power in the process of claiming global status. Visitors entered through a pseudo-Khmer gateway, visible proof that France could justify its conquest of Indochina as a *mission civilisatrice*. For two years the French government had been revealing to the world, and restoring, the monuments of Angkor. Such activities, of course, tend to exclude any real understanding of other cultures, appropriating their artifacts and reducing them to decor empty of content. The Exposition of 1900 jumbled together every available style, like an academic painter using all the tricks of the past to depict a masked ball. In this regard the Exposition of 1900 was a great deal more reactionary than that of 1889, from which Gauguin had derived some knowledge of Borobudur. It is irrelevant to wonder if Picasso saw his first African masks at the 1900 show. There probably were a few; and they would have been virtually invisible. Everything was on display to express the impeccable conscience of a bourgeoisie which thought itself the ruler of the world and to proclaim that such a conscience existed.

The other justification was industry. The Palace of Electricity, with its decor of Art Nouveau metallic ornamentation, was itself a hymn to extraordinary progress. Certainly Pablo encountered the twentieth century there in ways he could not have imagined, even in Barcelona. But he knew that to assimilate these surprises he had to take his time. We must remember that he arrived for the Exposition's final weeks; the event, which opened on 14 April, was to close on 12 November. His late appearance seems to confirm the traditional account that when Don José had paid the railway fare to Paris there was no more money.

For the first time the Impressionists were appearing in an official show. They had, of course, been part of the centenary exhibition. But that inclusion, by keeping them out of the decennial—where Pablo's *Last Moments*

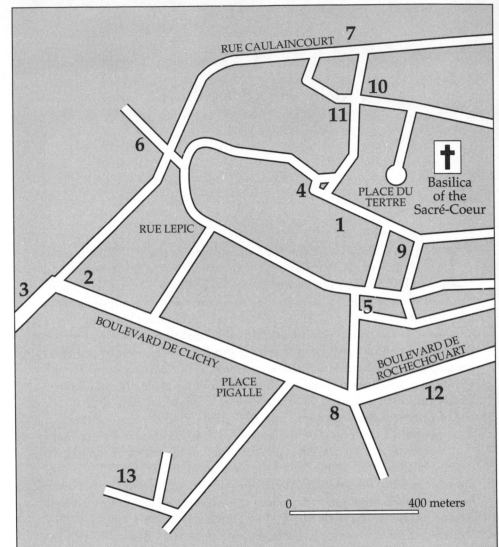

Picasso's Montmartre

1 Picasso's first studio, 49, rue Gabrielle.
2 Studio at 130 ter, boulevard de Clichy.
3 Café where Casagemas killed himself.
4 Place Ravignan and the Bateau-Lavoir.
5 Studio on the rue d'Orsel occupied by Braque, 1904–10.
6 Studio on the rue Tourlaque occupied by Derain from the end of 1906.
7 Studio occupied by Braque after 1910.
8 Studio occupied by Picasso after the autumn of 1909.
9 Hotel in the rue Chappe where Germaine, Odette, and Antoinette stayed in 1901.
10 The Lapin Agile, rue Saint-Vincent.
11 House in the rue des Saules where Germaine lived after her marriage to Pichot.
12 Cirque Médrano.
13 Lodgings at 9, rue Léonie (today Henner) where Apollinaire lived
 from 15 April 1907 to early 1909.

was hung—had effectively prevented them from exhibiting their most re-
cent works and enclosed them in the past. They were, nonetheless, recog-
nized; in May, in a Barcelona lecture, Miguel Utrillo had mentioned their
presence in the show. Picasso, therefore, up to a point, knew what he would
find: Manet, Monet, Renoir, Pissarro, Sisley; three Cézannes, and two
Degases.[1] And he surely knew, as well, the symbolic story of Léon Gérôme,
who planted himself in front of the president of the Republic to prevent him
from entering the room in which the Impressionists had been hung and said,
"Stop where you are. Through this door is the dishonor of France!"

Today when we calculate distinctions between individual members of
the Impressionist movement, sometimes even putting them at opposite
poles, we risk losing sight of what they had in common. Their paintings
destroyed appearances, destroyed, that is, the eclectic and variegated imag-
ery of cosmopolitan detail which was the substance not only of the "Univer-
sal" Exposition but of the good conscience of the reigning bourgeoisie. The
entire course of the young Picasso's brief history aligned him with such a
challenge to established appearances and assumptions.

Pablo arrived in Paris with Casagemas around 15 October. Pallarès, as
planned, had stayed in Horta to finish a commission. Picasso and Casage-
mas settled first in Montparnasse. But when they heard that Nonell had
gone back to Barcelona, they took over his studio, at 49 rue Gabrielle in
Montmartre. A letter to Ramón Reventos of 25 October—Picasso's nine-
teenth birthday—reports a visit to the Exposition, to a show of paintings.
Pablo sketches himself leaving the show with Pichot, Utrillo, and Casas—
all in a state of high excitement. Casagemas gave his arm to a woman.
Nonell, in fact, had introduced them to three models: two sisters called
Germaine and Antoinette and a third girl known as Odette. Casagemas
immediately declared an amorous passion for Germaine. Pallarès, when he
arrived in November, was to begin an affair with Antoinette. The young
women lived at 11 rue Chappe, about a hundred meters from the studio on
the rue Gabrielle, Montmartre, still at that time very much of a separate
village.

Today, at the Barnes Foundation, there is a little picture of Pablo's
showing the Spanish friends—Pichot, Manyac, Casagemas, among oth-
ers—and Pablo himself. And the mill, which in the work of Rusiñol and
Casas already signified Montmartre, is there, too, inscribed "a mont cheri
Odet."[2] Just how far did these flirtations go? The following spring Pablo
made a drawing of himself in bed with Germaine, caught by an indignant
Odette. He also dedicated a sketchbook of embraces "pour Louise." We
know from the police report on Casagemas' suicide that Odette's real name
was Louise Lenoir.

In the report Germaine is twenty. Her name is Laure Florentin, née
Gargallo, which implies that she was or had been married. She and her
sister were probably of Spanish origin. Picasso told me that the name was
a perfect homonym with the sculptor.

Why dwell on these details? Because the first love affairs to appear on Pablo's horizon were immediately registered in drawings (and probably in paintings, too), with a predilection for Germaine, who was the most striking, and the most flirtatious, of the girls. She was, however, reserved for Casagemas; Pablo, therefore, chose Odette. Is he simply posturing when he writes (on 3 November)[3] that because of these girls he thinks of abandoning bachelor life and the bordello of the rue de Londres? Casagemas adds that Odette drinks every evening. Picasso drew and painted couples embracing in public (a habit which astonished him) or intertwined in an alcove. Once, he even painted a man jerking off right there, in public.[4]

Picasso's first Paris canvas is the *Moulin de la Galette.* "It has lost all its character," Casagemas writes. And indeed, Picasso's brush gives this piece of bravura painting—a night ball under electric lights—none of the gaiety noted by Renoir. Pablo had surely seen the Renoir acquired by the Luxembourg through the Caillebotte bequest, a picture which—like Lautrec's *Bal du Moulin-Rouge*—dwells on the seamy side of Montmartre: bourgeois dandies out for an evening with girls of easy virtue. Two figures in the foreground are done with particular tenderness. The provocative girl on the left, cut by the frame in the manner of Degas, might well be Germaine.

Cancan, whose pastel version is closely derived from the *Troupe de Mme Eglantine,*[5] is another instance of Lautrec's influence. But the similarity between the effects of pastel and those of long brush strokes—as in the Barcelona paintings—is new and suggests Degas. Add a veiled lady (posed, perhaps, by Germaine); a portrait of a *Man in an Overcoat;* a *Stall at the Fair,* a picture painted from life of the stalls put up for the end of the year on the Grands Boulevards at the foot of Montmartre; a *Street Scene,* a view from the studio window, with all the melancholy of winter—and we have a survey of work in which Picasso recorded, without any great change in technique, the unfamiliar effects of the cold season in the north.[6]

Let us consider here these first encounters with Lautrec and Degas. Picasso borrowed from them certain technical successes: the "whiplash" arabesque used by Lautrec to divide a picture's planes and the squaring which punctuates Degas's compositions and figures. There is, as well, the latter's virtuosic mastery in pastels of soft, blurred outline. The adolescent Picasso was fascinated by these plunges into female intimacy: in Degas' studies of the "toilette" and its various attitudes and the moments of relaxation, free of clients, in Lautrec's bordellos. Later he was to imitate and employ both subjects and techniques in his painting. For the moment, however, he simply registered the unknown world, which they were teaching him to penetrate through art. Montmartre was still the border country of Paris, with fields and vines surrounding the windmills van Gogh had painted thirteen years earlier. It was dangerous terrain, where pimps and cutthroats settled their accounts with swift finality. The middle classes thought of it as a place to go for a taste of lowlife, still tinged with memories

of the Paris Commune, of the anarchists and the bloody street violence of the 1890s for which the district had been a center.

It was this revolt, this subversion by the rejected of society which Lautrec—even more forcefully than Steinlen—brought into painting. His effort was supported from the first by Félix Fénéon, the critic of post-Impressionist art who—like most of the movement's painters—was an anarchist sympathizer. (As we know now, Fénéon himself put a bomb in a restaurant near the Senate in 1894. Fortunately there were no casualties. Fénéon kept his secret till his death in 1944. The story was ultimately told by another anarchist sympathizer, Picasso's friend, André Salmon.) Picasso's Parisian apprenticeship, therefore, was from the beginning part of this subversion by the excluded, which he understood to perfection. But, as was always the case with him, he received novelty not as raw experience but as transformed by art. The shadow of Lautrec, wavering and unforgettable, was far more likely to cross his path in the alleyways of the Butte, far more likely to be his intermediary than that of Steinlen. And seven years later it was through the ferocious Montmartre of Lautrec's vision that Picasso envisaged the first bordello of *les Demoiselles d'Avignon*. Through memories, too, of Barcelona and of the "house" in the rue de Londres.

Patricia Leighton discovered that Picasso signed a manifesto of the city's Spanish colony, probably just before he left Paris. This demanded the liberation of political prisoners incarcerated at Montjuich after the antimilitarist demonstrations of 1898 and amnesty for exiles. Published in Barcelona on 29 December 1900 by the left-wing Spanish-language paper *Publicidad,* the manifesto declared human solidarity: "Our desertion was motivated by the horror . . . inspired by the spectacle of war . . . waged for . . . paltry aims. We are men, and partisans of universal well-being." The primacy of these ideas for the rest of Picasso's life, ideas which are fundamentally moral rather than political, makes this declaration all the more moving. Among the signatories are intimate friends like Casagemas, Carmona, and Francisco de Asís Soler, with whom, one month later in Madrid, he was to found *Arte Joven*. Asís Soler's appearance here, as a militant supporter of amnesty, changes the color which tradition has ascribed to this adventure. In a letter to *Libertaire* of August 1904,[7] Asís Soler repeats this support.

When Picasso and Casagemas left Paris on 20 December, Picasso was worried by his friend's low spirits—the product of an unhappy love affair with Germaine. After a brief stay in Barcelona, the pair turned up in Málaga, whence Casagemas was soon to depart as he had arrived—by boat and in a black depression. Later, through Pallarès, who had stayed in Paris, we learn that Casagemas wrote to Germaine every day. Sabartès adds that Picasso wished to confront what he had recently learned in Paris with his past, an idea which corresponds with what we know of Pablo's psychology. However that may be, during the second half of January Picasso joined Francisco de Asís Soler in Madrid. This young writer had decided, perhaps

while he was still in Paris, that since his father was making a good deal of money with a certain "electric belt," he and Pablo should launch a magazine. The magazine would be called *Arte Joven* (Young Art), a title which in itself constitutes a platform. The prospectus declares that even though sincerity seems "in our day to be something unattainable," *Arte Joven* would be sincere. It would be young after the fashion of those great artists of eternal youth: Virgil, Homer, Dante, Goethe, Velasquez, Rubens, Greco, Mozart, Beethoven, Wagner. "Come, youth, and join the struggle. We shall win, if we fight with faith. Come, and do not forget that to struggle is to win!"

Once again Picasso had no doubts about his ability to reach the summit. He rented space for a year in which to live and set up offices for the magazine. The format would be that of Els 4 Gats, whose successor, directed by Miguel Utrillo, was Pél y Ploma ("Brush and Pen"). Picasso was to be its Ramón Casas.

In Madrid, challenge to old ways from the "Generation of '98" provided a foothold for the young man fresh from Paris for ideas far less familiar to the capital than to Barcelona. This situation offered Picasso not only an advantage but also an agreeable opportunity to checkmate his elders. *Arte Joven* was *his* magazine; he filled its pages with drawings as earlier he filled the pages of his La Coruña notebooks. There are charcoal drawings, like those done for Barcelona magazines, because the medium was particularly amenable to the reproductive techniques of the day. In spirit, however, they are the height of modernity. These are drawings of social comment: women in ball gowns; street scenes; a staircase—No. 69—with prostitutes; and a graceful portrait of the paper's founders. His line, which has acquired a dazzling variety of rhythm, now in a series of sumptuously dressed women achieved the virtuosity of Degas pastels. The women's faces, however, are hard—bitter or conquering.

We don't know if these drawings were completed before or after the arrival of tragic news: Casagemas had killed himself in Paris, on 17 February, after trying to kill Germaine. A death notice appeared in *Catalunya Artistica,* accompanied by a portrait-drawing of Picasso's from the summer of 1900. It seems highly likely that the large canvas *Lady in Blue,* a courtesan in the grand manner, in which paint assumes all the delicacy of pastels, was a subsequent work. Picasso prepared this picture for the general Beaux-Arts Exhibition which was to open on 29 April:[8] clearly he had not abandoned the possibility of official recognition. The painting states that its subject is dangerous. (Was he thinking of Casagemas?)

Arte Joven collapsed. The dealer Pedro Manyac told him he could show in Paris in June, and Picasso immediately abandoned Madrid, leaving behind his *Lady in Blue;* leaving as well, perhaps, any hope of return. Later he was to mix recollections of that winter and his bout with scarlatina, retaining only the intense cold of a continental climate and perhaps a sense of chilled spirit, as well. Madrid had rejected his youth, a rejection he would never forget.

He returned directly to Barcelona, not like someone who had suffered a defeat but to throw himself into preparatory work for the Paris Exposition. Sabartès gives us a picture of Pablo's friends listening, wide-eyed, to accounts of exploits from the previous autumn.[9] Miguel Utrillo celebrated the return of the prodigal son with an exhibition at the Sala Parés. Picasso showed his Madrid pastels, adding a few fresh ones. But his principal effort was in painting.

Between Madrid and Barcelona there was a sudden change: an explosion of color. In the more or less rhythmic lines of the painting, individual brush strokes can be distinguished, a pointillism of tense and powerful contrasts, a pre-Fauvism astonishingly like the one Matisse—for his own purposes—had just invented. Each, however, was entirely ignorant of what the other was doing—they were not to meet for another five years. In a bullfighting scene Picasso employed with great freedom, and translated into modern pictorial terms, a composition by Fortuny (1838–1874), a celebrated painter of the generation just before his own. We see here the sudden implementation of all his Paris discoveries about Impressionism, post-Impressionism, the Nabis group. Working at an extraordinarily feverish pace, sometimes painting three canvases in a single day, Picasso was aware of pursuing an objective that was his alone. In Madrid he had used the signatures Pablo Ruiz Picasso, P. R. Picasso, and simply Picasso. Now this last choice, set off by two hyphens, became the rule. There are bullfights, full of light (one of them, for the first time, depicting the gutted horse who would appear in *Guernica,* thirty-five years later), and landscapes with churches. As he had a year earlier, Picasso concentrated on what the French might expect from a Spaniard. He took with him characteristic drawings done during a trip from Madrid to Toledo; adding to these, views of the Costa Brava, mothers by the seashore with their children, a female dwarf—the entire panoply of the picturesque.[10]

He drew himself debarking at one of the Seine quays with his friend Jaume Andreu Bonsons.[11] The sheer number of Parisian subjects rules out a date much later than 20 May. Picasso knew exactly what he wanted. He resumed occupancy of the studio in which Pallarès had installed himself—130 *ter,* boulevard de Clichy, at the foot of Montmartre, the site of a sizable Spanish colony where Casagemas had lived and Manolo and Manyac, among others, had settled. He immediately began to work.

Although he painted the *Portrait of Manyac* with long brush strokes, in the manner of the previous winter, the geometric firmness of outline and the simplifications of clothes and hands suggest a work completed just before 25 June. Picasso flung himself at everything his eye spotted as specifically Parisian; above all, women drinking on terraces or in bistros.[12] And perhaps with the *Buveuse d'absinthe* (Absinthe Drinker) or *Pierreuse, la main sur l'épaule* (Pierreuse, Her Hand on Her Shoulder) one can read into these pictures reunion with Odette.[13]

There are women of every sort: courtesans at the racetrack or at elegant suppers; stylish young creatures with a touch of "Madrid" about

them; naked prostitutes of the lower class; housewives and mothers of families at ease in a town square or tense with the miseries of poverty; and an abundance of children in their French freedom and dashing clothes. One girl's costume is so dazzling that Gustave Coquiot, the lively *préfacier* for the Vollard exhibition, called it *le Roi-Soleil* (Sun-King). Coquiot gave Pablo an opportunity for two bravura portraits done in high nineteenth-century style: especially the first of these which puts the *boulevardier* in the foreground of a music-hall scene. Picasso loved the local spectacles and painted these two from life: *Au Moulin-Rouge* and *le Divan japonaise* (Japanese Couch).[14] As the critic, Félicien Fagus, wrote: "He was entranced by everything."

But Picasso had the highest ambitions, as one can see in his self-portrait at work and in the portrait of Francisco Iturrino, the older Basque painter also represented in the exhibition at Vollard's.[15] Since we now know it was the biggest painting in the show—80 format—this picture leaves no doubt that the young virtuoso was thinking about and placing himself in the position of Nicolas Poussin, in the latter's *Autoportrait* at the Louvre. Never before had Picasso played so audaciously with his entire range of brush strokes and contrasts of pure color: a red cravat, white shirt, jet-black eyes and hair. The expression of the eyes is extraordinarily penetrating; the shadows of the face are green. "You can't imagine what a scandal that green made," Picasso told me years later, delighted to see his picture again on the occasion of a sale in the United States which broke all records. (A feat repeated in 1981 and in 1989, this time for over 47 million people.) At the Cage aux Fauves, at the Salon d'Automne of 1905, the green in Madame Matisse's face provoked similar torrents of outrage. Once again, although they didn't know each other, Matisse and Picasso were on similar tracks.[16]

There is a splendid nude from this period, radiating tenderness; we know that her first name was Jeanne. Picasso did a clothed portrait of her as well. Years later, when he spoke of her, his voice and his face were touched with emotion.[17] He told me, on another occasion, that very often with models he found his thoughts straying from the problems of painting.

A small picture of a young woman dressed to display her charms is inscribed "Picasso to Germaine," a relationship explained by an illustrated letter to Miguel Utrillo. In the letter, which discusses life at 130 *ter*, boulevard de Clichy, one sees Jaume Andreu and Manyac coming to blows and Picasso caught in bed with Germaine by Odette. The latter—not surprisingly—is indignant, while Manolo, beside Germaine and Picasso, is visibly jealous. A further scene shows him being evicted from Picasso's lair by a policeman, while Germaine lies in bed. A portrait of a young woman, "the lovely Faguette," refers to a popular singer, Louise Faguette.[18]

Picasso left Barcelona before the opening of his exhibition of pastels at the Sala Parés. The tragedy of Casagemas, it seems, had been put behind him, a forgetfulness which would prove to be more apparent than real. Anything remotely resembling fidelity in sexual matters was entirely for-

eign, indeed incomprehensible, to Picasso. He boasted of sleeping with Germaine but at the same time continued his liaison with Odette-Louise and had a fling on the side with Jeanne. Comparisons, he said, amused him.

Even though Vollard had not yet attained a stature of importance, his gallery in the rue Laffitte was already a center for those interested in new painting. He had exhibited Cézanne since 1895, a show that provoked a famous scandal. The *Journal des artistes* had denounced the "nightmare vision of atrocities in oil" which, it claimed, "exceeded the boundaries of legally permissible practical jokes." Since then, Vollard had moved from the top of the rue Laffitte to No. 6, near the Grands Boulevards, an area which is today a banking district. There he had as neighbors Durand-Ruel and Diot, who specialized in Daumier, Corot, and Jongkind. Further down the street, there was Clovis Sagot, later to sell Picassos of the blue and rose periods. Gustave Coquiot, then at the peak of his reputation as art critic and journalist of the boulevards, was probably responsible for most of the punning titles in the exhibition.

Contrary to Vollard's expectations, the exhibition was a success.[19] As well as Coquiot, Félicien Fagus gave it a prominent notice in *la Revue blanche,* still a rallying point for innovation. Palau i Fabre cites a letter of 13 July, sent by Picasso to his friend Juan Vidal y Ventosa, which claims that most of the papers had carried favorable reviews. Fagus's article did not, in actual fact, appear until the day after the letter was sent; a precise sense of press views, therefore, would seem to require further research. Only a few pictures were left, to be sold later at Berthe Weill's; many of these, postscripts to the exhibition itself. (For a list of the exhibition's works, see the Appendix.)

Picasso had made himself not only known but recognized before his twentieth birthday. To measure this achievement we should consider that Matisse, although some dozen years his elder, was not to have a one-man show until 1904 (also at Vollard's). As Fagus had warned, Picasso needed to be wary of his own excessive impetuosity and of a facility which was more diabolic than ever.

And then, he turned his back on a Parisian success, which had seemed to promise him everything. Having proved that he knew how to take, retain, and paint whatever he chose, he made a turn of 180 degrees: toward austerity and back to himself.

4

THE TRAGEDY OF CASAGEMAS
AND THE BLUE PERIOD

1901–1904

U ntil recently the explosion of light, lively color in Picasso's work in the spring of 1901 has been included in his blue period. The deaths of the original collectors, which brought their pictures back on the market, the increased availability of colored photographs, and a re-evaluation of Spanish youth—all of these were needed for an understanding of his prehistory. But even with them an essential element was lacking: the effects of Casagemas' suicide on his friend's work. It was not until 1965 that Picasso showed me the other paintings which altered the meaning of *l'Enterrement de Casagemas (The Burial of Casagemas)*—the single canvas on the subject known theretofore.[1]

Picasso continued his line of swift, externalized painting for the duration of his exhibition at Vollard's. *The Fourteenth of July* seems its quintessential expression: a pyrotechnic display of colors so fiery that the picture looks almost abstract. It is in this range of colors that he paints—seemingly without transition—his first suicide picture. Casagemas in his coffin, a bullet wound in his temple, is lit by a candle filling the canvas with multicolored rays and a violence which seems to derive from van Gogh.[2] The two other canvases in the set declare the preeminence of blue. The group as a whole is filled with the gravity of recognition: tragedy has just struck.

Picasso also provided information which helped me find police records of the inquiry into the case.[3] And a short time before that, following his eightieth birthday, he began to help identify Germaine's appearances in his work.

Later still he was to give Palau i Fabre the final details of Germaine's part in the drama. Like a good Spaniard, he detested indiscretions about his private life and protected friends, lovers, and companions at least until after their deaths. In this case he waited for over twenty years, Germaine having died in 1948.[4] But when we finally did speak of that time, Picasso stated without hesitation that the autopsy on Casagemas had revealed an anatomical reason for his impotence. Germaine's baffled incomprehension of her lover is understandable; he constantly declared his passion but avoided every opportunity for physical intimacy. One must also bear in mind the

Victorian bias of the period, which turned a simple phimosis into a blemish as inadmissible as it was irremediable.

On one hand, there was Germaine, an easygoing coquette with a taste for driving men to madness, to battle for her sake. And on the other, an adolescent who—even before he met her—was prey to morbid and oppressive ideas. But why was Picasso—clearly sleeping with Germaine and experiencing no difficulties other than Manolo's jealousy—suddenly and belatedly affected by the tragedy of his friend's death? Chronology, I think, supplies the answer. Taking down an exhibition is never particularly enjoyable. Picasso watched the departure of all his canvases and the ardent dreams of conquering Paris which had accompanied their display. How, at such a moment, could he have failed to draw up some kind of inner tally, weighing a success which had come too easily, which was, above all, too superficial and carried with it the mortal danger of entrapment? How, too, could he have failed to recall his arrival in Paris with Casagemas and their visit to the Universal Exposition to see his *Last Moments?* Six months later, life with its terrible irony had turned this salon subject into the final moments—all too real—of Casagemas himself.

To paint the actual death of Casagemas would be to reach the kind of sincerity he had extolled in *Arte Joven.* "It was thinking about Casagemas," he told me later, "that got me started painting in blue." Even if the idea came to him in part from certain works of Lautrec or the blue of photographic proofs, blue is, above all, a psychological matter—a return to the self, to life as it is. The world of factitious brilliance, of appearances, which he had tried to express, conflicted with everything he knew. In thinking about Casagemas, he could scarcely avoid the subject of poverty versus wealth: the intrusive contrasts of Montmartre, where abysmal wretchedness coexisted with prodigalities of free spending and high living. Or the gulf between Paris and the deprivations of life in the Andalusian or Galician countrysides or the outskirts of Barcelona. And the poverty which, in the end, might by lying in wait for him.

One can see this in the new self-portrait, *Yo, Picasso,* painted at the end of that summer. The face is surrounded by blue. Swift, elongated brush strokes, like those in the final canvas of the Casagemas suicide series, barely cover the underpainting. Compared to the self-portrait with green shadows, the face appears to have aged some twenty years. Lined and creased, it stares at us with a gaze which carries both the weight of misfortune and the will to confront it. These facial marks are not—as has been thought— meant to be realistic stigmata of misfortune. They are, rather, elements of Picasso's self-vision at that time.[5] From the outset he tried to picture the consequences of final rupture, the end of a life, and considered them in painting. These suicide canvases were to remain his secret. No one, he felt, would be interested in further works on the subject which he still carried in his head.

First he set out to construct a fitting memorial to Casagemas. He began

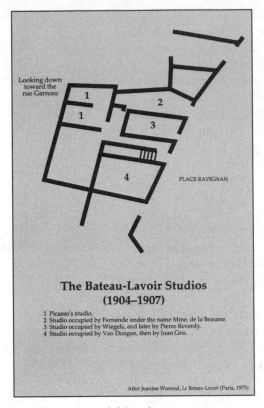

Looking down
toward the
rue Garreau

1
1
2
3
4

PLACE RAVIGNAN

**The Bateau-Lavoir Studios
(1904–1907)**

1 Picasso's studio.
2 Studio occupied by Fernande under the name Mme. de la Beaume.
3 Studio occupied by Wiegels, and later by Pierre Reverdy.
4 Studio occupied by Van Dongen, then by Juan Gris.

After Jeanine Warnod, *Le Bateau-Lavoir* (Paris, 1975)

by sketching a burial, organized like the *Saint Bonaventure on His Bier* which had caught his attention at the Louvre. Zurbarán unhesitatingly uses the saint's body as a diagonal with which to divide the canvas.[6] Picasso does the same thing, but then revises/reorders the Zurbarán, using it as the lower part of a layered composition after the manner of El Greco, another Spanish master whose work he had considered in careful detail. But Picasso was to mix the exaltation of a saint or martyr with a counterpoint of derision or humor, painting a heaven of naked girls. One of these, seen from behind (Germaine, perhaps?), attempts to retain a soul being carried off by a white charger. In the center a mother is surrounded by playing children. The picture is, of course, an Assumption, but an atheistic, even blasphemous one. Sabartès, who arrived in the autumn, saw the big canvas standing like a screen in the little studio and was astounded by it. *L'Enterrement de Casagemas* (The Burial of Casagemas) is now in the Musée d'Art Moderne de la Ville de Paris.

At the end of that summer, Lautrec died. "It was in Paris that I understood what a great painter he was," Picasso later told Antonia Vallentin. Clearly Lautrec's disappearance at the age of thirty-seven—"cursed," like van Gogh—provided food for thought. Lautrec's whiplash line, flat palette, and implacable gaze are all present in canvases which resume, with cruelty or pity, the themes of the spring. *L'Hetaïre,* in this scheme, corre-

sponds to *la Femme au collier de gemmes* (Woman with a Jeweled Neck-lace). *L'Apértif*—a new *Buveuse d'absinthe*—considers decline and sorrow; while *la Femme à la cigarette,* like *Deux Saltimbanques,* is about solitude, with each figure staring ahead, oblivious to the other. The woman in this group has Germaine's knot of hair. Four years later, with *Au Lapin agile* (At the Nimble Rabbit's), Picasso was to paint himself once again as a harlequin beside an actual portrait of Germaine. Again each figure stares ahead, neither noticing the other. The *Femme au chignon* is surely Germaine. She, too, her gaze fixed by some unknowable regret, does not look at us.[7]

Next, in *le Bock,* comes Sabartès with his mug of beer, lost in thought at the bistro. His myopic gaze is a piece of realism, but there is also a shift toward mannerism. In the tapering hands, which stress the expressivity of a dominant blue, and in the contrasting arabesques of the shoulders, there is something of Greco. A break in the clouds (so to speak) illuminates this point: *le Tub* shows a view of the Boulevard de Clichy studio, with a Lautrec poster for May Milton on the wall, and, in the center of the picture, a young blond woman, washing. Picasso always kept for himself this canvas, in which the nude girl is wrapping herself in a peignoir. It held an agreeable memory for him.[8] An arabesque in the manner of Lautrec gives rhythm to the draperies but curves the nude woman in the same way as a similar device used for *La Repasseuse* of 1904 (Woman Ironing), in which the central figure is weighed down by heavy labor. The same line occurs in at least three of the *Maternités* of the autumn of 1901, in which the mother is all protective love for her child.[9] Two others display the formal rhythms already in use at the time of the Vollard exhibition, rhythms also evident in the first *Harlequin,* alone in a café, wrapped in thought.[10] In the cele-brated *Enfant au pigeon* (Child with a Pigeon)—a return to his childhood and memories of his little sister, Conchita—Picasso achieved a concentrated intensity of tenderness. He repeated this emotion in *Enfant à la chaise*—a portrait of a little girl who would go blind, the child of a Spanish friend.[11]

In the paintings of that spring, children were a theme of wonder, of curiosity. Today we know what produced this emotion of charged compas-sion in a painter of twenty. The *Femmes à la fontaine* (Women at a Fountain)—with the background left roughly sketched—are wearing the white bonnets of venereal patients shut up in the prison of Saint-Lazare. The fountain appears as well in one of the maternity canvases cited above, situating the scene in the prison courtyard.[12] Stylistically this canvas is a starting point of the blue maternity series. Instead of the white cap, the mother is wearing a scarf which encloses her face. In future *Maternités* this scarf will become the enveloping Spanish shawl one finds in certain Greco *Virgins,* emphasizing the mannered curve of the mother's body enveloping the child and the rhythms of the cloth's folds. When one sees this sequence in its entirety, it becomes clear that the models for these nativities are venereal prostitutes. Although Picasso, through his painting, saluted these

women in the depths of their degradation, there is no doubt that he thought as well about the fate which awaited their children.

The series includes the cruel realism of the bestial portrait of one of these prostitutes—*la Femme au bonnet*—which Picasso kept. Another version was to be overpainted by the blue portrait of Sabartès. Only a few weeks after the *Gommeuse*, as a daring girl sunk in debauchery,[13] the atmosphere of wild times in Montmartre had completely disappeared from Picasso's paintings. On the contrary, he intensified his descent into hell by painting these draped women in the depths of solitude and despair—venereal prostitutes who have been isolated and imprisoned. According to Sabartès, he did this sequence at the end of his stay in Paris.[14]

Picasso knew Olivier Sainsère, counselor of state and collector, an acquaintance which enabled him to acquire the papers he needed for a stay in France. (The police, suspecting him of anarchism, had refused him, perhaps because of his signature on the manifesto of 1900.) Through Sainsère as well, Picasso met Dr. Jullien, head of the venereal department at the hospital-prison of Saint-Lazare. When I asked him what had prompted his visit, Picasso's first reply was "Free models," avoiding through humor, as was his habit, a subject too close to his deepest feelings. Subsequent remarks indicated a deliberate desire to see the tragic side of the dissolute life which he had painted in the spring. The discovery of Saint-Lazare intensified Picasso's transition to blue paintings of unhappiness. Saint-Lazare did not initiate the process but rather was part of it.

In 1900 Dr. Jullien had just published the first statistical study of 1,000 of the inmates in his care. This revealed that the majority had been infected at the age of nineteen. Next came the eighteen-year-olds; and, finally, those who had reached twenty. He found 651 instances of blennorhea and 421 cases of syphilis. Seventy-two of the women were suffering double infection. There can be no doubt that he told Picasso of these findings as well as of the fact that the majority of syphilitics left the hospital "bleached" but not clean. And what of their children? We can judge the distance, the transcendence Picasso achieves in his painting since it is in light of illness, death, and irremediable disaster for so many young lives that he paints his maternities, rivaling with blasphemy the Christian tradition of his art.[15]

"If we require sincerity from an artist," Sabartès writes, "we don't imagine this quality existing beyond the realm of misfortune. Picasso thinks of art as the child of Sorrow and Pain." This conception is supported by portraits of Sabartès, Mateu F. de Soto, and Picasso himself—all as blue as the imprisoned women and all, compared to their portraits of the autumn, aged by at least twenty years. Picasso saw himself gaunt and emaciated, with a blond mustache and beard. Later he told me that he never had such a beard. He had imagined himself crushed by poverty and had painted not a present reality but a fate which might overtake him. His latest work had just been rejected. "He had not," Sabartès explains, "considered the immediate material consequences of a change *ex abrupto*." Manyac refused to

support Picasso's work any longer and discontinued his monthly allowance, a move which undoubtedly produced Picasso's vision of an irrevocably bearded self, which he drew again a little later sitting with Sabartès and their friends at Els 4 Gats.

In actuality, however, Sabartès let him return to Barcelona alone.[16] Probably, as Sabartès has written, Barcelona meant "a roof and three square meals"; but, as always with Picasso, this return to Spain represented something deeper than that. In his treatment of Casagemas' death, he made a break with the brilliant Parisian world of external appearances he had recorded in his painting—a point stressed by Sabartès. "He was returning to his own identity. He understood perfectly well that what he had been observing had nothing in common with him; and that he had nothing in common with it. . . . One might characterize his blue period as an assertion of conscience."

At the same time, this return to the self led him back to Greco, to Zurbarán, and to the work of poets or writers he had illustrated or published in *Arte Joven*.[17] Those who follow the events of his biography too closely are often confused by the contrast between sequences of work done with meteoric speed and periods of slow, private gestation, the incubation of intellectual or emotional novelty.

To a certain extent his return to Spain began with the *Burial of Casagemas,* followed by visits to the Saint-Lazare prison, the maternity paintings, and portraits of himself and his friends in which the stigmata of poverty are a prominent feature. In Barcelona he continued the sequence of imprisoned women begun in Paris. Not only is there no discernible break in theme—the blue of Barcelona is quickly established as more luminous than that of Paris, a matter of differing local skies—but the painting becomes once again an expression of renewed identity with his deeper feelings, the more profound sentiments of Picasso's work before he committed himself to competitive entries for the exhibition at Els 4 Gats or the Universal Exhibition in Paris. This probably explains the abrupt slowing of production on his return to Spain.

In 1965 I showed Picasso the photograph of a "blue" painting at that time still unpublished. He identified the subject immediately: "That's Germaine, Pichot's wife." In fact, as we know from Gertrude Stein's *Autobiography of Alice B. Toklas,* Germaine didn't marry Pichot until 1906 or 1907.[18] Picasso told me that he painted the picture in Barcelona; and we know that Germaine stayed in Paris. Therefore it's clear that she continued to haunt his thoughts. In portraying her with a small, wild face beneath a vaulted arch reminiscent of the Saint-Lazare prison, is he condemning her easy morals? I think it more likely that he is measuring her, symbolically, against the Saint-Lazare paintings, testing in the features of her face the plastic power of the rhythms in her shawl, the value of contrast and interaction with the curves of the vault. Certainly nothing here is innocent. Since every step he took in Barcelona brought back the memory of Casage-

mas, Picasso uses this picture to express his anger at the woman who had destroyed his friend, who was undoubtedly continuing her life of coquetry in Paris as if nothing had happened. This anger was to be expressed again, in 1903, in the large painting *La Vie*.

The portrait of Germaine in 1902 is further proof of Picasso's difficulties as he tried to readapt to Barcelona after Paris. A letter to Max Jacob, who appears here as Picasso's first and best French friend, gives instances of these. They met at a Vollard exhibition and were immediately aware of strong mutual sympathy. Max, born in 1876, had abandoned his studies—which would have produced a career as a colonial civil servant—to lead a life of bohemian poverty. A misunderstood poet, an eccentric (he would not be published until 1910, by Kahnweiler), Jacob was tormented by his homosexuality, at that time a proclivity which could not be admitted. For Picasso he was an interlocutor who combined patience, brilliance, and generosity of spirit. "I show what I'm doing to my friends the ARTISTS [underlined by Picasso] hereabouts, but they find too much feeling, and not enough form. . . . They write bad books and paint awful pictures. But that's life."

One can almost hear Picasso's voice, employing a purely phonetic French. Next he speaks of a current project—a painting "of a whore, and a mother."[19] The self-portrait which accompanies these remarks is full of lively wit. Pablo is in front of the Barcelona bullring; there is no trace of the aging or the anxiety about poverty which mark the last self-portraits from Paris.

Les Deux Soeurs (Two Sisters), the painting mentioned in the letter, is a quintessence and then a surpassing of the Saint-Lazare sequence of prostitutes as a fundamental investigation of the meaning of life and of the powers of painting. Picasso worked hard on this canvas, and his mannerism is linked for the first time to a form of primitivism, drawing on Gothic sculpture and the theme of the Visitation. Picasso transformed the encounter by making the visitor pregnant. In the final version she carries a newborn infant, whose tiny hand we can discern.[20] In the Oballe chapel in Toledo there was a Greco *Visitation* (today in Washington) Picasso might have seen in 1901. In that version it is the visitor whose pregnancy seems to be furthest advanced, which refers to the Gospel of Luke, who states that when the angel came to tell her she would become a mother, the Virgin was on her way to visit her cousin Elizabeth, then six months pregnant with Saint John the Baptist. In the Greco the two women, draped in blue, meet under the vaulting of Zachariah's house. Picasso used all the plastic elements of this scene to transform its meaning into a particularly shocking blasphemy. In Luke's account Elizabeth salutes Mary as "a woman blessed above all women," and in reply the Virgin intones the Magnificat, a canticle of joy and gratitude. Picasso's commentary on Greco's scene adds a hidden content to an encounter in the parlor of a prostitute's prison, forcefully contrasting the Gothic rigor of the composition with the sordid realities of the

twentieth century. In the seaside maternities,[21] draperies and veils fulfill their functions as part of the design without any references to Saint-Lazare. Picasso expressed sorrow by painting figures from behind: the backs of a mother, a nude, or two courtesans sitting at a bar.[22] He wrapped the same scarf around the body of a dead woman seen at the hospital of his friend Reventos.[23] A pastel dwells on the solitude of a couple in which each ignores the other and turns away from the action which gives the picture its title, *Scène de café-concert*. The picture is an affirmation of the tragic.[24]

None of this interfered with the return of gaiety. Blue became illuminated by the sun of a rediscovered Mediterranean, and in May Pablo saluted the birth of Pere Romeu's son. He did the portrait of Romeu's wife, Corina, and multiplied the image of a dark-haired woman: first standing full face, then as a reclining Venus,[25] and again in front of a mirror with a bubble containing the words "Cuando tengas gañas de joder, jode!" ("When you feel like fucking, fuck!"). Picasso kept the drawing in his own collection. To commemorate a particular occasion? This seems likely. We find the lady again, in tears, on a beach, with an attentive Picasso beside her.[26] A loss of virginity perhaps.

The parody of Manet's *Olympia* dates from the same time. In that picture Pablo, naked, like his friend Sebastián Junyer-Vidal, tried to arouse the interest of a naked woman who this time is black.[27] There are a great many drawings which breathe physical pleasure and prowess: on the business cards of his friend Junyer-Vidal and on every kind of paper, in ink, colored crayon, and watercolor. They constitute a regular theater of the erotic, whose daring is breathtaking for a period still so profoundly Victorian in outlook, and were not, in fact, made public until after the cultural revolution of the 1960s. They provide us with a dimension fundamental to an understanding of the "blue" Picasso: sex—in all its experimental variety—must be recognized, because it is an important element in life and art.[28]

Except for an album of embraces, *Pour Louise*,[29] which is difficult to date and may be from a later period, these brilliant drawings, strongly highlighted, are in a clear, linear style. As Jürgen Glaesemer points out, Picasso was teaching himself to master the modeling of a figure with a single line, a problem he tackled again in his engravings of 1905 and in the reflections which derive from his discovery of Ingres' *Bain turc*. Eroticism as the proving ground of novelty and experimentation is another instance of the artist's desire to strip tradition of every fig leaf. At the same time, this is a counterweight to bourgeois morality and Spanish Catholic prudery, matched by an awareness of poverty and failure. At the end of 1905 and the beginning of 1907, during the creation of *les Demoiselles d'Avignon* we find this awareness wedded to primitivism. This is neither anguish nor remorse; it is recognition. It is transcendence through art and the assumption, through humor, of a certain distance.

Pablo painted his older friend Julio Gonzalez from the top of

Tibidabo, using the same style of drawing.[30] Don José had more or less vanished from his son's life, reappearing when Pablo needed his help—and the help of his Uncle Salvador—to buy his exemption from military service (by paying a substitute). Picasso was not only without patriotic fiber; the thought of an obligatory interruption to his artistic development was clearly intolerable. It was perhaps this problem that kept him in Barcelona; in any case, Palau i Fabre has found in *el Liberal* of 20 October 1902 documentation of Picasso's departure for Paris the previous day, "accompanied by the distinguished artists Julio Gonzalez and José Ricarol."

We know very little about this third visit. Manyac had left Paris, and as a result, Picasso seems to have tried selling his canvases on his own. Some of them were at Berthe Weill's (but not *les Deux Soeurs*). The trip was a setback. On his return to Spain, Picasso left some of the blue canvases in Paris with Ramón Pichot.[31] From Barcelona he wrote to Max Jacob: "I think of the room on the Boulevard Voltaire [where they had stayed at the end of the visit] and of the omelettes with green beans and brie and fried potatoes. But I also think of those days of poverty and that life of wretchedness. The thought of those Spaniards on the rue de Seine leaves a bad taste."

This sums it all up. He had been so cold that Sabartès believed him when he said he had burned his drawings for a little warmth. That, however, was a metaphor. To cheer himself up he wrote an illustrated *Histoire claire et simple de Max Jacob,* dated 13 January 1903. Jacob at long last was receiving a certain amount of money and recognition for his poems.

This trip was not, however, a complete loss. Through Paco Durrio, Charles Morice, the eminent avant-garde critic, had discovered Picasso's genius and written of his feelings in the *Mercure de France,* which replaced *La Revue blanche* as the primary intellectual review.

> Picasso seems to have assumed the mission of expressing all of reality with his brush. One might speak of a young god who wishes to remake the world; but this is a somber god who doesn't smile. . . . Might he not be destined—this child of appalling precocity—to consecrate with a masterpiece the negative power of life, the evil and sorrow from which he—more, perhaps, than anyone—suffers?

Morice, a friend of Gauguin, had published that artist's autobiography, *Noa-Noa,* in 1897 and sent a copy to Picasso. Certainly, through Paco Durrio, Pablo had heard of Gauguin and seen his work; but this was a direct contact with that already-legendary life. There can be no doubt that this discovery made a great impression upon him. He told me that he had covered his copy of *Noa-Noa* with drawings, but that volume has disappeared. In December 1903, learning of Paul Gauguin's death, he signed a nude in the style of his great elder "Paul Picasso."[32]

La Soupe and the sequence of *les Pauvres au bord de la mer* (Poverty at the Seashore),[33] with no discernible break between Paris and Barcelona,

focus once again on wretchedness without hope.[34] But one quickly senses that Picasso's self-confidence had returned. In his new studio—again the room on the Calle Riera de San Juan, where he had once worked with Casagemas—his paintings grew lighter. It was memory perhaps which led him to conceive in the beginning of May a view of the studio including himself, naked, much taller than he really was, and a young female companion, also naked, who has flung her arms around his neck. The young woman's face is strongly reminiscent of Germaine. On the easel one sees an exhausted couple; and to the right, an old artist, in whom Palau i Fabre recognized the profile of the sculptor Fontbona,[35] seems to be announcing the existence of misery. In finishing the canvas, Picasso put Casagemas beside Germaine, while the solitary mother holding her baby occupies the position of the old artist. This time, instead of being lost in thought, she stares at the couple with anger. A second canvas, on the floor beside the easel, reiterates the man's exhaustion. We know now from X-rays that Picasso painted this picture, which he called *la Vie* (Life), over the famous *Last Moments* of 1900, which closes the Casagemas cycle with the memory of his friend and with a symbol.[36] We can almost hear Picasso telling us, as he told Max Jacob about *Deux Soeurs:* "C'est la vie, c'est ça" ("and that's what life is").

Clearly Germaine still haunted him; but here, instead of suffering imprisonment as in 1902, she is naked, frightened, perhaps even repentant. She is exposed, as well, to the reproachful gaze of a mother holding her baby, a figure who seems to have stepped from the cycle of Saint-Lazare and the *Deux Soeurs*. The theme of maternity now disappeared and would not return until 1904, transformed into the joyful paternity saga of Harlequin-Picasso. *La Vie,* like *Deux Soeurs,* probably has a religious or antireligious subtheme. We are witnessing, after all, the resurrection of Casagemas, summoned by the studio of the Riera de San Juan but laicized by the title *Life.* There is surely an echo here of Gauguin's questions—"Where did we come from? Who are we? Where are we going?" And this must derive from the encounter with Charles Morice. Just before this Pablo had finished the extraordinary pastel—about a meter in height—*l'Etreinte* (The Embrace), in which the exhausted couple is standing, the man and the pregnant woman clasping each other and weeping.[37] His drawings portray a crucified Christ, surrounded by couples or by the celebration of a woman.[38]

On 4 June *el Liberal* celebrated the sale of *la Vie* for "a tidy sum," stressing that "the work of this artist has a strength and intensity which permit the claim that it belongs to the small number of truly significant paintings produced in Spain." Unfortunately, all we know of Jean de Saint-Gaudens, the collector from Paris who bought the picture, is his name.[39] *La Vie* is the testament of Picasso's blue period, even if subsequent months were to produce a flowering of masterpieces.

Stimulated, perhaps, by the rapid sale of *la Vie,* Picasso seems to have thought about making money. He painted his tailor's family and watercolor

evocations of life at Horta de Ebro, although we don't know if he went back to stay with Pallarès. There were, as well, some more female portraits.[40] An August issue of *el Liberal* illustrated the review of a book on the Paris Exposition of 1900 with drawings reminiscent of Eugène Carrière, Puvis de Chavannes, and Rodin's bust of Dalou.[41] This may be the origin of Picasso's sculpture *Chanteur aveugle* (Blind Singer).[42] In any case, thinking about Rodin liberated the expressivity of strongly modeled canvases like *le Repas de l'aveugle* (Blind Man's Repast) and *l'Ascète* (The Ascetic). *Le Vieux guitariste* (The Old Guitarist) achieves a quality of passionate rhythm after the manner of El Greco. *Le Vieux Juif* (The Old Jew) reverts to a certain sentimentality, but the disquieting mastery of the impeccably realistic portrait of an old woman with a cataract brings us the unforgettable *Célestine*.[43]

A new sculpture, *Picador with Broken Nose*, stresses how much Picasso needed separation from ordinary appearances, a need which produced the extraordinary watercolor *el Loco* (The Mad Man) and the idiosyncratic views of Barcelona. Picasso kept for his own collection the most remarkable of these, *les Toits* (The Roofs), in which the night blue is organized into an abstract structure. The picture was photographed for the catalogue of 1900–1906, and till the end of Picasso's life it hung in the sitting room at Picasso's estate in Mougins.[44] *El Loco* was dedicated to a painter friend, Sebastián Junyent (not to be confused with Junyer). Picasso's portrait of Junyent, like that of *Célestine*, is done with all the delicacy of a miniaturist. He seems in this period of 1904 to have experienced a sudden attachment to realism. In any case the two final portraits of that time, *Luis Vilaro*, and *Sabartès*, show both of these gentlemen dressed in high bourgeois style, with false collars and ties. They have nothing of the mannered bohemianism that marked the previous year's portraits of *Angel de Soto* or *Sebastián Junyer-Vidal*.[45]

These works were perhaps Picasso's way of testing whether he could earn enough from such efforts to support himself. We know from Palau i Fabre that Pablo left again for Paris on 12 April 1904. It is also a fact that, as usual, Picasso devoted much time and effort to his preparations and set out heavily laden with all his recent production. Perhaps he already knew he would not return. The illustrated account in which he describes his journey with Sebastián Junyer-Vidal (or perhaps imagines it—in his case one can never be entirely sure) is lively and cheerful. He says that he expects to get good prices for his work.[46] He clearly had no idea of the revolution about to explode in the world of Paris painting, or that, within two years, he himself would be in the thick of it.

LOVE AT THE BATEAU-LAVOIR

1904–1905

Picasso settled down in that curious structure whose top story opened onto the place Ravignan, on the peak of Montmartre, while the other floors were reached through a different entrance some twenty meters below, in the Rue Garreau. Max Jacob gave the building the name by which it is known to history: Bateau-Lavoir (Laundry Barge). Picasso took over Paco Durrio's studio when the latter moved to new quarters in the impasse Girardon, where he could have a kiln for his ceramics. Picasso's new studio was on the top floor, which meant that with its large panes, the place roasted in summer and froze in winter. And for the first time in Picasso's history, one hears an intimate feminine voice. Fernande Olivier, who was living in the building, met him during the summer of 1904. By the end of 1905 they were sharing life.

This voice at first expresses astonishment: "Everything exuded a sense of work; but work in such a mess, my God!"

She describes what she found:

> In one corner, a box spring on four legs. A rusty cast-iron stove with a yellow earthernware bowl on it, used as a hand basin. Next to it, a deal table with a towel and a butt end of soap. In another corner, a wretched little trunk painted black made a far-from-comfortable seat. And then a rush-bottomed chair; several easels; canvases of every size; tubes of pigment scattered about the floor; brushes; tins of oil; a bowl for nitric acid; no curtains.

In this instance, we can accept Fernande's account absolutely as well as her explanation that Picasso preferred to work at night, with an oil lamp because there was no electricity. By day the place was "a steady parade of Spaniards." She describes Picasso's "gang," which had instantly regrouped. There was Manolo, "bohemian; a bit of a wag; always on the lookout for a place to sleep, a meal, a crafty dodge of one kind or another that had something in it for him"; and Pichot, "who looked like Don Quixote, full of wit; a steely ironist with a heart of gold"; and Canals, whom Picasso

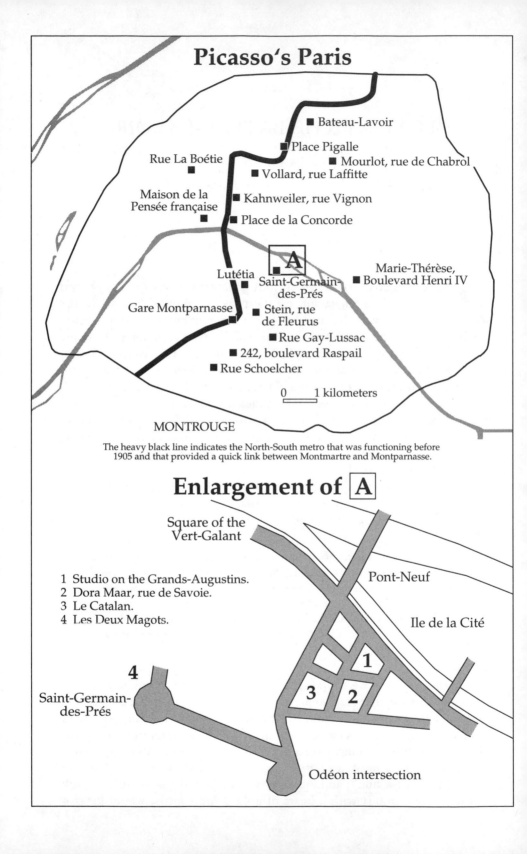

Picasso's Paris

- Bateau-Lavoir
- Place Pigalle
- Rue La Boétie
- Mourlot, rue de Chabrol
- Vollard, rue Laffitte
- Maison de la Pensée française
- Kahnweiler, rue Vignon
- Place de la Concorde
- Lutétia
- Saint-Germain-des-Prés
- Marie-Thérèse, Boulevard Henri IV
- Gare Montparnasse
- Stein, rue de Fleurus
- Rue Gay-Lussac
- 242, boulevard Raspail
- Rue Schoelcher

0 1 kilometers

MONTROUGE

The heavy black line indicates the North-South metro that was functioning before 1905 and that provided a quick link between Montmartre and Montparnasse.

Enlargement of A

Square of the Vert-Galant

Pont-Neuf

Ile de la Cité

1 Studio on the Grands-Augustins.
2 Dora Maar, rue de Savoie.
3 Le Catalan.
4 Les Deux Magots.

4

Saint-Germain-des-Prés

1

3 2

Odéon intersection

continued to see for instruction in the arts of engraving, and his wife, Benedetta, *"la belle Romaine,"* a former model for Degas. Except for Benedetta and Marie Laurencin, who in 1907 became the lover of Guillaume Apollinaire, Fernande has eliminated women from her recollections, including Germaine, who was still to become Mme Pichot. Fernande had wished to be Picasso's first steady lover, an ambition which she more or less realized. I can still hear Louis Aragon telling me, as if it were a secret, that "Picasso had no youth." And, until Fernande's death, in February 1966, Picasso said nothing to correct this legend. He refused, in any case, to discuss her memoirs, whose publication he had tried to prevent.[1]

In fact, after his arrival at Bateau-Lavoir, Picasso's life was far more eventful than Fernande would have us believe. A drawing—today at the Musée Picasso—dated *agosto, 1904,* depicts an embrace between a woman with Fernande's almond eyes and a man with Picasso's back, a drawing which he kept and which has the character of intimate disclosure. Fernande claimed to have met Picasso one stormy evening; Palau i Fabre found a newspaper account of a storm in Paris on 4 August. One would assume that this drawing is of Fernande. But there is a complication. One day in 1968, when I arrived at Mougins, Picasso brought out from the studio a remarkable portrait in profile, a picture which had long been lost and which he had just found, caught in the frame of another picture in his collection.

"It's Madeleine," he said, noticing my surprise. "I almost had a child with her. . . . You imagine me with a sixty-four-year-old son!" which takes us back to 1904. Maternity as a subject was strongly expressed in his work at that time. In the splendid gouache *Maternité rose,* the woman, with her sharp-featured face, resembles Madeleine far more than Fernande. And in the preliminary drawings, dated 7 September, the blurred face is not Fernande's. There is another drawing of the same date: a standing couple, embracing. Here, too, the faces are blurred, but the woman's body is as ardent and lithe as that of a figure in the watercolor *Deux Amies* (Two Friends), of two female nudes. In the latter drawing, the woman—moving toward a bed in which her female companion awaits her—has Madeleine's face.[2] Madeleine, of whom I know only that she was a model, painted in 1907 by Vasquez Diaz as *Madeleine, Amie de Picasso,* was perhaps a lesbian. Nonetheless, she released in Picasso a romantic saga of paternity, with Harlequin representing the artist, which would be a theme until March 1905.[3] When one considers Picasso's passionate interest in infants and maternity in his paintings of 1901, one can speculate on the ramifications of this adventure with Madeleine. One can also see how heavily he relied on art to provide what life has denied.

Fernande, as we know from her *Souvenirs intimes,* published in 1988, continued certain liaisons which Picasso must have known about, since she was his neighbor at the Bateau-Lavoir. This changes the standard version of the affair's prehistory, a phase which was to last for about a year. Fernande writes:

One Sunday, under a burning sun, I took my things over to Picasso's.
A whim had thrown me into your arms one stormy day. Then, suddenly,
I withdrew, and you suffered from that for months. . . . Then I called
you. You were working, but you dropped your canvas and brushes and
came running. I borrowed the little trunk of blackened wood you had
brought from Barcelona, and stuffed into it, pell-mell, scarves, trinkets,
clothes.

According to Fernande, this happened on the inaugural day on Mont-
martre of the statue of the Chevalier de la Barre. Krill—as already noted—
dates this as 3 September 1905, while Palau i Fabre gives 4 August 1904. We
shall see that in the interval Fernande spent much more time in Picasso's
studio than her written account would lead one to suppose. We should, at
this point, reconstruct her past, which has until very recently been incor-
rectly reported.

Fernande claimed to have been abandoned by her parents. Brought up
by an aunt who terrified her, she allowed herself to be carried off by
Paul-Emile Percheron, the brother-in-law of a friend. "And what followed?
A night of horror, of fright, and disgust. . . . I paid dearly for this whim;
my life was indelibly marked by it." She was forced to marry on 8 August
1899, shortly after her eighteenth birthday. In the spring of 1900, following
her child's death, she moved into the Bateau-Lavoir with the sculptor
Laurent Debienne, whose pseudonym, Gaston de la Baume might well have
been chosen by Fernande herself. Fernande first appears at Bateau-Lavoir
as Mme de la Baume. Picasso thought she was married to la Baume when
in fact, at her death, she was still the widow Percheron. "I couldn't remarry
until I found my husband and got a divorce. But nothing in the world would
have made me confront that man again."

Traumatized by Percheron's brutality, she claims to have been frigid
until she met Joaquim Sunyer (1875–1956), one of the painters of the
Spanish colony who was influenced by Degas and Bonnard. She became his
"consenting and loving mistress: physically loving only," and she gives a cry
from the heart: "How complicated men are, sexually." However that may
have been, Debienne did not abandon his pursuit of her; it was in the course
of that affair that she met Picasso. "I can't make up my mind," she writes,
"to go and live with Pablo. He's very jealous. He has no money at all, and
doesn't want me working (as a model). . . . I feel restless as soon as I'm not
alone. I'm never bored by a book; but a lover often makes me restless,
troubles me."

I will add that from confidences Pablo made to me I have always
thought that Éva, who became his mistress in 1912, gave him a kind of
physical contentment which far exceeded anything he had previously
known. Much later, Gertrude Stein, who watched the Fernande-Picasso
coupling with the eye of an entomologist and a lesbian, wrote: "Picasso said
a marvelous thing about Fernande: he said her beauty always held him."
And that is probably the key to their union: the fascination of an artist with

a body which set him dreaming. As for the rest, as Gertrude records it, "He could not stand any of her little ways." This didn't stop Pablo from being jealous (a jealousy also deriving perhaps from Fernande's flirtatious manner—the coquetry of the frigid). One day Picasso found her at Au Lapin Agile, the best known bistro on the Butte, founded by the famous chansonnier Aristide Bruant and owned by his successor Frédé. She had gone there without him. "I got the most unexpected, heavy-handed slap," she writes, "and felt myself brutally shoved from the place, which was taboo. . . . I don't think I just took the punishment without any reaction; but I don't remember what the reaction was."[4]

Madeleine was present far more than Fernande during the development of what is called the rose period and work on the engravings which followed *Saltimbanques*. But Madeleine was not the only alternative. Among the sharply pointed female faces of the time is that of Alice Princet. Two handsome ink portraits are dedicated to her, their workmanship clearly indicating the middle of 1905. Her lover was an insurance agent. Fernande gives her impression:

> The Princet pair: sad, so sad. He, his thin face consumed by a strong, reddish beard, never lost his expression of malicious irony. She, very pretty, dark, with smooth, matte skin and a willful, passionate mouth, was the opposite of her husband.

There was an affair between Alice and Picasso. She was twenty and had been living with Princet since the age of seventeen. She spent her time with the Spaniards of Montmartre. Another detail Fernande omits is that at the end of 1905 or the beginning of 1906, Alice was to enter the life of André Derain. Gertrude Stein tells the story:

> no sooner were Alice and Princet married (only in 1906) than Alice met Derain and Derain met her. It was what the French call a *coup de foudre,* or love at the first sight. They were quite mad about each other. . . . Within six months after the marriage, Alice left Princet never to return.

That was probably in the summer of 1906, when Derain left for l'Estaque. A letter from Apollinaire to Picasso, sent to Gosol in May, says that Alice is still with Princet.[5]

A photograph taken by Ricardo Canals in 1904 shows Picasso, his eye more determined than ever. Still very close to adolescence in his physical appearance, he is dressed with great care, in an art student's velvet jacket and a flowing tie. The poet André Salmon, who was the same age as Picasso, was brought to the studio by Manolo:

> The oil lamp gave very little light. To paint, to show his canvases, he needed a candle, a wavering light which Picasso held high over our

heads, introducing me humanely to his extrahuman world of the starving and crippled; of mothers without milk; the suprareal world of Blue-Period misery.

An observation which is not confined to the paintings brought back from Barcelona. The new version of *la Repasseuse* (Woman Ironing) and a *Couple de misérables* add to a blue hell all the mastery Picasso had now acquired. Dedications indicate that a drawing of an old man, abandoned and without hope, was done in May, and the proof of the *Repas frugal* given to Junyent in September.[6]

In fact, the *Repas frugal* of 1904 represents an amazing technical breakthrough. This is Picasso's first true engraving, and it is a masterpiece. It is on zinc—a cheaper metal than copper—probably a piece of zinc already used by Canals, who was Picasso's teacher. In any event, as Roger Passeron tells us, the engraving on steel done for Vollard in 1913, "reveals the leafy components of a landscape." It is remarkable that every time Picasso uses a new engraving technique, the trial run is a masterpiece. This derives from the feverish intensity of discovery which has always been an element of his fabulous virtuosity, and has always driven him to outdo himself. It is also a product of the extra stimulus he received from manual work, from his extraordinary artisan's skills. For the rest of his life, gravure, with all its technical possibilities, would be a favored activity, provoking an unequaled imaginative freedom. It also supplied fresh challenges to overcome and often tests for the eye and the hand equal to any provided by painting or sculpture. The scope and importance of gravure for Picasso has often been underestimated, particularly because Picasso tended to concentrate on the challenges of the work, leaving the diffusion of his results—the labor of of making them known—to Vollard or Kahnweiler.

As I've said, the dry point on copper *Tête de femme de profil* is Madeleine. And this establishes her presence at the beginning of 1905. Her arrival was undoubtedly responsible for lightening the blue, but she had not broken it, except for a touch of pink on the lips of the *Femme au casque de cheveux* (Woman with a Helmet of Hair). The celebrated gouache *Deux Amies* (Two Friends), two seated female nudes, remained blue and stresses the degree to which Picasso ascribed to his mistress a taste for members of her own sex. But it is extremely difficult in this period to identify in Picasso's drawings, prints, or paintings what is fantasy and what is real.

His commitment to Fernande, undertaken in the month of August, is reflected in a departure from blue. A warming of the palette is evident in the portraits of Gaby, wife of the actor Harry Baur; of Suzanne Bloch, the singer; and of friends like Manolo and Sebastián Junyer. It is even more notable in the mannerism which characterizes two portraits of the daughter-in-law of Frédé, and again in *Femme à la corneille* (Woman with Crow).[7]

In all likelihood the winter which Fernande describes, when they were

alone with Charles Dullin (future actor and renowned theatrical director) without money or coal, unable to celebrate the Christmas and New Year holiday, was the winter of 1904–5. Picasso seized that moment to draw studies of Fernande's face, part of his preparation for the large painting *l'Acteur,* whose central figure is as tall and well built as Dullin was puny. Olivier Sainsère, who came to see them during the opening days of 1905, bought some drawings from Pablo for three hundred francs. Two of these—blue drawings—reflect a first effort at shared life with Fernande or at the least are meditations on that possibility. The first, dated 1904, shows a hirsute man in deep reflection as he watches the naked Fernande, drying herself with a towel. The second, *la Saisie* (The Possessed), shows a young mother overwhelmed by anxiety, a slender young father, and a little girl, who shares their sadness. The mother sits on the famous black trunk which had come from Barcelona. This is perhaps the first image in what I call the saga of Harlequin's paternity.[8]

Is this the same big man whom a watercolor depicts leaning over a naked, sleeping Fernande and contemplating her? Is he the model for *l'Acteur?* Is this perhaps Debienne, whom Fernande describes as having an excessively prominent nose jutting "out of proportion to those thin cheeks engulfed by their stiff, overly black beard"? Another watercolor shows Fernande naked and sleeping, but this time under the questioning gaze of Picasso.[9] In a drypoint done with Max Jacob from early 1905 Picasso/ Harlequin brandishes a skull, Hamletlike, in the smiling face of Fernande, whose hair is decorated with the erect serpent of the pharaoh's crown.[10] Is the skull, as Reff thinks, a memento mori directed at Fernande and her coquettish ways?[11] Or does the serpent, on the contrary, turn her into a temptress who is dangerous to the liberty of Picasso/Harlequin? This "sentimental" period in his painting, as Picasso called it, reflects the uncertainties of a heart linked to Fernande until September 1905, a liaison which was liable to periods of eclipse.

In the final months of 1904 Picasso immersed himself in the saga of Harlequin's paternity, an account in which—as in *la Saisie*—the mother does not resemble Fernande. The subject is displayed and considered in the pink *Maternité,* radiating happiness. The sketch for this picture is dated 1904 and the celebrated gouache, 1905. This brings us to the turning point between the two years.[12] The cycle moves through the gouaches of *Famille d'arlequin,* in which once again we find the little black trunk. Harlequin here is an affectionate father to the baby.[13] In the *Famille d'acrobates avec un singe* (Family of Acrobats with a Monkey), which was to enchant Leo Stein,[14] the baby is adored by both parents.

Picasso had surely identified himself with Harlequin, already with Germaine, in *Deux Saltimbanques au Bistrot* of 1901. In this 1905 picture, Harlequin permits Picasso to be a spectator of his own dreams. He had quickly become a regular at the Cirque Médrano at the foot of Montmartre. Fernande tells us that he would "spend the evening at the bar, which was

permeated with the hot, faintly nauseating smell of the stables, swapping stories with the clowns. He admired them, and felt a real sympathy for them." But beyond Picasso's sympathy with clowns, Harlequin increasingly personifies the wandering life. This is striking, and curious, because Picasso was always more or less sedentary. One guesses, however, that a desire to leave—to rove—haunted him with increasing frequency. He satisfied this craving by going to Holland that summer—if his diary can be believed, the only trip of the kind in his life. But above all he satisfied it in painting.

He began with *Famille d'acrobates,* a gouache which became an etching, and is today at the Baltimore Museum of Art. Harlequin and the other figures in the group are shown at a typical traveler's stopover. The wandering life was increasingly a subject of painting both before and after the trip to Holland. This was made clear during the exhibition "Picasso, The Saltimbanques" at the National Gallery in Washington in October 1980. X-rays confirming Fernande's precise recollection revealed that the first version of the *Famille de saltimbanques*—the primary masterpiece of the period—was an enlargement of this *Famille d'acrobates.* Fernande, who was a regular presence in the studio in the spring of 1905, asserted that "the canvas was totally changed several times."[15] An intermediate version, disclosed by the same X-rays, substantiates this. The theme at this stage was taken from the painting *Deux Saltimbanques avec un chien* (Two Acrobats with a Dog), which had been shown at the Galeries Serrurier. This takes us back to the spring, when Picasso painted over his 1901 *Portrait d'Iturrino* a close-up of *l'Acrobate à la boule,* another element of the *Famille d'acrobates.*[16] The detailed landscape behind him resembles the wild hill country between Málaga and Almería, which Pablo had known since childhood. The fat Spanish buffoon Don José, or el Tio Pepe, must have caught Picasso's attention at this moment. Around this figure he sketched another version of the family of acrobats, lined up by height, as for a group photograph.[17] E. A. Carmean, Jr., called this part of the project *Portrait du cirque.*[18]

In the notebook which includes the fat buffoon is a date: 3 Mayo, 1905.[19] Is this a reference to Goya's big canvas (266 x 345 cm.) *3 de mayo?* Two pages further on, Picasso notes "234/222," probably the initial dimensions in centimeters of his *Saltimbanques* canvas. This, in my view, indicates not that he had just bought the canvas[20] but that he was comparing its dimensions with those of his great predecessor's. Picasso always measured himself against masterpieces. We have another point of reference to the period. Jean-François Rodríguez has established that on the insistence of his friend Zuloága, Spanish representative to the Sixth Venice Biennale, Picasso was invited to participate as "an impressionist of the future."[21] During the sale of the gouache *Acrobate et jeune arlequin* (which received a record thirty-eight million pounds) at Christie's in London on 28 November 1988, a Biennale label was found on the picture's back.[22] This, then, is the picture that was sent to the Biennale and returned without being shown.

Its dimensions—105 x 76 cm.—suggest the importance Picasso attached to it. The gouache disturbs and saddens with its confrontation of the generations, which in the final version is softened by nostalgia.

Like the largest independent canvas on the subject—*les Deux Arlequins,* at the Barnes Foundation—the gouache was not included in the galeries Serrurier's exhibition of 25 February 1905 on the saga of Harlequin's fatherhood,[23] probably because it was a later work. In his preface to the catalogue for the exhibition, Charles Morice recalled that by the age of twenty, Picasso already possessed an "alarming certainty of line" and saluted the fact that "through some benevolent anomaly, the spleen of the blue period has been succeeded by sudden light." And, most important, it was at this moment that Guillaume Apollinaire appeared in Picasso's life—another friendly critic whose supportive presence would be crucial. They had known each other since the end of 1904, but their intimacy dates from this moment.

Apollinaire was born in Rome, on 26 August 1880, some fourteen months ahead of Picasso himself. Shortly after birth, he was recognized by Angélique Kostrowitzki—then twenty-two years old—as her natural son. When he arrived in Paris, in October 1899, his foreigner's identity card described him as 1.65 meters tall, with blond hair—scarcely taller than Picasso. At the age of twenty, when he was working as a tutor to the daughter of a minor Norman squire, he fell in love with the young-lady companion of the establishment, an English girl, Annie Playden. This conjunction was to produce a masterpiece—*la Chanson du mal-aimé* (Song of an Unbeloved)—and for Guillaume some traveling as well, which resulted in a good knowledge of Germany, Bohemia, and Austria. In Paris he made a living as a journalist and had his poems accepted by *la Revue blanche.*

When Picasso and Apollinaire met, the latter's restless spirit and his fecund talent—already clearly out of the ordinary—combined to recommend him to the literati of the younger generation (as had not been the case with Max Jacob). This meant, most particularly, the group that met at the Closerie des Lilas, near Montparnasse, where poets like Jean Moréas and Paul Fort held court in the company of painters like Gleizes and Metzinger, who would be Cubists after 1910. The socialist chronicler Alexandre Mercereau—who shortly thereafter became a defender of modern art and introduced Matisse to Russia—was also a regular participant. In March 1905, Paul Fort began to publish a review, *Vers et Prose,* of which Salmon was deputy editor.

Very quickly Pablo discovered that Apollinaire and he were both curious about everything, and the poet became one of his most privileged interlocutors. Apollinaire seemed to embody the larger spirit.

The buffoon could not be, as has been thought, a transposition of Apollinaire. First of all, in 1905, the poet was still quite thin and as filled with the dazzling spirit of youth as Picasso himself. But above all, as Sabartès writes, he embodied the larger spirit of poetry "with his cultiva-

tion, imagination, and intelligence: three virtues essential to the milieu Picasso preferred, and three elements essential to the spirit of the revolutionary movement then in formation." By contrast, "Max was an example of the perennial, the constant in promises." But, Sabartès adds, both of these were

> for Picasso, the great actor of the theater of plasticity, spectators of the most brilliant character. Apollinaire's poetry, the ideas, witticisms, and jokes of both men constituted—for him and even more for his work— murmurs of approbation and echoes of applause. . . . One might say that the ball was tossed between them, passing from hand to hand without pause—an exercise which was profitable to all three.

The fireworks of jokes and puns, of verbal prestidigation was for Picasso not only an element of relaxation but of intellectual excitement.

Apollinaire contributed a dimension of fantasy quite different from that of Max Jacob. He was a friend of Alfred Jarry, and would introduce Jarry into what was becoming the new *Bande à Picasso*. Although Picasso never met Jarry in person, he was delighted by the cruel humor and sense of mystification which characterized the author of *Ubu roi* and *le Surmâle,* and by the erotic curiosity which drew Jarry to Apollinaire. Their relationship has been perceived too often through the stories of Max Jacob, who tended to exaggerate Jarry's eccentricity. This, in my opinion, led both Ron Johnson and Patricia Leighton to exaggerate his influence on Picasso. Apollinaire was the catalyst who transformed Jarry's flights of fantasy with his sharp, truculent lyricism, bringing to French poetry a conversational immediacy and a sense of emotion, alternately tender and ludicrous, and a delight in wordplay which was very like Picasso's own. In the same way he was able to heighten André Salmon's free, almost popular verve to the level of educated poetry. In talking to Picasso, I always had the impression that Apollinaire was the congenial friend with whom he could share everything, the friend no one else ever replaced.[24]

One should read Apollinaire's accounts of Picasso as if they were reports of their conversations in the studio. One can see this in his first article in *la Plume*, of 15 May 1905, in which he reports on the February exhibition. He notes that "paternity transfigures Harlequin" and that "love is good when one ornaments it; and the habit of living at home intensifies paternal sentiment. The child brings the father closer to the woman, whom Picasso wishes to be glorious and immaculate." (This is true of the gouaches.) He adds: "One must not confuse these mountebanks with actors. One should observe them with pious respect, because they are celebrating mute rites with a difficult agility. . . . This Spaniard batters us like a dry cold. His meditations strip themselves naked in silence."

In the work brought back from the summer's Dutch adventure, it is precisely this silence which is striking. Picasso, to leave his studio, must

have been torn by the difficulties of the big canvas with which he hoped to create a masterpiece. It is probable, too, that he was having difficulties with Fernande, because, when he decided to leave, he gave the studio "to Salmon, and to friends," not to the woman who was his neighbor. Later he explained to Palau i Fabre that she wasn't able to come with him because she was married. Whatever the reason, he leaped at the opportunity offered him by a young writer, Tom Schilperoort, who had just inherited some money. Picasso borrowed from his friends and left Montmartre for the country of Rembrandt, probably in early June.

He visited Alkmaar, in the northern dunes—the height of deracination for this Malagueño. He records the various surprises of the experience in his notebooks, soaking up the picturesque qualities of the district, which is unusual for him, even noting the shapes of the houses. One can find them in his finished work, done with strong plastic solidity and freedom of color, as in the gouache *Trois Hollandaises* or the sculptural nude *Hollandaise à la coiffe,*[25] which has a misleading resemblance to Fernande. Later he dedicated this picture to Paco Durrio, perhaps because of its powerful Gauguinesque contours. Removal to foreign territory brusquely stripped him of anecdotal sentimentality.

And it is now, in my opinion, that the transformation of the *Saltimbanques* theme occurs, a transformation we can see in a gouache which today is in Moscow.[26] The "wandering" theme, submerged and implicit in *Deux Saltimbanques avec un chien,* suddenly dominates the group, which has been joined by the fat clown and a traveler, who is seen from behind, holding the hand of a little girl. He appears to be on the verge of departure, to be separating himself from the others. There are no women. In the background a racecourse is visible. Were these meditations provoked by the solitary journey to Holland? In the present-day canvas[27] the smallest of the young acrobats wears a tunic which seems to have been borrowed from another painting about errancy—Manet's *Vieux Musicien* (Old Musician). Picasso could have seen this work only at the Salon d'Automne, which suggests that he had already begun to work on his own painting when Fernande moved into the studio in early September. She is, perhaps, a model for *Femme de Majorque,* a work of this period. Transformed, with a face closer to those of the young mothers at the start of the year, and positioned in the right foreground, she gives the canvas its foundation. The nudity of the landscape behind her suggests Spain. The other change is a jolt: the traveler becomes Harlequin, with the tallness Picasso attributed to himself in sketches for *la Vie.* That he is holding the hand of a little girl resumes the theme of paternity. He stands apart from the others, outside their group. Will he meet them, join them? Or is he separating himself from them for a life of ceaseless wandering? As we know, this painting was to inspire Rainer Maria Rilke.

Another canvas, *Au Lapin agile,*[28] portrays Harlequin as a stranger to the society surrounding him—this time very recognizable as Picasso filled

with bitterness. Because of its color, I am tempted to assign this picture to the same period. In the background Frédé plucks his mandolin; in the foreground Picasso/Harlequin, lost in thought, holds a glass. Between Frédé and Harlequin is a young woman of striking elegance, with a hard face. She, too, seems oblivious to everyone else. Later Picasso told John Richardson that she was Germaine.[29] This return to four years earlier, to the confrontational solitudes of *Deux Saltimbanques au bistrot,* indicates that he and Germaine have nothing more to say to each other.

The point is clarified by a chronological correction found in a notebook at the Musée Picasso. The notebook dates from the autumn of 1905 and contains the germ of the theme of *la Coiffure*[30] and studies of Harlequin flinging Columbine the farewell kiss one finds in *Les Noces de Pierrette.*[31] This canvas, known to have been blue, and traditionally thought to date from 1904, was believed to have vanished during the Second World War. It reappeared in Sweden in 1988 and was sent to Paris for sale at the end of November 1989. Fetching a price of three hundred million francs, it met the record set by *Autoportrait* in 1901. Launched at the end of 1905, this marriage of Columbine to a rich old man marks the end of all the adventures of "blue" youth, which is probably why in this instance Picasso once again used blue as a dominant color. The workmanship, however, is markedly different from that of earlier canvases. The incomplete forms and the raw effects of the pictorial material, down to the trickling of the paint, heightens the atmosphere of mystery and emotion. The work also records Picasso's farewell to everything he had painted during his sentimental period. On the back of the pasteboard on which in 1901 he had painted *Femme assise dans un jardin* (Woman Seated in a Garden) he sketched in the opening days of 1905 the preliminary design for the gouache *Mort d'arlequin* (Harlequin's Death).[32] This work forcefully represents a rupture with all the themes that until then had inspired his painting. Harlequin had to die before Picasso could paint *les Demoiselles d'Avignon.* But certainly it cannot be said that the first time a woman moved into his studio Picasso felt transported by happiness.

Harlequin will come back to life in 1908, at the time of the banquet for Douanier Rousseau and the beginning of the *cordée* with Braque, when Picasso's painting turns to Cubism. At the death of Éva in 1915, he marks the end of the great love associated with the revolutionary breakthroughs of 1912–14. And in the *Trois Musiciens* of 1921, he personifies a farewell to youth, and to companions in poetry. He is the double who enables Picasso to measure himself against his highest—and his most humble—human requirements.

PART TWO

TO THE AVANT-GARDE

More than ever, Picasso seemed, as Gertrude Stein re-
marked, like a little toreador leading his retinue, or, as she
was to say later in her portrait of him, like Napoléon,
followed by four enormous grenadiers. Derain and Braque
were both very tall; Apollinaire, tall and stocky; and
Salmon certainly wasn't small. But Picasso was the leader,
from head to toe.

—Gertrude Stein

6

DECISIVE ENCOUNTERS

1906–Early 1907

P icasso had caught the attention of important critics like Félicien Fagus, Gustave Coquiot, and, above all, Charles Morice. And through Apollinaire he was included in convivial evenings at the Closerie des Lilas.[1] But he had kept within the confines of the Spanish colony and of the bohemian group at Bateau-Lavoir and, paradoxically, had not yet encountered any important artist of his generation. In a period of two months in the autumn of 1905, he was to break through his isolation and poverty and enter the avant-garde. By May 1906, when he left for Gosol, although his acquaintance with Derain and Matisse was still very fresh, he had nonetheless perceived the point of their more radical efforts and understood what they were aiming at. On his return to Paris, he felt that he could meet them on a level footing and quickly conceived the notion of surpassing their audacity—a resolve which produced *les Demoiselles d'Avignon* in 1907.

At this point in his development, Picasso overturned—with a speed which is uniquely his—the conceptions that had previously informed his work.

The initial event in the sequence was the third Salon d'Automne. Picasso had certainly visited the second of these—the Salon of 1904, still heavily influenced by pointillism—and found it dull. On the other hand, the uproar of the 1905 Cage aux Fauves was directly and immediately interesting to him as he had already—in 1901—anticipated these paintings of strident color. The green in the face of *Femme au chapeau* (Woman in a Hat)—the portrait of Mme Matisse which had provoked a kind of insurrection—suggested the use of green for Picasso's own self-portrait of 1901. But for him the true novelty was the Manet retrospective, which allowed him to survey the trajectory of that artist, the creator of *Déjeuner sur l'herbe*. And Ingres' *Bain turc*, sequestered for over forty years in inaccessible private collections, was a revelation.

As we have seen, Picasso used elements taken from Manet in his *Famille de saltimbanques*. The influence of Ingres, however, worked on him in a different way. After his death in 1867, Ingres was transformed by his

disciples into an apotheosis of virulent academism. The *Bain turc* proved
that this view of the old painter censored not only his eroticism (which, for
the height of the Victorian era, was quite remarkable) but also disregarded
his exceedingly modern infractions of rules, an example of the latter being
a freedom—even abandon—of perspective as deliberate and significant as
anything ever done by Manet. Further, by the contrasting plastic rhythms
of these naked bodies, Ingres created space and volume, using actual color
instead of chiaroscuro. And that is the power which Picasso—in the numer-
ous gouaches of the *Saltimbanque* series—had just conferred on line in
works like *Arlequin assis sur un fond rouge* (Harlequin Seated against a
Red Background), *Famille d'acrobates avec un singe,* and the *Famille de
saltimbanques* itself.² This is clearly evident in the series of etchings and
drypoint printed by Eugène Delâtre, one of the best engravers of the time,
a project pursued over the better part of a year.³ Ingres, therefore, was for
Picasso a challenge on his chosen terrain. Throughout the spring of 1906,
surpassing the old master in this classic domain was to be a major preoccu-
pation. Picasso was also fascinated in the *Bain turc* by the rhythm in the
figures of two of the women—one arranging the hair of another. He made
several drawings of this pair, from which, in 1906, he did the celebrated
canvas *la Coiffure,* later at the Metropolitan Museum.⁴

By contrast, certain late Manets—and also some of the works by
Ingres at the Louvre—must have inspired a reversion to the more direct,
preclassical, even frankly archaic style already evident in the blue period.
The extremely hieratic profile portrait *Femme à l'éventail* (Woman with a
Fan), with its fresh colors, is an example of this.⁵ So are *Garçon de profil
à la collerette,* forerunner of the curiously romantic major canvas *Garçon
à la pipe* (Boy with a Pipe), whose head is crowned by a nimbus of flowers,⁶
and the heads of Harlequin, precursors to the gouache of his death. Ele-
ments of archaism—one cannot yet say primitivism—are present in all the
large, classic works done in Paris and Gosol during the opening months of
1906.⁷

Fernande, in her *Souvenirs intimes,* gives us the probable explanation
of the boys smoking and staring with hypnotic eyes. When she moved in
with Picasso, he had begun to smoke opium. He initiated her into the
practice. "Everything seemed simple, beautiful, and good. I owe it to
opium, perhaps, that I came to understand the meaning of the word 'love.'
And I discovered that at last I understood Pablo." We shall leave that
discovery to her. In any case, the use of opium was a transitory experiment
without any noticeable repercussions on the paintings, until it was inter-
rupted—in tragic circumstances—in the spring of 1908.

Picasso gave some of his work to Clovis Sagot, a dealer on the rue
Laffitte and a neighbor of Vollard's. Talking to a young American collector
who had just—not without hesitation—bought Matisse's *Femme au cha-
peau* at the Salon d'Automne, Sagot had praised "a Spanish artist of the first
rank." And that is how Leo Stein was captivated by the gouache *Famille*

d'acrobates avec un singe. He came back to the shop with his sister, Gertrude, and they bought a painting by that unknown artist, the *Fillette nue au panier de fleurs* (Nude Girl with Basket of Flowers). When Gertrude Stein declared shock at the legs, Sagot coldly suggested "guillotining" the canvas at the lower torso.[8]

Since moving to Paris in 1904, Leo Stein—with his remarkable curiosity and a certain tendency to theorize on the progress of art—had kept himself abreast of new developments in painting. At a time when the absence of reproductions prevented a sweeping view of the whole, Stein knew the history of the revolution in painting rather better than Picasso did. A few days later, in a letter to Mabel Foote Weeks, Stein characterized his discovery, stating that he had just bought two paintings "by a young Spaniard named Picasso whom I consider a genius of very considerable magnitude and one of the most notable draughtsmen living." In "More Adventures" Stein continues the account: "Soon after I learned that a friend, Pierre Roché, knew Picasso. Roché, a tall man with an inquiring eye under an inquisitive forehead, wanted to know something more about everything. He was born a liaison officer. . . . A few days later (he) led me to the rue Ravignan. (Picasso) seemed more real than most people while doing nothing about it. The atelier was a mess." Nonetheless, Leo quickly brought his younger sister to the Bateau-Lavoir.[9] Picasso and Gertrude felt an immediate sympathy. As Fernande wrote, "even before he knew her better," Picasso proposed doing Gertrude's portrait, a proposal she accepted.

They saw each other practically every day, Gertrude traveling across Paris from the rue de Fleurus on the Left Bank to Montmartre. Her conversation brought Picasso a sense of high international culture, as well as attitudes to art and painting with which he was unfamiliar—as heterodox as his own, and probably more revolutionary. She vehemently praised the work of Cézanne and Matisse. It was essential, she said, that Picasso meet Matisse.

Gertrude by then was over thirty. She had lost her parents as an adolescent and had come to depend on her brother Leo, although both of them lived off the family fortune as managed by their elder brother, Michael. She had freed herself intellectually from the suffocating condition reserved for women by respectable society on the American East Coast by studying psychology at Radcliffe, where she met William James, and then medicine at Johns Hopkins in Baltimore. It was at Johns Hopkins that she discovered her homosexual nature and suffered an amorous disappointment, an experience from which she drew her first novel, *Q.E.D. (quod erat demonstrandum).* Although the book was finished in October 1903, Gertrude did not show it—to enlightened friends like Bernard Fay or Louis Bromfield—for nearly thirty years. It was published, four years after her death, with the title *Things as They Are.* In 1906 Gertrude learned that the object of her passion had married. A year later she met Alice Toklas. At the

end of 1905, working on *Three Lives,* which would be her first published book, Gertrude had come to recognize her own creative talent.

She was to have ninety sessions posing for Picasso before she and Leo left for Italy in April 1906. From the first moments of their acquaintance, Gertrude had considered herself a supporter of the same revolutionary aesthetic as Picasso himself. He, in turn, was obviously delighted to meet a woman of such intellectual vigor, a pleasure increased by the fact that her physical qualities corresponded to the plastic sculptural themes he had discovered in Holland and which had so much moved him. "A handsome head," Fernande recalled. "Strong, with noble, strongly accented features. Masculine in her voice, her entire bearing." Did Picasso suspect her homosexuality? That would only have increased his interest.

To possess such an interesting woman through his painting was an entirely novel experience, and he invested the highest qualities of his art in such a challenge. One can infer from the pose that Ingres provided the standard which, from the outset, he was trying to match.[10] But one cannot now know if he had in mind a classical figuration like those of his contemporaneous portraits of Leo and Allan Stein or was already aiming at Gauguinlike simplifications of the kind noted by Françoise Cachin, particularly in the expression of the face or in the various versions of *Tête de Bretonne* (Head of Breton Woman) owned by Paco Durrio.

Gertrude had shaken up the life of Bateau-Lavoir by bringing along her friends. James R. Mellow recalls:

> Late in the afternoon of the first session, Leo, Michael, and Sarah arrived to take a look at what had been accomplished. They brought with them an American friend, Andrew Green. . . . The Steins were impressed with Picasso's initial sketch. Green began to plead—rather too forcibly—that the artist should leave it exactly as it was. . . . Picasso listened to the tall, young American's pleading, then shook his head emphatically: *non.*

It was specifically in the course of working on Gertrude's portrait that Picasso felt he had to change the painting. "I don't see you any more when I look at you," he said to Gertrude before interrupting work on the picture. He abandoned at the same time *la Coiffure*—a canvas in the style of Ingres begun at the same time as the portrait of Gertrude. Both would be completed in the same primitivist mode when he returned from Gosol in August.[11]

Up to that point, Picasso's attention had been caught by the symbolist aspect of Gauguin, close to Puvis de Chavannes. But now, in the process of defining the "primitive" in himself, Picasso returned to his dream of large Spanish spaces with a series featuring a herd of horses led by naked boys, often viewed from behind, as in Gauguin's *Cavaliers sur la plage* (Horsemen on the Beach). These canvases, painted in the Marquesas, had arrived

at Vollard's, and there is a strong probability that Picasso saw them there. Horses reappeared in his work in the spring of 1905, ridden by Harlequin. They were followed, in the autumn, by drawings of a circus horsewoman. The product of these preliminaries is at the beginning of 1906: *Meneur de cheval nu* (Nude Boy Leading a Horse). Alfred Barr has praised the "simple, natural nobility of composition and attitudes which make official guardians of the Greek tradition—like Ingres and Puvis de Chavannes—seem vulgar or pallid." In the young male nude there is a strengthening of contours, which, by their rhythms, effect interior modeling.[12] Here, too, one cannot exclude the consequences of reflection on Gauguin. The atmosphere of escape is very similar, and the exoticism reminiscent of Oceania.

Did this canvas precede Picasso's discovery of the *Bonheur de vivre* (Joy of Life) by Matisse, an established admirer of Gauguin? In that painting the ties between Gauguin and Ingres are obvious. The woman on the extreme left, lifting her arms to hang a garland of leaves, derives from the *Bain turc*. Picasso was to resume this plastic theme at Gosol, with *la Toilette*.[13] We know that he saw the *Bonheur de vivre* at the Salon des Indépendants, and then at the Steins', and that the Steins bought the Matisse and the *Meneur de cheval nu* at the same time, which emphasizes their convergence.

The Steins' purchases had, indeed, multiplied. Fernande recalled that on their first visit, they bought some pictures for eight hundred francs. A 1906 photograph of the Steins' "studio" on the rue de Fleurus[14] shows four blue canvases: *la Buveuse d'absinthe* (Woman Drinking Absinthe), the *Femme aux franges* (Woman with Fringe), and the *Femme au cachot* (Woman in Prison) of 1902, together with *Pierreuses au bar*. Picasso was now not only selling canvases from the period when he had been most desperate but was seeing them hung by knowledgeable connoisseurs beside a *Portrait de Mme Cézanne*. *L'Acrobate à la boule* and the *Fillette au panier de fleurs* were next to Lautrec's *Sofa* or Renoir's *Deux Femmes*. In short, it was an entry into the pantheon of painting which would have been unimaginable at the time of *Famille de saltimbanques*.

Jean Cassou, who was the most penetrating sleuth for those "sources of the twentieth century" which the Council of Europe exhibited in Paris in the beginning of the 1960s, links the explorations of Gertrude Stein, that "amateur of genius," into "forbidden regions of European art" to characteristics of the American School at the start of the century and with the part played by—among others—Alfred Stieglitz. Stieglitz proved that photography is an art and imposed it on American society, teaching that society to recognize the distinctive beauty of its own civilization. In the process, he overturned false arguments about realism. We should add at this point that with her own experience as a writer, and the unusual nature of her sexuality, Gertrude Stein was an embodiment of the fact that the reality of art is not the reality which is codified, recognized, and expected. In this she drew on the liberty of spirit which had already brought her to love Cézanne and

Matisse and would feed her continuing love for Picasso when his primitivism and radicalism had alienated Leo.

For Picasso her friendship constituted a priceless opening out: all the more so as Gertrude's American French freed him from his own linguistic complexes. He could speak to her about Manet or Ingres without fear of being corrected; could even perhaps confide in her about his move—on returning from Holland—toward "pure" painting, painting which had no justification beyond itself, which would find within itself the quality of transcendence he had known earlier, in *la Vie* or in the theme of paternity, linked to that of wandering. And he was thereafter to see his pictures at her place in the context of the revolution in painting in France. His new friends were, as well, intimately acquainted—through the art critic Bernard Berenson—with the great paintings of Italy; they immersed him in another art history.

In her writing Gertrude was changing the classical mode of story telling. She could scarcely fail to link her own art of transformation with that which the revolutionary painters were imposing on visual art, and very quickly compared herself to Picasso and Matisse. A recently published note reveals a private ambition: "Pablo & Matisse have a maleness that belongs to genius. Moi aussi, perhaps." Picasso, therefore, cannot escape comparison with Matisse, who triumphed at the Salon des Indépendants of 1906 with his large canvas *Bonheur de vivre*. The Steins were the first to assign Pablo his true place; but how could he forget that he shared it with Matisse? Matisse, to be sure, was his elder, a consideration which meant nothing to Pablo, especially as this particular elder practiced audacities which surpassed those of younger artists (including Pablo).

Pablo was too watchful of every move in the world of art not to have noticed this particular problem rather quickly in the course of ninety sittings with Gertrude. All the more so as Gertrude had an unbridled tongue and must have enjoyed noting Pablo's reactions.

According to the *Autobiography of Alice B. Toklas:* "There was the spring independent (Salon des Indépendants) and Gertrude Stein and her brother were going to Italy as was at that time their habit. Pablo and Fernande were going to Spain. . . . And the Matisses were back and they had to meet the Picassos and to be enthusiastic about each other, but not to like each other very well."

The Matisses, in fact, had gone to Biskra, in Algeria, right after the Indépendants. Picasso told me that he had met Matisse during the exhibition, which opened on 20 March, although the meeting could have occurred when Matisse returned to Paris in the beginning of April.

The importance of this encounter under the aegis of the Steins has always been underestimated.[15] The *Bonheur de vivre* challenged Picasso not only because of material derived from the revelation of the *Bain turc* but also because of its success within the terms of traditional Salon canvases, which had also been the case with his own *Famille de saltimbanques*.

Moreover, the theme embraced his own inclination to escape, to flee. Matisse was indisputably at the head of the class in painting. He also dominated Picasso with his height and expressed himself with authority. As a good Spaniard, Picasso had not up to that point thought about perfecting his French.

We should add that just before the Indépendants, Matisse had opened a big one-man show at Druet's. Picasso hadn't mounted a similar effort since 1901. There were forty-five paintings, watercolors, sculptures, and, above all, lithographs and woodcuts of revelatory power. Picasso took the entire show as a challenge, a challenge as great as that of the *Bonheur de vivre*. He felt particularly strongly about sculptures like *le Serf;* he himself had just finished *le Fou* (The Madman), modeled on Max Jacob, and a head of Alice Princet and was about to do his first head of Fernande.[16] Matisse was ahead of him in sculpture, even further ahead in engraving. After his own year of experimental etching, Picasso found in Matisse's work a style of drawing whose vehemence and simplifications, deliberately anticlassic, created a savage, gestural expressiveness.[17]

There can be no doubt that the shock of this occasion profoundly affected him. After a normal period of incubation, one sees the proofs. Novelties which had arisen during his talks with the Steins were suddenly presented as concrete challenge—the first of his life from a painter who, even though he was twelve years Picasso's senior, would have to be regarded as a member of his own generation. And the challenge was heightened by various circumstances which tightened the bonds between Picasso and the Fauves and loosened those to his former circles.

First, in December 1905, when a studio in the Bateau-Lavoir became available, Picasso told Van Dongen, whom he'd known since 1901, and Van Dongen, then one of the most violent of the Fauves, moved in. Next, Alice (who was at the beginning of her affair with Derain) brought her lover to Montmartre to join the Bateau-Lavoir group. Picasso had surely heard of Derain from Apollinaire. The latter, who lived in his mother's house in le Vésinet, a Paris suburb, was next door to the "école de Chatou" district, a proximity which brought Derain together with Vlaminck. Derain and Apollinaire had been friends since 1904.[18] Sixteen months older than Picasso, Derain was a communicative giant, as anguished as Matisse was dominating. He had reflected on the classics at length, and in depth, but was also a Cézannian as precocious as Matisse. He had thoroughly investigated various nonclassic schools of art, particularly those of the Middle and Far East and the primitives. Picasso very quickly felt confidence in both his knowledge and his judgment.

When they met, Derain had recently finished his large canvas *l'Age d'or*, with a subject parallel to that of *Bonheur de vivre*. As in the Matisse work, one finds in Derain's painting borrowings from the *Bain turc*. A naked woman lies, sprawled on the right, and contrasts of rhythm verge on pointillism. Derain in this work is even more radical than Matisse, a radi-

calism which would shortly be reaffirmed by his compositions with red trees and his canvas *la Danse*.[19]

In the autumn of 1905 and again in April 1906, Derain went to London. He was sent by Vollard, who hoped, by so doing, to produce an equal to the great success Monet had enjoyed with his *Thames* canvas of 1904. It was Matisse who had sent Derain to Vollard. One suddenly finds the latter, who had neglected Picasso's work since 1901, flinging himself into the affairs of Bateau-Lavoir and carrying off the entire production of Picasso's studio for two thousand francs (a sum at that time equal to twice the average workman's annual salary). It is impossible not to infer a link between this sudden enthusiasm and the rank accorded Picasso by the Steins. And who better than Matisse to tell Vollard of this success? It is probable that Derain helped in this matter as well. He, too, was a vehement partisan of Picasso and his dazzling talent.

"We decided to leave for Barcelona," Fernande writes. "We felt rich with that 2,000 francs, and thought the change would be good for us." In this way Picasso was able to take the journey to Spain which haunts his painting, a journey which assumed another significance that would inform his future work. Picasso went to Spain to rediscover and assert himself, free of the intellectual pressures of Paris. The trip was not so much a matter of resupply as of asserting independence.

In addition to the stimulating milieu of the Steins, Matisse, and Derain, an event in the opening months of 1906 had further contributed to Picasso's sense of shaking-up. A display of Iberian sculpture was installed at the Louvre: Iberian primitives, predating the Roman conquest. Pablo's new friends spoke with passion about rediscovering the strength of art before it was weakened by academic degeneration; and now the archaeological rummagings in Cerro de las Santos and Osuna were producing unfamiliar and remarkably expressive works from his own tradition.[20]

Here, too, he needed time for incubation, reflection. He left Paris for Barcelona, accompanied by Fernande. "It was the first time for her," notes Gertrude Stein with a touch of condescension. "He had to buy her a dress, a hat, perfume, a portable stove. At that time, all French women, when they traveled, took with them portable stoves for the kitchen." Did Pablo introduce her to his relatives? Fernande speaks of "charming, delicate friends" for whom she had become the "mona del Picasso": Benedetta Canals, Gargallo, Jacinto Reventos, by then a highly esteemed doctor, de Soto, Utrillo. But she says nothing about Pablo's family.

In a photograph taken in Barcelona by their friend Juan Vidal y Ventosa, we see Fernande in all her splendor. Through his friends the sculptor Enric Casanovas and Dr. Reventos Pablo heard of Gosol, a village in the high country of Catalonia to which the doctor sent convalescent patients. The place was accessible only by a narrow mule track, through a grandiose landscape of gray and ocher clays almost bare of vegetation—a remarkable resemblance to the naked backgrounds Pablo had imagined for

l'Acrobate à la boule, Famille de saltimbanques, and *l'Abreuvoir.*

Picasso's painting immediately filled with ocher, which was to create an enduring source of confusion with the pink works of 1905, a confusion enhanced by the fact that at the beginning of his stay in Gosol, Picasso painted adolescent nudes, very classical and Greek; but the Greece referred to was the country of Ingres, not of the lecythi at the Louvre. More than ever, line and contour alone create space and relief. In the asexual figure to the right of *Adolescents,* one finds the twisting body and hidden profile so interesting to Ingres. The contemporary theme of *Deux Frères* (Two Brothers) is a more direct link to the young boys of Paris.[21]

"At Gosol," Fernande writes, "life was enchanted. Not a cloud between Picasso and myself because, with no object of jealousy, his anxiety had disappeared." This remark corroborates the uneasiness apparent at the time of the *Mort d'Arlequin.* In fact, freed from the tensions of Paris—and probably most particularly those deriving from his encounters with Matisse and Derain, which affected his work—Picasso was happy. He went hunting and savored again the air of his native country. And here as well something extraordinary happened: he discovered Fernande's naked body. Except for two watercolors from the end of 1904, in which she is surprised in her sleep, there are no nudes of Fernande from before that time. Now she became a link with the handsome naked boys of the competition with Ingres.

There is a dazzling quality to these canvases: the *Nu aux mains jointes* (Nude with Clasped Hands) and *la Toilette,* in which Fernande is idealized in a posture taken from the woman with raised arms of the *Bain turc.*[22]

A letter from Max Jacob of 7 July written to Gosol suggests that Picasso had sent him studies or sketches of paintings of Fernande. "I like the drawings very much. You are augmenting—very much like music—[your sense of] grandeur and respect for the human person. Your model this time has a special grace which is altogether enchanting."

During the course of this exchange, Pablo began to think about something new. At the end of the *Deux Frères* sequence and the portraits of Fernande, harmony ruptures in pursuit of primitivist simplifications (which are still very moderate), producing the *Grand Nu debout* (Large Standing Nude), later bought by the Steins.[23] Picasso's next move was a canvas of recapitulation, *The Harem,* today at the Cleveland Museum of Art. Four nude Fernandes—one, combing her hair; the second, a leaning figure, drying herself; a third with raised arms; and a fourth, looking in the mirror—are enclosed by an empty room guarded by an old trout and a colossus with a shaven head in the same pose as that of the drooping woman on the right-hand side of the *Bain turc.* The link to trivial reality is accentuated by the presence, beside him, of an ordinary, vulgar snack: bread, sausage, some red wine—a gibe at the delicacy of the tea laid out on the low table of *Bain turc.*[24]

This is a manifesto: instead of using innovations for escape, as in the *Bain turc, le Bonheur de vivre,* or *l'Age d'or,* Picasso tests these against

realism. There is not much distance between *Harem* and the plebeian aspect of the *Bordel d'Avignon* some ten months later. This concern for actualization is marked by a gouache of *Trois Nus,* in which a girl holds a cigarette. At this moment, when Picasso is looking for what is personal to him, as distinct from his new friends, it is understandable that he should wish to distinguish himself with contemporary themes—an art of the present, faithful to his line of 1901, but also from the end of the blue period.

This does not contradict the purely pictorial experiments which filled the last part of his stay in Gosol. To develop expressive force, Picasso used distortions, divergences from appearance already practiced by Ingres. In this way he rediscovered the logic of primitive representation and the possibilities opened by the anticlassic drawings of Matisse. The notebook of drawings published as *Carnet Catalan* (Catalan Notebook) allows one to follow this experimental work of simplifying and schematizing the female face and body, of focusing the reduction of face to mask, to its plastic purity, cleansed of all individual details and psychology. He accomplished the same reductive purification with the lined face of Josep Fontdevila, an aged innkeeper, and discovered plastic rhythms which would propel him toward the ultimate facial deformations of *les Demoiselles d'Avignon.* He recorded his joy at having achieved such a breakthrough: "A tenor who reaches a note even higher than what's written in his part. Me!"

The consequences were to prove decisive.[25] Picasso had just freed himself from the constraints of classical representation. It is possible that the "simplicity of life" evoked by Fernande, "surrounded by people whom civilization has not touched" (is this an opinion of Pablo's which she is reporting?), contributed to this breakthrough toward primitivism. Pablo, after all, had tried to attune his painting to this innocence. "What we have found," Fernande writes, "might be happiness."

The stay in Gosol was abruptly interrupted in mid-August by a typhoid epidemic, which obliged Picasso to flee in the middle of work on female heads wrapped in scarves. He had perhaps also begun work on a sequence of nudes in masks, doing their hair, and on a large composition, *les Paysans,* in which he leans on another form of Spanish primitivism— that of El Greco.[26]

Back in Paris Picasso devoted himself to scrutinizing and editing the masks, abridging and simplifying sculpture,[27] and completing the head in the *Portrait of Gertrude Stein.* "The day he returned from Spain," Gertrude writes, "Picasso sat down and out of his head, painted the head without having seen Gertrude Stein again. And when she saw it, he and she were content." The same thing happened with the heads in *la Coiffure.*

In September both Matisse and Derain returned to Paris, the first coming from Collioure, the second, from l'Estaque. One can easily imagine the curiosity with which the three painters met again. Matisse and Derain had each for the first time acquired an African mask. Matisse had bought his in the rue de Rennes, while Derain, filled with enthusiasm for the

African objects he had seen in the British Museum during his spring trip to London, had bought one which had belonged to Vlaminck.[28] Thus, as Kahnweiler has consistently stressed: "For the true discovery of African and Oceanic art to take place, Picasso's preliminary work on *les Demoiselles d'Avignon* had to exist in the autumn of 1906, had to have created that enlargement of the aesthetic horizon. This is no discovery made by Vlaminck in a bistro. To grasp this, one has only to look at the paintings."

Kahnweiler did not then know Picasso. His remark derives from a reconstruction, which I shall reconstruct in turn, using information Kahnweiler didn't have and which affects the core of his thesis.

We should note, first, that Matisse had arrived at simplifications of the face to make a mask in the portraits of his daughter, Margot, and in his work on the *Jeune Marin* (Young Sailor). So had Derain in *la Danse,* although very differently. As Gertrude Stein says, "there was excitement in the air." For her part, she had just written the story of Melanctha, the negress, the second story of *Three Lives,* which was "the first definitive step away from the nineteenth century and into the twentieth century in literature." Just previously she notes: "in the long struggle with the portrait of Gertrude Stein, Picasso passed from the Harlequins, the charming early italian period to the intensive struggle which was to end in cubism." Pablo made her a present of her portrait. Later, replying to astonishment at such an important gift, Gertrude said that Pablo said that at the time the difference between selling and giving away one of his canvases was negligible.

The autumn was to prove full of excitement. To begin with, the fourth Salon d'Automne, in addition to ten Cézannes, displayed the first complete retrospective of Gauguin, whose paintings of Oceania Derain and Matisse had discovered the previous summer at Daniel de Monfreid's in Collioure. For Picasso these paintings constituted a windfall which seemed to him even richer than it had been for them. His work at Gosol and on his return to Paris had prepared him to see in Gauguin the primitivist rather than the symbolist, the supreme precursor of the modernity he himself was somewhat confusedly seeking.[29] And in that situation, on 22 October, word came that Cézanne had died.

Both Matisse and Derain were precocious Cézannians. They had thought through the work of the Aix master well before Picasso, who until then seemed to have given it little attention. Each of them had a Cézanne: Matisse, the *Trois Baigneuses* (Three Bathers); Derain, a reproduction of *Cinq Baigneuses* (Five Bathers; today the original is in Basel), which he hung in his new studio in the rue Tourlaque. One can see traces of it in *les Demoiselles d'Avignon.* There can be no doubt that Cézanne's death was a central event for all of them. Picasso drew from it a profound sense of convergence between the renewals of vision by Cézanne, Gauguin, and his new friends on the one hand and the primitives on the other, a convergence he was able to consider and verify at leisure when he visited the Iberians at the Louvre. Further, we should not be surprised that his work that autumn

was a development of activity at the end of his stay in Gosol.

Picasso, who had resumed the practice of preparing for paintings with preliminary drawings in notebooks, developed at that time the graphic laboratory of simplifications which appeared in the *Carnet Catalan*. The two earliest notebooks from the autumn of 1906, which contain more than 130 drawings, detach the figures from every trace of anecdote to reveal the rhythms and deformations which will create their presence.[30] The subject is a group of female bathers against a background of draperies. Their solid, stocky profiles are very close to Gauguin's Tahitians. Picasso enhances their volume with highlights, effects which are pushed to the limit in the major work of the period *Deux Femmes Nues* (Two Nude Women; today in the Museum of Modern Art), in which pure contrasts of volume and Ingreslike challenges to verisimilitude—like the *Profil perdu*—combine to produce the fantastic encounter of two massive idols.[31]

Beyond all psychology, Picasso henceforth radicalized expressive variations. He extended the simplifications of the mask to the naked body, expressing these simplifications in abstract, geometric forms. The growing number of drawings and paintings reveals an almost voluptuous desire to explore the possibilities of the human figure beyond anything that had already been done, to perfect primordial balances hitherto unknown. Over and over again in his self-portraits he would experiment with discoveries made during this search.[32] Iberian qualities were applied with increasing frequency. As Zervos explained it, after several conversations with the artist, Picasso sought in Iberian sculpture "the necessary support needed for disregarding academic prohibitions, surpassing established limits, and challenging all aesthetic legality." This, in fact, was what he had demanded of Gauguin. At Gosol, he had committed transgressions; now he was looking for respondents. His borrowings from Iberian sculptures in the general construction of heads, the shape of ears, and the drawing of eyes would increase after March 1907. Picasso was able to study in his studio two of the Louvre sculptures stolen by Géry-Pièret, an adventurer who frequented Apollinaire. When Géry-Pièret boasted of his larcenies at the time of the theft of *la Gioconda* in 1911, he often said that he had chosen a man's head because of its "enormous ears, a detail which captivated me."[33] And this, specifically, was one of the elements retained and studied experimentally by Picasso. Géry-Pièret had stolen precisely what he knew would interest Pablo.

Picasso did not try to make himself into a primitive after the fashion of Gauguin. He wanted rather—with the help of primitive vision—to cleanse art of what he called tricks, of the stale and paralyzing conventions which were merely sham compared to the profound truths of painting. He established that art, at its origins, was capable of an expressive force so powerful that even the great classic centuries might be said to have weakened rather than strengthened it. Gauguin, van Gogh, and Cézanne had already invented the primitivist renewal of vision, a renewal which pointed

in precisely the direction that suited Picasso's temperament as a painter. Sabartès heard Pablo exclaim as he launched into a canvas,

"We'll see what comes of this!" And then he found that "what came" suggested a whole new series of ideas, because the idea of *doing* led him to relive a vision, or even, perhaps, to create it. And this vision, in turn, is the beginning of a whole series of possibilities, of ideas, which, as a single sheet of paper or canvas couldn't possibly accommodate them, motivated an infinite quantity of drawings and paintings, an unimaginable quantity, given the astonishing number of modifications provoked by each line or brush stroke.

His classic virtuosity had enclosed him in the constraints of resemblance. This is why primitivism for him was a launching point almost beyond the power of dreams, an intellectual authorization to "be bad," to be clumsy, ugly, and brutal, to "leave the XIXth century," as Gertrude Stein put it. And, symbolically, as her face had been the first put to the test of primitivism and transformed into a mask, it was his own face that Pablo took for his next experiment. With that face he would try to abandon all his rooted conceptions and brave the test of looking at himself with the eyes of humanity's first artists, with the eyes of his own country's Iberians. He would look at himself with the whole history of art to remake.

And suddenly, beside his "primitivized" self, Fernande appears. She, too, has been Iberianized, and their child. (Perhaps the son of whom Madeleine had given him hope?) With this primordial family, Pablo is all tenderness.[34] What did it mean to him?

Gilbert Krill told me that after losing the child she was expecting at the beginning of her marriage "in consequence of a fall on some icy steps which had not been cleared, Fernande was unable to have another. And that this was one of the reasons for her break with Picasso." It is possible that at the time of this painting—the beginning of 1907—there was fresh hope of a child, hope which once again was disappointed. Shortly after this, Fernande began the process—ultimately unsuccessful—of adopting a child. Her *Souvenirs intimes* breaks off at precisely this moment. Picasso kept the picture until Fernande's death. He gave it to the Kunstmuseum in Basel in 1967.

When these canvases were brought together to be sent to Basel, I thought to ask Picasso whether he went to Matisse's. "Of course." "And Matisse came to Bateau-Lavoir?" He turned without a word, motioning me to follow. He showed me the *Portrait de Marguerite* (Matisse's daughter), dated 1906–7: precisely contemporaneous with his primitive family *Homme, femme, et enfant* (Man, Woman, and Child). "Doesn't that remind you of anything?" Perhaps my eyes followed his as we looked at the canvas. "Her nose is sideways, like the noses of the *Demoiselles?*" He laughed, like someone who has made a successful point. "You're beginning

to know how to read painting. You've got to be able to picture side by side
everything Matisse and I were doing at that time. No one has ever looked
at Matisse's painting more carefully than I; and no one has looked at mine
more carefully than he."

I did not think to ask him then, but dream about it now, What did
Matisse bring him from the French tradition of modernity? a tradition into
which Picasso plunged too suddenly to notice every detail or nuance. For
example, Baudelaire, standing behind Gauguin. Baudelaire, who wrote in
le Peintre dans la vie moderne (1863):

> I wish to mention an inevitable barbarism, synthetic, and childish,
> which often remains visible in perfect artistic style (Mexican, Egyptian,
> Ninevite); which derives from the need to see things grandly, to consider
> them above all in the effect of their ensemble. It is not superfluous to note
> here that many people have accused of barbarism painters whose vision
> is synthetic, reductive, like M. Corot, for example, whose effort at the
> outset is to draw the principal lines of a landscape, its skeleton and
> physiognomy.

I do not know if Picasso ever read that passage, but when we spoke of
Baudelaire, he often mentioned Matisse.[35]

On page 32 of the last sketchbook for 1906—a small book (15 × 11
cm.)—surrounded by drawings of female bathers and of the *Nu assis* of the
Musée Picasso, suddenly, without any warning, we come upon the first
version of the design for the initial *Demoiselles d'Avignon*—the bordello
with the student coming through the door and the seated sailor.[36]

LES DEMOISELLES D'AVIGNON

1907

Several mysteries surround the gestation of that great painting *le Bordel,* whose name was much later changed to *les Demoiselles d'Avignon.* André Salmon was the first to speak of it, but not until 1912. He gave the picture its title in 1916, a fact discovered only in 1976. Apollinaire never used that name; we know, however, that he showed the picture to Félix Fénéon, who looked at it and concluded that Picasso had a gift for caricature. In February 1907 Pablo used a drawing to tease his friend into collaborating in the review *la Culture physique.* In March the Iberian sculptures stolen from the Louvre by Géry-Pièret arrived at Picasso's studio, an event witnessed by Apollinaire and Fernande. On 25 March, Apollinaire was involved in a duel, a narrow escape which prompted a new drawing pulling the poet's leg. On 15 April, he left le Vésinet and moved to the rue Léonie (today, Henner). Instead of being an hour away by train, he was now no more than ten minutes' walk from Bateau-Lavoir. His intimacy with Pablo grew accordingly. From him, silence meant disapproval.[1]

With Fernande things were a great deal more complicated. She speaks of Apollinaire's move, but then her memoirs forget everything about Pablo's life until the beginning of 1908. She completely disregards the existence of *le Bordel.* We shall see why. Leo and Gertrude Stein—to judge by their surprise when they found it in September—were evidently unaware of the picture while it was being painted. Their departure for Italy in May provides a chronological reference.

Until the systematic exploration in 1988 of the sixteen working notebooks which deal one way or another with *les Demoiselles d'Avignon,* Kahnweiler's recollections—unique evidence on the creation of the *Demoiselles*—by referring to "two different periods of work on the picture," created more problems than they solved.[2] There had indeed been two distinct and separate periods of work, but they corresponded to two different conceptions of the project. The first, from the autumn of 1906 to the beginning of June 1907, produced a painted sketch of an introduction to a bordello. This was quickly covered over by the second version. The second

version used the first as a point of departure only and added to the execution of the picture as we know it other works deriving from it. The result of this accretion would be the first primitivist version of the large canvas *Trois Femmes* (itself later covered over).[3] There was probably no slackening of this primitivist exploration once *les Demoiselles d'Avignon* had reached its present state. This is not an unfinished canvas in the usual sense of the term. But Picasso must have felt very deeply that the problematic unknown which he had stirred up was far from being exhausted; that it comprised, in fact, several possibilities; and that to purge the lingering traces of his original idea of painting a bordello—retained by the *Demoiselles*—a new manifest version was required. A year later the *Trois Femmes* would become what we know today: no longer the final product of the *Demoiselles* but the opening of Picasso's collaborative move with Braque toward Cubism.

With the ardor of his twenty-five years and the challenge of proceeding into the unknown, Picasso had no thought of taking a break when he finished the *Demoiselles*. The picture nonetheless constitutes a summit of achievement. Breton, in the 1920s,[4] recognized this instantly, a recognition generally accorded since the painting's installation at the Museum of Modern Art in New York. Unlike Picasso, therefore, we shall stop to consider the work at length.

Our first observation and first surprise: although the idea of painting a bordello parlor touched the inner core of Picasso the man and aroused his complicity and competition with Lautrec and Degas, the subject as it appears in the final version was not the organizing theme of the first period of work. The subject took shape suddenly, resuming and reworking various earlier pictorial explorations (the old innkeeper Josep Fontdevilla at Gosol or the female bathers who are close to Gauguin's Tahitians), uniting these, and gradually finding its own dynamic. As the *Famille de saltimbanques* had been the synthesis of his successes and discoveries during his sentimental period, his bordello salon, at the outset, was a fusion deriving from his rivalry with Ingres, as well as with his new interlocutors, Derain and Matisse, from his experiments with primitivism, and the impact of the Gauguin retrospective.

At the beginning of the project, in the *Harem* and in the gouache *Trois Nues*, from Gosol, the escapism of the *Bain turc* is given critical scrutiny. In 1970 Pablo asked me, "Where could one find naked women in 1907, if not in a bordello?" To this he adds derision of the idealized pastoral of *Bonheur de vivre*, which brings back the girl with raised arms on the left of the *Bain turc* and of *Bonheur de vivre*. The low table which organizes the space of *Bain turc* will play the same part here; but its refined luxury is replaced by vulgar reality. And immediately Picasso called on Cézanne, sanctified by death. He put on the right side of the picture the crouching girl seen from behind, a figure he had been able to study at leisure in the *Trois Baigneuses* owned by Matisse.[5]

In the first phase, he unified the disparate elements, and dynamized the girl seated in the armchair. She derives from his bathing women, but can be found in any bordello *photo de présentation* of the period.[6] And he jolted and shifted postures, particularly those of the two masculine figures he could properly claim as his own: the seated sailor at the center of the picture and the medical student who is coming in on the left. He primitivized them, giving the student hair like that of the stolen Iberian head bought from Géry-Pièret. He pondered the problem of what to put in the student's hand: a skull, a book, both of these, or nothing at all. And this hesitation—strong but fleeting—is responsible for the multiplicity of ethical and psychoanalytic studies on the meaning of the project.[7]

Nonetheless, the extent of the joke should be limited as regards the Carrer d'Avinyo, a commercial street in Barcelona which opens into the Escudellers Blancs, a narrow alley of ill fame where, in 1899, Picasso had his studio. The joke, to be sure, uses phonetic similarity to lead from Avinyo—a village near Barcelona—to Avignon, the birthplace of Max Jacob's grandmother. Something of a shady reputation had clung to Avignon since the fourteenth century, the period of papal exile there. The present title of the painting, incorporating the city's name, is itself a joke. Except for the sailor, however, the canvas retains nothing of the poor bistro-bordellos of Picasso's youth—reminiscent of van Gogh's *Lupanar*. The salon itself has become one of the chic brothels he discovered in Paris, in which the girls put themselves on display.

Nor does one find any trace of the mental and spiritual attitude with which at the end of 1901 he visited the hospital-prison of Saint-Lazare. Nothing connects the girls of *Demoiselles* to the venereal prostitute-mothers he once painted so tenderly. And there is no reversion to the bestiality of *la Femme au bonnet*. The abundant, crudely sexual production of 1902 did not express any preoccupation with sin or punishment from the pox.

Earlier generations—those of Baudelaire, of Manet, of Lautrec, or Gauguin—had paid their dues to the pox, but none of Picasso's friends died from it. Although—as Alain Corbin shows in his thesis—a campaign was mounted in Paris against the dangers of venereal disease, the authorities' targets were "wild" street prostitutes. Bordellos were considered clean, regulated places. There were public pronouncements about the care and possible cure of persons afflicted with these diseases, which, it was argued, should cease to be considered "shameful." In 1906 at Saint-Lazare a free venereal dispensary was opened.[8]

Let us turn to Sabartès here, one of Picasso's most valued confidants:

> Picasso is curious about food, about drink, about amorous adventures, about wordplay, about the various possibilities of plastic expression. He is as curious about everything as the most curious-minded, and then some. . . . Let's say he's been through every possible experiment in connection with sex, some of these exceedingly brief; others of greater

STAGES OF LES DEMOISELLES D'AVIGNON

October 1905	First sight of Ingres' *Bain turc* at the Salon d'Automne.
End of 1905	Exhibition of Iberian sculpture at the Louvre.
	Le Meneur de cheval nu; rivalry with Ingres.
March 1906	First sight of Matisse's *Bonheur de vivre* at the Indépendants.
	Stops work on the *Portrait de Gertrude Stein.*
Summer 1906	*Le Harem,* a derisive version of *Bain turc.*
	Reduces Josep Fontdevilla's face to a mask.
Late August	Finishes the *Portrait de Gertrude Stein.*
October	Gauguin retrospective at the Salon d'Automne.
	Death of Cézanne.
	Nude female bathers, primitivized in the manner of Gauguin.
	Two Nudes, MOMA. Self-portraits. *Nu assis.*
Late 1906	First *ensemble* drawing of the bordello; seven figures.
Early 1907	Studies of primitivized figures.
	Homme, femme, et enfant.
March	Iberian sculptures stolen by Géry-Pièret arrive at the Bateau-Lavoir.
20 March	Matisse's *Nu bleu* and Derain's *Baigneuses* provoke scandal at the Indépendants.
April	Reduction of *Bordel* group to six figures. The nude is no longer seated but engaged in the act of sitting down.
May	Student replaced by a girl. Drawing now in the Cooper collection. The appearance of Raymonde.
	End of first stage.
June	"Negro" formalism. Still lifes. First application of "barbarism" to the subject *Homme nu aux mains croisées. Autoportrait.* Raymonde is sent back.
Late June	Work on *Bordel* resumed. Sailor eliminated. Philadelphia sketch.
July	Painting completed.
	Apollinaire and Feneon, then Uhde, then Kahnweiler see the *Demoiselles* in its present state.
Late August	Separation from Fernande. *Nu à la draperie* completed.
September	The Steins see the painting, followed by Matisse and Derain.
October	Cézanne retrospective at the Salon d'Automne.
Autumn	Primitivist version of *Trois Femmes.*
Late November	Fernande and Picasso reunite. Braque comes to the Bateau-Lavoir.
May 1910	First photograph published in the *Architectural Record* by Gelett Burgess.
Late 1912	In his *Histoire anecdotique du cubisme,* Salmon tells the story of the large canvas, which is still unnamed. The stretched canvas appears in a photograph of the rue Schoelcher studio.

(Continued)	
July 1916	Salmon shows the painting at the Salon d'Autin, under its present name. This first exposure is received with indifference.
Late 1923	Breton persuades Jacques Doucet to buy the painting.
Late 1924	Doucet takes possession of the painting.
July 1925	Reproduction in *Révolution surréaliste*.
Summer 1937	Painting leaves for New York.
January–April 1953	Appears in "Cubisme 1907–1914," first showing in France since 1916. Receives very little attention.

consequence. The rest could be the product of the kind of life he feels obliged to lead, his nonadaptation to the milieu, when this is not the result of some abuse provoked by his excessive curiosity. The principal work of this period of reconstructive initiation assumes concrete form in 1907, with the painting *le Bordel d'Avignon*. Why bordello? And why Avignon? It is impossible to say. It must have been the first notion which came to him as he clarified to himself his reasons for grouping several female nudes on one canvas. He told me that while he was painting the picture he kept finding ressemblances between the women of his imaginary bordello and actual women of his acquaintance: "That one is Max's mother; and this one . . . I don't remember the others."[9]

I asked Sabartès about this text—a translation from his Spanish—because of the word *consequence*—in French, a barbarism when used to mean "important." He anticipated my objection: he had heard it before. He explained: "Eight years of boredom with Fernande, and then what happened with his wife. He certainly suffered heavy consequences." Sabartès had a grudge against all women because of what Picasso suffered. But he didn't explicitly link *les Demoiselles d'Avignon* to these "trials."

In fact, to observe the setting and derivation of the initial idea in Picasso's private life is to observe as well a period of growing wisdom. Harlequin's desire for paternity and the installation of Fernande in Picasso's life developed in tandem with a desire to settle down. "At that time," Fernande writes, "Picasso went out less and less often. His life was at home, and his friends were in the habit of coming by regularly, at times when they knew he wasn't working or resting. . . . He would eat and chat, and then, at ten, leave them to work; and work nonstop until five or six in the morning."[10] The primitivism of the faces in Picasso's large *Homme, femme, et enfant*[11] of early 1907 is sufficiently elastic to permit the expression of all the tenderness the artist feels toward the child the woman is holding. This is true of his bordello sketches as well, even the most elaborate of these: the schematic drawing in the Cooper collection and the painted version—dating from May—revealed by infrared beneath *Buste de femme à la grande oreille* (Bust of Woman with a Large Ear).[12]

At this point everything changed. Picasso abandoned the bordello theme for an entire month, returning to it in the second half of June with a violence of figuration which seems almost paroxysmic. One can see this in every infraction of established norms. We are presented, therefore, not with two versions of a single theme, but with a radical transformation of conception and composition, of the entire initial treatment of *le Bordel,* and of everything in Picasso's painting which had preceded it.

What is the reason for this? Two events at this time seriously affected him. The first is connected with painting: the fresh uproar provoked by the Indépendants exhibition opened on 20 March by Matisse and Derain, each of whom had suddenly and violently radicalized his painting. The second event is personal: a crisis in Picasso's relationship with Fernande which led to their separation. The principal effects of this break were either disregarded or unknown until the present time. To all of the above we must add as well strong social tensions which—if they scarcely touched Matisse— had to be felt by Derain, Salmon, and naturally by Picasso.

Since Clémenceau's accession to power on 25 October 1906 (Pablo's twenty-fifth birthday), antisyndicalist repression had grown worse. Anarchists constituted the principal strength of the movement's active wing, and severe conflicts occurred with increasing frequency. In March 1907 at Nantes, troops intervened against the dockers and killed one of them. In the same month, the electrician's strike in Paris was broken by the army. Workers in the vineyards of the Midi (near enough to Catalonia) rose in protest, and, remarkably, the soldiers sent to quell them fraternized instead. This led the CGT (General Worker's Confederation), then in the process of formation, to cover the walls of Paris with antigovernment posters: "Gouvernement d'assassins!"

Following his portrait of Gertrude Stein and his primitivist explorations, Picasso had every reason to believe that he had placed himself at the same level of the avant-garde as Derain and Matisse; had even, perhaps, surpassed them. Further, he could scarcely have escaped a sense of challenge on his own terrain. Influenced by their discoveries of African art, both Matisse and Derain transmitted a sense of violence in color, which in 1905 had provoked the expression "Cage aux Fauves" (Cage of Wild Beasts). This violence was transmitted as well by a brutality of distortion and simplification in nudes and in masks—harder than those achieved by Picasso—which took the place of faces. When the critic Louis Vauxcelles saw Matisse's *Nu bleu, souvenir de Biskra,* his indignation exploded: "The drawing here seems rudimentary and the coloring cruel; the right arm of the mannish nymph is flat and heavy." He also condemned absolutely the "barbaric simplifications" of Derain's *Baigneuses.* The *Nu bleu* kept its shocking reputation for years after the Steins bought it; and, as Barr recalls, it had the distinction of being burned in effigy by students in Chicago after the Armory Show of 1913.[13]

André Salmon recorded these reactions and explained them. "The

hideousness of the faces struck the semiconverted with horror." We now know from the notebooks that this extreme hideousness took shape at the end of the second work period and during the execution of the painting itself. This means that if the shock of the Indépendants increased Picasso's dissatisfaction with an overly discreet bordello and pushed him into radicalizing his primitivism, it nonetheless does not explain the paroxysmic violence which characterizes the final version of the *Demoiselles*.

It is here, I think, that the intimate crisis of his relationship to Fernande makes itself felt. Except for Ron Johnson, no one has noticed this influence, although it is certainly discernible in the *Autobiography of Alice B. Toklas*[14] and is absolutely clear in Fernande's letters to Gertrude Stein. There is considerable evidence that the harmony achieved by the pair at Gosol collapsed sometime between the autumn of 1906 and the spring of 1907. On the back of the most idealized of the Gosol portraits of Fernande, *Nu aux mains jointes* (Nude with Clasped Hands),[15] is the inscription "a mon vrai ami [name removed]—Picasso, 1er janvier, 1907." (To my true friend.); which means that Picasso gave it or sold it at this time. Although Fernande may still be the primitivized heroine of *Homme, femme, et enfant,* she disappears from Picasso's painting as far back as 1909. She can be found, however, as a Van Dongen nude: standing and then seated at a bistro with a little glass beside her. Her almond eyes have become two large, black brush strokes, and her body is treated with the colors of Fauvism.

When Fernande describes Pablo's jealousy forbidding her to continue working as a model, or even to go out shopping, one is forced to conclude that she provoked it. Even if she was unaware of Ingres' dictum that "painting a woman is still the best way of possessing her," Picasso had made her his. And she knew it. This undoubtedly happened after *Homme, femme, et enfant.*[16] If this canvas was linked to a hope of maternity, the hope was disappointed, a disappointment which probably explains the curious step Fernande took that spring (not, as was previously thought, at the time of *Famille de saltimbanques*).[17] She went to a religious institution in Montmartre to find a child for adoption and returned with Raymonde, an adolescent girl. Given the bohemian discomfort and promiscuity of their establishment, the idea was entirely unrealistic. The gesture indicates, however, that she grasped the importance for Picasso of his longing for paternity. In the notebooks, surrounded by studies of extreme radicalization, one finds portraits of Raymonde, overflowing with tenderness.[18] How far did this tenderness go? Too far for Fernande. "The day came," Salmon tells us, "when Fernande—without malice—recognized that she had made a mistake. Raymonde was 'de trop'; just too much; an error." Although highly strung, Fernande was very much in control of herself. She took Raymonde back to the Rue de Caulaincourt (the orphanage), probably at the end of May.

A letter of 8 August indicates that Gertrude Stein knew the whole story. And Gertrude Stein left Paris for Italy that year on 29 May. Fer-

nande's letter of 8 August does not suggest happiness.[19] From a letter of 24 August one gathers why.

> Would you like some big news? It's that our life together—Pablo's and mine—is finished. He's waiting for the money Vollard owes him, so that he can give me something with which to wait for . . . *developments.* What will these developments be? And what can I make of life after this new defection? And don't imagine that things can still be patched up. Pablo has had enough: those are his own words. Although, he says, there's nothing to reproach me for. He's just not made for this kind of life.[20]

The most astonishing feature of this separation is its cool calculation,[21] financed by payments from Vollard, who had just bought all the paintings in the studio for the second time. The price on this occasion—twenty-five hundred francs—was a five-hundred-franc increase over 1906. This, along with the prehistory of the *Demoiselles,* was not known until 1988. Fernande asserts that she "always tried, in every way, to be no hindrance to Pablo's work," from which we can infer that he reproached her on this point. She adds: "The only thing I required from him—and that, jealously—was his tenderness." We know from Gertrude and from Alice that Fernande found her semisequestered life at Bateau-Lavoir irksome, centered, as it was, on a man who thought only about his big picture. And one deduces that her demands interfered with the organization of Pablo's life, something he could not tolerate. The tenderness which Fernande "jealously" required leads us directly to Raymonde. Even if Pablo's interest in the young girl remained platonic, for Fernande awareness of it produced a sense of frustration. We shall not know any more about it. The crisis became a crisis of life, in which it seemed that Fernande and Pablo lived on separate planets. He was in the process of staking everything on his *Demoiselles.* One can understand his remark that he "was not made for this kind of life."

For us, who know what violence will be unleashed in his painting by new scenes of jealousy and incomprehension of his art in the crisis of his marriage with Olga, and who know as well the cruelty with which he will attack the image of women after 1925, it is impossible not to infer that it is Fernande whose image he was now destroying—Fernande, whom he painted so voluptuously in 1906.[22]

What do Picasso's notebooks of the time tell us? That when he abandoned the bordello, he invented formal rhythms of deliberately stylized silhouettes clearly inspired by black African sculpture. These would lead, shortly after the *Demoiselles,* to the large, stylized canvas *Nu à la draperie.*[23] He then, however, moving in a contrary direction, followed this unbridled figurative violence with still lifes in which the Cézannesque elements are simplified, enlarged, and radicalized by color; and with savage figures whose Iberian features are exacerbated by rudimentary graphics and

the use of crosshatching to emphasize summary distortions.[24] And now he returned to the theme of the bordello, probably in the second half of June. But this time there are only girls—five of them; the last client, the sailor, has been eliminated in the watercolor sketch at the Philadelphia Museum of Art.[25] The bordello has been dynamized, with angular, geometrized girls. And now, in a reworking of the composition in Notebook 14,[26] which changes the architectural rhythms of the canvas, he pushed figurative savagery to the point of paroxysm, particularly on the right of the canvas. Using the facial distortions of the old peasant at Gosol as his point of departure, he gave the squatting girl a howling face/mask.[27] Recent X-rays show that the final modifications of the standing demoiselle on the right— and probably those of the girl on the left as well—were done during the actual painting of the picture.

In the initial version of the bordello, the girls were all looking at the student, who was coming into the room. Now they are all turned toward us, including the Gorgon face of the squatting girl and the prognathous mask of the girl on the right. The front-face eye in the profile of the girl on the left is a borrowing from the primitivism of *Manao Tupapao, l'esprit des morts veille* (Manao Tupapao, the Spirit of the Dead Keeps Watch) by Gauguin.[28] Nothing is left of the bordello-bistro of Barcelona. We have entered a bourgeois bordello in Paris; and it is this stylish brothel which Picasso attacks with savagery, destroying the aseptic appearances of the Belle Époque.

His bantering exchanges with Sabartès—like his jokes with the friends of his youth—indicate that Picasso was attacking the image of Woman in general rather than prostitutes in particular. And if it is legitimate to read a sexual metaphor of "total penetration"[29] into the final composition, as Leo Steinberg has done, one must nonetheless be wary of confusing sexual modes and must know how to quit the end of the twentieth century and all its liberations for the first stirrings of its start. Certainly in the early 1900s French society experienced a release of erotic impulse after years of the moral order of the Second Empire, established after the failure of the Commune. But, as Claudine Brécourt-Villars, the historian of these changes, has remarked, "the preeminent image of that time was of a devouring femininity. Woman is monstrous; simultaneously feared and desired—because she is perceived as being dangerous and inaccessible."[30] One finds this image in Mirbeau's *Jardin des supplices* (Garden of Torments) of 1898, illustrated by Rodin. This is the territory of the German novelist Sacher-Masoch, whose *Venus im Pelz* (Venus in Furs) was translated into French in 1902; and of Sade, whose *120 Journées de Sodome* (120 Days of Sodom) was published in 1904.

Picasso, in the accounts of his friends, was at the center of this explosive shattering of old restraints: first, with Alfred Jarry, whose *Surmâle* (1902) beat the record of the Indian Theophrastus (which astonished Rabelais) by repeating the act of love eighty-two times before exhaustion by the

"love machine" built to put amorous power to the test; and above all with Apollinaire, absolute connoisseur of the Bibliothèque Nationale's Hell, who wrote two erotic novels: les Exploits de Don Juan and les Onze Mille Verges (The Eleven Thousand Cocks) in 1907. In 1908 he published selected extracts from Sade.

Picasso held this last book in high esteem, and when I brought him the clandestine reedition of 1930 (with a preface by Aragon) openly reprinted in 1968, he began to imitate Apollinaire reading the most scabrous passages aloud, with the mannerisms of a tragic actor. Michel Décaudin has found a notice, probably by Apollinaire and quoted by Louis Perceau, from a clandestine catalogue of the period that praises the book as being "stronger than the Marquis de Sade," and having "an audacity which is scarcely believable," leaving "far behind the most alarming works of the divine Marquis." The notice concludes: "This is the novel of modern love, written in an elegantly literary language." Apollinaire transcends debauchery and bestiality, blood and death by the poetic excesses which provoke a distance of humor and parody.[31]

But beyond this eruption of sexuality, there is a deeper violence of feeling against the decadence of Western civilization, the violence expressed by Arthur Rimbaud, the poet—already a legend—whose rediscovery struck Max Jacob, Apollinaire, and Salmon with overwhelming force.

In 1907 this phenomenon was still fresh and dazzling, so much so that Max Jacob tells us he and Apollinaire would greet each other by shouting "A bas Laforgue! Vive Rimbaud!" It is no surprise to learn that Picasso had an edition of Rimbaud in his studio at Bateau-Lavoir: probably the widely diffused Paterne Berrichon edition, which included the poems Illuminations and Une Saison en enfer. Sabartès has confirmed the importance of Rimbaud for Picasso.[32]

Rimbaud brings us to the antireligious, anti-Christian dimension of the revolt in Picasso's painting, a dimension already discernible at the time of the Saint-Lazare cycle. And it is this point—not the subject of venereal disease—which contains and provides continuity. This time the point is not so much a blow to the Gospels but a resumption of the expression of paganism one finds in the Saison en enfer: "I think myself in hell; therefore, I am in hell. This is the teaching of the Catechism. I am the prisoner of my baptism."

In looking at this great canvas, one must imagine those lines declaimed under the studio windows. Rimbaud is the respondent who was closest to the Demoiselles. Picasso's task was to demonstrate that the violence of the Saison en enfer could be translated into paint, to learn what "being absolutely modern" meant. This prognosis is supported by the style of his Autoportrait.

Using his own face—probably at the beginning of the second period of work on the Demoiselles—Picasso painted himself as a savage, a barbarian, a pagan. In the faces of the two girls at the center of the Demoiselles, the enlarged, fixed eyes and enlarged ears derive from Iberian primitivism and

attest to simultaneity. But the true key to the picture is that here Picasso accomplished the passage from a savage brutality expressed by graphics to a brutality which is contrived, deliberate, and inflicted on the painting, which will remain forever inscribed *in* the painting. The vehement relief of the brush strokes in the painting of the hair and of the texture of the paint—so thick that the artist could dig into it with the stem of his brush—introduces violence into the internal texture of the painting. And this is precisely the workmanship which characterizes the masklike faces of the girls on the right. Later this insult to traditional techniques will reappear in every dramatic period: at the time of *la Danse* and the *Baiser* (Kiss) of 1925, and in paintings of the war period like *le Chat saisissant un oiseau* (Cat Grabbing a Bird) of 22 April 1939.

The *Autoportrait* (Self-Portrait) and the masks of the girls on the right-hand side use exactly the same "insults" to express savagery. Gertrude Stein was the first to understand that the true subject of the *Demoiselles* was their composition—the shift of vision that composition imposed. "Picasso said: look at that face, all faces are as old as the world. And so Picasso commenced his long struggle to express heads, faces and bodies of men and women in the composition which is his composition."[33]

It was this fundamental overreaching of the subject which opened for Picasso the transcendence of his painting over the trivial reality of which he was a part. Much later he would tell Françoise Gilot: "When I became interested in negro art . . . it was because at that time I was against what was called beauty in the museums." He added that he understood that

> men had made those masks for a sacred purpose, a magic purpose, as a kind of mediation between themselves and the unknown hostile forces that surrounded them, in order to overcome their fear and horror by giving it a form and an image. At that moment, I realized that this was what painting was all about. Painting isn't an aesthetic operation; it's a form of magic designed as a mediator between this strange, hostile world and us, a way of seizing power by giving form to our terrors as well as to our desires.[34]

This should be compared with what Picasso said to Zervos in 1935:

> How can a spectator live my picture as I have lived it? A painting comes to me from a great distance; who knows how great? . . . How can someone else penetrate my dreams; my instincts; my desires and thoughts, which have taken so long to develop, to reach the light of day? Above all, how can another person grasp what I've put into the painting; sometimes even against my will?[35]

Twenty years later, to Antonina Vallentin, he completed this thought: "I had finished half the picture. And I thought to myself, 'This isn't it!' I did the other half. And I asked myself if I should redo the whole thing. And then

I thought: 'They'll understand what I wanted to do!' "[36]

This period of work on the *Autoportrait*—between the two stages of the second phase of the *Demoiselles*—is precisely the moment at which the first imitations of African masks can be observed.

In 1970, after a series of conversations with Picasso, I wrote my article "There is No Negro Art in the *Demoiselles*," arguing against accepted theories, which were rejected by the artist himself.[37] The 1984 exhibition " 'Primitivism' in Twentieth-Century Art" proved that none of the masks invoked by historians was pertinent.[38] Today, when our knowledge of Picasso's work and ideas and of the period have both increased dramatically, I think we can understand more readily his denial of all black African influence on the *Demoiselles*. At the outset he wanted to tell Barr, who had launched the idea in 1940, that the violence perceived in his canvas derived from his own inner depths and not from a jolt by a style of art with which he was (allegedly) unfamiliar. Finally he felt that much of the comment in the case of the *Demoiselles* was in direct opposition to what he himself saw in black African art. From 1912 on he saw this art not as "savage" but as "reasonable," which is to say, "knowing," while all the world thought otherwise.

The most "progressive" art historian of the time, Élie Faure, whose portrait Picasso did in 1922, illustrates this point for us. In *l'Art mediéval*, which appeared in 1911 but whose preparation began earlier, Faure devotes a new chapter to the *Tropiques*. He compares and contrasts Egyptian art to the "wooden sculpture" of black Africa, in which he sees

> sensations as short as they are violent, an attempt to satisfy the most immediate requirements of a rudimentary fetishism. And it is perhaps because of this horrifying candor . . . that [the sculpture] is so expressive. . . . These sculptures of painted wood . . . possess a good-natured ferocity, and a murderous innocence which commands respect.

This description fits perfectly the collection from Oceania which Picasso found in the ethnographic museum at Palais du Trocadéro: intensely colored and, as Rubin has pointed out, even more dramatic than African work. I share Rubin's view that the shock of this display affected the final version of the *Demoiselles*.[39] As early as 1912 Salmon stressed this Oceanic source. Certainly the collection made possible the atmosphere described by Élie Faure. And made it possible, as well, for Picasso to exceed both the barbarity of Matisse's orientalism and the Far Eastern exoticism of Derain and by so doing to assert himself in the avant-garde.

The other source of influence is not more persuasive. Since Bernard Dorival in 1969, the question of Greco has often been raised but without any extended analysis.[40] The notebooks show clearly that there was no compositional borrowing from that artist. In fact, the question of Greco's influence arose during the course of work on the picture because the elimi-

nation of the sailor led to a disproportionate elongation of the central girl with raised arms. She, then, through the power of suggestion, becomes a Greco character. As Picasso was obliged concurrently to reconstruct the right side of the picture with the help of rhythmic draperies, he found himself grappling with a problem already treated by Greco. Whether he looked for support to the *Fifth Seal of the Apocalypse,* which was nearby at Zuloága's in Paris, or the *Visitation* of Toledo, which he remembered, or some other picture is not important. Picasso wasn't, as in 1902, asking Greco for a subject. He was looking for suggestions about method.[41]

When he laid down his brushes, Picasso could claim to have painted a truly modern work, in the sense that predecessors like Gauguin or Rimbaud gave to the term. He had freed painting from the trammels of academic tradition, religious lies, and social respectability and opened it to a new beginning which derived from primitivism and magic. With these means he was able to attain a kind of power over those aspects of the feminine, of Woman, of Madeleine and Fernande, which caused him anguish. He achieved what Rubin has rightly called "a relentless self-confrontation . . . comparable in this sense only to Freud's solitary self-analysis."[42]

Because *les Demoiselles d'Avignon* constitutes a similar "transfer," Kahnweiler's question about the picture's completion is without issue.[43] Picasso was aware of having achieved a breakthrough into the unknown— so much so that he quickly proceeded even deeper into savagery with the *Nu jaune* (Yellow Nude) sequence and with the *Femme nue aux bras levés* (Nude with Raised Arms), in which one can see direct use of black African elements (while the body rhythms have suggested "dancers").[44] There is also the oil painting *Mère et enfant* (Mother and Child), mysterious in its violence and cruelty. During the same period, as I have said, he developed in sculpture some purely formal elements, which he would elaborate in abstract paintings of foliage[45] and, above all, in *Nu à la draperie.*[46]

The notebooks reveal that the rhythm of the figure in *Nu à la draperie*—including the tapering of the face—was conceived during the first stage of the *Demoiselles.* They also indicate a drive, from the first, toward the deliberate, plastic purity of black art, which will cleanse *le Bordel* of all realism. This spirit reigns supreme in *le Nu* but is associated with a return to Ingres, as Picasso confers on this figure the abandon of the sprawling woman in the foreground of the *Bain turc.*[47] This reference to Ingres is also evident in Picasso's *Odalisque d'après Ingres,* a drawing with watercolor and gouache now at the Musée Picasso. Here the graphics of the *Demoiselles* summarize and reapply those of Ingres' *Grande Odalisque.*

This is a sharp turn toward form, combining the rhythms of Ingres and of Matisse's *Nu bleu* with the stylization of an "African" face to produce a unique calligraphy of figure and of spatial content. Picasso used the hatchings which first appeared during work on the *Demoiselles.* But now they are more controlled and refined. He allows us to make a visual tour of this naked body, to see it in the round. Simultaneously he creates a

dynamic which leads us to see a recumbent form, although the design of the picture, into which this body blends, presents her as a vertical.

The workings of fate withdrew *Nu à la draperie* from the public from the period of its creation until 1954, when it emerged from Russia for a few days. The Steins bought it almost at once, together with practically all of its preliminary drawings (Picasso's first experience of that kind), and then resold it to Tchukhin. The studies were scattered and reunited only in 1970 for the exhibition "Four Americans in Paris" at the Museum of Modern Art in New York. The *Nu à la draperie* (a poor title; Picasso called it "mon nu couché") must have been finished in the beginning of September. Even if Gertrude Stein's recollection of dates must be viewed with a certain caution, the wealth of verifiable details with which she describes Alice Toklas's first visit to Bateau-Lavoir in mid-October leaves no doubt: Picasso was showing her his studio, not, as has been claimed, simply the *Demoiselles*.[48]

The mixing together of initial drawings with drawings of the *Demoiselles* confirms that they are the product of a single creative period. Why does Kahnweiler say nothing about the *Nu à la draperie*? Why did Salmon—and, even more extraordinary, why did Gertrude Stein—fail to spot it? We shall see that Picasso's unique innovations, which began with the transformation of *le Bordel*, were greeted with an incomprehension that grew throughout the opening months of 1908 and became more or less general. To speak, in this instance, of the artist's heroism is very much to the point.

THE *CORDÉE** WITH BRAQUE

1907–1908

T he simple presence in his studio of an enormous canvas as unusual and apparently eccentric as *les Demoiselles d'Avignon* was in itself enough to precipitate Picasso's isolation. A belated recollection of Wilhelm Uhde's mistakenly places at the beginning of 1907 events which occurred during the summer: "I received a desperate note from Picasso asking me to come and see him immediately. He was tormenting himself for a new set of reasons. Vollard and Fénéon had come to his place and had left again without any understanding of what they'd seen."[1] We know that the same thing happened with Apollinaire, who brought Fénéon to the Bateau-Lavoir. Fénéon, it seems, told Picasso that he had a gift for caricature. Uhde arranged a visit by Kahnweiler (who had recently opened his gallery) but— as with the visit of Augustus John in the beginning of August[2]—the reactions of strangers did not compensate for rejection by those on whom Picasso counted. "The studio on the rue Ravignan was no longer the 'rendez-vous des poètes,' " writes Salmon,[3] the only one to remain faithful. Fernande, as we know, had left.

One can easily imagine the impatience with which Picasso awaited the return of Leo and Gertrude Stein from Fiesole. Gertrude came back sometime between 2 and 7 September;[4] Leo was probably with her. Leo was appalled and spoke of a "horrible mess," or worse. Only Gertrude took Pablo's part: "The beginning of this struggle . . . was discouraging, even for his most intimate friends, even for Guillaume Apollinaire. . . . I was alone at the time in understanding him."[5] This can be confirmed although she adds, "perhaps because I was expressing the same thing in literature." Gertrude has understood and is reporting here a notion which was for Picasso a source of encouragement throughout his life:

> He who created a thing is forced to make it ugly. In the effort to create
> the intensity and the struggle to create this intensity, the result always

**Cordée:* Braque invented this conceit—mountain climbers linked by a shared rope—for a 1950 interview with *Cahiers d'Art;* a metaphor of his relationship with Picasso in 1907–8, at the dawn of Cubism.

produces a certain ugliness. Those who follow can make of this thing a
beautiful thing, because they know what they are doing, the thing having
already been invented, but the inventor, because he does not know what
he is going to invent, inevitably the thing he makes must have its ugli-
ness.[6]

Picasso and Fernande had parted, but as no historian of the times took
note of the fact—with the exception of Gertrude Stein—it is from her
memoirs, published in 1933, that the decisive reactions of Matisse and
Braque are drawn.[7] These are attributed to their discovery of the *Demoi-
selles,* a misreading which produced distortions of this critical period and
misunderstandings which have survived to the present day. She writes:
"Picasso and Matisse, more or less in tandem, flung themselves into the
birth throes of Cubism, which had the effect of jolting Matisse from his
natural calm. He talked of 'sinking' Picasso, of making him beg for mercy."
Her remark about the birth of Cubism and the Matisse-Picasso rivalry has
usually been interpreted as referring specifically to the time immediately
after the *Demoiselles.* But that is a misunderstanding. For one thing, in the
fall of 1907 Matisse and Picasso exchanged canvases—the *Portrait de Mar-
guerite* for *Cruche, bol, et citron* (Pitcher, Bowl, and Lemon), one of the still
lifes contemporary with the radical novelties of the *Demoiselles.* This ex-
change proves that their relations were still good.[8] Gertrude claims that
they were at this time both friends and enemies and that in their exchange
of paintings, each of them, instead of choosing what was most interesting
to him in the work of the other, "chose each one of the other one the picture
that was undoubtedly the least interesting either . . . had done. Later each
one used [his chosen picture] as an example to demonstrate the mediocrity
of the other." However, I can state that, as regards Picasso, this is totally
false. He pointed out with delight that Marguerite had the same flattened
nose as the demoiselle who is seating herself. And Matisse surely noted in
the still life—which has extraordinary power—the significant, violent ap-
proach of Cézannism. Gertrude enjoyed provoking the rivalry between
Picasso and Matisse. Here, however, she seems to be relying on the judg-
ment of Leo, who hated the radicalization of both.

The key to this Matisse-Picasso imbroglio can be found in the fact that
Fernande applied the phrase "birth of Cubism" not to the *Demoiselles* but
to what she knew of the studio and its contents when she resumed living
with Pablo, which is to say, at the end of November or beginning of
December 1907. We shall see that this illuminates the reaction of Braque,
which she reports: "You paint as if you were trying to make us eat wadding
or drink petrol." Kahnweiler's own version, "It's as if someone had swal-
lowed petrol in order to spit fire," seems more accurate and undoubtedly
refers to Braque's reaction as well as his own. It is a reaction to Cubism,
not the *Demoiselles.*[9] No one, in fact, grasped the painting's Cubism at the
time. Eventually Kahnweiler did, but not at first. Kahnweiler leaves no

doubt that "the picture Picasso had painted struck everyone as something mad and monstrous." He adds: "Derain told me personally that one day Picasso would be found hanging behind his big picture."

By its size (244 × 234 cm.) the *Demoiselles* dominated the studio. But—and here is the crux of the matter—the picture was not alone. Braque, for example, found support for his *Grand Nu* of 1908 in *Nu à la draperie*, not in the *Demoiselles*. Similarly, we shall see that Braque's drawing for *Trois Femmes*, which we know from an article by the American Gelett Burgess, published in 1910, can only be explained with the help of Picasso's large painting of that name. Kahnweiler separates the *Demoiselles* from a body of production, but everything we now know points to a steady stream of work, without any breaks.[10]

He also separates Picasso's pictures from the Cézanne retrospective at the Salon d'Automne, the major event of the autumn of 1907 for Picasso and the entire group of painters who came to the Bateau-Lavoir. Among these was Braque, who had been introduced to the group by Apollinaire. Finally the Master of Aix could be judged by his entire trajectory, as well as by individual canvases. Everything becomes clear if instead of orienting each calculation to the *Demoiselles*, we shift to Cézannism as the heart of the debate. With Cézanne as point of departure, we can observe the growing rift between Picasso and Matisse. (Derain, who married Alice in October, would shortly thereafter be regarded as someone who had left the Matisse camp for Picasso's.) At the other end of the spectrum, the increasing closeness between Picasso and Braque would be entirely incomprehensible if the *Demoiselles* were the only issue in question.

Picasso adopted toward Cézannism a position which was entirely his own. He was at the beginning of his most "African" period—deliberately violent and primitive, borrowing directly from African masks. A short time later, in the *Nu à la serviette*, he put a mask on a bather in a Cézannesque setting, primitivizing Cézanne. One might say here—and this no doubt occurred to his startled friends—that with a subject taken from Cézanne, he was doing "African" painting. Primitivism transported him to paintings of great intensity, to canvases which are monumental and overwhelming in their volume. *L'Amitié* (Friendship), a painting of two nude women, is typical of these. And I now believe one should include in this set of paintings the initial, primitivist version of *Trois Femmes*. Leo Steinberg had already spotted this passage in the *Autobiography of Alice B. Toklas* in which Gertrude describes her friend's first visit to the Bateau-Lavoir.

Against the wall was an enormous picture, a strange picture of light and dark colors, that is all I can say of a group, an enormous group and next to it another in a sort of red brown, of three women, square and posturing, all of it rather frightening. . . . I cannot say I realized anything [it is Alice who is supposed to be talking] but I felt there was something painful and beautiful there and oppressive but imprisoned.

STAGES IN THE DISCOVERY AND APPROPRIATION OF PRIMITIVISM

Spring 1901	Picasso sees paintings by Gauguin at Paco Durrio's in the Bateau-Lavoir.
Autumn 1902	Charles Morice gives him a copy of *Noa-Noa,* which Picasso claims to have covered with drawings.
December 1903	On hearing of Gauguin's death, signs a drawing of a nude woman in the style of that artist "Paul Picasso."
Late 1905–early 1906	Visits the exhibition at the Louvre of Iberian sculptures dug up at Osuna and Cerro de los Santos.
	Begins *Portrait de Gertrude Stein,* in which the influence of the *Tête de Bretonne* is already perhaps discernible.
	Meets Matisse (who had bought Gauguin's *Jeune homme à la fleur* in 1898) and Derain. Both of them had seen the Gauguins from Oceania at Daniel de Monfried's, at Collioure.
Gosol, summer 1906	Picasso begins reducting to masks Fernande's face and the face of an old peasant.
Late August 1906	Completes *Portrait de Gertrude Stein* and *la Coiffure,* with faces reduced to masks.
Autumn 1906	Derain and Matisse return to Paris, each having acquired his first African mask.
	Gauguin retrospective at the Salon d'Automne.
	Deux Femmes nues. Primitivist self-portraits.
March 1907	Géry-Pièret brings Picasso two Iberian sculptures stolen from the Louvre.
20 March 1907	Salon des Indépendants opens. Derain's *les Baigneuses* and Matisse's *Nu bleu souvenir de Biskra* create an uproar.
Late May–early June 1907	Formalist drawings inspired by African art forecast the *Nu à la draperie.*
June 1907	Passage from the Iberian figuration of the *Demoiselles* to a paroxysm of primitivism.
	Visits the Trocadéro museum; discovers Oceanic art.
July–August 1907	Arrives at present version of *Demoiselles.*
	Works on African masks for faces of *Femme nue aux bras levés* and *Nu à la draperie.*
Autumn–winter 1907	Development of primitivist faces. *Trois Nus féminins.* During Alice Toklas's first visit to the Bateau-Lavoir, Gertrude Stein discovers primitivist version of *Trois Femmes.*
	Nu à la serviette; L'Amitié. Picasso primitivizes Cézanne. Matisse takes his distance. Braque is inspired by the *Trois Femmes* in the drawing reproduced by Burgess and by the *Nu à la draperie* for his *Grand Nu,* although he disapproves of Picasso's exacerbated primitivism.

(Continued)	
Spring 1908	When Burgess comes to see him at the end of April, Picasso has already amassed a collection of African and Oceanic subjects.
	Drawings and a box-wood carving are inspired by the Nimbas. Returns to African formalism.
August 1912	Picasso and Braque buy African objects in Marseilles.
October 1912	Picasso assembles a paste-board guitar inspired by a Grebo-Wobé mask, which he also uses as the basis for a new type of face in *papiers collés,* and in painting.
	His Cubism—and Braque's—abandons imitation, and becomes synthetic.
Late 1913	*Femme en chemise assise dans un fauteuil.*
After 1925	Influenced by the discoveries of Miró and the Surrealists, Picasso's interest in primitivist freedom of reorganization, expressivity, and sexual signs is renewed.

This text was later read to Picasso.[11] There is no reason to regard it with any suspicion. And we have the precise date of the visit: mid-October. This means that Pablo continued to consider the primary components of *le Bordel*—the "enormous picture" Gertrude describes—with the *Nu à la draperie* but also with *Trois Femmes:* formidably imposing with its height of two meters and the violently geometrized shapes reminiscent of similar volumes in paintings of Fernande. This is a return to the problems posed by the *Bain turc,* in which the positions of the nudes create space by their contrasting rhythms. But sensuality here is conferred on powerfully sculpted idols, larger than life, whose postures immediately suggest Cézanne's bathers. We know that in the first stage of the painting, these figures had masks similar to those in *Nu à la serviette* or the *Trois Nus féminins* and that the figure on the left held a towel against her thigh.

Salmon describes the situation in a passage recorded by Gertrude: "Painter friends withdrew. . . . Picasso found himself in the company of African augurers, and painted several formidable nudes, grating, and entirely worthy of execration."

Gertrude, born in February 1874, claimed to be thirty-four at the time of her first argument with Leo over Picasso. "He is attacking me," Pablo complained. "And yet he's the one who said that my drawings are more important than Raphael's. So why torment me over what I'm doing now?" Gertrude also dates the cooling in relations with Matisse to the latter's establishment of his school in the Boulevard des Invalides. Combining Cézannism with African masks ran counter to what Matisse was attempting in his canvas *la Coiffure* or in the two versions of *Luxe,* in which he emphasized the purity of rhythms and looked for harmony in precisely

those instances used by Picasso to slam us against brutal shapes and make his barbarous faces howl.

Apollinaire stresses this in *la Phalange* of December 1907. "We are not in the presence of an extremist experiment. 'Being reasonable' is a primary characteristic of Matisse's work."[12] This chronological and ideological correction, which shifts discussion between Picasso and his friends from the revelation of the *Demoiselles* in September or October to the totality of his primitivist production in the autumn of 1907, casts a different light on Braque's reaction. According to the corrected chronology of *Picasso and Braque: Pioneering Cubism,* Braque—who sent Picasso a postcard of greetings from La Ciotat (probably in September)—did not return from the Midi until mid-November. This places his visit to the Bateau-Lavoir at the end of November or beginning of December at the earliest, a date which corresponds with Fernande's return to the studio and her account of it.[13] Picasso and Braque had kept in touch with each other since at least the Indépendants of 1907.

Braque returned from l'Estaque with his first *Viaduc de l'Estaque* and his *Terrasse de l'Hôtel Mistral.* These works represent his apparently abrupt passage—influenced by the Cézanne retrospective at the Salon d'Automne—from Fauvism to Cézannism, a Cézannism which is carefully thought through, with its subjects further abstracted. Its shapes not only are simplified and contrasted through color but, above all, are reconstructed. His reaction translates the shock he felt when confronted with the violence of Picasso's primitivism, a violence which provoked reconstructions far more brutal, summary, and effective. Braque's comment is made by the drawing for *Trois Femmes* reproduced by Burgess, a drawing which cannot be linked to the final stage of *Demoiselles,* but constitutes a reworking of the original version of the primitivist *Trois Femmes.* (That original version can still be glimpsed in the background of Salmon's photograph of the Bateau-Lavoir.) In his drawing, Braque replaced each contrast of attitude with a posture taken much more directly from Cézanne's bathers than that of any of Picasso's women. And Braque's faces are not savage masks. But he maintained the challenge posed by Picasso: to build a composition based on rhythmic oppositions of volume of naked bodies, and he adopted Picasso's primitivist simplifications for the feet and hands.[14]

There is another important difference: instead of spatial content indicated—as with Picasso—by brutal crosshatching, Braque made the Cézannesque atmosphere surrounding each object vibrant by an interplay of contrast between hatchings and "passages." As William Rubin has stressed, Braque's *Grand Nu* is a development of the woman to the left of this drawing. We know today that there was another painting, between the drawing and the *Grand Nu,* which included at least two women (a point of similarity with Burgess's drawing). That picture, although not mentioned in the catalogue, was shown at the Indépendants of 1908.[15]

This illuminates the reaction of Fernande, who did not like Braque. At

the time of her break with Picasso, in 1912, he took Picasso's part, against her.

> A short time after this [Braque's remark that Picasso wanted to make him drink petrol], Braque exhibited a large cubist canvas at the Indépendants, a painting which, it seems, he had done in secret. He had talked about it to no one. Not even to Picasso, who had inspired him. The latter seemed to be 'rather indignant' about it.[16]

Similarly, Gertrude Stein writes: "The first time as one might say that Picasso has ever shown at a public show was when Derain and Braque, completely influenced by his recent works, showed theirs." She explains this through the mouth of Alice B. Toklas, reporting their conversation with a friend at the Indépendants of 1908:

> You have seated yourselves admirably she [Gertrude] said. But why? we asked. Because right here in front of you is the whole story. We looked, but saw nothing except two big pictures that looked quite alike but not altogether alike. One is a Braque and one is a Derain, explained Gertrude Stein. They were strange figures of strangely formed rather wooden block figures, one, if I remember rightly, a sort of man and woman, the other three women. . . . My friend and I sat without being aware of it under pictures which first publicly showed that Derain and Braque had become Picassoites and were definitely not Matisseites.[17]

It was at this Salon des Indépendants, according to Gertrude, that "the feeling between the Picassoites and the Matisseites became bitter." We find here, far from the revelation of the *Demoiselles* alone, an indication that the shock which affected Braque and Derain, which provoked colloquy through successive pictures, was produced by the entirety of Picasso's primitivism. Although, unfortunately, we don't know the actual painting *La Toilette* by Derain, the photograph which survives indicates a solid, simplifying primitivism analogous to that of his *Baigneuses* of 1907. As for Braque, we know from the recollections of Inez Haynes Irwin, who went to Braque's studio with Burgess on 27 April 1908, that there was "one fearful picture of a woman with exposed leg muscles; a stomach like a balloon that has begun to leak and sag; one breast like a pitcher, the nipple down in a corner, the other growing up near the shoulder somewhere; square shoulders." Which proves that the *Grand Nu* was not at the Indépendants and that by this date it was already well advanced.[18]

Braque demonstrates here that with Cézannesque methods and distortions which do not exceed those of Matisse's *Nu bleu*, one could obtain the powerful contrasts which Picasso exacerbated by the savagery of his masks. He challenged Picasso all the more in that his *Grand Nu* once again returned to woman as a subject. Here the figure, inscribed on the canvas

vertically, is meant to be seen as recumbent—a device analogous to that of the *Nu à la draperie,* itself a comment on the *Nu bleu.* For Matisse, however, the *Nu bleu* belonged to the past. At precisely that moment in 1908, he was setting out in an entirely fresh direction, organizing his compositions with the saturated color and decorative rhythms which would lead him to *La Déserte rouge.* It was immediately clear that Derain and Braque had left his camp, in that spring of 1908, to join Picasso's. On 12 May, when he returned from Havre, Braque invited Picasso to show with them, an invitation which, so far as we know, had no issue.

Inez Haynes Irwin went to Picasso's studio with Burgess on 29 April. There she saw two large canvases which must have been the *Demoiselles* and *Trois Femmes.* She adds, he "shows us a mask of [*sic*] the Congo and some totem-pole-like hideosities that he made himself." This evidence that primitivism was still his objective at that date is corroborated by Burgess' photograph of Picasso in the studio, posing in front of African and New Caledonian objects.[19]

Perhaps he showed them his sculptures as well or works like *Nu à la serviette, Trois Nus féminins* (which continues the primitivist theme of *Trois Femmes*), *l'Amitié,* or *le Nu debout* (Standing Nude, now in the Museum of Fine Arts, of Boston). A notebook found during work on the *Demoiselles d'Avignon* exhibition of 1988 indicates a reexamination of primitivism in the spring of 1908, a deepening understanding which will produce works like *la Figure,* a boxwood carving reminiscent of the Nimbas, and paintings like the Rupf Foundation's stylized *Tête d'homme* and the *Homme assis* (Seated Man), whose African frontality is precisely maintained. Themes close to the *Demoiselles* were explored further in *Vase de fleurs* and *Marins en bordée* (Carousing Sailors), and, above all, in *la Femme,* a highly rhythmic work with a primitivized face (a response, perhaps, to Braque's *Nu*).[20] The primitivism surviving here has exchanged its savagery for the clear and monumental geometrization of *la Femme à l'éventail* (Woman with a Fan).[21] The influence of conversations with Braque seems inescapable, talks which must have continued until the beginning of May, when the latter left for Havre. And Picasso surely saw *le Grand Nu,* still unfinished, as the back of the canvas is marked "June."

The *Trois Femmes* remains in the background of this notebook, which contains—in addition to a drawing for the initial version of *la Dryade*—a sketch for the geometrization of the central figure's arm. These are mentioned in letters to the Steins of 26 May and 14 June and appear in a number of photographs at the Musée Picasso showing various stages of work not previously reported. One feels that Picasso was engaged in a profound reconsideration of an entire period of work, a rethinking provoked by the final stage of the *Demoiselles.* This explains why Kahnweiler speaks of "desperate combat in the assault of heaven; a simultaneous engagement with every possible problem." He was at the time only an intermittent visitor to the studio and clearly knew nothing of Picasso's long labor on the

Trois Femmes, which he never mentions. Yet "the short spell of fatigue" Kahnweiler mentions does not seem to be connected to work.[22] It was, in fact, a fatigue of spirit after the suicide, on 1 June, of the German painter Wiegels, to which Picasso was a witness.

Fernande writes: ". . . once in a while we would go back to taking opium. We did this until a tragedy unfolded before our eyes, until, that is, our neighbor Wiegels committed suicide. After an eventful evening, during which he successively took ether, hashish and opium, he failed to recover his senses. . . . Being very shaken up, we decided never to touch drugs again."[23]

When he discovered Wiegels hanging at his studio window, Picasso was working on a primitivist face.[24] Everything suggests that the large *Composition à la tête de mort*[25] is a product of this time. A view of the studio which resumes the rhythms and strong contrasts of the 1907 still lifes opens a fresh approach to Cézannism. A purified primitivism transmuted into expressionism moves from a series of still lifes (which are still dramatized) to imaginary landscapes, rhythmic and reorganized, with simplifications which may be the product of reflections on the landscapes of Douanier Rousseau.[26] This reordering takes into account Apollinaire's criticism of the *"tentative outrancière"* (extremist experiment) which followed the *Demoiselles* and coincides with Braque's observation to Georges Duthuit that one "cannot remain in perpetual paroxysm."[27]

According to Fernande, after Wiegels' suicide Pablo was in such a state of depression that he couldn't work. Pablo claims that she was the most affected of the two. And, in fact, it seems that he felt the shock only after a certain delay. A letter to Leo Stein of 14 August spells this out. "I worked so hard in Paris this winter and last summer in the studio with all that heat that all my work finally made me ill." And we know through Burgess (a letter to Inez Haynes Irwin) that Picasso worked until 28 July. "Picasso was charming, more than usual. [He] was at work on a picture more horrible than ever, and I'll show you a picture of it."[28] This could refer to the *Seated Nude,* reproduced in Burgess's article and today at the Hermitage. Since Burgess left France almost immediately, if he had the photograph of the *Trois Femmes* with him, it would mean that the picture at that moment was almost identical to the canvas as we know it today. And would prove as well that Pablo had already effected a considerable disengagement from his initial primitivism.

On his doctor's recommendation, to calm his nerves (and perhaps calm as well the anguish provoked by unresolved questions in his work), Picasso left with Fernande at the end of July for la Rue-des-Bois, a village of no particular charm some sixty kilometers north of Paris, near the beautiful Halatte forest. Max Jacob, Alice, and Derain stopped to see them on their way back from Martigues. Picasso had literally "pruned" his subject, reducing it to cubes, to contrasts of rhythm between geometry and the natural forms of trees. These landscapes are without air, without space, filled with

volume and mass to the point of overflowing. One sees this, for instance, in the detailed close-up of *la Fermière*. Both portraits of this woman, with their geometric simplifications and *cadrage*, recall Derain's *la Toilette* but are far more decisive. The landscapes, too, are reminiscent of those which Derain brought back from Cassis and Martigues. In both cases—as in the still lifes—the reconstruction of the motif to make its lines distinct from its plastic forces is remarkable, like reaching beyond primitivism in the face of *la Fermière*.[29] If Picasso had not yet mastered Cézannesque workmanship, he nonetheless at this point replaced primitivist expressivity with a constructivism whose freedom derives from the Master of Aix. This new approach illuminates the output of la Rue-des-Bois and seems to support Burgess's claim that he saw *les Trois Femmes* when it was almost finished. It is also proof of the revitalized morale which Picasso announced to Leo, and he was visibly nourished by the months of reflection which followed his discussions with Braque and Derain. And it explains the shock he received in September when Braque returned from l'Estaque.

In fact, contrary to what Kahnweiler has written, the surprise was not that Pablo "discovered" in the canvases brought back from l'Estaque that "Braque, at present, has reached the same point as he [Picasso]."[30] It was, rather, that although in May he thought he had achieved the same solid constructivism in expressing volume as Braque, he now had to admit that his rival was resolving the relationship between objects or figures and spatial content in a far more supple, more "Cézannesque" manner than he himself was able to do; that in his own case, up to that point, his forms had no air, no atmosphere around them.[31] Braque says of that period that he was taking fresh steps in understanding Cézanne. "It was an initiation. Cézanne was the first to have broken away from erudite, mechanized perspective."[32]

And here we can grasp the nature of the exchange which would mark the joint adventure of Braque and Picasso. Braque had felt the primitivist thrust and challenged it by a deepening of Cézannism. The same primitivism shook Picasso in turn. They did not march in lockstep, but when one caught up with the other, they found that they were together.

Braque came back to Paris before 5 September to submit his work to the Salon d'Automne. Picasso was jolted by what he saw and immediately translated that shock into a new series of still lifes,[33] teaching himself to make forms which are vibrant in ambient space, and proceeding swiftly to the consequent transformation of *Trois Femmes*. We have Salmon's evidence on this point, confirming Fernande's recollection and the August letter to Leo Stein:

> The holidays interrupted these sad experiences. When he returned [to Paris], Picasso resumed work on his big, experimental canvas, which, as I've said, came to life only through its figures. He created their atmosphere with a dynamic decomposition of luminous forces, an effort

which leaves the experiments of Neo-Impressionism and Divisionism far behind.[34]

Salmon's words support precisely Rubin's observation that "what influenced the change in style following Picasso's decision to rework *Three Women* in the fall of 1908 was the experience of seeing the Estaque Braques." That was when he learned how to achieve "a smoothly graduated surface of muted green and terra-cotta planes whose very close light values permit them to pass easily into one another."[35]

This was an extremely important advance, which can be observed in *la Dryade,* whose definitive version, with a vault formed by trees, is close to the final version of Braque's *Viaduc* (a canvas later dated as from the autumn of 1908).[36] The same vaulting effect appears in *Paysage aux deux figures* (Landscape with Two Figures),[37] which should be dated as from that autumn. The exhibition of 1989 in New York indicated that *Maison et arbres* (House and Trees)[38] at the Pushkin Museum should also be shifted to that autumn. Previously the locus of the painting was thought to have been la Rue-des-Bois; but the organization of the composition, with the contrasting curves of the tree and the geometry of the buildings, is taken from Braque's *Maisons à l'Estaque* (Houses at l'Estaque), today at the Rupf Foundation. These are similar to elements of *le Paysage* (Landscape),[39] also a product of autumn 1908, given to the Museum of Modern Art in New York by David Rockefeller. Now the movement of Picasso's creativity between the brutal primitivism of the autumn of 1907 and the solid Cézannism can be perceived coherently.

Braque's exhibition of works rejected by the Salon d'Automne was held at the Kahnweiler Gallery between 9 and 28 November, probably timed to coincide with a banquet for Douanier Rousseau given by Picasso.[40] Braque's rejection by a jury which included Matisse highlights the antagonism between the "Matissists" and the "Picassoists," to borrow the language of Gertrude Stein, and stresses as well the degree to which Cézannism functioned as a touchstone. Braque, as meditative and detailed as Picasso was impulsive, had for the most part achieved his evolution through landscapes. The exhibition did, however, include some still lifes as well, like *Instruments de musique,*[41] which incites the eye to see all volumes in the round, bringing their hidden parts forward through distortion. Picasso, it should be noted, resumed his efforts to resolve these particular difficulties—previously approached by Ingres figures and Matisse's *Nu bleu*—with a manifesto canvas, *Femme nue au bord de la mer* (Nude beside the Sea),[42] which introduces the curved fragmentation of surfaces. Picasso—like Braque—had been painting pears, using that quintessentially Cézannesque item, the fruit bowl. And this is the actual birth of what Braque would call "la cordée en montagne"[43] (climbing the mountain, linked to the same rope).

That autumn Picasso found at Père Soulié's a large *Portrait de femme*

by Douanier Rousseau, and was able to buy it for five francs. To celebrate
this purchase, since Apollinaire knew Rousseau well, Pablo decided to
organize a banquet in his studio. Contrary to rumor, Picasso praised Rous-
seau's "naive" painting very highly. Orchestrated by propagandists as
gifted as Gertrude, Salmon, Apollinaire, and the young critic Maurice
Raynal, the event assumed historic dimensions. We know that Marie Lau-
rencin got drunk and that Fernande and Alice Toklas had to improvise
substitutes for items the corner grocer failed to deliver. Picasso surrounded
his Rousseau canvas with flags and garlands. Gertrude Stein reported that
"it was flanked by large statues, I no longer remember which."

All of Picasso's friends were there: Pichot and Germaine; Braque and
Max Jacob; Leo and Harriet Lévy. Apollinaire finally arrived with the hero
of the occasion, as Gertrude noted, "a pale little Frenchman with a little
beard, like all the Frenchmen one sees, no matter where." Raynal watched
him come in "with a soft felt hat on his head, his cane in his left hand, violin
in his right. He looked around the room. The glowing lanterns delighted
him, and he joked about himself."

He sat on a throne Pablo had constructed—a chair on a packing
case—played one of his compositions on the violin, and listened with
emotion to the eulogies. He said to Picasso, "We are the two greatest
painters of this time; you in the Egyptian mode, I in the modern." "Egyp-
tian" at the time meant everything that we would call primitive. "Modern"
was defined as it is today. At dawn the Steins drove Rousseau home in their
car. He was very happy and had fallen asleep.

Certainly there was a taste for celebration at the Bateau-Lavoir, but
this particular occasion became symbolic because at virtually the same
moment Picasso found a complicitous friend in Braque, and in Rousseau—
only five years younger than Cézanne—a grand predecessor in painting. He
had also found a faithful supporter in Kahnweiler, not included in the
celebrations probably because he was thought to be too serious. The moral
solitude of the last months of 1907 and the spring of 1908 was a thing of
the past.

Picasso began to think about a large banqueting canvas, which we
know today as le Carnaval au bistrot. A fine study of William Rubin's[44]
leads to an interpretation of the silhouetted personages as an homage to
Cézanne, on the left, in his Cronstadt hat; Rousseau, dressed as Pierrot, to
the right; and Picasso in the middle, as Harlequin. This is a postscript to the
banquet at Bateau-Lavoir. We know that Picasso transformed this scene
into the large still life which today is at the Kunstmuseum in Basel: Pain et
compotier aux fruits sur une table (Bread and Fruit Bowl on a Table) in
early 1909. His progress toward a kind of painting which does not draw its
strength from any ressemblance but rather from the quality of what is
inscribed on the canvas as rhythms and contrasts has led him to this
reinterpretation of painted forms beyond the sentimental subject from
which they derive, and toward the inherent still life, which one can divine.

It is a symbol which reveals that the new painting, in the process of stating its case, no longer draws its strength from "exterior" anecdote but from what it provokes the painter to imagine.

The bowl of fruit as a subject for painting was to undergo important development at Picasso's hands in a series of six works, two of these, large canvases.[45] Each painter, during their exchange of subjects and problems, remained himself. This was all the more profitable and necessary as each came to realize that in new painting, the originality of the artist derives above all from his ability to perceive unfamiliar problems as they arise during the course of work, from the process of work itself. Braque called the dynamic of forms which inversions or shifts of perspective thrust at the spectator "frames in flight." They discover a new pictorial space beyond Cézanne, which is the true birth of Cubism, of what continues to be *their* Cubism.

One can judge the entire distance between this revolution in composition and the act of birth attributed to Vauxcelles. After launching the term "Fauves" in 1906, Vauxcelles wrote—in his review of the exhibition at Kahnweiler's—that Braque had reduced "everything . . . to geometric schemas, to cubes." Seventy-five years later, these superficial attitudes continue to falsify.[46]

The effects on Picasso of his *cordée* with Braque can be seen above all in changes of palette and of plastic "signature." A heavy use of green— already evident in the space of *Trois Femmes* and again in the hangings of *Pain et compotier aux fruits sur une table*—will become one of the hallmarks of the period, in still lifes like *le Chapeau de Cézanne* (Cézanne's Hat) or the hangings at the back of *la Reine Isabeau* (Queen Isabella).[47] His brushwork became lighter, almost as finely striated as Braque's, which adds a sense of vibrancy to his volumes. One can see this particularly well in *la Femme à la mandoline*,[48] which went to the Hermitage. And somewhat differently, with workmanship of pictorial texture as subtle as Manet's in monumental sculptural figures like *l'Homme nu assis, la Femme nue assise* (Seated Male Nude, Seated Female Nude).[49] These are forerunners of a new découpage of forms in a powerful geometric simplification. All that remains of primitivism is the reduction of faces to masks, now without aggression to contradict their plastic harmony. Picasso imagined a canvas of bathers made from frankly Cézannesque themes. Although the project was not carried out, it nonetheless indicates the importance Cézanne assumed both for him personally and for his *cordée* with Braque.

After the final, Cézannesque reworking of *Trois Femmes,* one senses that under Braque's influence Picasso realized he no longer had to rely on violent tensions to give his painting a fresh expressivity. Light and the quivering presence of form in light produced a strong effect of presence for figures and for objects, revealing and disclosing them as never before, as "primitive" as on the first morning of the world. And it is from this point that he was to launch himself on a new adventure, fragmenting forms in

order to achieve their perfected, living presence in movement. This transformation was worked out entirely in painting.

Since the suicide of Wiegels, there had been no exceptional events in his life. The bloody suppression of a strike in Draveil, a suburban district south of central Paris on 2 June 1908, the day after Wiegels' suicide (with two deaths and six wounded among the strikers), did perhaps influence the conception of *Composition à la tête de mort* (Composition with Death's Head). But his formidable output of the summer was apparently unaffected by the crushing of the builders' strike at Villeneuve-Saint-Georges, in the same southern district, on 30 July, an action which left four dead and hundreds wounded. He and Fernande seem to have reached a modus vivendi. Since her return to Bateau-Lavoir, Fernande had abandoned her demands that Pablo give more of his free time—time that was not devoted to painting—to her. As Gertrude remarked, he put all his sexual energy into his work. But they were living better. Kahnweiler had begun to take Vollard's place. He brought his friend Hermann Rupf to Picasso's studio, and Rupf bought some works. Tchukhin, introduced by Matisse, began his purchases, as did a young Frenchman, André Dutilleul, who paid with monthly installments of a hundred francs. The Steins bought *Trois Femmes*, in itself a kind of victory after Leo's refusal of the *Demoiselles*.[50]

As we shall see, this calm was not destined to last. Fernande began to feel poorly again during the winter and would crack at Horta de Ebro.

Apollinaire—at least in appearance—was enjoying a perfect affair with Marie Laurencin. I say "in appearance" because Picasso told me there was always a certain physical incompatibility between them. Nonetheless, Apollinaire was immensely proud of his conquest. They spent nearly every day at Bateau-Lavoir. Apollinaire was beginning to write art criticism on a regular basis, but one senses that increasingly he was taking advice from Picasso. He published at Kahnweiler's his *Enchanteur pourrissant*, with woodcuts by Derain, bringing that ancient technique back into prominence. The crisis of the end of 1907 and the beginning of 1908 seemed remote. The Picasso *bande* was not only reunited, it was productive.

Fernande alone was uneasy. She never cared much for Braque, which is entirely understandable, even though Picasso's remark "Braque is the woman who loved me most" is entirely without homosexual intent. Fernande saw in Braque "an expression—often deliberate—of brutality, of grossness in his voice and gestures," even though she credited him with a "subtle intelligence." She condemned his ability to "adjust himself with such facility; his mistrustfulness, adroitness, and slyness; in short, his typical Norman nature." Which indicates that she had not looked at—or had not understood—the canvas *le Chapeau*, in which Picasso celebrates the Cronstadt hat bought by Braque in homage to Cézanne.

The *cordée* would take off for its assault on the heights, leaving Fernande behind.

THE INVENTION OF CUBISM

1909–1911

T he most perceptive account of Braque's November exhibition at Kahnweiler's was written by Charles Morice. "Mr. Van Dongen retains taste, having regard to the accepted belief that forms should in general be 'plausible'; from this last 'trammel' Mr. Braque has shaken free. Visibly he proceeds from an a priori geometry to which he subjects all his field of vision." The "trammels of plausibility" was an expression of Gauguin's to which Braque here found himself connected.

Then at the Salon des Indépendants of 1909, seeing Braque's *le Port* and a still life (which has been destroyed), Morice asked "where this dangerous route which (Matisse) has chosen might lead"; and then concluded that

> this, perhaps, is why the intransigents, the absolutists, who formerly accepted his tyranny, have now renounced it. Today, in fact, if not by express declaration, the leader in this audacity is M. Georges Braque. ... I believe that M. Braque is, on the whole, a victim—setting "cubism" aside—of an admiration for Cézanne that is too exclusive or ill considered.

This text is highly instructive. To begin with, published on 16 April 1909, it is the first that I know of to use the word *cubism*. And then it anoints Braque as leader of the *audacieux* against Matisse, which represents a small earthquake in the ranks of the avant-garde.[1]

The photograph of *la Femme assise dans un fauteuil* (Woman Sitting in an Armchair) on a postcard sent to the Steins on 23 March indicates that by the beginning of that month, Picasso was already well advanced in the new découpage of shapes. He made his figures more dynamic, so that they now appear to have "moved," and, sharply reversing the perspective of *Nature morte à la brioche*,[2] united rhythms to volumes and spatial content to figures or objects. He helped himself achieve these objectives by, for example, undulating hangings or striated brushwork or further recourse to abstraction, as in the *Femme au châle* and *Arlequin accoudé* (Woman with

a Shawl; Harlequin Leaning on His Elbow).[3] This inventiveness produced the first découpages of surfaces into facets and experiments in portraiture. There was a new *Femme à l'éventail* (Woman with a Fan), based, according to John Richardson, on Etta Cone, a friend of Gertrude Stein's youth; and a portrait of the dealer Clovis Sagot, done with a deliberately Cézannesque figuration. Clearly at this moment, on the verge of a breakthrough into the unknown, Picasso needed to control himself, to keep his balance, with the help of Cézanne. We should henceforth assign to this period as well *Femme au vase* (Woman with a Vase of Flowers), a particularly harmonious climax to these efforts.[4]

Up to this point Picasso's geometrization of forms in the portrayal of figures had been synonymous with violence. This was still true of *la Fermière* of la Rue-des-Bois in the late summer of 1908 and the final version of *Trois Femmes*. But his work on still lifes had taught him the power of contrasting rhythm and the spatial constructivism which resulted from it. The fragmentation of surfaces is a device to refine these contrasts and to give volume a tactile sensuality like that achieved by Braque. This is drawing close to material suggested by the model and simultaneously distancing oneself from it, since fragmentation is in fact an assertion of the painter's attitude. In the middle of these contradictions, which appear in certain canvases as flights toward abstraction, Picasso left for Spain to plunge once again into the scenes of his youth in Barcelona and Horta de Ebro.

Barcelona was an important staging point. We still do not know whether he introduced Fernande to his relatives, but from his hotel room he did some important ink drawings, which he told me about much later: "From them," he said, "everything else developed. . . . With those drawings I understood how far I would be able to go." He was speaking of the free reconstruction of forms, which he would carry to the point of contrasting a palm tree (not an element in Barcelona's flora) to the geometrical rigidities of buildings.[5] Here he painted the *Portrait de Pallarès*,[6] simplified by the same kind of tremulous highlighting in the brushwork that characterizes the paintings brought from Paris.

Their departure from Barcelona for Horta was delayed by an illness of Fernande's, which Fernande mentioned to Alice on 31 May. We know from Fernande's letters to Gertrude that they set out on 5 June. On the 15th Fernande sends their address, adding that they have been there for ten days.

On the 24th Pablo writes that he has begun two landscapes and two figures.[7] Stylistically, as was made clear by "Picasso and Braque: Pioneering Cubism," these are the two landscapes of *la Montagne de Santa Bárbara*, a subject he had painted earlier, in 1898. Now, however, he was applying to that subject lessons drawn from Cézanne's *Montagne Saint-Victoire*.[8] As for the figures, since he wrote to Gertrude that it's "always the same thing," he must mean *The Athlete* (destroyed when the São Paolo Museum caught fire), which in its découpage was very close to *Femme au vase* and one of his first portraits of Fernande.[9]

He had reached the point of "cracking" Fernande's skull, but he did it without aggression or sensuality; he did it, rather, because she—like *la Montagne de Santa Bárbara* or the *Bouteille d'Anis del Mono* (Bottle of Anis del Mono, a popular aperitif on which he was to base a still life)[10]— was there. In his first découpages he recorded with clinical detail his increasing girth, his tiredness, the first marks of aging on his face.[11] It was painting itself which reigned supreme, manifested by a fresh vitality beyond all rules and subject only to the imperatives of refining geometric simplifications. The persistence of this vitality, which marks the entire production of the visit to Horta, is all the more striking because everything that summer seemed to conspire to interfere with the creative solitude he needed.

First there was Fernande's illness, which struck again with fresh vigor and—as he wrote to the Steins in July[12]—had kept him from going to Madrid and Toledo. The doctor then authorized the trip, and Pablo expressed his delight. "I would be very happy to go. I've been wanting—for a long time, now—to see Greco again in Toledo and Madrid." Unfortunately for Pablo, Fernande couldn't go. She sent Gertrude a despairing letter.

> I've been in Spain for two months and have not yet had an entire day to rest. . . . I most certainly would be better off in Paris, where I could receive treatment. But to travel now would too greatly aggravate the illness. . . . Life is sad. Pablo is glum, and I can get no mental or physical comfort from him. . . . Pablo would let me die without realizing the condition I'm in. Only when I suffer does he stop for a moment (from working) to take care of me. . . . He is too much of an egoist to understand . . . that he, in large part, made me this way over the winter. He has completely disorganized me. And all of this is nervous; I'm sure of it.[13]

This has a ring of plausibility and gives a sense of the tension between them. Pablo, preoccupied by his painting, left Fernande alone, cut off from everything, in a rural village less isolated than Gosol but, from a tourist's point of view, less interesting. Above all, the sensuous ardor of 1906 seems a thing of the past.

A second source of trouble was generated by a revolutionary uprising in Barcelona. The government, because of disastrous reverses in the Rif war, recalled the reserves on 9 July, but only in Catalonia. Resistance quickly took the form of a general strike: against militarism and clericalism and in favor of social justice. Patricia Leighton gives an idea of the scale of repression: 175 workers killed, 2,000 arrests, and that many again taking refuge in France.[14] Picasso wrote to the Steins, "We have been in Spain in full revolution." Fernande is specific: "The events . . . in Barcelona have isolated us from the world for about ten days, and as the government has hindered all external relations, the letters which I sent you must not have

reached you for a long time after I sent them."[15] As the *semana tragica* occurred mid-month, this dates Fernande's letter to roughly 20 July.

Pablo, in fact, had gone on working without any reduction of tempo. His palette, as their stay in Spain grew longer, became luminous, playing with a range of grays in almost metallic bursts, pale ocher, and pale greens. He photographed subjects before painting them to record transformations of form, as Cézanne had done in his exaltations of Gardanne. He used inversions of perspective, purified the geometry of *Houses on the Hill, Réservoir,* and, in particular, of *l'Usine* (Factory).[16] In this last picture he once again employed imaginary palm trees, whose curves provide contrast to the painting's rectangles (and, incidentally, surpass the plastic echoes of Matisse's *Nu bleu*).

The treatment of faceted découpages in Fernande's bust and face is another instance of this process. He fused her naked body with the mountain behind it to create greater energy and force and achieved the masterpiece *Nu dans un fauteuil* (Nude in an Armchair), a work of admirable monumentality and haughty elegance whose geometrization is so abstract that Fernande is no longer an identifiable pretext.[17]

A letter from Fernande to Gertrude during August tells us that Picasso was sorry to miss his sister's wedding, but that they were planning to spend two weeks in Barcelona. On the 28th, however, they were still in Horta. Picasso asks the Steins if they have received photographs of four of his paintings. "One of these days, I'll send you the others of the countryside and of my paintings. . . . I'm still doing studies and am working fairly regularly. Kahnweiler will be there at the beginning of September and that bothers me."[18]

In fact, he cut short their visit to Barcelona, spending only a few days there, perhaps because of the increasingly violent repression. In mid-October moral responsibility for the disturbances was assigned to Francisco Ferrer, guiding spirit of the anarchist movement, and he was executed. Picasso told me that he cried when he heard the news: Ferrer had been for him a symbol of the new Spain. In 1901 Ferrer had opened a nonclerical, rationalist school for workers' children and, with Elisée Reclus, had founded a publishing house for works of popular pedagogy. This happened in Paris at a time of huge demonstrations directed by Jean Jaurès. Picasso did not say that he had participated.

His haste to return to Paris made him abandon any thought of stopping at Cadaqués or Céret, a decision which also had the advantage of cutting short the encounter with Kahnweiler. He was visibly proud when he showed the Steins the successful products of his stay in Spain. On 13 September he had written to them in Paris: "The paintings will not be arranged till Thursday noon," which is to say, the 15th.[19]

Picasso's political concerns were as vital to him at this time as they had always been. But the current events of the year did not appear in his work of 1909 because his art was responding only to its own imperatives. The

discovery of that autonomy was a matter of passion for him. It was not until three years later, in the autumn of 1912, with the new perspectives opened by *papier collé* that he once again felt a pressing necessity to forge links between his art and his political ideas.

On returning to Paris, he felt pleased with his Spanish campaign. He had managed to move beyond the contradictions which marred many of the experimental canvases done at the beginning of 1909, to attain a triumphant lyricism, a new kind of beauty. Gertrude Stein hung his landscapes in the Rue de Fleurus. Picasso had, as I've said, taken photographs of their subjects; there were also photographs recapitulating his work on Fernande. (He was to produce such summaries again at Cadaquès in 1910 and at Sorgues in 1912, each time he was able to leave without undue upheaval.) Gertrude compared paintings and photographs and bought *L'Usine*, declaring it in her *Autobiography of Alice B. Toklas* the "beginning of Cubism." One senses her enthusiasm for these canvases, which struck her as typically Spanish and whose transformations she appreciated. Did Matisse's irritation begin at this juncture? "Mademoiselle Gertrude," he explained, "likes local color and theatrical values. It would be impossible for anyone of her quality to have a serious friendship with anyone like Picasso."[20] The phrase "theatrical values" must, it seems to me, refer to the famous palm trees of *l'Usine*—which reminded him, perhaps ironically, of the palms in his *Nu bleu (Souvenir de Biskra)*.

The great upheaval of returning to Paris included for Picasso a move to a new apartment at 11 Boulevard de Clichy, in the Pigalle district, just at the foot of Montmartre. "He had rented a big studio in the northern part of the city," Fernande writes, "and an apartment in the south, whose windows opened onto the trees of the charming Avenue Frochot." She also notes that he had decided on the move with great reluctance, which is readily understandable to anyone who knew his horror of any move which might jeopardize the order around him (order which struck others as perfect disorder). Gertrude remarks: "Things were not in those days going any too well between them" and reports a scene in which Fernande "shook him and said, you think you are witty, but you are only stupid. He ruefully showed that she had shaken off a button and she very angrily said, and you, your only claim to distinction is that you are a precocious child."[21]

What is certain is that Fernande thereafter wished to keep house in proper bourgeois style. They must have furniture, china, and a maid. "One only tidies the studio when he orders it. One doesn't sweep: he always had a horror of dust—unless it's stagnant and still. Dust which floats in the air and sticks to his wet paintings drives him crazy."

We must add to Fernande's list of disapprovals and displeasure Spanish schedules, working at night, getting up at the end of the morning, and the fact that "the maid has become quite negligent, and regularly sleeps late." The worst, however, was not that Pablo imposed his hours but that he tended to occupy all available space. Now that he had money he was able

to give free reign to his taste for collecting: old tapestries, African masks, musical instruments—all in a jumble of canvases and sculptures scattered across the floor.

"In matters of decoration, Picasso's taste—often with irony—led him to buy the most ordinary objects." How aware of this irony was Fernande? "The dining room walls were decorated with cheap chromos in straw frames, which would have been at home in the concierge's sitting room; he laughed at them." In short, it amused him to find a charming quality in things which for others would be the height of the ridiculous. Her lover's taste directed him "above all, to Ingres, whom it pleased him to study at the Louvre," a matter which, on the evidence, she could neither distort nor invent.

Preoccupied as Fernande was with establishing her "day," she had not yet grasped that he was beginning to find her tiresome. Picasso, with some malice, fixed her "day" for Sunday, because for him such constraints were like a ball and chain. Fernande, however, was unaware of his feelings. Nor did she take into account the contradiction she vaguely perceived between his taste for going out almost every evening and his complaints about the growing number of quasi-obligatory social occasions: events like receptions given by the couturier Poiret or grand dinners arranged by Frank Burty Haviland at his studio on the Avenue d'Orléans. Haviland had been a regular at the rue de Fleurus and owned a fine collection of African art. Fernande describes Pablo at the Steins' Saturdays challenging Matisse, "a passionate propagandist for his approach, which he defended jealously against Picasso's muttered attacks. Picasso rarely took the trouble to persuade, and was always rather sardonic."

At these evening occasions, "which were far from unpleasant," Fernande continues, "Picasso, most of the time, was surly and glum. People wanted him to explain himself—which he found difficult in French; they wanted him to explain things he didn't want to explain." One can see that a quarter of a century later, these recollections still disturbed Fernande. She had thought to organize life, to settle in, but she had been mistaken. The rift between her middle-class tastes and aspirations with their limited range, despite her bohemianism, and Picasso's indifference to everything which did not directly touch his art could only grow.

Once again, as in the spring, there was no slackening of pace in his combative assault on work. Quite simply, Picasso integrated into his painting the new Parisian environment, cutting into facets not only—as at Horta—the glassware of a work like *Bouteille d'Anis del Mono* but sugar bowls and cut-glass boxes. He used tokens of a new domestic reality—a fan, glasses, a melon[22]—to create a vocabulary of geometric quantities and curved discontinuities. First he painted an apple, which he deconstructed; then he made a three-dimensional model of it in the studio of his friend Manolo.[23] He moved on to a head of unfired clay, followed by a plaster *Tête de Fernande*.[24]

By translating the facets of his painting into three dimensions, Picasso broke through the outer skin, the epidermis of classical sculpture. It was a truly revolutionary move, assuming all the primitivist distortions of African, Oceanic, or Iberian objects and simultaneously realizing in material terms the discontinuities imagined in his painting. In the studio, after this forward plunge, the disconnected volumes of Fernande's face and hair would catch the light variously, creating shadow and chasms. Above all, once Vollard had cast the head in bronze—which seems to have happened very quickly—Picasso had at his disposal a model which developed in three dimensions the actual structures of his spatial research, a purified materialization of his painting.

This was an important moment. Previously—far more often than he realized at the time—Picasso had produced in painting what were, effectively, sculptures. He now found that he could break with traditional techniques in three dimensions as well and pursue the same re-evaluation of space he had been attempting with the lighter, more flexible means available to painting and drawing. This was a double liberation. First in sculpture, the domain in which, when all is said and done, he would prove to be even more of an innovator than in painting. And then in painting, through a fresh dialogue between sculpture and painting. Up to this point he had tried to translate pictorial imagination into tangible substance. Now he would attempt to translate optically, in two dimensions, effects attainable in three.

Braque returned to Paris in October for his twenty-eight days of military service (as a future officer) after a summer in la Roche-Guyon (where Cézanne had stayed in 1885) and September in Havre. He had also stopped at Carrières-Saint-Denis, on the Seine, to see Derain. At the very least, he seems to have been in no hurry to see Picasso, of whom he surely had news through Kahnweiler. Since the spring, the divergence in their efforts had continued to grow. Braque brought back canvases which refined the Cézannism of the Estaque landscapes or the painting *Port,* while Picasso had "broken" Fernande's head and accumulated discoveries about cutting forms. Braque, as was his habit, had above all deepened what one might call his Cézannesque craftsmanship. Through mastery of color resonances he had attained a supple fragmentation which—as Jean Laude noticed—eroded the intersection of volumes, authorizing in this way a pictorial script unique in both its spatial content and the forms of its objects.

We do not know the chronology of Braque still lifes between the autumn of 1909 and the spring of 1910 well enough to reconstitute the dialogue in painting between Picasso and himself. But what is striking about the entirety of their course together is that gradually, for both of them, objects, figures—and still, for Braque, landscapes—became modalities of pictorial space, of its coalescence.

Braque, who, unlike Picasso, commented on his work, told Dora Vallier in his old age:

What greatly attracted me—and was the guiding direction of Cubism—was the materialization, the translation into matter, of that new space which I felt. And so I began doing still lifes above all, because in still lifes there is a kind of tactile—one might almost say manual—space. ... And it was that space which so greatly attracted me, because that was the first object of cubist exploration: the exploration of space.[25]

With his fiery ardor Picasso multiplied the découpages of Fernande's head and shoulders, some of them probably suggested by unexpected aspects of her sculpted head. He treated in the same way the head of a man wearing Cézanne's Cronstadt. And he and Braque discussed it, as if it were the *Portrait de Braque*.[26] This studio joke would be taken seriously: the practice of increasingly "pure" geometric reconstruction developed from it, culminating in the *Buste de femme,* which Kahnweiler bought back at the end of his life.[27] But a blond *Nue assise dans un fauteuil* introduced a new, delicate female type, very different in kind from Fernande. *Mademoiselle Léonie,* a faceted portrait in the manner of Braque, was identified by Max Jacob with the heroine of his book *Saint Matorel,* which he had just finished.

Femme à la mandoline was Picasso's first oval picture.[28] This picture also expresses the influence of Braque, who was well-acquainted with various "recipes" from his family's painting-decorating business. He put several of these to serious use, translating them through Cubism into art. By eliminating the corners of the classic rectangle, the oval format allows a useful, global grasp of pictorial space without overcrowding it. This—at the point reached by both Picasso and Braque in their explorations of a new space—was an appreciable help.

Picasso turned again to a favorite subject—a woman seated in an armchair—and either remodeled it entirely in geometrized facets which permit the plastic rhythms to develop beyond all recognition or constructed spatial content using the same facets as those of the figure itself. He achieved some remarkable successes, like the nudes seated in armchairs, at the Musée national d'Art moderne in Paris and at the Tate Gallery in London. In these canvases the women's silhouettes, although entirely reduced to abstract geometrization, preserve their grace and attain a curious monumentality.[29]

The sequence culminates in a splendid work which opens new horizons: the *Jeune Fille à la mandoline* (Girl with a Mandolin), of the Nelson Rockefeller collection at the Museum of Modern Art in New York. The model, Fanny Tellier, who posed nude, is rendered with a charm that turns the painting into a portrait. This figure was to some degree forecast by the entirely geometrized nudes. Here, however, Picasso liberated himself from the reduction of forms to pure structure, allowing ripples of wavy hair, the schema of a look, an evocative breast, the curving shapes of a musical instrument, and the natural beauty of a young girl.

Then, carried by the movement of the figure itself, Picasso tilted forward the three-quarter profile, making it irreconcilable with the rest of the face but creating a new kind of relationship with the spatial content, a new and original fusion of a face with its surroundings. Picasso completed this process by the geometrization of a surface which one cannot identify as being part of a shoulder or of the background.

During this period Picasso had increased the required number of sittings for his models. Roland Penrose remembers that one day "Mlle. Tellier announced she was unwell, and would not be able to return the next day." Picasso understood that she would not be coming back at all and decided to leave the picture unfinished. When I questioned him about the picture several years later, after Fernande had died, I received a somewhat different impression. It seems that Fernande's jealousy had been a factor in the version of the story Pablo told at the time and in Kahnweiler's denial that a portrait of Fanny Tellier was involved. In any case, Picasso did not deny an attraction between himself and the young girl. When I asked if it was true that the picture had remained unfinished, he shrugged: "I really don't see what I could have added."[30]

Braque's large still lifes assigned to the final months of 1909 and the beginning of 1910—*Piano et mandore, Violon et palette, Violon et cruche*—deploy a similar network of facets. Beneath our eyes solid quantities gradually emerge from a space which trembles with pale ochers and silvery grays. *La Mandore,* a canvas of contrasting grays and greens (which I believe is somewhat earlier), gives the impression of floating in space. Here one can see Braque tightening the vertical format of his still lifes. Next he discovered how to anchor the spatial content of a composition. In *Violon et palette* he hung his palette on a nail in the wall and added its trompe l'oeil shadow. He found an object so simple that it could not be cut into facets, which by its presence alone provided spatial orientation for everything else on the canvas, acting as an unvarying point of reference and symbol. Braque planted it in the wall at the back of *Violon et cruche.* The sign once again was functioning.

If, from this perspective, one examines *Jeune Fille à la mandoline,* one finds that Picasso treated the hair and above all the eye as signs (as identification tags and points of reference). In these opening months of 1910, he liberated himself from figurative relationships with the appearance of an object, which he had preserved in spite of everything. He found that he could reduce these to simple modulations, to condensations of space. If they functioned as abstract symbols, that would be adequate for identification and "reading" with which to reconstitute the object.

We know from a letter of Fernande Olivier's to Gertrude Stein sent on 17 June 1910 that Picasso at that moment was still working on the *Portrait de Vollard,* which, second only to the *Portrait de Uhde,* is a remarkable realization of fusion between figure and ambient space.[31] Contrary to my view when I did my catalogue of Cubism, I now believe that the *Portrait de*

Uhde should be placed between the *Jeune Fille à la mandoline,* whose textural modulations he summarized in the spatial content, and that of Vollard, which—as the exhibition "Braque and Picasso: Pioneering Cubism" showed—was finished that autumn, at the same time as the *Portrait de Kahnweiler.*[32] In this *Portrait de Uhde* Picasso introduced an equivalent of Braque's nail: a key to a drawer, on the sitter's left. In the portrait of Vollard the device became a bottle. The system of relationships between pictorial space as an object of composition and the signs which identify a subject was now functioning for both Picasso and Braque.

Fernande's letter contains two other pieces of news. First, that Picasso had received an article by the American Gelett Burgess, which had just appeared in the May issue of the *Architectural Record* with photographs of *les Demoiselles d'Avignon* and *Trois Femmes*—the first ever published— and of the violently squared *Femme nue assise* of 1908. There were also photographs of works by Braque, Derain, Friesz, and Herbin. They were collectively labeled "The Wild Men of Paris," which might create some confusion with the Fauves. Picasso wrote to Leo Stein that if he could get hold of the article he would "have a good laugh."[33]

Fernande also writes that there are too many painters at Collioure, so Pablo and she will go to Cadaqués, where the Pichots take their holiday every year. Alice and Derain will join them. At that time, as Palau i Fabre has stressed, Cadaqués was remote and isolated. Picasso undoubtedly planned to soak up Spain and Spanishness as he had the year before at Horta; but it is telling that this time he went with friends. The Cadaqués holiday, it seems, was a success but probably cut short. Did Fernande get along with Germaine and Alice? Details of this kind have not survived in abundance.

Picasso once again was obliged to act as point man in the movement of his own painting. As at Horta, he took important steps toward an almost complete abstraction of subject. The only recognizable graphic elements here are the masts of *Port de Cadaqués.* He found new symbols in still lifes: a slice of lemon, the key to a drawer. The discontinuities which Kahnweiler saluted as the "exploding of homogenous form" prepared for their conceptual reconstruction instead of the dissolution to be attempted by Kandinsky and the Delaunays.

In fact, Picasso pursued his sculptor's reflections beyond the innovations of *Tête de Fernande.* Once again his painting imagined sculptures which had not yet been invented. Instead of breaking the surface, Picasso conceived the pure structures of sculpture, armatures of a special kind which would add monumentality and enhance spatial composition. Relationship to the spatial content is expressed by discontinuous facets which increasingly assume the character of volumes, like some sort of irregular brickwork, emphasized by the cameolike effects of tone upon tone.

Le Rameur, le Guitariste, la Femme à la mandoline (The Oarsman; The Guitarist; Woman with Mandolin), and a large *Femme nue* (187 × 61

cm.) attest to this reinvention of an appropriately structural figuration.[34] These canvases are so sculptural in quality that any effect of color—particularly of localized color—would destroy their composition. The marks of identity—so strong in the still lifes—can be inferred only by the titles of the works. Suffice it to say that the frontier of abstraction, at least for the spectator, had been crossed. The power of the compositions nonetheless excludes the possibility of entrapment in simple "decorativeness." To painters in the second half of the twentieth century, these canvases are figurative.

We know now, from the research of William Rubin, that on 2 August at Cadaquès, Picasso received the detailed information he needed for decorating the "library of Hamilton Easter Field, a Brooklyn painter, critic, and patron of American artists," which he had agreed to undertake in 1909. The commission, at just this moment, was obviously a piece of luck, a promotion which put him at the level of Matisse, who a short time before had been given similar work by Tchukhin. Picasso invested a good deal of time and effort: one can infer from the dimensions sent by Field that the elongated format of the large *Femme nue* correlates with one of his first attempts to execute the commission. It was followed by several others, some of which, as we shall see, were diverted from their original objectives.[35]

Should one believe Kahnweiler's account of this juncture? He writes that Picasso "returned to Paris in a state of considerable dissatisfaction, after weeks of painful effort, bringing with him some unfinished work." The only point which can be verified is the last; but the production from Cadaquès, with its return to the golden transparency of southern light, is particularly strong, as we can see, for example, in the magnificent *Still Life with Glass and Lemon* at the Cincinnati Art Museum. The etchings done to illustrate *Saint Matorel*, the first book published as much by Kahnweiler as by Max Jacob, must be included in this group. As usual with Picasso, his change of attack was not the product of external circumstances. In the name of the heroine, Mademoiselle Léonie, he went on to engrave images of women taken from drawings and canvases done in the spring of 1910, which are characterized by even more discontinuity than before. He added to these an engraving taken from his Cadaquès canvas *la Table de toilette*, in which discontinuities increase as the spatial content of the painting's tonalities is refined, while the figurative elements are made more precise. The fourth engraving in the series, *le Couvent*, is a landscape reduced to its structural rhythms.[36] We know—from a postcard sent by Braque, in Paris, to Picasso, in Cadaquès—that Derain had returned to the city on the 16th. Had there been some sort of friction between them? Derain, who brought with him a landscape done in a highly Cézannesque mode, found himself at a considerable remove from Picasso, in both painterly and intellectual terms.

In the autumn a masterpiece emerged from the Cadaquès experiments: the *Portrait de Kahnweiler*. In this case, unlike that of the *Portrait de*

Vollard, we are unable to visualize the subject. Gradually, however, through a mesh of illuminating signals, we begin to guess it. To the left, a bottle on the table, and, higher up, a sculpture from New Caledonia announce the studio on the Avenue Frochot. Gloved hands, a jacket button, eyes, nose, and wavy hair—these provide clues which function with the words of the picture's title. Two years later, Apollinaire would write: "Cubism is the art of painting new aggregates with elements borrowed not from the reality of vision but from the reality of conception."[37]

However, the winter and spring of 1910–11 were essentially a period of reflection in which Picasso seems to have discarded old ways and started again, at ground zero, with a completely new figuration. Fernande describes this: "In spite of material facilities, he became increasingly gloomy. . . . He seemed bored, although he was actually completely absorbed. He wasn't very well, or thought that he wasn't, and kept to a strict diet." This description sounds like the kind of trouble we would call psychosomatic. The crisis in their relationship suggested by the change of model in the spring of 1911 and the evident gloom of their stay in Cadaquès had probably grown worse. It is also highly likely that Picasso felt anxious about a "Cubist" style which burst into public consciousness at the Salon des Indépendants in the spring of 1911, one he could only regard as a parody of his own efforts. Critics and journalists had already begun to link these works to him. But this crisis—as a general view of the final months of 1910, into the spring of 1911, makes plain—was primarily a crisis in his painting. A new figuration created misunderstanding—a woman is seen as a torero. Fifty years later Picasso admitted to me that he himself was no longer able to decode the subject of a composition he had not seen for years. And in the end, with *Pointe de la cité,* it was the abstract structures of a composition which captured his attention.[38]

Since 1910 Manolo, who was a deserter from the Spanish army, and his wife, Totote, had been living at Céret, on the Spanish frontier. There, at the little monastery which had been bought by Frank Burty Haviland, the *limousin* porcelain manufacturer of American origin, Manolo was working on his sculpture. We do not know what specifically prompted Picasso's decision, only that he went to Céret alone around 10 July 1911. Immediately a strong sense of liberation could be felt in his painting. The color range of his Paris work—bister to dark brown—gave way to a golden luminescence. He played with the shapes of musical instruments, which he put on bistro tables to construct dazzling rhythms, as in *Nature morte à la clarinette* (Still Life with Clarinet), and discovered a new kind of unvarying symbol: the printer's letter. He painted a newspaper title, *l'Indépendant,* and using the fragmentation of a bullfighting journal to indicate a Spanish setting, produced *le Torero.* Then, transposing pyramidal armatures—a marvelous device for the elaboration of figures—he created three masterpieces: *l'Homme à la pipe, le Poète,* and *l'Accordéoniste.*[39]

It is clearly possible that this return to Catalan life, with long after-

noons on the café terrace as a prelude to a night's work, released for Picasso
the creative wealth slowly accumulated in the course of his Parisian re-
search. But one cannot help noting, in these paintings done without a
model, that the absence of Fernande seems to have been beneficial. We find,
in a letter of 8 August which Fernande kept, that he had taken his monkey
with him.[40] "He's quite funny. Someone gave him the lid of a tin box, and
he spends the day gazing at himself. He is very intelligent." Perhaps he took
along the dog as well. This letter of 8 August does not seem particularly
warm, even if Pablo adds, "Je t'embrasse et t'aime toujours" (I love you and
embrace you always). However, we have no other letters for comparison.
We also learn that Braque and Fernande were not expected for several days,
which means not before the middle of August.

On 16 August he wrote to Braque, asking him to come. "I'm very
happy that you're working well, and that you've promised to come here.
Don't forget it." On the 25th he wrote again, a letter which suggests the
unparalleled creative effervescence of this stay at Céret. He was doing small
watercolor still lifes and had begun two canvases: *Poète et paysan* (a first
stage, perhaps, of *le Poète*), and a young girl playing the accordion, which
would become *l'Accordéoniste*. Picasso was finding new, non-imitative
relationships between objects.

Despite Picasso's appeals, however, Braque seems to have been in no
particular hurry. He took his time, traveling by way of Orléans, Guéret, and
Limoges, with a detour through the western part of the Massif Central,
arriving on 17 August. A period of intense exchange between himself and
Picasso now began. "Braque is really pleased to be here, I think," Picasso
wrote to Kahnweiler on the 17th. "I've already shown him the countryside,
and he has a whole pile of subjects in his head." Did Braque instantly follow
Picasso's lead? His abstract landscape *les Toits de Céret,* which replies to
one of Picasso's, and paintings of figures composed in the pyramidal archi-
tecture of *l'Homme à la pipe*[41] point to that conclusion. But haste of that
kind would be inconsistent with Braque's thoughtful nature, which un-
doubtedly needed time to reflect on the multiplicity of novelties produced
by the brushes of his friend. Picasso's compositions had gained not only in
clarity but in their relationship to reality as well. The structural qualities of
objects, like a glass, a bottle, a fan, a clarinet, their contrasting shapes, the
dissociation of letters (which, in spite of everything, retain their power of
allusion)—these are the things which inform the spectator and create his
knowledge, as if painting were acquiring supplies from outer reality so that
it could take sustenance from the things that inspire it.

From Braque's correspondence with Kahnweiler, we know that in the
beginning of September he began his large canvas *Woman Reading,* on
which he worked for the rest of the autumn, and shortly after that a second
canvas—*Emigrant*—which became *le Portugais*.[42] Although their partner-
ship—*"la cordée"*—was functioning well, Braque and Picasso stayed to-
gether for only two weeks and didn't meet again for over five months. But

such a loose and relaxed infrequency of encounter, as in 1909, was—with the single exception of 1910—the rule: the pressure of circumstances created interruptions.

On 23 August Picasso learned that the *Gioconda* had been stolen and the Louvre closed. *Paris-Journal* was offering fifty thousand francs for its return and the guarantee of anonymity. On the 29th Géry-Pièret boasted that in 1907 he had stolen from the Louvre two Iberian statuettes, which he had sold to a collector. A card from Fernande to Alice Toklas on the 31st announces their arrival in Paris. As soon as Picasso heard the news, he recognized the possibility of catastrophe. At the back of his cupboard in the studio, he had the two heads, which he had bought from Géry-Pièret in 1907.

Fernande both heightened and falsified reality in her account of this incident. She pretended for the police that on the day of their return, Picasso had met by chance a "horrified" Apollinaire. The two friends needed to rid themselves of the heads as quickly as possible. They decided to give them back via *Paris-Journal*. Picasso had surely known their origin, but as no one seemed to be bothering about their disappearance, he hadn't thought much about it. He evidently told the investigating judge something entirely different. To describe him as "losing his head with fear" and being "incapable of dressing he was trembling so much" seems scarcely convincing. Fernande also says that Apollinaire was "limp with fear, and painful to behold."[43]

Both of them were foreigners who risked deportation should the affair go badly. Picasso told me later that Apollinaire's urgent efforts to enlist in 1914 sprang from his desire to rehabilitate himself after conviction for his part in this affair. Prison at that time was an immediate and irremediable disqualification. In matters of that kind the times were closer to Wilde, destroyed by Reading Gaol, than to various forms of almost surrealist ease. Picasso was not charged. Apollinaire, after six days in the Santé, had produced a few poems to register the experience, and on 14 September wrote a sharp piece, *Mes Prisons*, for *Paris-Journal*.

In the end all was well. Salmon arranged as early as the 21st to run an article about Picasso in *Paris-Journal*, a way of telling the world that he was all right and out of the affair. It was Fernande who would pay.

Her letter of June 1910 indicates that she had not yet understood that Picasso was tiring of her. She tells Gertrude that they spend every evening with clowns and acrobats; although at the time, the circus was not yet one of Pablo's subjects. In plain truth, he was bored, and looking for distraction.

With these latent tensions as a subscript, the affair of the statuettes pushed Picasso to a separation which—unlike the break of 1907—would be permanent. In the course of their evenings, covering all the bistros of Pigalle, he would discover love.

For her part Marie Laurencin seems to have taken badly both Apollinaire's imprisonment and the fact that he had to wait for his dismissal: which gives us a further idea of the affair's social consequences in relation to the morality of the time.

PART THREE

ÉVA OR LIBERTY

New man, the world is his new representation. He enu-
merates its elements with a brutality which knows
ways of grace. He is a newborn bringing order to the
universe. This enumeration has
the grandeur of an epic.
—*Guillaume Apollinaire*

THE CUBIST EXPLOSION

Summer 1911–1912

T he press album of the Kahnweiler Gallery—at the time a novelty
as great as the systematic photographing of paintings[1]—indicates
that it was the Salon d'Automne of 1911 which provided the
official recognition of Cubism and, paradoxically, of Picasso as well. Al-
though he was absent, as he had been from the Salon des Indépendants in
the spring, he was nonetheless recognized as the "master" of the movement
and a driving force of change.

This success was due first of all to Kahnweiler's policy of export,
which had sent Picassos to Berlin and Frankfurt, London, and Amsterdam.
Clovis Sagot, too, had lent pictures to London. And then there were the
activities of Gertrude Stein and Alice Toklas. Their liaison had begun in
earnest in 1908 but was kept an impenetrable secret. As Linda Simon
remarks: "Gertrude and Alice were polite ladies, and Queen Victoria had
been dead for only seven years." Alice played the part of impresario, in the
first instance to publicize the work of her friend. Picasso, however, was to
benefit from these efforts as well. It was through Alice that Gelett Burgess,
whom she had known in San Francisco, made his way to the Bateau-Lavoir.

Max Weber, Edward Steichen, and Alfred Stieglitz also discovered
Picasso by way of the rue Fleurus. This led to the exhibition organized by
Marius de Zayas at the Photo-Secession Gallery, 291 Fifth Avenue, New
York: eighty-three drawings and watercolors from 1905 to the end of 1910.
The show, which ran from 28 March to 25 April 1911, was the first Picasso
trajectory to be shown as a whole, anywhere in the world. Marius de Zayas
did his best to provide a critical examination of the pictures in an essay
published by the magazine *Camera Work*. Although the piece was often
inaccurate, Picasso nonetheless was becoming an object of discussion. In
August John Middleton Murry wrote a piece for his review, *Rhythm,* which
had wide repercussions: suddenly the Anglo-Saxon press was examining
Picasso, considering his part in the uproar of the Salon d'Automne. On 8
November the *New York Times* credited him with "a colossal audacity."
The article was accompanied by a photograph taken from Burgess's piece,
which shows Picasso in his studio with sculptures from New Caledonia.

Burgess's article was reprinted and became part of a series. It was also widely disseminated in Europe, through the *Heraldo* of Madrid and *De Amsterdammer*. Picasso's isolation had been definitively broken.

Picasso was now "in." Kahnweiler came by to see him nearly every day, and it seems that this period was the actual beginning of their intimacy. Although from 1905 on his connection with the Steins had drawn Picasso out of a certain Spanish provincialism, the autumn of 1911 brought him the kind of international stature which Matisse had enjoyed since 1909. Opportunities like this—more usual in Germany and almost "normal" for Russians like Kandinsky—were extremely rare in France. Picasso was ready to profit from this situation, finding on a larger scale the wider possibilities of advancement which Barcelona had offered in his adolescence. This could only exacerbate the sense of misunderstanding and lack of harmony with Fernande, whose horizons were limited. Further, she liked Kahnweiler no better than she liked Braque.

We don't know what Picasso thought of the Cubist rooms at the Salon des Indépendants in the spring of 1911. Apart from the question of what adjective the studios of Paris would apply to him and to Braque, the pictures in question—which took him back to the beginning of 1909 at most—were no cause for concern. The Salon d'Automne had caused an outcry because, since 1905, it had become more moderate, and it seemed that the jury, in choosing to hang "horrors," had failed in its duty. In fact, if one examines the matter more closely, one finds through Apollinaire that the Cubists occupied only one small room: room 8. Although Salmon, in *Comoedia*, saluted Metzinger's *le Goûter* as "the Gioconda of Cubism," the picture from Picasso's point of view was nothing but a portrait which had been fragmented with a rather heavy hand in order to achieve "geometric" quantities, not to create the new space which he and Braque were in the process of working out. Gleizes, Le Fauconnier, Duchamp (who showed *Jeune Homme et jeune fille dans le printemps),* Léger *(Essai pour trois portraits),* Lhote, Picabia, or Villon—none of these could have given Picasso much ground for enthusiasm. We know, through the critic Henri Guilbeaux, that Apollinaire visited the Cubist room accompanied by "a sympathetic Picasso who was trying not to laugh, to maintain a serious expression, and whose real talent as a painter is beyond question. Both of them were poking fun at these canvases of cubes and cones and tubes, and voicing opinions which were more or less unfavorable."

Picasso, in fact, was aiming at something else in his work. Increasingly in his still lifes, for instance, the abstract and conceptual details of objects organized the composition. The crisis of Apollinaire's arrest did not seem to have had any lasting effect on his efforts, even if his precipitous departure for Céret meant interrupting work on several canvases. Some of these, like the great still life *Verre d'absinthe, Bouteille, Éventail, Pipe, Violon, et Clarinette sur un Piano*[2]—a recapitulation of all the figurative advances of the period, in the dimensions of the decorations for Field—were not completed until the spring of 1912.

With a palette darkened by his return to Paris, Picasso produced *Jeune Fille à la Mandoline* (Mandolin Player), a work which strongly emphasizes the pyramidal, architectural volumes of Céret, and the masterpiece *Homme à la clarinette*,[3] which gives concrete form to the degrees of freedom now available to painting and drawing figures by combining the new sense of space with pure but nonetheless recognizable formal rhythms. From Kahnweiler's correspondence we know that Picasso worked through the autumn without Braque, who did not return to Paris until mid-January 1912.[4]

This five-month interruption in the *cordée* reveals the difference between their methods of work. Picasso was already very far from his Céret figures, even from *l'Homme à la clarinette*, when Braque wrote to Kahnweiler to announce his return to Paris on 15 January. In his letter Braque says that he "will finish the guitarist in Paris." He had been refining the details of that picture, of his *Femme lisant*, and of some still lifes. Suddenly the confrontation between them became even richer: a guitarist, done for a "bistro" known as *le Portugais*, introduced a major innovation. It occurred to Braque to replace painted lettering by letters and numbers done with a stencil. This use of standardized forms, which owes nothing to painting by hand, completely objectivizes these references, turning them into signs which are external to the composition. They become intrusions of actual reality outside the picture. The idea of collage is close at hand, all the more so as Braque's bistro window displays a list of drinks in block letters, including their prices.

For his part Picasso had kept to Cézannesque devices like the pipe rack; hung on the wall in a view of the studio done at the time of *les Demoiselles d'Avignon*, this object reappeared in Céret, in *le Poète*.

But his circumstances had changed in other ways, outside the realm of painting. He had met a great love. Éva had entered his life, an event he celebrated with a splendid canvas *Femme à la cithare* (or Guitar),[5] painted in the style of Céret—probably in October or November—but with a palette that seems to have been darkened by a return to Paris. The painting bears the inscription *Ma Jolie* in painted letters. These are words taken from a popular song—the coded dedication to a love that Fernande, in theory, knew nothing about.

Éva Gouel was four years younger than Picasso. She was the friend of a young Polish painter, Louis Markus—which Apollinaire Frenchified into Marcoussis—the name of a charming village in the southern suburbs of Paris. Severini described the encounters of the two couples—Fernande and Picasso, Éva and Markus—at l'Ermitage brasserie, on the boulevard Rochechouart, near Pigalle. They seem to have become very close during the autumn of 1911.

As frail, delicate, and finely drawn as Fernande was majestic and placid, Éva brought Picasso a sympathy and understanding that was certainly both physical and intellectual, a combination he had not experienced before. Although he treated Fernande as a sumptuous model, whose appearance he particularly appreciated, his relationship with Éva seems to

have been deeper, from the first. When we spoke of her two thirds of a century later, tears came to his eyes. They had truly lived together, and Pablo, when success came, needed her. Dealing with severe adversities had not shaken him; but the responsibilities of success were an entirely different matter. Especially, as we shall see, because the arrival of the Futurists in Paris would create a considerable uproar.

Picasso resumed occupancy of a studio in the Bateau-Lavoir. Braque's latest discovery led Picasso to use stencils in his still lifes. Once again they were very closely linked. Braque surely knew about Éva; Pablo had introduced him to a young girl, Marcelle Lapré, who would become his wife. She joined him at Céret during October, but he left alone in January to visit his family at Le Havre. Braque returned to Le Havre without her between 26 and 28 April 1912 (it is from his letters to Marcelle that we know the exact date of the trip). Picasso was with him, and included traces of this adventure in two oval canvases, transforming the stencil into a fracturing device. In the first painting he treated the stenciled inscription as a foreign element, painting a vivid red "75" (centimes) in *Violon, verre, pipe, et ancre* (Violin, Glass, Pipe, and Anchor) and adding to it the blue corner of a French flag. He accentuated the common quality of the stencil by using industrial shellac and Ripolin, to make the color more dazzling.

The Italian painter Severini happened to be at the Bateau-Lavoir when Braque discovered this technique. He remembers that Braque was surprised by it, exclaiming in a voice which was half-serious, half-joking: " 'So, we're shifting the gun to the other shoulder!' " Picasso didn't say a word but went on filling his pipe. His face wore that typical smile of his which seemed to say, "What a good joke!" *Le Sourire,* in its account of the last Salon des Indépendants, had tried to demonstrate that "the Cubists have courageously 'shifted their guns' after liquidating their last cube." In short, according to Severini, Braque was reproaching Picasso for "liquidating" their Cubism by reintroducing color.

The color which both had thought to be incompatible with their new, pictorial space and the precise découpages of their Cubism was now returning with an arrogant assertiveness. Picasso began the process with *Souvenir du Havre* by using the French flag: all of it this time. It was this canvas which made Braque wince. Picasso knew perfectly well that Ripolin produced the effect of a break with their new conventions. He can be seen making a great point of this in his letters to Kahnweiler. Gertrude Stein makes Alice say: "He spoke to us at length about colors achieved with Ripolin. 'These [Ripolin colors] are,' he told us gravely, 'the health of color.' " Which makes the long period of obliviousness as to the importance of this discovery all the more surprising.[6]

In *Souvenir du Havre* Picasso introduced for the first time a piece of *faux bois* done with a steel comb, a decorator's technique which Braque had taught him and which worked in support of the same challenge as stencils and Ripolin: the inclusion of an industrial technique which is foreign to "normal" painting.

Violin, verre, pipe, et ancre is a simultaneous celebration of the new review *les Soirées de Paris* (Paris Evenings), of which Apollinaire would become editor in 1913, and of Éva, *Ma Jolie*. The third canvas of this series—*Nature Morte Espagnole* (Spanish Still Life)—is an oval, and is painted with Ripolin. It is not a product of Céret, as I had thought, but of Paris, and it signals the intention of fleeing with Éva.[7]

In his enthusiasm, Picasso painted still lifes, oval or horizontal, in which Ripolin once again fragments the French flag, and the displacement of letters in the inscription *Notre avenir est dans l'air* (Our future is in the air) constructs a conceptual depth.[8] (The account by Vauxcelles in *Gil Blas* of the Braque exhibition of 1908 was followed by a brief notice: "The conquest of the air. Wilbur Wright has won the prize for height.")

The two painters were now well launched on a conquest as marvelous as the conquest of the air. If the découpages into facets—and later the discontinuities—remained as part of the realm of painting, the stencil, the surfaces indicated with Ripolin, and the *faux bois* broke the homogeneities of that realm, turning pictures into an assemblage of methods and of codes. Picasso's speed was remarkable. While Braque (judging by the timidity of his approach to color in *la Bouteille de rhum*)[9] seemed somewhat overtaken and left behind, Picasso forged ahead, risking fresh possibilities of rupture by including elements which were already made. He had already—perhaps by chance—done a collage by repairing a hole in a drawing of 1908 with an advertisement for the department store Au Louvre, making a joke about the name of the museum. And he had stuck a real postage stamp onto the still life *la Lettre*.[10] But just as he transformed the effect of a stencil by fusing it with Ripolin color—which, with its lacquering, eliminates every trace of a brush stroke—he now boldly employed a fragment of oilcloth, already printed to look like the caning of a chair seat, and glued it onto the canvas, integrating it into the composition with a few long brush strokes. He then constructed the base of a glass on top of this, added a newspaper, a pipe, a knife, a slice of lemon, and the seashell always present since Le Havre. The result, in the horizontal/oval format of the series *Notre avenir est dans l'air*, is the *Nature morte à la chaise cannée* (Still Life with Chair Caning).[11]

This was a major breakthrough, not only pictorial but intellectual: a new space is not dependent on the means and methods of painting as a noble art. One can replace colored signs, Ripolin, synthetic wood—all of these—by industrial imitations. (One thinks of Baudelaire here: "What true lover of art has ever confused art and industry!") From now on everything is possible; there is an enormous expansion of liberty.

Gertrude paid a call with Alice at the Bateau-Lavoir.

> Picasso had gone out, and Gertrude Stein, by way of a joke, left her visiting card. A few days later, we went back and found Picasso working on a canvas inscribed "Ma Jolie," with the visiting card painted into the bottom corner. When we left Gertrude Stein said to me: "Fernande is

certainly not Ma Jolie. I wonder who is." A few days later we knew who it was. Picasso had run off with Eve.

Gertrude bought the canvas, which, as well as her visiting card, included the first imitation in painting of a collage: a burgeoning still life, *la Table de l'architecte*.[12] Picasso had flung himself into the project with enthusiasm, treating objects as simple signs, irrespective of their material links. It is most remarkable—as we can now establish from the date of the trip to Havre—that this astonishing breakthrough was effected in just a few weeks: Picasso left again for Céret on 18 May.

From a note of Picasso's to Braque, we know that Fernande had gone ahead of him. "Fernande has left with a Futurist. What am I going to do with the dog?" Pablo had been watching this shifting group—Marinetti, Boccioni, Russolo, Carrà, Soffici, and Severini. The last two of these he already knew.

> By talking about painting among themselves, in their Milanaise solitude [Severini notes], they had created a kind of dialectic which seemed to them quite remarkable but which was actually a tissue of old, worn-out arguments: relative and absolute dynamism, subjectivism and objectivism. . . . That kind of chatter gave Picasso the horrors: "What's the point of yammering on like that? One paints, and that's it."

The following pronouncement of Apollinaire's, in fact, could very well have originated with Picasso. The Futurists, Apollinaire says,

> wish to paint shapes in motion, which is perfectly legitimate; and they share with the majority of conventional painters a passion for painting conditions of the soul. They wish to maintain the benefits of a subject, which could well be the shoal on which their plastic good faith is wrecked.[13]

The Futurists constituted the first organized avant-garde. After their exhibition of 5 to 24 February at Bernheim-Jeune's, the influence of their extravagances was felt at the Salon des Indépendants, which opened on 20 March 1912. The show included Kandinsky's abstract *Improvisations* (of which Apollinaire wrote that Kandinsky "was pushing to the limits Matisse's theory of instinct"), and Juan Gris's *Portrait de Picasso*.

Suddenly Vauxcelles was treating Picasso as the "leader of the Cubists; someone like Father Ubu-Kub," a reference which is not quite so harmless as it sounds: in the chauvinistic hysteria of the moment, *Kub bouillon* had become a quintessential symbol of *boche* merchandise.

Picasso, however, maintained his distance from these upheavals and (apart from his painting) devoted himself to his new love. Sabartès was at the time in South America but later was given confidential details:

With Éva's arrival, everything changed. Picasso was incapable of systematic roving. . . . Because he needed to change his life, because he was tired of the circus and cabarets, and no longer needed any of that to surmount the boredom of eight years shared with someone else, he decided to abandon everything—Montmartre, the boulevard de Clichy, Paris—and look for some sort of terrestrial paradise in which to escape from the daily din.[14]

His whereabouts unknown to everyone except Kahnweiler and Braque, Picasso disappeared. However, he had been wrong to think of Céret as paradise. In February at the Dalmau Gallery in Barcelona, there had been an exhibition of his earlier work. Dalmau had wanted to include some of his Cubist work as well but had bungled the arrangements and finally showed other Cubists, but not Braque and Picasso. This created a certain commotion which caught up with Pablo although he would have liked to avoid it. Junyer saw him arrive with Éva and must have mentioned it on his return to Barcelona. Immediately the Barcelona papers took up the story. On 20 May Picasso, still unaware of these developments, wrote to Kahnweiler:

As for the dogs, I've asked Braque to send me Frika. And Mme. Pichot told me she'd look out for the monkey and the cats. . . . Please make a package of the canvas at rue Ravignan, and the panels, and send them to me here, at Manolo's address. Some of the canvases have only been sketched with charcoal; those should be fixed by Juan Gris.

All went well until 10 June.[15] "We are together, and I'm really happy. But don't tell anyone." He needed his paints, and "the palette at the rue Ravignan, which is dirty. Wrap it up in some paper with the frame and the letters and numbers [stencils], and the comb for making *faux bois*." In short, all his new materials.

On the 10th he finished "work, which at the moment isn't going too badly." And then he learned that the Barcelona papers "are talking about my being here. And that bloody idiot Pichot who wrote to someone here to find out if I was at Céret: completely useless, since no one is going to answer him anyway."

On 12 June some more bad news. Braque had seen Pichot at Wepler's, a large café on the Place Clichy, and discovered that he was planning to go to Céret with Germaine and Fernande and stay for the summer.

I'm really annoyed by all this [Picasso wrote] because I don't want my love for Marcelle [Éva was using the name Marcelle Humbert] to be hurt in any way by any trouble they [the newspapers] could make for me; I don't want her upset in any way, and, for my work, I need to be left in peace. . . . Apart from all that, I'm working hard. I've done quite a few

drawings, and I've already begun eight canvases. I think that my painting
has gained both strength and clarity.

As it was Braque who had warned him, Picasso wrote to Kahnweiler
on the 17th that he was "not in any way annoyed by [his] letter, but, on the
contrary, really touched." And in any case, painting was the main thing.
"You say that Uhde doesn't like my latest pictures with Ripolin and flags,"
Picasso continued (to Kahnweiler). "Perhaps we'll manage to disgust every-
body, and we still won't have said it all."

This remark, as stunning as it is memorable, indicates how important
he felt the use of Ripolin was for the introduction of color.

But things were growing worse with Fernande. She had taken to using
the signature "Fernande Picasso," but her illusions were collapsing.[16] Pablo
felt obliged to leave Céret, but, having told Kahnweiler about it, he immedi-
ately switched back to the subject of Ripolin. The photographs he had just
received of the pictures he had sent prove that "[I'm] right. The ones done
with Ripolin, or in the Ripolin mode, are the best. Really some of those
pictures aren't at all bad, and now that I see the ones I'm going to send you,
I find them not bad at all."

The beginning of the letter indicates that among these latter works
he is talking about a *Violon couché* which probably became *Violon et
raisins*. With unparalleled vigor, the violin is broken up; refracted in
multiple fragments of *faux bois* done with a steel comb; the grapes, per-
haps, were added during his stay at Sorgues later that summer and fall.
There were, as well, two still lifes on a bistro table. *Bouteille de Pernod
et verre*—later bought by Tchukhin—is still relatively calm (which is
why I misdated it to Paris). The table, however, is the scene of an ex-
traordinary interplay of flagrant disproportions between the *faux bois*
and the geometry of the bottle and glass of absinthe, across which is
balanced a spoon holding a lump of sugar. That work, however, seems
tame beside *Compotier aux fruits*. In the second canvas, crammed with
overlapping inscriptions—MAZAGRAN, ARMAGNAC, CAFÉ—the fruit bowl
seems enormous, and the wild color contributes to a sense of dazzling
lyricism.[17]

This lyricism indicates the presence of Éva, a presence even more
strongly felt in the *Ma Jolie* series of 1914. The series shows a strongly
directed enthusiasm which liberated in Picasso a sense of boundless, almost
baroque intensity, spurred on by happiness. The anguish and violence of the
Demoiselles and the primitivism of 1908 seem swept away by a great surge
of joy. Suddenly the sensuality previously contained or ignored explodes,
manifested by a tactile quality of color and paint, which is a point of
encounter for Picasso and Braque. (Picasso as sculptor had not yet shown
his hand, but that would happen very soon, during the transition from
collage to pasted paper.)

At this point Picasso left for Perpignan, punctuating the trip with

postcards to Kahnweiler. On 23 June, he and Éva arrived at Avignon; by 25 June they had settled into Sorgues, a northern suburb of the town; and by the 29th, he was at work. A letter from Pablo declares: "You know my system of work. I've already begun 3 canvases: an Arlésienne, a still life, and a landscape with *affiches*." His creative flame was burning strongly, and, with an almost voluptuous boldness, he launched exploratory moves in the new directions suggested to him by the discovery of transformation into *signes*, the transformation not only of color but of every reference to outer reality.

L'Arlésienne—in its two versions, the oil painting and the gouache—brings back a profile for the first time since the portrait of Pallarès in 1909. The *Paysage aux affiches* (Landscape with Posters) multiplies flat planes of color, treated as if with Ripolin, which could themselves be fragments of collage. Picasso was constantly proving that his art did not depend on any particular medium or mediums, that he could always imitate or substitute one element for another. In this way he made classic trompe l'oeil available to Cubism. And this was just a beginning.

The violins cut into planes analyze space and, with the new trompe l'oeil, make the viewer's eye move so that Picasso did not need to use the distortions and deformations of 1908. Now he was able to realize effects he had been trying to achieve since 1909, a relief which gives the picture depth and allows a pivoting of vision. In a *Violon* later bought by Tchukhin, a white horizontal creates enough of an optical contouring to dynamize the whole composition. The process is helped by the shifting and disproportion of the instrument's sound holes and the displacement of the strings and bridge. This new still life, once again, is oval.[18]

Picasso's correspondence with Kahnweiler gained in freedom—even effusiveness—so that for the first (and perhaps only) time one can follow the artist's life on a daily basis during a period of change in his painting. There were always practical problems with Fernande:

> 3d July
> The furniture from the rue Ravignan, the easel I'm very attached to—I've had it so long, and I'm used to it—and the stand for sculpture: if you don't think it's wise to keep them at the boulevard de Clichy *(because of Fernande)*, then I think we should put them in storage or, if Braque (and I think he does) wants to keep them for me, we should take them to him.

On 4 July he returned to the subject of work:

> As I told you, I've begun some new things since the Céret pictures. I'll have to put those aside now, and it's just as well that I sent you the others, which I would probably have ruined if I'd just gone straight on with them here.

We learn in passing that Picasso had begun "a fellow about 60/MA-
RINE," now known as *l'Aficionado*. On the 6 July, when some pictures had
arrived at Kahnweiler's:

> So you like the pictures. I would have worked on them some more, but
> I was afraid—with changing countries—of ruining them. . . . Braque will
> tell me what effect the pictures I sent you are having in Paris. It's always
> such a surprise, seeing them again when one gets back.

But work did not preclude distractions:

> I've been to Nîmes and seen a bullfight. What a marvelous thing: an
> intelligence suited to an art within an art. Only Manzatinito did anything
> worth noticing, but all the same, the fight was agreeable, and the day
> beautiful. I love Nîmes.

So life proceeded, and clearly Picasso found it good. Bunches of grapes
and a gingerbread heart inscribed "J'aime Éva" (the canvas is listed in the
gallery's archive as "Collection Mme Éva Picasso." The gingerbread heart
survives only in a photograph taken by Kahnweiler) are evidence of this
happiness and inventiveness. Color was no longer the only element to be
deployed as a sign; now every optical differentiation and, in the end, every
figurative indication received this treatment. As we have noted with Braque,
it was the conceptualization of a previously noncommunicable undertak-
ing. This conceptualizing is effective and brings aesthetic regulation to
proceedings previously beyond the frontiers of recognized art. However, it
reduces the thrust of these penetrations by dividing into two processes what
had in fact been two aspects of a single, coherent experiment. Between
Céret and Sorgues, in this summer of 1912, Picasso was pushing simulta-
neously the analysis of all methods and mediums of painting, simplifying
these into separable components which could be recombined, and an exam-
ination of the possibilities of the whole composition in all its aspects and
elements. In short, rather than simply proceeding in sequence, analysis and
synthesis were interacting, each upon the other, sharpening and refining.[19]
Braque arrived with Marcelle:[20] two simultaneous honeymoons. Éva
abandoned her pseudonym—Marcelle—and became simply Éva. During
the course of this reunion, the two painters had a lot to tell each other; the
current of sympathy and understanding between them was quickly reestab-
lished. Braque had followed up his figurative découpages in still lifes—most
often oval—which are sometimes as overloaded as Picasso's *Table de l'ar-
chitecte*. His round canvas *Verre et pipe, soda* is an instance. The bunch of
grapes, which Picasso used in *le Violon* (begun at Céret), dates, in Braque's
canvases, to his arrival at Sorgues. So does the simplification of the frag-
ments of the violin in *Mozart Kubelick*. Considering his teammate's latest
works, Braque surely measured, in light of these syntheses, the distance

covered since *Souvenir du Havre* and the speed of that trajectory and even more since his own trompe l'oeil nail of 1909. They were in the process of discovering the possibilities of escape from what, as Kahnweiler put it, was hampering them: "the necessity of using illusionist means to represent volume." Braque could draw various solutions from his knowledge and experience as a painter-decorator: *faux bois,* strokes of thick paint as in Picasso's violin, or the impasto of the grapes. He knew that he could transform the visual aspect of a painting by mixing some sand into the paint. Two still lifes—*Verre, Pipe, et Raisin Al* and *Compotier, Bouteille, et Verre*—recall this experiment.[21]

The two couples left for Marseilles in the beginning of August because Braque wanted to buy a house near l'Estaque. In the end, however, he decided to settle for good at Sorgues. Picasso wrote to Kahnweiler on 11 August:

> With Braque we've made so many promenades and had so much talk about art that time has passed quickly. . . . We bought some *nègres* in Marseilles. I got a fine mask and a young woman with big tits, and a young man. Now that I'm home I'm back at work on something I left for at least a week, and feel full of fresh sap.

We know from Kahnweiler that it was an African mask of the Wobé tribe (today known as Grebo) which inspired Braque and Picasso to change their art in 1912. Was this the mask bought in Marseilles? That Picasso already had one and that he could have seen another at Apollinaire's counts for little beside the fact that all of their experimentation had already led to the first collage, the inclusions of Ripolin and of relief, and had inspired them to look further at black African art, with its non-imitative treatment of volumes and its use of multiple signs.

Everything that summer encouraged Braque and Picasso to visit the colonial boutiques with which Marseilles—center of traffic with the French colonies in Africa—was filled to overflowing. Just as in 1906 primitivism had prepared the way and initiated the encounter with black African objects, one might say that now—since Cadaquès and above all since the first stay in Céret—it was the restatement of structural, non-imitative forms in dialogue with a variety of plastic signs which aroused and entirely altered Picasso's interest in African art. This art no longer struck him as primitivism but as skillful, knowing, individualized work—the creation of a new plastic space.

Kahnweiler has described this discovery, emphasizing that the Wobé masks "by renouncing any attempt to imitate, require the spectator to imagine the face whose forms the masks do not repeat." We notice particularly that the hollows of the eyes become protuberant cylinders. Unfortunately we no longer have the paper reliefs which Braque made of them, but the stages of this new intellectual breakthrough can be seen in his painting,

visibly liberated by his resumption of reflections on African art.

His still life *le Compotier*[22] simplifies the theme (which he had already treated) of the fruit bowl on the table with the glass, the newspaper, and the pipe; but although it uses sanding—either for imitative relief in the individual grapes or for pure spatial contrasts—the two bands of *faux bois* painted on either side no longer have any imitative link with the table they are supposed to be identifying. They in turn have become pure pictorial signs.

When Picasso went to Paris in the beginning of September to deal with the complications of his move, and also, it seems, to transfer the lease of the boulevard de Clichy, which was in Fernande's name,[23] Braque invented a *papier collé*. He imitated in drawing what had been painted and sanded in his canvas *le Compotier* and replaced the painted *faux bois* with a strip of wallpaper border which he found at a specialist paper shop in the rue Joseph-Vernet in Avignon.

Braque took Picasso's *Nature morte à la chaise cannée* and began over again. His painted strip—like Picasso's oilcloth—was ready-made, without any addition from the painter's hand other than the form which had been cut out. A great difference, however, was that the drawing, with its addition of wallpaper border, did not depict a table, whereas in Picasso's collage the fragment of caning was clearly identifiable. "At that point," Braque said later, "we achieved a clear dissociation of color and form."[24] True enough. But more particularly, it is true here of color and form which are in any way connected to imitative reference. The actual shape of the fruit bowl on the table is no more present in the painting than an actual face is present in the Wobé mask. It is left to the viewer to reconstitute these actualities with the signs—the signals—supplied by the drawing, a drawing which now attempts to assume simultaneously the optical qualities of painting and of shallow relief. The *papier collé* puts to full effect the synthetic potentialities of Picasso and Braque's latest paintings. Its technique, I should stress, involves all the tricks of the painter-decorator trade. Braque was familiar with these and knew how to glue wallpaper. This is not, as the Surrealists have often tried to believe, simply a game. It is a new form of art.

Naturally neither Braque (who, like Picasso, was most inventive when alone) nor Picasso immediately perceived the full consequences of this innovation. Picasso, who returned from Paris to Sorgues on 17 September, continued working—although the *mistral* had given him a cold—on paintings which were assemblages of synthetic surfaces and on the head of a *Poète,* full of humor, in which he uses a steel comb made for the manufacture of *faux bois* to create a trompe l'oeil of hair and mustache. He also completed *l'Aficionado,*[25] a masterpiece with a profusion of concrete detail which assures the presence of a balanced, imposing, and radiant pyramidal construction, the fascinating final issue of the line of personages begun at Céret.

Perhaps Picasso did his *Guitare*[26] at Sorgues as well, a translation of

his paintings of dissociated and superimposed planes into planes of paste-board. In *Guitare* the central hole—like the eyes of a Wobé mask—is a cylinder in relief. This is the first free-form sculpture. It hung on a wall in the boulevard Raspail, presiding over a couple of photographs and Picasso's first *papiers collés*.

This guitar, in fact, would be Picasso's springboard to *papiers collés* and was the end of a process already evident in the break with traditional painting techniques exemplified by the use of Ripolin, *faux bois,* and the first collage. The chronological rectifications since 1970 and particularly since 1983–84 have clarified the stages of this mastery by Picasso and Braque of the presence of objects in their painting—not against what might be called their Cubism but, to the contrary, with its help. This presence of objects characterizes the second stage of their Cubism—broadly speaking, Synthetic Cubism—which declared itself very early. We are the first, how-ever, to quantify its mental mechanisms.

That the activities of this autumn of 1912 were indeed a climax is born out by witnesses who are external to the Braque-Picasso *cordée,* notably Apollinaire, whose article "Exoticisme et ethnographie," published in *Paris-Journal* in September 1912, was recently rediscovered. Apollinaire stresses that the "jewel of the Dahomey collection" at the Musée de Trocadéro is an iron statue of a god of war in which "none of its compo-nent parts resemble any part of a human body."[27] This, of course, is exactly the type of reconstruction to which Picasso devoted himself between his Sorgues figures *(l'Arlésienne, l'Aficionado)* and those at the end of 1913.

It is clearly very difficult to measure at what point this transformation of Picasso's Cubism was influenced by the appearance of other Cubists and by the comment they provoked. If Salmon's writings and Apollinaire's, and Marius de Zayas's reflect above all what was being said in Picasso's circle, there were also more autonomous critics like Henri Guilbeaux and Olivier-Hourcade. In addition, English interest and curiosity was evident very early, not only in the case of John Middleton Murry, whose *New Age* Picasso knew, but, even earlier, with the critic Frank Rutter, who published at the end of 1910 a short book, *Revolution in Art: An Introduction to the Study of Cézanne, Gauguin, Van Gogh, and Other Modern Painters,*[28] in which Picasso was intelligently defined as the "chief of post-Matisseism," and his "great influence" was stressed, although he was not represented at the Salon d'Automne of 1910. Rutter describes Picasso's "new vision of form, constructing his paintings with a series of three-inch cubes—grayish or yellow-green, more or less square. Some of them are to be seen straight on, others are turned at an angle to the viewer; all are ingeniously arranged to express his feelings about form. This is highly logical."

Frank Rutter is describing paintings done between Horta and Cadaquès, which he must have seen at Kahnweiler's. And probably, either from Kahnweiler or the Steins, Picasso knew of the book.

Similarly, through Apollinaire, he knew what was thought about the

links between Cubism (in general) and the "fourth dimension" of non-Euclidian geometries, which were very fashionable in circles frequented by Gleizes, Metzinger, and Villon. It is extremely unlikely that he found any specific encouragement here, but he must have taken comfort in the idea of correspondence between the new pictorial space whose possibilities he and Braque were establishing pragmatically and the advances made by mathematicians. This must have been true as well of his discovery among unknown African artists of the same non-imitative problems which arose in the course of his *cordée* with Braque, a discovery whose depth increased as his knowledge of their art grew.

When he left Sorgues, it was to grapple alone in his new studio with what he knew increasingly was a revolution in painting. This leads me to conclude that *la Guitare* was done after he reached Paris.

THE REVOLUTION OF *PAPIERS COLLÉS*

Autumn 1912–Summer 1913

T he most fruitful and revolutionary of the exchanges between Picasso and Braque took place in 1912. The stenciled letters of Braque's *Portugais* had led to the return of color with Ripolin and then to the first collage, Picasso's *Nature morte à la chaise cannée*. Braque replied with paper sculptures, sandings, and the invention of *papier collé*. Each then needed a period of work in isolation. Braque once again was in no hurry to return to Paris; when he did, he left almost immediately for Le Havre. Montmartre was now forbidden territory for Picasso because of Fernande. He could not go to see Braque, and it seems that Braque very rarely made his way to Montparnasse.

The contrast that autumn of 1912 between the laboratory calm of Picasso's new studio, 242 boulevard Raspail, and the tumult in the external world of painting in Paris was extreme. Certainly anxiety about the outcome of these experiments, pursuing an entirely unfamiliar route, was no longer a factor, as it most emphatically had been in 1910 and the beginning of 1911. Picasso's stock at Kahnweiler's gallery included a great many successful canvases. Tchukhin, who had stopped buying after the forward surge of Cadaquès, came back that summer at Kahnweiler's urging and had insisted on buying—for ten thousand francs, an enormous sum for the time—a large still life of 1908 that Picasso had not really wanted to sell.[1] The picture was probably *Composition à la tête de mort*, a souvenir of Wiegels' suicide, which would explain why Picasso was reluctant to let it go.

The Salon d'Automne was "making even more noise," Braque wrote to Kahnweiler from Sorgues "than the din of Saint Polycarp" (which, in Montmartre, means noisy revels during a move intended to create a diversion behind the landlord's back). This was not—as with Manet's *Déjeuner sur l'herbe* or his *Olympia*—because of any specific picture or pictures. Apollinaire, who visited the show before the opening, notes: "This year there isn't that sense of battlefield, as there was in 1907 and 1908, and again last year. Matisse, Van Dongen, Friesz accepted because of public acclaim, occupy the places of honor in the rooms where they were hung." What

provoked the outrage of right-thinking people was the accumulation of provocations over the last eighteen months. The Cubists continued to push their case and had gained some ground. And their challenge to officially recognized "beauty" appeared to be amplified and orchestrated by a group of arrogant, didactic newcomers. The invasion of this last group looked like an organized onslaught, seeking deliberate confrontation. The Futurists, apart from anything else, were foreigners—Italians. They were also the first to function as an effective avant-garde group, an innovation which after the war would link the Dadaists and the Surrealists. This explains the swift transition of the uproar from the realm of art to that of politics. And it explains as well the fact that in politics, agitation was not confined to the chauvinist wing of organized public life. It was a socialist deputy from the Cher, Jules-Louis Breton, who challenged the government because he considered it "absolutely inadmissible that our national palaces [the Salon d'Automne was held in the Grand Palais] should facilitate manifestations whose character is so anti-artistic and anti-national." The doyen of the Municipal Council of Paris, a photographer named Lampué, attacked the undersecretary of state for the Beaux-Arts: "I hope you will leave the Salon as disgusted as many people I know; I even hope that you will ask yourself: 'Do I have the right to lend a public monument to a bunch of hoodlums who comport themselves in the world of art as apaches do in ordinary life?' "

Vauxcelles had already, after the Salon des Indépendants and the Futurist exhibition, charged into battle against the *"métèques"* (foreign scum) who were "colonizing" Paris. Frantz Jourdain, who advised Matisse against exhibiting the portrait of his wife at the Salon d'Automne of 1905, returned to the assault with such vigor that Jacques Villon resigned from the group of sponsors.[2]

Picasso could not remain indifferent to this tumult. The affair of the statuettes, even before Vauxcelles returned to the attack with "Ubu-Kub," had reminded him cruelly of the possible costs attached to being a *métèque*. On the other hand, as an artist he was not involved. The idea of painting a picture expressly for a salon had, since adolescence, been foreign to his nature. This attitude was encouraged by Kahnweiler, who understood very well that the work of his painters would have to develop outside the official institutions of French art. Picasso, however, felt equally outside in relation to the Cubist room at the Salon and to the parallel exhibition of the Section d'Or. The latter show was organized by the Duchamp brothers (Jacques Villon, Marcel Duchamp, and the sculptor Raymond Duchamp-Villon) expressly to correct the exclusionary attitudes of the Salon.

In fact there had been a point of encounter between Marcel Duchamp and the dynamism of the Futurists: Duchamp's celebrated *Nu descendant un escalier* (Nude Descending a Staircase). This painting, finished before the Futurist show, was first seen at Dalmau's in Barcelona, part of the exhibition in which neither Picasso nor Braque had figured. But the Section d'Or (given its name by Jacques Villon to posit the notion of geometric

perfection in painting) emphasized the general spread of Cubism during these last months of 1912. Cubism had become a terrain of passage for young painters who wished to escape both academism and naturalistic realism. And it also stressed, as Maurice Raynal noted in his criticism of new paintings, the "explosion of Salon cubism." Raynal wrote:

> There is the same degree of difference in the work of painters like Fernand Léger and Marcel Duchamp, Picabia and La Fresnaye, as there is between A. Gleizes and Juan Gris. Just as no one any longer treats Cézanne and Renoir as a pair of "Impressionists," so the term "Cubist" is daily losing whatever defined significance it may have had.

As at the Indépendants, so at the Section d'Or Picasso found that Juan Gris, although a newcomer, was closest to his own view of problems and solutions. Gris was showing *le Lavabo,* a painting with paper collage and the innovative inclusion of a fragment of mirror. Not only was Gris situating himself right in the middle of Picasso and Braque's latest experiments but his innovation—the mirror—was a much more serious intrusion into the picture than a simple piece of printed linoleum.

Sorgues had led Picasso in two opposing directions. On the one hand, he had progressed in the use of symbols in his pictures; on the other, his optical experiments had pushed him toward abstract figuration. Simultaneously he painted pigeons, *l'Arlésienne,* and *l'Aficionado* on the one hand; *l'Homme à la guitare, le Modèle,* and geometrized guitars on the other. He didn't want to lose any of the structural successes realized since Cadaqués, but Ripolin and collage had given him the means with which to express a sensuality heightened by Éva's arrival in his life. The 1912 paintings from Céret, as from Sorgues, translate and reveal an atmosphere of happiness and warmth, regulated by the natural distancing power of humor and self-confidence. The head of *Poète,* in which the steel comb of *faux bois* was used to produce hair and mustache, symbolizes, like the *Arlésienne,* a return to the human face.[3]

Tellingly, while thinking of Éva and probably of the impossibility of returning to portraits, he managed to dispel enough contradictions to produce the first female nude since the dislocated figures of Cadaqués.

While the projection of shapes on different planes scrambled the features of *l'Aficionado* or *Poète,* the emphatic eyes in *l'Arlésienne,* their protrusion, linked to protruding mouths in the *papiers collés' Tête d'homme* and *Tête de femme* (in the former Tzara collection), demonstrate that in using solutions taken from the Wobé-Grebo masks, Picasso rediscovered a kind of facial coherence. He would use this figuration again— probably at the end of that autumn—in the canvas *J'aime Éva,* with its graceful curves and tender colors.[4] This is the most splendid "conceptual" portrait imaginable. Picasso put into it all his feelings for love and for the first home ever shared with a beloved woman. By contrast Bateau-Lavoir

STAGES OF THE REVOLUTION IN *PAPIERS COLLÉS*

Summer 1908	Picasso repairs a tear in a drawing of *Baigneuses* with an advertisement for the store Au Louvre.
1909	Attempt, and failure, by Picasso to bring a surface forward with relief.
Spring 1910	Braque introduces into a still life a trompe l'oeil nail as a real object.
Summer 1911	Céret. Picasso's systematic use of painted printer's letters. Braque, arriving in mid-August, does the same.
End of 1911	Céret or Paris. Braque, in his canvas *Le Portugais,* uses stenciled letters.
Beginning of 1912	Picasso, after briefing by Braque (mid-January), also uses stencils.
March–April 1912	Picasso paints stenciled figures with Ripolin, a return to color used as an external element, a symbol.
	In two canvases on the theme *Souvenir du Havre,* Picasso uses Ripolin and, in the title picture, *faux bois.* (In April Picasso had accompanied Braque to le Havre.)
	Series with Ripolin and the French flag: *Notre avenir est dans l'air* and *Nature morte Espagnole.*
20 June 1912	Letter from Picasso to Kahnweiler: "The pictures done with Ripolin, or in the Ripolin mode, are the best."
Early August 1912	Picasso and Braque, who has just arrived in Sorgues, go to Marseilles to look at African objects and buy a Grebo mask.
August 1912	Picasso manages to create relief in a painting of a violin. Braque thinks of sanding some parts of a still life to create optical differentiation.
Mid-September 1912	Braque creates the first *papier collé.*
Early October	Picasso completes a pasteboard assemblage of a free-form guitar.
October 1912	Picasso paints a sanded *Guitare sur une table,* translates it into a *papier collé,* and a picture done with collages, and then repeats it in oil.
Mid-November 1912	Picasso uses newsprint in his *papiers collés* and systematically imitates them in oil.
Late November 1912	Based on the Grebo-Wobé mask, Picasso does a non-imitative composition of a face and makes experimental variations in *papiers collés.*

was bohemia, and 11 boulevard de Clichy, life with Fernande. In the same way later on, the apartment on the Rue la Boétie would be marriage with Olga.

The intellectual landscape of Picasso's return to Paris with Éva must include the first Douanier Rousseau retrospective, which opened in the beginning of October, two years after his death. William Uhde had brought together at Bernheim-Jeune's fifty paintings and drawings. Of course

Picasso no longer needed, as he had in 1908, to extract degrees of formal liberty from Rousseau's "naïveté," but there is no doubt that seeing a collection of this kind for the first time strengthened his non-imitative tendencies.

The assemblage of the guitar must date to this moment, for logic requires that it predate the guitar which figures in a recently published letter sent to Braque, who had stayed at Sorgues. The letter is quoted here with its original spelling:

> Mon cher ami Braque, je emploie tes derniers procédés paperistiques et pusiereux. Je suis en train de imaginer une guitare et je emploie un peu de pusière contre notre horrible toile.

> (My dear friend Braque, I'm using your latest paper and dust procedures. I'm in the middle of imagining a guitar, and I'm using some dust against our horrible canvas.)

"Dust" should be read as "sand." The guitar must be *Guitare sur une table,* which would be bought by Gertrude Stein, always on the lookout for novelties. This was the first Picasso painting to contain sanded sections and would—together with the *Guitare* assemblage—guide Picasso's exploration of *papiers collés,* a simultaneity which is established and stressed by the letter to Braque.

Picasso, in fact, did not work like Braque, carefully meditating each step. Proceeding from this *Guitare sur une table* we have a drawing, which is repeated by a sanded oil; a *papier collé* with a minimalist collage of wallpaper; a derivative composition entirely made of assembled wallpaper fragments with drawings of *faux bois* highlighted by colored pencil; and finally an oil painting containing several new objects—all, it seems, the product of just a few days.[5] In this way throughout the autumn Picasso was to multiply dialogues between all the resources of painting from drawing to *papiers collés.* After *Guitare, partition, et verre* (Guitar, Sheet Music, and Glass)[6] he added to a piece of wallpaper with background lozenges (similar to those in some of Manet's still lifes, and some of Cézanne's) a fragment of a musical score and a structural charcoal drawing of a glass, itself treated like a collage. There was another innovation: a fragment of newspaper. The paper—dated 10 November—is one of the oldest to be used. Picasso cut off the paper's name—*le Journal*—at *Jou* to preserve the suggestive effect of his first painted inscriptions at Céret in 1911. But in the découpage he kept the headline *La bataille est engagée* (the battle is joined). The headline undoubtedly referred to the war in the Balkans, but he was clearly applying it to the battle in painting.

We already have all the elements of the prodigious season of *papiers collés,* which is just beginning. Picasso immediately painted three pictures of equal value: two violins and a violin with newspaper. The first two are

sanded; the third, sanded on a base made of glass and therefore transparent, which makes possible—to the degree desired—the intrusion of external reality.[7] The use of newspaper instead of wallpaper permits interpretations which can be drawn from the verbal meaning of the fragments. A bottle carries a label for Cherry-Rocher or for a marc from Burgundy.[8] A headline proclaims a *coup de thé*(âtre); an advertisement, *la Force virile* (with a sexual hint).

None of this is innocent. But if humor plays its part, one must nonetheless beware of equating all *papiers collés*—especially Picasso's—to a game, a way of tweaking the public's nose. Picasso exploited all the possibilities in the texts of the fragments he used, including the most serious of them. When I showed him the photographic enlargements of his *papier collé, la Bouteille de Suze,* which had been sent to me by the library of Washington University in St. Louis and which includes long passages of a speech given by Jean Jaurès favoring peace in the name of the Socialist party, I asked him if he had chosen the text deliberately. "Of course," he replied and then explained: "That was my way of showing that I was against the war." Patricia Leighton, who has systematically reconstructed newspaper texts used by Picasso in *papiers collés,* has shown that this instance is far from exceptional. It was, in fact, a rule with Picasso to focus on items about the war or the dangers of war.[9]

Thus in this period, after heightened tension with Germany in the wake of the Agadir incident in Morocco and a dangerous growth of nationalist hysteria in France, Picasso demonstrated in his own way that he aligned himself with the camp of pacifists, socialists, and anarchists. In this he shared the opinions of the German Kahnweiler but not, as we shall see, his illusions. He was more on his guard.

The offensive against Cubism took a new turn on 25 October, nine days after Lampué's diatribe. At that point Delaunay chose to send an open letter to Vauxcelles breaking his solidarity with the Cubists. Shortly thereafter Archipenko did the same thing.

The dynamics of *papier collé* were for Picasso a principal and passionate interest, providing, as they did, experiments in innovation with which to exercise his extraordinary and inventive gifts as artisan and gadgeteer. Unlike painting and drawing, which take shape gradually, a combination of drawing and precut surfaces creates an immediate, global composition and permits previously unimagined effects. For example, with *Bouteille sur une table* as a subject, Picasso could do two *papiers collés,* each the inverse of the other. The first is drawn on a piece of newsprint, the bottle appearing in white lines; the second, like a negative, is a bottle of newsprint on a white sheet.[10] He had found a non-imitative symbol of rotundity, one which Braque would use in 1913 in his *Nature morte vin.* Within a few weeks in an intense creative fever, Picasso was to produce literally dozens of *papiers collés.* He had brought to a point of perfection the conceptual symbols of a violin—the two *f* holes as opposed to the circle for the central air hole of the guitar.

On 16 December, after signing his letter contract with Kahnweiler,[11] Picasso left with Éva to spend Christmas at Céret. They were in Barcelona at the end of the year and stayed until roughly 20 January, a visit which constituted official recognition of their status as a couple by Picasso's parents. Newspaper fragments studied by Edward Fry suggest that *Bowl with Fruit, Violin, and Wineglass,* as well as for *Bon Marché,*[12] a matter of interest because these two *papiers collés* reintroduce actual images of pasted fragments among other more or less conceptual representations.

The *papier collé* is thus, as Jean Paulhan was to observe, an extraordinary "machine for seeing" painting in the process of self-elaboration, while at the same time it has its own existence as an independent medium. Picasso worked unremittingly to reproduce in painting all the specific qualities of *papier collé,* including differentiation of substances and collage in shallow relief obtained by stencils of paste and, at least once, by gluing canvas to canvas. As he positioned and manipulated the fragments of paper, he was learning the essentials of an unknown, unexplored method of composition. John Golding was the first to draw attention to the novelty of composition by contrasting vertical bands, which derives from the technique of *papiers collés.*[13] In order to perceive and reveal every available possibility, Picasso needed to be highly alert to the capacities of non-imitative expression, as in fact he had been since his period of reflection on the Grebo mask.

Picasso found that he could organize informative and symbolic elements to structure the appearance of an object without the previously obligatory armature; that he could use instead an axial composition that rested on differentiated planes. He proceeded from reconstructions conceived with the help of a grid to non-representative architectural arrangements in which combinations of ideograms and symbols made it possible to imagine the object or figure. In this new space he was able to reintroduce the walls of a room and objects like a gas jet, wooden wall paneling, and *faux marbre,* in a series of complex and masterful canvases beginning with *Nature morte à la guitare* (Still Life with Guitar) and moving on to *Violon accroché au mur* (Violin Hung on Wall) and *Violon au café* (Violin at the Café).[14] At the end of his life, when to establish their order I spread out in front of him color reproductions of this sequence, he said that with these pictures he had "gone the furthest" ("qu'il est allé le plus loin").

At the end of February 1913, with a view to photogravure reproduction, he drew in black China ink and lead pencil the portrait of Apollinaire which would be used as the frontispiece for *Alcools.*[15] We should note that he and Braque had only seen each other a few times, since Braque didn't return to Paris until 29 November. Therefore, for each to examine, consider, and discuss the work of the other, they were limited to the last three weeks of 1912 and roughly six more weeks from the end of January to the beginning of March 1913. After that, they were not to meet again until 8 December 1913.

This distancing can be noted by the divergence in their work. Picasso moved from the use of newsprint through painted reproduction of all the

effects of collage to compositions which develop the abstract structure of pasted strips, achieving a genuine conceptual figuration with perfectly controlled plastic symbols. The result of this sequence are compositions which are almost wholly abstract. Braque, on the other hand, who had surely seen the first transcriptions of Picasso's *papiers collés* in painting, carefully translated his own into canvases with charcoal drawing. Color here is reduced to the limited range of *faux bois,* as in *Violin and Newspaper (Musical Forms),* or strips of single color, as in *Violin "Valse,"* to increase in depth and range only with *Fruit Dish, Ace of Clubs.*[16]

We have a photograph of the boulevard Raspail studio with one of his most astounding constructions, now lost. On the wall is an abstract, conceptual drawing with symbols which identify it as a man. Dangling against it are two arms cut from newsprint, holding a real guitar suspended from the ceiling by string. This conception derives from the unity between non-imitative sculptures and real objects achieved by African art. It also proves that conceptual figuration functions in traditional, three-dimensional space. The abstract guitarist exists! Picasso had just united the discoveries of his first collage—*Nature morte à la chaise cannée*—and the dialogue between his assemblage of *Guitare* and his *papiers collés:* a synthesis of two and three dimensions, of abstract symbols and concrete reality, which had no precedent.[17]

Because of an error by Zervos, this third visit to Céret was for nearly thirty years confused with the second. The result of this confusion—until 1970—was a chronological account of *papiers collés* which was the reverse of what actually happened, a mistake which made Picasso's posture toward Synthetic Cubism—and by the same token the root of his differences with Braque—incomprehensible.

With the move to Céret the range of basic questions about *papiers collés* altered. Some of these involved substantive inclusions. In the autumn, for instance, Picasso had already made a *papier collé* by gluing colored reproductions of fruit onto a piece of paper. He also paid meticulous attention to the quality of paper. Often these had an unusual texture, as in the Museum of Modern Art's *Guitare,* or a certain antiquity, as in a sequence made with an issue of *Figaro* from 1883.[18] Picasso knew that the medium was fragile; that it would grow old. In other *papiers collés* he developed a tendency to radical abstraction, which first appeared in Paris. This led to the most important paintings of the period: a *Tête de jeune fille* (Head of a Girl), its curly hair done with a steel comb; an entirely conceptual *Arlequin;* and an *Homme à la guitare,* which is a sumptuous patchwork of subtle fragments of painting.[19]

The weather, superb at the beginning of their stay in this mid-mountain village, had become miserable. Éva was ill with angina or bronchitis or both, from which, it seems, she never entirely recovered. On 11 April Picasso wrote to Kahnweiler, asking him to give Max Jacob the money for a trip to Céret. He adds: "You've sent me some pretty sad news about all

these discussions on painting. I've received Apollinaire's book on Cubism. These rows really upset me."

The upset was not from Apollinaire's book. When I talked to Picasso about it, he told me he hadn't agreed with Kahnweiler's opinions, which were vehemently negative. In *les Peintres cubistes* there was a great deal which would seriously annoy a rigid aesthetic theoretician like Kahnweiler. There were also passages more or less dictated by Picasso, which, beneath their poetic allusions, were quite precise, an *Histoire anecdotique de cubisme* by André Salmon, with a similar emphasis on style and the first account of *les Demoiselles d'Avignon* (the picture had not yet been given that name). Above all, there was the treatise *Du cubisme* of Gleizes and Metzinger, based on their experience of various Salons; their account entirely omitted references to Picasso or Braque.[20] All this agitation was extremely disagreeable to Kahnweiler, who would have liked exclusive control of everything that concerned the work of *his* painters.

According to Max Jacob, these Parisian rumblings scarcely touched Picasso. He describes for Kahnweiler "M. Picasso in a dark blue robe, or a simple pair of trousers," who at eight in the morning

> comes to bring me phospho-cocoa accompanied by a heavy, succulent croissant. . . . Each day I find myself admiring the character of M. Picasso; the true originality of his tastes, the delicacy of his senses, the picturesque details of his wit, and his genuinely Christian modesty. Éva's devotion to the humble tasks of running the house is admirable. She likes to write, and laughs easily. Her temperament is even, and she does her best to please a guest who—when he isn't being mad and imbecilic—is naturally quite filthy and phlegmatic.[21]

Alas, it rained. And was raining again in early May when Picasso learned that his father, in Barcelona, was ill. He was in Barcelona himself for his father's death on the 3rd and his funeral on the 5th. A letter from Éva to Gertrude tells us that he returned to Céret on the 14th. "I hope," she writes, "that Pablo will get back to work, because that's the only thing which will help him over his sadness."

Already Max Jacob's letter was praising Éva's qualities of heart (in considerable contrast to those he perceived in Fernande). Éva's letter indicates how well she understood her lover, how well she understood that for him, stopping work told the whole story. And the way she writes of it to Gertrude indicates her assumption that Gertrude understands. The letter also, in passing, does justice to Picasso's supposed lack of feeling on this occasion. He was too Spanish to flaunt his sorrow. His father's death touched him at a moment when, by a long and entirely different route, he himself had come to employ a compositional trick of the older man's. Don José painted his pictures section by section, pinning the painted fragments to the sketch to make sure they were positioned properly. And now, in his

papiers collés, Picasso was imitating his father.[22] He was to use this method at different stages of his work. Françoise Gilot surprised him as he was pinning up sketches to balance his *Femme fleur* in 1946. And sketches of this kind are apparent in his preparations for his UNESCO piece in 1958.

Picasso, Éva, and Max Jacob went to Catalonia in June for a bullfight at Figueras on the 11th and a visit to Gerona on the 14th. Before leaving, on 10 June, Picasso had invited Gertrude, who had just broken with Leo, to visit Céret for Saint-Paul, on 29 June. But a letter of the 19th announces a hasty return to Paris because of what Éva calls "une petite typhoide" (a small outbreak of typhoid). Throughout July her letters kept Gertrude and Alice Toklas informed about this subject, which was also a matter of concern to the papers.

Éva and Picasso were back at Céret on 9 August but left again before the 19th because there had been fresh trouble with friends of Fernande's.[23] During this interval they encountered Juan Gris, who was settling there himself. Watching Picasso from close at hand, the young painter had made huge strides since the end of 1912, boldly transposing the effects of collage and using colored or representative elements which Picasso did not yet permit himself.

This last—and longest—visit to Céret seems to have been a sequence of debates between sensuality and austerity; between an increasingly lively taste for the concrete and various returns to abstraction. Picasso explored the possibilities not only of plastic symbols but also of substance, of what the American critic Clement Greenburg would call optical painting when painters of the younger generation, like Fautrier or Dubuffet, rediscovered it after the Second World War. It is decisive that he perceived these approaches to be complementary for painting which no longer draws its strength from representation; painting which today we would call abstract but which he, in fact, practiced as a liberated figuration.

Unfortunately we know nothing of the contacts Picasso surely maintained with his old friend Manolo and with Frank Haviland, who had one of the finest collections of African art at the time. When he returned to Paris, Picasso proved that he had thought a great deal about three-dimensional assemblages and about the inventions and plastic symbols of African art.

12

FULFILLMENT

Autumn 1913–Summer 1914

I n September 1913 Matisse sent Gertrude Stein a postcard with news which, had it been public, would have turned the art world of Paris upside down: "Picasso is a horseman, and we're making a horse together. Everyone is astounded." Gertrude, in fact, had already been given the news by a postcard from Picasso dated 29 August, which says that the project is under way in the Bois de Clamart. Other than Gertrude, only the socialist Marcel Sembat knew anything about it. (Sembat provided Matisse's most consistent French support.) Picasso was clearly disinclined to boast of this development,[1] not that he was particularly affected by the various Cubists who were using him against Matisse, but because the return to color and sensuality in his painting—which drew him closer to his elder—must have made him anxious. He felt obliged to question his own motives: Were his new moves in fact regression? An intellectual weakness which might compromise the gains of the last three or four years?

Picasso hadn't seen Matisse's fourth show—at Bernheim-Jeune's in April—because he had been in Céret. But he had certainly read the reviews in the press, including Apollinaire's. Nor had he looked at the large canvas *Café Maure,* which had already gone to Tchukhin's. However, he knew that Matisse had taken a turn toward painting which was less imitative, more abstract. He also knew that sculpture had been an important element in the show. Certainly for those who equate Cubism with the geometrization of the painters who showed at the Salons of 1911 and 1912, Matisse is not a Cubist. But to Picasso's eyes it was clear that a new convergence in their work was taking shape.

This was certainly equally important for both painters. As Alfred Barr has stressed, in that year—1913—Matisse and Picasso became the recognized leaders of modern painting throughout the world. Matisse was still ahead in Scandinavia, England, and the United States; but Picasso had overtaken and surpassed him in Russia, Germany, and, thanks to the Futurists, in Italy.[2] As I have shown in my *Journal du cubisme,* Matisse's turn toward compositions which were more structural, more geometric, was reaffirmed in 1914–15. Conversely, Picasso's consideration of a more

decorative style would during those same years become more emphatic and more detailed, an attempt to dominate the external, visible world by reappropriating natural forms—even turning back to portraits. Much later Picasso acknowledged and saluted these rediscoveries of 1913. In 1944 he bought one of the largest Matisse still lifes of that time—*Nature morte aux oranges*—and showed it with his own paintings in the Salon d'Automne of the Liberation, which honored the painter of *Guernica*.

At the time such a rapprochement must have seemed equally incomprehensible to Braque, to Kahnweiler—and to Apollinaire. We know that on 20 September Picasso and Apollinaire lunched at the boulevard Raspail.

He and Éva had already found a new studio, a little further up the boulevard by the rue Schoelcher. The window looked out over the Montparnasse cemetery—an enormous view. Éva had never liked the dark recesses of the boulevard Raspail apartment found by Kahnweiler. Picasso took advantage of the move—the emptiness of the rooms, the shifting of furniture—to satisfy his craving for sculpture. The sculptures, however, were of a kind never before conceived or done, sculptures assembled in the manner of the *découpée* pasteboard *Guitare* he made after the visit to Sorgues.

Guitare et bouteille de Bass, a *tableau-relief* probably dates from the autumn, even though it includes a clipping of 23 April 1913 (when Picasso was at Céret).[3] Then he launched a series of constructions whose common object was to realize his structural drawings of objects in three dimensions, using ordinary materials—wood, pasteboard, even a novel plastic cone. These are, in fact, free-form assemblages and sculptures, and it was probably at this time that he translated his pasteboard guitar into sheet metal, including it in the complex montage (discussed in chap. 11) which survives only in a photograph taken by Kahnweiler.[4] He was making, in fact, what would now be called environments. His imagination and fantasy transmuted objects, turning, for instance, a molded table leg into the neck of a bottle and producing a wooden light bulb. And then, no longer fragmenting forms, the montage with the guitar was transposed into painting, creating a new *Guitare sur une table*.[5]

Photographs of these unprecedented constructions appeared on 1 November, illustrating the first issue of the review *Soirées de Paris*, edited by Apollinaire. This enterprise was supported by the generosity of the Cubist painter Serge Férat and his sister, the Baroness d'Oettingen, with whom Apollinaire had found some consolation after his loss of Marie Laurencin. The magazine's offices were at 278 boulevard Raspail, a stone's throw from the rue Schoelcher. This first issue made an overwhelming impression on a young Russian artist, Vladimir Tatlin, who was in Paris at the time, and who, when he returned home, undertook analogous constructions. It also dazzled André Breton, a young medical student, who was then seventeen. For him this was a "first encounter with the work of Picasso" and the "shock of what has not been seen before." These extraordinary and entirely novel transmutations are, in fact, "surrealist."

This anachronism is evident in two canvases in which a conceptual head becomes *Étudiant à la pipe* (Student with Pipe) and then *Étudiant au journal* (Student with Newspaper). In the first the mouth is in contact with the drawing of a pipe, and the hair, done with a collage of crumpled paper which includes the traditional beret, is worn askew. In *Étudiant au journal* the beret is painted. New symbols build the piece with the help of a fragment of molding and of *faux bois*. There is also some decorative pointillism.

These transitions from symbols to reality give *Femme en chemise dans un fauteuil* a strong fascination which Breton will define in 1925 in *le Surréalisme et la peinture*. These exceptionally numerous studies detail the possibilities envisaged by the artist for placing this conceptual, demonstratively non-imitative figure in a "real" armchair. Picasso provided one face and two sets of breasts: European and "African." This final touch of alienation (this final destruction of racial links) was achieved by a poetic and magical triumph of humor.[6]

Picasso looked at the color reproduction:

> Apollinaire said to me: "I always want to take off her shirt." And I said: "You can see very well that she's a real woman; that what she's hiding, she's got. . . ." Standing in front of her, with Braque, I asked him: "Is this a woman or a picture? Do her armpits stink?" And so on.

I will never know how Braque answered this. Picasso stroked the geometric ribs and explained that he had started them over again in 1940 in his monstrous *Femme nue se coiffant* (Woman Dressing Her Hair). "I wanted her to stink of war!"

It could not be entirely irrelevant that in two studies and one of the large canvases, Picasso drew not a conceptual head but a face strongly reminiscent of Éva.[7] Despite abstraction and symbols, this was his first return to portraiture since 1909. The thrust toward abstraction in 1913 had been far stronger than the superficial move in that direction during the summer of 1907 or the structural explorations of Cadaqués at the beginning of 1911. Whether he was aware of it or not, Picasso was caught this time by the current of abstraction which also inspired the orphism of Delaunay and was celebrated by Apollinaire, Kandinsky, and Mondrian. And although a fear of falling into the merely decorative does not seem to be a primary motive, he turned aside. Should we try to find reasons which are more deeply buried? Twenty-five years later, Julio Gonzalez, confronted with the entirely abstract paintings of Hans Hartung (who would become his son-in-law), assumed that a religious motive was primary. Abstraction pushed to such lengths seemed to him an outrage to creation and to the Creator. The Catholic bias of Gonzalez and the Protestant bias of Hartung appear in sharp opposition over the need for or the rejection of a cult of images. Was Pablo also affected by this question? No one knows.

What is certain is that the honeymoon with Éva had not come to an

end. Picasso was happy and was settling down in Montparnasse with Apollinaire, Serge Férat, and his sister the baroness, the Futurists Severini and Boccioni, and De Chirico, whom he saw very often. Salmon, Max Jacob, Alice, and Derain emigrated from Montmartre in a very avant-garde group, which included Cubists like Jacques Villon, Metzinger, Gleizes, and Fernand Léger, and Alexandre Mercereau, who organized "advanced" exhibitions in Moscow and Prague.

Since *Étudiant à la pipe* Picasso's painting had been joyous and full of light. *Le Joueur de cartes* (The Card Player) combines a decorative workmanship and conceptual elements. The *Tête d'homme* and *Tête de jeune fille au chapeau garni de raisins* (Head of Girl with Hat Decorated by Grapes) develop with a light touch the liberties derived from Grebo masks. Increasingly, natural forms break the geometry of still lifes.[8]

Braque returned on 8 December. As I have said, they had not met since the beginning of March. On 2 October Braque had complained to Kahnweiler, "It's been a long time since I've heard anything from Picasso."

When he got back, Braque had with him some large and very fine *papiers collés: Checkerboard: Tivoli Cinema* and *Guitar and Program: "Statue d'épouvante,"* which Picasso would acquire. The shock of discovering these *papiers collés* coincides precisely with the start of a third season of more than forty Picasso *papiers collés*. The folded newspaper in *Nature morte avec journal et paquet de tabac* (Still Life with Newspaper and Packet of Tobacco) is dated 3 December.[9] Beside the *sablages* there are reliefs made with sawdust which achieve the decorative effects of pointillism. Sometimes Picasso painted trompe l'oeil frames with crooked moldings. Everything which could be pasted on was used: packets of tobacco or cigarettes; visiting cards; an entire folded newspaper (in its wrapper); painted imitations of a pipe, dice, playing cards, a cut pear. These are the offspring of the conceptual guitarist holding a real guitar and the *Femme en chemise dans un fauteuil,* conceived during the unanticipated encounters of collage. Conceptual figuration is combined with natural imitation; the work moves from structural drawing to illusionism but also from Cubist space to the space of classical perspective. And now Picasso moved on to new assemblages which provided his latest discoveries with material proof. In *le Casse-croûte* (The Snack, later at the Tate Gallery) a pedestal table is indicated by the arc of a wooden circle edged with trim, and a strip of molding which extends beyond it is enough to suggest a sense of interior. A factitious fragment of bread, two equally implausible slices of sausage, a Cubist glass made of wood seen simultaneously as an elevation and a transparency add up to a still life which is simultaneously conceptual and illusionist.[10]

From this a new sculpture is born in which the glass acquires a free and easy form, while an opening in its goblet reveals its transparency. It is surmounted by a spoon with a silver grill, of the type used to pour absinthe on a sugar lump, which here is given an evidently factitious rendering. The

contrast between precise realism emphasized by the inclusion of the objects themselves and the baroque, conceptual, and anti-natural character of the sculpture permits what might be called a new and original encounter between trivial presence and poetic form. Picasso accentuated this dynamic juxtaposition by painting differently each of the six bronze castings of the original wax model.[11] In the strongly accented contrast between the "ready-made" spoon (whose silver shape is beautiful) and the vulgarity of the artificial sugar, Cubism's new modality, turning toward the baroque, is brought to its height.

Picasso's painting had become baroque. He was experiencing an evident pleasure in painting, in exploiting every available decorative possibility, urged on perhaps by those whose Cubism he had inspired, like Juan Gris or Severini.[12] Two rather ironic *papiers collés,* which use the title of the review *Lacerba,* indicate in the opening months of 1914 Picasso's strengthening ties to the Italian Futurists. But Éva was once again the queen of this flowering, which, with a sequence of still lifes dedicated to *Ma Jolie* and an explosion of color, combines the most intense lyricism and humor. This will later be called Rococo Cubism, a particularly ill chosen term. It is, in fact, Amorous Cubism.[13]

In that spring of 1914 everything was going well for Picasso. On 2 March the association *la Peau de l'Ours* put up for auction some of the work it had acquired. It was the first time new painting was given such a test, a test heightened by the understanding that the artist would receive 20 percent of the selling price. Salmon spoke of "an *Hernani* premiere for painting." All the important dealers were there: Vollard, Kahnweiler, and some of the latter's German friends: Thannhauser from Munich and Flechtheim from Düsseldorf. The first stir was produced by a Matisse fruit bowl, which fetched 5,000 francs: 1,000 more than either Gauguin or van Gogh. A Picasso gouache of 1905—the *Trois Hollandaises*—went for 5,200 francs. But the key sale was that of the *Famille de saltimbanques,* bought by Thannhauser for 11,500 francs, a triumph for the Cubists and their allies in the room. Kahnweiler rushed off to give the good news to Picasso, who— true to form—hadn't bothered to be there.

The violent reaction of the conservative press the following day has become a legend. According to *Paris-Midi,* "Inflated prices were paid by undesirable strangers for grotesque and disgraceful work; and it was the Germans who paid these prices and engaged in pushing them up! Their scheme is quite obvious!"

The message was clear: the hereditary enemy was trying to pervert French painting. Picasso found himself treated as an imitator who "having parodied and copied everything, and with nothing new to imitate, is foundering in Cubist bluff."

At the same time, on the other side of the Rhine, the Expressionists (and their dealers) were accused of selling to the French, a symptom of the heightening chauvinist passions which would lead to war. A symptom, as

well, of the rift between the impetuous development of modern art and traditional culture—a rift whose consequences became apparent after the war.[14]

That spring Picasso arranged a surprise for Kahnweiler, who described it in 1961: "He showed me two drawings which were not Cubist but classicist: two drawings of a seated man; and he said 'Better than before, *hein?*' Which shows that the idea had already begun to germinate, at that time."[15]

In fact, this idea had already been broached with the face in studies for *Femme en chemise*. Here Picasso considered the possibilities of combining non-imitative figuration—either conceptual or structural—with a traditional, illusionist approach. He was weighing whether or not traditional illusionism could be employed in Cubist space without putting at risk the additional freedoms—the effects of substance and pure color—forbidden by the reductive, rationalist framework of perspective.

We should recall that at the time—especially in France and mindful of Descartes—pupils were taught that perspective was part of "nature." And—although chroniclers who kept themselves up with the times thought they might explain the astonishing appearance of Cubist work in the Salons by references to the "fourth dimension"—the idea that physical space might exist in a scale or scales other than those which human beings can apprehend was just beginning to be discussed by a few advanced intellectuals. Picasso, therefore, had at his disposal no intellectual tools with which to analyze his discovery. And it was because his Cubism functioned in a practical way, *because* his *Femme en chemise* was a non-imitative but real woman, that he felt he could return to portraits. We have drawings of this experimental period which show that he resumed portraits with the deliberate prudence of a cat. He evidently feared falling back into the classic virtuosity of the period that produced *Famille de saltimbanques*.[16]

We have a letter from Éva to Gertrude Stein that provides some points of reference for this final summer of peace: "We couldn't stay at Tarascon: there was nothing to rent. So we're at Avignon. This morning, Pablo found a rather Spanish house right in town. . . . It's high time we were settled in our own place. This life of hotels and wandering about doesn't do us any good."

That was on 23 June. Almost a month later, on 21 July, Picasso was showing at Kahnweiler's: "I'm only doing big canvases; at least that's all I think about. I've started one which is already quite far along. It was quite hard for me to get started before I was used to working in a dark attic. But that phase is over, and I hope the good Lord just lets me keep going."

Braque and Marcelle had settled at Sorgues; Derain and Alice at Montfavet, the other suburb of Avignon. Later, the war and Éva's death made memories of this little circle almost unbearable. A letter from Picasso to Kahnweiler discusses some photographs of his work in the press: "They're not bad. For a while now he [the photographer] has been doing pretty well.

But the little glasses are no good at all: they're almost indecipherable."

Kahnweiler was more than a dealer of modern paintings who had an international outlook. He also acted as critic and committed supporter of his artists. And photographs were more than a matter of simply registering a work and, up to a point, its chronology, an idea which had not until then occurred to proprietors and managers of galleries. Photographs could also act as mirrors for the artists, could provide a fresh look at their paintings, as if through another set of eyes. Today none of this has any novelty, but at the time Braque and Derain as well as Picasso eagerly awaited from Kahnweiler these two-dimensional black-and-white translations of their work.

This period in Avignon was perhaps even more productive for Picasso than his time in Paris. If one considers that there was only a very short span before the beginning of August and the brusque interruption of the war, which broke the ardent thrust of his work, it is clear that this was a moment of great happiness. Glasses had never been rendered more lyrically; their settings had never been more alive. *Nature morte verte* (Green Still Life) is a chant of saturated color. Some of this enthusiasm is still apparent in *Vive la France!*, a still life completed after the outbreak of hostilities.[17]

In drawings and paintings of the time we find figures so fantastic that, as Barr points out, their surrealism was never surpassed, either by Picasso himself or by Miró. We are at a polar opposite of geometric figuration. Two large canvases, *l'Homme assis au verre* (Seated Man with Glass) and *Portrait de jeune fille*, were finished. The first interprets in undulant forms a café waiter carrying a napkin and a glass, the glass being one of the wildest Picasso imagined at Avignon.[18]

The *Portrait de jeune fille*, in saturated green, is a luxuriant recapitulation of ingredients made for collage, which Picasso kept. The painting is thus an illusionist imitation of an identical *papier collé* which had not, in fact, been made. Even more than in *Homme assis au verre*, the entire composition is governed by a supple rhythm which links the bust, the arm, and the fur boa around the figure's neck. Both of these works are masterpieces of humor in which the painting plays with the traps it holds out to our vision.

Two uncompleted canvases are the product of the classical drawings which Kahnweiler had seen in the spring. Both had undergone considerable development: *Arlequin,* not finished until 1918, and *le Peintre et son modèle,* which Picasso never showed to anyone and which, in fact, was unknown until the inventory made of his studios after his death. The thoughtful painter is very close to the signed studies done in Avignon. The plate on the table no doubt explains the highlighted drawing of *Nature morte aux cartes à jouer et aux pêches* (Still Life with Playing Cards and Peaches). The model, a naked young woman, does not reappear in his work. Her delicate grace suggests that she is perhaps a version of Éva.[19] There would be no resumption of classicist experiments until the *Portrait*

de Max Jacob at the beginning of 1915. Everything, therefore, leads to the conclusion that the war broke off this exploration, which Picasso must have considered dangerous.

When one looks at the preparatory drawings for a return to the human face, it is interesting to note that they were elongated in a manner quite close to Derain's when he drew his own face or Iturrino's in 1913–14. When it came to moving in a direction which he clearly found tempting, Picasso had no need of anyone's help. Nonetheless, to be suddenly deprived, by the war, of talks with Braque, his constant companion in Cubist explorations, and with Derain, whose rich culture and tormented spirit made him a thoughtful critic, could only be sad. He and Derain—as if to celebrate their conjunction—had painted together a panel of four still lifes.[20] We should remember as well that behind his return to portraits is a confrontation with the great classic works of painting, something that Derain, too, understood and had in mind.

Picasso, like everybody else, probably believed in a short war, which would be over by winter. Nevertheless, he soon realized that he had lost Kahnweiler for the duration of hostilities, since Kahnweiler, as a German citizen, was in danger of mobilization against France. And the bulk of his production, including the six versions of *Verre d'absinthe,* were at the gallery in the rue Vignon.

He would also lose Braque and Derain. Their apprehensions for the future, when they separated on the platform of the Avignon station, can be readily imagined. Picasso, as a Spaniard, remained outside the conflict and more alone than at any time since his arrival in Paris ten years before.

THE WAR AND ÉVA'S DEATH

Summer 1914–1916

No one in Picasso's circle actually witnessed the war's arrival. Alice and Gertrude Stein were caught in London; Kahnweiler was climbing a mountain in Bavaria. "All my life," Kahnweiler explains, "had been based on the assumption that the war would not happen. Until the very last minute, I refused to believe in it. . . . During the night of 30 July, we beat a hasty retreat—I didn't want to be stuck in Wilhelm's army—and were able to cross the Swiss frontier." On 2 August he arrived in Rome, which was still neutral. He was very quickly to find himself without a penny; his Paris gallery was closed, and all the paintings he had sent to Germany were confiscated because of his refractory attitude toward military call-up.

Overnight Picasso lost all possibility of sales. True to habit, he wrapped himself in work; but color had fled along with happiness, and he took no risks. He moved on to a Cubism which was rigorous, cold, and—to the extent that it was no longer adventurous—classic.

From a letter of 14 November to Gertrude Stein, we know that he and Éva were preparing to return to Paris. On the 30th Max Jacob writes to Maurice Raynal, who has been mobilized, "Picasso's return is marked by pure lines, replacing the vulgarities of nature," a remark which could apply equally to the darkened still lifes and to the fantasy canvases.

Juan Gris informs Kahnweiler on 30 October, "Matisse writes from Paris . . . that Picasso withdrew a large sum—they say 100,000 Fr.—from a bank in Paris at the outbreak of the war." What is certain is that Picasso was considering his professional situation. He asked André Level, whom he had known since 1906–7, when the latter had made his first purchases for la Peau de l'Ours, to intervene on his behalf with the sequestration administrator of the Kahnweiler gallery so that he might recover his pictures. These overtures, however, proved fruitless. Picasso was angry at Kahnweiler for failing to take precautions. He was trying to do what he could, but felt very much alone.[1]

Apollinaire, in Nice, was making urgent efforts to join the colors. Picasso told me later that Apollinaire hoped in this way to cleanse his honor

of the taint left by his brief imprisonment in 1911. Only Max Jacob,
Matisse, who was too old, and Juan Gris were still outside the war. Alice
and Gertrude, who had returned to Paris in September, would leave for
Spain in March 1915, as they no longer had enough money to live in the
French capital.

The studio on the rue de Fleurus was empty; Leo had taken his
pictures. For Christmas, as a replacement, a "souvenir pour Gertrude et
Alice,"[2] Picasso did a Cézannesque watercolor of an apple. If one looks at
the picture closely, it is clear that the apple—an object of classicist concep-
tion—is situated in Cubist space. In any case, Gertrude Stein bought two
Avignon still lifes. At her apartment Picasso could see the major stages of
his 1913 painting, from *Homme à la guitare* to *Étudiant à la pipe*. There
was also a *Femme à la mandoline,* which may well have been finished in the
autumn of 1914, when Picasso took some Russian lessons with the Baroness
d'Oettingen, the sister of Serge Férat:[3] brother and sister jointly had col-
lected a few friends in support of the *Soirées de Paris.* As for the Russian
lessons, rumor classified those as "private." Éva was unwell during the
winter,[4] and in such matters Picasso was an Andalusian of the nineteenth
century: any indisposition in a woman who shared his life was a personal
injustice to him.

Picasso had been surprised not by the threat of war but by its outbreak.
We have seen the pacifist declarations included in the *papiers collés* of 1912.
Gertrude Stein reports "that he used in those days to tell Kahnweiler that
he should become a french citizen, that war would come and there would
be the devil to pay. Kahnweiler always said he would when he was past the
military age."

This is important for an understanding of Picasso's separation from
the overheated excitement which led many Frenchmen to expect a rapid
victory and the capture of Berlin. His critical judgment and his resistance
to the mobilization of attitudes would later draw him closer to the Surreal-
ists and then to the Communists. He had to put up with insults in the street
because other men his age were at the front. He did not, like Apollinaire,
feel a need to buy back his honor because of the stolen statuettes. And he
never for a single moment thought of dropping his Spanish citizenship,
which he kept to the day of his death. Picasso was not a militant interna-
tionalist; he was on the side of the French. But he maintained his own
attitude and an open, questioning mind.

Gertrude Stein describes herself and Alice at the end of 1914, walking
with Picasso and Éva

> on the boulevard Raspail, on a cold winter evening. There is nothing
> on earth colder than the boulevard Raspail on a cold winter evening. We
> called it the retreat from Moscow. Suddenly a big cannon crossed the
> street, the first that any of us had ever seen painted like that; camou-
> flaged. Pablo stopped dead, as if nailed to the ground: "We're the ones
> who did that," he said.

The discontinuity in his painting and Braque's did, in fact, seem a precursor to this camouflage, done in Cézanne's range of colors. At the front Léger was to have the same experience.

Picasso did not, of course, wait for the war to perceive links between his Cubism and the industrial era. But with war—the first total war and the first to be heavily technical—obvious signs of mechanization increased sharply. It is particularly noteworthy that rather than proceed toward an imitation of mechanical forms—as Léger did, for example—Picasso chose to oppose them by returning to natural forms. I believe, as well, that his efforts to resume the painting of portraits in the spring of 1914 did not derive solely from his love for Éva. They also represent, it seems to me, a presentiment of the war and its destructive power. In the same way, I don't think that his undertaking a real portrait of Max Jacob in January 1915 depended solely on an intimacy heightened by the fact that they were the only members of the *bande* still at large. It was also heavily affected by the knowledge that the war would drag on, that it would be a butchery. There is a certain balance between a leaning toward portraiture, the coldness of Cubist still lifes, and borrowings from Giorgio De Chirico, painter of an emptied, silent world, populated by unreal figures and with perspectives rigged like traps.

This secret Picasso cannot be found unless one sheds the groundless idea spread by Wilhelm Uhde in 1928, when he came upon a portrait:

> Was this an interlude, a game—handsome but without any significance—that involved the painter's hand, while the spirit, wearied by the distance covered, enjoyed some repose? Or . . . did he feel that he was pointed at by innumerable, reproachful people who suspected him of profound Germanic affinities and accused him of secret connivance with the enemy? . . . Was he trying to align himself with a specifically French side?[5]

The key to these incomprehensions and errors lies essentially in the fact that, apart from Éva, who died, and Kahnweiler, who was off the scene for years, no one was familiar with all of Picasso's work between 1913 and 1914. Even less was known about his political ideas. Éva alone had shared with him the first months of the war; shortly thereafter, she died.

If Picasso had had the French taste for self-analysis, like Braque or Matisse, or for self-explanation, like Derain, the misunderstandings sooner or later would have been cleared up. But he considered epilogues on the past of his paintings an idiotic waste of time. When he had his back to the wall, he tried to extricate himself with jokes. And these, in turn, were piously collected and taken as true coin, first of all by the Surrealists. For various, often opposing reasons it seems that neither Breton nor Aragon nor Éluard suspected that Picasso might be putting up smoke screens in order to avoid conversations he already thought pointless. For example, the Surrealists' flattery of Picasso and Breton's jibes at De Chirico began at roughly the

same moment in the middle twenties. Why—at this point—would Picasso bother to tell his young supporters that he had been close to De Chirico ten years before in the Parisian solitude of the opening months of the war? De Chirico and Picasso met anyway, at Serge Férat and the Baroness d'Oettingen's, under the Douanier Rousseau's painting *Moi-même, portrait-paysage,* at gatherings which looked just like De Chirico's drawings of them.[6]

De Chirico found that for him the problem which troubled Picasso required a different approach, in an almost opposite direction. He put classical figures in pictorial spaces in which perspective is just as dislocated, as heels over head as it was in the beginnings of Cubism, during the period, for example, of Picasso's Horta de Ebro landscapes. In taking this approach, with works like *Énigme d'une journée* or *le Cerveau de l'enfant* (The Child's Brain), which Picasso had surely seen, De Chirico shows that in practice it is entirely possible to realize a portrait in Cubist space. This is exactly what Picasso achieved in drawing Max Jacob in a space which although it reduces him to the dimensions of the paper, heightens the sense of his presence all the more in that his face and torso are stressed.

Max writes to Apollinaire to tell him that he, a Jew, has been converted to Catholicism and that Picasso is going to be his godfather. "Pablo wants to call me Fiacre,[7] and I feel dashed. . . . I am posing at Pablo's, and for him: he is making a pencil drawing of me which is very handsome. It looks all at the same time like my grandfather, an old Catalan peasant, and my mother." The letter is dated 7 January 1915. The portrait does include some features of the old Gosol peasant on whom Pablo based his first masks. But this is not a backward step: he had learned his Cubism, after all, by abandoning classical resemblance and achieving abstractions of masks and deformations. Henceforth he understood that with themes like the Gosol peasant, he could abstain from these techniques without devaluing the new sense of space and its principles. But this is evidently incomprehensible to everyone who makes the retrograde assumption—that there is a fundamental incompatibility between Cubism and classical painting, that one must be a betrayal of the other and vice versa. When the *Portrait de Max Jacob* was published by a magazine in 1916, it provoked a considerable uproar among the avant-garde.[8]

Considering *le Peintre et son modèle* in the light of the *Portrait de Max Jacob,* one might well wonder if the picture is really unfinished, even though only the woman and the room behind her have actually been painted. The drawing in itself manages to reorganize the space, faking perspective by the expressive disproportions of the figures. The chair's feet are hidden so that one cannot place them in relation to the ground. The top of the table and the fruit bowl are compressed toward the viewer. In the *Portrait de Max Jacob* Picasso uses infractions of classical perspective and transitions from finished drawing to suggestive sketch to program our vision so that it reaches beyond what is actually shown. This seems to me a transposition of knowledge derived from the Grebo mask and from the "synthetic" drawings Picasso did in connection with it, in which construc-

tion of the image proceeds on the basis of instructive symbols alone, without any illusionism.

Eight months later Picasso produced another counterproof: a classical portrait of Vollard, of whom his Cubist portrait of 1910 is a masterpiece. This time he replaced primitivist deformations with others which derive from close-ups of the new cinematography. He made the left sleeve advance by enlarging it in relation to the right; and he did the same thing with the shoes in relation to the head. The chair seems crushed by the torso. Just as the *papiers collés* of early 1914 move from the space of perspective to that of Cubism, so here a Cubist dynamic overturns classical proportion.[9]

The need to do portraits is on a par with the reconquest of surrounding space. With Cubism pictorial space shrank to the dimensions of a bistro table. *Papiers collés* achieved the same effect. The 1913–14 return to figures barely extended beyond the limits of an armchair. It is in fact with assemblages that the frame opens somewhat more to the inner depths of a room. Apart from two *papiers collés* of village views from the Céret visit of 1913,[10] there will be no landscape canvas until 1915—*Nature morte au paysage*[11]— which is contemporary with a similar exercise by Gris: a still life with the place Ravignan in the background. We must remember that Gris—the principal victim of Kahnweiler's absence—found himself entirely without resources and was helped by Matisse, whom he saw frequently during the winter of 1914–15. In canvases like *Tête blanche et rose* (Pink and White Head), Matisse had reached his closest approach to Cubism. This is equally true of his series *Poissons rouges,* with its background of urban landscapes visible from his studio on the boulevard Saint-Michel.

To speak only in terms of influence is once again to misconstrue the problem. Picasso was looking for solutions with a view to establishing a fresh mastery of all the possibilities of classical painting, using the means and methods of Cubism. And he surely gave Matisse's results as much attention as those of Gris. He turned again to Chirico while painting *l'Homme au chapeau de melon assis dans un fauteuil* (Man in a Bowler Hat Sitting in an Armchair),[12] a work in which he rediscovered both the luxuriance of his decorative Cubism and the structures of multilevel refractions of a figure by which he began his approach to portraits in the spring of 1914. But the face with its eyes closed is a direct reference to De Chirico's canvas *le Cerveau de l'enfant.* Picasso transformed the isolation, the enclosed desert world, into a bursting and shattering of character in the space of an explosion. He intensified the sense of distancing by touches of humor, displacing the ears, and using a curved feather to indicate an eyebrow. Paradoxically, however, the effect of apparition which disconcerts the viewer is just as strong here as it is in De Chirico. In the background one sees, like a stippled shadow, the equivalent of the model's head reduced to a ball—the ultimate simplification, the inhuman reduction which has just begun to appear in the work of the Italian artist. Picasso, for his part, added a menacing grimace with bared teeth.

This may well be a reflection of the increasingly obvious inhumanity

of a war without end, Braque's serious head wound, and Éva's illness, which had taken a desperate turn. In any case, Picasso rejected every natural element in the new *personnage* with which he closed the period. This time nothing remains but the reduction to mannequin, with a purely geometric imbalance of the face, whose identity with Harlequin is established only by an interplay of contrasting lozenges. The sole "human" symbol is the rictus of teeth, which, stuck into the mannequin's spherical head, adds a sudden note of fantastic cruelty.[13]

A letter of 25 November 1915 from Léonce Rosenberg, a new dealer interested in Picasso, tells us that Matisse had just seen *Arlequin* in his gallery. "The Master of *Poissons rouges* [The Goldfish Bowl of early 1914] was—like me—somewhat taken aback. . . . Level was there, but once he'd gone I was able to get Matisse's real opinion. After looking at your picture—and looking again—he honestly felt it was better than anything else you've done; that it was the picture he preferred above all the others. . . . And finally, he expressed the opinion that it was his *Poissons rouges* which had led you to *Arlequin*."

This gives, I think, an interesting glimpse of the relations between the two artists as they were engulfed by the storm of war and of the means employed to excite their sense of rivalry.

Since the *Carnaval au bistro* and the primacy of pure painting in the beginning of 1909, Harlequin had disappeared as a character. Was he now reappearing as Picasso's double? As an image hardened by the mirror of painting? Or was this, rather, the discovery that the impersonal plastic symbols of the conceptual *Arlequin* of 1913 were not a simple, formal game but could support the weight of all the current tragedy? That the new painting, in other words, conceded nothing to the highest achievements of tradition.

On that basis the union of classicist elements and Cubist structures assumed a further value. The question no longer was simply balance and fusion in a single composition, but correspondence within expressive capacity. Picasso exploited these expressive possibilities in a sequence of dancing couples, which, using the obliquity of geometrized forms, indicates the masculine by thrusting rectangles, and the feminine by an academic mannequin's globular head.[14] Another sequence found symbols of even greater femininity to indicate the woman seated in an armchair.[15] And there are couples whose quality of surrealist fantasy makes the spectator a witness to combat between natural elements and mechanical—or soft—forms with as little humanity as possible.[16]

The conclusion, in 1916, is expressed by three large canvases: one, in *Guitare, clarinette, bouteille sur un guéridon* (Guitar, Clarinet, Bottle on a Small, Round Table), which seems to endow objects with the allusive power of personages, as was done in 1909 with the loaves of bread on the table in *Carnaval au bistro*. The second, *Homme accoudé sur un table* (Man Leaning on a Table), is constructed with vertical bands of *papiers collés* which provide differentiation of color, pointillism, oblique lines,

contrasting curves, and two little circles as eyes. And finally, a *Joueur de guitare* in the same style. Humanity is minimal; mechanization, total.[17]

Between these canvases and *Arlequin,* tragedy had come full term. Braque had not recovered; De Chirico had left for Italy, where he, too, would have to join the war; and Éva was dying. She had to enter the hospital when every bed was filled with wounded from the trenches. Picasso found a bed for her in a clinic, but at Auteuil, on the other side of Paris. A letter of early December to Gertrude Stein, then in Spain, says it all:

> My life is hell. Éva has been ill the whole time—every day, a little worse. For a month now she's been at a sanatorium. . . . I've almost stopped working. I rush to the sanatorium and spend half my time in the Metro. I really don't have the heart to write you. . . . But I have done a *Harlequin* which in my opinion—and in the opinion of several others too—is the best yet. Monsieur Rosenberg took it. You'll see it when you get back. In short, my life is full, and as always, I don't stop.

This is one of the most revealing letters Picasso ever wrote on the tension between his love and his work and on the pressures from the milieu in which he moved to turn to the most abstract Cubism. Jean Cocteau, who met Picasso for the first time in the autumn of 1915, later wrote that "Montmartre and Montparnasse were in the grips of dictatorship. Objects which could sit on a café table and Spanish guitars were the only pleasures allowed." Picasso was too much of a poet: his painting had to reflect both his private tragedy and the tragedy of Europe. Harlequin, therefore, is himself—in hell.

Éva died on 14 December. Picasso wrote to Gertrude Stein on 14 January: "My poor Éva is dead. . . . This has been a great sorrow for me, and I know that you will miss her. She was always so good for me. I too would love to see you: it's been such a long time now. I would have liked to talk to a friend like you."

Just as the misery of the blue period is reflected in a flowering of erotic drawing, this hell, too, had a derivative and an injustice. Picasso's pencils replaced portraits of Éva, which we don't have, with drawings of Gaby, a young neighbor in the boulevard Raspail—nudes of a quality not seen since Gosol.[18] Picasso drew himself taking her a box of chocolates. He is under the clock at the crossroads between the boulevard Raspail and the boulevard Edgar-Quinet, while the Mexican painter Diego Rivera walks toward him, beside the Montparnasse cemetery (which is overlooked by the windows of the rue Schoelcher studio). Gaby is a silhouette in one of those windows. Although the uneven perspective is Cubist, everything is very true to life.[19] For Picasso physical fidelity never had any meaning. But the painting, or rather the drawing, in this case states with remarkable clarity that just at that moment, hell is the abstraction while pleasure flowers with a classicism barely touched by Cubism.

John Richardson has recently published[20] a collection of Picasso letters

and paintings which give some details of this adventure. Gaby was born
Gabrielle Depeyre in Paris in 1888. Gertrude knew nothing of the affair
because when she and Alice returned from Spain in June 1916, it was
already over. Gaby, in fact, had been heavily involved with Herbert Les-
pinasse, whom she married in Saint-Tropez on 23 April 1917. The secret
significance of the drawing Picasso discussed with me was that he had been
waiting under the clock for a signal from Gaby that the path was clear. In
this case, Picasso considered himself released from the reserve he generally
maintained in connection with former affairs when Gaby put on the market
some drawings he had done of her, erasing the dedications, which allowed
Zervos to publish them in his volume 6.[21]

The enflamed declarations which Richardson published afford us the
interesting opportunity of catching Picasso in full amorous fettle. For exam-
ple, he painted with all the subtlety of which he was capable a watercolor
of a Provençal kitchen—astonishing for Paris and probably the sign of a
visit to Gaby's in Saint-Tropez. Of the staircase in the back Picasso remarks
(in his curious, idiosyncratic French), "the way to your room my life I love
you my sweetness. . . . To have you for myself always I don't ask more than
that I swear . . . I love you and in every color." In medallions he pastes on
a photograph of himself and one of her, three still lifes in hot colors and an
amoretto opening the curtains of the bed in which a naked Gaby lies
sleeping. He writes: "J'ai demandé ta main au Bon Dieu Paris 22 février
1916" (I asked the Good Lord for your hand Paris 22 February 1916).

Gaby was to choose a more certain future rather than this genial,
excitable Andalusian. One year later, after several flaming affairs, Picasso
paid determined court to Olga. He had always thought that amorous
possession was free, or, more precisely, that there would always be time—
later—to think about the price.

PART FOUR

OLGA OR MARRIAGE

May God wish to succour us
His children ardent and sage
May he bless our marriages
Each poem every picture
and later my dear Pablo
May he receive us with our wives
To the souls in bliss
Constellations of heaven
Singing to eternity.
 —*Guillaume Apollinaire*

PARADE AND MARRIAGE

1916–1917

J ean Cocteau, then a worldly young poet, was taken to see Picasso, in the Rue Schoelcher, by the musician Edgard Varèse. It was the end of autumn. Through the window Cocteau could see the Montparnasse cemetery, while Picasso talked of a young woman about to die. The poet remembers only a jumble of African carvings on the floor, which he did not like. But he must have noticed the Harlequin canvas because when he came back on leave in 1916, he arrived at Picasso's wearing a Harlequin costume under his raincoat. Without the costume, Picasso might have paid less attention to a project explained by the overly agile young man who seemed, with his effervescent manner, always to be acting.[1] Picasso clearly had no idea that this project would profoundly affect his private life for the next twenty, even forty, years.

Given what Picasso represented and the work he was doing at the time, the proposal was remarkable: that he should participate in the creation of a ballet for Serge Diaghilev, proprietor and founder of the Ballets Russes, who had brought his company out of Russia. The story was to be by Cocteau, the music by Erik Satie, the sets and costumes by Picasso. Ballets designed by painters rather than theatrical designers was a Russian idea, dating back to the beginning of the century. Diaghilev had already brought two splendid successes to Paris: *Firebird* and *Petrouchka* by Stravinsky, with sets by Bakst, and a triumphant *Swan Lake*. Cocteau had collaborated with him in the scenario of *Dieu bleu,* danced by Nijinsky in 1912. He had already published two collections of conventional poems; the war was delaying his third, *Potomak,* a "modern" outcry.

Cocteau had surely been aware, in 1914, of the stir provoked by *Famille de saltimbanques.* He proposed a program—*Parade*—within the context of the rose period: a group of circus artists at a street fair on a Paris boulevard. An acrobat, a Chinese conjurer, and a young American girl would perform, attempting to attract the attention of the public. Picasso reserved his answer until he had moved from the Rue Schoelcher,[2] where Éva's memory was a painful presence, to Montrouge, some twenty minutes' walk from Montparnasse. In the interim he had some long talks with Satie,

whom he had known since his first stays in Montmartre and who was his neighbor in the southern suburb of Arcueil, and on 24 August he accepted.

His last large abstract canvases represented a form of conclusion. Picasso was no more prepared than Matisse to move to entirely non-representative painting as Mondrian and Kandinsky were doing at that moment. He lacked the necessary religious conviction. Picasso was capable of assuming any imaginable distance from appearances, but not from life. He needed coloration which was either tragic or erotic, ice-cold or filled with humor, independent of the painter's hand or a display of technical virtuosity—but always honest. For him total abstraction was decorative—the death of art. To schematize, one might say that between *Arlequin* and *Homme accoudé sur une table* the inhumanity of form reflects both the war and Éva's death. Yet when Picasso did the portraits of his mistresses—even nudes—these works were no more "dedications" to their subjects than were the portraits of Max Jacob or Vollard. They were the accidental breakthroughs of art as total honesty.

This is true as well in the first attempts of a Cubism which is colder and more severely purified than Cubist work after 1914. This work probably reflects the influence of conversations with the sculptor Henri Laurens, a friend of Braque who was spared military service because tuberculosis of the bone had required the amputation of his left leg. After 1916 Laurens joined in experimenting with the new forms invented by Braque and Picasso. But from Picasso's point of view, these moves were simply consolidation. And the war, dragging on in a way which was literally unthinkable, was tragically striking his friends. After Braque it was Apollinaire's turn to be severely wounded. He had a cranial operation on 9 May and, as a result, was subject to bouts of melancholia and rage. The profile drawing Picasso did of him in June shows a tense, clenched face and betrays, as well, his own anxiety about his friend's future. Would he ever again be as before? And how could painting in any way affect the outcome?

Although spared himself, Picasso was closely affected in two of his deepest friendships, and his sense of isolation was increasing. His new dealer, Léonce Rosenberg, had no close knowledge of the creative fever which since 1907 had lifted him beyond himself, and he was painfully aware of Kahnweiler's irreplaceable value. Pablo still did not know that Gertrude Stein was preparing to return from Spain: Cocteau's proposal fell into a gulf of emotional and intellectual deprivation, which was particularly hard for him to bear. The proposal was instantly seconded by Diaghilev himself.

Then, almost immediately and in a most unexpected way, an artistic revival occurred in Paris, plunging Picasso back into his heroic period. André Salmon was organizing a trial exhibition, "l'Art Moderne en France" at the Salon d'Antin, the first of its kind in France. Breaking with his usual practice, Picasso not only participated but provided the show with his *Demoiselles d'Avignon*, which was given its name on that occasion.

As this fact was not rediscovered until after the deaths of both Salmon and Picasso, we know nothing of the exact circumstances. However, a photograph found in the Picasso archives and exhibited at the Musée de l'Hôtel Salé reveals a corner of the frame of *Demoiselles* in the studio of the rue Schoelcher, which invalidates two myths. One holds that the canvas was rolled up until the picture was sold, and the other, that the picture was kept with its face turned to the studio wall. The photograph, which also shows, hanging on the wall, the assemblage of the guitar on the table, must have been taken between the end of 1913 and the spring of 1916.

If Picasso and Salmon expected anything from the show, they were cruelly disappointed. The failure was so complete that nearly sixty years went by before Edward Fry reconstituted an event which until then had been ignored by art history. Louis Vauxcelles, writing in *Événement,* seized the opportunity for heavy irony: "The *Demoiselles d'Avignon,* painted a few years before Picasso took up the *affaire cubique,* scarcely reveals anything except his influence on Mlle Laurencin." The painter Bissière, a newcomer to art criticism, writing about the same Salon in *l'Opinion* (a journal of the Right) remarked: "The disappearance [of the Cubist movement] seems to be more or less a *fait accompli.*"[3]

Although he might not have had any very great hopes, and perhaps entered the show in a spirit of "Cubist" solidarity, a failure of such proportions could only have made Picasso more accessible to the proposals of Cocteau and Diaghilev and to the large element of the unforeseeable which they entailed. But, regardless of circumstance and true to form, once he had committed himself, his commitment was total.

He began by multiplying the classicist Harlequin drawings and imagined a curtain in the same style. Then, almost immediately, he perceived benefits to be gained from the enterprise. He could make Cubist assemblages which were capable of motion; he could organize confrontations between Cubism and the classic space of the stage.[4] And he was faced for the first time with the challenge of functioning artistically with *données* which were external instead of the constraints imposed by materials or engraving. Very quickly he modified these and found himself reshaping Cocteau's project.

A letter of 14 September from Satie to Valentine Gross (the future Valentine Hugo, painter, musician, and friend of Cocteau and Diaghilev) states the problem.

> If only you knew how distressed I am! *Parade* is turning into something even *better,* behind Cocteau's back! Picasso's ideas I find even better than those of our Jean: what a *malheur!* I am for Picasso, and Jean doesn't know it! What to do? Picasso tells me to keep working with Jean's text; while he, Picasso, is using another: his own. . . . And *his* is staggering! Prodigious! I feel both lunatic and sad!

It was Picasso who had the idea of Managers dressed in Cubist constructions. These vie with each other, in mime, as they try to present their acts but are laughably awkward. When Cocteau was given this version, he agreed to it.

At this point Gertrude Stein came back from Majorca. She and Alice, enjoying a perfect affair, decided to return after the battle of Verdun and put themselves at the service of France. After 20 June, before they acquired their Ford ambulance and Gertrude had learned to drive it, they were back in the rue Fleurus. A " 'très gai' Picasso . . . came to the house constantly. He brought with him Paquerette, a very pleasant girl, or Irène, a beautiful young woman who had come from the mountains looking for libery."[5] Apollinaire was resuming some activity, working with Paul Guillaume, a young dealer in African art. He had just published the most autobiographical of his narrative works, le Poète assassiné. In October, for Paul Guillaume, he did a preface for a Derain exhibition. Derain was still in the army, and it is interesting that Apollinaire stresses "an expressive grandeur one might characterize as antique." He defends the painter against accusations of archaism, stressing that his art derives from "ancient French schools; particularly, from the school of Avignon." One can safely assume that Picasso knew and perhaps even discussed this text with Apollinaire: the Picasso–Max Jacob–Apollinaire trio had regrouped that autumn.

With Blaise Cendrars, a Swiss poet who had joined the Legion and been seriously wounded, Cocteau multiplied his *manifestations* at the salle Huygens; hanging the works of "modern" painters, Picassos and Matisses, side by side. It was he who pronounced Apollinaire's poems "hampered by a glorious headache." The crowning event was a banquet of homage to the *Poète assassiné* on 31 December. Assisting in the organization of the event were Picasso, Max Jacob, Salmon, Juan Gris, and Pierre Reverdy, a young poet who would in future be much discussed.

On 15 January 1917, a banquet was given to honor Braque. We don't know what Picasso and Braque said to each other on this occasion; we do know that Cocteau was worried because *Parade* was running late. In a note of 1 February 1917, Picasso reassures him: "Miassine [*sic:* Léonide Massine, Diaghilev's choreographer] will be pleased. You can write to him and tell him that everything will be all right. I am working on our project almost every day; I hope no one disturbs me." He left for Rome on 17 February with Cocteau. Everything about the trip suggests that he was delighted.

It was a working trip, and immediately good relations were established between Massine and Picasso. Picasso found some of the Futurists he had known in Paris, minus Boccioni, killed at the front. Carra and De Chirico were both at the military hospital in Ferrara. "We met in Depero's studio," Massine notes. "Picasso thinks very highly of him." Picasso and Cocteau were staying at the Hôtel de Russie on the via del Babuino, but Picasso soon found a studio on the via Margutta, with a view of the Villa Medici. As

usual, he familiarized himself with a new place by drawing it, rediscovering in the process traces of passage of Ingres.[6]

This stay in Rome produced portraits of all his new companions, done with the swiftness of the Paris drawings of Apollinaire and Cocteau. There were also two large canvases, *l'Italienne* (Italian Woman) and *Arlequin et femme au collier* (Harlequin and Woman with Necklace), which revive the stylizations of Cubism after 1914, but combining them—sometimes with naturalist elements, sometimes with perfectly decipherable geometrizations.[7] Although powerful rhythms drawn from the most abstract canvases of 1915–16 are certainly present, there is nonetheless a perceptible turning toward what one might call a classicist Cubism, toward compositions organized by a classic vision.

Ernst Ansermet, the Swiss conductor traveling with the Ballets Russes, was astonished to see Picasso one day moving from a naturalist to a Cubist drawing. The answer to his question was "But can't you see? The results are the same." Nonetheless, the effects of this Italian visit on Picasso are noticeable. Looking at the scenes which Ingres and Corot had observed made him analyze their paintings differently. He and Stravinsky visited all the museums. In March the group left for Naples. "Antiquity," Cocteau notes, "swarms anew in this Arab Montmartre." They visited Pompeii and made a trip to Florence, then back to Rome and work with Massine from morning to night.

"I have sixty dancers," Picasso writes to Gertrude Stein. "I go to bed late. I am beginning to know a few Roman ladies. I've done several Pompeian fantasies which are somewhat gross and caricatures of Diaghilev, Bakst, and a few of the dancers."[8] He doesn't yet say that among these dancers, one of the youngest—Olga Kokhlova, a classic beauty—has caught his eye. A colonel's daughter, she had just been given her first starring role. "Be careful," warned Diaghilev, "Russians get snapped up," which was probably just what Picasso had in mind.

He told Gertrude he was planning to finish the two canvases he'd started and that the sets would be painted in Rome. (In the end, however, the curtain was done in Paris.)[9] The curtain was conceived as a contrast to the sets it disclosed: as romantic in theme as the latter, with their imbalances and contradictory perspectives, were vehemently Cubist. As Douglas Cooper observed, "Picasso gently unveils these circus folk in a dreamlike setting. A few minutes later, he plunges them into reality, when the curtain rises to reveal the Manager-colossi announcing the Parade as they tramp the stage." And Cocteau concludes: "Before Picasso, the décor had no part in the play; it was simply there."[10]

This is very characteristic of Picasso's method of work and transformation, so essential to his art. This revolutionary had never subjected his painting to preconceived schemes, but aligned himself with whatever the exigencies of the moment suggested or allowed him to do, with a view, as

he put it, to "doing something else." His paintings often included an imaginary theater, as in the original version of *les Demoiselles d'Avignon*. The Cubist adventure banished this theater, but with *Parade* he found it again in reality. *Parade* contributed greatly to the understanding that Cubism for Picasso had never been the geometry of forms to which criticism reduced it. It was, above all, a transformation of visual space. Thus the constructions set in motion by the Managers' dancers create what Barr has called a "Cubist domination" of the spectacle; while the traditional dancers beside them look like small dolls. This conjunction accounts for much of the sense of a smack in the face that shook the public at the Théâtre du Châtelet on the night of the opening, 18 May 1917.

Apollinaire put his foot in it by insisting vehemently on Picasso's Cubism and asserting that, with Massine, he had accomplished "for the first time that alliance of painting and dance, of plastic and mimic which signals the arrival of a more complete art. It is this realism—or, if you prefer, cubism—which has, in the last ten years, most profoundly shaken the arts."

Apollinaire found in this "a kind of sur-realism, in which I see the point of departure for a series of manifestations of this new Spirit which . . . promises to modify arts and morals from top to bottom in a spirit of happiness; for good sense requires that they attain at least the same level as scientific and industrial progress."

Picasso, cloistered in Rome while he painted sets and finished costume designs, was probably unaware of the feverishness in Paris in that spring of 1917. The Americans were arriving to help the French: help the French certainly needed after the failure of the bloody offensive at Chemin des Dames. Morale was low; there were outbreaks of mutiny; and the Russian Revolution raised doubts about the reliability of the ally in the east. On 15 May, in an atmosphere of catastrophe, General Nivelle was replaced as commander in chief by General Pétain. *Parade* opened three days later. The evening was a gala to benefit the victims of the French eastern provinces, still in the hands of the enemy.

The first night of *Parade*—the Cubist sets, the Managers, the jazzy music—produced an uproar. "Without Apollinaire," Cocteau remarked, "his uniform and unshaven cranium, his scarred temple and bandaged head, women armed with hairpins would have gouged out our eyes." "Go back to Berlin! Shirkers! Draft dodgers! Foreign scum!" The next day Cocteau, Satie, and Picasso were labeled "les trois boches."

The hatred of Cubism, plain enough between 1912 and 1914, had broken out again, revitalized by three years of implacable war. The collective unconscious, expressed after victory by what was dubbed a "return to order," felt rejected by precisely that *esprit nouveau* which had forcibly struck Apollinaire. The press created what Pierre Cabanne has rightly called

the scandal of *Parade*. . . . Henri Bidou in *les Débats*, Simone de Caillavet (age twenty-two, and not yet Mme André Maurois) in *le*

Gaulois, Albert Flament in *le Temps* vied to exceed each other in stupidity, vulgarity, and ignominy. The depths of imbecility were reached by one Guy Noël, who advised reserving revolutionary arts for Red Russia.

Picasso remained impassive. In 1911 the scandal of the statuettes had been beyond the purview of art. This time, with Apollinaire, Satie, and Cocteau, art itself was provoking the outcry. To Picasso that was normal, as was the rumor in the ranks of "official" Cubists that he had "deserted Cubism." He knew that he had learned to "do something else," that he had opened his art to new possibilities. As Douglas Cooper noted, Picasso found "in this experience a unique opportunity to observe the human body in action, to draw freely from live models."

He had also observed Olga, and when the ballet company left Paris for Barcelona, he took advantage of the occasion. His return to Barcelona was something of a triumph: to a town which had seen Marie Laurencin, the Delaunays, and Gleizes; where Dalmau continued to show work of the avant-garde, where Picabia published *391* (in which he criticized the *Portrait de Max Jacob);* and where Francophiles had organized a grandiose exhibition of works from Impressionism to Matisse. The photograph of the banquet at the Galerias Layetanas shows Picasso receiving treatment appropriate to an Academician.[11] At the request of the king, Alfonso XIII, the troupe performed *Parade* in Madrid. There, according to Douglas Cooper, Picasso met a rich Chilean woman, Eugenia Errazuriz. She belonged to the same snobbish society world as Diaghilev and immediately spotted the young Spanish artist who had designed the sets and costumes.

> He was handsome, but from Eugenia's point of view, his clothes left something to be desired; particularly, to meet the King of Spain, who had asked Diaghilev to present this creation of one of his subjects. Eugenia immediately took Picasso in hand and displayed a serious attachment to this young genius, whom she obliged to undertake a vestimentary transformation of his person, and later, to accompany her to the salons of the beau monde which constituted her circle of friends.

Douglas Cooper evidently underestimates the innate Andalusian sense of elegance.[12] Eugenia guided Picasso and he obeyed because she was still very beautiful and sufficiently liberated to strike him as convincing, although no match for Olga's simplicity. For Olga was the first to be delighted by the changes Eugenia prescribed for the man who was still her public admirer. In Barcelona Pablo stayed with his mother on the calle de la Merced (his sister, Lola, had just married a doctor, Juan Vilato Gomez), while Olga settled into the Pension Ranzini, Paseo de Colón, beside the column supporting the statue of Christopher Columbus. At the end of June the Diaghilev ballet performed *las Meninas,* with Olga as one of their number.

In July Picasso was given the honor of a banquet to which all the friends of his youth were invited: Pallarès, Doctor Reventos, Jaume Andreu, the Junyer brothers, de Soto, even Iturrino, who had come straight from a lecture. Picasso was delighted by this plunge back into Catalan life. He was also obliged to court his mother's favor: she disapproved of his marriage to a Russian. After many Madrid-Barcelona round trips, and after the Diaghilev ballet performed *Parade* on 10 November (a modest success), Olga let the troupe leave for South America without her, waving good-bye to her companions from the dock. In the interval Picasso needed to find an expedient by which Olga could reenter France. Her imperial Russian passport, no longer recognized by the Bolsheviks, had lapsed. He asked Cocteau's help.

Six canvases remain from this visit, stylish recapitulations of the Cubist experiment through to its most abstract forward thrusts. The palette, however, reflects an explosive return to the deep, dark colors of the country, above all, blacks, greens, and reds. One is a view of the *Paseo de Colón*. "I stayed in the same hotel as Olga," Ansermet recalls. "Picasso was there every day. Often, he painted, sitting on my balcony, or on Olga's." A *Femme à la mantille,* the mistress of the painter Padilla, whose studio Picasso used, became a rehearsal for the great project of the moment: *Olga à la mantille.* This is not, however, a direct comparison to Fernande, who had also been painted "à la mantille," but rather a hispanicized Olga, whose lace and fine veil reflect all the tenderness of the miniaturist Picasso knew how to be. The picture is a form of homage in which he presents his future wife to his mother; and as such, Señora Ruiz kept it. Later, another portrait of Olga turned up in the studio archives: sitting, like Madame Récamier, in an easy chair. Olga already has a center part in her hair, which was not there in the Rome photograph. One cannot help but wonder if it was she who chose this Ingresque style.[13]

Massine returns in a classicist portrait, as Harlequin.[14] In Naples, with Stravinsky, Picasso discovered the real commedia dell'arte, and suddenly, Harlequin was no longer his double. This portrait of Massine objectivizes him, prepares a personage who will henceforth play his own part opposite Pulcinella in Picasso's private theater. Spain has also brought him back to bullfights, horses gutted by the bull, spasms of agony. Through them he renews ties with the most successful of his Barcelona works of the spring of 1901.[15]

After peace in a neutral country, returning to Montrouge seemed all the more dreary and ominous because torrential rains had penetrated the studio. Coal was scarce; the town was bombarded night after night. According to Zervos, "One night when the din was too loud, and he couldn't find a fresh canvas, he painted over a Modigliani he'd just bought, in thick paint which let nothing show through: a guitar, and a bottle of porto."[16] Nothing is known of his prolonged engagement, except that Alice Derain was disappointed by Olga. "I would have taken her for a maid: a simple little woman, her face covered with freckles."[17] Also, a letter was sent by

Picasso to Apollinaire during a visit to Pablo's family in Barcelona. This letter, hitherto—and wrongly—predated 16 January, 1917, was in fact written on 18 October, 1917 (as Hélène Seckel has established). It suggests that Pablo is not happy, as one would expect of a young man before his wedding. He writes that he is *"trop embêté"* (too troubled) and still sorrowful over Éva's death. He sends his regards to Ruby, the *"jolie rousse"* (pretty redhead) who would become Mme Apollinaire.

Pablo painted two portraits of Olga and at the same time finished *Femme au corset lisant un livre* (Woman in Stays Reading a Book), a final farewell to Éva perhaps or a last pang of regret.[18] Both portraits are classical and were probably painted at the same time. The canvas called *Olga Kokhlova* (today in the collection of her granddaughter, Marina Picasso) is a pensive image of a seated woman, her arms somewhat inflated as in the *Portrait de Vollard* of 1915, the rhythms of the volumes very marked, in an archaizing style (but less marked than in the *Portrait de Gertrude Stein*).

The *Portrait de Olga dans un fauteuil* (Portrait of Olga in an Armchair)[19] transports the sitter directly to Monsieur Ingres. With the central parting of the hair emphasizing the perfect regularity of the face, as in the *Portrait de Madame Devauçay,* Picasso conferred on his subject the immobility of eternity which characterizes the *Portrait de Madame Rivière*. He nullified references which give perspective, but, instead of relying on the oval frame, left the background outrageously incomplete while manipulating virtuosic contrasts between the black dress and the decorative sumptuousness of the chair. This time he gave the arms delicate rhythms and, above all, that singular sweetness, that incomparable caress of the brush against the softness of skin—as in Angélique's arms or the *Bain turc*— which expresses the emotion of the aged Ingres contemplating female nakedness. Olga, in 1917, was a young woman. The photograph taken by Picasso reveals how much he wished to idealize—and transpose—her while meticulously replicating details of the armchair. But precisely by assuming an attitude similar to that of Ingres, and idealizing Olga as Ingres idealized his models, is he not expressing a strong internal equivalence? Is he not placing himself in the same situation of sensual reserve toward his models as that required of Ingres by his times? The artist who translated the *Bain turc* to a bordello must establish a chaste distance toward his future spouse.

Added to this there was probably a subconscious desire to test Olga against France, as he had done—with the mantilla—against Spain. Like Apollinaire, Picasso had chosen France because it was the country of the arts; and his return visit to Spain had only strengthened that decision. Now he was proposing to establish a conjugal household with a Russian—a home, which he had been dreaming about for so long, reflecting those dreams in his art. Now that the dream was about to become real, he would try to achieve what neither of his predecessors had managed to do. Neither Poussin nor Cézanne had any kind of real married life or home; Ingres never had a child. He, Picasso, would get Olga into the Louvre.

He had reached in his painting a point of comprehension. He understood what there was in common between Poussin, Ingres, and Cézanne and the quest conducted by Braque and himself during Cubism's grand phases of discovery: the perfect rigor and order of compositions which carry the powers of painting to their peak of purity and strength. The date should be stressed: winter 1917. Precisely as he had foreseen the Cubist explosion in the uproar of 1911–12, so now he anticipated the "return to order" which would come after 1919.

RETURN TO ORDER

1918–Early 1920

I n early 1918 Picasso was a celebrated unknown. With the exception of his old *bande,* which essentially meant Max Jacob and Apollinaire, no one had followed the course of his artistic evolution. Work from before the stay in Avignon remained firmly sequestered in Kahnweiler's gallery; the rest had hardly been shown. *Parade* was considered a rejection of Cubism, and Olga encouraged him to give up the Montparnasse cafés. At this juncture news spread which made him a traitor in the eyes of the militant Cubists. Paul Guillaume, the ambitious young dealer who sold African art and works by Derain and Modigliani and who commissioned prefaces from Apollinaire, was planning a Matisse-Picasso exhibition in his gallery, from 23 January to 15 February 1918. The gallery, at 118 rue la Boétie, was an instance of the trend which was shifting the art market in the direction of the Champs-Élysées.[1]

Unfortunately the catalogue from the show does not identify individual works. As well as some rose and blue Picassos, the show probably included *Portrait de jeune fille* from Avignon and *Arlequin et femme au collier,* painted in Rome. The numerous heads and still lifes referred to by the catalogue probably belong to what Vauxcelles designated "the latest works of a formidable Cubism." The show was, in fact, a collection of available works by both painters and not intended as a confrontation of any kind.

Picasso probably had no wish to delve deeply into work which was under way. He gave the impression at the time of checking over every route he had ever tried, passing back and forth from one to another. Work of this time includes purified still lifes with guitar, glass, pipe, and tobacco packet, stylized to the limits of abstraction; geometrized women; resumptions of canvases left incomplete in Avignon; a classic landscape which would be used in the ballet *Tricorne* (Three-Cornered Hat); and a transcription in Seurat-style pointillism of Le Nain's *Retour du baptême*—all evidence of a fundamental reconsideration of painting's methods. Apollinaire was an interested party, as we know from a letter of 22 August 1918 made public at the time of bequest: "I would like to see you do some big pictures like

the Poussin; something lyric, like your copy of Le Nain." One should read this period—from the end of 1917 to the summer of 1923, in cap d'Antibes—as the expression of Picasso's single, driving determination. Whether that determination was expressed by Classicism, Classic Cubism, constructions, or even by ballet sets is of no great importance. Once again—twelve years after his discovery of the *Bain turc*—this drive carried him back to Ingres. But now, no longer in opposition to Ingres' idealizing, he strived to exceed the maximum clarity that painter achieved, to reach beyond the qualities which embody the *cosa mentale*.

As Pierre de Champris has pointed out, in what remains the best study of relations between Picasso and his precursors,[2] this was what led him

> after Ingres, to interrogate the shade of Nicolas Poussin, whom Ingres proclaimed, with his customary vehemence, as his master of art and philosophy. . . . To "do a Poussin," toward Nature, had—after the example of the Master of Aix—become the only sound route. Picasso, now contemplating a dazzling study of form and construction, will "do a Poussin" beyond nature, carrying the speculations of that master to a summit of acuity, bringing to nature as conceived by Poussin a Cézannesque contribution.

We should consider here the exemplary qualities of this project, whose execution and consistency are evidenced by works of dazzling success. In his thirty-seventh year (the age at which both van Gogh and Lautrec died—and how could he fail to think of it? the age Apollinaire would reach by autumn, when he, too, died) Picasso simply and naturally wished to assume the heritage of French painting at its most classic. His ambition was to encompass and become the modern point of convergence of Poussin, Cézanne, and Ingres. He began to implement this scheme in the middle of the war. Those, on the other hand, who as late as 1919–20 wished to theorize a *"retour à l'ordre,"* seemed in comparison like parody.[3]

On 2 May Picasso, with Vollard, witnessed the marriage of Guillaume Apollinaire and Ruby, the *"jolie rousse"* (pretty redhead). His wedding present, a watercolor of a guitarist, is a triumph of the limpid Cubism which would be known as "crystal Cubism." On 18 May he participated in a supper party to honor Stravinsky's *Renard*, rubbing shoulders with Joyce and Proust. We also know (through Painter) that after 1917, Proust mentioned to a correspondent "the affinity between the cave paintings of prehistory and the art of Picasso"; and that in his preface to Jacques-Emile Blanche's *De David à Degas,* he speaks of the "grand and admirable Picasso who has concentrated all of Cocteau's qualities in a portrait of such noble rigidity that, as I contemplate it, even the most enchanting of the Venice Carpaccios slip into second place in my memory." There is no doubt that Proust spoke the same language in the elegant drawing rooms he frequented, which leads to the inference that in high society, Picasso was already more than just an object of curiosity.

Picasso married Olga on 12 July in the Orthodox church of the rue Daru, with Cocteau, Max Jacob, and Apollinaire as witnesses. Apollinaire composed an epithalamion:

> Nos mariages sont enfants
> De cette guerre et triomphants.
>
> (Our marriages are infants
> Of this war, and triumphant.)

Picasso communicated the news to Gertrude Stein by sending her a "crystal" watercolor of a guitar and a photograph of the *Portrait d'Olga*, which does not mean that he found the portrait either flattering or a good likeness, but that, in regard to his new objectives as an artist, it seemed to him significant. In his letter he stresses the fact that Olga is "une vraie jeune fille," which means, perhaps, that he waited for consummation until marriage or was forced to wait by Olga.

Immediately after the ceremony the newlyweds left for Biarritz, where Eugenia Errazuriz had invited them to stay in her enormous villa. Picasso had a studio at his disposal. They were close to Spain, but to the Atlantic coast and the Basque country. The worldliness of the surroundings must have enchanted Olga, and Picasso probably hoped that Eugenia would help his wife get used to Spanish life. But would she get used to his bohemian ways—to the manner, that is, with which he assumed total occupancy of his studio? These questions didn't really arise until later. Sending Apollinaire a tobacco flower, Picasso summarizes the situation: "I see the swell world. I've decorated a room here, and put up some of your poems. I'm not really unhappy; I work, as I've told you, but write me some long letters. A heap of similar thoughts to your wife. And for you, my most complete friendship."

Anyone who wants to read a honeymoon between those lines is free to do so; in Éva's time Picasso poured out his heart in quite a different way.

The "beau monde" meant, among other things, the presence of the dealers Paul Rosenberg and Georges Wildenstein. Rosenberg, acting on behalf of Wildenstein, made a contract with Picasso, a transaction marked by some splendid drawings and canvases and portraits of *Madame Rosenberg et sa fille* and *Madame Wildenstein*.[4] Here Picasso borrowed squarely from Ingres portraits in which the delicacy of line for the body and its surroundings is done with a sharp pencil, contrasting with the emphatic relief of the face. Mme Wildenstein sits in an armchair covered in a floral design, whose elements are nullified reference points for perspective—subtleties which derive from Ingres, as does the accentuation of dissymmetry in the facial profiles, which Picasso balanced with rhythms in the neck of the dress. It is the double oblique of the arms which leads the eye to conceive depth. But the changing value of the line—more forceful on the right-hand side of the picture—creates a pivot. Beneath the classical appear-

ance here the line is that of *Max Jacob* and *Vollard* of 1915, the structural line of *papiers collés*.

The great discovery which Picasso made that summer was a beach in the new French mode—the chic beach of Biarritz, so far from the front that the war was almost forgotten. He did a group of *Baigneuses* (Bathers)[5] which allowed him a direct confrontation with the *Bain turc;* but this time, the scene was neither cloistered in a bordello nor primitivized. On the contrary, it was liberated in the harmony and open air of the beach, with its recognizable rocks. To the left, barely brushed by the tip of the pencil, two women arranging each other's hair—like a signature of indebtedness— are seen in three-quarter face but with all the freedoms won since 1906, and filling the rest of the page are thirteen other young women—nudes—in postures which reveal their volumes in far more detail than we would normally see. One, in the foreground, even has her bust turned to the front on a body seen from behind. From now on Picasso would feel enough self-confidence to cleanse Monsieur Ingres, without primitivism, of every- thing that seemed confining, particularly the surcharges and coquetries which had provided an escape—without excessively stressing the point— from his rules and his Victorianism.

We should include here Picasso's obvious nods in the direction of Matisse's *Bonheur de vivre* and *Nu bleu souvenir de Biskra,* as if to assert that henceforth it is Picasso alone who knows how to go further than Ingres. He demonstrated this with a breathtaking little canvas *Baigneuses sur la plage* (Bathers on the Beach),[6] which he always kept. Here, in a frenzy of colored rhythms, he carried mannerist disproportions and distortions to an extreme. The standing bather vitalizes the movement of the standing woman to the left of the *Bain turc,* while the central bather derives from the sprawling woman in the foreground of the *Bain.* As Pierre de Champris has said, Picasso here was running risks which Monsieur Ingres could not assume. He "liberates [Ingres] from the complex of Raphael," but he creates at the same time that other, imaginary world, that "extraneity" of painting which he had always sought and before which the Master of Montauban too often failed.

The point of departure for this little canvas was a drawing of two female bathers attacked by a crab. This led to the compositions of nude women dancing, playing, and swimming with which Picasso decorated his bedroom walls at Eugenia's villa. He also copied, on a piece of paneling beside the bedroom window, some lines written by Apollinaire before he was wounded.

> C'était un temps béni, nous étions sur les plages
> Va-t'en de bon matin pieds nus et sans chapeau
> Et vite, comme la langue d'un crapaud
> L'amour blessait au coeur les fous comme les sages
> (The times were blessed, we were on the beach

Run down in the morning, bare feet, bare head
And quick, like the flickering tongue of a toad,
Love struck in the heart both the mad and sage.)

We have the edition of the set of drawings done at the time,[7] which Picasso gave as a present to Eugenia. They are prophetic in that they were done with a speed equal to that of the automatism sought by the Surrealists. It is clear that Picasso was not aiming at a display of sheer virtuosity for its own sake but rather at renewed examination—with the help of Matisse—as he undertook a graphism which would move even more quickly than thought. The bathers resume movements or groupings taken from Cézanne, who is almost as much of a presence as Ingres. They are also derived from scenes of the circus, from paintings and drawings of Harlequin and Pulcinello, from fashionable caricatures, and from a satirical portrait of Apollinaire.

On 11 September Apollinaire writes one of the long letters Picasso requested of him.

> I'm very glad you've decorated the Biarritz villa, and I'm proud that my lines are included. What I'm doing now will fit your present preoccupations somewhat better. I'm trying to renew poetic tone, but with classic rhythm. However, I certainly don't want to go backward and make some sort of pastiche. What is there today which is newer, more modern, less encumbered with superfluities, more endowed with value and true wealth than Pascal? It sounds as if you're giving him a try; and if you are, you're right. There is a man we can love. He touches us more than someone like Claudel, who drenches with an adequate dose of good Romantic lyricism only theological commonplaces and political or social truisms.[8]

Everything here reflects their meeting of minds, including the reference to Pascal, which takes us back to the world and the vision of Poussin and to the fear that classical revival might lead to pastiche, to imitation. (Ingres, for example, was himself never entirely able to escape this problem in relation to Raphael, which sheds some light on Picasso's thinking when he pushed Ingres beyond his limits.) Suddenly one grasps what an irreplaceable interlocutor Picasso would lose only six weeks later. We understand as well how different, had Apollinaire survived, the "return to order" would have been from that which in fact occurred, with a chastened Derain and Salmon and Cendrars occupying the high ground with survivors from before the war.[9]

Apollinaire had seemed disconcerted by Pablo's plunge into primitivism, by his push to the limits of savagery in the hope of finding the origins of art, and erasing every trace of academic degeneration. But he had also recognized the value of reconstruction in 1908, the new order of Cubism, and the significance of this effort to create a new vision—the integration of

art and the industrialism which no one other than himself and his friends had recognized as a new poetic domain. Also, emerging from the butchery of the trenches and what that experience had revealed about the primary and fundamental disorder of society, he understood that modern art would have to be judged by the standards of humanism. But to succeed in these aims would modern art have to betray or deny itself? Apollinaire's reply was the same as Pablo's: contemporary art must accomplish its mission by outstripping the classics, by opening classicism to modernity:

> Soyez indulgents quand vous nous comparez
> A ceux qui furent la perfection de l'ordre
> Nous qui quêtons partout l'aventure
> Nous ne sommes pas vos ennemis
> Nous voulons vous donner de vastes et d'étranges domaines　.
> Ou le mystère en fleurs s'offre à qui veut le cueillir
> Il y a là des feux nouveaux des couleurs jamais vues
> Auxquels il faut donner de la réalité.

> Be indulgent when you compare us
> To those who were ordered perfection
> We who seek adventure in all places
> We are not your enemies
> We wish to give you vast and strange domains
> Where the mystery in flowers offers itself to all who wish to pluck it
> In those places are new fires, in colors not yet seen
> Flames and colors we must make real.

Apollinaire was carried off by the Spanish flu on 9 November. During his death throes, he heard the crowds under his window shouting, "A bas Guillaume!" (Down with William, the emperor of Germany). Picasso was in the Lutétia Hotel,[10] where he and Olga were staying until the apartment Paul Rosenberg had found for them in the rue La Boétie was ready. His reflex was to fix on paper, with a drawing, the image the mirror sent back to him when the telephone gave him the news he had been dreading.[11] On the day of the funeral, he told Gertrude he was moving. He would occupy the floor above Olga, with all her odds and ends. While she ran a conventional bourgeois household, he did a self-portrait in front of a bird cage, the face marked with alarm.[12]

Thus the conquest of Olga was played out, as well as the role of intimate counselor assumed by Eugenia. But one would have to know nothing of Picasso to imagine that either Eugenia or Olga was responsible for his turn toward a new classicism. He had symbolically given to Eugenia his most violently abstract canvas of 1916—*Homme accoudé sur une table*. (And, no less significantly, Eugenia kept the picture until the pressing needs of her old age obliged her to let it go.) As for Olga, when he turned her into a model for Ingres, he enclosed her in an immobility stripped of everything

Ingres had not dared to eliminate, a quality shared with *Femme au pichet* (Woman with a Jug)[13]—another work of early 1919 in which there is a renewal of ties with another familiar interlocutor: the Corot of *Bohémienne rêveuse* or of *l'Italienne à la cruche.*

> In this way [notes Pierre de Champris], by endowing Ingres with the tenderness of Corot, and Corot with the haughtiness of M. Ingres, by moving beyond the will of the first and the sentiment of the second, he imposes new conditions on proven strengths. This . . . , while bringing their convictions or their doubts to an unexpected conclusion—because he has on their behalf ideas about what they could or should have done had they possessed the impossible privilege of seeing more clearly into and, at the same time, beyond themselves.

Which is an excellent definition of Picasso's recognition of his modernity, of its opportunities and its obligations. Painters, he noted, have always looked for reality in nature, but the search—the seeking—is in painting itself. It is only through painting that the reality of nature becomes clear; and it is only through painting that novelty reveals itself. And that is the crux of the problem, which led him to reduce to their graphic rhythms the photographic reproduction of *Ménage Sisley* (Sisley Household) or a portrait of the old Renoir; to fix for eternity the dancers with Olga or to move from a *Pierrot au loup* (Pierrot with Wolf), sunk in chiaroscuro, to an aggressively Cubist *Arlequin jouant de la guitare* (Harlequin Playing the Guitar) and the violinist of *Si tu veux* (If You Like), which combines Cubist figuration and appearances. There are also some Cézannesque still lifes, like *Sur la commode* (On the Chest of Drawers), which he always kept, and the breathtaking *Nature morte au pichet et aux pommes* (Still Life with Pitcher and Apples), made known to the public only at the time of bequest, in which the architecture of the objects by itself creates an entire world and calls on an immemorial order, on the absolute presence of a demiurge. But an equally unknown *papier collé* re-creates a *Nature morte devant une fenêtre* (Still Life in Front of a Window) of an equally absolute purity. Another imitates the assemblage of *Oiseau dans un cage* (Bird in a Cage); and there are the extraordinary trompe l'oeil assemblages: *Compotier et Guitare* (Fruit Bowl and Guitar) and *Table et guitare devant une fenêtre* (Table and Guitar in Front of a Window), while a mask of painted cardboard sends back to the striped space of Cubism the still lifes pursued by painting. Then there are a couple of dancers as surrealist before their time as *les Amoureux* (The Lovers), done in Avignon in the summer of 1914, and given the inscription *Manet.*[14]

The truly experimental works of this time never left Picasso's collection, either because Paul Rosenberg, who had the right of first refusal, didn't keep them or, which is more likely, because Picasso didn't show them to him. Picasso may have felt their diversity would confuse a dealer who

was just beginning a relationship with an artist. It may also be that, deprived of Apollinaire and Kahnweiler, Picasso felt that there was no one who understood his need to attack all the problems of his work at once, as he had in 1908. The sole difference now was that he treated his Cubist past as if it were the art of his forebears, while enjoying the present privilege of knowing where he was going. This, in consequence, led to his asking where he ought to go as he dismantled, piece by piece, first Illusionism and then those qualities of Ingres, Cézanne, and Corot that he had been able to appropriate.

His disquiet was certainly not unrelated to the fact that Braque in March 1919 at Léonce Rosenberg's had received reactions of appreciation from just about every quarter, particularly from Bissière, the young critic who had emphasized the disappearance of Cubism in 1916.[15] It was he who established that Braque's Cubism, continuing to refine what he had done in 1914, "will lead painting back to the traditional methods, from which we have been separating ourselves for some fifty years. He will have taught us once again respect for the manner and métier of painting. . . . Cubism, a summons to return to order, will have saved modern art."

Fifty years back would lead, not by chance, to 1869, before Impressionism. Picasso had effectively countered the Impressionist dilution of form, but he recognized immediately that Cubism, under the guise of declared acceptance, had been reduced by Bissière to a modern formalism, to the negation of the revolution in pictorial language which he and Braque had brought to fruition. Those fifty years also eliminated the language of Cézanne, of van Gogh, of Gauguin, and Matisse for a Cubism of pastiche like that which Braque was now practicing in relation to Picasso.

I don't think I'm mistaken to see in the exacerbated baroque of *les Amoureux* (significantly labeled *Manet,* a painter who never allowed his Impressionism to annihilate form) a Picasso manifesto against a summons to return to order of the kind described above. In Picasso's eyes to follow such a course could only mean a retreat, enclosing in parentheses the revolution in modern painting. Such a retreat was, indeed, a consideration responsible for the immediate success of the formula. In Picasso's eyes art should pursue precisely the opposite course, should proceed as he was proceeding in relation to his predecessors, turning them toward their future, throwing them into the adventure which their generation ignored or forbade.

These contradictions explain, no doubt, the eagerness with which he approached the adventure of a new ballet. As soon as Diaghilev made the offer, he was off to London with Olga in early May 1919. They stayed at the Savoy and entered the world of London society. Picasso's success in absorbing the lessons taught him by Eugenia Errazuriz was put to the test on the opening night of *Parade*, at the Alhambra Theater.

The *Three-Cornered Hat (Tricorne)* seemed like a subject made to order. Taken from Pedro de Alarcón's novel of Andalusian life, *el Sombrero*

de Très Picos, which was published in 1874, the ballet had a score by Manuel de Falla. This offered Picasso a fine opportunity for inventiveness, which he seized with enthusiasm, using the occasion to produce a manifesto of sorts.

The ballet is much longer and more complex than *Parade.* A *corregidor* (magistrate) arrives with his wife in a village of southern Spain at the end of the eighteenth century. Charmed by the miller's wife, he undertakes to seduce her, while keeping her husband at a distance. For all his efforts, he has no success; the despot in the three-cornered hat is mocked and ridiculed. Picasso did a multiplicity of studies for sets, costumes, and curtain, on which he depicts an *arrastre*—removal of a bull killed in the ring—as if he were developing a drawing done for Max Jacob in 1902. This time, however, the scene is viewed from a box, with a couple to the left, three women to the right, a young vendor of oranges in the center, and a bottle of sherry in the foreground. The mastery of the composition is asserted here even more strongly than in the curtain for *Parade,* with all its audacious risk-taking in foreshortening and disproportions. This central part of the curtain is framed by Cubist lozenges. One of these—a vertical lozenge—has become a separate work: oil, charcoal, and *papier épinglé* (pinned paper) today at the Museum of Modern Art.[16] The sheet which carries the conceptual symbols for the guitar is pinned simultaneously by a painted trompe l'oeil nail—like Braque's nails in 1909–10—and real tacks. This sheet is further separated from the surface of the lozenge by the insertion beneath it of a genuine newspaper. It is clear that this aggressive anthology of the most revolutionary Cubism has a twofold intent: to call Braque back to the parameters of their joint breakthrough, countering his widely celebrated pastiches; and—as Robert Rosenblum and William Rubin have stressed—to emphasize Harlequin's most geometric and abstract incarnation. The message common to both points is that Picasso is not reneging on any part of Cubism; that, on the contrary, he will bring it applause. A drawing of the time shows a table broken into several planes supporting a Cubist guitar which mirrors the curtain for *Tricorne.* An astonishing, recapitulative still life derives from this—*Guitare, bouteille, compotier, et verre sur une table* (Guitar, Bottle, Fruit Bowl, and Glass on a Table).[17] The work, which returns to the forms and the dazzling colors of Avignon, combines conceptual lyricism and Cézannesque references.

Whether or not Picasso was flattered by the success of *Tricorne* is not known. According to Penrose, this work—after ten years of doubt—reconciled London to the modern painting of Paris. Of course, he had himself given the English a few doses, but as contraband. Picasso and Olga appeared at several worldly and elegant occasions before leaving to spend the rest of the summer at Saint-Raphaël—his first visit to the Côte d'Azur at a time when no one ventured to go there in summer because of the heat. Like a true Spaniard, he accepted heat with equanimity. For him Saint-Raphaël must have seemed another commodity: not the most agreeable place, per-

haps, but the most fashionable. Its worldly acceptability was important to Olga; for his part, he wanted simply to relish the Mediterranean.

Picasso had not experienced that light since before the war, and his reunion with the sea he had known in adolescence was illuminated by the discovery at Biarritz of bathers, free on the beach. However, instead of resuming that subject, he concentrated on the light. In his drawings of dancers he had returned to the expressive disproportions of his *Portrait de Vollard* of 1915. The sight of ripe fields under the dazzling sun suggested a series of drawings whose final product was the watercolor and tempera *Siesta*.[18] This painting—a color-filled incursion onto the territory of van Gogh—launches the colossal monumentality in his work, which, from the end of 1920, becomes increasingly obsessive.

But this was the real turning point. A flowering of drawings and watercolors flooded with Mediterranean light shatters the tight Cubist frame, broadening into the open air of perspectives offered by windows on the sea. This development had been in preparation for a long time—since early 1913—but had never come to a head. The rupture of Cubist space, by reasserting dominion over the *veduta* of the early Renaissance—was also, of course, a form of rivalry with Matisse, who since settling in Nice in 1916 had also felt the fascination of a window opening onto vastness. But the proclamation of marriage between the Cubist revolution and Renaissance perspective by and through painting was what Picasso had proposed in the spring of 1914 and now consummated. Two of the watercolors done for Gaby and published by John Richardson have windows in the background. One opens onto a luminous night; the other, onto a sunny sky. These make me suspect that Picasso may have had a Saint-Tropez escapade with Gaby. But isn't this memory—despite Olga—reflected in the *Balcons*?

Once again Picasso was years ahead of his time. Cubism—even Braque's sobered variant—was pushed into the past. Cendrars would write that "it no longer offers enough novelty or surprise to nourish a new generation"—the generation returning from the front. André Lhote noted in the *NRF* of June 1919 that at Braque's exhibition "the atmosphere is morose and heavy, like that of a Hypogeum. One is truly attending a death."

Derain, whom Picasso had seen again in London, where Derain was working on sets for *la Boutique fantastique,* flung himself feverishly into both the pastiche of classics and devising theories about the practice. He declared to the *Matin,* one of the most reactionary dailies of the time, that Raphael was "the greatest misunderstood painter," a remark with a target, which is underscored by his next observation placing Raphael "well above Vinci, who is an able calculator, and who—far from being divine—has a certain taste for corruption." This alludes to the Cubists and, above all, to Picasso. Were Salmon and Lhote being inattentive here? Or were they swept along in the wake of fashion? Salmon celebrates Derain as "le regulateur, the most French of artists." And Lhote proclaims in the *NRF* of January

1920: "The Renaissance [is] close to finding its premier artist in Derain, the greatest living French painter."

Picasso was putting together his *Balcons,* in which Cubist space reverberates to an infinity of sky and sea. The results of this effort became his first private show in Paris since 1905, opening at Paul Rosenberg's on 20 October. The show was announced by a lithograph—Picasso's first—which summarizes the subject, while the catalogue includes a classic portrait of Olga (also a lithograph), a way of publicizing both aspects of this pictorial combination.

Criticism was based on a single point: Cubism or the abandonment of Cubism?[19] Just as the critics knew nothing at all about Picasso's work and even less about his problems, so, too, their understanding of the show was back to front. Waldemar George drew a moral from the event which unfortunately was received as historic truth for some forty years. "Brandishing their caducei [the snake-entwined wand of Mercury, herald of the gods], the critics and the buffoons sounded the knell of Cubism. Picasso conceded defeat. The purists and fanatics of absolutist painting refused to follow the traitor's lead. Their slogan was 'Live Cubist or die.' " Cocteau, at a conference in Brussels, posed as the author of Picasso's conversion. André Salmon was more perceptive, noting that "the exhibition of Picasso's drawings forced estheticians and moralists anxious about order . . . to represent Cubism as a classic quest."

The height of misunderstanding was attained in the reaction of the official Cubists, who had planned to react and to demonstrate their vitality with a collective manifestation at the Salon des Indépendants, scheduled to open on 28 January 1920. The group included Braque, Léger, and Gris; Gleizes, Metzinger, Villon, and Marcoussis; André Lhote, Herbin, and Serge Férat. Picasso declined when asked to join. In his view the group no longer represented innovation but a celebration of the past. He was interested in something entirely different: the fact that young poets who admired Apollinaire and Reverdy came to ask his support. A drawing of a pedestal table in front of a window was used as frontispiece for Louis Aragon's first collection, *Feu de joie,* printed in Zurich on 10 December 1920.

On 21 November 1919 Picasso drew the *Salon d'Olga,*[20] a worldly gathering, sage and composed, which includes the seated figures of Cocteau, Erik Satie, and Clive Bell, London proponent of Cubism. The broken lines of the parquet destroy perspective. A mirror over the fireplace was to have reflected the author of the drawing, but he is absent. For Christmas Diaghilev suggested *Pulcinella,* a ballet to music by Stravinsky and a project as much to Picasso's taste as *Tricorne.* It would mean a return to the discovery of Naples, to a living commedia dell'arte in the company of a musician for whom he felt strong friendship tinged with complicity. He accepted immediately.

PATERNITY AND CLASSICISM

1920–1923

In Paris the year 1920 began with the first big Dada manifestation introducing *Littérature,* the group founded by Breton, Aragon, and Soupault. They linked themselves to older members of Picasso's circle like Max Jacob, André Salmon, and Cocteau. Picasso himself, however, was absent from the exhibition of paintings, which included Léger, Gris, and De Chirico. As a final touch, Picabia showed an abstract work with inscriptions like High, Low, and Fragile in enormous red letters, running from top to bottom. It was also inscribed with the obscene pun L.H.O.Q., which was proposed at the same time for the Duchamp's mustachioed Joconda. This last work, however, was not shown until 1930, as part of the exhibition "la Peinture au défi" (Painting in Defiance).[1]

The tumult of the occasion was augmented by Breton's erasing of another Picabia work done on a blackboard. Picasso must have seen this anti-art as a parody, a rehash of his *papiers collés* and canvases of 1914, in which already he had reduced a bottle of Bass (ale) to Bas (low). He considered Picabia, a Catalan somewhat older than himself, to be a painter without personality, someone, he said, who was always trying to make more of himself because he didn't have the skill to make enough. More than ever, as he saw it, Cubism was not a method of destruction with a view to making a clean sweep but, on the contrary, a method of construction.

This was put to the test by his work on *Pulcinella,* which delighted him, despite some stormy discussions with Diaghilev over his first conception of the ballet, which Diaghilev thought excessively modernized the characters. In his dealings with others, Diaghilev was authoritarian; but, when all was said and done, Picasso found him stimulating, and the final version of the set attains a kind of Cubist perfection, which everyone in the company admired. Picasso had prepared for the job with still lifes of a guitar on a table, or sideboard, which are masterpieces. With the impetus of those works, he produced some dazzling variations when he got to the costumes in April: two-dimensional gouaches of Pierrot, Harlequin, and Pulcinella engaged in daily life. One sees them reading *le Populaire* (the socialist daily of moderates like Leon Blum), sitting at a table on a café

terrace, or playing the guitar. The entire set is extremely lively; the vivacity of the stylization and the contrasts of rhythm created by the flat, strongly colored planes forecast the *Trois Musiciens,* the masterpiece to be produced in the summer of 1920.[2]

The opening night of *Pulcinella* on 15 May was a great success. Stravinsky praised the show, in which, as he put it, "each part supports all the others." Picasso, he felt, had made a marvel; and he praised the "astonishing theatrical sense of this extraordinary man." Picasso's pleasure is evident in portrait drawings of Satie, Stravinsky, and Manuel de Falla.

Two events occurred during this time which were to have a considerable ripple effect. The first involved his friend Max Jacob. Picasso invited him to the performance of *Tricorne* at the Opéra. Max had been feeling, increasingly, that the distance between himself and the friend of his youth was growing. Just as Éva had adopted him, so Olga rejected his poverty, eccentricity, and bohemianism. In short, he felt exiled from the rue La Boétie. The invitation to the Opéra was for Max both a kindness and a vexation. He had to rent the obligatory top hat and tails, which left him without enough money for a taxi. Crossing the boulevard Sebastopol on foot, he was knocked down by a coachman driving a rich man's carriage, an accident with which the poet's unconscious probably had some connection. He received many visits from Picasso at the Lariboisière Hospital, but this accident of fate gave a final push to his decision to quit Paris. In the spring of 1921, he moved to Saint-Benôit-sur-Loire.

Another echo from the past: Kahnweiler returned to France on 22 February. Had he listened too much to Gris, with whom he had been in continuous correspondence and who criticized Picasso's changed arrangements to the point of making trouble with Gertrude Stein? Was he wounded by Picasso's agreement with Paul Rosenberg? And did he, too, disapprove of Picasso's participation in Diaghilev's enterprises? There was a coldness between them. Kahnweiler in this respect was like Gertrude Stein: he could not bear sharing "his" artists, particularly not Picasso. He renewed contracts with Laurens, Derain, Braque, Vlaminck, Manolo, and Léger, who, as a former combatant, attempted to regulate the difficulties arising from sequestration. (His efforts, however, were fruitless.) Max Jacob also tried to help him reenter artistic circles, putting Kahnweiler in touch with André Malraux, then an unknown young writer.[3] We should note that while Kahnweiler republished an augmented version of his essay *Der Weg zum Kubismus* (The Way to Cubism), his monographs in French were about Vlaminck and Derain, who in their fervent support of a "return to order," were at an opposite pole to Picasso.

The latter since May had gone back to drawing nudes: a man sleeping after love, while his partner, sitting on the edge of the bed, combs her hair, and an old woman—also nude—washes the floor. Then, anticipating a return to the beaches, some bathers.[4] In the middle of June, he dragged Olga to Juan-les-Pins, at that time a completely unknown place, with none of

Saint-Raphaël's chic. A few villas were lost in the vast pine wood that also covered the cap d'Antibes, where la Garoupe was then a wild beach, in a state of emptiness unimaginable today. Olga had been obliged to accept the move with a certain bad grace, to which Picasso paid little heed. In an imaginary landscape painted in Paris,[5] he had felt a premonition of Juan-les-Pins, as he had so long before about Gosol. Much later he told Antonina Vallentin: "I was stupefied; I knew right away that countryside was for me." Which remained true for the rest of his life, at least until the galloping urbanization of the late 1950s.

This time he took possession of the place with particular care. He seems to have drawn a sense of quasi-Italian order from Poussin, a prophetic vision of what he would find in this part of the Côte d'Azur. And then escaped it in a series of strong and brilliant transpositions, built on the contrast of differently decorated space—pointillist or striated—which surpass in luminous happiness the attitudes of *l'Homme accoudé* of 1916 and the Jansenism of his contemporary still lifes—an exuberance expressing his joy at rediscovering the Mediterranean.[6]

A series of drawings of Olga sitting in an armchair, sewing, greets the moment when she knew she was pregnant. (Paulo would be born on 4 February.) A very beautiful drawing poses her as a seated ballerina, enlarged legs in the foreground, representing, perhaps, her farewell to the dance.[7] The saga of Harlequin at the time of *La Maternité rose,* and Madeleine, had revealed the depth of Picasso's feelings about paternity. He was to anticipate the birth with drawings of the child from autumn on.

He returned to nude bathers in drawings and pastels; this time they are actually bathing, with variations of movement or gesture: studies which lead to the large canvas *Trois Baigneuses,*[8] later mistakenly dated 1923 by the artist himself. Disproportions pushed to their extreme and deformations accentuate the dynamics of a space in which every other perspective depth is nullified. Here Picasso found that his post-Cubist figurative space can support every break or absence of proportion, creating a previously unknown diversity of rhythms and contrasts and a previously inconceivable monumentality. He was to keep one of these variations: *Baigneuses regardant un avion* (Bathers Watching an Airplane).

At the end of the visit, a classic and brutal subject appeared in the midst of the bathers. Five drawings, a gouache, and a watercolor depict the centaur Nessus raping Dejanira, the fiancée of Hercules. And a tempera on wood, *le Rapt* (The Rape), shows a warrior dragging a woman from the corpse of another warrior. All three figures are nude, probably, as Giovanni Carandente has shown, derived from the Herculaneum fresco *Perithoos Saving Hippodameia from the Centaur Eurythion.* But if one compares the sexual vehemence of canvases (like *Femme assise,* which he kept) in which Picasso seems to dramatize Olga's anguish, it appears that the couple had entered a period of tension between them.[9]

The nude women that autumn are increasingly in contradiction to the

summer's bathers. They are more precisely women at the bath, like those who preceded *les Demoiselles d'Avignon*. A large pastel which remained in the studios adds unevenness of level to disproportion. And the Walter P. Chrysler collection[10] contains a pair of monumental women, the first "giants," whose disproportions make them even more colossal, in a motionless placidity which removes them from time. They date from the end of October.

Picasso pursued his Cubist explorations, returning to the 1916 subject of fireplaces and chimneys, but simplified, playing with contrasts between the working drawing, the planned and the accidental. He even went so far as to use dotted lines; while at the same time, his still lifes became increasingly limpid. Perhaps the completion of his large canvas *Femme au tablier* (Woman in an Apron) dates from this period as well. Begun in Montrouge in 1917, the painting seems to be a Cubist variation based on Olga.[11]

Stylized découpages of various kinds—like the celebrated *Feuille d'études* (Page of Studies)—continue at the same time as these classical subjects. This last work is traditionally dated 1920. But the studies of the hands, the head of the woman in profile, and, above all, the couple holding hands (which one must not separate from the large pastel *la Danse villageoise* [Village Dance])—all of these suggest that the picture should be assigned to 1921, an example of the coexistence of Cubism and Classicism.[12]

Paulo's birth on 4 February 1921 produced portraits of the baby and maternities. But the multiplication of portraits of Olga and the differences—often profound—between them are a reminder that for Picasso circumstances were first of all an incitement: the presence of a motif came second. The most realistic maternity is a large drawing in red chalk, in which the mother is seen in a state of casual semiundress, and the baby as a classic Virgin's child. The molding of forms is powerfully stressed, the disproportions assert continuity as much with the return to portraits of 1915 as with the future series of giant women. A tendency to "hemstitch" the eyes links these heads and busts to the primitivism of 1906–7, which is to say, to the first means Picasso found for creating a purely plastic distancing; for conferring on his figures the timelessness of idols.[13]

He did not, however, return to his point of departure but undertook a more deliberate classic exploration of the possibilities which had punctuated the Cubist adventure. In March a group of three nude women appeared, which in April seemed to be in the pool of the *Bain turc* as part of another landscape, before appearing on a beach in May.[14]

This was probably the starting point of what would during the summer develop into a large project: *Trois Femmes à la fontaine*. At that point, however, Picasso seemed wary of pastiche or repetition and lacking in conviction. He once again grabbed at an opportunity for diversion which presented itself in mid-April. Diaghilev, who had just fallen out with Massine, needed to improvise a ballet. He had at his disposal some Andalusian

dancers and wanted to create a "typical" spectacle—*Cuadro Flamenco*. He needed a set and costumes. He thought of Gris first of all; but then, to Gris's great disappointment and bitterness, gave the commission to Picasso. The sets Picasso had originally proposed for *Pulcinella* (which Diaghilev had rejected) would, he thought, be suitable for this occasion, a calculation which would save some time.[15]

Cuadro Flamenco took Picasso back to the Andalusia of his youth. He reworked the on-stage theater set of his first project, surrounding it with boxes, one of which alludes ironically to Renoir's *loge*. The music of de Falla, who was himself repossessing "his" Grenada, filled Pablo with enthusiasm. The gypsy costumes were splendid.

But despite the Diaghilev project, Picasso was not distracted from his idea of a group of women. The cover of the program for a single performance of *Cuadro Flamenco* in May displays four nude women, who have no connection with the ballet's plot.

Complications arose four days later, on 30 May, with the sale of the Wilhelm Uhde collection, in liquidation of sequestered enemy property. This was the first entry into the market of works from the early days of Cubism: seventy-three in all, of which thirteen were by Picasso. He did better this time than Braque, whose seventeen canvases fetched sums ranging from 300 to 100 francs. Picasso's ran from 2,000 francs to 18,000 for the *Femme à la mandoline* of 1910, bought by René Gaffé. The greatest gains, however, were made by Douanier Rousseau; prices for his paintings started at 9,000 and rose to 26,000 francs. The entire collection went for 247,000 francs—three times the anticipated value.

The first of the four Kahnweiler sales followed almost immediately, on 13 and 14 June. This close sequence had been planned to flood the market and "break the back" of Cubism. But the results were a fresh setback for the enemies of modern art. Braque's prices rose somewhat, and Derain made a triumphant gain, in part because Paul Rosenberg pushed his *Portrait de Madame Kahnweiler* to 18,000 francs. This last was, at the very least, an unfriendly gesture toward a colleague who had no right to acquire anything in his own name. Kahnweiler, meanwhile, formed a clandestine "syndicate" with Alfred Flechtheim and bought back eleven of the twenty-two Braques and eight of the nine works by Gris; but no Picasso. The sale made 273,000 francs.

Picasso wanted to leave Paris for the summer. Because of the baby, the heat of the Côte d'Azur was ruled out, so he rented instead a villa in the cool freshness of the Forêt de Fontainebleau. There, in the solitary stillness, he undoubtedly calculated the effects of the Uhde and Kahnweiler sales, the degree to which they marked the end of an era, the end of his youth, and of his *cordée* with Braque, especially as Max Jacob had just withdrawn to Saint-Benôit-sur-Loire, to a presbytery next door to a cloister—a layman's way of entering orders. Max's decision revived Picasso's sadness over the loss of Apollinaire. Certainly nothing of the intellectual and poetic excite-

ment of Bateau-Lavoir survived. This nostalgia produced some master-
pieces. At the same time, however, he assumed a greater distance from
Cubism, frankly asserting his classical ambitions. His time at Fontaine-
bleau—roughly three months between July and the end of September—
would come to be recognized as a period of fecundity without parallel and
would remain a summit of his achievement.

He began to paint—perhaps simultaneously—two pairs of large can-
vases with entirely different objectives. *Trois Musiciens,* for which no
preliminary studies are known, is both a balance sheet and a farewell to
Cubism. He derived free gouaches from the rhythms of Harlequin and
Pulcinella, as he did from work for the ballet *Pulcinella,* but carried these
discoveries to quite another level.

The version in the Philadelphia Museum of Art seems somewhat less
elaborated, less audaciously composed than the one in the Museum of
Modern Art in New York, in which Pierrot's torso and Harlequin's face are
jumbled together, creating a visual equivalent of syncopated jazz music.
Presuming that this is the correct order of the two versions, the canvas now
in New York seems more detached and humorous, with a calmly sprawling
dog representing Picasso's taste for household pets—unsatisfied since leav-
ing the rue Schoelcher. It is a symptom of nostalgia, but one can see, as
Theodore Reff does, that the choice of subject itself evokes the friends of
his youth: the monk signifying Max Jacob in his retreat; Pierrot, Apol-
linaire; and Harlequin, once again Picasso's alter ego.[16] Two months earlier
a committee had been formed to erect a monument to Apollinaire. Picasso
was given the commission.

There have recently been fresh indications of a link between Picasso's
nostalgia for vanished or distant friends and a Cubist testament in the form
of these two virtuoso canvases. The inventory of studios revealed *la Lecture
de la lettre* (The Reading of the Letter), a large canvas seemingly from
mid-1921: two young men beside a road, with volumes which are power-
fully rendered but simplified in the Cézannism of the folds in their clothes,
as in the *Portrait de Clovis Sagot* of 1909 or Picasso's return to portraits in
1914. Dominique Bozo is right, I think, to see here "above all else, a work
which can only be the elusive evocation of a friendship. Of the poet Apol-
linaire, of Braque, artist of the Cubist adventure. The bowler hat in the
foreground is the hat of the portraits of Apollinaire and of Braque. But the
books and the text—surely these must be attributes of the poet.

La Lecture de la lettre fits into the group which includes *la Danse
villageoise*—an extreme of technical virtuosity combining pastels and oil—
and an astonishing *Femme au chapeau* (Woman in a Hat), which exists as
a large drawing and as a pastel. The characters in these drawings, we should
note, have "hemstitched" eyes.[17]

Deriving from the groups of nude women, from drawings connected
to the *Femme au chapeau,* and from others—like *la Source*—that are highly
classical, seemingly descended from sculpture at Fontainebleau or Ver-

sailles, the *Trois Femmes à la fontaine*—with its long period of ripening—is a very deliberate challenge. This time Picasso had his sites set squarely on Poussin, on *Eliézer et Rebecca,* which he had looked at and carefully considered at the Louvre. The picture is a reconstruction. "With startling directness," notes Pierre de Champris, "he distinguishes the audacious character of a work full of scholarship and returns to it the element of surprise." Picasso here leapt over Poussin, back to a Greece which he rejuvenated, as he had done at Gosol. There are classical tunics, noses which continue the line of the forehead, and the color—a pale terra-cotta. Many might feel that the version now in the Museum of Modern Art is the one in which these symbols are most fully applied. But Picasso was unable to forget his ocher *Trois Femmes* of 1908, the Cézannesque issue of his *Demoiselles.* In the garage he used as a studio, Picasso could consider simultaneously the superseding of a youth devoted to Cubism, to which he now must bid farewell, and his classical exploration, whose capacity he was testing as the next stage in his dreams of an art never before realized.

With both these pictures, I believe, he achieved ringing success.

The need for Classicism was declared in the spring of 1921 by searching pastels of groups of nude women. The drawings show that work done in connection with *Femmes à la fontaine* and the postscripts engendered by their success released the remarkable sequence known as *les Géantes* (Giantesses). Picasso was aiming for monumentality. He sometimes began with a very small format, as in *Nu assis sur un rocher* (Nude Sitting on a Rock, painted at Fontainebleau, on wood: 16 x 11 cm.) or in the *Nu à la draperie* (done at Dinard, 19 x 12 cm.). But he immediately changed scale, as, for example, with the pastel *Femme assise se séchant les pieds* (Seated Woman Wiping Her Feet) or the *Grand Baigneuse* (Large Female Bather) in the Jean Walter–Paul Benjamin collection, which is frankly larger than life. His Classicism, however, despite appearances, was continuously jolted by escapism, by a syntax of extreme foreshortenings, bloatings, disproportions, simplifications, and touches of primitivism in contrast to the breathtaking delicacy and minute virtuosity of an artistry in which pastel and paint are in dialogue, at a summit of elegance. Picasso here attains the timeless.

At the same time, Cubist still lifes, increasingly built on contrasting streaks and planes of an extreme geometrization, accentuate this flight beyond time. It seems that the implicit humor of *les Trois Musiciens* or *le Chien et le coq* has disappeared, a product perhaps of the unanticipated but daily disenchantments of paternity, the various ailments and illnesses of Olga and the baby.[18]

In the background there were, at six-month intervals, the jolting Kahnweiler sales. The second of these, on 17 and 18 November—a period of economic crisis—realized the organizers' objectives. Kahnweiler to Derain: "The results were terrible—as foreseen. The intelligent Léonce [Rosenberg], once again, is nearly bankrupt. At the present moment, he despairs of Cubism." Vauxcelles crowed in triumph: "Picasso enthusiasts could rub

their hands with glee, picking up the work of their great man for the price of the stretcher." This was true, but it was also true that the prices of new paintings at Paul Rosenberg's had begun to climb and would soon be in the neighborhood of 100,000 francs. Picasso was above the storm.[19]

Until the summer of 1923, classical revision was combined with a stylized Cubism, seemingly the painting of an ideal world. In the maternity pictures Olga appears as a Greek woman—in work derived from *Femmes à la fontaine*—or simply idealized, in a state of harmonious perfection. These were products of a holiday in Dinard in the summer of 1922; Olga did not reappear as herself until the end of that visit, in an admirable and sad red ocher noting the moment when they had to return to Paris for her surgery.[20]

Dinard was the chic beach in the cool freshness of Normandy. We don't know what Picasso thought about abandoning the Mediterranean, but the silvery sunlight of the channel was new to him, and he registered his surprise in his work. His painting began to stir with fresh spirit. Women acquired the gracious plenitude of his maternity pictures. He drew the novel countryside and painted a limpid landscape. The large *Nature morte aux poissons* (Still Life with Fish)[21] is bathed in the same light, and accidents tend to disrupt the geometric purity of the still life. Next there is the gouache *la Course,* destined to be celebrated, despite its small size.[22] Against a background of intensely blue sea and sky and gray sand, two female giants move from placidity to lively action, the disproportions and roughnesses of the scene sculpted by light.

Picasso, who had accompanied Olga to Paris, went back to Dinard to fetch Paulo and his nurse, an experience which produced paintings of the child done with a close attentiveness and tender frankness unsurpassed by any artist. Picasso would bestow such moments of grace on all his children.

That autumn Breton, who had visited Picasso for the first time on 1 November 1918 and met him casually many times afterwards, spoke in Barcelona on "Features of modern evolution [in art], and of its participants." He separated Picasso from a Cubism "whose exegetes are unable to elevate the debate" and saluted "a man who—in some respects—appears to have started the whole thing. . . . This is the first time, perhaps, that a certain outlaw attitude asserts itself in art." Picasso couldn't dream of more fitting praise. The text was published in the journal *Littérature,* which was probably Breton's way of letting the interested party know what was being said about him.

At just this moment Picasso received a commission from Cocteau for sets for the free adaptation of *Antigone,* with costumes by Chanel, which would be produced by Charles Dullin at the Théâtre de l'Atelier, in Montmartre. Cocteau recalls:

> Picasso calmly pulled from his pocket a scrap of white paper, deliberately crumpled and wrinkled. Then, in his inimitable accent and with an

ironic look in his eye, he said to Dullin, "Well, here's your model." And
the surprising thing was that the model presented in this way was not a
joke; the results were marvelous. The wrinkled paper which Picasso
pulled from his pocket and proposed as a model represented a set to be
made from a single jute canvas, so much too big for the frame of the
stage that it folded and bent according to plan.

This improvisation had another element: columns at the back of the
stage: "He began by rubbing a piece of red ocher on the plank which—with
the roughness in the wood—turned into marble. . . . Suddenly he blackened
a few hollows, and three columns appeared. This apparition of columns
was so sudden and startling that we all applauded."

This genial tinkerer at work in a poor, small theater was not in any
kind of polar opposition to the painter uniting Classicism and the twentieth
century. Chronology suggests that this work for the stage was an origin of
the *saltimbanques'* return to painting.

THE APPROACH OF SURREALISM

1923–1924

J ust as Picasso was a Cubist before—and beyond—the movement which claimed the title, he was a Surrealist before any of the angry young people who gave themselves that name. Everything was complicated, however, at the time of his Paris retrospective of 1955, by his statement to Maurice Jardot that Surrealist influences had not affected him before his drawings of 1933.[1] In this case, as with *les Demoiselles d'Avignon,* one should take Picasso's words literally. He was not, in fact, influenced, because he was himself a pioneer. But he had never protested against the Surrealists' use of his pictures in their review *la Révolution surréaliste,* and as early as 1925 he took part in a Surrealist exhibition.

Starting with his discovery of Cubist pictorial space, which offered possibilities of conjugating various figurative modes, he was attracted to Surrealism by the fantastic, baroque quality which appeared in the movement's work at regular intervals. His exploitation of accidents which occurred during the course of work and his taste for unexpected encounters, facilitated by the discovery of collage, were additional factors which drove him to explore for his own purposes mediums and techniques theorized by the Surrealists, like automatic painting or writing, a free expression of the unconscious, the intimate *"modèle interieur."*

There was also a constant pendulum movement in Picasso's life and art which drove him to refuse order, harmony, and the already-accomplished as symptoms of torpor, which is to say, of death. The year 1923 was such a turning point: the moment of greatest classicist achievement in representing the human figure accompanied by still lifes which express a sense of growing disquiet. Paintings show Olga pensive and withdrawn. Then, for the first time since 1917, there is the face of a young woman who is neither a model nor Olga. And Olga disappears.

The beginning of the year still expressed harmony. February produced the *Saltimbanque assis les bras croisés* (Seated Acrobat with Crossed Arms), which would break all records for sales in New York in 1980. This was followed by the celebrated couple in *Amoureux*[2] (not to be confused with the baroque pair of 1919), whose ease surpasses everything produced by the

Classicism of 1906, except for pictures of Fernande. Then the *saltimbanque* turned into Harlequin. The Catalan painter Jacinto Salvado came and posed in the Harlequin costume which Cocteau, years back, had brought to the rue Schoelcher. But beneath the evident and unequaled virtuosity, it is clear that Picasso was standing back from the model, analyzing his craft, and in a certain sense deconstructing it.[3] Some drawings turned back to the subject of nude bathers, with the Ingresque theme of *coiffure*, renewing the eternal dialogue with the *Bain turc*. But here, too, with a systematic duplication of drawings, Picasso was pursuing technical, destructive variations of illusionism on the possibilities of producing modeling—with or without shadows.

We have a witness to Picasso's life that summer in the person of Gerald Murphy, who had just decided to become a painter himself after seeing the work of Picasso, Braque, and Gris at the rue La Boétie.[4] Taking advantage of a favorable exchange rate, he and his pretty wife, Sara, like many other American intellectuals, were living in Paris with their children.

The Murphys had loved the first sight of *les Noces,* a Stravinsky-Diaghilev ballet, and decided to celebrate the event on 17 June 1923 with a party on a barge, which was moored in front of the Chamber of Deputies. They invited Stravinsky, Ansermet, Diaghilev, Picasso, Cocteau, Tzara, Blaise Cendrars, Darius Milhaud, Germaine Taillefer, and a few of the dancers from the corps de ballet. The key event of the evening was a distribution of toys instead of flowers. "Picasso was delighted. He immediately collected a quantity of toys and arranged them in a fantastic, haphazard pile, surmounted by a cow perched on a fireman's ladder."

Immediately after the party the Murphys left for Antibes, where—a sign of the changing times—they had been able to persuade the proprietor of the Hôtel du Cap to stay open for the summer. Very soon after the Murphys, Picasso arrived with Olga, Paulo, and his mother, Señora María Ruiz, who had come to France for the first and only time in her life to meet her grandson. She didn't speak a word of French, but she and the Murphys got along famously. On the other hand, the Murphys saw Olga, as a pretty girl "who always agreed with whatever anyone said, and whose manner was entirely prosaic."

Sara made a great impression on Picasso. He was struck by the way, on the beach, she turned her pearl necklace so that it hung down her back, saying that it was good for the pearls to get some sun. And in drawings of bathers at the time, there is often a pearl necklace. Picasso rented a villa nearby but continued assiduously to frequent the Murphys and the Comte and Comtesse Etienne de Beaumont, who lived in the district.

Picasso appears, bare chested on the beach of la Garoupe, in a photograph taken by Murphy. He is wearing Sara's pearls. And although he is holding Olga by the hand so that she can assume a ballet attitude, his painting makes this Sara's summer. Not only because of the part the necklace plays in his drawings—notably those of a concert on the beach with panpipes,[5] which will result in one of the most extraordinary classic can-

vases, *les Flûtes de Pan*—but for his portraits. Two are entirely covered with sand from the beach, on top of which Picasso placed his colors; one of them remained in his collection.[6] It seems impossible not to recognize Sara in most of the female heads done that summer. Fortunately Olga never went to the disorderly jumble of her husband's studio.

Gertrude Stein and Alice came to spend a few days on the Cap. Murphy noted that Gertrude and Pablo "stimulated each other to the point that each felt recharged on seeing the other." André Breton was another visitor. His presence produced an engraved portrait which became the frontispiece for Breton's new collection of poems *Clair de terre*. He undoubtedly provoked streams of conversation as well. For the Surrealists, this was the great moment of "automatic writing," in which—by speed of writing and other methods of reducing control—the unconscious could express itself. Breton, that summer, was twenty-seven. He had just been through an intellectual crisis and had even for a time decided to abandon writing. Picasso instantly perceived his prophetic quality and drew him as head man of the group.

Three months later, in November 1923,[7] when Breton was arranging a schedule of art purchases for the important couturier Jacques Doucet, his familiarity with Picasso's work suggested a rather close relationship with the artist. However, when these details became of interest to historians, after the Second World War, Breton had already broken with Picasso because of Communism and deleted him from his recollections. In reality, however, from 1923 to 1939 their relations were extremely close.

Antibes at that time was a sleepy little town livened by tourists only during the mild winter season. To the astonishment of the Murphys, telephone service was suspended for the siesta and cut at seven in the evening. Nonetheless, they decided to settle there and bought a villa on the cap, near the lighthouse. The Picassos went back to Paris in September. For Pablo the summer had been visibly happy. He painted a handsome portrait of his mother and undoubtedly relished the family reunion. But it is particularly clear that the presence of the Murphys—and especially of Sara—had provoked a creative fever.

The chronology of works from that period is still confused; nonetheless, it seems reasonable to attribute to the stay in Antibes a resumption of sanded still lifes which are remarkable in their renewed lyricism, especially in comparison with the geometrization of 1922. The glass in *Verre et pomme, bord lilas* (Glass and Apple, Lilac Verge) returns to the fantasies of early 1914, with a heightened freedom of forms, while *Mandoline et portée de musique* (Violin and Musical Staff) is singled out by Alfred Barr as an archetype of what he call curvilinear Cubism.[8] This work contains two important novelties. First, and highly significant in a monumental work which is larger than life, all geometrization of forms is abandoned. Curves, often "soft" curves, dominate. And second, there is the evident use of accident, the hazards of execution, which the artist seeks to provoke. Sanding, a thick impasto, the scratching of lines in the paste, either with a

knife or with the handle of the brush—all are intended, as at the time of the *papiers collés* of 1912–14,[9] to impede the painter's virtuosity and sureness of hand. Of course, a similar cult of clumsiness emanated from Dada and its anti-art aspect, but Picasso here was his own precursor. He was ahead, too, of the young painters who would become Surrealists, like Miró and André Masson, whose first "sanded" pictures came incontestably later than his; not to mention Dubuffet, who reinvented *hautes pâtes* (thick impasto) and generalized accidents of execution, but not until 1943–44—twenty years later.

Parallel to these successes in making the operations of chance an acceptable component of art, Picasso went back to assemblages, like the large *Guitare* in painted canvas, which stress the element of impromptu tinkering. But this renewed involvement with illusionism took place against the perfection of *Flûtes de Pan* and also, most probably, against what he perceived to be the *embourgeoisement* of his conjugal life. The Murphys provided an example of a much more liberated, American way of living. Compared with Sara, Olga must have seemed limited and dull.

Picasso saw the Murphys again in Paris during the autumn. Léger, who was preparing the sets for Milhaud's *Création du monde* (Creation of the World), had commissioned a *ballet d'ouverture* from Murphy, who did the job with Cole Porter. Picasso, who was at the opening night, congratulated Murphy for his set. His interest in ballet was as strong as ever, and a short time later Massine was able to involve him in a new adventure.

It was then that Picasso received from Breton news which disturbed him. Jacques Doucet wanted to buy *les Demoiselles d'Avignon*. They had known each other since 1916, perhaps through Gertrude Stein. Pablo had arranged for him to be invited to the Salon d'Antin. We don't know if this decision actually originated with Pablo or whether it perhaps came from the insistence of Breton, who had visited the Salon. Aragon gave himself the credit—with Breton—but in error put the date of purchase back by two years. The account sent by Breton to Doucet, however, on 6 November 1923, is a certain fact.[10] After expressing his embarrassment at having to choose between Picassos, Breton writes:

> One thing is certain: I believe in *les Demoiselles d'Avignon*, because with it one enters directly into Picasso's laboratory. It is the heart of the drama, the center of all the conflicts which Picasso has brought to life, and which will prove to be immortal. For me, it is a work which reaches conspicuously beyond painting; it is the theater of everything that has happened over the last fifty years. . . . If this work should vanish, it would take with it the greater part of our secrets.

His remarks are overblown, of course. But they indicate that Breton was the first to perceive the general significance of the *Demoiselles* and that Picasso had decided to sell the picture, to bring it into the public domain. In this we should certainly see a consequence of Surrealism, because the

price which was accepted—25,000 francs, payable in monthly installments of 2,000 francs—was weak, and Picasso at the time wasn't short of money. The picture was reframed in the spring of 1924 and must have arrived at Doucet's in December 1924, which was probably when Breton photographed it. He published the photograph in *la Révolution surréaliste* in 1925. It is possible that Jacques Doucet thought of leaving the picture to the Louvre, as he had done with Douanier Rousseau's *la Charmeuse de serpents*. If this was the case, however, the appropriate officials knew how to dissuade him.

At the end of 1923 *Compotier, mandoline, partition, bouteille* (Fruit Bowl, Mandolin, Musical Score, and Bottle), with its soft, hesitant forms, bears further witness to accidents of execution. Dimensions are still monumental. And a short time later, in *Bouteille et mandoline sur une table*,[11] Picasso made the trail even more aleatory, the results of slashings and nickings against a background which seems to have been sanded at random. His work on *Mercure*, Massine's new ballet to music by Satie, would reveal this fluid Cubism of improvised forms. Picasso designed both curtain and sets in this manner. Douglas Cooper describes the set of *Bain*, one of the ballet's three tableaux:

> The water level, painted blue, followed an inclined plane. . . . It had three openings so that the Graces could appear, showing the upper part of their bodies. In fact, these Graces were men disguised as women, with wigs of long black hair and exaggerated breasts painted red. . . . After their bath, the Graces returned to the stage in costumes of lattice-work painted blue or white, with little heads which rose and fell at the end of an expandable trellis.

This produced outrage and shock, with *le tout-Paris* whistling with scorn at what was taken to be a bad joke. The Surrealists were outraged as well because the producer, the Comte de Beaumont, had organized the evening as a benefit for Russian refugees. They accused Picasso of working "for the well-being of the international aristocracy." Breton forced his group to deny this and to make a volte-face by voting a motion of support published in the *Paris-Journal* of 20 June, two days after opening night:

> We wish to proclaim our profound and total admiration for Picasso, who, in contempt of easy pieties, has never slackened in his attempts to create disquiet and to provide that disquiet with its highest expression. . . . Picasso, far beyond those who surround him, seems today the eternal personification of youth, and the incontestable master of the situation.

None of that, however, prevented Picasso from attending the count's ball in evening clothes. A photograph shows him holding the hands, simultaneously, of Mme Errazuriz and Olga.

On that same 20 June Diaghilev put on *Train bleu* at the Théâtre des

Champs-Élysées: book by Cocteau, music by Darius Milhaud, curtain by Picasso. He had enlarged to the dimensions of the set his gouache of 1922, the two female giants of *la Course,* multiplying them by twenty-five. The result was conclusive: monumentality prevailed. The ballet had just established two proofs: the first, by the practice of three dimensions, verified curvilinear Cubism, which might more conveniently be called free Cubism; and, the second, through enlargement, the classic figuration of the *Géantes.* Both functioned precisely like *Parade,* which seven years earlier had supplied through movement confirmation of Synthetic Cubist assemblage.

In that spring of 1924 Picasso had begun the confrontation between fluid forms and the geometry of a window: *Mandoline, compotier, bouteille, et galette sur une table* (Mandolin, Fruit Bowl, Bottle, and Pancake on a Table) dated May.[12] In the summer, when he returned once again to Juan-les-Pins, this time, to the villa La Vigie, the confrontation became more insistent in the monumental (140 × 200 cm.) *Mandoline et guitare,*[13] which multiplies the decorative effects. This canvas, today at the Guggenheim, re-creates the environment and sense of opening onto the sea. Other still lifes derive from the set of *Mercure,* but the opposition between free forms and rigid geometry are accentuated as if the two had been placed on the canvas by different methods. A typical instance of this is *Guitare et compotier sur un guéridon devant la fenêtre* (Guitar and Fruit Bowl on a Small Round Table in Front of Window).[14]

This picture leads us directly to a notebook of drawings done that summer which became celebrated by publication in *la Révolution surréaliste* of 15 January 1925. These are abstract drawings done with a network of dots and lines. They are actually, however, extremely schematized rerenderings of subjects taken from still lifes *à la guitare,* for instance. The most complex, with black circles and arcs, suggest feminine silhouettes, like the first phases of *papiers collés.* In fact, as always with Picasso, the abstraction is not absolute. What is striking is the automatic character of these drawings, in which the hand seems to be acting on its own. This hypothesis is confirmed by other notebooks, less celebrated, in which Picasso once again seems to be pressing himself to make his hand move faster than his mental control. From this same time a large canvas known simply as *Nature morte,*[15] the table, guitars, and fruit bowl all but indecipherable, in smoky colors, exacerbates the aleatory figuration, the impasto, the sandings, and the lines scratched with a sharp point.

The Murphys were still living at the Hôtel du Cap, as their own villa was not yet ready. Picasso once again tasted their free way of life. Except for a large canvas whose subject—the Three Graces—derives perhaps from the ballet *Mercure,* only *la Grecque* recalls the classic figures of 1923.[16] And she is very evidently inspired by Sara Murphy. Although Picasso was more tender than ever toward his son, Paulo, Olga had disappeared from his painting.

And this disappearance was definitive.

CRISIS OF MARRIAGE

1924–1926

T he Surrealists allotted the autumn of 1924 to the sign of provoca-
tion. The death of Anatole France, Academician venerated by the
Left and recent recruit to the Communist party, occasioned the
pamphlet *Un Cadavre*. In the pamphlet Aragon asks: "Have you already
slapped a dead man?" And Breton states, "A small part of human servility
has gone." At just that moment Breton also published the *Manifeste du
surréalisme* and in December brought out the first issue of a new review:
la Révolution surréaliste.

Picasso was represented by a photograph of his assemblage *Guitare:*
folded, painted metal, tin, and wire—probably taken from the sets for
Mercure—and by the notebook of abstract drawings of Juan-les-Pins.
Picasso's presence in that publication, at that moment, was on the face of
it a thumbing of the nose at the beau monde so dear to Olga. The Surrealists
were in the throes of vehement radicalization and would soon be seeking
"revolution," in close alliance with the Communist party, at the time a
sectarian group with dreams of "bolshevizing." Moreover, because of *Un
Cadavre,* Jacques Doucet banned Breton and Aragon from his circle of
intimates.

None of this, however, kept *les Demoiselles d'Avignon* from joining
Doucet's collection in December, as planned. Breton produced a triumphal
paean to escort it.

> Here is the painting which would be promenaded through the streets
> of our capital, like a Cimabue Virgin of former times, if skepticism
> hadn't triumphed over the great private virtues by which, in spite of
> everything, this period has agreed to live. It seems to me impossible to
> speak of this painting with anything other than reverence. . . . The
> *Demoiselles d'Avignon* defy analysis, and the laws of this vast composi-
> tion cannot be formulated. For me it is a pure symbol, . . . an intense
> projection of that modern ideal which we are able to grasp only by
> degrees. In mystical terms, with this painting we bid farewell to all the
> paintings of the past.[1]

Did Breton use similar language to Picasso? He must have told him, as he told Doucet, "I know that the thought embodied in this painting is part of what has sustained me most—in my attitude, my beliefs, and my hope."[2] And Picasso surely remembered one of Doucet's arguments in favor of lowering the price: "You must understand, Monsieur Picasso, that the painting's subject is rather . . . special, and I cannot decently hang it in Mme Doucet's drawing room." In fact, Doucet put the picture "at the end of a sequence of rooms: a showcase room for exotic objects, the studio, and the anteroom/landing . . . it became the focal point of the whole perspective."[3]

Although Picasso still accompanied Olga to elegant evenings in the great world, his heart was no longer in it. Olga felt bored and embittered. And with her growing sense of isolation, her jealousy increased. As always when a relationship deteriorates, deciding which partner is to blame poses a false problem. The world of Diaghilev's ballets and the interest Picasso had felt toward it were both dead. The Murphys and the Surrealists had stirred his taste for bohemia, and the more Olga made scenes, the more he was inclined to distance himself from her. In his case this inevitably meant adventures. The discretion of the paintings on this point is no proof of fidelity. Picasso had resumed an exploration of space which meant a reconnection with his most audacious Cubist work of 1913–14. And that inclined him toward still lifes: large paintings built on contrast between fluid forms and geometry. December produced la Nappe rouge (The Red Table Cloth),[4] with highly refined contrasts, transparencies, and a provocatively unexpected conjunction of objects on a table with a bust.

The impact of colliding Surrealist images is evident; but when Picasso uses a bust to disrupt a still life, he nonetheless integrates it with the picture as a black Cubist element. From this point on, the bust is associated with a palette and with the full range of the first papiers collés.[5] A marble arm now accompanies guitar and fruit bowl.[6]

This sequence reached its climax during the summer of 1925, which Picasso once again spent with Olga and Paulo in Juan-les-Pins, in a villa called Belle-Rose. L'Atelier à la tête de plâtre (Studio with Plaster Head),[7] resumes the series, but without fluid forms. Picasso's objective was no longer what it had been. Many things had happened in his life and art which would not be disclosed until later and not be perceived for decades.

L'Atelier makes use of every possible ambiguity. For example, Picasso put a toy theater of Paulo's in front of the window, scrambling the perspective of the picture with those of the theater's construction, which are Cubist, in the style of the ballet sets for Pulcinella. An orange seems to be suspended in the foreground, while on the table a carpenter's square is disappearing under the plaster bust. Further back a sculptured arm is holding a spool. A leafy branch separates it from a sculptured foot; the foot, too, stands alone.

The figurative contrasts particular to Picasso are felt here in the contradiction between the two combined profiles of the plaster head, as well as

the contradiction between them and the shadow the head casts on the wall. The sense of unreality is total; the systematic repetition of objects dear to De Chirico indicates a desire to prove that Cubism includes all the effects of oddness, of the unexpected, which the Surrealists admired in the "metaphysical" painter, as well as a few others which are even stronger and more disconcerting.

In the spring of 1925 *la Révolution surréaliste* of 15 April launched a discussion of surrealist painting: Is it or is it not possible? In the July issue Breton replied with a manifesto, *le Surréalisme et la peinture,* in which he strongly invoked Picasso. He published five of Picasso's works, three of them Cubist; *les Demoiselles d'Avignon,* published in France for the first time, and a single work of formidable violence—*la Danse*—which had just been finished. Picasso had put himself at issue; made himself the stake. *L'Atelier à la tête de plâtre* proves that he accepted the challenge, especially as De Chirico's last exhibition, in which the artist seemed to be repeating himself, raised some difficulties for the Surrealists.[8]

In April Picasso went to Monte Carlo with Olga and Paulo to join Diaghilev, and he did several classicist drawings of dancers at work. Perhaps by reimmersing himself in the world of ballet, he was hoping to resume a harmonious relationship with Olga. We know nothing of that, however, nor of his encounter with Diaghilev; but *la Danse* was a product of the trip. Our knowledge of the initial project is, again, conjectural. But the painting's physical dimensions (215 × 142 cm.) indicate that from the first Picasso had a grand scheme in mind. Although an abstraction is made of the subject, which we know he reworked, the treatment derives from contrasts of form and from some of the earlier large still lifes, as we were able to see in 1966 when it was shown in Paris, hung between *Nature morte aux oiseaux* of 1923 and *Mandoline et guitare* of 1924.[9]

It is not correct that *la Danse* was begun in Monte Carlo. It was done on returning to Paris in May, an evident record of failure, which Cooper calls "a masterpiece in which sorrow takes the upper hand over the exaltation that such a subject would have inspired in him earlier."[10] This abandon to the new frenzy of jazz dances breaking the purity of ballet rhythms looks like an insult to everything Olga represents. The composition is out of joint, "syncopated," like the wildest of ragtimes, in conjunction with a window opening onto a balcony, as in the still lifes of the moment.

The canvas was transformed by news of the death of Ramón Pichot in Paris. Picasso had stopped seeing him after 1912, when he took the part of Fernande, a break which had left a sense of guilt. Added to this should be his anger at Germaine, who by her infidelity had hastened her husband's end, just as she had destroyed Casagemas. But had Pablo escaped these dangers from women, now that Olga was doing all she could to destroy him? At this point he recovers the violence of the great *Arlequin* of 1915, done at the time of Éva's death, during the massacres of the war. Moreover, May 1925 saw the mobilization of Surrealists against the war being waged

by France in Morocco; and the publication of *la Danse* proves the close links, from July on, between Breton and Picasso.[11]

This was the moral context of *la Danse* as it has come down to us. Picasso painted a disheveled maenad on the left, while the dancer on the right projects against the blue of night the hugely enlarged shadow of Pichot. This is a "burial" of Pichot, his silhouette as long as a day without bread. The figurative dislocation, transposed here from still lifes, announces what one might call the convulsive period of the closing years of the 1920s and at the same time indicates a release of private tensions. One detects signs of cruelty; drawings of fingers which seem to be separated by nails or to assume the appearance of claws or pincers; the insistence on the placement—or displacement—of sexual attributes. *La Danse* is an indicator of the importance of the *Demoiselles* in Picasso's art: a work to which he surely made frequent mental reference.

La Danse is henceforth inseparable from *le Baiser* (The Kiss), painted at Juan-les-Pins during the summer of 1925, eclipsing the sequence of large figure paintings like *Femme au tambourin, la Statuaire, la Femme à la mandoline,* and even the astonishing *Leçon de dessin* (Drawing Lesson), in which Paulo, whom his father had represented in 1923 as a well-behaved child doing a drawing, now finds himself with dissociated profiles.[12] In *le Baiser,* dislocations, sexual projections, signs of cruelty are carried to an extreme. *La Danse* was the negative of his life; *le Baiser,* on the other hand, retrieves the other aspect of *Demoiselles:* its virile penetration and violence.

It is clear that the *Demoiselles* are at issue because in that painting Picasso once again crossed the frontier breached in his *Autoportrait* of 1907, and in the final reworking of the faces of the girls on the right: the frontier of purely plastic violence expressed by the vehement brush strokes of the painter, the violations of pictorial texture. *Le Baiser* illuminates *la Danse* by its mastery of scorings and squarings hurled at the flat planes, which multiply the shock imposed by decomposition and recomposition of faces, and further sharpened by symbols whose sexual content assail us. These symbols combine, interchangeable in their deplacements, the woman's eye, mouth, and sexual organs. The painting plunges us into the atmosphere of ancestral myths as Claude Lévi-Strauss has taught us to read them.

Le Baiser, bowing to a modern god of insatiable sexuality, exacerbates ambivalences and unslaked impulses and anticipates the plastic emblems and the posture of possession to which Picasso constantly returns in the recapitulations of his final work.

A comparison of these two major works, which mark a break in the artist's trajectory as profound as that of the *Demoiselles* in their time, teaches us to keep our distance from what appear in the work to be personal preoccupations or crises. And first of all to take into account the unconscious. It is not clear that Picasso deliberately dismembered Fernande's

body in the spring of 1907; nor that in the summer of 1925 he identified the destructive power which—as he saw it—Germaine represented with the disaster of his marriage to Olga. For him primitive violence provided relief, precisely because it excluded the realistic, rational expression of his feelings and furthered a hallucinatory liberation of painting. This is pure painting precisely because it prevents the reduction of image to trivial experiment, just as the disheveled Maenad transcends Germaine's vulgar excesses with the demented dance of a Bacchante celebrating an antique mystery. The dance, however, is a dance of 1925, which adds a topical element to a sense of the bizarre, beyond time.

It is legitimate for biography to relate turning points in work with vicissitudes of private life, provided that the first are not reduced by the second; that in the process we learn how better to perceive the transformations which, for Picasso, constituted the characteristic essence of his art; the system of changing values he found for expressing through plastic means the emotions, reflexes, urges, dreams, and challenges which he hurled at his own conduct of life. Ambient Surrealism had helped in this process, but, one might say, as a proof that Apollinaire's sur-realism was a road to the future.

The period which begins at this point is one of the least known in Picasso's life; its details are still buried in archives which cannot yet be opened. In the autumn of 1925 he had just turned forty-four. Although Breton was proclaiming his admiration with increasing zeal, asking, "What lies at the end of this anguishing journey? Will we ever know?" Picasso could see new stars rising in the firmament: the work of his young friends, the Germans Max Ernst and Paul Klee, his compatriot Joan Miró, and the Frenchman André Masson.

Picasso joined them in the first Surrealist exhibition at the Galerie Pierre, which opened on 14 December, with a catalogue preface by Breton and Robert Desnos. This was the moment at which the Surrealists experienced a heightened radicalization: a notable consequence of their campaign against the French war in Morocco. A letter from André Masson published in October is typical:

> We are a few men proclaiming that life—as it has been shaped by Western civilization—has no further reason to exist; that it is now time to plunge more deeply into the interior darkness in order to find a new and deeper reason for existence; but also, that it is necessary to participate in class struggle . . .

There are, henceforth, two Picassos: the artist in sympathy with angry young people and the man whom Brassai was to find, seven years later, "attending every reception and elegant evening accompanied by his chic and beautiful wife." But the artist increasingly identified himself with the

first group and would in his own way plunge into his "interior night," leaving the class struggle to others.

Brassai describes the studio:

> Never has a bourgeois lodging been furnished in so *unbourgeois* a way: four or five rooms, each with a marble fireplace surmounted by a mirror—and entirely without the usual furnishings. They were filled with stacked paintings, boxes, packets, bundles holding, for the most part, molds for sculpture, books, reams of paper, a rag-bag of miscellaneous objects piled against the wall, on the floor, covered with a thick layer of dust. . . . Picasso had put his easel in the largest room, the room with the most light. . . . The window faced south, with a fine view over the rooftops of Paris, bristling with a forest of red and black chimneys, and—between them—the slender, distant silhouette of the Eiffel tower.

At Olga's, on the floor below, "not the least hint of casualness, not a grain of dust. Polished, gleaming floors and furniture."

In January 1926 Picasso began a large canvas which returns to the trenchant contrasts of *la Leçon de dessin* and simplifies them. Simultaneously, the picture alludes to the complex violence of *le Baiser:* color has vanished, giving way to an alternation of dark or luminous surfaces. *L'Atelier de la modiste* (The Dressmaker's Studio)[13] is an abstract rewriting, powerfully rhythmic, of Picasso's view through a window on the rue la Boétie. *Le Peintre et son modèle*[14]—not quite so tall—presents itself as an interlacing of supple forms in a space which has been broken into large planes of light color. The woman is extraordinarily disproportioned, with an enormous foot in the foreground and a tiny head reduced to the "conceptual" points of 1913: the painter here seems released from the pictorial frenzy of *le Baiser*. In the figurative reorganization, violence is confined to the exacerbation of deformations and reconstructions which radically disorder the composition. A drawing from the 1985 Miami exhibition of unknown works from Marina Picasso's collection indicates that Picasso had pursued experimentation with his son's face further than previously thought. A canvas dealing with the same problem which Zervos until then had dated 1934 now appears to have been done on 20 November 1926. In the hellish, deteriorating relationship with Olga, Picasso no doubt saw the undoing of his paternity saga. The reappearance of Harlequin, subjected to the same plastic interrogatories—and tortures—seems to confirm this. But the true catharsis of violence occurred in April and May in a sequence of constructions—or, more precisely, of *tableaux-reliefs,* as they came to be called at the Musée Picasso.[15]

To begin with, they are a tinkerer's tour de force, producing little

guitars of tulle, cardboard, string, a button, a lead weight—all of this very small. Then there is a shift to monumentality, with formats of *60 figure,** accompanied by an eruption of aggression. *La Guitare à l'aiguille à tricoter* (Guitar with Knitting Needle) is made of a piece of old shirt, which has been nailed down and pierced by several long wooden needles. That work is mild compared to *Guitare à la serpilliere* (Guitar with Scrubbing Cloth), presenting vertically, in a position which is impossible in relation to hanging, a scrubbing cloth with a circular hole cut in the center. The cloth is studded with nails, their points toward the viewer, and is flanked by a strip of newsprint collage. According to Roland Penrose, "Picasso had even thought of garnishing the rims of the picture with razor blades, so that anyone who picked it up would cut his fingers. An explosion of aggression in a language of evident sorrow."[16]

If Picasso's art ever cried out, ever howled, it was that spring. But the source of his sorrow—Olga—never appeared in his work. She was indirectly called to account by these remodelings and constructions, which are, strictly speaking, unbearable. And, one might say, she is evoked throughout the studio: since *la Danse* and *le Baiser* everything that Picasso made was for himself, never for dealers or collectors. Not that he deliberately and expressly kept these things secret. The *Guitare à l'aiguille à tricoter* was published in *la Révolution surréaliste* of 15 June 1926, as soon as it was finished.[17] This once again proves the close relationship between Picasso and Breton. In the same issue Breton published *Surréalisme et la peinture,* harshly attacking De Chirico: "In his powerlessness to re-create either in himself or in us any past emotion, he has released a large number of marked forgeries, including servile copies. Most of these, moreover, are pre-dated. . . . This fraud, by some miracle . . . has lasted far too long."

Picasso himself was less than ever inclined to risk a similar approach. He was refashioning links with the untrammeled revolt of *les Demoiselles d'Avignon* in an extraordinarily enriched plastic language, and in the conviction that he was clearing an unexplored poetic continent.

The summer of 1926 found the family once again at Juan-les-Pins, in a new house: la Haie Blanche. The Murphys had their villa but in July left for Spain with Hemingway and for the rest of the summer seemed fully occupied with the extravagances of Scott Fitzgerald and his wife, Zelda. No details have survived about Picasso's work or social life except for a photograph by Man Ray which shows him bare chested on the beach. He is in the prime of life, but the air of youth so evident in a photograph of 1923, also taken by Man Ray, has gone.

Except for a quick trip to Barcelona, we know nothing about the autumn. But it was then that his painting began to produce canvases which exceed in brutality anything he had previously done. A *Harlequin* has eyes

*Paintings of *"60 figure"* are figure paintings which measure 130 × 97 cm.

placed at the two extremities of a right angle; a soft and hideous shape is marked by indications of nostrils and mouth. Harlequin here seems to be Picasso himself, suffering, deconstructing himself, tearing himself apart.[18]

In her *Picasso* Gertrude Stein says that at the time of the guitar and scrubbing cloth work, Picasso didn't paint for six months. One should not, perhaps, take this literally; but, in fact, many works were put aside, left for months and sometimes longer before being taken up again. One of these— *Instruments de musique sur une table*—would be modified (not finished) in an altogether unexpected way because his private crisis no longer struck him in the same terms as before. Another phase in Picasso's history was about to begin.[19]

Conjectures on Picasso's Philosophy
at This Critical Juncture

The homage given to les Demoiselles d'Avignon *in 1924–25, relayed by the figurative rupture of* la Danse *and* le Baiser, *brings to a brilliant end the period which began after the trip to Rome, a period marked by important classicist explorations. The coincidence between the almost definitive disappearance of these in Picasso's painting and the return of paroxysmic expressions of the human body and face cannot be considered fortuitous. Perhaps this turning back to the* Demoiselles *was induced by a certain parallel between the crisis of his marriage and the first failure of a shared life with Fernande. Although these considerations (perhaps unconscious) may have played a part, they do not adequately explain why the evident turn in painting toward dislocation and the systematic reinvention of human forms will never again be an issue. Picasso will employ various figurative modalities but always as part of dismantling illusionism. Is this a change of intellectual attitude toward his art? A change of philosophy?*

What follows can only be conjectural, but it makes possible a linking of several indexes and offers an explanation of the importance Picasso clearly attached to the most frenzied distortions of the female form in what has been called his "convulsive" period, "metamorphoses," and sometimes "monsters."

The first hypothesis is that Picasso at that time was shifting to a full anticlassicism. Up to this point he had been making an inventory of infractions of classical illusionism, turning to primitivist expressivity or Cézanne's constructivism, or arriving at the creation of a new space produced by optical contrasts of textural effects associated with ideograms and symbols. Then, starting in the spring of 1914, he established proofs for the new space of Synthetic Cubism by associating it and confronting it with the classic space of perspective. In this way he

discovered that the new space enclosed perspective space; that perspective could function as a particular case within Cubist parameters. From the Femmes à la fontaine *to* Flûtes de Pan, *Picasso had shown that he could reproduce the classicist achievements of Poussin or Ingres by cleansing them of illusionist conventions, by using the experience of new space, of its powers of simplification, that is, by eliminating "tricks"—the factitious and artificial display of academism. But in savoring his progress, was he neglecting that search for the hidden truths of painting which had led him to the discovery of new pictorial space? Was he allowing himself to be once again caught up by appearances? And, in a more general way, had he not, since his marriage, allowed mundane superficiality to invade his life?*

Now that he was measuring the falseness of his marriage, wasn't it time to stop priding himself on surpassing Poussin, Ingres, or Corot? Should he not resume his proper task, which no one could do in his place and which was the true task of twentieth-century art? This meant exposing to the light of day—for the first time—the primordial, deeply buried realities of existence. He felt driven in that direction not only by his own present experiences but also by the thinking of his new Surrealist friends, with its inherent Freudianism; and by their audacity: their readiness to say anything and everything in breaking sexual taboos. In 1924 the Manifeste du surréalisme *was published, as was the first part of Aragon's* Paysan de Paris, *a clinical description of every gesture during a visit to a quick-service bordello near the Opéra. As a demolition of evasion, it was not so far from* les Demoiselles d'Avignon.

But Picasso's situation was no longer that of 1907. First, because the crisis in his marriage, for a man of forty-four, was different in kind from the discord he had experienced with Fernande as a young man of twenty-five. And above all because he now linked the discovery of a properly pictorial expressivity in his Autoportrait *of 1907 to everything he knew about the effects of texture, aleatory lines, and the wellings of the unconscious.* La Danse *and* le Baiser *are the first attempts—infringing all taboos—to associate the pictorial expression of the unconscious and the expression of sexuality. But this time he moved beyond any and all traditions. No African, Oceanic, or Neolithic solution could serve as point of reference or guarantee. He was carving out a passage where no one else had attempted to go, for which art had not yet provided any signposts. He could no longer think of reproducing a certain quality in a Cézanne canvas or a Grebo mask but needed to move squarely to the other side of the mirror, to invent unknown forms with no knowledge of whether they would work; or if they did (*la Révolution surréaliste *had, after all, published* la Danse *and abstract drawings from the notebook of Juan-les-Pins), without the least idea of the reaction they would produce among other paint-*

ers, critics, and amateurs. The whole of artistic tradition since the Renaissance had provided its various models. Picasso not only turned his back on all of that, he frankly created a world in which living forms no longer obeyed current laws; in which every frontier between those forms and inert geometries disappeared. Just as Kant thought that understanding did not derive its laws from nature but prescribed them, so Picasso acted as if painting did not derive its forms from nature but prescribed them.[1]

When Kahnweiler's collected notes of his relationship with Picasso are published, a relationship which resumed shortly after this critical moment, we shall perhaps be able to tell whether or not the sense of Kantianism provided Picasso with intellectual equipment capable of helping him in the aesthetic revolution he undertook. It is, however, a fact that Picasso adopted the expression "synthetic" to designate his non-imitative, Cubist drawings.[2]

What seems plausible in any case is that Picasso broke with imitation, a fundamental element of Classicism. His painting no longer began with known appearances but reached out to meet the unknown, whether the question was one of aleatory effects or radical transformations of experience. A Classical painting employs external references, cultural references, and references to traditions. While a painting by Picasso develops as the result of an apprenticeship by trial and error, as if the artist were seeking an extreme limit at which his figurative overthrowings would cease to function. In this way he returns to his own inner depth, and returns the spectator as well to communication with hidden impulses and unexpressed emotion. Where a Classical painter has at his disposal a whole range of support and structure, Picasso takes the greatest risks. His intellectual posture is much closer to that of a twentieth-century physician dealing with problems which were previously inconceivable. Beginning with la Danse, *he practiced an open form of painting and then of sculpture—open to all who might come to criticize or to refute. He was to be his own most severe critic, the author of the most complete investigations, the most pitiless refutations. This is not a negation of art but a means of proceeding toward realities which are even more deeply hidden and perhaps richer. And this, it seems to me, is the meaning of his remarks to Zervos: "Previously, pictures proceeded by degrees toward their end. Each day brought with it something new. Pictures have been a sum of additions. With me, now, a picture is a sum of destructions. I make a painting, and then I destroy it. But in the end, nothing is lost. The red which I take away in one place turns up somewhere else."*

In this, we should note, Picasso at his best embodies what might be called the spirit of the twentieth century. For David, Ingres, Delacroix, or Corot, the world was a complete and finished place; everything in it was established, visible. This was true, too, for Courbet. It

was Impressionism which made painters discover that their work could contain something other than the subject or the picturesque. Picasso came of age in a world which no longer completed each day in the situation it had seemed to occupy the day before. The world of electricity, of waves, of the "fourth dimension" and the unconscious was remodeled by the invisible presences which act on our senses and our spirit. This remodeling affected other unseen presences—cultural presences—which had been thought eternal. It has produced some extraordinary revivals, like romanesque art or the art of Greco. But Picasso's generation—after Gauguin and the importations of Universal Expositions—did not slacken in its efforts to show that many more art forms had existed in human history than had previously been recognized. Japanese prints and the Angkor temples made way for African, Oceanic, and Neolithic art.[3] An opening up to the unknown was the most pressing intellectual necessity.

To this we should add the previously inconceivable events of the First World War, whose cultural measure—in 1925—was just beginning to be grasped. The sequence of violence and destruction, followed by the collapse of the oldest regimes in Europe and of all the empires except the British; Revolution in Russia; inflation in Germany; and to crown it all, the smashing—perceived even by partially informed laymen—of physical and mathematical theories (like Newton's laws) previously considered unshakable, and their replacement by new theories, like Einstein's relativity theory, which seemed entirely inconsistent with common sense. (Eddington's first proof of Einstein's theory was a major item in all the scientific journals of 1919: a proof of progress by the human spirit in science if not in politics.) The period transferred this progress to art, turning its necessity into need, as avant-gardes continuously succeeded one another. Dada and the Surrealists had codified the process; and Picasso in his work felt a similar need.

It was precisely this turn in his painting—toward the primacy of the imaginary and the unknown; toward the most astounding and unlikely of interior models—which allowed him to reach beyond the hazardous uncertainties of the avant-garde to touch something more basic. And by so doing, Picasso restored to painters their central position in the creative process, a position Impressionism had tended to make them lose. It was this knowledge of reconquest, of return to centrality which would lead him from the painting of private paroxysms to a new painting of history whose determinating expression would be Guernica. But this conviction also oriented his confrontations with those whom he considered precursors. One might say that this was how Picasso humanized twentieth-century painting—at the very moment when his audacious transformation of feminine and masculine images might suggest that he was insulting them.

In his hands painting became a generator of the possible. That this might initially have meant a hellish "possible" should not deflect us. When one plunges into depths, one may encounter sorrow more readily than joy. But this liberty was soon to serve a lyricism, a hymning of sensual love whose like Picasso had never before encountered or painted; and would reach a truly unprecedented intensity of discovery.

This is, I repeat, a conjectural reconstitution of what—for lack of a better term—I call a philosophy, which I associate with Picasso's personal surrealism. Will we someday know more about it? At the time there was no one in whom to confide. But it seems to me impossible that Picasso would not have elaborated for his own use and formulated at least to some extent a general view of aesthetic reflections. And his perseverance undoubtedly was marked by it. He must have needed such help to navigate the hazardous passage for which there were neither maps nor the aid and comfort of traveling companions.

PART FIVE

MARIE-THÉRÈSE OR THE SECRET

We joked and laughed together, happy in our secret . . .
You know how it is to be really in love . . . One has no need
of anything else . . .

—*Marie-Thérèse Walter*

THE *MÉTAMORPHOSES*

1927–1929

A t forty-five, Picasso had become a successful man. He was about to buy his first Hispano-Suiza, the automobile of kings, which would be driven by a liveried chauffeur. In June 1926 a retrospective of his work over the last twenty years was shown at the Paul Rosenberg Gallery. But these are the successes—a selective list, which excludes both his marital troubles and the aggressiveness of the constructions he kept for his Surrealist friends.

In France it was a period of great intellectual turmoil. A headlong pursuit of pleasure had failed to hide the fact that with victory the country had not regained its prewar position. Significantly, modern art was accepted only in the form of *arts décoratifs,* as demonstrated by the big exhibition of that name in 1925. Surrealism had run out of steam. The December issue of *la Révolution surréaliste* would not be followed by another for a year.

Yet a new kind of criticism and focus on modern art began in January 1926 with the first issue of *Cahiers d'Art,* a magazine started by Christian Zervos, a young Greek philosopher. He collected people interested in experimentation, like Élie Faure, Jean Cassou, and Tériade. He had strong and definite ideas on the future of art in general and Picasso in particular, which was very helpful to Picasso at this point. An article by Marius de Zayas, based on conversations with Picasso and published in the United States, had been translated by Florent Fels and published in *Arts.* However, there was another version making the rounds, a forgery, written in Russian and filled with inanities, which Jakulov published in the magazine *Ogoniok* as a "letter from Picasso." Since no one formally repudiated it, the piece would prove to have a tenacious life of its own.

At the end of 1926, Jean Cocteau's book *Le Rappel à l'ordre* returned to his *Picasso* of 1923 with additional material which shed new light on the crisis of 1919–20. Although he exaggerates his own influence, giving *Parade* too much credit for the transformations in Picasso's work, he nonetheless provides some valuable insights:

Clairvoyance infuses his work [with an intensity] which would burn dry a small spring. Here, that power is used with economy, directing a concentrated jet. . . . Harlequin is a resident of Port-Royal.* Each work draws on private tragedy, producing an intensity of calm. Tragedy indeed is no longer a matter of painting a tiger eating a horse but of establishing between a glass and the molding on an armchair plastic links capable of stirring the emotions without the intervention of any anecdote.

In relation to Cubism Cocteau notes that Picasso "proves that character does not reside in the repetition of audacities but—to the contrary—in the independence which such audacity makes possible."

The Surrealists were outraged. To them Cocteau was quintessentially a sham and derivative poet. Picasso remained above the fray. He almost certainly paid more attention to an article by Tériade in *Cahiers d'Art* which intelligently linked Cézanne and Cubism. The piece was also very well informed on the latest developments in Picasso's painting and considered them highly poetic.

These, then, were the events and circumstances of Picasso's life in early 1927 when he first encountered a young girl whose existence he would transform and who in turn would inspire his art as no other woman had yet done. Some forty years later, Marie-Thérèse Walter confided to *Life* magazine: "I was seventeen years old. I was an innocent young girl. I knew nothing—either of life or of Picasso. Nothing. I had gone to do some shopping at the Galeries Lafayette, and Picasso saw me leaving the Metro. He simply took me by the arm and said: 'I am Picasso! You and I are going to do great things together.'"

Marie-Thérèse lived with her "Maman" in a southern suburb of Paris. She agreed to a rendezvous in two days' time. She knew that the painter was married.

She resisted, as she put it, for six months, the least one could expect from a young girl in 1927. This chronology is borne out by a letter from Picasso which their daughter Maya released in 1981.[1] "Today, 13th July, 1944, is the seventeenth anniversary of your birth in me, and twice that of your birth in this world, where, having met you, I began to live." Their romance thus became a physical affair on Marie-Thérèse's eighteenth birthday. It remained such a secret that no one in 1932 would understand the paintings she inspired. Even after Maya's birth, their relationship continued to be clandestine; the discovery that it actually began in 1927, not 1931–32, was made only recently.

Picasso, however, took a rather diabolical pleasure in playing with fire.

*Translator's note: Port-Royal was a religious and educational establishment responsible for a severe, somewhat "Puritanical" strain in seventeenth-century French Catholicism. Pascal was perhaps its most celebrated product.

In the first place, as he had predicted when they met, he filled his notebooks with drawings of his young companion. Then, as I revealed in 1983, almost certainly at the beginning of their affair he began to rework a large still life, *les Instruments de musique sur une table*. Filled with aleatory shapes, the picture was painted not, as Zervos believed, in 1925 but in 1926. Picasso used monumental forms to inscribe with white lines and incisions a nude, reclining Marie-Thérèse, who, once perceived, is highly recognizable.[2] It is at this point, I believe, that he added the bright blue planes which make the whole design more luminous and match the rhythms of his lover.

Probably in the same period he continued his games of provocation with a series of guitars. Apparently geometric, and as abstract as those in the still lifes, their composition derives from the intersection of a capital M and a capital T: Marie-Thérèse's initials. These pictures do not in any way resemble the *Ma Jolie* series of Éva's time but are just as moving and just as successful in pictorial terms. With an impulse very like that of fifteen or sixteen years earlier, Picasso could not resist celebrating his new love in his painting.[3]

Olga, of course, never came to the studio above her apartment. But Picasso surely did not hide these acts of homage from his visitors. The symbolism of the abstract guitar is heightened by a large right hand at the back of the picture. Picasso here created and put on display a plastic vocabulary of Marie-Thérèse, relishing the sense that no one would be able to decode it. In 1932, right in the middle of his Marie-Thérèse period, he confided to Tériade, "work is a way of keeping a diary," an admission which seems all the more perverse because Picasso was at pains to keep his codes secret and played on misunderstandings. Avowal in this instance strengthens protection.

"I lived with my family, and had to lie to them more and more. I would tell them that I was spending the afternoon with a girlfriend, and then go to see Picasso. We would joke and laugh together all day long, so happy with our secret, living a love totally free of bourgeois constraints, *un amour de bohème*."

This is Marie-Thérèse speaking the simple truth, dazzled by a life lived beyond the limitations of her usual setting, not to mention the restrictions of the period, which were still very cramped.

On 7 February 1926 Picasso painted a domestic scene with Paulo on his rocking horse. The undulating shapes, which are cut in two, recall those of the *Atelier de la modiste*, but the woman in the armchair—Olga's spot—is more or less annihilated.[4] *La Femme assise* had been one of Picasso's subjects since December 1926. Here there are obvious signs of cruelty: fingers shaped like carpenter's nails and a tooth-filled mouth, prominent in a face deformed by anguish. These characteristics were pushed to paroxysm in 1927, with a new *Femme assise*, today at the Museum of Modern Art. A comparison of these works produces a whole new range of symbols for constructing a portrait. Some are purely plastic, derived from contrasting

anterior curves, heightened by flat planes of color; others recall ideograms of violence and cruelty with which he had already experimented either in the *Arlequin* period of 1915 or at the time of *la Danse:* the depiction of an eye or a jaw; fingers as sharp as a carpenter's nails. In each instance the woman is tightly enclosed in a small, low space, prefiguring the cellars he would paint during the Nazi occupation. We are in Cubist space of 1913–15, with the same free reinvention of shapes. But everything, including contrasts of color, is now used to create a sense of anguish, of what an American critic has called an "ideogram of neurosis, threat, and domination."[5]

The affair with Marie-Thérèse not only failed to compensate for the scenes of bitterness—and probably of jealousy—Picasso endured with his wife; it seems to have exacerbated his awareness of them. Marie-Thérèse was a new model with a strong presence, a vessel for his art, an opportunity which Olga's presence threatened to destroy. It is the depiction of this danger which Picasso would paint over and over again, translating his private drama into truly mythic dimensions, where his painting would venture into unknown vastnesses of guilt, of loss of control, and irreparable unhappiness.

Let us note, too, that from the Surrealist point of view, the age was one of explosive eruption. Breton, Aragon, and Éluard considered themselves "uncompromising" in their condemnation, which they demonstrated with a chorus of allegiance to the Communist party.

Picasso's painting, therefore, as in 1907 or 1915, experienced a transfusion of pervasive violence which clearly exacerbated his private tensions. This sense of unease was further heightened by the death of Gris in May. While his doctors were treating him for tuberculosis, Gris was actually dying of uremic poisoning. He had returned to Paris in January; his agony, barely assuaged by morphine, would drag on for more than three months. Picasso inescapably felt a certain guilt for having treated his young compatriot as a competitor. Although Gertrude Stein overdramatizes in her usual manner, her account nonetheless merits attention:

> When Juan died, and Gertrude Stein was very sad because of it, Picasso came to the rue de Fleurus and spent the whole day. . . . Once Gertrude Stein said to him bitterly: "You don't have any right to weep for him," and he replied, "You don't have any right to tell me that!" "You never understood the qualities he had, because you don't have them yourself," she replied harshly. . . . Picasso never felt the same jealousy toward Braque.

We should also bear in mind the specifically Spanish dimension of this crisis. For Picasso the death of Gris recalled the death of Pichot; in both cases, although for different reasons, he could reproach himself for having abandoned a compatriot. This feeling undoubtedly drew him closer to

Gonzalez the following year, and to Miró, a younger colleague from Barcelona, whose penetrating forward thrusts in the direction of Surrealist painting were dazzling. Miró, like Gonzalez, would contribute to the opening of new and creative ways of escape from the unease and distress which Picasso felt.

According to Breton the tumultuous entry of Miró in 1924 marked an "important stage in the development of Surrealist art. . . . From that moment, his work is infused with an innocence and freedom which have not been surpassed. One might say that his influence on Picasso, who joined the Surrealists two years later, was decisive."[6]

This alleged "joining" corresponded perhaps to the discovery of the cloth and guitar but not to the actual truth, and one can see why Picasso protested the comment.

Yet Miró's effect on Picasso was striking—but in the sense John Golding has suggested: the liberation and sexual intensity which Miró drew from his discovery of Neolithic art.

> The influence [of Neolithic art] was incalculable, Golding stresses. Its impact [on Miró] was comparable to that of African art on Picasso. . . . One of the qualities of Neolithic art which seems to have interested Miró from the first is the way in which, very often, human limbs and genital organs are given precisely similar treatment, so that all parts of the body become interchangeable, and all have a phallic significance.[7]

This new primitivist shock occurred at a critical moment—at precisely the time when Picasso must have felt a need to review his entire life, a state of mind and spirit very like those which drove him during the *Demoiselles* period. Miró revived as well the sense of avant-garde challenge which Picasso felt at that time from Matisse and Derain. And Miró's return to the earliest origins of human art paralleled for Picasso the nature of his own personal discoveries. These inevitably were based on his own sexuality.

We should add here that just as he had after the Vollard exhibition in 1901 or following the classic virtuosity of 1905–6, Picasso now felt the need to break with a previously successful style. This feeling was all the more acute because the successes in question were inescapably linked to the approval of Olga's world, the world of the comte de Beaumont, Paul Rosenberg, and the Wildensteins. What part of his soul had Picasso left with them? He was no longer nineteen or even twenty-four, with all of life ahead of him. He was well into his forties.

Further, since his earlier primitivist campaigns of 1905–6 and 1912–14, knowledge of African, Oceanic, and Neolithic art had—to an astonishing degree—become more widely diffused, subtle, and complex. The Surrealists played a considerable part in this process. Some, like Aragon, under the influence of Nancy Cunard in 1926–27, were even making money out of it. Dealers, like Charles Ratton, had made the identification of these cultures

easier; and the plastic qualities of objects to be sold had been raised to a higher level. These factors together had altered public attitudes toward these works. Appreciation of their exotic and magical fascination had greatly increased, as had the awareness of their importance to the art of humankind.

Picasso's new primitivist campaign pushed further in the direction of sexual or cruel expression and the freedom to transform shapes than toward plastic invention, as in 1912. It stirred his imagination and inspired a boldness of recomposition that allowed him to plumb the depths of his hallucinatory dream-images.

The stimulus of these new sources and the expression of intimate truth, of the *modèle interieur* became fused. The *Femme dans un fauteuil* of January 1927, in the animality of the powerful arabesques which depict her abandon, probably, as John Golding suggests, reflects the influence of the Easter Island hieroglyphs. Her disarticulation and her obscene flaccidity make her femaleness more assertive than it would be in real life. The head of a *Dormeuse* (Sleeping Woman) in the same style focuses on genitals, which, in the head of a *Nu sur fond blanc* (Nude on White Background) become huge. (A sketchbook assigns the latter work to summer 1927.) A *Figure*[8]—in the style of Miró's *Personnage jetant une pierre à un oiseau* (Person Throwing a Stone at a Bird)—will show only a woman's breast and an enormous foot. Most of these canvases are swept by colored bands, which—as with Léger in the same period—create space or a sense that Picasso accented these reorganizations of the female body as if with a spotlight. The pictures have a strong sense of rhythm and, strangely, of presence.

As in the *Demoiselles* period, primitivist distortion of natural forms broke new ground in the liberation of painting. Space created in this way permitted the most aggressive distortions, every figurative dissociation, and new plastic contrasts. Sexuality was no longer simply a breach with Victorian prudery or an oddity, as with Apollinaire. It was now immersed in the depths of life pioneered by Freud and was used by the Surrealists to explore the innermost recesses of both life and art. In 1907 Picasso had burned his bridges, cut his ties to conventional painting with no certainty that a valid solution to his experiment even existed. Twenty years later the *Demoiselles* had become the touchstone not only of modernity but of the new intellectual equipment. Breton confirmed the *"primitivisme intégral"* of Surrealism, which, as Golding puts it, burned to "be in a state of grace and innocence, freed from all prudery and restraint." This explains the predilection for Oceanic arts, endowed with a *"sexualité intense."*

The summer of 1927 was spent in Cannes, with the family. Picasso had perhaps hoped to secrete Marie-Thérèse in a house nearby, as he would do from the summer of 1929 on. But in 1927 a young woman of eighteen—even one as relatively independent as Marie-Thérèse—could not dream of such an arrangement. Picasso was totally obsessed by their sexual affair. A

photograph of this holiday shows him with Olga on a terrace—probably the terrace of the Hotel Majestic. Both are heavily dressed. Olga reeks of boredom and distress. He alone is looking at the camera. She, her head down, is lost in bitter thought.

His sketchbook of the holiday resumes the most fantastic reworkings of women from his paintings—like a *Femme dans un fauteuil* and two *Tête(s) de femme*. One of these is sanded, a trademark in 1923 of his paintings of the cap d'Antibes. But from now on, bathers would be male as well as female, and the atmosphere would be completely changed. Their oversized volumes produce powerful erotic currents, which emphasize sexual attributes of provocative mass. These figures are usually struggling with the keys to their bathhouses—a Freudian allusion which is all the more obvious in that at the time all forms of nudity outside these cabanas were strictly forbidden. Pablo's imagination roamed the beach, and the pretty young bathers could not help but make him long for the young mistress whose charms he had only begun to enjoy.[9]

Because of the transposition of organs, his drawings were called *Métamorphoses*—an inadequate summary. In 1929 in *Cahiers d'Art* Zervos revealed that some of these were plans for a monument almost certainly intended for Apollinaire, whose interest in sexuality makes the design a suitable one. A young American researcher, Michael Cowan Fitzgerald, has discovered that the committee which had commissioned Picasso met in December and declared in all earnestness that the plans were "entirely inappropriate as sculpture for a tomb."

During the winter Picasso, who had done no sculpture since 1914, made a small painted plaster based on these drawings, with a copy in bronze.[10] This resumption of sculpture marked a turning point. His exploration of the classic had led him away from his experiments in the third dimension. His work for the ballet had put his Cubism to specific, substantive tests, while his assemblages of 1926 afforded direct expression of his violence. But he clearly needed to experiment with his remodelings. How to translate their fantastic forms? Their figurative contrasts? How to move from the rhythms of drawing to volume? He was truly dreaming sculpture, which in his case was a sign of sensual excitement—from the heads of Alice and Fernande in 1906 to the *modelages* of the *Verres d'absinthe* done concurrently with the most voluptuous of the *Ma Jolie* series. But he would need another four years—and some very unusual experiments in three dimensions—before Marie-Thérèse inspired the most extraordinary period of sculpture in his life.

In the autumn a Picasso exhibition at Flechtheim's, in Berlin, displayed drawings, watercolors, and pastels from 1902 to 1927 as well as four bronzes. During the winter there was a show of recent works at the Pierre Gallery, an indication that he showed in this Surrealist setting things he had done for himself. Perhaps Rosenberg did not want them. Or perhaps he was not consulted. Picasso had, in fact, begun an experiment even more danger-

ous than those he had been working on since the beginning of the year. "Geometrization" returned—of the most deliberate kind. First there is *Deux Femmes à la fenêtre,* a figurative confrontation in which the woman on the left—all triangles and circles—faces a silhouette of split curves. And then, an even stronger example, *Atelier,* now at the Museum of Modern Art.[11]

It is possible that the idea first came to him during work on the canvas *Artiste et modèle* and the fantastic remodelings of that summer in which the model is made of organic forms while the painter is geometrized. But the confrontation with *le Peintre et son modèle* of 1926 indicates a desire to rewrite these remodelings in symbols, and at the height of abstract, geometric reduction. Thus the painter on the left and the bust on the right, on either side of a fruit bowl on a red tablecloth, are now simply their schemas. A short time later, a new *Peintre et son modèle*[12] gave these geometric structures some organic attributes, like the woman figure's hair, at the top of the "head," and the profile which the painter inscribed on the canvas with his phallus-arm—a profile endowed with all the purity of Marie-Thérèse. A circle with a dot in its center could be a green apple—or a breast. The painter's head, with its superimposed eyes, is striking. Like those of the model, these eyes are "African," an indication of renewed primitivism, at least of a conceptual kind. This head, after 20 March, became a working drawing for a sculpture.

Picasso was more Surrealist than ever, drawing from the central interests of his new friends authorizations and incitements for his imagination, enabling it to take heightened liberties with the shapes of perceptible reality. He did Minotaurs, all legs and head, with no body: a large collage on January 1928 and an oil painting in April. Various signals suggest an increasing need to confer concrete presence on these extraordinary remodelings.[13]

An occasion presented itself in May when Julio Gonzalez, in serious financial difficulties following the death of his mother, wrote simultaneously to Picasso and to Brancusi offering his services as a metalworker-technician. Picasso answered him immediately[14] and from that moment was constantly at Gonzalez's rue de Médéah studio, near the gare de Montparnasse. There he found himself once again on the territory of *his* Spain, together with a jumble of decorative objects which excited his taste for tinkering. The place included a presence which must have moved him: Gonzalez's companion, whose name was Marie-Thérèse. The strong current of sympathy between Gonzalez and Picasso proved for Gonzalez to be a valuable catalyst. Within a short time he had found his own personal approach as a modern sculptor.

Although Picasso left Paris for another holiday at Dinard, the motivating impulse of Surrealism did not slacken. Next he produced a breathtaking series of small pictures, whose vehement, angular disproportions achieve the boldest remodelings of the female body he had done to this point. Women bathers playing with a ball or fitting their keys into a bathhouse

lock compose a dynamic scene which Pierre de Champris has rightly compared with the Mycenaean idols on display at the Louvre.[15] But the touch of Freudianism, and the renewal of sexual exuberance in the boldness of reconstructions and dissociations of form, are illuminated this time by the presence of Marie-Thérèse. On 11 and 12 August she was saluted by portraits of unequaled harmony, whose masterpiece is the lithograph *Visage*. His young mistress here is at a holiday resort, and Pablo is watching her as she frolics on the beach. The picture reflects frustration, heightened by a dash of perversity.[16]

The *Carnet de Dinard* (Dinard Notebook), published by Werner Spies,[17] records the sources of these paintings. One can also see transitions developing between the remodeling of figures with distinct, ossified shapes and the "drawings of lines in space" which in the autumn, at Gonzalez's studio, would assume material dimensions as wire sculptures.[18] ("Lines in space" is an expression of Kahnweiler's: he and Picasso had buried the hatchet.) These sculptures, in fact, give material substance to the figures in *l'Atelier* or *le Peintre et son modèle*. Sculptures without surfaces, they organize the space around them, projecting their open forms onto terrain which in the elementary *bricolage* of *Guitare* (1912) remains a simple sketch.

It was probably at this point—at the end of the year—that he made an extraordinary *Figure* in which the head of the artist in *le Peintre et son modèle* (a being who has received tangible existence in various sculptures) sits resplendent on a woman's body. This subject occupies the entire surface of the *60-figure* canvas, remodeled in the geometric forms of the initial painting. The composition has acquired a sumptuous power, bringing us into the presence of a mysterious and disquieting idol, a black Virgin. Picasso seems dazzled by the variety of possibilities at his disposal.[19]

Picasso alternated Cubism, Surrealism, and graphic innovation with a new social consciousness. His work reflected continuity but also fresh ambitions. Once again a monument for Apollinaire was under consideration. At the end of *le Poète assassiné* the poet remarks through l'Oiseau de Benin (who is Picasso) that he should erect a statue. " 'A sculpture in what'? Tristouse asked. 'In marble? Or bronze?' 'No, that's old hat,' replied the Bird of Benin. 'I must make him a sculpture of profundity out of nothingness; out of poetry, or glory.' "

The enlargement of this statue "out of nothingness" to monumental dimensions now stands in the garden of the Musée Picasso in Paris—a realization not in fact effected until 1985.

Not effected, that is to say, in Paris. The same monument has been on display at the Museum of Modern Art since 1972. We should simply note that either the committee for a monument to Apollinaire or the authorities refused all Picasso's proposals until 1955, which says a great deal about the minimal appreciation in France for Apollinaire, for Picasso, and for the meaning of their friendship.

At the start of 1929, faced with a Surrealist movement in crisis, Breton

sent a letter to all its former members asking if they thought a resumption of communal activity might be possible. Michel Leiris and André Masson didn't even bother to answer. This makes Picasso's persistence all the more remarkable, deepening the elements in his work which had prompted Breton's tentatives of incorporation. It was also a far-from-negligible instance of Picasso's independent spirit, which never faltered, and explains the comment Michel Leiris wrote at the time:

> Among the glaring but pernicious errors propagated about Picasso in recent years, one of the most prominent has tended to confuse him—to a greater or lesser extent—with the Surrealists; to make him . . . into a figure in revolt against—or at least in flight from—reality. (A vain effort, as words so often say something quite other than what was originally intended.)[20]

In fact, Picasso was more than ever caught up in the sur-realism of Apollinaire. These surpassings—this going beyond—in his art saved him from everything: from Olga's rages, dissension between Breton's friends, and the growing economic crisis. He didn't flee. Michel Leiris is correct. He faced things. Everything.

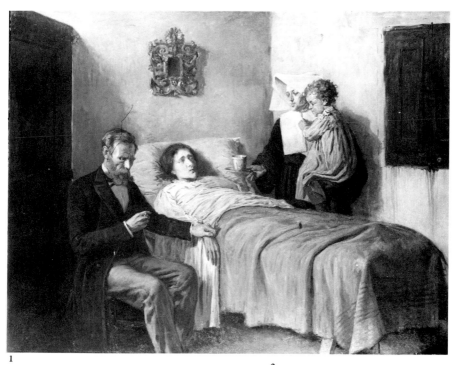

1

2

1. *Science et Charité* (Science and Charity), 197 x 249.5 cm. Picasso Museum, Barcelona. Picasso painted this large academic canvas before his sixteenth birthday. The doctor on the left is his father.

2. *La Tante Pepa* (Aunt Pepa), 57.5 x 50.5 cm. Picasso Museum, Barcelona. Painted in Malaga during the summer holidays of 1896. Picasso was not yet fifteen.

3. *Autoportrait à la mèche rebelle* (Self-portrait with Untidy Forelock), 32.7 x 23.6 cm. Picasso Museum, Barcelona. Painted during Picasso's fifteenth year.

4. Interior of the cabaret Els Quatre Gats in Barcelona, photographed c. 1899. The French expression "There isn't any cat" becomes "There aren't four cats" in Catalan. The painting on the wall represents Casas and Pere Romeu on a tandem bicycle, with Casas holding the handlebars. Archives of the Picasso Museum, Barcelona.

3

4

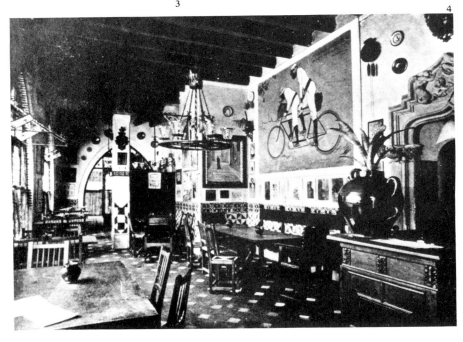

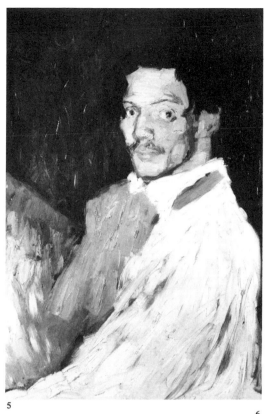

5

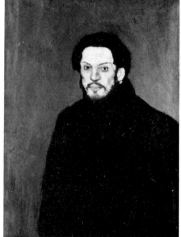

7

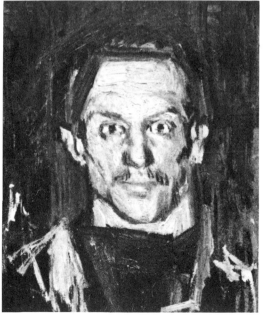

6

5. *Self-portrait*, May–June 1901,
73.5 x 60.5 cm. Private
collection. This is the Picasso
work that fetched a record price
for a modern painting (over five
and a half million dollars) in
New York in 1981. It is also the
self-portrait with touches of
green in the face.

6. *Self-portrait*, summer of 1901,
51.4 x 36.8 cm. Musée Picasso,
Paris.

7. *Self-portrait*, end of 1901, 80 x
60 cm. Musée Picasso, Paris.

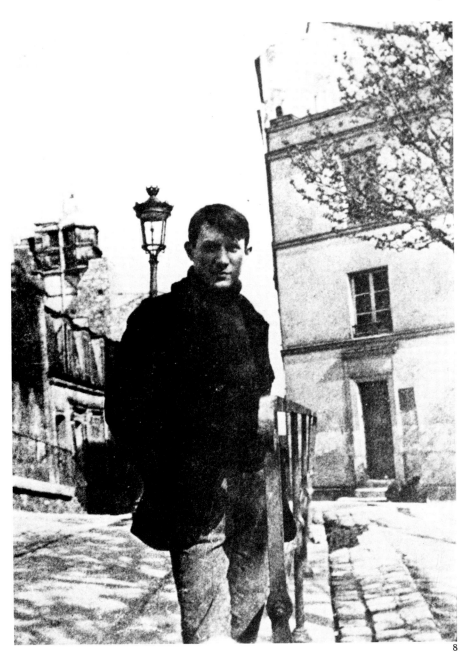

8. Picasso on his arrival in Montmartre in the spring of 1904. Archives of the Musée Picasso, Paris.

9. *La Vida* (Life), Barcelona, June 1903, 196.5 x 128.5 cm. Cleveland Museum of Art. Painted over *Les Derniers Moments*, the picture shows Germaine and Casagemas, on the left.

10. *Alice Derain*, Paris, 1904 or 1905; drawing, 21.5 x 13.8 cm. Musée National d'Art Moderne, Paris (gift of Alice Derain).

11. *Les Deux Amies* (Two Female Friends), Paris, 1904, 27 x 37 cm. Private collection. The standing woman is Madeleine.

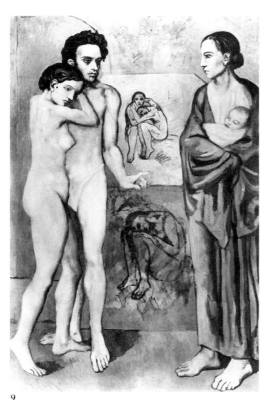

10

9

11

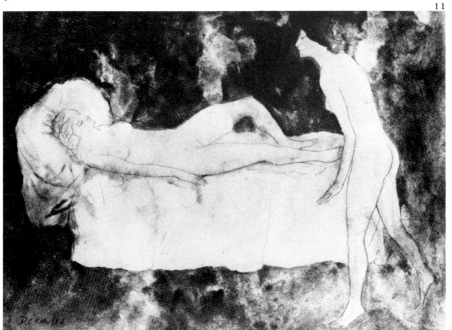

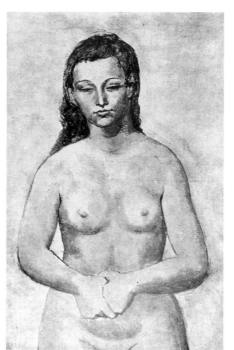

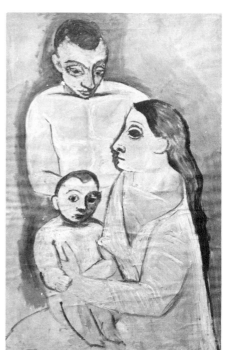

14

12

13

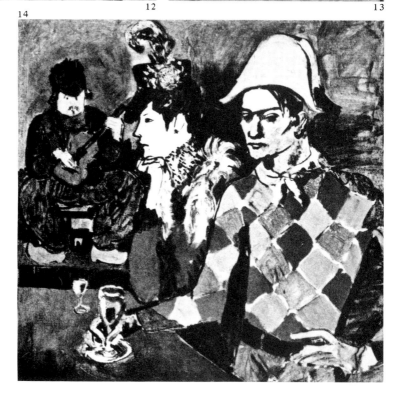

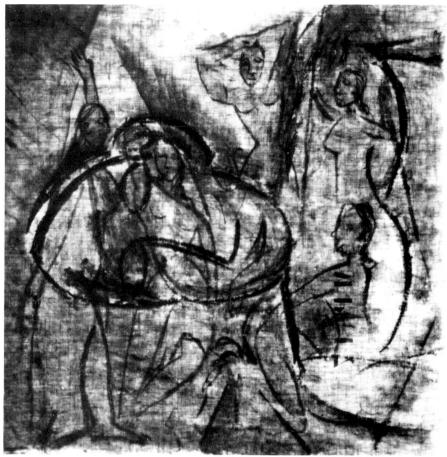

12. *Nu aux mains jointes* (Nude with Clasped Hands), Gosol, spring of 1906, 95.8 x 75.5 cm. Private collection. This splendid portrait of Fernande bears a curious inscription on its back: "To my true friend/Picasso/1st January, 1907." Does this imply that Picasso, annoyed with Fernande, gave the painting away on that date? And if that was the case, to whom?

13. *La Famille primitive*, 115 x 88 cm. Basle Museum. The standing man is Picasso with an "Iberian" face. The seated woman is probably Fernande, who has also been "primitivized."

14. *Au Lapin agile*, Paris, early 1905, 99 x 100.3 cm. Private collection. The guitar player in the background is Frédé, proprietor of the famous Montmartre cabaret. Germaine is to the left of Picasso/Harlequin.

15. Infrared analysis of *Buste de femme à la grande oreille* (Bust of a Woman with Large Ear), revealing one of the initial versions of the *Demoiselles d'Avignon*. Musée Picasso, Paris.

16

17/1

18

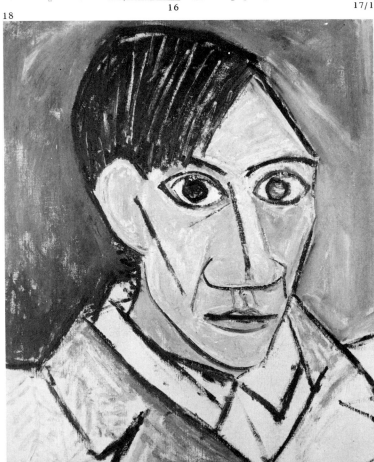

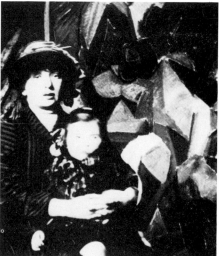

17/2

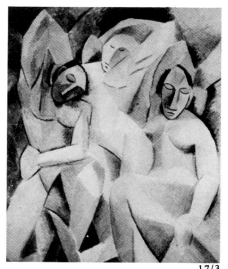

17/3

19

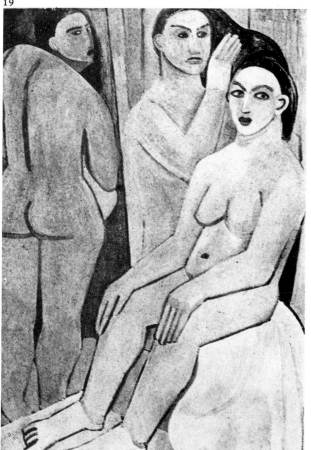

16. *Raymonde,* late spring
or summer of 1907. Page
from a sketchbook, 22.5 x
17 cm. Private collection.

17/1. The painting "not
finished but impossible to
finish, very pale, almost
white, two people
completed in the main but
impossible to finish" seen
by Gertrude Stein and
Alice Toklas during their
first visit to the
Bateau-Lavoir. Study for
l'Amitié (Friendship),
gouache, 63 x 48 cm,
Musée Picasso, Paris.

17/2. Fernande holding
Dolly Van Dongen in her
arms in front of the first
corrections to the
primitivist version of the
Trois Femmes (Three
Women). Photographic
collection of Dolly Van
Dongen.

17/3. *Les Trois Femmes,*
definitive version, 200 x
178 cm. Hermitage, St.
Petersburg.

18. *Self-portrait,* late spring
or early summer of 1907,
50 x 46 cm. Prague Museum.

19. *La Toilette,* by André
Derain, Paris, early 1908.
This canvas, 172 x 120
cm., disappeared after
being sold at Kahnweiler's
second sale in July of 1922.

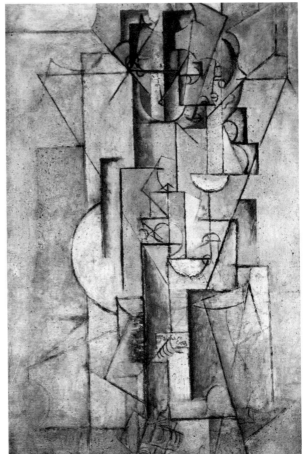

20

21

22

20. Éva and Picasso's dog Fricka,
photographed either at Sorgues or
the boulevard Raspail in late 1912.
Archives of the Musée Picasso, Paris.

21. *Femme nue, J'aime Éva*, 98.5 x
63.5 cm., Columbus Museum of Art,
Ohio, gift of Ferdinand Howell. This
is a "conceptual" portrait, with the
inscription *"J'aime Éva"* ("I love
Éva") in the middle. The painting
was done in late 1912.

22. Fernande photographed by
Picasso at Horta de Ebro, 1909.
Archives of the Musée Picasso, Paris.

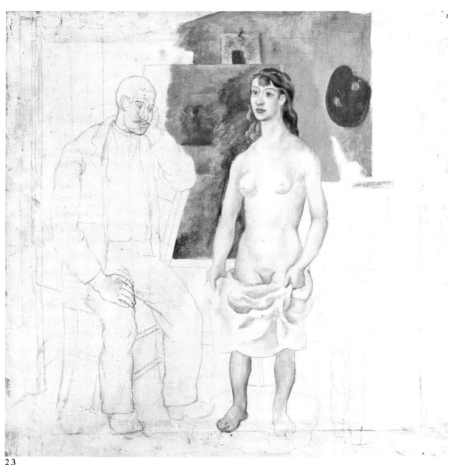

23

24

23. *Le Peintre et son modèle* (The
Painter and His Model), 57.5 x 55.6 cm.
Musée Picasso, Paris. This
unfinished canvas was probably
begun at Avignon during the
summer of 1914, and interrupted by
the war. The woman is clearly
inspired by Éva.

24. Guillaume Apollinaire in the
boulevard de Clichy studio. The fact
that the drawing behind him has
been "squared"—which is not the
case in photographs of
1910—indicates that the photograph
was taken after the drawing's return
from the Stieglitz exhibition in New
York, probably after May of 1911. It
is possible that the photograph was
taken in September of 1911, after
Apollinaire's release from prison.

25

26

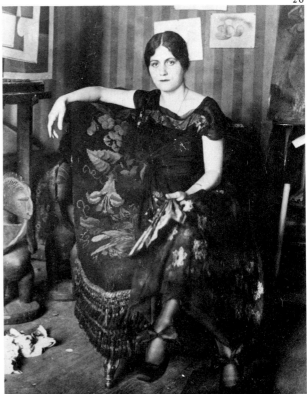

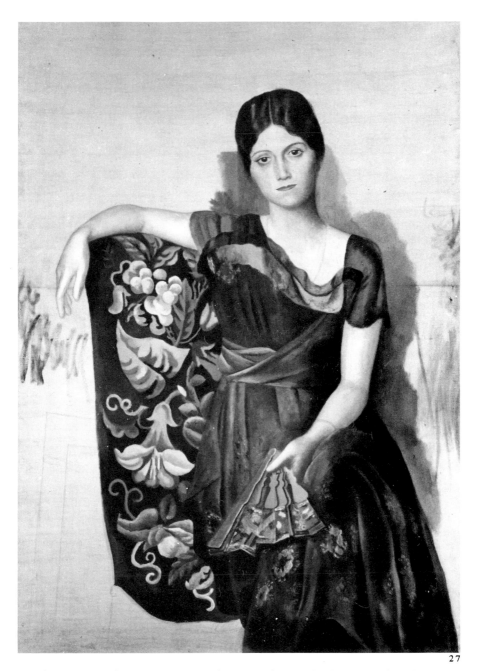

25. Olga, Picasso, and Cocteau in Rome in the spring of 1917. Olga does not yet have the Ingresque central parting in her hair, and Picasso's expression as he looks at her needs no comment. Archives of the Musée Picasso, Paris.

26. Olga, photographed at Montrouge by Picasso, posing as in the portrait he would later do of her. Archives of the Musée Picasso, Paris.

27. *Olga Picasso dans un fauteuil* (Olga Picasso in an Armchair), 130 x 88 cm., Montrouge, winter of 1917. Musée Picasso, Paris.

28

29

30

28. *La Femme au collier* (Woman with Necklace), Cap d'Antibes, 1923. Picasso dreamed of Sara Murphy's pearls at the time.

29. *La Lecture de la lettre* (Reading the Letter), Paris, 1921, 184 x 105 cm., Musée Picasso, Paris. This great painting was revealed only after Picasso's death.

30. Marie-Thérèse photographed by Picasso in 1929, on the beach at Dinard. She was spending her holiday at a vacation colony. Archives of the Musée Picasso, Paris.

31. *L'Atelier* (The Studio), Paris, 1928–29, 162 x 130 cm. Musée Picasso, Paris. The artist's impassive profile confronts a frenzied ideogram.

32

33

34 35

32. *L'Homme au masque* (Man with a Mask), Juan-les-Pins, April 1936. Marie-Thérèse holds Maya in front of a Picasso dressed as a Greek hero. Musée Picasso, Paris.

33. *Faune dévoilant une femme* (Faun Unveiling a Woman), aquatint with sugar and varnish, done with *grattoir* and burin on copper, June 12, 1936. Museum of Modern Art, New York.

34. *L'Artiste devant sa toile* (The Artist Before His Canvas), charcoal on canvas, 130 x 94 cm., Paris, March 22, 1938. Musée Picasso, Paris.

35. *Portrait of Paul Éluard,* Paris, January 1936.

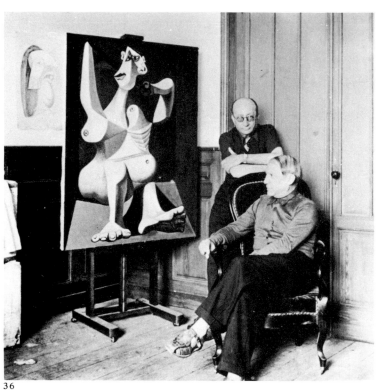

36

37

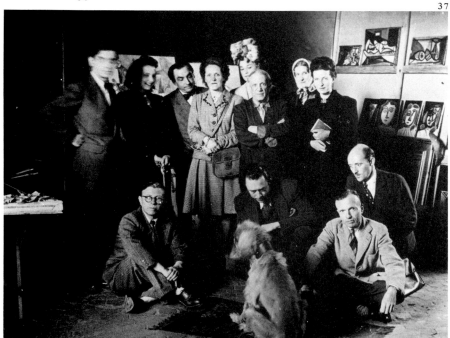

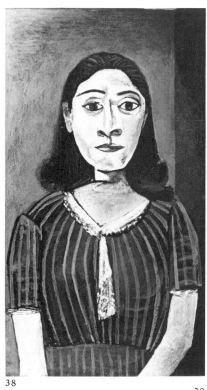

36. Picasso and Sabartès in the studio at Royan, in front of *Femme nue se coiffant* (Nude Woman Arranging Her Hair), also known as *la Drole de guerre* (The Phony War). The photograph must have been taken between June and August of 1940, during the invasion of France.

37. Reading of *Désir attrapé par la queue* (Desire Caught by the Tail) at the Leiris', on March 19, 1944. From left to right: Jacques Lacan, Cécile Éluard, Pierre Reverdy, Louise Leiris, Zanie Aubier, Picasso, Valentine Hugo, Simone de Beauvoir; seated, Jean-Paul Sartre, Camus, the dog Kazbek, Michel Leiris, and Jean Aubier. Photograph Brassaï.

38. *Dora Maar à la blouse rayée* (Dora Maar in a Striped Blouse), Paris, October 9, 1942, 97 x 73 cm. Musée Ludwig, Cologne.

39. *La Femme-fleur* (The Woman-Flower)—Françoise Gilot—Paris, May 5, 1946. Private collection.

40. Picasso and the author in the arena improvised for the Vallauris corrida of July 1953. Photograph André Villers.

38

39

40

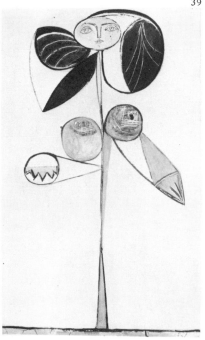

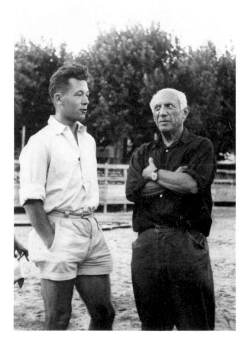

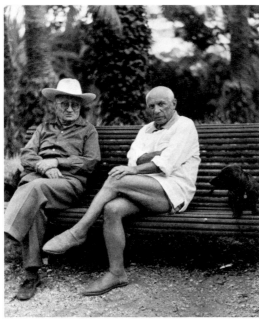

41. The last visit of Jaume Sabartès to Picasso. Photograph Jacqueline Picasso.

42. Picasso assembling the sculpture *la Taulière* (The Landlady). Photograph André Villers.

43. Picasso at Vallauris with his children Claude and Paloma. Photograph André Villers.

44. Picasso in the company of the great cellist Rostropovitch, who at the time was being persecuted in the USSR. Picasso signed the photo so it could be reproduced in the last issue of the weekly *les Lettres françaises*, October 10, 1972. Photograph Jacqueline Picasso.

41

42

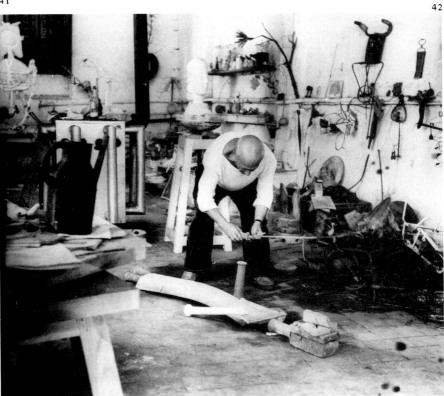

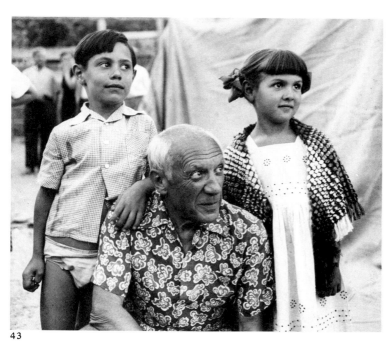

43

44

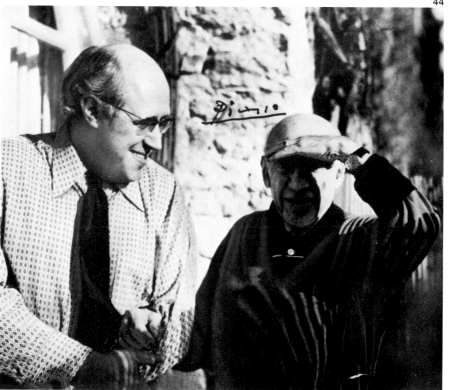

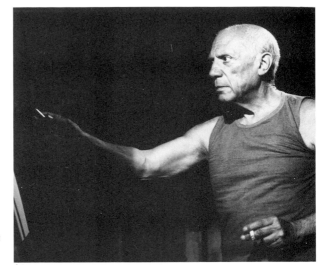

45. Picasso drawing, 1955.
Photograph André Villers.

46. Picasso in his studio at
la Californie, 1955.
Photograph André Villers.

45

46

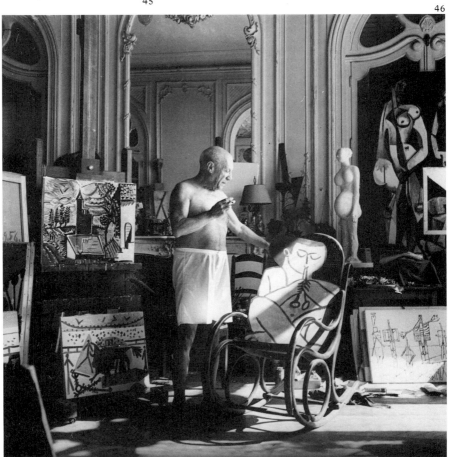

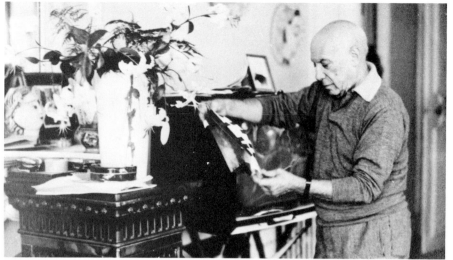

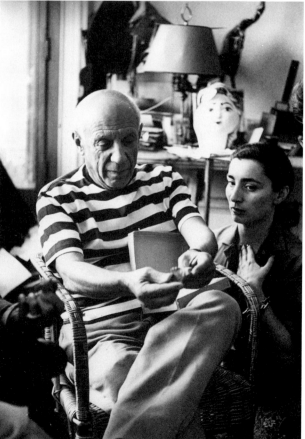

47. Picasso at Mougins. Photograph Jacqueline Picasso.

48. Picasso and Jacqueline at la Californie. Photograph André Villers.

49. *L'Autoportrait face à la mort* (Self-portrait Facing Death), 65.7 x 50.5 cm., Mougins, June 30, 1972. Galerie Louise Leiris, Paris.

20

RENEWAL OF SURREALISM

1929–1930

A t the end of 1928 it was clear that Picasso's return to sculpture had been good for him. In his emotional life he had reached a kind of balance—a landing on the staircase. A great deal was now being written about him. There was Wilhelm Uhde's book, *Picasso et la tradition française,* as well as *Picasso* by André Level, another old friend from before the war. Level's book includes a lithograph of *Visage,* Marie-Thérèse's face—a highly provocative gesture. In *l'Intransigeant* of 26 November, Tériade describes a "Visit to Picasso." The artist, showing his guest some wire sculptures and his sketchbook for *Métamorphoses,* declares that he has never done a painting or drawing which does not reproduce exactly a vision of the world. "I would like, someday, to show my synthetic drawings beside the same subjects done classically. Then you would see my concern for precision."

Kahnweiler deeply regretted that he had sold nothing: the Depression was already taking its toll. But, as he said, "Picasso can wait." His young sister-in-law, Louise Leiris, was running the gallery. Michel, her poet-husband, together with Georges Bataille, had begun a new review: *Documents.* The magazine would run an article on Alberto Giacometti, a newcomer to sculpture, whose *Homme et femme,* in its violence and abstraction, could have come from Picasso's sketchbook. A special issue of the magazine devoted to Picasso would be published in April 1930, following by exactly a month Aragon's praise of Picasso in *la Peinture au défi* (Painting as Defiance). In addition, the fecundity of Max Ernst and the innovations of Miró and André Masson had re-created a climate of discussion and novelty of a kind Picasso had not encountered since 1914. When confronted by new questions on the meaning of art, he surpassed himself. At such times he was at his most daring, going to the greatest lengths in what might be called his personal Surrealism.

Picasso was not trying to give form to the unconscious of dreams or fantasies—yet another category of subjects "external" to painting. What Picasso drew from Surrealist ideas was the liberty they gave to painting to express its own impulses, its capacity to transmute reality; its poetic. Which

FROM SUR-REALISM TO SURREALISM

Early 1913 or summer 1913	Assemblage of a "conceptual" guitarist holding a guitar (now destroyed, photographed in the boulevard Raspail apartment).
End of 1913	*Femme en chemise assise dans un fauteuil.*
Spring 1914	Sculptures of *Verre d'absinthe.*
Avignon, 1914	Baroque drawings, *Homme assis au verre, Portrait de jeune fille.*
May 1917	*Parade.* Apollinaire launches the term *sur-realism.*
September 1918	Aragon praises Picasso's *papiers collés* in Louis Delluc's review *le Film.*
November 1919	Frontispiece for Aragon's *Feu de joie.*
Summer 1923	Meets Breton at the cap d'Antibes. First *sablées* paintings.
November 1923	Breton persuades couturier Maecenas Jacques Doucet to buy *les Demoiselles d'Avignon.*
June 1924	Uproar over sets for *Mercure.* Surrealists support Picasso.
Summer 1924	Notebook of abstract drawings known as *Carnet de Juan-les-Pins.*
January 1925	*Révolution surréaliste* publishes *Carnet de Juan-les-Pins.*
July–August 1925	*Révolution surréaliste* begins publication of Breton's *Surréalisme et la peinture* and publishes *les Demoiselles d'Avignon. Le Baiser* and *la Danse* completed a few weeks earlier.
November 1925	Participates in Surrealist exhibition at the Galerie Pierre.
Spring 1926	Aggressive assemblages. *Guitare-serpillière. Guitare à l'aiguille à tricoter* immediately published by *la Révolution surréaliste.*
June 1926	*Révolution surréaliste* publishes photograph of Melanesian ritual scene, with masks.
Summer 1926	Picasso begins new Primitivist campaign.
Summer 1927	Cannes. Drawings for *Métamorphoses.*
Early 1928	*l'Atelier* and *le Peintre et son modèle.*
Summer 1928	Dinard. *Baigneuses* and study for monument to Apollinaire.
Autumn 1928	First iron sculptures at Gonzalez's studio.
February 1929	*Buste de femme avec autoportrait.*
May 1929	*Grand Nu au fauteuil rouge.*
February 1930	*La Crucifixion. Baigneuse assise au bord de la mer.*
April 1930	Special edition of *Documents* dedicated to Picasso. *La Peinture au défi.*
Summer 1930	Juan-les-Pins: Series of sanded assemblages, with objects in unusual combination.
February 1931	Tzara's article on *papiers collés (Cahiers d'Art).*
August 1932	*Baigneuse jouant au ballon.*
October 1932	Drawings after Grünewald's *Crucifixion.*

(Continued)

February 1933	*Une anatomie.*
June 1933	First issue of *Minotaure.*

is why he dreamed of giving concrete form to the visions his brush created: a project in this case which was without precedent.[1]

In 1907, or in 1909, he had used sculpture to produce Primitivist or Cubist models with which to test the validity of his pictorial experiments. Similarly the free-form *Guitare* of 1912 re-created the inverted volumes of the Wobé-Grebo mask and became the point of departure for the revolution in *papiers collés*. With the assemblages of 1913 and 1914 and the *Verre d'absinthe*, Picasso assumed an inverse posture: creating objects which gave material form to the challenges posed by painting. This happened again beginning with the autumn of 1928 but in entirely new conditions, which were driving him to establish the autonomy of his work in three dimensions. Until then he had compensated with *bricolage*—with tinkering—for any technical inadequacies which might have inhibited full expression of the forms he imagined in his painting and drawing. His collaboration with Gonzalez would now allow him to take some decisive steps.

The question was somewhat obscured by the first critics, who knew none of the earlier history of Picasso the sculptor and *assembleur*. Further, Zervos' publication after the war of Picasso's sketchbooks was far from complete. Through the efforts of Werner Spies and with access to working notebooks and to corrections made by the staff of the Musée Picasso in Paris, we have only recently established a precise chronology, bringing us closer to some of the secrets of creation. Picasso began to work on his first metal *Tête* in Gonzalez's studio in the autumn of 1928. This is an assemblage which is more or less clobbered together. However, from early 1929 on, a major piece was under way: *la Femme au jardin*, whose date is fixed by the large canvas of 24 April 1929, *Femme, sculpture, et vase de fleurs*.[2] Like the first *Tête*, the *Femme au jardin* derived from the abstract schemes of *l'Atelier*. Here Picasso enriched them with little "tongues" of metal, which suggest a head of hair, while two metal flowers inspired by a philodendron at the rue la Boétie create a setting.

Michael Cowan Fitzgerald has established that in 1928 the Comité Apollinaire held its annual meeting on 10 November. At the meeting Picasso announced that the maquette for the memorial was ready and then proposed his wire sculptures. These once again were rejected. The following day, 11 November, the first sketches for *la Femme au jardin* were done. Picasso had no illusions as to their probable reception by the committee. The sketches do, however, reflect his continuing interest in pursuing Apollinaire's sur-realism in various works of sculpture. *Personnage feminin*, reduced to an armature, is a postscript to these efforts. One of Brassai's photographs shows it embellished by various objects which Picasso hung on it.[3]

Meanwhile his painting suddenly—with *Buste de femme avec autoportrait* (February 1929)[4]—began to reflect the violence of his domestic situation. And it was then that the ideogram of Olga took shape, undoubtedly drawn from the image she presented as she screamed invective at her husband. Her head is reduced to two angular bands—almost at a right angle—with two rows of enormous teeth from which thrusts a pointed tongue. Other long marks suggest hair. And in the background, the framed, impassive profile of the artist. Is he thinking of his marriage, which so closely followed Apollinaire's? Is he painting his life as it was at that time? Forcing himself to feign detachment, he had to endure Olga's vociferous outbursts, which sometimes pursued him down to the street or onto a holiday beach. In another version the shrieking head is done in curves. The artist's profile is in the foreground, but here the setting of *l'Atelier* is restored, the setting, stressed by the title of the great canvas, which Picasso kept.[5] The same violence is evident in *Femme au fauteuil rouge,* and above all in *Grand Nu au fauteuil rouge;* these, too, stayed in Picasso's collection.[6] In the exaggerated lengthening of the flaccid arms, which resemble dangling viscera, there is something like compassion for this delirium of solitary misery. Life had been destructive to this woman whom Picasso had wanted, who had become his wife and the mother of his son. The painting which surmounts this disaster is its strongest element.

A parallel work to this one—a nude *Femme couchée,* with her hands behind her head—brings the plastic remodelings of Dinard to a modern interior. Her legs are parted; placed between them are three fruits. The painting's colors are those of Marie-Thérèse. The large canvas of 24 April puts an immense "synthetized" woman in the shadows of the studio. She faces a sculpted head on a plinth, which seems also to be holding a vase of flowers. The head, in profile, is pure Marie-Thérèse. There is also a synthetized *Baigneuses à la cabine* and then on 26 May a *Grande Baigneuse,* which is an imaginary monument.[7] This work is followed by the painting *Projet pour un monument,* a geometrized head of Olga in a structure of five levels, with little personages to give the scale.[8]

The following summer, spent at Dinard, did not reduce the increasingly clamorous sense of crisis evident in the paintings. Marie-Thérèse once again was there, probably at a holiday camp. (She had just turned twenty—an age which at that date ruled out any possibility of living alone.) Other elongated bathers appeared in the paintings, but the reorganization of forms was more contained, and the erotism of face and breast is keen. Marie-Thérèse is not recognizable here but can be detected if one knows her synthetized image. These paintings would not be made public until David Duncan's *Picasso's Picassos* in 1961. Violence erupts in *le Baiser* of 25 August: Olga, her nose sharpened into a murderous beak, seems ready to pierce a head as blond as that of Marie-Thérèse.[9]

Dated 22 November, the large canvas *la Fenêtre ouverte*[10] is a staging point. Against the impassive landscape of Saint-Philippe-de-Roule, as seen

from the rue la Boétie, the ideogram of Olga's head is to the right, at the end of a vertical arm. The arm in turn is supported by its hand, which rests on the ground. To the left, two feet, connected by a leg, stand on a ball. The leg is pierced in its center by an arrow. Is this a dream—or a nightmare—of flight through the open window? The same phantasmagoria appears in a *Nageuse* (Swimmer), disarticulated in its element and its weightlessness and—on 18 January 1930—in the extreme contortion of *Acrobate*.[11]

Meanwhile Picasso suddenly discovered how to translate the rigor of his facial ideograms into sculpture. Pages from a sketchbook of 12 January display the transformation of one of these into a latticed assemblage in which the nose becomes a triangle of metal rods in front of a concave shape. The tangible realization of this idea is an astounding *Tête de femme*, a sculpture-assemblage without precedent, whose volume, behind a concave mask, is made of two colanders soldered together. Gonzalez went to buy them; he remembers that he and Picasso "cracked a lot of jokes" as they worked—an indication of the speed with which these three-dimensional inventions evolved from the initial, inciting ideas. The woman's hair is made with springs and strips of metal.

Through the solidity and autonomy of metal Picasso reclaimed the powers of transmutation which in 1914 made the neck of a bottle from a sawn-off table leg. Another, more abstract version of *Tête* puts greater stress on re-use of African sources: particularly of a Kota reliquary mask (also used, one might note in passing, by Giacometti in 1927 for a plaster woman).

A recollection of Gonzalez's—more precise than anything we had earlier—was unearthed in 1978 by Josephine Winters.[12] He remembers that while working on his *Monument à Apollinaire* (probably the *Femme au jardin* version), "Picasso repeated—quite often—'I feel as happy as I was in 1912,' " which takes us back to the discoveries of Ripolin, the first collage, and the *Guitare* and suggests just how important this rebirth of sculpture was for Picasso.

Beginning with *Buste de femme avec autoportrait* we have followed a transcendence through art which culminates in these unprecedented sculptures: the dramatics of private life transmuted by plastic expression. In painting there had been a similar process of transcending and exceeding. But here, one might say, it has been in an inverse sense, because it is expressive violence itself which supplies the subject, *la Crucifixion*, of 7 February.[13] The convulsive heads and fantastic distortions of scale are carried to an extremity of unbearable violence in a small canvas (50 × 65 cm.).

Roland Penrose has shown that in the initial studies, the convulsive women at the feet of Christ derive from the frenetic maenad to the left of *la Danse*. This link to the transposition of Germaine-as-killer—killer of Casagemas; killer of Pichot—indicates the degree to which Picasso could transform his own impulses into symbols. These, although abstracted from

their intimate origin, preserve its violence. Here Christ on his cross is crucified by Olga's invective. This Christ, who delivered himself to every outrage, is living the measureless sorrow of an all-too-human agony.

I don't think the anthology of resemblances to predecessors—to which exegesis of this work is too often reduced—is particularly pertinent. The illustrations for l'Apocalypse de saint Sever,[14] however, as Golding stresses, are an exception. Picasso drew from the dramatic repertory of symbols, emblems, and plastic distortions he had been using since la Danse and le Baiser, putting these at the service of the oldest subject in Western painting. References to the corrida are a notable instance of this; the conjunction of corrida and Crucifixion; the presence of the little horseman bearing his lance.

To paint la Crucifixion, even a heavily sacrilegious version, is nonetheless to paint a subject: a subject, an historical tableau par excellence. To be sure, Picasso gave the subject a highly Surrealist treatment. But who or what is being attacked? Is it the Surrealist interdiction of such subjects (and of any subject, echoing the parallel Cubist interdiction)? Or is it the belief that modern painting cannot be reduced to large Classic events? If a Surrealist painting can use the Crucifixion, can interiorize it, retaining its meaning, its anecdotal details (the centurions playing dice, the bodies of the thieves who had been hung, etc.) that would mean that all the theorizing about what was impossible for Surrealist—or modern—painting was false.

This kind of testing was normal for Picasso because, as Rubin notes, "The areligious character of La Crucifixion is extreme, in that it is literally antisacramental. . . . Since the vantage point of spectator and artist is the same, a man, here, substitutes himself for God."[15]

La Baigneuse assise au bord de la mer (Bather Seated beside the Sea),[16] a canvas of the same period, constitutes with the Crucifixion the apex of Picasso's personal Surrealism. (We do not, unfortunately, know which of the two came first.) This praying mantis, given form by a network of bones, totally transparent—like the wire sculptures—but nonetheless prehensile and devouring, is probably one of the most typical and justly celebrated images of this period in Picasso's work. It summarizes the entire cycle of outrage provoked by Olga, her rages, and the theme of cruelty. One can without undue reference to psychoanalysis appreciate that this is a form of catharsis.

In any event this unburdening had its effect. The work of the time indicates that the peak of the crisis had passed. Marie-Thérèse would be a principal element during the summer that followed, and Picasso organized himself so that he could take the fullest advantage of his lover's independence. In the spring he bought the Château de Boisgeloup, near Gisors, in the furthest northeast of Normandy and accessible only by car (which, at the time, makes surprise visits extremely unlikely). Under the pretext of installing a studio for sculpture in the former stables, he had a perfect excuse for escaping Olga and freely receiving Marie-Thérèse. By autumn Picasso could not do without her, and back in Paris settled her into 44 rue

la Boétie, right across the street from him. Once again there was the spice of playing with fire, but the secret was kept so closely that even Kahnweiler suspected nothing. His gallery in the rue Astorg, right next door, was one of Picasso's standard excuses for having to go out.

The summer holidays were once again at Juan-les-Pins, which suggests that in agreeing to Dinard for the two previous summers and feigning to yield to Olga's preference for that bourgeois watering place, Pablo was really thinking of seeing Marie-Thérèse at her summer camp. Now, however, Marie-Thérèse could come to Juan like an adult. The paintings of that holiday are characterized by a remarkable easing of tension: so much so that—through an error of Kahnweiler's—they have often been assigned to 1933 because of their Surrealism. The pictures are sanded, reworked, made with fragments of *objets trouvés;* but in composition they are diverted from their original identity to become beach scenes. A glove, some straw, a few twigs, nails, a leaf, a butterfly, a fragment of palm frond, even a child's toy boat—all are incorporated into collages-assemblages of an entirely new genre which will stimulate successors right down to Dubuffet.[17] One senses in them a return of alacrity, with the power of deliverance. He was probably resigned to the ruin of his marriage, which does not mean that he planned a separation.

At the end of the summer he inaugurated his studio at Boisgeloup by rough-cutting pine branches into sixteen female figures. These are very elongated and entirely non-imitative but nonetheless bear an astonishing resemblance to Marie-Thérèse. Werner Spies has linked them to the publication of Etruscan bronzes in the Surrealist magazine *Documents*. But Picasso had found here the respect for a material's natural form which imbues all primitive art and African art in particular.[18]

Once again one can confirm the degree to which Surrealism had carried to an apex the cultural mutation which began in the 1870s. Launched by the discovery of non-perspective space in Japanese woodcuts, it was spread still further by the Primitivism of Gauguin. During this critical period of 1929–30 Picasso organized all of the discoveries he had made since 1924 into a fresh set of mental equipment. And, of primary importance, he found within that equipment the explanation and intellectual justification of intuitions as far back as 1906. Surrealism had made possible a census of proof that the art of humankind was far richer than that fragment retained by the classics; but further, by looking everywhere for precursors and guarantors, it corroborated the validity of associating certain ideas and shapes, metaphors and symbols of great expressivity in primitive arts. And, during the course of the most serious domestic crisis of his life so far, he had proven the power of exorcism and liberation inherent to such transmutations; and had proven as well their plastic validity. The most fantastical of his formal inventions had been shown to work. He had proved these things as much by the energy of his latest paintings as by the force and novelty of his metal sculptures.

His slashed pine-branch figures demonstrate that now that he could

associate Marie-Thérèse more closely with his life, he wished to externalize everything she inspired in him. In the autumn of 1930, Albert Skira, who was making his first moves as a publisher and who had surely heard of Picasso's *Métamorphoses,* asked him to illustrate an edition of Ovid on that subject. Picasso accepted. The result would be astounding. As he had done previously with Cubism, transmuting it into portraits which resembled their subjects, so, now, he inscribed the remodeling of his Surrealism with engravings of transcendently Classical graphism. And why not in the guise of these amorous transvestisms sing with full voice his love for Marie-Thérèse? In 1926 in the reworking of a still life, the two *eaux-fortes* of *Chef-d'oeuvre inconnu,* and the lithograph *Visage,*[19] such avowal—even masked—had been impossible.

The thirty *eaux-fortes* were almost all done between 13 September *(Femme couronnée de fleurs)* and 25 October—Picasso's forty-ninth birthday *(Amours de Jupiter et de Sémélé).* Sémélé is Marie-Thérèse, endowed with the symbol Pablo used for her face, a nose whose prominence in relation to the brow is repeated in sculpture. He, of course, is Jupiter. In sequels done in 1931 Marie-Thérèse is the reigning queen: in *Deux Têtes de femme* and the sublime *Fragments d'un corps de femme,* which immortalize her body.[20]

Painting would take its turn next, to be followed and surpassed by sculpture. The season of Marie-Thérèse had begun.

HYMN TO MARIE-THÉRÈSE

1931–1932

I n the spring of 1970, in the most retired part of the *mas* of Notre-Dame-de-Vie, Picasso in my presence pulled from a heap of paintings *Nature morte sur un guéridon* (Still Life on a Pedestal Table), a canvas considerably taller than either of us. Dated 2 March 1931, the work is a powerful interlacing of black curves which project contrasting volumes in bright colors. "I said it myself to Barr, and he even wrote it: 'Here's a real still life,' " Picasso shouted behind me. I said, "It seems to me I can still see Marie-Thérèse." Picasso went and traced on the canvas with his finger, against the rhythms of the still life, which were practically unchanged, the curved outlines of Marie-Thérèse. He turned back to me and tapped me on the shoulder. "That's why I've always said to you, 'Here's a real still life!' "[1]

On that day I realized the degree to which Surrealism had liberated Picasso and, if I might say, confirmed the power of inspiration. Since the blue period, through a succession of insurrections against academic realism and rationalism, he had "yielded" to inspiration, particularly since he began to draw on the primitives but often with a sense of infraction. Now he knew that the opposite was in fact true: that far from indulging in infractions, he was drawing on the true sources of art.

March 1931 was the moment at which Picasso separated himself from the cycle of anguish and violence and opened himself to lyricism and love; and his painting reveals the secret broached in his engravings. *Figures au bord de la mer* (Figures by the Sea) of 12 January, with heads like toothy vulvas, and *Femme lançant une pierre* (Woman Throwing a Stone) of 12 March still belong to the Olga cycle. Marie-Thérèse appears, three-quarter face, in *Femme au fichu de dos* (Woman in a Shawl from the Back) of 20 March and is present again at the end of April in *Deux Femmes nues devant la fenêtre* (Two Nude Women beside Window).[2] *La Lampe*[3] of 8 June proclaims possession of Boisgeloup, illuminating an imaginary bust of Pablo in front of the stable door.

Once again the summer at Juan-les-Pins radiated happiness. Pablo, as usual, drew his house. Then, taking up a drawing from the beginning of the year, he painted a sleeping Marie-Thérèse. Her profile stands out against a

loop of blond hair, which melts into an arm. *Femme aux cheveux blonds* (Woman with Blond Hair)[4] is still a hidden portrait. A drawing of 4 August, *le Sculpteur et son modèle*, suggests things to come. Marie-Thérèse's face is not that of the principal figure; it is, however, in the picture's foreground, its eyes lowered, in the attitude of the most admirably classic sculptured head: *Marie-Thérèse à la tête inclinée*, which was probably the first to be conceived. The engravings of June and July to be included in the *Suite Vollard* were specifically of Marie-Thérèse, particularly *Homme dévoilant une femme* (Man Uncovering a Woman, with the woman sleeping; offered in the innocence of sleep); and again in *Femme nue à la jambe pliée* (Nude Woman with Bent Leg), done in July, at the same time as a *Viol* (Rape).[5]

When Boisgeloup was ready, Picasso turned to sculpture. A *Baigneuse* gives concrete form to a drawing of 1927 based on the Venus of Lespugue; while a *Baigneuse allongée* (Recumbent Bather) recalls the recumbent nudes of Matisse, even though it in fact derives from August drawings at Juan, which show her in fragments, in the manner of *Figures au bord de la mer*. Picasso's desire to return to sculpture was surely connected to the Pierre gallery's 1930 show of no fewer than sixteen of Matisse's recent sculptures. A *Tête*, a *Buste de femme*, *Yeux* (Eyes), and a *Tête de taureau* (Bull's Head) were in preparation for the great leap forward made by four large modeled heads of Marie-Thérèse, a head in high relief, and a left profile.[6]

Work began in early December. A drawing of 4 December and an oil of 7 December on plywood show the sculptor with a beard in the antique mode meditating before a bust of Marie-Thérèse. The group seems to have been done simultaneously. Picasso moved as if with a single impulse from the "naturalist" head and profile to the most extreme—even dissociated— plastic variations: the cumulative production of a series. The two noblest heads—with the nose which divides the brow and enormous eyes—were almost entirely imagined in a drawing of 11 August, done at Juan, at the same time as the drawing which breaks Marie-Thérèse's curving lines into separate fragments.[7]

The "classic" head of Marie-Thérèse rivals the *Tête de Fernande* of 1906, with a marvelously harmonious woman's face. As one can see in the almost diabolic dialogue between painter and sculptor which follows, this harmony is sustained in the canvases *Fauteuil rouge* (Red Armchair) on 16 December; the admirable *Sommeil* (Sleep) on the 23d; *le Rêve* (The Dream), the most celebrated painting of the series, on the 24th, in which the forehead is contoured like a piece of sculpture; and finally a repetition of this last effect with another *Lecture* (Reading) on 2 January. From these we are taken to the most complete dissociations: those of the *Femme au fauteuil rouge* of 27 January and of *Femme assise au fauteuil rouge*—both of these done at Boisgeloup.[8] These fragments, which have been remodeled and separated, preserve the model's grace and prepare for the glorification of her plastic rhythms, in which the sculptor allows his imagination free reign. There is a sense of reciprocal rivalry, of challenge between Picasso the

painter and Picasso the sculptor, as if they were arguing about the best way to exalt Marie-Thérèse. And it is Boisgeloup, with its isolation and its possibilities for sculpture, which produced this sensual effervescence.

The contrast with the dislocations and remodelings derived from Olga is total. Did Picasso imagine—or in fact was there—a particularly severe crisis of jealousy with Olga at or near Christmastime? (One must, of course, concede that she had her reasons.) Between 19 and 25 of December Picasso painted one of the most disquieting in his series of monstrous, flabby women: the *Femme au stylet* (Woman with Stiletto), a work destined to engender a certain posterity.[9] The outpouring of feeling in this picture stresses better than anything else all the oppositions in continuity of plastic recomposition, of plastic language—from the *Femme au fauteuil rouge* (Woman in Red Armchair) to the *Figures au bord de la mer* (Figures beside the Sea) done almost exactly a year earlier. One must remember this in order to appreciate the figurative liberty Picasso now allowed himself. His personal Surrealism had now literally become his pleasure, in both painting and sculpture.

On 3 March he translated his excitement into *Nature morte, Buste, Coupe et palette* (Still Life with Brush, Goblet, and Palette), resuming as if for an anniversary a colloquy with *Nature morte sur un guéridon* (Still Life on Round Table). These were followed during the next few days by the sleeping Marie-Thérèse in *Nu sur une couche noire* (Nude on a Black Couch) and *Nu au miroir* (Nude before a Mirror) sold in New York in November 1989 for $26.4 million.[10] The multiplication of profiles, the interplay of curves, the reflections of the mirror which make possible the display of all forms in the round, the dissociation of the breasts, the sectional view of the belly as a womb, reflected in a three-quarter turn to emphasize the vulva—all combine to express amorous emotion. The decorative sumptuousness, however, suggests rivalry with Matisse. In June 1931 the first Matisse retrospective in Paris since 1910 opened at the Georges Petit gallery: 145 canvases with many from the Nice period of the 1920s. And in the autumn Picasso had received the Carnegie Prize from a jury which had included Matisse. That the prize had been for one of the most classical of Olga's portraits was also, perhaps, a contributing factor in the release of a torrent of images as Picasso unburdened himself of the feelings inspired by his young mistress over a span of four years, feelings as yet unslaked.

Kahnweiler came to the studio on 17 March, three days after *Jeune fille au miroir* (Girl before a Mirror), which he surely saw. He wrote to Michel Leiris:

> Yes; as you say, painting is really sustained by Picasso: and so wonderfully. We saw two paintings at his place which he had just finished. Two nudes, perhaps the most moving things he's done. "A satyr who had just killed a woman might have painted this picture," I told him. It's neither

cubist nor naturalist. And it's without painterly artifice: very alive, very erotic, but the erotism of a giant. . . . We left feeling quite overwhelmed.[11]

In June Picasso organized his own retrospective at Georges Petit's. The show was aimed squarely at the important dealers: the Bernheim brothers and Étienne Bignou, as well as Paul Rosenberg and Georges Wildenstein, a choice of targets whose wisdom has been amply demonstrated. The show brought together for the first time a bullfight of 1901, the public part of the Casagemas cycle, l'Enterrement (The Burial), le Mort (Death), la Vie (Life), the blue Autoportrait (Self-Portrait), la Célestine (The Celestine), classical canvases from Gosol, and Deux Femmes nues of 1906. Missing was work from the Demoiselles period and "African" works. It seems Picasso wished to avoid discussion of these subjects. Yet Horta was represented—the Femme nue assise (Seated Female Nude) from the end of 1909; the Portrait d'Uhde and the Jeune Fille à la mandoline, for the birth of Cubism; and other Cubist works, among them, Femme à la cithare (Woman with Zither); l'Homme à la clarinette (Man with Clarinet); Souvenir du Havre; some elaborate papiers collés, including Guitare of 1913 and la Femme en chemise (Woman in Chemise; known at that time as Femme aux seins dorés, Woman with Gilded Breasts), the Portrait de jeune fille (Portrait of a Young Girl) from Avignon. The grand Arlequin of 1915, the abstract Homme accoudé (Man Leaning on Elbow) of 1916, lent by Mme de Errazuriz led to Olga, the Trois Musiciens (Three Musicians), Flûtes de Pan (Pan Pipes), la Grecque (Greek Woman), la Danse, l'Atelier de la modiste (Dressmaker's Workroom), and la Crucifixion. To conclude there was a splendid bouquet of canvases inspired by Marie-Thérèse, ending with le Rêve.

Picasso had mined his ample store of work, excluding the most violent sequences not to censor himself but more probably because in the spring of 1932 these were not in accord with his happiness in painting. Further, he knew that no one would understand them. His interview with Tériade for l'Intransigéant of 15 June does not provide a thorough technical description of working methods. "Pictures are always made the way princes make their babies: with shepherdesses" (a smile here to Marie-Thérèse). But then he immediately resumed his mask. "One never does a portrait of the Parthenon; never paints a Louis XV fauteuil. Pictures are of a shack in the Midi, with a packet of tobacco, an old chair."

All his interlocutors were present, except the classics: Braque and Cézanne, van Gogh, himself. To banish any possibility of misunderstanding, he stated it squarely: "In the end, everything depends on one's self, on a fire in the belly with a thousand rays. Nothing else counts. That is why, for example, Matisse is Matisse: the only reason. He's got the sun in his gut. And that is why, too, from time to time, there are some pretty good things."

Who can know exactly where this "fire in the belly" comes from? Had he even confided it to Marie-Thérèse? In the fragment quoted above,

Picasso went even further: "I have made a solitude for myself which no one suspects." This avowal is preceded by a fundamental reflection which casts a certain obscurity: "I don't work from nature, but in front of it, facing it, and with it."

France was then belatedly entering into the economic crisis of 1929, and, as André Fermigier has noted, criticism treated Picasso as if he were personally responsible for a parallel "crisis of the arts." Germain Bazin, then a young curator at the Louvre and considered a modernist, had no hesitation in writing that "Picasso belongs to the past, and his downfall is one of the more troubling problems of our time." Waldemar George launched a notion which would be widely accepted and in vogue: "In attacking mankind, Picasso is satisfying his iconoclastic rage. He kills like a murderer incapable of satisfying his thirst for possession." When the retrospective moved to Zurich, Jung gravely demonstrated in the *Neue Zürcher Zeitung* that the fragmentation of the paintings proved Picasso's schizophrenia.[12]

Here a double fault line becomes apparent. First between the United States—or rather New York—and Europe; then between the younger intellectual generation in France—the Surrealists, the *Cahiers d'Art* group and the young artists attached to their ideas—and the official artistic institutions. The situation was no longer what it was before 1914, when Cubism and the beginnings of abstraction were opening up a new pictorial and plastic continent whose future was generally unknown. The *retour à l'ordre* post-1919 was not limited to artistic matters. France—victorious but bleeding and ruined—clung to its cultural past and feared modernity. Picasso, like Matisse, symbolized a readiness to consider an opening toward the transformations of the twentieth century.

The best piece on the retrospective was written by Jacques-Émile Blanche, a critic-painter some twenty years Picasso's elder and normally far too affected by worldly calculations. It was he whom Proust had urged, fifteen years earlier, to "do justice to the great and admirable Picasso." At seventy-one this man, who had always painted in exactly the same way, noted before "these heroicized easel paintings" that "there are so many different kinds [of painting] here that accurate observation of one would almost surely give a false view of another. Each mode, each stage of Picasso's journey requires the critics to alter their posture."

And that, in fact, is the principal element of intellectual disturbance. By his life and work, by the transformations he effected, Picasso proved that art in the twentieth century, like the sciences, had become multifaceted. Beauty was no longer the single solution to a unique problem but numberless explorations of numberless impulses from the vast unknown. Blanche concluded:

> In recapitulating my feelings, I would turn to the latest avatars of the Proteus of the rue la Boétie for the key to the enigma. Taste, taste, and

then again taste, manual dexterity, the virtuosity of Paganini, the whim of the artisan who, with a bit of string, of brass, creates an object which is stimulating, ingenious, and poetic. He can do everything, knows everything, and succeeds in everything he tries.

Proust himself would have been pleased by such a comment.

For the summer of 1932 Picasso sent Olga and Paulo alone to Juan-les-Pins and spent most of his time at Boisgeloup. Kahnweiler came to visit, as did Louise and Michel Leiris and Yvonne and Christian Zervos (who in the autumn published the first volume of his catalogue of Picasso's work from 1895 to 1906). Maurice Raynal came, and Braque. And Gonzalez, which makes me suspect that not enough sculpture has been assigned to that summer. Gonzalez in 1936 said in *Cahiers d'Art* that Picasso "considered everything, every object and subject. Because every shape meant something to him; he saw things as a sculptor." I think that the two roughest, most abstract women's heads come from this summer, too: one modeled, the other carved in stone.[13]

No one had met Marie-Thérèse. But on 30 August Picasso produced a *Baigneuse jouant au ballon* (Bather Playing with Ball) which collects all the painted and sculpted organic remodelings. In the background there is a beach, edged by cliffs, as at Dieppe or Etretat, which are both quite near Boisgeloup. To imagine Marie-Thérèse spending the summer there, with Pablo secretly joining her, is not altogether improbable. Especially as in the autumn, beach scenes will haunt both painting and engraving, scenes in which Marie-Thérèse plunges into the water, scenes of rescue from drowning—the young woman is omnipresent.[14] Figurative work rediscovers the dynamism of Dinard and formal reworkings as decisive as those attempted in the Acrobat series of early 1930.[15] As always with him, an idea and plastic rhythms provoke new subjects. It was probably a recollection of 1930 which on his return to Paris led him back to the Médrano circus.

Brassaï, who since the beginning of the year had spent a lot of time with Picasso, followed him there with Paulo. A few days later Picasso showed him "a stack of paintings, face to the wall": the tightrope acrobats, of a few evenings before. "They disappeared," Brassaï noted, "as the composition became more clenched, more searching."

These are not—any more than the scenes of *Sauvetage* (Rescue)— simply the "game" of painting. They indicate a return of anguish—perhaps Olga's return to Paris. The provocative agent here (the item which triggered this release) had been a reproduction of the Isenheim altarpiece by Grünewald at the Colmar museum. The force and violence of the central composition had inspired Picasso on 17 September to an attack of comparable vehemence. He took a series of drawings based on the violent forms of the 1930 *Crucifixion* and put them through a passage of abstraction to become—on the 19th—a redrawing as skeletal structure. After a passage through pathos, the bones (between 7 and 21 October) were brought back to indicate the body of Christ.

With this work Picasso reached one of the pinnacles of his baroque style and of his obsession with death. But neither quality inhibits the element of humor which—in a naturalistic study—imagines a piece of drapery held in place by an infant's safety pin, depicted in meticulous detail, with a drawing of a screw to hold the bones in place.[16]

Like a cinematographic reverse shot, the gravures of *Sauvetage* led to engravings of the sculpted heads at Boisgeloup, which he first included in a painted still life.[17] He then moved to a "novel" of the sculptor's life, of which Marie-Thérèse is the heroine. The tale begins with the artist and his model; next, a marvelous nude of Marie-Thérèse: a canvas propped on the easel, facing a sculpture derived from the free remodeling of forms. This is followed by Marie-Thérèse and a Surrealist sculptor.

A sculpture of her head presides over *Repos du sculpteur,* the sculptor here being a warrior-cum-god, his head crowned with a laurel wreath. He holds his young nude model in his arms. On 17 May 1933 he became the Minotaur, his cup in his hand, facing Marie-Thérèse in a laurel crown; we shall learn why. The saga was interrupted between 22 and 23 April by four scenes of rape. There are forty-one plates, most of them etchings, an average of an engraving per day. Bearing in mind that many of these subjects are complex, and that there are often two and sometimes three stages, one can understand why it was necessary for the engraver, Louis Fort, to bring his presses to Boisgeloup.[18]

The Minotaur arrived by way of a commission: a cover for the first number of the review *Minotaure.* Tériade and Skira were launching it with the Surrealists, headed by Breton and Éluard. (Aragon had broken with the movement in 1932.) Brassaï arrived one afternoon to surprise Picasso at work:

> He had pinned a piece of waffled cardboard to a board with some thumbtacks. Onto this he had put one of his engraver's tools to represent the monster. Around this he organized fragments of silver-paper lace and a few somewhat bedraggled artificial leaves which—he told me—came from an outmoded hat Olga had discarded. When this montage was reproduced, he insisted that the tacks be included as part of the composition.[19]

Such unexpected reuses and surprise encounters could only delight the Surrealists. Even though much of the incitement was incontestably external, they flocked to Picasso from afar. Since the Surrealists were naturally inclined to see this as proof of Picasso's membership in their movement, the development of a certain misunderstanding between them and Picasso was inevitable, under the circumstances. Picasso transformed into painting or sculpture everything within reach which was at all usable: Olga's rages, the various forms of Marie-Thérèse's body, and the array of objects he could endow with this or that significance. As Brassaï understood well, "If Picasso loved the Minotaur for its human—its too human—side, the Surrealists

loved it for everything which, in their view, [the monster] comprised of the counternatural, the sur-human, the sur-real." At this moment, Breton's need for Picasso's support was too great for him to cavil over trifles. As Brassaï remarked, the movement "was no longer a radical break with the world, but, in fact, a grand re-entry to the world by Surrealist art and poetry."

The first number of the review *Minotaure* included *Une anatomie,* a sequence of thirty Picasso drawings in which he created women transformed into wooden objects, into things multiplying their organic permutations. Meanwhile, the Minotaur was pursuing his course through the sequence of gravures. On 18 May he ardently caresses his young companion beneath the placid gaze of the sculptor and sundry youthful figures. On the same day he participates in a Bacchic orgy and then, having fallen asleep, is contemplated by a woman. On the 23d he attacks an Amazon; is wounded on the 26th; vanquished the 29th; and in agony on the 30th. Marie-Thérèse, on his left, extends a helping hand, but he doesn't notice.

One can see these collected scenes in what came to be known as the *Suite Vollard.* Three scenes were omitted: the engraving of 24 May, in which the Minotaur makes passionate love; a scene of 18 June, which shows him gazing at the sleeping Marie-Thérèse; and a scene in which he commits what is unequivocally a rape. This period of heavy work was interrupted by the summer holidays: Picasso took Olga and Paulo to Cannes.[20]

This account, however, touches only the surface of his output. It was only twenty years later, after World War II and Liberation, that Zervos published volumes 7 and 8 of his catalogue. These revealed the immense size of the graphic laboratory, of its output, which included the *Métamorphoses,* as well as the perfecting of symbols for Olga's rage and the sensuous curves of Marie-Thérèse. Oils as well as sculptures and subjects for engraving—some, including improvisations, perfect successes at first try—pour in a flood of constantly renewed experiment, coarsened or refined as the case may be. This prodigious sequence reveals as well as anything does the degree to which art was Picasso's life. Looking through this sequence from the end of summer 1933, one has the impression of a completed creative cycle.

Consequent developments would conform this truth. At fifty Picasso felt a need to consider his life not simply from the standpoint of a "modèle intérieur" but also in relation to the external world. His double approach to the Crucifixion is an indication, as is the fact that for the first time in his life, in the beginning of 1932, he signed a political petition: the Surrealist protest against the indictment of Aragon for anarchist propaganda on the grounds of his poem *Front rouge.*

A MARRIAGE ENDS

1933–1934

The crisis in Picasso's marriage took a more dramatic turn in the middle of 1933, when Olga learned that her husband's efforts to prevent publication of Fernande Olivier's memoirs had failed and that the book would go on sale in September. Gertrude Stein had provoked this flood of retrospective jealousy by reading aloud during one of the couple's visits to the rue de Fleurus fragments about Picasso's youth and the Bateau-Lavoir from her *Autobiography of Alice B. Toklas,* which she was just finishing. When Olga heard Fernande's name, she rushed from the room, white with anger. Picasso asked Gertrude to continue reading. "You should try to catch her," Gertrude said. "All that is so long ago." Advice which was in vain. For years Olga refused to see her again, refused to countenance the notion of any trifling with her monopoly of a legitimate spouse. Picasso's private feelings about all this can be well imagined.

Drawings from that summer show the Minotaur in possession of a Marie-Thérèse as overwhelmed and abandoned as the inanimate version of herself in *le Sauvetage* (The Rescue). They were done at Boisgeloup, before leaving for a summer in Cannes. From Cannes she reappears indirectly in a series of ink drawings with gouache or watercolor, which begins, on 6 July, with a scene of bacchic orgy on the beach near Silène and then proceeds to a highly Surrealist phantasmagoria. On 15 July one of the wooden women *chosifiées* (thing-ified characters) of *Une anatomie* enters a room in which one sees the profile of a Boisgeloup sculpted head against an inner wall. On the 20th the bearded sculptor, his arm resting on a giant head, contemplates the statue of a nude Marie-Thérèse: a calm and serious scene. On the 27th a fragmented Minotaur reigns over a seaside landscape scattered with fragments of familiar objects. And the drawing of the 28th dismembers a statue. On the 30th a man's head balanced on a plaster arm and the head of the Minotaur on a vase stand before a naked woman. The drawings are virtuosic in the extreme but lack conviction.[1] Picasso was thinking ahead to mid-August, when the family would pack into the His-pano-Suiza for a pilgrimage to Barcelona. This was to be a return in grand style; they had taken rooms at the Ritz.

On 1 April 1933 the Spanish Republic was finally proclaimed, and Catalonia recovered the sense of pride which Picasso had experienced himself during the renaissance of 1898. These were symbolic reunions, which did not prevent daily inflamed and inflammatory letters to Marie-Thérèse. Picasso went to Sitgès, to Rusiñol's home territory, and enjoyed a demonstrative reunion with Manolo and Totote, the de Soto brothers, the brothers Junyer-Vidal, Pallarès, Dr. Reventos, and Vidal y Ventosa. He visited all the scenes of his youth, accompanied by the twelve-year-old Paulo and his nephews Fin and Javier Vilato—Lola's children. The year before, the district government had bought from Luis Piandura—one of the first Picasso collectors—some twenty works done between 1899 and 1902. There were drawings and pastels and a few canvases from the period of the Vollard exhibition: *Pierreuse la main sur l'épaule* (Street Girl with Hand on Shoulder), for instance, and *la Naine* (Female Dwarf)—two paintings from the blue period; and the *Portrait de Madame Canals*. Picasso's pleasure at seeing these pictures again was heightened by the fact that they were destined for Barcelona's Museum of Modern Art.

Picasso's perception of "black" Spain, as he called it, in the grip of a fanatical clergy and an aristocracy of large estates, was one of his principal reasons for exile. In that country, he used to say, they "would have burned Cézanne alive." The proclamation of the Republic, therefore, was very important to him, especially as it was accompanied by a wave of fundamental reforms and a turn to the left which would culminate in the victory of the *Frente popular*. That his installation in a Spanish museum was an act of this renewed Spain surely moved him profoundly, more profoundly even than his public declarations indicated.

He returned to Paris having realized a consummate objective: avoiding all journalistic interviews. And there his troubles struck. The publication of Fernande's memoir drove Olga to distraction, while he himself found little to appreciate in a maneuver by his former companion which made her some money at his expense.[2] But above all he felt that his private life belonged to him, and that included whatever transpired between him and his women. His love affairs were, if he chose, inspirational sources for his work. They did not belong to anyone else. He resented the book's publication (he told me that he had "never read it") as an intolerable intrusion and a betrayal of his confidence. Thirty years later, at the publication of Françoise Gilot's book, he had the same reaction. Fernande's book contributed to his habit of shutting like a clam at any reference to his youthful life, in the hope of avoiding further confidential disclosures.[3]

His unease is apparent in his painting. There are corridas deriving from memories of his Spanish visit, in which death is a principal subject. But the death in question is an extraordinary one: the *Femme torero*, painted at Boisgeloup, depicts Marie-Thérèse carried off by her horse. On 19 September, at the peak of plastic violence, the torero dies. He does not look like Picasso, but these two paintings—which he kept—prefigure the

images and terms of the drama which—dominating the engravings of *Minotauromachie*—will lead to *Guernica*.[4]

There are suggestions of eased tension in the six etchings for an edition of *Lysistrata* and their preparatory drawings. As he did in the sculptor series, Picasso celebrated—on 17 January 1934—an adorable Marie-Thérèse, as Myrrhina in the arms of Kinesias. His emphasis on the warriors, however, indicates that his spirit would not allow him an easy embrace of happiness. An accident of copper stirred Picasso's interest in Rembrandt—his true rival in matters of engraving. And then the theme of combat returned on 25 January, in a Surrealist guise: a torsoless Minotaur brandishing a javelin at a warrior who clasps a woman.[5]

His anger was not purely private. The tensions in his painting cannot be separated from the political crisis of these months in which people began to perceive a link between Hitler's seizure of power, the Reichstag fire, and, in France, the violence of the extreme Right, a perception which infused the general strike on 6 February 1934. The Surrealists were highly alarmed. On 8 March Kahnweiler tried (in vain) to persuade Vlaminck that "Fascism will be the most desperate enemy of all, as it is in Germany. It will stop us all—and that includes you—from working, or showing our work." Picasso, too, was well aware of these developments.

At the end of the month, he did *Deux Filles lisant* (Two Girls Reading): Marie-Thérèse and her young sister, Jeanne. This subject would undergo a series of figurative reworkings: the most extreme of these, a still life of 10 April, transcribes into the register of emotional tenderness symbols which denoted cruelty in 1929–30. Very quickly Marie-Thérèse, a wreath of flowers in her hair, is established as dominant in *Jeune Fille écrivant* (Girl Writing). On 22 May, at Boisgeloup, her geometrized body appears in a dazzling *Nu au bouquet d'iris et au miroir* (Nude in Mirror with Bouquet of Iris and Mirror). And again, on 4 August, *Nu dans un jardin* (Nude in a Garden) is a sumptuous conclusion to a sequence which sings with love and praise of the young woman's curved lines. Picasso deliberately kept both these canvases as well as the large wash drawing in which the Minotaur carries off Marie-Thérèse, who once again has fainted.[6] There is a new, engraved sequence of the female torero: exposed to the fury of the bull, dragged nude from a stricken horse, thrown to the ground in the center of the arena; and, in a print of 4 August, embraced and ravished by the Minotaur. Three days later a dazzled Bacchus lifts his glass above her nude, abandoned body. She had already encountered Bacchus—seen in profile—at the beginning of the year in the complex engraving of 30 January. The etching of 31 January—*Femme nu dans un fauteuil* (Naked Woman in an Armchair)—remains one of the most beautiful and tender declarations of Picasso's love.[7]

His spirit was all the more preoccupied by his young companion because the furious presence of Olga was always at hand, always felt. It seems that Marie-Thérèse herself could not avoid attack. A large drawing

of 5 June, revealed only after Picasso's death, depicts a swimmer in head-
long flight. Since early February, in fact, a dimension of madness had been
a constant element in his work, beginning with drawings of "Constructions
with Swallows" which placed the wooden implements of *Une anatomie* in
the service of the "Olga" theme: an Olga spewing invective.[8] One finds as
well the psychological components of the explosive mixture present in *les
Demoiselles d'Avignon* carried to an entirely different dimension by Sur-
realism, and by art itself. Behind them are the political anger engendered by
the rise of Fascism, the lacerating strain between Marie-Thérèse, with
whom he was so much in love that the following autumn they would make
a child, and the drama personified by Olga.

The times were more than ever "out of joint." The "Night of Long
Knives" of 30 June 1934 was the first of Hitler's mass killings to be noticed
in the democratic countries. Once again Picasso's inspiration was colored
by the profound anguish he always felt in the face of inhumanity. That July
his painting at Boisgeloup carried violence to paroxysmic intensity in a
sequence of corridas. On the 16th there is the death of a bull, and on the
22nd—in the largest and strongest of the paintings—the bull guts the horse.
Shapes doubly outlined intensify the sense of shock felt by the massive
beast, and exacerbate the dying agonies of the horse. On the 27th the bull
once again guts the horse; this time, however, a picador "punishes" the bull
in turn. There is also a large array of preparatory drawings which indicate
the anger Picasso was trying to assuage, the fantasies of vengeance which
animated him. They exploded on 2 August: a corrida so paroxysmic that
it has never been catalogued.

A commission to illustrate a work by Benjamin Péret was part of the
instigation. Picasso does a *Mort de Marat* in which the horrible Megaera
personifying Charlotte Corday assassinates an exposed, collapsed, and
fainting Marie-Thérèse. In the gravure of 21 July, which establishes the
subject, there is no longer any doubt: Olga is the murderess.[9] This passage
from private to historic and political violence—and vice versa—is part of
the innermost depths of Picasso's psychological makeup in which Woman
is the image, the double, the model, the incarnation of life. None of that,
however, interferes with rest periods of tenderness, like the colored hymn
to Marie-Thérèse of 12 July: *Femme de trois quarts gauche.*

The corridas anticipate a trip to Madrid by the classic route via
Burgos, once again with the family. He visited the Escorial and Toledo,
where he saw again the Grecos he had discovered in 1901, and returned via
Saragossa and Barcelona. An article in *Publicidad* of 6 September declares
that Picasso enjoyed the museum of Romanesque art, with its frescoes
removed from Pedret, Seo de Urgel, and the *Pantocrator* from Taüll.

Back in Paris he did a series of the blind Minotaur led by Marie-
Thérèse, who has become a little girl. Of these, he kept the drawing of 22
September, a sketch with highlights, and a large charcoal drawing. At the
beginning of 1934 his new printer, Lacourière, had shown him how to do

aquatint with sugar, which makes it possible to paint directly on copper. *Garcon et dormeuse à la chandelle* (Boy and Sleeping Girl by Candlelight) is a virtuoso experiment with this novelty—the principal subject, a sleeping Marie-Thérèse. *Minotaure aveugle guidé par une fillette dans la nuit* (Blind Minotaur Led through the Night by a Little Girl) reaches a summit of technical dexterity, in which Picasso treats aquatint as if it were a "manière noire," a "mezzo-tinto" engraving. In the background a ship arriving in port links this new Marie-Thérèse cycle to recollections of Barcelona paintings of 1902. A young man and some fishermen discuss the Minotaur, who is totally dependent on Marie-Thérèse; she holds a dove. It is now mid-November 1934.[10]

The theme turned to fantasy in December with the etching *Taureau ailé contemplé par quatre enfants* (Winged Bull Observed by Four Children). Maya was conceived during this season of engraving. While Marie-Thérèse was pregnant, Picasso moved on to the group's finale, and most important work, the *Minotauromachie,* begun on 23 March 1935. The Minotaur here has the same giant head as the winged bull. He advances toward the matador (Marie-Thérèse, with bare breasts and a round belly) who lies unconscious on a gored horse which is losing its entrails. A little girl holds a bouquet of flowers and a lighted candle, which fascinates the monster. Two young women read at a window; two doves sit on the sill. On the ladder from *la Crucifixion* a bearded man gazes at the scene.[11]

A drawing of 24 July 1934[12] provides Marie-Thérèse with a candle which illuminates the spectacle of the bull gutting the horse. The beloved woman lights the world in all its sound and fury. Two years later the source of light will be the *Guernica* lantern. Confronting this woman, the Minotaur embodies Picasso's guilt and desire, the various dark impulses which painting must sublimate. The *Minotauromachie* is the culmination of the Marie-Thérèse saga. As he worked on the five stages of engraving, Picasso knew that the child Marie-Thérèse carried—her images stress the fullness of her breasts, her swollen belly—would force a crisis with Olga. And divorce, under common-property law, would require division of his studios' treasures—an unbearable prospect. But how else to reach an agreement? Later he told Duncan, "That was the worst time of my life."

In January, before the *Minotauromachie,* he had painted a geometrized Marie-Thérèse in a *Jeune Fille lisant.* She became the Muse, with a wreath of flowers, drawing beside her sleeping sister, in front of a mirror or asleep herself.[13] The mastery of the double profiles and the limpidity of rhythm show Picasso at the height of his abilities. And yet, after violent abstractions of a scheme for a monument with a harlequin head, a *Femme au chapeau,*[14] a work of 15 April in which an enraged Minotaur, wearing a striped maillot, attacks the gutted horse with a wooden shoe,[15] and finally, on the 24th, a drawing of the monster[16] himself, Picasso laid down his brushes.

He chose this moment to explain to Zervos, who had come to Bois-

geloup, what was happening with the characters who appeared in his work.
If they had ever existed, he said, that rapidly ceased to be the case. Very
quickly Picasso said that

> they no longer existed. The sight of them [he said] gave me an initial
> emotional impulse. But gradually their real presence faded away; they
> became for me pure fiction [a phrase we should retain]. They had disap-
> peared, or, more precisely, had been transformed into problems of every
> kind. They were no longer characters for me but shapes and colors.
> Please understand me: shapes and colors which nonetheless summarize
> notions, ideas of these characters, and preserve the vibrations of their
> lives.

We must not forget that while Picasso's paintings, drawings, and
engravings were filled with the presence of Marie-Thérèse, she herself
remained totally unknown. She was the reigning queen of an extraordinary
abundance of production, but for the external world she did not exist. Art
for Picasso was more than ever provocation—the creation of life which
remained the secret of its creator, and yet had more strength and wealth
than life in the everyday world. This account of the Marie-Thérèse story
has not yet mentioned Picasso's sculpture, developing concurrently, with
unfailing inventiveness. William Rubin has entirely convincingly compared
the plastic rhythms of Marie-Thérèse's torso sculpted at Boisgeloup with
New Guinea Nimbas masks, one of which Picasso possessed.[17] Their special
strengths struck him afresh as he worked with the forms of a beloved
woman; and, particularly at that moment, their symbolic expression of
female fertility. He was also at that time making faces and masks, using
crumpled paper, folded paper, and every imaginable mold, even including
objects like tennis balls and leafy twigs.[18] His various modelings of Marie-
Thérèse led to protracted dialogue with engraving, producing some of his
finest work.[19] In the summer of 1933 the Femme au vase appeared, like a
scale drawing of the painting. Today a bronze cast of this work marks his
grave at Vauvenargues.[20]

It was at this moment that the Tête de guerrier (Warrior's Head),
Personnage barbu (Bearded Figure), and Femme au feuillage (Woman with
Foliage) added the transmuting power of collages and assemblages to mod-
eling.[21] Picasso had finally acquired techniques which allowed him to ex-
press in three dimensions the pure plastic forms that moved him so greatly
in African art. Until then he had been able to express these only in painting.
But after La Porteuse de jarre (Woman Carrying Jar)—a construction of
painted wood—sculpture, too, was broken off, coming to a halt on a
Figure[22] made with forks, a small ladle, and a few fragments of wood and
rope: one of the cruelest and most anguishing personages his imagination
ever conceived.

In June, as Marie-Thérèse's pregnancy approached term, he was con-

fronted with the necessity of trying to reach a tolerable separation agreement with Olga. The precise moment of Olga's enlightenment as to the existence of Marie-Thérèse is unknown; there can be no doubt, however, about the intensity of her anger. When a bailiff arrived at the rue la Boétie to make an evaluation of conjugal property, Olga fainted and Pablo was obliged to ask the man to leave. A few days later Olga agreed to move—with Paulo—to the Hôtel Californie, a short distance from the apartment. And Marie-Thérèse awaited delivery at her mother's, in Maisons-Alfort, a southern suburb of Paris. When he wasn't visiting Marie-Thérèse or trying to settle his affairs in Paris, Picasso spent most of the summer at Boisgeloup.

He found himself confronted by his worst nightmare: the impossibility of re-establishing a creative equilibrium. Marie-Thérèse had inspired him at fifty with the enthusiasm of fresh youth and creation. With her he could forget the disarray, the emotional costs of his married life. But not only had this resource been taken from him, the joy of paternity had changed to guilt. He could not marry the woman who was giving him a second child. For the sake of preserving a modus vivendi with Olga and Paulo, he could not even reveal her existence.

This situation struck at Picasso through his studio. All the objects and letters, the invitations stuck between the mirror over the fireplace and its frame, creating, as Sabartès remarked, an effect "curiously like little curtains," constituting a "palpable memorandum"—all of that was threatened. What was in question was not simply a memory but the substance of a creativity which nourished and renewed itself from transmutations of its immediate material setting. His refusal to permit visits by outsiders to his ménage, his "lair," was not a product of maniacal self-regard, but an attempt to protect the substrata from which his art developed. (After his death I tried in vain to suggest to those responsible for inventory to treat his studios as archaeological sites, noting the location of each object and dossier, of everything he had put in the drawers.)

He was now camping in the field deserted by Olga. Eugenia Errazuriz reappeared at this point. She was seventy-five and could keep him company without adding any complications to the divorce proceedings. She had a sense of the halts and pauses in matters of the heart, and Pablo had no secrets from her. She also grasped the Spanish appreciation which Paulo's father had of his son's situation. It was very much the same kind of sentiment which led Picasso to write to Sabartès, the old friend of his youth who had been working as a journalist in South America. Sabartès had recently returned to Barcelona; Picasso suggested that he come to Paris and share his existence for a while. "I'm sure you can imagine what's happened, and what's still in store for me."

THE BIRTH OF MAYA

1935–1936

Maya wrote to me at the end of 1979 to tell me that contrary to generally accepted belief, she was born on 5 September 1935, not 5 October. This makes her a Virgo but reduces by a month Picasso's anxious, solitary wait, pacing his room on the rue la Boétie like a caged beast. The child was named María de la Concepción in memory of Pablo's little sister, who died of diphtheria in La Coruña. This choice of name after forty years indicates, I think, the traumatic importance that death had for Pablo. He was delighted to be the father of a girl.

He drew Marie-Thérèse nursing Maya; Maya at three months; Maya at her first Christmas. The oil paintings which came later are well known, but this record of discovery was not revealed until 1981 in Geneva by Maya herself. The drawings are masterpieces of delicacy, of tenderness without sentimentality. They join portraits of Marie-Thérèse at home, which, like the portrait of 1929, were also unknown until 1981. It is therefore not true that Picasso did no painting or drawing between June 1935 and March 1936. Rather, the drawings he did then, like the canvases of March–May 1936, belonged to the secret part of his life.[1]

What was public knowledge disturbed his contemporaries much more: Picasso was writing poems. He always had jotted down—in his notebooks, on scraps of paper—whatever images or thoughts came into his head. But at this juncture it was clearly the Surrealists and their automatic writing who had given him the idea, especially as they had been using mixed media, as, for example, in their collages. In fact Picasso did not believe in spontaneous poetry—or painting. His attitude was that of a professional: someone who had put written fragments into his paintings and could certainly paint poems as well. The graphism of his letters and the way they were placed on a page were also a deliberate, visual creation. As for the texts, they were directly a product of Picasso's pleasure in their associations of words and a tendency to rather affected preciosity—as much Spanish (often in Catalan or Andalusian dialect) as French. The arrival of Sabartès on 12 November gave Picasso an audience of pure gold: someone capable of understanding the most subtle of his allusions, and a master craftsman himself in manipulating snippets of Spanish.

Picasso received two very different reactions. Praise from Breton, who prefaced Pablo's poems in *Cahiers d'Art,* and declared that "his poetry cannot fail to be as plastic as his painting is poetic." And from Gertrude Stein somewhat scandalized disapproval of what she considered an amateur intrusion into the realm of letters, where she was reigning queen. A contributing aggravation was that Gertrude had heard nothing from Pablo since her quarrel with Olga over the *Autobiography of Alice B. Toklas;* nothing, that is to say, since 1932. And she had just learned from Kahnweiler of the poems' existence. This situation produced a series of Homeric scenes, in which Picasso clearly derived a certain malicious pleasure from pushing her as far as he could. He knew that Gertrude was totally devoid of humor whenever her genius as a writer in any way came into question. "You have always said that I am an extraordinary being," he taunted her. "Well, an extraordinary being can do absolutely anything!"

The quarrel came to a peak during a Braque opening at the Paul Rosenberg gallery. Gertrude also had a grievance against Braque, who had been none too tactful in his review of the *Autobiography.* Finally she and Picasso kissed and made up, and the affair was consigned—with no more punctuation than in Picasso's poems—to two paragraphs in her new book *Everybody's Autobiography,* which appeared in 1937.

In fact Picasso was in the process of re-evaluating his recent life. The presence of Sabartès had led him to redefine his position as an artist; to take fresh bearings. An exhibition in the spring of 1935, introduced by Tristan Tzara, at which he had shown a collection of *papiers collés,* was another contributing factor. In March 1936 at Rosenberg's he would show paintings of 1933–35. But at present among the few familiar faces who came to the rue la Boétie—as well as Kahnweiler, Zette and Michel Leiris, and Braque, with whom he also had been reconciled—were a few Spanish chums like the sculptors Gonzalez, Joan Rebull, and Fenosa. The rupture with Olga had distanced him from more worldly circles; it is significant that his new entourage was definitively on the left.

The radicalization of French intellectuals had been intensified by the threat of Fascism. The ominous and growing menace was also responsible for the reunification of Communist and Socialist labor unions and then a coalition of those parties with the Radicals to form the Popular Front. The government of the Right in France, led by Pierre Laval, had just signed a mutual assistance pact with Stalin. And in Paris a World Congress of Writers for the Defense of Culture had brought Aldous Huxley, Robert Musil, and Bertolt Brecht together with Gide and Malraux. The occasion produced an altercation between Breton and Ehrenburg, suggesting the first stirrings of anxiety about the real nature of Stalinism. Zinoviev and Kamenev had just been condemned in Moscow to ten years in prison as morally responsible for the murder of Kirov. During the night which followed this flare-up, the Surrealist René Crevel killed himself. Éluard intervened between Breton and the Communists so that the Congress of Writers could continue.

The whole affair was profoundly disturbing not only to the Surrealists but to the intellectuals of the Left, and Picasso was kept closely informed. In the autumn, after Maya's birth, when he began going out again he was often seen at Saint-Germain-des-Prés, at that time the meeting place of the Surrealists, very near the offices of *Cahiers d'Art*. Usually on those occasions he was with Éluard and other intellectuals belonging to the most politically active Surrealist faction. And it was at this moment, according to Brassaï, that he noticed Dora Maar, a painter and photographer linked to the extremist group of Georges Bataille. At this moment, too, Roland Penrose, who wished to acquire a *Nu sur la plage* he had seen in *Cahiers d'Art*, was introduced to Picasso by Éluard and his girlfriend, Nusch. Picasso took them to Boisgeloup and let Penrose have the picture for a good price. He confided to Penrose that Rosenberg had not been at all pleased with the backside of a naked girl (Marie-Thérèse), and had shouted, "I don't want any assholes in my gallery."

Because Picasso loathed romantic ruptures, it has been too readily assumed that he was indecisive in these matters. In fact, whether with Fernande or Olga, he always preferred to add (secretly) to his romantic liaisons rather than to discard those he had tired of, hoping against all probability to safeguard the freedom of spirit he needed as an artist. His choices depended on impulses of the present far less than on the ability of his companions to participate in the imaginary world of his art. His dream was that life should conform to art, a dream which left his mistresses as confused as the rare witnesses or confidants to whom clearly—and always—Picasso gave only one aspect of a situation or of his love affairs.

The ongoing secrecy about Marie-Thérèse, and the little Maya, whose grace enchanted him, as well as the continuing crisis with Olga effectively separated his private and public lives. At the same time, political events brought his public persona into ever-increasing prominence. Rosenberg was certainly a denizen of the beau monde favored by Olga; but the renewal of relations with Kahnweiler could only stress for Picasso his loosening ties with the worldly commerce of painting. Rosenberg not only criticized him and pushed him to paint even more for himself (think of his indignation at the "asshole"!) but by so doing helped to separate him from the new problems of the age, from everything which stirred his new and his refound friends. Picasso owed it to himself to draw conclusions—strategic for his work—from the silence imposed by his new family situation. The saga of Marie-Thérèse and Olga's threats, which once inspired him so successfully, was over. But what to paint now? And why paint at all?

The issue of *Cahiers d'Art* which contains Picasso's poems—dated 1935 but published at the beginning of 1936—also ran a piece by the Surrealist Georges Hugnet, which expressed the views of Picasso's circle. "Picasso knows, we all know, that we shall be among the first victims of Fascism, of French Hitlerism. That movement does not underestimate us." This was the tone of Paris politics in the autumn of 1935. The atmosphere

was heightened by a Spanish venture, ADLAN (Amigos de las Artes Nuevas; Friends of Modern Art), which had decided to organize a Picasso exhibition in Spain. The animating force of the project was José-Luis Sert, a young Catalan architect with a promising future. He was not interested in Picasso's early Spanish period, wishing instead to focus the show on *papiers collés,* work from the Cubist period, and recent work. This confirmed Picasso's hopes at the birth of the Spanish Republic that at last he would be recognized in his native country. Éluard was to represent France in this act of homage—a way of indicating that although Picasso would not go himself, Éluard would act as his ambassador. The arrangement also indicates that ties of confidence between the poet and Picasso went back at least to the period of preparations for the show, that is, to the autumn.

Éluard and Picasso had long been aware of each other, probably since the poet's return to Paris in October 1924 after his frantic flight in a *tour du monde.* Of all the Surrealist writers, Éluard was the most passionate about painting. A friend of Max Ernst, he had bought Picassos at Kahnweiler sales and was a passionate admirer of De Chirico. Picasso, who had sponsored Dali's arrival in France, knew all about the separation of Éluard and his wife, Gala, when she left him in 1929 for the young Catalan painter. But until 1933 and the launching of the review *Minotaure,* Picasso and Éluard pretended when they met not to know each other. For seven years, Éluard had lived with Nusch, a young, sharp-featured Alsatian of rare charm, but he had not forgotten Gala. Despite the solid ties binding him to Nusch, he and Gala still met from time to time to make love, and his letters to her, which she kept,[2] burst with poetic fervor. Éluard, as an explorer capable of every audacity, had associated Surrealism and sexual liberation. He fled from any idea of "possessing" the woman he loved, believing in an almost mystical "higher fidelity." Nusch accepted all this without any of her Russian predecessor's perverse coquetry. For Picasso they made an endearing couple.

As Sabartès wrote in some amazement, "Picasso is eminently curious; curious about the games of love; about reading, and wordplay; ideas, and plastic expression. As curious as the most curious, and then, more curious than anyone else." Éluard was able to satisfy this curiosity in many ways, the first to do so since the death of Apollinaire. In addition, as a friend of Picasso's youth, he was a brilliant spectator of Picasso's theatrics, himself able to transform events of their friendship into theatrics. The only difficulty was that like many Surrealists, he had not escaped commercial dealing in paintings and rare books. Picasso, however, accepted this.

All things considered, it was not surprising that their friendship flourished. A portrait of Éluard endowing him with all the attributes of youth makes the quality of their relationship evident. The picture is dated 8 January 1936: the eve of Éluard's departure for Spain. By the 12th the poet was explaining to René Char that in Barcelona "the Picasso exhibition is an enormous success; in part a *succès de scandale.*" On the 15th the Zervoses,

Picasso, and Gonzalez sent him greetings from the Café de Flore, dated "the hour of onion soup."

At the opening, texts by Gonzalez and Dali were read aloud, as were new poems by Picasso, read by Sabartès. Miró made a speech. Éluard gave a lecture on the 17th before accompanying the exhibition to Madrid, where it was received with much less hostility than in Barcelona and with reverent admiration by the young poets Federico García Lorca, Rafael Alberti, and José Bergamín. Through them Picasso was publicly associated with the electoral victory of the *Frente popular* in the middle of February.

In Paris he prepared a show of recent paintings—1934 and 1935—to open at Paul Rosenberg's on 3 March, with special emphasis on bullfights and young girls reading. "Le Tout-Paris had its breath taken away," writes Penrose. It seems that the rumor of a Picasso reduced to impotence had gained some credence in those circles.

A week before the end of the show, scheduled for 31 March, Picasso disappeared in the utmost secrecy with Marie-Thérèse and Maya, a move which took Éluard completely by surprise. He and Picasso had last met in the beginning of March, on the poet's return from Spain. On 11 March Picasso gave him a watercolor and pastel with a collage which links a subject deriving from crucifixions to those of the Surrealist watercolors of 1933. Did Picasso finish the picture just then? The dedication supplies surnames of the new *bande: Soupe à l'oignon* is Christian Zervos; *Chaux vive*, Zervos's wife, Yvonne; while *Vif-argent* is Éluard. Nusch alone keeps her own name. We know, too, from a letter written at this moment by Éluard to Louis Parrot in Madrid,[3] that Picasso was starting a portrait of Nusch, to whom on 23 March he dedicated a childhood photograph of himself: "For Nusch, my only portrait."

In the opinion of Jean-Charles Gateau, the reason for Picasso's hasty departure with Marie-Thérèse was that Éluard had introduced him to Dora Maar.[4]

> The agitating effect the young woman had on the painter was considerable. To grasp this, one need only look at a photograph taken on the occasion of a stroll at Boisgeloup in March 1936 of the Éluards, Picasso and Paulo, and Roland Penrose, and study the glance—at once rapacious and fascinated—which Picasso fixes on the photographer [Dora].

That may be. For this voluptuous brunette had a definitive effect on the painter. But to conclude that he then took flight is to make assumptions which don't fit with other aspects of Picasso's character. Sabartès puts it correctly: "Given that he doesn't worry about the probable, eventual, foreseeable, or indubitable consequences of a new romantic adventure, difficulties do not deter him, or cause him to waste time calculating, or weighing the pros and cons of every contingency. He plunges ahead impetuously and blindly."

On the same 23 March a note from Pablo to Marie-Thérèse, published by Maya, reminds her to bring back the sheets, turn off the gas, electricity, and water, and adds, "This evening I love you more than yesterday, less than I will love you tomorrow. . . . I love you I love you I love you I love you Marie-Thérèse." He explains to Sabartès how to send on his mail incognito by using his legal name, Ruiz. On the face of it, he wants to have this new experience of family life in peace and quiet but wants also to achieve a balance with his work, with what he wishes to make. He reaches back to dream of new wire sculptures beside the sea, as in 1928, at the beginning of their affair. On 6 April an affectionate Minotaur, his head in the stars, drags his household goods in a cart, including a framed picture he does not want to leave behind and a mare who is giving birth. Marie-Thérèse appears on the 9th, in front of an Henri II desk in the rented villa at Juan-les-Pins (as, previously, with Olga; Picasso did not simply enjoy comparisons of his love affairs in the same places, they were necessary to him). This picture is followed by a burst of portraits of Marie-Thérèse: in a beret on the 13th; bare headed on the 15th; and on the 17th in the style of *Femme lançant une pierre*. Then she is represented again in a new Muse sequence: reading; sad; asleep; weeping; finding her wreath of flowers; and finally, standing with an absent air in front of an empty mirror. Violence breaks out in early May, with a return to the theme of the rescue. This time, however, it is between two wrinkled hags. Then the monster heads reappear, and the grimly black mirror.[5]

One should not overhastily assume failure here. Returning to Paris also meant seeing Olga. In the interval, on 7, 23, and 27 April, drawings of rare perfection sing of paternity and of little Maya.[6] Picasso kept Sabartès abreast of the different stages of his work, stressing that he had begun to paint again and that he was still writing poems. It was a convalescence. And as far as his feelings for Marie-Thérèse were concerned, Dora's anticipated arrival and then their encounter changed nothing. The splendid drawing of Maya at ten months, on 10 June, as well as the most sensitively loving of his portraits of Marie-Thérèse on 28 July (as he was preparing to join Dora in the Midi) are corroborated by a note of 15 October, published by Maya: "I shall come to lunch as soon as possible so that I can see you, which is the most agreeable thing in the world in my dog's life. I love you a little bit more every moment. À toi, Picasso."[7]

So much for the atmosphere between them. Dora was added on to Marie-Thérèse—we shall see why and how. But, in my opinion, the mother of Maya—and Maya, too, of course—lost nothing. It is essential to emphasize this for an understanding of the whole period which now begins, and lasts until at least 1945–46. Dora would be the public companion, while Marie-Thérèse and Maya continued to incarnate private life. Painting would be shared between them, with Maya, as she grew up, playing more and more of an autonomous role. Each woman would epitomize a particular facet of a period rich in increasingly dramatic repercussions.

Picasso turned up again without warning on Friday, 15 May, when Éluard, dumbfounded, ran into him at Wolfgang Paalen's opening at the Galerie Pierre. All the Surrealists were there: Breton, Max Ernst, Miró, Man Ray. Paalen in that spring of 1936 was a new recruit to the group. It is significant, too, that Picasso should put in an appearance.[8] Éluard intoned his pleasure in his poem *Bonne journée, j'ai revu qui je n'oublie pas* (Good day, I've seen again the one I won't forget).

> A good day, which started sadly
> Black under green trees
> But suddenly, soaked in gold
> Slipped into my startled heart.

Picasso had come back overflowing with activity. No one knows what transpired with Olga on his return, but whatever it was, it did not interfere with the success of his creative convalescence. In early May a series of Surrealist compositions with the Minotaur[9] accompanied some rather sinister canvases. In Paris he began to engrave and make at Lacourière's the plates for Buffon's *Histoire naturelle*, which he had promised to Vollard. On 24 May, with a process invented by Lacourière, he engraved a plate already inscribed by two of his poems and dedicated it to Éluard. Éluard responded on 3 June by writing on another plate, with his beautiful, even handwriting, his poem *Grand Air*.[10]

The following day Picasso framed it with figures. Just before this, for Éluard's collection *la Barre d'appui* (The Handrail), Picasso had engraved a marvelous portrait of Nusch. One can see here as well, with a wildly feminine image and the artist's handprint, the face of a sleeping Marie-Thérèse, at the base of the house in the *Minotauromachie*. Proof, if proof be needed, that she was still in her lover's thoughts.

PART SIX

DORA MAAR OR THE WAR

A true artist doesn't worry about the necessities of the times; rather, he senses them. He knows what the present moment in time is, and what its novelty is. He knows this through a power of intuitive vision one might characterize the "feeling of the times." Although an artist may live in the bewildering multiplicity of small, anonymous events which fill—and constitute—a period, he is nonetheless able to grasp that period in its entirety. It becomes the "novelty" of his art.

—*Hermann Broch*

SPAIN AT HEART

1936–1937

P icasso was now—with the exception of Gonzalez—the senior figure of his *bande*. Christian Zervos was born in 1889; Éluard, in 1896; and Dora, née Markovitch, on 22 November 1907 in Tours. The child of a Yugoslavian father and a French mother, she had spent her adolescent years in Argentina and was fluent in Spanish. As a photographer beginning to work in cinema with Louis Chavance, she attached herself to the Surrealists in 1934. A recollection of 1935 in Marcel Duhamel's memoirs catches her as she pursues a particularly taxing piece of *reportage* in a mountain mine. Her character, in his view, was overwhelmingly defined by its leading quality: "cabocharde" (stubborn). "Inclined to storms—with thunder and lightning" was how Georges Bataille put it. According to Michel Surya, Georges Bataille's biographer, she was Bataille's mistress at the end of 1933 and early 1934, and in the wake of that experience, tended to favor the more radical solutions—for private life as well as for politics. In short, she was in every way an opposite to Marie-Thérèse, with her placid temperament and indifference to art.

Nusch, born in Mulhouse in 1906, began as an actress in Germany, playing small parts (especially old women) in Strindberg's plays and posing for postcards. She came to Paris, where she led a life of crushing poverty. She was working for the Grand Guignol when Éluard met her in December 1929. They were married in August 1934.

Although the Popular Front won a solid victory in the elections of May 1936, the interim period before the new government took power was a time of unprecedented strikes. These were more widespread and more violent than any in the history of the country and came to an end only with the accords signed on 7 June. Picasso and Éluard during this time seemed to be living in another world. Picasso's engravings of the time—beginning with the poem *Grand Air*—were done as an accompaniment to the collection *les Yeux fertiles*. The book, which included poems he himself had inspired, was illustrated by Man Ray with admirable photographs of the nude Nusch.

None of this, however, prevented Picasso from painting, on 28 May,

a gouache of a man with an eagle's head brandishing the cadaver of a Minotaur dressed as Harlequin. Approaching him, a man wearing a horse's skin carries on his back another young man, who is crowned with flowers. The scene takes place on an empty beach. There is no need here to fine-comb the internal dynamics: Surrealism was sublimating political confrontations. In any case, Picasso chose to enlarge that gouache to make the curtain for *Quatorze juillet*,[1] a symbolic stage piece based on an old play by Romain Rolland. The spectacle's polemic point was to identify the victory of the Popular Front with the first wave of the Revolution of 1789.

Thirty-odd years later, looking at the aquatint *Faune dévoilant une femme* (Faun Unveiling a Woman),[2] done on 12 June, I said to Picasso, "The faun is you. But the woman?" He smiled. "Not yet Dora." Which doesn't mean that Dora hadn't crossed his mind. But that splendid body must surely be Marie-Thérèse. The engraving is also a technical master-piece. Drawing, painting, aquatint with sugar, and varnish worked with *grattoir* and *burin* on copper. Six states. A flood of light and a magnificent faun.

On 18 July the Spanish generals launched a rebellion against the government of the *Frente popular*. Picasso was a strong supporter of the Republic, and in September as a symbolic gesture President Azaña would make him titular director of the Prado. For the moment, however, knowing that the Ramblas had run with blood, Picasso was worried about his family: his mother, his sister, and his sister's children—all in Barcelona. Éluard and Nusch were waiting for him on the Côte d'Azur. On 27 July he did another young faun, lusting after an adorable sleeping nude of Marie-Thérèse,[3] but everything suggests that he was already seeing a great deal of Dora Maar. They could talk—in Spanish—of Spain. Dora followed with passionate attention events which he could not begin to discuss with Marie-Thérèse. A wash drawing of 1 August shows Dora arriving at a door. A nude painter is waiting on the other side, bearded in antique style, with a dog on his knees.[4]

Picasso left for Cannes in the big Hispano, taking all his painting gear. He joined the Éluards at Mougins, a hillside village which would play a considerable part in his life. "I don't travel incognito," he writes to Sa-bartès. "You can give my address to anyone who wants it." There are photographs of Roland Penrose and his wife, Valentine. (Picasso was in a car crash with them. The accident was not serious, but Picasso had a few cuts and bruises and made a great fuss over them.) Zervos and his wife came down, and Paul Rosenberg, and René Char. On a visit to Lise Deharme at Saint-Tropez, Pablo was able to see Dora. According to Penrose, "After dinner they disappeared to take a walk on the beach. He spoke to her frankly, telling her about the complications of his life, and the existence of Maya. He asked her to come to Mougins with him."

Pablo painted very little that summer. He did a drawing of Nusch on 20 August and one of Cécile Éluard in colored chalks and another Nusch.[5]

On the 30th, with Éluard, he discovered the potteries of Vallauris. And that evening Éluard describes the scene in his poem *À Pablo Picasso:*

> Show me that eternal gentle man
> Who said that fingers raise the earth.

The Éluards returned to Paris. On 19 August Federico García Lorca had been executed by firing squad in Granada. But this was not yet public knowledge. In September Dora Maar made her first appearance in Picasso's painting. She is wearing her red coat and seems, still, like a visitor. Then we see her long red nails, which, like her gaze and her brown hair, will become her plastic identifying signs. Pablo put her through the same plastic itinerary already used for Marie-Thérèse, dissociating the volumes of her upper face as he did with the sculpted heads of Boisgeloup. A portrait of 11 September was, he claimed, done from memory;[6] on 20 September he returned to Paris. Once there he applied to Dora her own photographer's craft, using techniques perfected by Man Ray which allowed him to combine on the same plate printed shadows and a drawing. By these means Dora's profile "appears" against a mantilla—an abrupt confrontation with both Fernande and Olga, which also stresses her Hispanic heritage.[7]

Dora continued to live with her parents in the rue de Savoie. Picasso saw Marie-Thérèse and Maya every weekend and kept in touch with Dora, who enjoyed in this way the advantage of a mistress over a legitimate spouse. The two women, in fact, did not coexist openly until they were both staying in Royan in 1939–40. That autumn of 1936, Pablo in his work was passionately involved with his new conquest, but not just as a subject for portraits. The large *Nu couché,* painted between 12 August and 2 October, displays under a starry sky one of his most fantastic remodelings of female nudes.[8]

Picasso had to give up Boisgeloup; one of the conditions of separation with Olga was that she should have the château. She hated the place and never went there; nonetheless, she was keeping it from Marie-Thérèse. Vollard had organized a studio for Rouault at Tremblay-sur-Mauldre, some forty kilometers west of Paris. As Rouault wasn't, in fact, using the place, Vollard offered it to Picasso. Marie-Thérèse and Maya were installed there, and Picasso went every weekend. The studio was their home until the war.

He took immediate possession of the place through painting. Brightly colored still lifes were a signature of Tremblay, compositions whose axis is a casement window with a handle.[9] In this substitute for Boisgeloup, Picasso used the happenstances of moving—the fortuitous reappearance of this or that object—for assemblages. And into these, as with the dolls he made for Maya, he put all the skill at his command.[10]

Sabartès and his wife found the situation unbearable. They thought they had assured a transition between the broken marriage with Olga and

a new pairing with Marie-Thérèse. They saw Dora as an intruder and made her feel it. Dora, for her part, hated the rue la Boétie. She found a large studio at 7 rue des Grande-Augustins, very near where she lived with her parents. The seventeenth-century building had been part of the Hôtel de Savoie-Carignan, where Balzac set the action of *Chef-d'oeuvre inconnu* (Unknown Masterpiece). It seemed to her perfect for Picasso. He agreed.

Meanwhile support for the legitimate government of Spain had become a ruling passion for French intellectuals. Malraux joined the fighting before the International Brigade was formed. Éluard, too, was thinking of enlisting, despite his poor health. But his friendship with Breton—thought to be a Trotskyite—was considered an obstacle by the French Communist Party, and Éluard did not insist.

Letters from Éluard to his first wife, Gala, only recently made public, indicate a first break with Breton in April 1936. "All of this lacked seriousness—and far too often, because of Breton. I had already—long before—decided that I would no longer support childishness, inconsequence, or bad faith." The bombings of Madrid—the first air attacks against civilians on such a massive scale—led Éluard to break with Breton's interdiction of poems triggered by specific events, and he wrote his first political poem: *November 1936.*

> See the builders of ruins at work
> Rich patient ordered black stupid
> They are trying to be alone on earth
> Striking next to a man they load him with filth
> And fold the brainless palaces to the ground.
>
> We'll get used to it all
> Except for these lead birds
> Except for their hatred of what's on fire
> Except for giving up.

Éluard had lent the text to Louis Parrot, and Aragon had asked him for it on behalf of *Humanité,* the Communist party daily. Éluard writes to Gala:

> It's the first time one of my poems has had a printing of 450,000. I wonder what Breton thinks of it. I don't see what's against collaborating with *Humanité,* read by workers, rather than the *NRF,* or some other publication which is read exclusively by the bourgeoisie, provided, of course, that I don't change my poetry.

This was written on 17 December, the day of publication. Éluard had emerged from the *modèle intérieur* to address the war being waged against the Spanish people. He also wished to demonstrate—without "changing his poetry"—that poetry could be simultaneously "modern" and open to his-

tory. Picasso followed his friend's work all the more closely because he himself was often its subject. In this case he felt it in a very direct and personal way. Further, by publishing in *Humanité,* Éluard was making an innovative move: multiplying his infractions of Surrealist rules by writing a topical poem and by collaborating with a journal of the Communist party, the only one at the time to receive him and to rejoice in such a development on his part.

But by taking this step Éluard also revealed a contradiction in the Surrealist position. Its adherents were permitted to function creatively using any idea or circumstance as a point of departure except the one that, since 1933–34, had alarmed them most: the rise of Fascism. And how could Picasso accept such a restriction? He had always expressed distress or anguish through his private theatre—the faces and bodies of the women in his life, corridas, the Minotaur. Now he must think of pressing further, of breaking the Surrealist taboo, especially as—to a certain extent—he had inflicted it on himself. He knew that Éluard's poem was inspired by the ferocious hand-to-hand combat between Republicans—aided by the first International Brigades—and Francoists in the buildings of the City University in Madrid. And what was he doing himself, just then?

Éluard's move also involved the major political choice of the time. When André Breton proclaimed, "Neutralité = non-sens, crime et trahison," and urged the government of the Popular Front to help the Spanish Republic, he was equally forceful in denouncing Stalin's repression and demanding the right of asylum in France for Trotsky. Éluard, however, was for fraternization if not downright alliance with the Communists. In February 1937 he wrote to Gala: "Breton is very involved with the Moscow trials. Not me." In fact, he refused to protest, thereby consciously choosing, like Malraux, to do nothing which might impede rapprochement with the Communists. In early 1938 Éluard explained his position to Penrose: "The proletariat of the whole world is under attack in Spain. And it's the future of mankind that the Spaniards—and a good many foreign revolutionaries too—are defending." When the Communist leader Bukharin was executed along with other Bolsheviks in Russia in 1938 and Breton returned from Mexico, where he had seen Trotsky, the rupture between Éluard and Breton became definitive.

At the end of 1936 things had not yet reached that point; it seems likely, however, that Picasso's basic feelings were closer to Éluard. He did not engage directly in political action, as the poet did, but in his work one can see that he was moving toward intervention in the war. In early 1937 the poet, José Bergamín, returning from Spain, met Éluard at *Cahiers d'Art.* Éluard wanted to do an issue with him: *Au Poids de l'or* (At the Weight of Gold). Bergamín, fresh from the horrors of combat, poured out his feelings, whereupon Éluard proposed changing their title to *Au Poids de sang* (At the Weight of Blood). This in turn launched Picasso's cartoon strip *Sueño y Mentira de Franco* (Franco's Dream and Lie). Of course for him engraving

was a normal medium for the reporting of history; here, however, he turned
it into political denunciation. Like Éluard, he did not change his poetry. He
reused the figurations of violence devised for the *Métamorphoses* and for
Olga's rages to introduce into his work the *pulpos de mal aguerra* (octupi
of evil augury). In *Sueño y Mentira* Franco set out for war with a banner
on which the Holy Virgin, beneath a laughing sun, looks like a louse. A
funambulist, he straddles his enormous prick, but his thrust comes to an
exhausted halt in front of a woman with a noble profile. Protected by
barbed wire, he kneels in vain before a monstrance in which the Host is a
one-douro piece. A charging bull dislodges Franco's crown. He comes back
as a woman, wearing a mantilla and carrying a fan. Perched on a hog, he
aims at the sun. He hurls insects and serpents, fails to mount Pegasus, but
manages to stab the creature with his lance. Pegasus dies at his feet, and a
woman lies dead in a landscape of disaster. A white horse sleeps in a man's
arms. Only a bull made of light regards the monster with respect—and guts
him when he changes into a horse.

This creation, at the limits of inspiration from the unconscious, holds
the keys to what in May–June would become *Guernica*. And it was then—
after completing that grand canvas—that Picasso would finish the series
and decide to sell the engravings as a portfolio, accompanied by a facsimile
manuscript of a long, automatic poem, filled with "cries of women cries of
birds cries of timber and of stones cries of bricks cries of furniture of beds
of chairs of curtains of pots of cats of papers cries of smells which cling to
each other cries of smoke pricking the shoulder."

Although politics and political commentary had become urgent,
Picasso was not drawn away from his primary concerns as a painter.
Between January and March 1937, a magnificent series of tender portraits
of Marie-Thérèse balances the Dora portraits of the autumn. Five canvases
are dated 6 March.[11] Novelty is expressed by a return to simplified figures
—*Femme assise avec un livre, Femme assise sur la plage*, which seem to be
made of stone. With the *Baigneuse au petit bateau* and *Deux Femmes nues
sur la plage*, dated February, the figures become monumental.[12]

Dora would never be more beautiful than in her portrait of 27 Janu-
ary—a pencil drawing, and, sleeping, on 2 March (right in the middle of the
Marie-Thérèse sequence).[13] On 19 February the Minotaur returns with a
group of women—bathers—and carries off one who has fainted or died.[14]
This return of the subject of rescue will reappear in *Guernica*. Picasso
moved next to still lifes. *Sculpture nègre devant une fenêtre* (Negro Sculp-
ture in Front of Window) shows a Minotaur with a human face, in the
words of Alfred Barr, "as tranquil as a Manet."[15]

A few days later, history would impose one of its turning points on
painting. On the afternoon of 26 April, Guernica, the holy city of the
Basques, was methodically destroyed by Nazi aircraft—the first time that
a civilian center had suffered such a fate.

FROM *GUERNICA* TO MUNICH

1937–1938

D uring the 1914 war the innovative setting in which Picasso had been developing as an artist since the autumn of 1905 was gradually destroyed, but his own vital center had remained intact. Now, however, with war in Spain and the threat of aggression from Hitler, the situation was entirely different. Both the victory of the *Frente popular* and a Spanish Republican government allied to France seemed threatened, along with everything Picasso believed in, everything which had made him leave his own country and settle in France. With civil war in Spain, with Fascist Italy and Nazi Germany just across the French borders, anyone in a public position felt pressured by circumstances to take sides. One had to be either for or against—a choice which, with all its consequences, was consuming.

Since January 1937 Picasso had been struggling with a commission from the Spanish Republican government: a painting to occupy one wall of the official Spanish pavilion at the Universal Exposition. The exhibition was scheduled to open in Paris in June. Since 1906 Picasso's work as an artist had been based on the premise that the meaning of life could be found in the shape of a glass on a table, in a woman's face reduced to its volumes or to its violence, or in the musical rhythms of anatomy. But never by abandoning the language appropriate to painting—its essential medium and forms of expression—for the sake of an external idea or narrative.

This belief was not simply a "theory": it was the central vision of Picasso's art. He could remember very well his sense that he was moving toward his true self when he refused wholehearted commitment to extreme virtuosity of the kind that won him early acclaim, with the astonishing technical accomplishment of his adolescent paintings *First Communion* and *Last Moments*. Although he felt a powerful drive to work and struggle in the company of allies, his efforts nonetheless would have to be with weapons of his own choosing. And certainly his aims could never be accomplished by capitulation to those—even among friends—who wanted him to produce repetitions or variations of Goya's *Tres de Mayo*. He also knew very well that his painting probed far more deeply into the crises of the time

than the work of others, which clung to verisimilitude, although even intelligent critics who favored him said that "up to the present moment [his work] has refused all and any meaning."[1] He felt that he could not escape his duty as he saw it; but he knew that by persevering he risked losing everything. Who would understand that he was lifting a cartoon strip—his *Sueño y Mentira de Franco*—to the dimensions of an historic painting? Such transformation had always been thought impossible. And yet he had achieved it, by radical alteration of his images' space-time and by the invention of appropriate pictorial methods.

We will probably never know how much *Guernica* owed to Dora Maar, one of the small number of intelligent women (which at the time included Gertrude Stein, Eugenia Errazuri, and, I imagine, Éva) on whom Picasso felt he could lean at critical moments of his life. Dora reacted to events as intensely as he did; and she photographed *Guernica* as it proceeded through its various stages, thereby granting one of Picasso's most dearly held wishes: the conservation of all the buried paintings which lay beneath a final version. I have always thought that *Guernica*'s original image—the woman in the center of the picture carrying a lantern—was a form of homage to everything which united Dora and Pablo in the face of tragedy, this painting, as a response to tragedy, being one of them. Dora's image echoes back to Marie-Thérèse, the first of Picasso's lantern carriers in the Minotaur saga. Much of *Guernica* was worked out at Grands-Augustins in the studio chosen by Dora.

Ce Soir, the evening daily directed by Aragon, read by Picasso, and founded by the PCF only a short time before, published photographs of the battered town on 30 April. These gave Picasso the initial impetus for his painting.[2] The next day—1 May—Picasso did six drawings. The only feature common to all of them is the woman with the lantern. She is present, too, in the final, definitive version. There is perhaps an echo here of Prud'hon's *la Justice et la vengeance éclairant le crime* (Justice and Vengeance Illuminating the Crime, 1808), which Picasso had seen at the Louvre. But from the outset he assembled his entire panoply of emotive images, including the bull and the horse and the warrior in an antique helmet lying dead on the ground. There were even trial efforts to revive Pegasus from *Parade.* On 2 May the horse received the dagger-tongue of an enraged Olga. On 8 May the picture assumed its definitive scale and design with the dominating bull and the mother carrying a dead child. This mother is a direct descendant of sprawling, battered Marie-Thérèse and the subject of *Sauvetage,* of 1933.

Picasso drew on the entire repertory of pictorial invention he had used in his work to express anguish, despair, violence, and dementia. His approach paralleled exactly that of Éluard, convoking clusters of Surrealist images as a confrontational response to the fighting in Madrid. So that his plastic language would be honest, Picasso exposed to the bombs pulverizing Guernica emotions generated by the depths of his personal unhappiness. He

would not begin the work of refining his picture, sharpening its "message," until these emotions had been declared. By 11 May, when he drew the full design on the canvas—captured in the act by Dora Maar's photograph— the bull had already received a thoughtful, human head, with a benevolent expression. On 20 May a second head appeared, shrieking at the sky; this would eventually belong to the mother, carrying her dead child. On 24 May she was a woman in tears.

It was not until the seventh phase of the painting, after 4 June, that the head of the dead warrior stared at the sky, like a fragment of statuary or a flower, beside his broken sword. The body of the horse was covered with little lines, recalling Picasso's imitations in painting of his newsprint collages. An electric bulb replaced the sun, shifting the subject to an interior setting. And the principle of rupture with anecdote is affirmed. This is not "scenes of massacre at Guernica" after the fashion of Delacroix but the cries and torment of painting at the moment of massacre. The picture is not an allegory. The bull here is a noble adversary, turning away from the killing which humiliates him, while the horse howls the anguish of death. This linked couple of the corrida indissolubly represents murdered Spain. And the accused killer is the foreign violence, blind and inhuman, which has fallen from the sky. The mark of the actual event is in the horse, of trompe l'oeil newspaper collage, and in the immense canvas, which, like the illustrated journals and magazines of the time, is almost without color. Finally, it is in the woman with the lantern. She represents the impossibility of denying or hiding this tragedy, because the painting will forever bear witness.

In May, while immersed in this work, Picasso made the first political statement of his life:

> The war in Spain is a war of reaction—against the people, against liberty. My whole life as an artist has been a continual struggle against reaction, and the death of art. In the picture I'm now painting—which I shall call *Guernica*—and in all my recent work, I am expressing my horror of the military caste which is now plunging Spain into an ocean of misery and death.

Each word counts. The statement is a reply to General Millán Astray, who a short while before at the University of Salamanca, while pointing a revolver at the Spanish writer and philosopher Miguel de Unamuno, had shouted, "Abajo la inteligencia! Viva la muerte!" (Down with intelligence! Long live death!)

Guernica was hung in the Spanish pavilion and received a barrage of partisan, utilitarian criticism, even from its own "side." Years later one of the Communist leaders told me that the painting seemed to be "an acknowledgment of grief rather than the call to arms we were expecting." In Spain itself the Left went even further and declared the painting "antisocial

and entirely foreign to a healthy proletarian outlook." This criticism, which treated the picture as a piece of conventional painting in order to destroy it, survived the war, appearing in the United States, for instance, in the work of Clement Greenberg. Picasso answered these arguments in advance, with cutting derision. When Henry Moore came to see him, accompanied by Penrose, Picasso brought the picture into an everyday context by fetching a piece of toilet paper, which he attached to the hand of the woman running away on the right side of the canvas. "One of the first and most basic effects of fear, don't you think?"

The Spanish pavilion accomplished the transcendent feat of dedication to art at a time of war. As well as *Guernica,* Picasso was represented by two pieces of sculpture: the most elegant of the large heads of Marie-Thérèse from Boisgeloup and the *Femme au vase.* There were also works by Calder, Miró, Julio Gonzalez, and Alberto Giacometti.

Picasso continued his trajectory, pursuing the theme of a weeping woman in drawings, oil paintings, and an admirable aquatint of 22 October, *Tête d'homme au profil à gauche.*[3] This last picture should rule out the "realist" interpretation which ties the subject to his intimacy with Dora. Both Marie-Thérèse and Dora were used for experimenting with imbalances and unevenness of profile. (Just as he used both in variations of carrying the lantern.) If there is rather more of Dora, it is because he could read bad news from Spain on her face, as he could read the miseries of the war. On those subjects, with her, he could open his heart. And there was no shortage of bad news: Bilbao fell on 19 June. But there is no doubt that for Picasso the summer of 1937 was Dora's. So much so that Sabartès, who couldn't accept the relationship, was excluded from Picasso's intimacy.

Guernica, a response to tragedy by art, received wide exposure through the Universal Exposition, which, traditionally, made an artistic point—a first instance of the twentieth-century pictorial revolution in an official setting. Raymond Escholier had included foreign painters living in France since 1925 in this exhibition "les Maîtres de l'art indépendant," expressly so that he could introduce Picasso. But there was no need to worry about arranging the route of the president of the Republic to spare him the sight of a painting so anti-academic as *les Demoiselles d'Avignon:* that work had been sold by the heirs of Jacques Doucet to the Jacques Seligmann gallery in New York, without any effort by the state to keep it in France. Georges Salles, at that time curator of the Asian section at the Louvre, arranged to hang in its place *la Demoiselle d'Avignon,* a study— which he owned—for *Nu à la draperie.* The other Cubist Picassos in the June exhibition were lent by Gertrude Stein. There were thirty-two works in all, two of them sculptures. For Braque, Gris, and Léger as well the occasion was first and foremost another chance to show their work. Only Matisse—with sixty pictures—was given a special status. Picasso also figured in the exhibition "Origines et développement de l'art indépendant," hastily organized by Zervos, Breton, and Kandinsky at the Musée du Jeu

de Paume to correct the injustices and ostracisms of the "Maîtres."[4]

In the Paris art world these exhibitions made as much political noise as *Guernica* itself. One of the Paris municipal councilors felt no reluctance about taking up the old cudgels against Cubism. In his view,

> [there is something] unhealthy, even morbid about some of our modern artists. . . . This art which they wish us to admire as *advanced* is first and foremost outmoded. What is certain is that Germany *from which this art comes* [author's italics] has rejected it; literally—since the arrival of the Nazis—vomited it out. This summer there was an official exhibition in Munich whose object was to expose trash of this kind to the righteous indignation of the German people.[5]

Picasso evidently occupied a prominent position in this Nazi exhibition of *Entartete Kunst* (degenerate art), paradoxically enough with three blue and rose works. He considered the official German attitude quite normal—on a par with French traditionalist indignation in his regard. Unlike his elders—Cézanne, for instance—and unlike some of the younger artists who came after him, Picasso was not concerned about acceptance by museums: about working for that kind of recognition. He was already thinking then, as he would think in 1945, "I feel that in my painting I have always worked and struggled as a true revolutionary." Thus, to receive blows was entirely appropriate. It also indicated that at fifty-five he was still on the right track. During an international congress in Madrid, which brought Spanish and French writers together with Russians like Ehrenburg and Fadeyev, Picasso arranged to spend his holidays at Mougins with the Éluards. This time Dora came with him openly.

Political ideas, Picasso felt, were one thing; art another. Picasso helped his Republican friends financially. He lent them the moral credit of his name, and, above all, his work. That was his way of fighting at their side. But, like most Frenchmen that summer, the first year of the *congés payés* (vacation with pay: a major piece of social legislation extracted in 1936), Picasso had arranged his holidays, and—despite Spain—had a happy summer. Penrose was also a member of Picasso's group, accompanied by Lee Miller, a young American friend and model of Man Ray's whom he married a short time later. Penrose recalls, "Picasso made himself felt not only by the physical joy which the sun gave him, but also by the constant inventiveness of his spirit."

Dora's image has been falsified by simplistic identifications with qualities of violence and tragedy in her lover's painting during the war years, as well as by her nervous collapse at the end of the Nazi occupation and the beginning of the postwar years, when Picasso was leaving her. Passionate, jealous, and quick-tempered, she pleased Picasso all the more because with her he could play all the games of a romance *à l'éspagnole*. He enjoyed mastering her, breaking her in, forcing her to accept sharing with Marie-

Thérèse and with others. Dora, for her part, was an artist as well as being attracted by the man—fully appreciated association with the artist, and participation in an unprecedented adventure as modernism assumed the highest ambitions of grand art in the past.

Picasso flung himself into portraits: Nusch and Dora, a sun queen, as she emerges from the sea beside Picasso in one of Lee Miller's photographs. On 29 August Picasso succeeded in combining with Dora's features the exploded, fragmented profile which he hadn't managed to his satisfaction since Fanny Tellier in 1910. She appears with bronzed skin, marked by red and black—the red of long nails matching her red lips. But nothing is ever simple with Picasso. On 9 August Marie-Thérèse is back, wearing a beret.[6] This might be a souvenir or a stirring of guilt or might indicate a secret meeting.

The *Femme au chat* of 30 August is full of humor. But September brings harsh variations of Lee Miller, as an Arlesienne in traditional headdress. It may be that Picasso here, wishing to measure personal distances, is returning to a subject he first painted in 1912, at Sorgues.[7] His painting seems a new declaration of anguish. There are some aggressively geometric landscapes and portraits filled with scorings, like caning, which transform the subjects into objects.[8] The news from Spain—many deaths in the fighting—revived anxieties about his family in Barcelona.

At the end of September Picasso took back to Paris not only his canvases but pebbles he had collected on the beach and then engraved and an ox skull washed up by the tide, which was to figure in his painting.

Once resettled in the city, he did his most beautiful portraits of Dora; the most tender and calm.[9] Picasso always kept them. In October, too, he went briefly to Switzerland on a private matter concerning Paulo. Bernard Geiser, who did the catalogue of Picasso's engravings, took him to see Klee in Bern. A victim of scleroderma, Klee was dying and knew it. Picasso felt deep admiration for the only painter of his time other than Miró who had invented an entire world of plastic symbols comparable to his own. Both had figured in the Munich exhibition of "degenerate art." Picasso and Klee scarcely spoke, but embraced.

On 26 October the theme of the *Femme qui pleure* (Weeping Woman) reached a height of intensity.[10] This canvas, with its blackness of hair and the red of the cheeks—symbols for Dora—has for some people seemed to include her portrait. But this is to forget Sabartès' observation: "For Picasso, woman is shape, line, and color worthy of study, like any object he might study in the course of his elucubrations of plastic order." On 18 December Dora yields to a Spanish woman screaming in pain. Her dress, neck, and fists are done with the kind of crosshatching Picasso used for terror.[11]

This, however, does not interfere with the return of Marie-Thérèse on 22 October and her alternation with Dora Maar in November: a gentle sky blue as opposed to fire and storm. Picasso was indefatigable, reorganizing

their faces, their contrasts, to the point of doing two canvases on a single day: 4 December.[12] At the new year a faun lies on a beach, pierced by an arrow. Compassionate women emerge from the sea to tend it.[13] The year 1938 begins with Marie-Thérèse and Maya, whose recomposed profiles and heightened coloring express an unsurpassed tenderness.[14]

By February Picasso found the insistent quality of the Spanish tragedy inescapable. Teruel was about to fall, which would clear the way to Catalonia for Franco's forces. He painted *la Femme au coq,* a scene of daily life heightened to the point of sacrificial rite. Barr sees in this bound cockerel about to be killed by a woman who gives neither the creature nor her act a moment's thought a reference to the misery which threatened the artist's family.[15] On the 18th an orange and a jug are infused with a sense of imminent catastrophe.[16] And in March Hitler entered Austria. During the spring Picasso howled protest against this crime with the most direct and earthy images. But there was also a cockerel of liberty in a sequence of dazzling pastels in strong color, which show the bird proudly crowing, ready for combat. Years later Picasso explained to a young American painter: "There have always been cockerels. But, like everything else in life, we have to discover them; just as Corot discovered morning and Renoir, young girls."[17] It is the same old story: painting teaches human beings to see nature.

But however passionate Picasso's involvement with political events, painting imposed its moments of surcease, of happiness. There was a heart-stopping quality to Dora's hair; and he painted her face, too, at one with the fiery summer light. On 25 June he showed her surrounded by summer flowers. "Of course," Picasso said to Duncan, "if she'd really gone out in a blouse like that, she'd have spent the summer in prison."[18]

Once again summer holidays at Mougins. Nusch joined Dora as a subject for painting. Picasso also did the head of a man eating ice cream or sucking a sweet, rendered with furnace heat reminiscent of van Gogh. Another head wears a straw hat with fringe as unkempt as the subject's beard. In *Femme assise* of 29 August, Dora's breasts, like her hat, are done with brilliantly contrasting streaks.[19] And a woman's head, taut with tension, assumes a muzzle like that of Kazbek, his Afghan hound, radiating violence and anger.[20] Hitler threatened Czechoslovakia; Picasso attacked and distorted female heads with increasing ferocity, twisting a doglike muzzle into an elephantine trunk. On 10 September the head belonged to Marie-Thérèse. Picasso shouted his rage through the heads and faces of the women in his life.[21]

And this is an enduring lesson of *Guernica.* A "subject" does not generate the emotive intensity of painting. The artist's task is to give a subject its innate powers of expression, to permit that expression, to make it possible by using everything he sees and everything he has experienced in life. To give a subject through painting its maximum voice. "Of course," Sabartès notes, "to exclaim, 'We'll see what comes of this'—as I have often

heard him do while preparing a canvas or beginning a drawing that, in a certain sense, is to shut one's eyes to life in order to see only into the self. It was as if he'd been struck by a sudden impulse to leap from a height which was making him dizzy."

History was calling him to make such a leap, not once, for a salon painting, but every day, as he worked. On 22 March, the day after the Anschluss, he drew himself in front of a blank canvas. And he gave himself precisely the same look—two eyes in a single profile—that he had given Dora as her hair was being dressed. Which is a form of self-reminder that no Minotaur can be his substitute. Once again, as at other decisive moments in his life, everything depended on him. A reminder, too, that in confrontation with tragedy, he was not alone.[22]

We cannot properly complete an account of 1938 without touching on two works of that year which reveal the degree to which Picasso extrapolated the formal findings generated by his passionate concern for current events into expressive penetrations whose basic position is externally verified, beyond any narrowly defined conception of painting. Marie Cuttoli had already in 1934 contrived to get a tapestry design from him: the large collage *Confidences,* based on Marie-Thérèse's relationship with her sister, Jeanne. Now he began again, on a larger scale, with *Femmes à leur toilette:*[23] collages of wallpaper and oil paint, using the central—and Ingresque—theme of a woman dressing another's hair. He recapitulated the possible variants of a woman's profile showing both eyes—a masterly composition, as distanced and calm as *Confidences.*

At the same time, he was using one of the largest copperplates he would ever undertake (66.5 x 51.2 cm.) to engrave *Femme au tambourin,*[24] whose five states constitute an exhaustive trial of distortions of a woman's face and body and the remodeling of her limbs so that the viewer can grasp the full volume of her silhouette as she dances. *Femmes à leur toilette* is linked to the *Bain turc,* while the *Femme au tambourin,* one of the most virtuosic of all engravings, assumes all the challenges which in 1907 Matisse's *Nu bleu* handed to Picasso's *Nu à la draperie.* Picasso now committed his art to the expanding war. But he did not in any way compromise his sure knowledge that his work must be judged for and as itself; and that he was still the same artist he was when he took his first flight into the unknown realms of modernism nearly a third of a century earlier.

26

THE WAR

1938–1940

A lthough mounting tensions and pressures to declare loyalties and close ranks increased daily, deep differences inside the anti-Fascist camp were also intensifying. Picasso found himself caught in the rupture between Éluard and Breton. The execution of Bukharin in Moscow in March 1938—the month of the Anschluss—had precipitated their political divorce, and Breton, with his usual authoritarianism, called on all Surrealists to shun Éluard. They should, he said, neither see him nor mention his name, on pain of exclusion from the movement. He wrote a number of threatening letters. "Picasso is right in the middle," Éluard lamented.[1] He was so shaken, he didn't notice that his friend had refused to yield to the admonitions not only of Breton but of Max Ernst, Man Ray, and Roland Penrose as well. Such discord in his own camp as Spain was falling to the Fascists made Picasso both sad and angry. The future now seemed blocked, cut off. At just this point he was stricken with a painful attack of sciatica. The injustice of biology was always particularly difficult for him to accept.

In the still-lifes, a bull's-head—black, and then red—yields in January 1939 to an ox skull picked up on the beach:[2] a subject already loaded with death. At the same time a *Femme sur une chaise* (Woman on a Chair) painted during the spring, in howling striations, explodes onto a large canvas to become *Femme au jardin* (Woman in a Garden), completed on 10 December 1938.[3] The chair on which she sits resembles an instrument of torture. The picture is an absolute "chosification" (thingification) of the "wicker-work" woman.

On 13 January, thirteen days before Franco's troops entered Barcelona, during the final agony of the Spanish Republic, Picasso's mother died. This loss was compounded: not only his mother Doña María but the city of his youth as well and his hopes that Spain might escape from a black past. On 15 January the bull's skull appears in his painting. When one follows the entire sequence of paintings, the distance between Picasso and the Symbolists can be readily understood. This skull is an instrument with which to make painting scream and weep. It represents an aspect of death, of course; but above all it is a reflection of the death that Picasso carried in

his heart. Dora and Marie-Thérèse in turn represent martyred Spain, and Maya is an image of all little girls killed by bombs. One can see this in the way she pulls her toy boat on 28 January.[4]

On 21 January Picasso had sought his private truth by painting two complementary canvases of women reading. In the first Marie-Thérèse lies naked in a room whose opaque window is barred. The two profiles of her face are melted together, and her body is all curves. In the second an angular Dora, her face infinitely long and twisted into itself, is in a room which opens onto green growth and light.[5]

In February birds scream the agony of Spain, as if Picasso already knew that by 22 April Prague would be in the hands of Hitler, Madrid, in those of Franco. And the bird will be in a cat's mouth—one of the most hellish executioners in the history of painting not only because of its claws and its size—far larger than life—but because of the sandy impasto which makes the texture of the paint itself seem to howl. Picasso achieved this quality of paint at moments of extreme spiritual tension.[6]

Picasso settled into Grands-Augustins, giving shelter to refugee friends at the rue la Boétie. Sabartès, too, had returned to Paris. Portraits done in May and June are agonized: a sequence of women—in a hat, head and shoulders, or streaked and crosshatched, seated in a chair. The figures seem to be moving ineluctably toward tragedy.[7]

On 17 June he did a *Femme assise au chapeau bleu et rouge:* Dora, reconstructed against a decorative background. The extraordinary probing of her face conveys a sense of deep anguish. On the 18th, with the same anxiety and distress, he painted Maya and her toy boat—a Maya crowned with flowers, her face close to tears.[8] Picasso was projecting his own tearing grief through images of his own intimates, which are more real than nature. And the most crushed and overwhelmed of his seated women were yet to come. As the tragedy intensified, Picasso saw them grown old, as on the 23d and 24th. The *Tête de femme* engraved for the martyrdom of Czechoslovakia is the most dislocated he had yet done. Dora appears in these gravures, too; but in her case, tenderness is not diminished by anxiety.[9]

Early in July Picasso moved for the summer to the Côte d'Azur, where Man Ray had lent him an apartment at the top of a modern building. The place had a magnificent view. Picasso shifted the furniture to make room for a studio and hid the flowered wallpaper by covering the wall with a big piece of cloth. Whether *Pêche de nuit à Antibes* (Night Fishing in Antibes) had already been started when news came of Vollard's death is unclear. Vollard was killed in his car by a piece of Maillol's sculpture, which fell forward from the back seat, where it had been propped behind him. Despite the collapse of a project to publish a book of engraved poems, Picasso and Vollard had remained on close terms. Picasso left for Paris immediately to be present at the burial on 28 July.

On his return he brought Sabartès with him, a move which was not calculated to please Dora. Penrose was there, too, and Picasso's nephews—

Lola's boys—who had managed to avoid internment in French camps. Their tales plunged Picasso back into the agony of the Spanish Republic.

Every evening in Antibes fishermen in the harbor prepared for their night's work. They would fish through the hours of darkness with a *lamparo*—an acetylene lamp, whose brilliant light attracts the fish. The smaller ones were taken with a net; the larger, harpooned with a trident. Picasso was fascinated by this ballet of death. His *Pêche de nuit à Antibes*[10] is based on all the details he had observed, as well as the emotions and sensations the scene produced for him. The two female spectators in short summer dresses—one of them licking ice cream—originated, respectively, with Dora and Jacqueline Lamba, at that time the wife of André Breton. In the background one sees the two towers of the Château Grimaldi, which had been suggested to Picasso as a place he might buy and which was to become one of his museums. In the painting the sun is replaced by the *lamparo,* but the night is Mediterranean: mauve, with a range of deep, gentle blues, a mixture of sensuality and violence. The dynamics of the composition are filled with plastic references to *la Danse* and *la Crucifixion.* In Picasso's personal vocabulary, fish and crustaceans are always linked to cruelty. It is pure painting which cries out with as much strength as *Guernica.*

Wrenching private distress was added to worry about public events. Maya has published a letter from Picasso to Marie-Thérèse postmarked Antibes, 19 July. The letter reflects Picasso's attempt to console the mother of his daughter for what she must have felt as an abandonment. He had sent Marie-Thérèse and Maya to the far side of France: to Royan, on the Atlantic coast.

> My love, I have just received your letter. And I have written several to you, which you must by now have received. I love you more every day. You mean everything to me. And I will sacrifice everything for you, and for our love, which shall last forever. I Love you. I can never forget you, my love, and if I am sad, it is because I cannot be with you, as I would like to be. My Love, My Love, My Love: I want you to be happy, and to think only of being happy. I would give anything for that to be so. . . . My own tears would mean nothing to me, if I could stop you from shedding even one. I Love you. Kiss Maria, our daughter.[11]

Pêche de nuit à Antibes is far from being Dora's only appearance that summer. She was *the* woman during the summer months when war threatened to break out over Dantzig and Poland, Spain lay crushed beneath Franco's boot, and the Rome-Berlin Axis was imposing its rule through almost all of the former Austro-Hungarian Empire. Picasso worked well in her company because of the understanding and sympathies which had united them since *Guernica.* But how to reconcile pairing with Dora and the tenderness he felt for Marie-Thérèse and Maya?

With the formal declaration of the Nazi-Soviet pact, tragedy seemed to

have reached a zenith. The gates of war were now yawning wide, and there were clearly no further grounds for the hope to which Picasso and Éluard had clung: that the democracies and Soviet power might together put an end to the "insolence of the dictators." This was the defeat of everything Picasso had tried to defend. It was the victory of reaction, the "death of art." On 25 August, leaving his chauffeur, Marcel, to bring back the luggage and the paintings in the big Hispano-Suiza, Picasso took the train to Paris with Dora and Sabartès. Of course he had not forgotten the sequestration of 1914 and all the dreary frustration that entailed. The need to protect his enterprises in Paris as best he could now seemed urgent.

There were, first, a large number of paintings scattered throughout the world in various exhibitions. *Guernica* and its preparatory sketches, on exhibition in London at the time of Munich, had gone next to Scandinavia, then, on 15 November, to New York, where Alfred Barr had organized a retrospective at the Museum of Modern Art. The pictures in New York were safe. But there could be no certainty about the stock in Paris, where bombing—like the bombing of Madrid—was a contingency that had to be considered. He couldn't bear the thought of dismantling either the rue la Boétie or the Grands-Augustins. On 29 August, after discussing prospects and options with various people, he left for Royan with Dora. There he would finally see and attempt to console Marie-Thérèse and embrace Maya. All his loves would be collected in one place, for it was clear at this moment of sharp political and spiritual crisis that he greatly needed Dora.

But his plan was almost immediately shattered. With the threat of war, foreigners had become suspect. Max Ernst was interned as a German citizen, and Picasso discovered that he needed a residence permit. This meant returning to Paris, where André-Louis Dubois, assistant director of the Sûreté (Criminal Investigation Department), took care of the problem. Picasso went back to Royan and settled into the Hôtel du Tigre with Dora. Marie-Thérèse and Maya were at the villa Gerbier-de-Joncs, and Picasso pretended he had rented a hotel room as a studio.

Royan is a seaside watering place of the Belle Époque grafted onto a small fishing town. The holiday villas display a somewhat bewildering eclectic variety, but there is a fish market and an auction house. Picasso took walks with Sabartès; in the evenings, between two sessions of work, they went to the café. There Picasso drew a convoy of requisitioned horses. (There were still a few generals who thought the technology of 1870 appropriate opposition to Hitler's tanks.) He also did a man in a striped sweater;[12] and Dora, washing herself in a bathtub, like the blond woman in the Boulevard de Clichy studio in 1901. On 20 September he did Marie-Thérèse.[13] To feed Kazbek, the insatiable Afghan hound, he bought a quantity of sheeps' heads, which became a study of death.[14] On 22 October Picasso imagined Sabartès, bored with his lot as a seventeenth-century Spanish grandee.[15] The resemblance is striking, despite the twisted features and the vast collar. In the interval he had been—briefly—back in Paris: to

buy painting supplies and put some of his paintings in a bank vault, as a shelter from possible bombing. The visit also gave Brassaï an opportunity to photograph him for *Life* magazine at the brasserie Lipp, the Café de Flore, and in his studio.

On 21 October Picasso painted Maya's grandmother, with contortions similar to those used in the portrait of Sabartès.[16] He did Dora, too, wearing a hat, sitting in an armchair; and once again, dressed for summer. This time, however, she is cut into quarters, and her face is divided by a long snout.[17] Do these paintings suggest that Marie-Thérèse and Dora had already met? Picasso needed all his attachments at once: in his life and in his art. And after all, there's a war on. Jacqueline Lamba arrived with her daughter, Aube. And Picasso introduced this friend of Dora's to Marie-Thérèse so that Aube could play with Maya.

Although the illegitimate family was emerging from clandestine obscurity, Dora's situation, nonetheless, was not bad. Picasso hated to be alone and took her with him to Paris for two weeks in mid-December and for almost the whole month of February 1940. From mid-March to mid-May she was openly installed there. He got news of friends who had been mobilized. Éluard was a lieutenant in the supply corps in the center of France. They were all trying to understand what was happening in this war-without-action, as if, somehow, people thought they could "handle" Hitler. There was still some intellectual life. Picasso became closer to Giacometti, who as a Swiss citizen was outside the war: a circumstance which played a part in Picasso's return to sculpture. And in the spring he would also see more of Matisse when the latter moved to Paris.

At the end of 1939 he did a life-size profile of Dora brushing her hair. The streaks and scorings of her body make a rhythmic sweep as if the young woman had been swept by a devastating storm.[18] This language of striation accentuates the anguishing distortions of geometrization in the portraits of that moment.[19] Picasso then conceived of turning the two profiles back, on each side of the nape, like two halves of a book seen from behind, displacing the geometrized profiles even further.[20] Violence found expression—and relief—once again with the fish and crustaceans at the Royan market: *les Anguilles* (Eels); *l'Araignée de mer* (Spider Crabs); and *Soles*.[21]

In Royan Picasso had taken a real studio on the seafront, on the third floor of the villa les Voiliers (Sailboats), whose proprietress, Mlle Roland, was to publish in 1967 recollections of her odd tenant. The view from the villa was splendid. "How magnificent this would be," Picasso said to Sabartès, "for someone who thought he could paint!" He at the time was preoccupied by other things. Finally, on 14 March, all the anger provoked by the growing structure of disaster found expression in painting: the appalling *Femme nue se coiffant*.[22]

Sabartès stayed in Royan with Marie-Thérèse and Maya. Picasso wrote to him, a message that in fact was for them, "I am working; I am painting; and I'm fed up. I would like to be at Royan; but everything takes

too long." In fact, he was seeing the Zervoses. In April Yvonne showed some of his gouaches and watercolors. He saw Brassaï and, above all, Éluard, who was back on leave. Suddenly he began to relax, to draw graceful scenes like *la Nymphe et le satyre*.[23] But the ferocity of the war was constantly increasing. On 10 May German troops attacked Holland and Belgium, and on the 13th, they broke through. Picasso ran into Matisse just then and observed that the French generals belonged to the "Beaux-Arts school," a pessimism that unfortunately was justified. On the evening of the 16th, he set out for Royan with Dora, just ahead of the pitiable flood of refugees from Belgium and northern France. It was defeat—unconditional and unthinkable. And it was in this atmosphere that Picasso began his large canvas *Femme nue se coiffant*.

The preparatory drawings properly speaking were done between 3 and 8 June. (Paris would fall on the 14th.) Picasso began by defining the movement of the enormous legs, thrusting toward the spectator, and sketched in the distorted body. The triangle of flayed ribs to the right, the amputated stumps of hands, the decomposition of the face, with perpendicular eyes and a snout-nose, accentuate a violence which borders on the unbearable. Two canvases painted on 11 June give the impression of skulls which have retained living eyes. This "undone" aspect of the face appears again in a portrait of Dora on the 16th, when the national rout seemed unlimited, and the Nazis were close.[24] The Germans would enter Royan on 23 June. On the 25th, the day of the armistice, Picasso drew Maya full face, in all the dazzled freshness of her five years.

The red flag with its central swastika was flying in front of the Royan hôtel de ville, two steps from the Voiliers. The arm movements of the *Femme nue se coiffant* look like a swastika, but Picasso told me later, "It just came to me like that. I didn't foresee that comparison." Later his friends would call this monstrous female *"la drôle de guerre"* (a pun which might well apply to all of the complicated emotions Picasso felt and projected into this work at capitulation by those who had abandoned his Spain).

During this period he clearly used his sketchbooks as a form of private diary. On 11 July, for instance, an embrace with the savagery of rape, an abundance of skulls, female nudes and faces are subjected to his fury at the dementia of the times. He regained some calm at the end of the month.[25] On 11 August he did two self-portraits in pencil and gave one to Marie-Thérèse.[26] He was invited to Mexico and to the United States. But with all the quiet courage this implies on the part of the painter of *Guernica*, he wouldn't budge. On 1 September Matisse, who had made the same decision, wrote to his son, Pierre, in New York: "If everyone did his job as Picasso and I are doing ours, all of this wouldn't be happening."

When communications began to be restored, Picasso painted the scene from his window before leaving Royan. *Café à Royan*[27] conserves in the

summer light the image of a town which would be annihilated during the liberation of France in 1945. Leaving Marie-Thérèse and Maya behind, Picasso returned to Paris in the big Hispano, heavily laden with recent work. Like any refugee, he was returning to his domicile. And thereafter he would not leave the occupied zone of France.

To the Nazis he was one of the champions of *Entartete Kunst* (degenerate art); to the Fascist-dominated Vichy government, a destroyer of traditional values: one of those responsible for the collapse of the country. The "return to order" which Picasso had experienced in victorious France of 1919 was nothing compared to the program now being announced under the aegis of Marshal Pétain, the premier of the Vichy government in unoccupied France. Kahnweiler, a Jew, had fled, secreting himself in the Limousin—in the unoccupied zone. Paul Rosenberg was in New York, and the Nazis confiscated his gallery. Retreating French soldiers had broken into Boisgeloup and smashed the plaster casts of Picasso's sculpture. But when the estate was occupied by the Germans, there was no damage.

The contrast with what was happening in those parts of world which were still "free" was extreme. In the United States the Museum of Modern Art's retrospective was making a triumphal tour through Chicago, St. Louis, Boston, San Francisco, Cincinnati, Cleveland, New Orleans, Minneapolis, and Pittsburgh, transforming public ideas about modern art in Europe. Because of *Guernica,* Picasso had become a symbol of intellectual resistance to the Nazis. And he knew it. Forbidden to show anything in France, he was engaged in what amounted to internal exile. He would scrupulously observe the obligations imposed on him by his status as a foreigner, the citizen of a "neutral" country; would exploit the rare possibility to mark his presence still offered by a luxury edition; and would devote himself entirely to his art.

Because it has not been altogether understood that Picasso's refusal to give the Nazis any kind of undertaking whatsoever was in itself a political stand, many foolish things have been written about his attitude during those years by people who were—to put it politely—not themselves in the Resistance or were not even in France and have no idea of actual conditions at the time. Members of the Resistance considered him one of theirs. As Penrose recalls, when tempting Nazi offers were made—of extra food or coal—Picasso merely replied that a Spaniard was never cold. For the rest, like everyone else, he managed as best he could at a time when the most trifling items of any quality were only to be found on the black market and when casting a piece of sculpture in bronze was an open defiance of German policy. The Nazis were rounding up for their war machine not only French public monuments in bronze but all their own.

Although the defeat of the Spanish Republic had been his own personal defeat, the defeat of 1940 affected him only by its consequences: Nazi rule in Paris and "reaction" in Vichy. He was clearly on the side of the

English, at that time fighting alone. The United States was still neutral, and Stalin was allied to Hitler. Tragedy had engulfed Europe. There were no glimmers of light on the horizon. More than ever before, Picasso's art was his stake. How could the death of art be prevented when the Nazis—like the Francoists—were the porters delivering it? How could the survival of art in such times be guaranteed?

THE RESISTANCE

1940–1944

P icasso felt that he was faced with circumstances of virtually unprece-
dented difficulty. *Guernica* was, despite all the differences, a modern
translation of Goya's *Tres de Mayo*. And in 1937 there had been a
war with a front line between good and evil, between the future of human-
ity and the death of art. Now the ideas he believed in had been defeated.
In France, as in Spain, there was no more "front line," and one had to refuse
defeat, refuse to accept it, as an internal matter, within the self. What could
he paint or sculpt now that would have meaning and direction? That would
be something more than a simple five-finger exercise or reflex action?

At his side Dora felt even more crushed than he, because she had been
more politically active. He and Dora were perhaps never closer than during
that first, cold winter in the Grands-Augustins studio. Éluard and Nusch
were back in Paris, and his intimate friendship with them was resumed.
They all sat up together to see the new year in. This closeness was to have
considerable consequences. As soon as the German-Russian war in June
1941 had clarified the situation, Éluard made contact with the Communist
Resistance. He joined the clandestine Communist party in 1942. The Zer-
voses had resumed their work at *Cahiers d'Art* and gave Éluard a room at
their house in Vézelay. They edited volume 2 of the Picasso catalogue,
devoted to his Cubist work, and Christian Zervos printed it in 1942. For the
first time, Picasso saw himself as someone with a large past and no present.
The Nazis made inventories of the safe-deposit boxes at the bank, and
Picasso was present when his were opened. Fortunately his paintings struck
the inspectors as pointless daubs; any echoes of Cézanne or Renoir escaped
them.

A literature of Resistance—some of it legal—and occasional exhibi-
tions of paintings in styles condemned by the Nazis or by Vichy managed
to maintain a sporadic existence. This was for the most part due to the
ignorance of the police in questions of art (and sometimes, although less
often, to the complicity of certain German intellectuals). In the autumn of
1940 John Hemming Fry, an old American with Fascist leanings, published
the first attack on Picasso in a pamphlet called *Art décadent sous le règne*

de la démocratie et du communisme. But this effort fell flat.

More serious was a denunciation by Vlaminck published in *Comoedia* on 6 June 1942. The old Fauve, long past the talents of his youth, enjoyed the flattering attentions of the German ambassador and was perhaps hoping to please the new masters.

> Pablo Picasso is guilty of dragging French painting to a mortal impasse, a state of indescribable confusion. From 1900 to 1930 he has led painting to negation, impotence, and death. For, in and as himself, Picasso is impotence made human. . . . One can guess who is behind each of his several and various maneuvers. The only thing Picasso absolutely cannot do is a Picasso which is a Picasso.

In the same article Vlaminck harshly dismissed the critics and the public as "stupefied, hypnotized, and totally disoriented by such a deluge of claptrap."

There was a reply by André Lhote, who came to the defense of Cubism, and protests by younger painters. But Camille Mauclair, agreeing with Vlaminck, found the moment ripe to resume the abuse he had been directing at "modern art" since 1905. In the end, however, these attacks only cleared the air, illuminating issues of contemporary work too often confused with Fascist obscurantism by a left which identified realism and humanism.

Picasso, officially reduced to silence, did not immediately find subjects which satisfied him. As at the time of his marriage crisis in 1935, he turned to writing. On 14 January 1941 he drew himself writing,[1] as if observed from the studio ceiling. As the piece in question opens, a character called l'Oignon is speaking. Further down the page, the manuscript is marked "Act One," as if the author had not known at the outset that he was beginning a play. *Le Désir attrapé par la queue* (Desire Caught by the Tail) remains one of the best examples of theatre in automatic writing. It is more than probable that Picasso was aware of Surrealist efforts during the 1920s.

A cruel farce, the piece is based on the obsessions of cold, hunger, and love. The hero, Gros Pied (Big Foot), is a poet who lives in an artist's studio. His rival for the favors of the Tarte, the nude heroine, is his friend l'Oignon. The Tarte has two female friends: l'Angoisse maigre and l'Angoisse grasse (Thin Anguish, Fat Anguish). The torrent of images and corrosive humor make this piece an indirect self-portrait in which Picasso assumes a certain distance from the hostile world of the Occupation. Painting has its place in this world. "The Demoiselles d'Avignon have already been raking in cash for thirty-three years," Gros Pied declares.

Picasso had regained his vitality. In the same vein as the self-portrait in *Désir,* he drew *Vieille Femme* and *Bibliophile.*[2] Dora became the highly delicate and subtle *Tête peinte et construite en papier* (Constructed and Painted Paper Head).[3] Marie-Thérèse and Maya returned from Royan, and

Picasso installed them in an apartment on the boulevard Henri-IV, near the Bastille. From the Grands-Augustins this meant a fifteen-minute walk along the river, an appreciable distance in a city without automobiles. Once again Picasso spent every weekend with them and drew little scenes for his daughter, who was going on six. These visits were his moments of détente, his relaxation. There was also one day a week for Olga and Paulo, who had stayed on the Champs-Élysées. Picasso almost always returned from those sessions in a very bad mood. The difficulties of the times pressed him to assume his paternal duties with some regularity; but he also helped his Spanish friends as much as he could. Since Dora revealed nothing about her time with Picasso, his private history during those years has too often been drawn from anecdotes by rivals or interpretive accounts of paintings. She, however, more than ever, was his principal and pre-eminent companion.

In August 1944, when the end of the nightmare was in sight, Picasso spoke with an American correspondent: "I didn't paint the war because I'm not the kind of painter who goes out to look for subjects, like a photographer. But without question, the war is in my painting. Perhaps, later on, an historian will demonstrate that under the influence of the war, my painting changed. Myself, I don't know."[4]

And in fact in these paintings at the limits of automatism, it is absurd to ask whether the female faces—hashed, chewed, and discarded—derive from Dora Maar or incarnate the war as her presence at the artist's side.

Although Picasso painted some more still lifes and a *Table mise* (Laid Table)[5] (food was in short supply), nineteen drawings from 19 May study a woman seen from behind, with a head whose two profiles diverge like the two halves of an open book.[6] There are also heads whose surfaces and perspectives have been disordered, assigned to different levels. Dora's face, imprinted with panic, appears again on 8 June in *Femme au corsage bleu* (Woman in Blue Blouse),[7] and, more than a year later, in the masterpiece *Portrait de Dora à la blouse rayée* (Portrait of Dora in Striped Blouse).[8] Discussing this picture, Picasso said to Braque, "I'm glad that you noticed the blouse: entirely invented by me. Dora never wore it. . . . Whatever people may say or think about my facility, I, too, can have plenty of trouble with a picture. I really sweated over that blouse; painted and repainted it for months." It is this blouse—as much as the reinvention of the face (despite its realistic appearance)—which gives the painting its symbolic quality: a representation of misery under Nazi oçcupation.

At other times the paintings express a primary tenderness, as in a head and shoulders of 1941, which Éluard included in his 1944 *Picasso*. Dora here is nude, suddenly very much the little girl who needs protection.[9] But at practically the same moment, she was the model for some monumental nudes: a powerful expression of Picasso's need for sculpture.[10] And it is now, at this moment, that Picasso did a monumental sculpture of Dora's head, in the bathroom of the Grands-Augustins. As beautiful as his heads of Marie-Thérèse, it became—in 1955—the monument to Apollinaire,

which stands in the little square of Saint-Germain-des-Prés in Paris.[11] Dora was simultaneously a point of departure for her creator's impulses and herself. As model and mistress she was subjected to her lover's pitiless analysis, which dissects, as John Richardson puts it, "each of her expressions—serene, sleeping, irritated, loving, distant, happy, sullen, laughing, pensive, melancholic, languorous, ecstatic, desperate, radiant, enclosed, hysterical."[12] Studies by a lover who would like his painting to master her, once and for all.

Fernande, by contrast, seems to have remained an exterior figure—like Olga, an embodiment of happiness in marriage and paternity before becoming an image of anger and destruction. Marie-Thérèse was the light of youth, but Dora from the first represented a challenge. One day, as he and I were talking about that dark time, Picasso said: "I always started pictures just as they came to me. And told myself, even if this leads nowhere, by evening you'll have made a little something. . . . It seemed to me that I built up my supply of pictures just as one had to stockpile copper and paper for engraving: a little here, a little there."

An overview of this period—all those women in hats or in armchairs, all those busts of Dora or of Nusch—gives an impression of frantic enterprise, day after day, in that blackest of times, precisely as a refusal to be reduced to silence. And through these attacks on the human face (which in turn make moments of love all the more expressive) the painter is constrained to protest the inhumanity of each day and show himself stronger than the enemy.

The *Femmes assises* seem to have been surprised in prison, thrown onto the canvas with heavy brush strokes, tremulous and hurried. Nonetheless they hold together with that extraordinary sense of composition which captures things at the point of dissolution and draws heightened strength from imbalance denied. From the autumn of 1941, Picasso gradually defined an opposition between a seated and a recumbent woman, which on 9 May 1942, during the spring of terror in Paris, would produce that great canvas *l'Aubade* (Dawn Chorus).[13]

A gouache of a *Nu couché* dated 2 January 1942, kept by the artist, expresses the basic direction of this new enterprise: the destruction by paraphrase of the harmonies considered essential to great painting of the past. Picasso here was referring to both *Olympia* and Velasquez's *Venus in the Mirror*. *L'Aubade* was conceived—with its crashing rhythms, its unbearable contrasts and wounding cruelty—to carry these tearing assaults to a zenith of ferocity. Painting cannot possibly express the horrifying violence of that year, which would prove to be the worst year of the war in Europe, except by attacking not simply its own materiality, as in the *Autoportrait* contemporary with *les Demoiselles d'Avignon,* but the moments of transcendence it has achieved in the course of its history.

Carefully prepared for a large format (195 x 265 cm.), the picture was given by Picasso to the Musée national d'Art moderne in 1947. The unbear-

able tension which exudes from the empty room and its implacable geometry, the broken stripes of the bed, the cadaverous emaciation of the nude, who seems to be guarded by a policelike mandolin player—all attest to new plastic symbols which Picasso used to express violence. A month earlier, at the death and burial of his old friend Julio Gonzalez, he had painted a sequence of still lifes with a bull's skull. In the best known of these the closed window (painted the obligatory blue-mauve, against possible air raids) composes an orchestrated mourning centered on the skull. And then the *Nature morte à l'épée de matador* (Still Life with Matador's Sword) turns its back on symbol and with its guitar refines the subject so that it expresses the innate tension of material objects.[14]

There is always a counterpoint of humor, as well, coming from *Enfant à la langouste* (Child with Lobster), for instance; or *Femme assise au chapeau en forme de poisson* (Seated Woman with Hat in Shape of Fish), a real fish, ready to be eaten, accompanied by a knife and fork; or *Femme assise au petit chapeau rond* (Seated Woman in Small Round Hat), who seems to be paying a call.[15] From April, just before finishing *l'Aubade*, there is a graceful drawing of Venus, after Cranach the Elder.[16] Daily life is scrutinized in *Femme à l'artichaut* (Woman with Artichoke), who brandishes that vegetable like a scepter (artichokes had become exceedingly rare) and in *Nature morte au buste de femme,* a handsome and successful instance of joining the two profiles of a face at the nape. The model is in the studio of Grands-Augustins, where one can see the cage of doves.[17]

In fact, the style of *l'Aubade* is dominant, giving resonance to the long, low prison/room of the still life known as *aux oeufs* (with eggs) and ruling the large *Nu couché* of 30 September.[18] The portrait of Dora done on 9 October, which I've already mentioned, summarizes the tragic quality of the period. Dora had just lost her mother. Painting was interrupted to do engravings for Buffon's *Histoire naturelle,* producing successes like *le Coq, la Sauterelle* (The Grasshopper), and a lovely nude of Marie-Thérèse for *la Puce* (The Flea).

In January 1943 Picasso paid a Sunday morning visit to Dora, in the rue de Savoie, which was an exception, because Sunday morning was for Marie-Thérèse. He gave her a copy of the *Histoire naturelle,* which the publisher Fabiani had just printed. On the title page there is a drawing of Dora as a bird. In Catalan Picasso has written, *"Per Dora Maar tan rebufon,"* which translates into French as *"Pour Dora Maar si rebufon":* wordplay on *bufona* (sweetheart) and *rebufant* (huffing with rage). In French the words sound a bit like *"Pour Dora Maar ton buffon"* (for Dora Maar, from your clown).

In fact, the break in painting at this point was caused primarily by new ideas for sculpture.[19] Since the war began in earnest, Picasso had been working with whatever came to hand: cardboard, cigarette packages, bones, pebbles. Dora's head was the first piece of genuine sculpture in that period. And then Sabartès persuaded him to cast in bronze the roughly

mended plasters from Boisgeloup. Picasso narrates: "A few devoted friends took the plasters to the foundry—in wheelbarrows, at night. And then brought them back here, cast in bronze, under the noses of German patrols. That was even riskier." This was probably one of the more decisive contributing factors leading to what would become *l'Homme au mouton* (Man with Sheep). And the fact that the first drawings date to July 1942, that is, immediately after Vlaminck's attack, is not unrelated. Picasso felt that the fate of art depended on him; therefore he would certainly accept the challenge put to him in the name of tradition. He would demonstrate that in 1942 as in 1917–18 his purpose was to realize the classical values of humanism with twentieth-century methods and materials; to prove himself heir to classical Mediterranean tradition. The slow maturation period which preceded the actual making of the sculpture is striking: some one hundred drawings between July–August 1942 and February–March 1943. So is the technical skill in preparing the metal armature on which, in one or two working days, Picasso laid the clay.

There is also a strong contrast between this classicism and the freedom of his contemporary assemblages. These may be the product of some contradiction; but when one knows Picasso's reactions, one cannot help but think that the death of Gonzalez—on 27 March—aroused his sense of responsibility as a sculptor. Albert Elsen thinks it is not exaggerated to see in *l'Homme au mouton* a symbolic tribute to Gonzalez's *Montserrat*—the peasant woman at war, carrying a baby. That he should be conducting these two sculptural explorations simultaneously is characteristic of Picasso's creative thinking and supports the idea that the classicism of *l'Homme au mouton* is deliberate. Albert Elsen, for his part, develops this notion in an article of 1977, linking it to confidences made by Picasso after the war to John Pudney. (I shall return to these later.) Picasso said "that he believes that outside events caused him to seek greater objectivity. He said that the tendency in the creative artist is to stabilize mankind on the verge of chaos."[20]

At an opposite extreme to *l'Homme au mouton*, Picasso made the famous *Tête de taureau* (Head of a Bull) of a bicycle seat and handlebars, probably shortly after the death of Gonzalez. A photograph of it appears in the Surrealist collection *Conquête du monde par l'image* (Conquest of the World by Image) of June 1942. In parallel development there are masks of torn or crumpled paper and, in *Faucheur* (Reaper), moldings of corrugated cardboard. The figure's head is the sun, vibrant with inventiveness regained. A *Tête de femme* plants a conceptual rectangle on a stem, foretelling the sculptures with central axis of the 1950s. The reemployment of a mannequin leads to *Femme à la longue robe* (Woman in Long Dress). And a child's scooter makes *la Grue* (The Crane). Picasso confided to a young woman who had come to the studio, "What interests me is to make what might be called links, connections, over the widest possible distance—the most unexpected link between objects I wish to consider. One must rip and

tear reality." The young woman to whom he said this was Françoise Gilot.[21]

Life went on. Éluard, since confirming his commitment to the Communist party, had been obliged to quit his legal domicile; and in late 1943 had to leave Paris for several months. Yet Louise Leiris, because she was "Aryan," was able to reopen Kahnweiler's gallery. The obligatory yellow star for Jews had just been instituted, and mass deportations had already begun, measures which threatened that old friend Max Jacob. Perhaps it was assumed that his age or his poetry would protect him. In any case, no one had seen to it that he went into hiding. Picasso didn't realize the gravity of the situation until after Jacob's arrest. And then it was too late.

On 21 May 1943 he painted *les Premiers Pas* (First Steps), the first steps of the child of Inès, housekeeper at the Grands-Augustins since 1938. Barr has stressed Picasso's transformation of a heartwarming scene into a dramatic test, painting the baby's apprehension as he confronts stepping into the unknown, that "mixture of impatience, determination, insecurity, and triumph."[22] As a definition of Picasso's frame of mind as he worked, that cannot be improved on: the transformation and transcendence of every subject into something else; and the baby, discovering its own autonomy, as it enters a world of war, a war whose outcome at that moment was still totally hidden, without even glimmers of a possible future.

And yet outside at this moment it was spring. Picasso shows us the narrow rue des Grands-Augustins as it reaches the *quai* and the Seine; and a sequence of cityscapes depicts the square of the Vert-Galant, at the point of the Ile de la Cité with all the exuberance of Douanier Rousseau. This name—at the dawn of a new love—must surely have induced romantic dreams.[23]

In the turbulent rush of his emotions, Picasso considered immediate surroundings, like his studio. *La Fenêtre* (The Window) introduced into his painting that novel but—for the period—obsessive character the radiator, reduced to impotence by coal rationing. And *L'Enfant aux colombes* (Child with Doves) seems here to be in a dungeon cell. On 28 June another *Grand Nu couché* (Large Recumbent Nude) seems truly imprisoned, in a room which is far too low. Anguish is the dominant emotion. The *Femme assise dans un rocking chair* (Woman Sitting in a Rocking Chair), geometrized within the curving lines of the chair, conveys to the world the vertigo of her movement. *Nature morte au panier de cérises* (Still Life with Basket of Cherries) and *La Chaise aux glaïeuls* (Chair with Gladiolus) are both statements: that the pleasures and sweetness of life are not strong enough in themselves to blot out the ferocity of combat.[24]

To wonder, in the face of these works, whether or not Picasso supported the Resistance is an absurdity. Everything he did at the time bears witness to a period of madness, terror, and murder. The link between these canvases and external reality is neither symbolic nor realistic. As *Guernica* became the destiny of painting after the bombing of the town, so in the

fourth spring of war in Paris and the fourth summer of Nazi occupation, Picasso put into his paintings life—or what was left of it. And whatever statement art might make of current circumstances: make, and then transcend.

On 15 August the canvas *Tête de mort au pichet* (Death's Head with Pitcher) tells us that Picasso had sculpted a death's head and that it had probably been cast in bronze—a hypothesis confirmed by Brassaï, who photographed the painting in September.[25] Brassaï states: "A marvelous work: more like a monumental, petrified head with empty sockets and obliterated lips than a skull. One might say a rolling block of stone, corroded and polished by rolling through the ages."

Mineral death. In the petrified bathers of 1930–31, as in the re-ordering of bones between 1928 and 1932, there was surely a premonitory flavor of death. But now a direct vision of death itself must be faced. Specifically the death of humankind, not generalized death, as suggested by the ox skull. Picasso's ideas at the time can be detected perhaps by noting that his *Femme au corsage rayé* (Woman in Striped Blouse) of 20 September congeals—or petrifies—the subject so that she assumes the qualities of a nearly impenetrable block, carved with extreme difficulty.[26]

Françoise came back in November. *La Femme en vert* (Woman in Green) is, because of her, a woman in love, embracing her gallant as they sit on a bench. This was followed by the *Amoureux sur un banc* (Lovers on a Bench); first they are nude, then, on 8 February 1944, they are meeting at the Vert-Galant. Françoise appears, nude, in April in *Nu et femme assise* (Nude and Seated Woman). Picasso quickly established her ideogram: a long nude, with big breasts and a round head.[27]

As winter drew to a close, the police were striking at Picasso's friends. Robert Desnos was arrested on 22 February; he was deported and died after fifteen months. On 28 February Max Jacob was interned as a Jew in the Drancy camp; he died there, of pneumonia, five days later. Picasso attended the service in his memory and confided to Françoise, "I don't feel like taking risks, but I won't give in—either to force or terror."[28]

On 19 March Louise and Michel Leiris organized a reading of Picasso's *Désir attrapé par la queue* (Desire Caught by the Tail) in the Grands-Augustins studio, an event which today seems like an act of intellectual resistance. Albert Camus directed Simone de Beauvoir and Sartre, Dora Maar, Germaine Hugnet, Raymond Queneau, and Jacques Laurent-Bost; Georges Hugnet had prepared a musical accompaniment. Also present were Brassaï, Braque, Valentine Hugo, Jacques Lacan, and Cécile, Éluard's daughter. Only the *clandestins* and combatants were missing: Éluard and Nusch in the first category; the Zervoses in the second.

The war was now more than ever a felt presence in still lifes, whose component objects—coffeepot, glass, jug—seem mutually hostile. Picasso painted Paris: Notre Dame and all the bridges. He may have feared that the city was in danger of destruction, but he didn't forget Françoise.[29]

On 6 June 1944, the day of the Normandy landings, Picasso received a group of Spaniards in his studio. The group included Antoni Clavé—a young Catalan painter who had fought in the civil war and become a refugee in France. Picasso's meeting with Clavé was the beginning of a lifelong friendship.

On 20 July, the day of the assassination attempt against Hitler, the glass and apple calmly returned to the table—a still life that Picasso offered to Matisse.[30] He followed it with *le Plant de tomates*,[31] growing on the balcony of boulevard Henri-IV. He spent the entire period of the Paris insurrection and street fighting with Marie-Thérèse and Maya. A watercolor of Marie-Thérèse records that time. She is rendered with so much feeling and such tenderness that Barr, when he reproduced it, called it *Tête de jeune fille* (Head of a Young Girl).[32] On 18 August Picasso returned to the theme of spring with the canvas *Nu couché et femme se lavant les pieds* (Recumbent Nude and Woman Washing Her Feet).[33] Between 13 and 15 August he painted a profile portrait of a young street fighter,[34] and in the final week of the month, *Bacchanale d'après Poussin* (Bacchanal in the Style of Poussin).[35] This was the turning point in Picasso's paraphrases—begun at the time of *l'Aubade*—of scenes of violence from heroic Classical painting. Here, abruptly, he was communicating unbridled joy. The two nude nymphs who lead the dance are both Françoise—precursors to the queen in *Joie de vivre* (The Joy of Life), which he would paint in Antibes two summers later.

PART SEVEN

FRANÇOISE AND COMMITMENT

I am proud to say that I have never considered painting an art of charm or seduction or distraction. I wanted—through painting and drawing, since those were my weapons—to penetrate, to advance, always deeper, always further, in knowledge of the world and of humanity.... And I am conscious of having always through my painting struggled as a committed revolutionary.
—*Pablo Picasso, declaration to* New Masses,
24 October 1944

28

A NEW DEPARTURE

1944–1946

At sixty-three Picasso reappeared in public, after four years of voluntary confinement and public silence. He had begun a new love affair, which was still secret and probably more fraught with risk than earlier ventures of the kind because Françoise—born after the First World War—was from another generation. Did he recognize the risk? She was still only an intermittent presence in his life, but a presence already felt in his painting. Would his work enter a new phase now as it did after 1918? For that to happen, peace was necessary. Although France had been almost entirely freed from Nazi occupation, both Germany and Japan had still to surrender. At this point Picasso's first move was to put his past in order—an imperative which led him to join the Communist party. He gave his reasons in an interview with the American magazine *New Masses,* which was reprinted by *Humanité.*

> I have joined the Communist party without the slightest hesitation because, basically, I have always been a supporter. . . . These terrible years of oppression have taught me that I must fight, not only with my art but with my person. I felt a pressing and urgent need to find my homeland. I have always been an exile. But now that's over. While I wait for the day when Spain once again can receive me, the Communist party of France has opened its arms. And in that embrace I have found all those whom I admire . . . and all the fine faces of insurgent Paris which I know from the days of August on the barricades. And I feel that I am once again with brothers.

As with Picasso's ties to the Surrealists at the time of the Minotaur, the passage of time raises questions in this case, too. Were there not, right from the start, considerable misunderstandings? Certainly Picasso was the star catch of a national campaign of recruitment. On 4 October in the offices of *Humanité,* Marcel Cachin and Jacques Duclos solemnly received the painter as a member, along with the art critic Francis Jourdain, who was five years Picasso's elder, with little taste for either Cubism or Surrealism.

Éluard, Aragon, and Pierre Villon, director of the Front National, were
there as witnesses, as was André Fougeron, considered by the PCF to be the
rising star of *engagé* realist painting. Éluard wrote that he was thrilled to
see Pablo Picasso and Marcel Cachin embrace. At that moment Picasso
truly believed that with the liberation of Paris, the new world he had sought
in his painting and Communist promises for the future coincided. And that
coincidence was, so to speak, compensation for defeat of the same promise
in Spain.[1] But he undertook nothing that might have alienated him from
what he had always been.

 None of his friends—neither Éluard nor Zette and Michel Leiris (who
had sheltered Laurent Casanova, one of the party directors while the party
was illegal)—thought any differently at that time. All believed that Commu-
nism would realize the promises of humanism and liberty embraced by the
Resistance. And although almost immediately the party heavily exploited
his commitment, Picasso had no doubts that he would be in the forefront
of a new politics. Éluard had written in *Humanité* about Picasso's joining
the party, calling his piece "Promesse inouïe" (Extraordinary Promise),[2] all
that mattered in the fever of a victory which, for so long, had seemed
impossible. A scant six weeks earlier no one would have staked any bets on
the success of the insurrection and a Nazi withdrawal which did not also
mean the destruction of Paris. And now the country was reborn, apparently
intact. On this last point Picasso was none too sure. He explained himself
to André-Louis Dubois, the prefect who had helped him during the war and
under the occupation:

> We're not yet free of the Nazis. They've left us with their pox; and
> many people are infected who don't have the slightest idea. But we'll find
> out. And all those poor people! We're going to abandon them perhaps.
> Well, they certainly won't support anyone or anything. And they're
> going to defend themselves, too. There will be strikes and riots. . . . And
> you think that while all that's going on I'm just going to sit on the
> balcony and watch the show? That's impossible. I'll be with them, in the
> streets.

 A projected rebellion recalled by a prefect? Perhaps. But certainly
Picasso was criticizing his behavior at the end of the First World War, when
he watched the large strikes of the time, which led to the founding of the
French Communist party. He tended, as well, to judge matters from the
perspective of that earlier return to peace, twenty-five years earlier, and to
fear a repetition of that intellectual fatigue which then had led to the
"return to order." To let matters simply drift was dangerous. To John
Pudney, an English poet who at the time was also an aviator, Picasso said,
"Art which is more disciplined, liberty which is less uncontrolled: that is the
artist's defense and shield in times like these. This is probably the moment
for poets to write sonnets."[3]

And there is the core of Picasso the man and his inevitable restlessness at a moment of victory. One must not succumb to facility. If we consider in this light his transformation of Poussin's *Bacchanale*, we will understand better what Picasso meant by "discipline": a confrontation with the artist whom he considered the quintessential French Classical painter. That is what he meant when he told Pudney of beginning work on his *Bacchanale* as the Nazi Tiger tanks were firing at the corner of the Boul' Mich'—a few yards from his Grands-Augustins studio. "It was an exercise," he said, "discipline." Pudney, it seems, didn't understand that for Picasso discipline meant making "something else" while taking Poussin as starting point. For example, he might liberate all those women—nude or dressed, reclining or sitting, wearing a hat—whom he had enclosed in room-cages, room-prisons, just as in 1918 he had taken Ingres' *baigneuses* out of the harem and onto the beach.

The studio was always full of visitors: Lee Miller, now war correspondent of *Vogue;* Hemingway; and groups of GIs, like those photographed by Cecil Beaton. Picasso had become a monument of the Resistance. The Salon d'Automne, in which Picasso had never participated, offered him all the room he needed for a retrospective as part of the institution's rebirth. This was announced with all the grandiloquence of the time: *"Salon de la Libération, préparé pendant l'occupation ennemie, organisé pendant la bataille . . ."* (Salon of the Liberation, prepared during enemy occupation, organized during the fighting . . .)

Picasso accepted and prepared a selection of what seemed to him the strong points of his work since *Guernica*. The PCF had undoubtedly fixed the announcement of Picasso's party membership to coincide with the exhibition, scheduled to open two days later. But—a remarkable detail whose sequel was to give it significance—*Humanité* illustrated its account not with a Picasso but with a realist painting by the "young master Fougeron."

Except for a few friends, no one knew Picasso's work after *Guernica;* young people knew nothing about it at all. The retrospective was dominated by his larger paintings: *l'Aubade* (Dawn Song), *Femme à l'artichaut* (Woman with Artichoke), *Chaise aux glaïeuls* (Chair with Gladiolus). *Premiers Pas* (First Steps) was included as well, and many portraits of Dora, Marie-Thérèse, and Maya. There was also *Sabartès* of 1939. An historic dimension was contributed by the *Nature morte à la tête de taureau noir* (Still Life with Black Bull's Head) of November 1938 and *Nature morte au crâne de taureau* (Still Life with Bull's Skull) of 1942. Unfortunately the public did not understand the references and for the most part did not grasp that the paintings were anything other than a joke. Sculpture might have been some help: the show included the large head of Marie-Thérèse from Boisgeloup as well as *Chat* (Cat), *Coq* (Cockerel), *Tête de mort* (Death's Head), and *Tête de taureau* (Bull's Head) (which the catalogue listed as "Bicycle Seat"). But grasping these would have required at least a glimmer-

ing of familiarity with modern art—a capability not widely diffused among leaders of the Salon d'Automne or its visitors.

The scandal was immediately an uproar. The public, drawn by the publicity given Picasso's party membership, was properly shocked. And the clan of reactionaries, having learned nothing since 1919, felt that the moment was ripe for taking revenge, for denouncing the "foreigner" in the name of true French art. André Lhote, in *Lettres françaises*—the clandestine journal founded during the Occupation by writers of the Resistance—described "young numbskulls who had something better to do than join the FFI,* and conventional gentlemen of a certain age who look down the row of pictures shouting 'Refund!' and "Take it down!' "

But Picasso's pictures collected a nucleus of young painters and students, and a protest was signed by everyone who had any kind of name in the literature of liberated France: from Éluard and Aragon to Paul Valéry, François Mauriac, and Sartre, which gives the measure of his moral authority. Many of the signatories felt no particular affinity with his audacities.

He began painting again once the uproar had died down: still lifes, often with a candle, all with an extraordinarily rigorous limpidity. Precisely the program he had outlined to Pudney. The masterpiece of the group is *Casserole émaillée* (Enameled Casserole) of 16 February 1945.[4] Skulls returned in a series situated on a kitchen table, beside some leeks, a jug, a coffeepot, and—in a summer variant—a fruit dish filled with cherries.[5]

Except for portrait drawings of Maurice Thorez, the secretary general of the Communist party, on 23 May 1945—the eve of the first legal Party Congress since 1937—Picasso's work contains no overt reference to his membership. These portraits were deliberately and surely provocative toward some of his former Surrealist friends or certain rich collectors. Yet they were just as surely a sign of goodwill toward the party, especially as, given the kind of portraits he had just been doing during the war and Occupation, a certain disquiet at the prospect of entrusting the party leader's features to his interpretive skills is altogether understandable. This kind of complicated multiple challenge was never displeasing to Picasso. He maintained his subject's likeness while employing, as usual, his powers of psychological penetration. The most elaborate version detects beneath the features of a flourishing quadragenarian the old man's face that will come into being, prefiguring even the deformation to be inflicted by an attack of hemiplegia five years later. Picasso looked at Thorez as clearly as he looked at any of his companions.

In the same way, the victory of 1945 is marked by a return to the anguished, trembling scenes of Notre Dame in 1944, replicating that moment before liberation when destruction of the city was an ever-present threat. These compositions are based on powerful webs of straight lines, the

*Forces Françaises de l'Intérieur, clandestine army of the Resistance, then integrated into the Allied forces.

last of these at the limit of abstract geometrization. A small painting of 14 July, which went from Pablo's collection to Jacqueline's, expresses a burst of joy.[6]

Since late winter Picasso had been working on a large composition derived from a tragic scene of the Spanish war and displaying a murdered family. A work of fidelity to the self, a reply to *Guernica*, translating with understated irony the human sufferings inflicted by war. This time death rules: enlarged, close up. Death fills the canvas without detraction or distraction, putting the painting in its entirety to the test of tragedy. This will produce some misunderstanding with those who wish to see only realism here; all the more as the title, *le Charnier* (The Charnel House), is equivocal. Picasso had painted the house of death, the passage of death—not a place of stacked cadavers like those of the newly liberated Nazi camps then being revealed in the press.

This ultimate subjection to the test of events which his painting assumed after *Guernica* states clearly that the essential for Picasso is that his painting find its own proper logic in the face of events. Tragedy had struck not only his own country but—as he understood from the first—all of Europe. Can painting take the measure of such enormity? Face up to it and be present in the reconstruction of spirit? This touches on Picasso's feeling that the demands of his art and his joining the party could work together, move in the same direction. But it touches as well on what separated him—without his explicit awareness—from a party whose doctrine of realism, as Roger Garaudy put it to the Congress of 1945, made art a reflection of history.

The framework is revealing: it is the inner space—imposed in *Guernica* and dominating paintings of the war—which gives the composition a fresh organization, with the table on which the jug and casserole of the latest casualties declare yet another interrupted meal. The man comes from the dead fighter of *Guernica,* but his hands, tied together and lifted, empty, to the sky suggest the tortures of the Gestapo and the innocence of the trussed lamb in *l'Homme au mouton* (Man with Sheep). The naked woman wears the stigmata of all those faces undone by war which after 1937 haunt Picasso's work. The baby, whose little paw receives the blood pouring from its mother's stomach, looks like the babies of *Guernica.* These deliberate re-employments state the painting's hidden meaning: torture and murder can blend into everyday life in unforeseeable ways, and the artist at every moment risks the judgment of posterity. Alfred Barr emphasizes this actuality of death: "The fury and violence which make the agonies of *Guernica* bearable are reduced to silence here. For the man, the woman, and the child, this picture is a *Pietà* without grief, an entombment without lamentations, a requiem without pomp."[7]

This judgment of Barr's, made in 1946, in a country whose soil had not known daily civil war in the shadow of the Gestapo and its killers, is infinitely more coherent and subtle than any made in France itself when the

work was first shown in 1946. The title of the exhibition, "Art et Résistance," might, however, have led viewers to grasp *le Charnier*'s profound truth.

I first met Picasso in December, as he was finishing work on the picture. He had heard about me from Paul Éluard, who had just obtained from him for Madeleine Riffaud, then my wife, a frontispiece drawing for a collection of poems, *le Poing fermé* (The Clenched Fist). Picasso had drawn his portrait. Later on some members of the Communist party expressed amazement that Picasso had painted a scene of mourning instead of rejoicing in victory. Picasso asked to see me because I had escaped from the Mauthausen camp.

I felt too overwhelmed by emotion to remember much of our conversation. I had felt the extraordinary power of *le Charnier*'s three deaths to evoke the piles of cadavers among which I had just survived the final days of the war. It was on that occasion that Picasso told me he had painted the picture before the charnel house images and living skeletons of the camps were public knowledge. He had imagined his picture, or rather, he had "let it come." The anticipation of reality by his imagination did not in the least surprise him. Painting, once all the tricks have been jettisoned, has extraordinary powers for ascertaining the truth. After all, he had painted *Guernica* right at the beginning of the war, in 1937, when most people thought such horrors would never come anywhere near them.

He showed me other canvases, among them the still life *Casserole émaillée*. "You see," he said, "casseroles can shout too. Everything can. An ordinary bottle. Cézanne's apples." He explained that when things don't organize themselves into proper patterns for a picture, the painter's problem is to understand whether that's his fault, because he stopped to pee or had fought with his wife. . . . And in that case (if it was his fault) he would have to start all over again . . . or whether it was because of the objects themselves, who felt like screaming because they knew very well that the painter's love life wasn't all it should be or that there was a war. . . . One must never force things, but learn to let the painting say whatever it has to say. . . . For example, *le Charnier** was a picture without color—like *Guernica*—because that was the way he'd seen it. And the top of the picture was nothing but drawing. What does that mean? Not finished . . . incomplete . . . as they all say . . . Finished! Death is the only way anything is ever finished. . . . He added that it was only since painters had "killed 'finished' " that they had discovered what lay beneath it, the moment when one has said all that it is possible to say on a particular canvas, and one must stop adding whatever it might be; or—alternatively—the moment when one must cover the canvas from one side to the other, because the painting should extend

*Obviously, Picasso did not use that title. It simply did not exist at the time. Picasso said: "ma peinture," my painting. This title was not given by Picasso and isn't accurate at all. Picasso didn't paint a "charnel house" but the massacre of a family.

far beyond the frame. . . . He had reached that understanding a long time back, during Cubism—he and Braque—before *papiers collés*.

Some forty years after our first meeting, as I worked on the *Demoiselles d'Avignon* exhibition at the Musée Picasso, I discovered that when that great canvas was being finished, the composition on the upper right side extended well beyond the frame. In 1945 I was so surprised that I noted the fact in my memory without daring to ask why this was so.

Later I learned that some months earlier Picasso had told Brassaï that when it was possible for him to do it, he quit a canvas, leaving it

> just as it was, ready to begin again and bring [things] closer to conclusion on another canvas. . . . There would never be [he said] a *finished* picture; they are all different stages of the same picture, which, most of the time, disappear during the course of work.

This is what Dora photographed during *Guernica*. And it is also what—shortly before we met—Picasso had wanted to get at when he began making lithographs at Mourlot's. I knew nothing of that at the time. I remember only a portrait of Françoise, because, as he was walking me home, Picasso let slip who she was and that she was the same age as my wife.

Le Charnier had lifted me beyond that spring of 1945, the spring of victory and of the French Communist Party Congress with its public rejoicing at Picasso's adherence and its hopes that art was entering the path of "realism which celebrates the role of the working class." In that June of 1945 two other events put Picasso in the limelight: Roland Petit's ballet *le Rendez-vous* was given at the Théâtre Sarah Bernhardt, with a curtain by Picasso; and Louis Carré, the most influential dealer of the moment, organized an exhibition of twenty-one canvases from 1940 to 1945.

As soon as he could Picasso left for the Midi—alone. It seems that he and Françoise had agreed on a mutual test. And she, in any case, had planned a trip to Brittany. Dora Maar, who had been seriously ill—a recurrence of depression undoubtedly connected with Françoise—found herself with Picasso at Mme Cuttoli's on the cap d'Antibes. Picasso, his head full of engravings, set himself up with the engraver Louis Fort at Golfe-Juan and rented a room for Françoise, ready to resume a double life, with his studio as a cover. However, Françoise stayed in Brittany.

Picasso went to see an old house in Ménerbes, formerly a Protestant stronghold, in the Vaucluse; he bought it with money from the sale of one of his latest still lifes and returned to the property with Mme Cuttoli and Dora, to whom he gave the house as a farewell present. He knew that Françoise would not agree to shared possession, except for what was necessary because of Paulo and Maya.

Picasso returned to Paris in mid-August. He had two new canvases for the Salon d'Automne. And it was in those circumstances that—through

Braque, who had praised the quality of his work—he met the printer Fernand Mourlot. In a flush of enthusiasm he returned to lithography for the first time since his early portraits of Marie-Thérèse, a good fifteen years before.

That is perhaps why his first attempts begin with Françoise's face.[8] But in a drawing of two female nudes, although the younger, seated woman is Françoise, the reclining figure is Dora. These predate Françoise's return to the Grands-Augustins studio on 26 November. Was this deliberate or was he simply allowing his hand to indicate his division between two loves?[9] Picasso delighted in the possibility of multiple states, and we know from various concurring recollections of both Françoise and Mourlot how much he enjoyed defying technical traditions.

Françoise was now his companion, and it is she who describes the studio on the rue de Chabrol near the gares du Nord et de l'Est: "a dark place, untidy, cluttered, dilapidated, damp, and cold . . . almost a scene out of Daumier, all in black and white with a few splashes of brightness on the big printing presses. . . . There was also a touch of Daumier about those stones. Many had been in use since the last century."

These lithographs tended toward abstraction. The rhythms in the illustrations to Reverdy's poem le Chant des morts attest to this as well, like her corrections of a bull's profile: increasingly pruned of all naturalism. Françoise does not stress this in her memoirs, but differing here from many painters of her generation, she was a figurative artist, like her older colleague André Marchand, whose friend she had been, and like Dora, who in common with many photographers had moved on to painting and exhibited austere canvases. It seems that abstraction was then part of the air of the times. Attacks by the Nazis, who considered abstraction to be part of "degenerate art," and the limitless violence of an era in which the atomic bombs of Hiroshima and Nagasaki followed the discovery of Auschwitz dissociated more than ever the inner worlds of painters and sculptors from overly direct or limited figuration. But when Kandinsky died at Neuilly the last year of the war, he seemed to be forgotten, and although Mondrian, who had vanished to New York, began his glory there, in Paris he continued to be misunderstood and undervalued. When the exhibition of Fautrier's Otages (Hostages) introduced by Malraux opened at the Galerie Drouin in early November 1945, it caused outrage because it dared to express the sufferings under Nazi occupation through the tactile quality of raw substance. Éluard had certainly spoken to Picasso of Dubuffet, who was illustrating some of his poems. But his painting, which draws its violence from graffiti or the apparent naïveté of children's drawings, did not attract Picasso any more than the informality of Fautrier.

The rigor, the Jansenism of his still lifes, like the fact that le Charnier remained an épure (a working drawing), attests to his need for discipline and his mistrust of the baroque cruelty which often overwhelmed his paintings of the war. But he certainly felt a similar mistrust when confronted

with the Communist party's pressing demand for a new Classicism. In 1917–23 he had confronted the "return to order" to confirm that Cubist modernism embodied and illuminated the liberty of Classicism. In that case there was not only nothing to prove, the question itself seemed poorly conceived. Modern art had incarnated civilization in the face of Hitler's monstrosities. But would it now enclose itself in its own past? In the rejection of all reportorial art? Or would art be able to respond to the exigencies of the peace which was now beginning?

Cubism and Surrealism had each had its day. His many American visitors and André Masson, just back from the United States, were all struck by a new wave of aggressively modern painting. The war and Nazism had exiled to that country not only Masson and Max Ernst but Chagall, Léger, Lipchitz, Zadkine, joining Tanguy, Matta, and Duchamp, who had arrived before them. The number of refugees in the United States attained a degree of critical mass and constituted an appreciable trans-Atlantic transfer of modern art. Group shows at Pierre Matisse's gallery or Peggy Guggenheim's contributed to the radicalization of young American painters. Masson and Léger renewed themselves through their American experiences.

Picasso's immediate perceptions of these developments are not known. He was probably aware of his influence on Motherwell and Arshile Gorky, Pollock, and de Kooning; however, nothing he knew of their painting at the time was of any particular interest to him. In any case, these developments, like their analogues in France, gave him a sense of being pushed into the background: precisely what—above all else—he wished to avoid in his sixty-fifth year, the official age of retirement. He wanted to link Françoise as closely as possible to his own life, which probably contributed a sense of urgency—more or less conscious—to his need for participation in the ideas of the rising generation.

That generation was trying to find itself. Both Éluard and Aragon, when I met them, felt that the period needed a new movement analogous to Dada but that such an initiative was beyond the power of any individual. Picasso, too, found the young painters far too calm and quiet. Long before Françoise began to think of him as an historic monument, I heard him use that expression in anger against colleagues who covered him with praise without looking at his painting. "What have I done to deserve this treatment? Why do they treat me like an historic monument?" The question haunted him, and he couldn't help but be alert to it.

In mid-January he interrupted his work on lithographs to begin a large canvas *Monument aux Espagnols morts pour la France* (Monument to the Spaniards Who Died for France).[10] It was to hang with *le Charnier* in the exhibition "Art et Résistance," to open on 15 February 1946. And once again Picasso transmuted painting of the moment—still lifes with skull and mirror—into painting of history. In that effort he seems entirely alien to the debate which was beginning to agitate his comrades in the PCF, disturbed by the inroads of abstraction. This anxiety is apparent in *Arts de France,*

FROM SURREALISM TO THE PAINTING OF HISTORY, AND RESISTANCE, AND ON TO COMMUNISM

February 1929	*Buste de femme avec autoportrait*
7 February 1930	*La Crucifixion.*
25 December 1931	*Femme au stylet (la Mort de Marat)*—Woman with Stiletto (Marat's Death).
25 January 1934	*Minotaure au javelot*—Minotaur with Javelin. (Political crisis leads to riots of 6 February 1934.)
10 February 1934	*Construction aux hirondelles*—Construction with Swallows.
21 July 1934	*La Mort de Marat* (engraving).
Spring 1935	*Minotauromachie.*
28 May 1936	*Composition au Minotaure* (Curtain for Romain Rolland's *Quatorze juillet*).
November 1936	Éluard's first political poem.
January 1937	*Sueño y Mentira de Franco* (Franco's Dream and Lie).
May–June 1937	*Guernica.*
22 April 1939	*Chat saisissant un oiseau* (Cat Seizing a Bird) Fall of Madrid.
August 1939	*Pêche de nuit à Antibes* (Night Fishing at Antibes).
September 1939	War breaks out.
Spring 1940	*Femme nue se coiffant* (Female Nude Arranging Her Hair).
End of June 1940	France is invaded by the German Army.
5 April 1942	*Nature morte au crâne de taureau*— Still-Life with Bull's Skull (The Death of Gonzalez).
4 May 1942	*L'Aubade* (Dawn Song).
9 October 1942	*Dora Maar á la blouse rayée* (Dora Maar in Striped Blouse).
1943	*La Tête de mort* (Death's Head; sculpture).
5 October 1944	*L'Humanité* announces Picasso's membership in the PCF (Communist Party of France).
Early 1945	Begins work on *Le Charnier* (The Charnel House).
May 1945	Portrait drawings of Maurice Thorez on the eve of the first congress of the PCF—once again, a legal party.
January 1946	*Monument aux Espagnols morts pour la France* (Monument for Spaniards Who Died for France).
February 1946	Participates in exhibition *Art et Résistance.*
August 1948	Participates in Congress of Intellectuals for Peace, Warsaw.
9 January 1949	*Lavis* of the dove. A few weeks later Picasso allows Aragon to use dove in poster for the Peace Congress which will be held in Paris, and which he will attend.
November 1950	Picasso is awarded the Lenin Peace Prize.
10 January 1951	Opening of Fougeron's exhibition *Au Pays des Mines* (In the Country of Mines), celebrated by the Party as a prime example of "Party art."
18 January 1951	Picasso paints *Massacres en Corée* (Massacres in Korea).

(Continued)	
Spring 1952	Begins work on panels for *la Guerre et la Paix* (War and Peace).
March 1953	*Portrait de Staline* condemned by the PCF.
22 November 1956	Signs protest by seven Communist intellectuals against Soviet intervention in Hungary.
May–June 1958	*Nature morte à la tête de taureau* (Still Life with Bull's Head). Rebellion by Army in Algeria; assumption of power by General de Gaulle.
Late 1962–early 1963	*L'Enlèvement des Sabines* (Rape of the Sabine Women). Cuban missile crisis: the last subject of political resonance in Picasso's painting.

the periodical which the PCF had just launched. There are articles by Jean Cassou, "Du plus ou moins de réalité" (Of More or of Less Reality), and by the young philosopher Henri Mougin, who declares, "There is no pure poetry, and there is no pure painting." Abstractions were excluded from "Art et Résistance."

I ran into Picasso at "Art et Résistance," organized by the Association de Francs-Tireurs et Partisans (Association of Snipers and Partisans), of which my then-boss, the minister Charles Tillon, was president. Picasso stayed close to Françoise and seemed very much in love. He asked for news of my wife, and when I told him she was expecting a child, he took me by the arm. "You're quite right," he said. "Young women are made to have children." I had the impression that he was looking particularly at Françoise. As we walked past his pictures, whose hanging he had been supervising, he said, "You see, the war is really over."

A few days later Paul Éluard took me to Dora's, to the rue de Savoie, where the walls were covered with portraits by Pablo. The circle of Picasso courtiers had deserted her, but Paul, who wished to display loyalty, brought me up to date. "Picasso can never stand it if a girlfriend falls ill," he said as we were leaving. "With him a woman is never allowed any slack, any slipping below the mark." Perhaps he thought these explanations would counter the painful impression made by Dora's abandonment. Some forty years later I recalled those remarks and the circumstances in which they were made as I read an interview with Françoise Gilot. With Picasso, she said, "one needed to be like Jeanne d'Arc: always in armor, from morning to night. And to prove one's strength, twenty-four hours out of twenty-four."

But that surely was not Françoise's opinion in those early days of their connection. To the outrage of puritans in the PCF, Françoise and Picasso that spring of 1946 met the rest of the world as a couple.

FRANÇOISE

1946

Picasso was pursuing his exploration of still lifes, which now included a little owl-familiar on a chair and a crane.[1] But an accident interrupted him: Françoise broke her arm during an electricity cut. (France was still very short of energy during that first winter of peace.) Picasso organized her convalescence in a house owned by Louis Fort, on the harbor of Golfe-Juan: the house Fort had already offered him for the summer of 1945. The young woman set off by herself in mid-March 1946 and began working on engraving. Picasso lost no time in joining her. He felt increasingly determined to make her part of his life. He introduced her to Matisse, who lived in the Hôtel Régina, above Nice, and Matisse, with Lydia, received Picasso and Françoise as a couple. Matisse went so far as to imagine doing a portrait of Françoise. Françoise recorded Pablo's reaction: "Pablo, at that point, had done only two small portraits of me; but as we were going to the car, he became very possessive: 'Really! That's too much! Do I go around painting portraits of Lydia?' "

This instance of the possessive feelings he already had toward Françoise as his model suggests how explosive those feelings must have been when he learned that after his dazzled paintings of Fernande at Gosol, she had posed nude for Van Dongen.

On their return to Paris in late April, Picasso virtually besieged Françoise. He wanted her to move into Grands-Augustins for good.

For him this was a new kind of necessity. He and Marie-Thérèse had actually lived together only for a month at Juan-les-Pins in 1936 and then weekends; Dora was with him for summer vacations at Royan and otherwise waited in the rue de Savoie for his signal. In fact, since things had begun to go badly with Olga, shortly after Paulo's birth, Picasso had lived alone. And, as part of his campaign to persuade Françoise, he insisted on this point, on his need for solitude. He had, of course, been through far more difficult times. Kahnweiler was back in business, was buying his paintings, and was preparing to undertake his lithographic operations. And Louis Carré—increasingly recognized as the most important dealer in post-war Paris—was showing Picasso's work. As an artist he enjoyed a prestige

equaled by none. The PCF was in the government and was, practically speaking, the primary party in France. The Cold War was still far in the future.

Picasso would not have been Picasso if this sense of euphoria had driven out every vestige of anxiety. And in fact the opposite was the case. He worried that his success was simply a product of his past, that there were no guarantees about the future. And with a companion forty years his junior, whom he wished to attach to his life, the question of the future was a piercing one. He arranged a meeting between Françoise and Dora. The latter was supposed to confirm that Picasso was no longer pursuing any kind of affair with her. In fact, she told Picasso that his adventure with *"cette écolière"* (this schoolgirl) couldn't possibly last. If she had said *"jeune étudiante"* (college student) instead, and discounting the element of jealousy, the label would have been accurate enough. Françoise seemed to be barely twenty. Picasso, of course, carried his years lightly. If one looks today at photographs of that time, he appears to be in his fifties; in person he seemed even younger. But all the same, the difference in age between him and a young girl in the full bloom of youth was striking. And he knew that in Spanish tradition his old friends were mocking him as a *vejancón,* a ludicrous old graybeard.

I think that this sense of imbalance is responsible (in part anyway) for Pablo's cruelty to Dora. He had always carefully maintained a certain space between affairs and shown a marked preference for avoiding painful scenes if at all possible. This time, however, he seemed to be deliberately provoking trouble, although he knew that Dora's psychological balance was quite frail. "Choosing someone," he told Françoise, "is always, to a certain degree, killing the other one." And later he would express to a girl younger than Françoise much the same sentiment in regard to *her* predecessor.

Pablo's initiation of Françoise included a visit to the haunts of his youth: to the rue des Saules in Montmartre. "There he knocked on a door and then went in, without waiting. I saw a little old lady, thin, ill, and toothless, lying on her bed. After a few moments, he put some money on her bedside table. She thanked him, with tears in her eyes." When they were back on the street, Françoise asked him about her. "I want you to learn about my life," he told me, in a gentle voice. "That woman's name is Germaine Pichot." Then he gave an account of Casegemas' suicide.

Françoise felt somewhat perplexed by his modalities of instruction, but, as she put it, "the more time went by, the more I realized that I truly needed him. Sometimes it even seemed to me—when he wasn't right there—physically impossible to breathe without him."

At Grands-Augustins she began to shut herself away. Sabartès and Inès both sensed she was to occupy more of a position than Dora and Marie-Thérèse combined; and they made her feel it. However, painting came to the rescue. The moment had come for Pablo to take possession of her on canvas. He got her to pose nude, only once, and for not more than an hour.

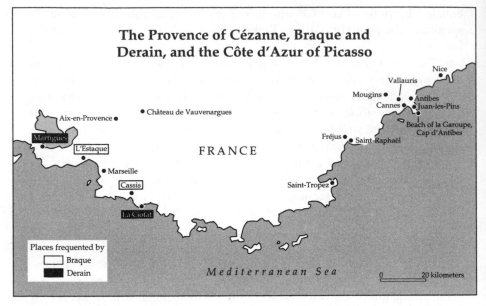

The Provence of Cézanne, Braque and Derain, and the Côte d'Azur of Picasso

Françoise was able to observe him in his office-laboratory. He seemed totally oblivious to her presence.

> At intervals [she notes] he paced the studio, from one end to the other. And he would sit for a while in that wicker chair with a high, Gothic back, which appears in many of his paintings. He would cross his legs, and, with an elbow on his knee, prop his chin on his fist, so that he could study the picture. Sometimes he sat like that for an hour, without saying a word. . . . He always had several canvases to choose from, which were unfinished, half dry.

The success emblem for Françoise, the *Femme-fleur* (Woman-Flower) of 5 May, is a product of the great blossoming which proceeded throughout the month of June, constituting an exhaustive exploration of the possibilities suggested by her presence—and their contrasts.[2] There was a third presence in the studio as well. Finally Picasso confessed, "Matisse isn't the only one who can paint you with green hair!" Matisse's proposal three months earlier at the Hôtel Régina had hit home: but that wasn't the end of the story. First Picasso had to tear Françoise loose from an idea of Matisse's. Then he calculated just how to transport her—right into Matisse's painting.

Françoise's account also reveals that the *Femme-fleur* was composed in the manner of *papiers collés*:

> Picasso painted a sheet of paper sky blue, and then cut out oval shapes corresponding . . . to the conception of my head, which he was trying to work out. . . . And when he'd finished cutting them out, he drew on each

one: little symbols for eyes, nose, and mouth. And then, one after another, he pinned them to the canvas, setting them down to the left, to the right, to the top, to the bottom.

In its various versions, one can follow the process of refining the body until it becomes the stem of a plant, with the imbalance of the breasts balanced by the rhythms of the arms and the wavy hair. However, Picasso didn't achieve elimination of the obsessive moon shape he had assigned to the head. That shape, he said, escaped from his control:

> An artist is not as free as air. It was the same with the portraits I did of Dora. I just couldn't get a portrait of her while she was laughing. . . . For years I painted her with tortured shapes. This was not because of sadism, but not because of any particular pleasure either. I was simply obeying a profound vision that had imposed itself on me. A profound reality.

Françoise comments: "Within two years, while he was painting me, Pablo was able to break those limits."

A series of eleven lithographs done between 14 and 15 June concluded with a new portrait in which Françoise's hair is a sunburst.[3] On 30 June and 3 July he reorganized the abstract elements and symbols conceived and defined during his graphic conquest of Françoise, making a *Femme allongée* (Reclining Woman) which might be classified as nonfigurative. Then, between 30 June and 3 July, canvases of Françoise sitting in an armchair recouped these abstractions.[4]

When he had finished these explorations, Picasso took Françoise to Ménerbes, to the house he had just given to Dora, baptizing the property (so to speak) in this way. The trip was not really to his companion's taste; but none of that appears in paintings which record a three-week visit: landscapes and a limpid Mediterranean pastorale with goat and flute player.[5] Each night he saw the owls which appear in his still lifes. He also saw scorpions—his symbol for himself. At the end of the month he took Françoise to the Cuttolis' on the cap d'Antibes—a fresh inspection *de passage* for his young companion (and comparisons with Dora, who had been there the summer before). Finally they settled into Louis Fort's at Golfe-Juan.

Picasso went to the limit of what Françoise could accept. At Ménerbes he had read her the enflamed daily letters from Marie-Thérèse. That liaison, too, was ending. The date of Claude's birth—15 May 1947—indicates that he was conceived during August, which seems to mark the conclusion of that crisis. Many external events combined to point Picasso toward a new life. Gertrude Stein had just died at the American hospital in Neuilly. They had broken, of course, over Gertrude's sympathy for Pétain; but nonetheless this was the disappearance of a passionate friend of his youth. In New

York Alfred Barr's book *Picasso: Fifty Years of His Art* had just been published. This was the first book on his full trajectory as an artist; that it should have appeared in the United States was a symbol of Picasso's universality.

However, a symbol of inverse meaning presented itself as well. By chance one morning Picasso ran into Breton, on the terrain where they had met in 1923. During the Occupation he had maintained good relations with the Surrealist group of *la Main à plume* (The Hand with Pen), even after the latter had attacked Éluard, maintaining the same posture of neutrality as in 1938. Picasso held out his hand to Breton, but Breton wouldn't take it, demanding an explanation for Picasso's Communist party membership. "My opinions," Picasso said, "derive from my experience. Myself, I consider friendship more important than politics." This was clearly an allusion to the Breton-Éluard split. Breton, however, would have none of it.

This meant rupture. Breton's intransigence would not concede that friendship might override fundamental differences. And he couldn't understand what Picasso meant when he linked his party membership to his experiences in life. They were separated by all the differences inherent to an exile's life in the United States on one hand and on the other participation—albeit tangential—in the Resistance in occupied France. On that point, as well, Picasso must have seemed to Breton a dreamer who was unaware—or who wished to be unaware, who did not recognize—or who wished not to recognize that element in his work "which the party's Stalinist leaders jeered at, while using it for their own ends."

This was a divorce which anticipated the Cold War, but it was even more significant inside the domain of art. Picasso, according to Françoise, closed the discussion by recalling what he had seen in Spain when he went back in 1934–35: groups of intellectuals with vehemently opposing views: "Our arguments were too stormy, and we knew that if it came to blows, we'd be in hostile camps; but not one of us perceived that as a reason for breaking off a friendship. On the contrary, if one does not agree, if one thinks various and opposing thoughts, all the more reason to leave the matter open."

Which is a far cry from Communist orthodoxy. But in this new phase of his life, when more than ever he was staking his future in art, Picasso was also placing an opening bet on the unforeseeable, the unknown. From this point of view, Breton seemed to be encasing himself in an attitude appropriate to the past. Of course Surrealism—like Cubism—represented increased freedom for painting and sculpture. And this freedom could be used, and would provide support if one remembered, always, to look beyond the immediate task and knew how to "make something else" from it. As, of course, one had to do with all the art of the past. Picasso's sense of optimism was strengthened by his new love and he grew more extroverted, opened himself to the passing world, as he had during his time of happiness with Éva. This drove him to quit the *modèle intérieur* that had ruled his life during the confinements of the Occupation.

This constituted the background of Picasso's encounter on the beach on 8 September with Romuald Dor de la Souchère, who offered Picasso the Château d'Antibes, of which he was the curator. On the highest point of the coast, the place had big rooms, magnificently lit. This was the first time in Picasso's already long experience that he had been offered the use of public property in France. I had heard him muse on the possibility that he might be asked to give or lend to museums the paintings which had formed the "Art et Résistance" show; but nothing of the sort happened. *Le Charnier* was bought by Walter P. Chrysler, and he himself kept *Monument aux Espagnols morts pour la France* as an *oeuvre refusée*. He meant it when he said that he was getting down to work "with pleasure because, this time, I know that I'm working for the people."

During the month of September he collected the necessary materials. Françoise recalls:

> He had to order some of it from Paris because at that time such things were in very short supply. . . . He bought a certain amount of marine paint because, he said, it would stand up better to the environment. . . . As marine paint is generally applied on wood, he decided he would paint on plywood. Then he ordered large panels of Fibrociment, saying that the paint was also suitable for them.

He was filled with energy, enthusiasm, and confidence in his abilities. Once settled at Golfe-Juan, he began doing oils on paper—fauns' heads and Mediterranean still lifes like *Bouteille, citron, Compotier* (Bottle, Lemon, Fruit Dish), which he began the day of Dor de la Souchère's offer. Antibes was to be the flowering of everything which had begun at Ménerbes. He would have two months of work—from the beginning of October to the end of November, a period which produced twenty-two pictures, including still lifes with fish, octopi, cuttlefish, urchins, and watermelons; and studies of local characters—from the *Gobeur d'oursins* (Eater of Sea Urchins) to fishermen sitting or leaning on their elbows. Recent radiographs show that Picasso painted over an old canvas he found in the house.

The number and importance of abstract works is striking. *Femme aux oursins* (Woman with Sea Urchins) frankly recalls the hermetic figuration of 1910–11. And Matisse, when he visited the Château d'Antibes in 1948, was extremely interested by the *Femme étendue* (Recumbent Woman). He made a sketch in a notebook, which he could ponder at leisure. The free plastic inventions suggest sculpture, and in fact some of these resemble the inventive reflections of Henry Moore—instances of convergence rather than reciprocal influence.

But Antibes above all produced the largest of the panels known as *Joie de vivre* (The Joy of Life): a hymn to the youth of Françoise, queen of that dance of joy. The central dancer, with a tambourine, made in her image, could have figured in the *Bonheur de vivre* of 1906, which he had wished

to mock at the beginning of *les Demoiselles d'Avignon*. He had really been hymning Françoise while transporting her to Matisse. In regard to painting, Picasso was capable of a tenacious jealousy. And this time he had won. Antibes remains one of the most luminous periods of his work, in which he added a classic richness to modern, often abstract, liberties.[6]

BETWEEN SOCIALIST REALISM AND ABSTRACT ART

1947–1951

R eturning to Paris from Antibes in late November 1946 was to leave an oasis of poetic calm and re-enter a world of tensions, disputes, and war. France was shaken by the murderous bombing of Haiphong, a large port on the Gulf of Tonkin. This marked the beginning of a colonial war—a brutal awakening from the illusions of peace produced by the Liberation and victory of 1945. This shock was closely followed by a private tragedy: the sudden death of Nusch, who collapsed in the street on 28 November, a victim of cerebral congestion. With her end, a part of Picasso's life as a painter ended, too. And as for Éluard, his friends feared for his reason.

The pastoral happiness of Antibes seemed no longer relevant or fitting. Instead, still lifes began to include the owl perching on a chair, while lithographs returned to fauns, centaurs, and bacchantes. Inès appears with her child, and pigeons forecast the dove which in 1949 will become the consecrated "dove of peace." Françoise can be recognized in the plastic variations deriving from the *Femme-fleur*. Picasso was seeking his current self.[1] In a lithograph he attacked a Cranach painting—*David and Bathsheba*—of which he had a photograph.[2] He concentrated the composition, nullifying the distance between David, playing his harp on a terrace, and Bathsheba, sitting in a garden while a servant washes her feet. This scene is a point of departure. In the four states which followed, the forms were simplified using a multiplicity of virtuosic techniques.

Since autumn the Communist party had been debating the question of a Communist esthetic: Could such a quantity, in fact, be said to exist? Roger Garaudy, speaking for the Central Committee, said it could not. As proof he submitted that "a Communist has a right to enjoy and admire the work of Picasso—or of anti-Picasso." To which Aragon replied that "the party has an esthetic, which is called Socialist Realism." Picasso himself felt that his work fitted neither that brand of "realism" nor the "anti-Picasso" category and that the argument was entirely irrelevant to the problems confronting art in the wake of World War II. Both sides were becoming extremely exercised: Breton, who was preparing to exclude Picasso (as well

as Dali, Giacometti, André Masson, Dominguez, and Magritte) from the International Exhibition of Surrealism, which he was organizing for the Galerie Maeght; and the friends of Dora Maar. Picasso himself wanted no part of these disputes, which seemed to him to belong to the past.

In particular, since the appearance of Sam Kootz, a dynamic American dealer, very sure of himself, who had turned up in December 1946 without any of the usual preliminaries and precautions which previous encounters with dealers had led Picasso to expect. Kootz had plunged him into the New York renaissance of painting, of which Kootz was one of the principal instigators. He had written books on modern art, was a consultative member of MOMA's committee, and in 1945 had decided to open his own gallery. One of his objects had been to make his artists known in France, which wasn't easy. But he had finally arranged to have an article in Zervos' *Cahiers d'Art*. He wanted Picasso to provide some sort of security for his efforts to increase the French reputation of his "comers"—Gottlieb, Motherwell, and Baziotes.

Picasso gave himself time—and the pleasure of making Kootz wait until summer—before selling him a group of paintings at prices he could not have obtained from either Kahnweiler or Louis Carré. Glimpses he managed to get of work by Kootz's "comers" gave him the impression that New York was still more or less at the point reached by works in the show Breton and Zervos had put on at the Jeu de Paume in 1937. As for himself, he felt that through his experiences of the war, his painting had gained in strength and clarity. He felt that he possessed a much larger register, even if he was also acutely aware that the question of what to paint was a serious problem. The problem was exacerbated by ideological pressure from the Communist party, in which "anti-Picasso" sentiment—already expressed by *Humanité*—was identified with André Fougeron. Able and rather bland, without any particular personality of his own, Fougeron was attempting to modernize demonstrative realism. Aragon, who considered the Surrealist exhibition a piece of American intervention in favor of abstract art, denounced its "non-statement, [its] voluntary resignation." An album of work by this "anti-Picasso" provided, he felt, an opportunity to strike out at André Breton and Roger Garaudy as well. "André Fougeron!" Aragon exclaimed. "In every one of your drawings the destiny of Figurative Art is at stake. Laugh if you like. I shall make a further claim: at stake is the destiny of the world!"[3]

Picasso, however, was not in the least inclined to laugh. Precisely this kind of figurative realism constituted the shackles from which great predecessors had freed painting almost a century earlier. And as for what his comrades understood as "abstract" art and condemned as a cancer, he knew better than almost anyone how central a component it was in the contributions to painting made both by himself and Matisse—exactly as the quality now being categorized as *matièrism* in the work of Fautrier or Dubuffet had already been present in the collages he did with Braque. He

had been able and had known how to advance further in "synthetic" art than Ingres or Corot or Cézanne, how to open doors which Poussin could not even see. But this achievement had not been founded on external reality, even if that reality had changed. It had been realized by learning more about painting and about art, about their possibilities and their autonomy. Using materialism as a pretext, these party critics were denying the materiality of painting—the concrete work of the artist which was teaching him to discover reality—precisely as it had done thirty years earlier. They were trampling underfoot acquisitions of skill and understanding which had released artists from the chains of that celebrated realism at the price of hard and constant effort and the jeers of the uncomprehending. Picasso found himself constrained by a kind of solitude he had never foreseen.

Art more than ever seemed to offer him the best means of justifying his existence. That spring Jean Cassou had taken over the Musée national d'Art moderne, an institution not yet in working order. Just before the war Cassou had written the best French book on Picasso.[4] Born in Spain, grievously wounded as a member of the Resistance, he had obtained from Picasso a gift of twelve paintings. Beginning with *l'Atelier de la modiste* (The Dressmaker's Workshop) of 1926 through *l'Aubade* (Dawn Chorus) of 1942 to the *Casserole émaillée* (Enameled Casserole) of 1945 (which seemed to Aragon a work of "realism"), the paintings were a sequence of dazzling stylistic exemplars and a response to the simpleminded incomprehensions of the PCF.

Georges Salles, at that time director of museums, arranged for the arrival of Picasso's canvases at the Louvre. He invited Picasso and Françoise to come on a Tuesday, the day the museum is closed. Françoise describes what happened:

> [Salles] wanted the guards to take Pablo's paintings to various parts of the museum. . . . "You will be the first living painter to see his work in the Louvre." . . . When we arrived at the painting galleries, Georges Salles asked what painters Picasso would like to have beside his pictures. "First, the Zurbarans," Pablo said. We looked for *Saint Bonaventure sur sa civière* [Saint Bonaventure on His Bier]. . . . Then he asked to see his paintings next to Delacroix: the *Mort de Sardanapale*, the *Massacres de Scio*, and the *Femmes d'Alger*.[5]

They moved next to Courbet's *Atelier* and his *Enterrement à Ornans* (Burial at Ornans) and Uccello's *Battle of San Romano*. Picasso looked and moved on without a word. The Zurbaran had carried him back to the summer of 1901 and the start of his painting in Paris, when he had begun the *Death of Casagemas* cycle. The others were personal reference points of his, with—for Courbet—the additional fact that the PCF was at that time extolling him as a champion of revolutionary realism. Picasso considered this attitude a mistake. Courbet was being drawn toward his past and

not toward the future announced by compositions which contravened anec-
dote. That visit to the Louvre seems to me the probable beginning of
Picasso's discussions—brush in hand—with great precursors, which would
occupy such a major place in his work over the course of the next fifteen
years.

In early summer Picasso left for the Côte d'Azur with Françoise and
young Claude. Marie-Thérèse lent Maya, who was now nearly twelve.
They were joined by Paulo, who had married—a reconstituted tribe in the
Spanish manner. Olga, however, had just settled herself in Cannes, from
which she sent a series of vengeful letters. She went so far as to ambush
Françoise as she pushed her baby carriage, showering her with curses. The
past cannot be undone. Whether she wished it or not, Françoise found
herself the center of a constellation of people ranging from old loves to old
friends in need of help. Although Sabartès was there to deal with all the
problems bound to arise, Françoise herself could not escape them, espe-
cially as the PCF demanded contributions from Picasso with increasing
frequency: posters or gifts to its various enterprises.

In the beautiful countryside and on the beaches of the Golfe-Juan, still
relatively free of people, Picasso sunbathed and swam, and some of the
disturbances and difficulties of Paris could be forgotten. Early in August
Picasso went to check on the ceramic experiments he had begun the previ-
ous year at the Ramié potteries in the hills at Vallauris, the next village.
Since then he had designed some new projects for them, and he liked their
studio, under its tiled roofs. Picasso in fact had no studio. He thought he
might complete the panels for the museum at Antibes. These, however, had
not yet been shown due to the extreme dilapidation of the château. Further-
more, Picasso was given to understand that the Administration des Musées
was not pleased by his interest in a mediocre municipal establishment.

The Ramié pottery was welcoming. Vallauris was once again almost
entirely somnolent after a revival of pottery kitchenwares during the Occu-
pation, to replace unobtainable metal utensils. The isolation and calm of
the place seemed propitious; Parisian polemics and intrigues of every kind
could be set aside. Except for an almost abstract set for an *Oedipus Rex* put
on by Pierre Blanchar in December and lithographs to complete Reverdy's
Chant des morts, on stones brought by Mourlot, the entire autumn and
winter was devoted to ceramics.

Picasso found in that medium a plastic liberty without equal.[6] But he
took particular delight in the constantly renewed surprises of transmutation
of oxides, ceramic slips, and colors experienced by the enamels as they went
through the baking process. And in the course of acquiring technical exper-
tise, he was able to jolt tradition, with his models as much as with his use
of enamels. He could to some degree satisfy his appetite for inventive
tinkering. This brought a renewed sense of youth, which in turn quickly led
him back to sculpture proper. He was delighted to find a pretext—vis-à-vis
his Communist comrades—for creating objects which could be said to have

some utilitarian application. Plates, after all, are used for eating. Soon, thanks to him, Vallauris, whose municipal government was Communist, would revive as a place on the tourist itinerary, even if the local pottery workers didn't always appreciate Picasso's jolting effect on their methods.

I saw him during that time on one of his brief trips to Paris. He was bursting with vigor and spirit, while Françoise seemed tired and strained. Fougeron had produced a painting-as-manifesto, *les Parisiennes au marché,* for the Salon d'Automne, and during the opening Maurice Thorez had stopped in front of it. Since the late summer the press had made much of the views of Gerasimov, that pontiff of Soviet painting, as printed in *Pravda:* "It is inconceivable that Soviet socialist art should be in any sympathy with decadent bourgeois art represented by those two exponents of formalist thinking, the French painters Matisse and Picasso."

During this period social tensions in France were brought to a fever pitch by the PCF, which as directed by the newly created Kominform, made a sudden switch to a posture of violent opposition. Picasso remained above the fray. "The Soviets? They've always said things like that. Fougeron? Why not . . . if he wants to make daubs." On that occasion, or perhaps a little later, Pablo told me that if Fougeron had asked, he (Pablo) would have taught him how to do hands and, above all, feet. Fougeron didn't seem to realize it, but those particular skills were essential to his kind of painting.

Picasso settled into Vallauris. In the summer of 1948 he bought la Galloise, a villa in the hills. I was stunned when I first saw the place to find a suburban cottage, albeit one whose interior had been transformed by Picasso's bric-a-brac, by objects like a mechanical piano bought during the sales which followed the closing of brothels in France. Françoise on that visit made me realize what a change this villa represented. Previous Picasso establishments on the Golfe-Juan had always been marked by a quality of improvised and temporary installation; while Pablo himself seemed to be camping. (This quality was also, it seemed to me, a fundamental element at the Grands-Augustins.)

The summer also included an experience without precedent. Picasso had accepted an invitation to attend a Congress of Intellectuals for Peace to be held in Wroclaw in the Silesian territories which became Polish after the war. This was, of course, an act of goodwill toward the PCF, but Picasso accepted the proposition that one must struggle for peace. Further, given what was said about painting in France as well as the USSR, it suited his purposes to demonstrate that contemporary art was on the side of the highest moral values, as it had been at the time of *Guernica.* He was contributing his presence; and that in itself was a statement of support for the liberty of his friend, Pablo Neruda, for example, then being persecuted by the government of Chile. At the same time, he was restating his position at the time of the Spanish war and ridiculing Gerasimov. I accompanied him on his visit to the Cracow Museum, where he bore without flinching long explanations by an Academic painter. We also visited Wawell Castle

and the reconstruction of the admirable Witswoch altarpiece and observed together the wondering amazement of children when they met the Martinique poet Aimé Césaire—their first encounter with a black. Picasso was delighted by the colors of the peasant blouses at the market. We visited the ruins of the Warsaw ghetto; I served as his guide to Auschwitz and Birkenau.

Picasso's indefatigable curiosity to learn, see, and understand everything was accompanied by a natural arrogance, a reluctance to waste any time on the repetitive or the insignificant, like the diatribe against Sartre by the novelist Fadeyev, the leader of the Soviet delegation. And once or twice he put his foot down, either to show that official inanities annoyed him or to shake the stifling decorum of an overheated party dinner by pulling off his shirt and displaying an astonishingly young, bronzed torso.

He had left Françoise—once again pregnant and uncomfortable—at la Galloise and rejoined her there after an absence of two weeks. Shortly thereafter they went back to the Grands-Augustins.

Picasso showed his abstract drawings from the Antibes period at Kahnweiler's and his ceramics at the Maison de la pensée française, then in the hands of the Communists. He invited Spanish guitarists to play at both galleries in the evening, creating his own ambience. Although the autumn was marked by fresh strikes and increased social tension, Picasso impressed me by his easy manner. His paintings indicate that he was at the top of his form, with stylized images of Françoise; while Claude, wrapped in the embroidered costume brought back from Wroclaw, was the occasion for some fresh lithographs. Then Françoise reappears in an embroidered Polish jacket.[7]

Were these the fruits of reflection following his Polish journey? In early November he painted a large canvas entirely re-creating a room at the Grands-Augustins with all its ambient space. A mesh of lines and symbols produces *la Cuisine*,[8] one of his most abstract and strongest pictures. Does this indicate a liberty of spirit regained? Is it the fruit of long meditations on contemporary developments in abstract art with which he had already experimented in his portraits of Françoise? She took note of his explanations one day while he was painting her breasts.

> If one is too concerned with what is already obvious—that is to say, with an object as a positive form—surrounding space is reduced to almost nothing. And if one is overly preoccupied with the space surrounding an object, the thing itself is reduced—almost obliterated. So which is most interesting: what is on the inside or what is on the outside of any form? Look at Cézanne's apples: you'll see that he hasn't actually painted apples as such. What he has done is to paint extremely well the weight of space on those round shapes. . . . It's the weight of space [that] counts, . . . the pressure of space on the shape.[9]

On 9 February 1949 he painted a second version of *la Cuisine*, which gives objects a greater presence and adds more color. And concurrently—between lithographs of Françoise with her own face, in which, as with Olga nearly three decades earlier, he appears to be seeking the baby about to be born—he presents fresh proof of the period of grace he was enjoying at the time. The washes on zinc of the *Colombe* on 9 January present subtleties in the grays of the feathers, white contrasts, and an unequaled limpidity of execution. A few weeks later, Aragon used the bird for the official poster of the Peace Congress to be held in Paris. Picasso had told him to take what he wanted (as an alternative to actually making the poster himself). Picasso always remembered the irony that doves are in fact bellicose birds. He knew this very well because he usually kept a cageful. The lithograph was done at the same time as *Homard et poissons* (Lobster and Fish) and *Homard et crapaud* (Lobster and Toad)—Picasso never manifested a particularly peaceful spirit in the presence of crustaceans.[10]

Françoise was growing more and more uncomfortable. The painting *Femme sur un fond étoilé* (Woman against a Starry Background) makes it clear that she was close to delivery.[11] Paloma (dove in Spanish) was born in the middle of the Peace Congress held at the Salle Pleyel. Picasso celebrated the event with lithographs combined with poems in automatic writing. These are interrogations on the meaning of life and of painting, on Françoise, and an old, sad, bearded faun who strongly resembles the artist. He turned back to Cranach: three variations on *Vénus et l'amour*.[12] Then he departed for Vallauris.

Meanwhile, at the end of April Sir Alfred Munnings at the Royal Academy banquet in London, forgetting (perhaps) that his remarks were being broadcast, launched into an attack against modern art, Matisse, and Henry Moore. He said that he and Churchill would willingly give Picasso a "boot on the b.t.m." His comments produced a storm of protest. A few months earlier, members of the American Congress identified modern art as Communist subversion. For Picasso such attitudes were of a kind with those of Gerasimov and Fadeyev. And with those of the director of the PCF, who proclaimed that "attacking Fougeron is attacking the party."

The important event of that period for him—next to Paloma's birth—was the acquisition of the warehouses formerly used by perfume makers and potters at Fournas in Vallauris, which he turned into studios. One of these was for painting; the other, for sculpture, with a few surplus rooms for storing ceramics. The year before, he had done some small modeled sculptures with inverted relief. For these he used the readymade materials he had begun to accumulate: fragments of iron, various bits of scrap, pebbles.

Femme enceinte (Pregnant Woman) had been the subject for 1948. Now she returned first as a variation of *Femme-fleur* and then as a piece of statuary. This was, in fact, a disguised assemblage, with the belly and

breasts made from jars. In 1959 Picasso would add realistic details and modify the figure's foundation. This, according to Françoise, was one of the first pieces done at the Fournas studios.

La Chèvre (She-Goat), which preliminary drawings date to March 1950, is just as much of a hymn to fecundity. Picasso used a rush basket for the rounded belly, with flower pots and palm fronds. With *Petite Fille sautant à la corde* (Girl Jumping Rope) he successfully met an old challenge: a piece of sculpture which doesn't touch the ground. The skipping rope—an iron tube made at the Vallauris forge—is the sculpture's foundation. It supports a body whose bulk is an orange basket. *Femme à la poussette* (Woman with Baby Carriage) is even more directly a three-dimensional collage, because an actual baby carriage is one of its basic materials of construction. The woman is done with the front of a wood stove; her breasts and the baby, with molds for baking tarts and pieces of tubing. *La Guenon* (Female Monkey)[13] starts with a balloon and two toy cars which belonged to Claude (toy models of a car which Éluard's new companion, Dominique, had just bought). Full of vigor, Picasso turned next to a still life, *Crâne de chèvre, bouteille, et bougie* (Goat Skull, Bottle, and Candle). (There are two versions of this: the first, a painted bronze; the other, oil on canvas, was not done until April 1952.)[14]

These transmutations in sculpture, however, did not supplant painting. They were no longer in sequences but individual works, each one the product of long reflection and ripening. First Picasso extended the linear analyses of both versions of *la Cuisine* and considered two classics, resulting in the *Portrait d'un peintre d'après le Greco* (Portrait of a Painter, after El Greco), completed in February 1950, and *Demoiselles au bords de la Seine d'après Courbet* (Women on the Banks of the Seine, after Courbet).[15] Although Greco was a partner of long standing, Picasso's reworking of the Courbet was undoubtedly a way of intervening in the PCF's scholarly debates on the subject of realism. Picasso focused on the pressure of the leafy ceiling and the space surrounding the two women. Compared with the Courbet, he reduced the height of his canvas by about two fifths and used the folds of the dresses and all breaks between actual surfaces to orchestrate his own fragmentation, which he stressed with double contours (as in certain corridas of 1934). He subjected forms to spatial content so that he would be able to establish their presence more successfully. This was the height of what the party condemned as formalism. At the same time, Picasso was showing the comrades that Courbet was not quite so realistic as they thought. What made Courbet his unique self was his way of rendering spatial rhythms, the vibrations of air, and the abandon of his two women. They only needed to be cleansed of illusionism.

Other paintings tell of life with the children: Claude on his rocking horse (like Paulo in 1926), *Claude et Paloma, Femme entourée de ses enfants* (Woman Surrounded by Her Children), *Maternité à l'orange*. There is a *Paysage nocturne* from Vallauris and two portraits of *Madame H.P.*,[16] the

novelist Hélène Parmelin, married to Edouard Pignon, the most gifted of the young Communist painters and the closest to Picasso. But these last two are from 1952. In the interval Picasso was to find himself caught up by the Communist party debates on art. There was to be no escape for another three years, a period which Michel Leiris dubbed *"une détestable saison en enfer."*

"A DETESTABLE SEASON IN HELL"

1951–1953

S ince June 1951 the hot war in Korea had exacerbated the tensions of the Cold War. Picasso's life was governed by his work and by the joy he took in his two new children, especially now that Claude was old enough to register as an autonomous presence at la Galloise. But Picasso was nonetheless very much aware of external events. He designed a poster for the October meeting of the second Congress for Peace in Sheffield, England; the police, however, prevented his attendance. The poster—a dove in flight—equals in beauty the first dove, which was to circle the globe and receive the Pennell Memorial Medal from the Philadelphia Academy of Fine Arts.

His ties to the Communist party were firmly established. Picasso had thought to put a bronze of *Homme au mouton* (Man with a Sheep) at the Château d'Antibes, but when that plan presented difficulties, he proposed giving it to the municipality of Vallauris. The town, however, found the offer disconcerting and accepted only under pressure from the French party directorate. As Picasso had asked, *l'Homme au mouton* was installed in the village square; but even though he said he would like children to be able to climb on it and dogs to piss, the plinth was a little too high. All the same, Laurent Casanova, representing the party, came to the inauguration to preside with all due pomp and to celebrate Picasso, who was made an honorary citizen of the town. A small, deconsecrated chapel was put at his disposal to decorate as he chose. And the PCF arranged for him to receive the Lenin Peace Prize in November.

But in October Maurice Thorez was stricken by a cerebral hemorrhage, an event which disrupted the possibilities of political harmony. Until then he had been protecting Picasso from the Soviet offensive against "decadent formalism." In November and December *Humanité* embarked on an unprecedented effort to ensure the success of Fougeron's new exhibition "Au Pays des Mines" (In the Country of Mines), to be held in Paris at the Bernheim-Jeune galleries.

None of this troubled Picasso. On 12 January he produced *Fumées à Vallauris* (Smoke at Vallauris), a handsome painting of the town penetrated

by smoke from the kilns, and a drawing of a horseman with all his trappings. And on the 18th he signed *Massacres en Corée* (Massacres in Korea), a striking and intimate reaction to a distant war—a population of pregnant women and children confronted by robotic warriors.[1] But, apart from its limpidity of composition, the painting contains almost none of the internal signatures which give *Guernica* and *le Charnier* their strength. Here the intention was to treat a subject rather than let the painting itself speak. Deliberately or otherwise, the painting was a political act.

On 10 January, for the opening of Fougeron's show "Au Pays des Mines," the PCF pronounced that "anti-Picasso" its official painter. The 12 January issue of *Humanité* devoted an entire page to these scenes of combat between the miners and the CRS done with grotesque overstatement. Auguste Lecoeur, one of the party directors, inquired with a rhetorical flourish, "Have subjects of this kind ever been painted with such courage? Never!" The paper arrived at Vallauris the following day, perhaps the final ingredient leading to the release of *Massacres en Corée,* and in any case, part of the context in which the painting was produced.

Picasso did next a series of ironic lithographs: *le Chevalier et le page* (Knight and Page), *le Départ du chevalier* (The Knight's Departure), and then a painting—*Jeu de pages* (The Pages' Game).[2] Inside the PCF the canonization of Fougeron continued, accompanied by violent pressure and sanctions against any dissenting critics. Yet the party celebrated Picasso's Lenin Prize in his absence with a gathering at which Fernand Léger saluted *Guernica* and the *Dove of Peace.* The occasion also produced a formula: Fougeron, the party declared, was fighting at his "battlement of Communism"; and Picasso, at his "battlement" as a "partisan of peace."

Three months later, when Picasso showed *Massacres en Corée* at the 1951 Salon de Mai, of which Edouard Pignon was a founder, the picture was, on the whole, poorly received. Young people, as described at the time by the critic Michel Ragon, withdrew from "this cumbersome genius of whom it has been said that he, in himself, constitutes a repertory of the history of art. . . . The public must be taught to *un*learn Picasso." The PCF assumed a posture which was tantamount to boycott. For them any identification of the valiant Chinese and Korean comrades with these female nudes striking soldierly postures was impossible. Hélène Parmelin writes that when the painting came back to Vallauris, Picasso propped the picture outside the Fournas studios and said to Pignon, "Even if nobody likes it, it's still got something, hasn't it?"

He had already decided on his next move, but unforeseen material difficulties kept him from beginning work until the following spring. Louis-André Dubois, the prefect who had been protecting him, was replaced by an anti-Communist. In a time of severe housing shortage, unoccupied apartments were requisitioned. The rue la Boétie apartments were not, in fact, lived in, and Picasso was informed that he must give them up. Moving, under the best of circumstances, was a great ordeal for him: the loss of a

framework, of a particular and detailed relationship to a particular space and surroundings. But, above all, there was the physical and emotional ordeal of moving paintings, drawings, sculptures, and large, diverse archives. Sabartès filled the Grands-Augustins apartment with these, while the furniture was sent to storage. Picasso rented two apartments in the rue Gay-Lussac, at the top of the Latin Quarter: one for Françoise and the children, the other for Inès and her husband. For Picasso his various lodgings constituted a form of autobiography. At the end of the summer, he wanted me to come and see him. "At the rue Gay-Lussac?" I asked. "No," he said laughing. "Rue Gay-Lussac is *chez Françoise*." I had, in fact, guessed as much. Later, when everything was over with Françoise, he told me that he had just rediscovered Saint-Tropez, "you remember the little girl who came to see me after the Liberation on behalf of *Lycéen* Communists . . . you knew her."[3] I did not, in fact, know her, having spent the autumn of 1944 at Mauthausen.

In the summer of 1951, Picasso distanced himself from Françoise. Their last photograph as a couple is dated 14 June. They were witnesses to the wedding of Paul Éluard and Dominique at Saint-Tropez. Eight days later Picasso was back in that town, only this time with Geneviève Laporte, the "little girl" of 1944. He had compromised Éluard by asking him to find an apartment for the summer in Saint-Tropez, a town which played an almost fetishistic part in his amorous escapades. Dominique could not but feel somewhat guilty vis-à-vis Françoise. Picasso always behaved this way with friends at the beginning of a new adventure.

According to Geneviève, Éluard

> said to Picasso, "No solution would make you entirely happy, even if you were free to choose whatever you wanted." Picasso's face darkened. . . . "So whom should I kill? Or is that another false problem? Whomever one kills off, at least two others are miserable." Picasso looked wretched. He felt that the friend he had regained did not understand him. . . . He pressed the point. "I was ready to kill myself: she made me laugh." He repeated this, his voice taut with anguish: "Laugh, you understand? Laugh." And Paul, with all the tenderness he could muster, said to him, "And even if she had made you cry, she'd have saved you."

Picasso, in fact, placed a certain Spanish emphasis on evoking his love affairs, and in these recollections one can almost hear the individual voices of his friends. It was also true that the problem, in this case, did not include a solution. The summer, therefore, was broken up between absences in Saint-Tropez and returns to Paris.

The chapel which Matisse had decorated at Vence was opened on 25 June. This event provoked some of Picasso's anticlericalism, as well as a certain scorn, since he knew that the elder painter was not in the least religious. Nonetheless, his long-standing rivalry with Matisse led him to

consider once again the Temple of Peace which he wished to decorate at the Vallauris chapel (and which would be a strictly lay undertaking).

He spent most of September in Paris with Geneviève, according to whom "Françoise wrote him letter after letter—some of them threatening—which he showed me." He went back to Vallauris and on 25 October, during the celebrations of his seventieth birthday, he collected a bouquet of red carnations and sent them to Geneviève: "Souvenir de tous les instants." He then returned to Paris so that Françoise and the children could spend the winter there. In Paris he was threatened with further requisition, this time for the Gay-Lussac apartments. Political persecution, therefore, continued, while the enforced stay did nothing to forward accommodation with Françoise. At Vallauris Picasso resumed sculpture, painted a *Paysage nocturne,* and did the lithograph *le Visage de la Paix* for a deluxe volume with Éluard, edited by the PCF.[4]

That winter the PCF mounted a major political campaign in an effort to save Beloyannis, the Greek Communist leader for whom Picasso did the drawing *l'Homme à l'oeuillet* (Man with Carnation). Beloyannis was executed, and in the United States, the Rosenbergs—condemned to death— were in danger of the same fate. The Communists then began a fresh campaign: this time, against the bacteriological warfare which they accused the Americans of waging in Korea. Picasso was anxious to get back to Vallauris to begin work on the large panels he was dreaming of but had to wait until the municipality had completed the preliminary arrangements. Just before he left, Kahnweiler organized a first exhibition of Françoise's paintings. The difficulties of her struggle to find a personal mode of expression and have it recognized as hers by all those who perceived only Pablo exacerbated the crisis in her relationship with Picasso.

In short, Picasso wanted Geneviève as an escape and Françoise as part of living with his children. From the end of April through early September, he was heavily involved with work on *la Guerre et la Paix* (War and Peace).[5] The notebooks were quickly made public, with commentaries by Claude Roy, a young poet and novelist—at that time a Communist—who watched the work as it evolved. These indicate the degree to which Picasso had been affected by the failure of *Massacres en Corée.* Large numbers of repetitive drawings were carefully aimed at creating the internal signatures the picture lacked in early 1951. He returned to his familiar world above all in the panel *Paix* in which the Pegasus from *Parade,* led by a child, is plowing, while a sun with rays like thorns replies to *Guernica.* Although these large canvases hang together admirably, they lack the unity imposed by *Guernica* or *le Charnier.* Despite his concentrated efforts, Picasso did not achieve a convincing biological warfare phantasmagoria. And he knew as well as anyone that painting is inextricably bound to the unconscious. He received fresh proof of this a few months later with his *Portrait de Staline.* A year earlier, he had told Kahnweiler, "At our age, we still can do what we want. But to desire, and be unable: that's really terrible. I must do the *Temple of Peace*

now, while I can still climb ladders." During the final months of that year, he had the great joy of completing two large panels.

In the autumn he left alone for Paris and a reunion with Geneviève. A new peace conference was being prepared, scheduled to be held in Vienna. The PCF asked him to do its publicity poster. As his first dove had already soared into flight, Picasso conceived for this occasion a rainbow with a dove which is discontinuous, like a collage of paper cutouts (or the ensembles of colored cutouts which Matisse was doing at the time). The result was a great success, of marvelous vigor. Picasso's clients, however, astounded by a dove in fragments, turned the proposal down. Next, deferring to their wishes, Picasso drew a dove in flight across a rainbow and made an etching of it;[6] party leaders felt they had pushed him into a break with formalism.

Then, on the morning of 18 November, he received a severe shock: the sudden death of Paul Éluard. Now he was entirely alone. Paul had known of Picasso's double life, as he had shared the experiences of Surrealism and membership in the Communist party. Pablo attended the burial, which the PCF wished to stage in grandiose style. The police, however, showed no reluctance to employ tactics of harassment, rushing the ceremonies along as fast as they could. Picasso at this juncture went back to writing, as he had during the crisis of 1935: a play, les Quatres Petites Filles (The Four Little Girls). As the Slánský trial proceeded in Prague, with all of its untenable testimony (Slánský, a Czech politician, was accused of leading a plot to overthrow the Communist government), followed by the horror of eleven hangings, Picasso withdrew to Vallauris, where he did a set of lithographs of Paloma, Claude, and their mother, marked by an extreme tenderness. In others Françoise's face is hard and closed, as it was in the lithograph of November 1950: Françoise sur fond gris (Françoise against a Gray Background).[7] In her memoirs, published in 1964, Françoise comments on that image:

> Picasso had insisted that I have children because I was not enough of a woman. And so I had them. One might have thought that I was, therefore, more of a woman; but it became clear that the whole question was for him a matter of complete indifference. . . . However difficult he had sometimes made things for me, I had always felt that this was less important than the things which tied us one to the other. And then, I began to feel bitter.

Two more years, and the bitterness had grown. Françoise, as a woman of thirty, was beginning to worry about wrecking her life and beginning to want—if she was not already at liberty—to take a few liberties, at the very least. Picasso was too much of a different generation to understand her disappointment beyond the fact that their life as a couple was no longer working and that Françoise's solitude at Vallauris made the situation worse. He left for Paris in mid-January and acquired at Mourlot's a century-old zinc plate destined to obscurity: an engraving of a painting—

l'Italienne—by the Lyonnais artist Victor Orsel.[8] Picasso's painted version of this work is done with large, sweeping brush strokes; its margins are embellished by a female nude, a piper, and a faun, and finally by Françoise and the two playing children.

In February of 1953, back in Paris from Vallauris, *Femme et chien sur fond bleu* (Woman and Dog against a Blue Background) expresses misery.[9] And it was in this atmosphere that the uproar of the *Portrait de Staline*[10] erupted. The commission was, in fact, a test or trap laid for Picasso, primarily by the Communists, who had already asked for some kind of homage at the time of Stalin's seventieth birthday in 1949. Picasso had sprung that trap by drawing a hand raising a glass, with the inscription *"Staline, à ta santé"* (To your health, Comrade Stalin). This use of the familiar form shocked right-minded party members, but no one felt able to comment. On the morning of the official announcement of death, Aragon, who the week before had become editor of *Lettres françaises,* and I, back after three years of directing *Ce Soir,* hadn't settled anything and telegraphed Picasso, telling him to "do whatever he thought best." When he asked for a set of photographs of Stalin, I began to have my doubts about his meeting the test. He chose as his subject a young Stalin, from a photograph of 1903, and sent us a drawing which modifies a cliché with the same kinds of simplifications as in Victor Orsel's *l'Italienne.*

The drawing arrived at 11:30—at the last possible moment—and occupied the center page of the weekly, which was printed three hours later. There was an immediate outcry in the offices shared by *Humanité* and *Lettres françaises.* This sudden return to youth was considered brutal by thousands in mourning for a hoary old man. In the atmosphere of the time, with *Pravda* and *Humanité* on constant watch for conspiracies (the latest of these being the "Doctor's plot," of physicians accused of wishing to assassinate the Soviet leaders), Picasso's *Stalin* was thought to look cruel and therefore to have been drawn from a "bourgeois" point of view. Picasso certainly hadn't intended anything of the sort: the drawing was a product of his unconscious.

The *Portrait* was officially condemned by the PCF "without in any way casting doubt on the sentiments of that great artist, Picasso, whose attachment to the working class is well known."

This was worse than outright demolition. Thirty years earlier Picasso had told Tériade, "One of the ugliest elements in art is the 'I beg you to accept, sir, assurances of my humble respect etc. etc.' which, throughout history, has stained even the best work, because it is an expression of general submission." And now he was receiving just that sort of low swipe from his own party, a blow which obviously delighted everyone who resented his decision to join the Communists. He avoided the press, which flocked to Vallauris, and refused to discuss what he considered a family affair. His offering had not been appreciated, a situation which is common enough.

The PCF forced Aragon to publish a whole dossier of letters condemn-

ing—even cursing—Picasso. One of these, signed by Fougeron, declared
that he would have rejected "this so-called *Portrait de Staline*" for the
exhibition which he was organizing to honor Karl Marx. The party cen-
sored a crude telegram from Léger, as well as every letter of approval.
Aragon sent me to Vallauris to prepare Picasso for this publication and to
tell him that we remained solidly on his side. I found Françoise alone, angry
with us and with the portrait and bitter that I had not also come to see her
work.

Picasso returned from Saint-Tropez the next day, which perhaps ex-
plains the tension between Françoise and him. She left immediately with the
children for Paris. She had a commission to do sets and costumes for a ballet
by Jeanine Charrat. I shared with Picasso days in which no one came to La
Galloise except Jacques Prévert and Dr. Dalsace, who, since the Kahnweiler
sales, had owned some admirable Cubist paintings. Together we read
Aragon's self-criticism "To Be Read Aloud," which was published on 9
April.[11] In this case Picasso was not confronted by socialist realism, which
he might well have considered a transient disorder, but with the phenome-
non later known as the "cult of personality" and with everything about the
PCF which he would have preferred to ignore. And with that whole seg-
ment of his life which had developed since—with Éluard in 1936–37—he
began to think that art might serve the people if not the revolution itself.
Éluard had died in time. Françoise had left. And he didn't know if she'd be
back.

With a touch of historical irony an exhibition "le Cubisme 1907–1914"
opened at the Musée national d'Art moderne on 30 January. For the first
time since the largely disregarded exhibition of 1916, *les Demoiselles
d'Avignon* was being shown in France, and in a museum to boot. Once
again the picture fell flat, which says a great deal about the general attitude
in Paris toward modern art, the widespread ignorance of modern art history
in general, and in particular the refusal of the Communist party to accept
or recognize Picasso's professional history. This history was exhibited for
the first time since the war in a set of excellent retrospectives. These,
however, were in Italy: in Rome and then Milan. Another, more restricted
show followed in France, but in Lyon. It seemed that in spite of all the
incomprehension and hostility, appreciation of Picasso's painting was
growing. He took comfort in the sense that at seventy-two he was still very
much in the forefront. And, all things considered, the crisis over the *Portrait
de Staline* produced more of a gain than a loss. He was no longer simply
a historic monument. He accepted philosophically a message from Maurice
Thorez on the latter's return from three years of medical treatment in the
USSR. Thorez let Picasso know that he disapproved the condemnation of
the *Portrait de Staline*. However, diplomatic politics required that this
opinion be kept secret until September 1953.

During the summer the "fundamental questioning" which Leiris
speaks of began in earnest for Picasso. He sculpted long, stylized figures,

which he then painted. When Françoise returned for the holidays, he did several heads and busts for which she—in a mature, ripened version[12]—was the model. To freshen his ideas Picasso accepted an invitation to Perpignan from the Lazermes (friends of Manolo and Totote). And the Communists of Céret, hoping that he would settle there, organized a celebration in his honor. He attended the corridas of Collioure and Perpignan and made many round-trips between that French Catalonia and Vallauris, a journey which at the time, without a modern highway, meant long hours on the road. And friends came to see him, in particular, Zette and Michel Leiris.[13] Increasing tension with Françoise, the absence of Geneviève Laporte, an attraction to Rosita, the adopted daughter of Manolo and Totote, and strong affection for his hostess Paule de Lazerme—the sum of these factors added to his trouble and indecision. In his work Picasso was the quintessence of decisiveness; but in the private complications of daily life he could be as hesitant and as contradictory as anyone else. And, as life is not like a picture which one can revise at will, he returned, in the end, to Vallauris.

On 30 September Françoise left for Paris with the children, whom she had enrolled in the École Alsacienne. Their separation was now a fact. Perhaps, right to the end, he tried to keep her. Before she went Françoise said to him, "You know, I may have been a slave to love, but not to you."

PART EIGHT

JACQUELINE AND THE FREEDOM OF OLD AGE

Painting is stronger than I am. It makes me do whatever it wants. Picasso wrote that comment on the last page of a notebook crammed with drawings. It is inscribed in pencil, in large letters, dated 27 March 1963, as if he wished to situate precisely in time a discovery which was important to him. . . .

If one manages to break through all resisting barriers which might temporarily impede progress, how, then, to escape vertigo? In the absence of any restraining wall, and with all completed work at one's back, there is nothing ahead but a void, a void one must make haste to conceal by immersion in a new work which—when done—will reveal the same void.

—*Michel Leiris*

32

QUESTIONING EVERYTHING

1953–1954

There are never "proofs" of genius, only fleeting insights and perceptions. And among these, the more indirect, the harder to quantify may be the most valuable. In Picasso's life there had been many significant changes. His chauffeur, Marcel, confidant of many an escapade, had been dismissed. Paulo was now filling that position with virtuosic dexterity. The Oldsmobile once bartered by Sam Kootz for a painting had been replaced by a black Hotchkiss. And there was a bevy of women under the impression that Françoise's position was up for grabs. Once the various automobiles of visiting ladies had been cleared from the chemin des Mauruches, which led to la Galloise, Picasso, laughing with pleasure, would burst from the house and climb into my minuscule Renault *ni vu, ni connu* (neither seen, nor recognized). This piece of byplay gave me access to some of the feelings he entertained when face to face with himself.

Over the course of years I had begun to understand these a little when the double void created by the departure of Françoise and the affair of the *Portrait de Staline* led him to a particular appreciation of friends like Hélène Parmelin and Pignon and André Verdet, a poet who lived in Saint-Paul-de-Vence. Maya, then nearly eighteen, became the mistress of la Galloise, and Pablo reconstituted a family life there. There were also tribal excursions to the bullfights in Arles or simply to the Colombe d'Or in Saint-Paul.

These fluctuations in his personal life took Picasso back to his earlier season in hell, in 1935. This return to the past was in effect a closing of parentheses around the period of political engagement in his life: debates with Éluard and Dora and membership in the Communist party. He was not "depoliticized," like Baudelaire after 1848; but he had reached a vantage point above the fray, a posture he did not occupy at the time of the *Massacres en Corée* or even of *la Guerre et la Paix*. The outcry over the *Portrait de Staline* had exposed a great many people for what they were; but it had also brought into the light of day many things which Picasso had separated from issues of the war itself, because he had come to think of his painting as a form of participation in battle. He now had to balance his accounts, after eight years of living with Françoise, and at the same time

calculate the effects of losing his bet that art would renew itself in response to current events. The best things he had done derived directly from emotion generated by images of Françoise and the children or from technical problems, problems of artistry in his sculpture, and the dialogue between sculpture and painting, his formal refigurings of the classics, and his inventions in lithography.

This did not bring into question his relationship to the Communist party, which during that period of the Cold War was under heavy legal pressures. Further, right after the crisis over the *Portrait de Staline*, changes in the USSR began to be evident. In July 1953 he and I read together in *le Patriote de Nice* that Beria had been arrested in Moscow—a foretaste of what would become de-Stalinization. Picasso intuitively sensed the rehabilitations and attacks on the terror which were to come. But, more broadly, I understood that he was taking the measure of what was beginning to be the postwar period, in which nothing would be as before. And that, of course, included art.

On 20 September the Picasso retrospective moved from Milan to Rome. The show was enlarged in order to bring together for the first—and only—time major works on the subject of war, from *Guernica* to *Massacres en Corée* and the panels for *la Guerre et la Paix*. The political stir caused by these certainly accelerated Picasso's decision to return to work whose value lay entirely in itself. He was at that moment in Paris. In her memoirs Geneviève describes how instead of leaving together for the Midi, she and Pablo separated: because of a misunderstanding.

Paule de Lazerme had come with her husband to the Grands-Augustins to pose for a portrait drawing. Totote and Rosita had followed. When Picasso returned to la Galloise alone, he understood very well why.

The period of work which followed this move was one of astonishing fecundity, characterized by a sense of return to origins, to the original wellspring in all its intimate detail. At first his painting (excepting landscapes) was linked to his creative work during the varying turbulences of the summer. Thus, *Femme assise* (Seated Woman) of 9 July—a nude derived from Françoise—explores geometrized simplifications conceived during studies of Dora, as she had been at the beginning of the Occupation. Picasso pushed this sculptural monumentality even further with a *Nu dans l'atelier* (Nude in the Studio).[1] This was followed by a sumptuously decorative *Paloma au jardin* (Paloma in the Garden),[2] and then a drama of cat and cockerel in a kitchen,[3] as cruel as the combat of woman and dog at the beginning of the year. The closing days of December produced two paintings in which the artist's shadow is projected across a bedroom at la Galloise, where a naked woman is sleeping.[4] For Christmas Françoise brought the children as far as Cannes. She herself, however, went back to Paris, without pushing on to Vallauris.

Picasso was testing, trying, and seeking an updated truth. He had not changed any of his ideas—those which might be categorized as political, but recognized that the rationale behind *Guernica* or *le Charnier* might now be

harboring what he had always feared as the worst danger for art: a routine, which inevitably threatens entrapment, a closed and demarcated route. He would thereafter disregard pressures exerted by the PCF.

This decision is evident in the sequence of drawings begun on 28 November.[5] Their subject is for Picasso a theme of themes: everything that can happen between a painter and his models. Never had a studio nude seemed so triumphantly young, so provocatively sensuous, with a sensuality both promised and refused. Picasso drew on all the skill and knowledge acquired over a long working life to invent fresh abbreviations, symbols which are simpler, further reduced—minimal lines against the white paper. The painter saw each of these young ladies differently: the girl who prides herself on the firmness of her breasts, and another who is pensive when confronted by a vision of herself; and all the others—indifferent, serene, or overfamiliar, as the case may be. On 4 January 1954 a girl plays with a kitten, disregarding the bespectacled artist and his ardent efforts to capture her image. On the 5th, sixteen drawings follow a delicious nude girl in her struggles with Cupid and then with an army of Cupids.

On the 7th the nude women are joined by men from the circus. The women arouse the men with provocative contortions; the encounter ends in an orgy. On the 10th both painter and model pass through every stage of life, the most decrepit painting the ripest. However, when an overaged painter is watching an adolescent model, a death's head is interposed between them. A seductive model is confronted by a monkey on the other side of the bed, while the painter is pursued by an ancient spouse. In another picture ecstatic or bewildered viewers, absorbed by abstract canvases, completely disregard a succulently sensuous model. Then a homely female painter appears, followed by monkeys, clowns, fauns, and masks, gathered for a finale over which a charming knight presides.

This is the end of the saga but not of the subject, which was continued in lithographs. The Minotaur returns: a man wearing a bull's mask, who frightens some nude beauties in *Jeu du taureau* (Bull's Game), to bow before the lady who performs the *Danse des banderilles*.[6] Spanish motifs reappear here—*cuadrilla* and *dueña*, acrobats and actors. Picasso organizes all his characters into a group at the painter's studio, centered on the nude model.[7]

Picasso had returned to the dramas of his past—the Harlequin paternity saga of 1905, the *Suite Vollard*, and, above all, the sculptor and Marie-Thérèse. But without a shred of complacency. These were a test of eye and hand, met with unsurpassed virtuosity. And a test of the heart as well. Which is to say that Picasso's art—before and after Cubism and throughout the Surrealist period—was always concerned, whatever its inventions and transformations, with exploring the multiple transactions between men and women and the meaning of youth, age, beauty, ugliness, life, and death. And the meaning of love and why people wear masks—of the theatre and the eternal commedia dell'arte.

Picasso was in full command of his powers. With his pen flashing like

lightning, he confessed everything in these drawings, without the least hint of repentance. His memory was able to re-create any model. Françoise may have left; he made her reappear in *Nu se coiffant,* alone or facing a young man.[8] When the children came for the Easter holidays, he painted *Claude dessinant* and then Paloma. When they left, he did a silhouette of the woman who took care of them.[9]

Fashion changes the way women do their hair. From his earliest youth, Picasso was extraordinarily attentive to details of that kind. He did young girls who had let their hair grow long in order to pull it up to the back of the head like a chignon and then fall in long ponytails. As early as 1953, some paintings show triumphantly feminine models with their hair in this style. Picasso found a flesh-and-blood sample of this model in the streets of Vallauris. She was twenty, with a body which could shake the vows of the most saintly ascetic and an English fiancé, a manufacturer of chairs who, quite understandably, never stirred from her side, particularly when it was a question of posing for Picasso.

Picasso glowed with enthusiasm and spoke of her with such warmth that I suspected he had fallen in love. He disabused me by describing the fiancé. The challenge posed by Sylvette was in fact the challenge of a new type of woman. Through her he would appropriate for his own purposes the generation which followed that of Françoise, and even of Geneviève Laporte. At this point he plunged into one of his most extraordinary campaigns of possession, not through working and reworking an oil painting but with a dazzling series of forty paintings and drawings done inside a month. Sylvette seated in an armchair; Sylvette in three-quarter face; Sylvette in profile; in the vigorous geometrization used for the nudes of Françoise; and in all the grace of her natural curves, with the neck more or less elongated; somewhat stockier; somewhat thinner; Sylvette obdurate; closed; ironic; absent. How to capture the secret of her youth? The secret of painting?[10]

If one regards this romance in drawing as a form of parenthesis, it was at this point that Picasso's art definitively entered the postwar world. Thereafter, the only vital issues for painting were generic and specific. This shift for Picasso represented post-Communism. One senses that he was no longer affected in any way by party opinion, by whether or not the comrades would detect signs of formalism or of new realism. He had never before been so entirely free.—He knew it, and gave himself to this new liberty wholeheartedly. Aragon was well aware of this development. When Tériade published *180 Dessins* in *Verve,* Aragon devoted five issues of *Lettres françaises* to an interminable article attempting to exercise a modicum of control over this disturbing phase of Picasso's evolution:

> Throughout, one is confronted by passwords, a confidence, a confession, in short, by autobiography. . . . The significance of all this has been relegated to private life, because critics find it necessary to believe—or

have it believed—that a major work of this kind by Picasso, an ensemble
in which all the world will recognize the stamp of genius, could *only*
derive from private life, from individual particularism.

Aragon was carried away here by the pleasures of his own prose. Picasso
drew and painted his "individual particularism": which is to say, he painted
his own life and the powers of his art to transform it. Did he really capture
Sylvette in the fine mesh of lines he threw at her? Fifteen or sixteen years
later, I was at Mougins when Sylvette came back for a visit. She had
aged—more than I expected; more, too, than Picasso had hoped. I watched
him decoding her, as it were, probably undressing her, certainly comparing
that present with what he remembered. Suddenly he got up and went into
the studio. I knew that he would come back with her portrait, which he had
kept in his collection. Calmly he put it beside the model. Smiling with
satisfaction, which aggravated the cruelty, he launched into a series of
anecdotes from the time of the portrait's creation. And there was no doubt
at all that the real Sylvette for him was the woman in the painting. As soon
as the living Sylvette had left the house, Picasso took the portrait back to
the studio, remarking as he went, with one of his sardonic grins, "So, you
see: art is stronger than life."

The sequence of drawings and paintings had already said it. After all
the destructuring and restructuring of her lineaments and attitudes, the
portrait of 30 May 1954—the last of these—was also the most "natural,"
as if all the struggles of work had enabled him to assimilate the essential
qualities which had always been there but which first he had to master.

There was no hiatus between the Sylvette visit and *Madame Z*, three
large portraits done on 2 and 3 June, which is to say, three or four days after
Sylvette's visit: *aux mains croisées; aux fleurs; aux jambes repliées* (Ma-
dame Z: with crossed hands; with flowers; with folded legs). It suddenly
seems as if all the refinement and figurative enrichment elaborated during
the Sylvette sequence had been arrived at specifically for this new model,
with something fresh in the organization of space around her.[11]

He was fascinated by the carriage of his model's head. He enlarged the
neck and geometrized the hair, imposing a sense of proud charm. Antonina
Vallentin, just then finishing her biography of Picasso, immediately charac-
terized the painting: *Un sphinx moderne*.

Madame Z soon regained her own name—Jacqueline Roque. A young
divorced woman, the mother of a little girl, Catherine, she was a member
of Sylvette's generation, back from a trip to Africa. She appears for the first
time in a group photograph taken at Madura's pottery in Vallauris in
December 1953. Picasso is lighting her cigarette. In the exhibition *De Pablo
à Jacqueline,* at the Museo Picasso in Barcelona (December 1990–February
1991), Catherine showed for the first time a drawing by Pablo of Jacqueline
lying barebreasted and wearing shorts. The drawing is dated 27 January
1954. She maintained her independence, and her intermittent presence at

first made no difference to the tumult of Picasso's immediate setting, as more and more women grasped the fact that the break with Françoise was definitive. Paulo vented his feelings about them: *"Les putains pour papa"* ("Tarts for Pops").

An exhibition was mounted at the Maison de la pensée française in July, which might be considered a rehabilitation of Picasso by the PCF. There had been many changes in party policy since the *Portrait de Staline*. Aragon had given Fougeron a double execution: first on the occasion of the Salon d'Automne of 1953 ("It would be dishonest not to tell Fougeron—publicly this time—that he has strayed from the path of realism") and then during the last congress of the PCF, at which August Lecoeur was expelled.[12] There was no longer an official Communist painting; and it seemed that the notion of "anti-Picasso" was best forgotten. In the USSR, Khrushchev was beginning to loosen Stalinist rigidities, which presented an opportunity to bring to France for the first time some of the masterpieces bought by Tchukhin and Morosov and now in Soviet museums. Alice Toklas added some major pieces from the Stein collection. The exhibition displayed the critical moments of Picasso's youth in which he became a modern painter, providing a bridge between the Classicism of the blue and rose periods and the breakthroughs at Gosol, the Horta landscapes, and Analytical and Synthetic Cubism.[13]

Lamentably quickly, however, nothing remained of the show but a book. One of Tchukhin's heiresses took the opportunity presented by the show to ask that paintings seized during the 1917 revolution be sequestered. Even though the point was under consideration by a French court, the Soviets immediately repatriated the disputed works. The *Portrait de Madame Z* was made public when Picasso sent some of his recent paintings to fill these gaps and ran into critics (Aragon, for instance) who saw nothing but repetitions of the portraits of Sylvette.[14] Picasso was not amused by this, because he knew that Elsa and Aragon were partisans of Françoise. They felt—and said—that his publicly displayed adulterous betrayal of his youngest children's mother (and at his age, too) was outrageous. Therefore, he thought that their mistaken reading of his paintings was deliberate, done expressly to hurt him. I realized then that *Madame Z* was more than just an episode in his painting. I tried to defend Aragon, but Picasso stopped me: "Even if Fougeron is a bad painter, why should he pay for the idiocies of others . . . or of Aragon? Those people say anything about painting. Realism! Realism! They haven't got the slightest idea what goes on in a painter's head."

And suddenly, right there, in front of le Fournas, I found myself with a man whose patience and restraint had been exceeded. How, he asked, could these people prate of realism when they had never even begun to understand what goes on in a painting? That's what reality is. And how could Aragon, who after all was a poet, accept the idea that the public is the judge of reality? (Aragon's self-criticism in the aftermath of the *Portrait de Staline* had clearly stuck in Picasso's throat.) It was impossible to turn

vision and understanding back to what it had been before Courbet. . . . And their understanding of what made an abstract picture was no better. A painter is always at war with the world. Either he wants to conquer it or crush it, change it or celebrate it; which it will be depends on his mood of the moment. "And if, in your painting, you've really trampled down everything, KO'd the world so that there's nothing but nothing left, whom have you beaten? Your own painting?" He stopped for a moment, staring into space. "But even that might still be painting, because if your aim is simply what they call reality, you begin by botching your own work. Why yell at Fougeron? His only mistake is listening to them."

Fifteen months earlier, following the *Portrait de Staline,* Picasso had still been thinking along more or less political lines, which had led him to paint *la Guerre et la Paix.* But now, I felt, he was changed, liberated, had returned to his own track. I risked saying something of the sort. He took me by the arm. "You're right. And painting isn't like women. Painting can grow younger while it waits."

I didn't know how to prolong this conversation. I needed to think about what I had just learned, and I was not yet well enough versed in Picasso's life to know all the right questions. But one thing was clear. In the course of the most profound crisis of his life, he had well and truly renewed his relationship to his art. Which meant in turn a definitive distance with all those, like Aragon, who put politics and the PCF ahead of painting.

Suddenly, looking around the studio, he told me that he would perhaps have to quit the place, as it belonged to Françoise. Then he spoke of his earlier separation from Olga, when he had been obliged to leave Boisgeloup. He carried in his head a comprehensive catalogue of his work, listed according to the place in which it was done: the Bateau-Lavoir; avenue Frochot; boulevard Raspail; Céret; rue la Boétie. All of that I knew already; but as I had not liked la Galloise, I had no idea what a wrench was presented by the prospect of leaving the Vallauris studios. And, just as a few minutes before, while speaking of painting, I had been in the company of a vigorous, ageless man, so now he seemed suddenly enfeebled. But then he pulled himself together. "Well . . . I've got to get out. I've been invited to Perpignan." He asked me to come, too. But I have always hated tribal groups and didn't go. Friends had warned me: one didn't refuse an invitation from Picasso. Subsequent events, however, proved that he much preferred frank dealing.

Accounts of this next move differ in proportion to the interests they represent. Picasso settled at the Lazermes'. The visit produced a fine portrait in profile of Paule de Lazerme, in a Louis XIII armchair with carefully detailed *geueles* at the ends of the arms. Local Communists and friends like Totote tried hard to get him to settle in the region. This was a difficult period of probation for Jacqueline, who faced many an ambush. But it was she with whom Picasso decided, at the end of September, to return to the Grands-Augustins.[15]

33

TURNING POINT

1954–1956

A nd now, as if in response to a basic and private decision, the rest of life seemed to be shifting, readjusting. Works shown at the Museum of Modern Art retrospective of 1939 were repatriated from New York, giving Picasso the opportunity—after a lapse of fifteen years—to look again at these high points of his revolutionary trajectory. He had a first taste of crowd worship at the annual sale of the National Committee of Writers, which he attended to sign copies of the book made from *la Guerre et la Paix*. The public—Communists and fellow travelers—gave him a hero's welcome.

On the other hand, there were the deaths of friends—the growing price which age must pay. First of all, Derain, who was knocked down by a car. Certainly, differences of public attitude had divided them, like Derain's trip to Weimar during the Occupation, sponsored by Nazi propaganda authorities. But Picasso wished to remember above all his friend and fellow artist of 1906–14, especially as Matisse, the eldest of a trio in those young days, was dying. Maurice Raynal, a critic who had begun writing during that increasingly remote time and had just finished Picasso's biography, and the sculptor Henri Laurens, another younger man, were the first to vanish.

And then on 3 November Marguerite Duthuit telephoned the news he had been dreading: Matisse had just died. Pablo did not take the message himself because, as far back as the death of Apollinaire, he found the telephone physically unbearable as a medium for transmitting news of a death in his group of friends. And in any case, words could not express his feelings at this definitive break in dialogue with his elder friend. Whenever he visited the Midi, he had gone to see Matisse at the Regina in Nice. And whenever visitors broached the subject of modern painting, he invariably remarked that "basically, there's just Matisse." Matisse was the only painter he recognized as a rival. Over the years the two of them had made a team of sorts—a *cordée*—as he had done with Braque. But the object with Matisse had been a secure grasp on the new territory seized and explored by painting rather than a scaling and conquering of previously unknown heights.

Françoise Gilot, whose generation was not concerned with the rejections and dismissals of their elders, reports a conversation between the two painters, probably around 1950. In a catalogue put out by his son Pierre's gallery in New York, Matisse saw some reproductions of Pollock, then highly abstract and informal. He remarked to Picasso that he felt incapable of pronouncing on that kind of painting "because one cannot very well judge what will follow us." Picasso felt vehemently opposed to such a permissive attitude, protesting that there was not and could not be such a thing as totally automatic painting, which was entirely an expression of the unconscious. He judged Pollock in the light of his own experience, an experience he clearly considered valid for future generations. That is why he felt such need of Matisse and so strongly admired the marvels he accomplished with his *papiers découpés* and why, too, he felt with each new work that Matisse was still Matisse, which is to say, incomparable.

Hélène Parmelin recalled a conversation between Picasso and Pignon which took place at some point after Matisse's death. They were discussing the increasingly frequent and widespread attacks against painting as done in France. They agreed that there were no longer any obstacles which might prevent a painter in Tokyo or New York or Rome

> from doing the same thing; and doing it either better or worse than a painter in Paris.
>
> "If someone makes a hole in a canvas in America," Picasso said, "that's no reason to pay for a French hole. . . . Art exists for everyone."
>
> "And that's what changes everything," Pignon replied. "No one could make a Cézanne or a van Gogh—or even a Gauguin—but those painters themselves."
>
> "No one could make a Matisse either," Picasso said. "No one but Matisse."

In 1953 Picasso showed me his lithographs of variations on Balzac's face.[1] He began talking about Matisse. Realizing that I didn't grasp the connection, he explained that when Matisse was working on a portrait, he did preliminary drawings "by heart": fifteen, twenty, however many were necessary to acquire the unique gesture with which to capture at a stroke the automatism of the line. "And at that point, it's a portrait, a portrait by Matisse." Picasso then propped his studies of Balzac in a row. "In my case, as you can see, what's going on is stronger than I am, always changing. I add, subtract, shift. . . . While Matisse allows the line to come of its own accord, to make itself, and remake the model." After that, whenever I told Picasso about exhibitions which included Matisse, he always asked first of all, "And were there any drawings?"

At the time I didn't understand how much of a revelation Matisse's drawings had been for Picasso in 1906, surprise and discovery which were comprised in Pablo's comment "Matisse left me his *odalisques*." As far

back as the women in *Bonheur de vivre,* well before *Nu bleu, souvenir de Biskra.* As always for Picasso, this legacy included conflict and was all the more valuable because of it. At Grands-Augustins he had begun to paint and draw Jacqueline again: full face *sur un fauteuil à bascule* (in a rocking chair), then in profile, and finally *à l'écharpe noir* (with a black shawl)—a close-up with the shawl enclosing the face, as he had done in 1906 with Fernande at Gosol.[2] Perhaps it occurred to him that he had done Françoise in *Femme-fleur* and in *la Joie de vivre* at Antibes as if to surpass what Matisse might have made of her.

Jacqueline, in the hunched position she affected, looked astonishingly like the woman holding the *narghile* (water pipe) on the right of Delacroix's *Femmes d'Alger* in the Louvre. During the summer of 1954 Picasso had done in pencil—almost mechanically—the figures from Manet's *Déjeuner sur l'herbe* and sketched a portrait of Delacroix. During that November the Algerian insurrection for independence began. Delacroix had painted his *Femmes d'Alger* immediately after the French conquest of Algeria, like a victor arrogating to himself the right to open up a seraglio. Picasso had always loved the sense of delivering secluded harem beauties to the gaze of the public, and Jacqueline was already his recluse, the woman undertaking to organize his life for his own retreat and reflection.

Sabartès writes, at that time:

> So that the woman he loved could integrate his circumstances and position, he took her with him wherever he went, especially during the short preparatory period for any project of domination, during what we might call his grand parade of conquest. . . . In her role as Woman, she could continue as long as she fit into the tableau which Picasso's imagination continued to organize. But if she penetrated his intimacy too directly, she would disturb the composition of his purely personal style of life. . . . One had to take care not to speak to him, not to make noise or bustle around him when his eye became fixed on what was often scarcely a breath of a thought.

Jacqueline by instinct was the anti-Françoise, who, when it was over, confided that the ten years she spent with Picasso, although "humanly" they were "hell," happened as they did "because [I] was young, and I thought that he was capable of evolving. That idea was part of an impossible, utopian dream." Jacqueline from the first accepted the Andalusian obsessed with his art, and Picasso found with her the calm he had lacked since Marie-Thérèse, this time linked to the intellectual companionship he had enjoyed with Dora and Françoise.

With *les Femmes d'Alger* Picasso began an unprecedented adventure.[3] Or perhaps, as suggested by Maurice Jadot, who first showed the painting, one should state more precisely that the starting point was Delacroix's picture as transmuted by Picasso's memory—a composite which drew on

both the 1834 version in the Louvre and that of 1849 at Montpellier. Up to this point he had drawn on the work of great predecessors or tested his own innovations of figuration against particular effects or techniques of theirs (as with Courbet, for instance, or Greco in 1949). This time, however—perhaps under the pressure of events, as in August 1944, with Poussin's *Bacchanale*—his relationship to a masterpiece of the past was a straightforward case of borrowing, of annexation. He treated Delacroix's image as if it were something imposed on his eye as an object would be or a landscape or a figure. And he set out to transform the image, to dissolve and recompose it, precisely as he did with the external world. This was not a case of turning away from that world. I don't think it is wrong to say that the death of Matisse left him with a sense of responsibility for continuing by himself the great painting of the masters. This obligation was their heritage.

And of course it was also, in some sort, a judgment on the work of their contemporaries. He was severe toward Léger, who he thought relied overmuch on facility and repetition; less so with Braque, who never stopped deepening his own particular furrow. Miró seemed, above all, in the abstract camp. For Picasso art moved between the poles of external inspiration and internal necessity (and/or vice versa): mutually antagonistic and essential. To place Delacroix at the first of these was to run unsuspected risks. He would tear Jacqueline from Delacroix as he had wrenched Françoise from Matisse.

In the first two pictures, Picasso kept only the right-hand section from Delacroix, stripping the torsos of a counterpart to Jacqueline and of the woman sitting beside the narghile and moving the serving girl to the background. Picasso sharpened the rhythms of the scene, accentuating them as if, with the intrusion of the harem's owner (in this case, the painter), he wished to disturb the serenity of this retired place. Although the serving girl appears to be in flight, the Jacqueline figure sits, half-asleep, her head resting on her folded arms. A second version simplifies and abridges the scene, with color restricted to variations of gray. A third version done three days later totally alters the design, reintroducing a third, hieratic woman to the center of the picture and massing the woman on the left with the horseshoe shape of the door. Above all it reorients the sleeping woman—now nude, with her legs in the air—putting her on the small polygon table borrowed from the Montpellier painting (from which, in turn, it was transported to the *Bain turc* and then to the *Demoiselles,* as already described).

"Picasso needed a day's grace," Jardot writes perceptively, "before proceeding from Delacroix's subject . . . to the woman sitting on the ground, watching over a sleeping figure." The fifth version, of 16 January, focuses the canvas on this watcher. Now, in the situation formerly occupied by Françoise meeting Dora (in lithographs of 1946) and—once in 1947—by Geneviève Laporte, there are two nude women who derive from Jacqueline. Furthermore, in the version of the 17th, the watching woman has Françoise's round head and breasts. The sleeping woman's head rests on the

Françoise figure's feet. A sequence of variations follows: gracious, tender, and fresh; others press geometrization to an extreme purity of plastic rhythms and contrasts. The final scenes—canvases of great strength painted in mid-February—consider these four women, first by pairing the sleeper-watcher couple with the subject as portrayed in version three and finally by returning the woman on the left to a state of autonomy. The violently geometrized space reflects the rhythms of subjects and objects. In the center the woman with raised arms derives from the *Demoiselles* and resembles Françoise. Transmutation has now been completed. The *Femmes d'Alger* have become Picasso women of dazzling erotism, vintage 1955.

The day before this final version was painted, Olga died in Cannes. Picasso left her burial to Paulo, who, with an inheritance from his mother, was now independent of his father. Furthermore, since Picasso began living with Jacqueline, Paulo's chauffeuring services had not been needed.

Following the creative tension of *Femmes d'Alger,* Picasso's engravings convey a sense of release. *Peintre sur la plage* (Painter on the Beach), for instance, and *Visiteurs divins dans l'atelier* (Divine Visitors in the Studio) are both marked by wit and humor.[4] For Picasso, however, the principal event of the spring was his first retrospective in Paris since 1932. The presentation this time was very different from that of the Milan and Rome shows. The exhibition as a whole, although it included *Guernica* and *Massacres en Corée,* had no underpinning of political engagement. The panels of *la Guerre et la Paix* (War and Peace) had been returned to Vallauris and replaced by *les Femmes d'Alger* (Women of Algiers)—a symbolic shift. Picasso felt that he was playing for high stakes, because his work was being presented across its entire range; and that whenever fashion deserted him, this was what would be judged on its own merits. He stripped himself naked, and although Fernande or Olga are only indirect presences, Marie-Thérèse and Dora and Françoise are all there as well as Mme Z.

Maurice Jardot had put the retrospective together with a maximum number of canvases representing strong points of achievement. The *Demoiselles* seems to have been virtually the only important absence. From the *Portrait de Gertrude Stein* through the Horta landscapes to the *Jeune Fille à la mandoline* of 1910 and the *Femme en chemise* of 1913; from the *Nature morte à la chaise cannée* to the abstract *Joueur de guitar* of 1916, *Trois femmes à la fontaine,* and *Trois Musiciens aux masques* (the titles of the day) and *la Danse*—no significant point of the trajectory was left unrepresented.

Despite detailed notices elucidating the works on display (with an extraordinary assiduity, Picasso read these through and amended them), the show seemed to bewilder a great many of its viewers. Arguments over Picasso's political orientation were still too recent, and the PCF as well as its adversaries felt caught in contradiction. Aragon kept his own counsel. The show as a whole seemed crushing and impossible to categorize, an eventuality which Maurice Jardot had foreseen in his concluding remarks:

"It is not impossible that Picasso's art—like that of Rimbaud—will prove to be unassimilable, and for a long time; that it is essentially unsuited to the conformism of a society or a period, whatever these might be."

Before the show closed there were some 128,000 visitors—a large number for that austere collection, as well as for the period. Furthermore, at the time no studies of Picasso's entire output were available in French. Cassou's book was unobtainable; Barr had never been translated. Raynal, Antonina Vallentin, Frank Elgar, and Roland Penrose were all published subsequently. Picasso's status as the most celebrated unsung hero of the mid-twentieth century explains the success of an imaginary confession concocted by the former Futurist Giovanni Papini in his *Livre noir*. Papini "reveals" that Picasso is actually thumbing his nose at the public. With some help from Franco's police, this nonsensical mystification was taken as gospel by various easily gulled simpletons and so-called experts.

Picasso—with Jacqueline—had already left for Provence. It was on that trip that they found their house—la Californie—in a residential quarter (also known as Californie) in Cannes. Although the house exuded pretension and an absence of style typical of "1900s eclectic," it had vast, high-ceilinged rooms which opened onto a handsome park with palm trees and views over Cannes bay. Unlike la Galloise, the place also provided privacy. When I went there in the summer, Picasso explained how he had Picassoized (no other word quite covers it) the house. He had emptied it out so that he could stack the packing cases and furniture from the rue la Boétie; the salon had become his studio, generating paintings and engravings, masks and sculptures in various stages of production. The last two categories, in their bronze versions, gradually invaded the park as well. Over the course of years I was to observe the accumulating strata of Picasso's creative ambience composing the landscape of his reflections. I was struck by his evident intention to settle in for a long stretch. Despite suggestions of variability and impermanence generated by Picasso's famous bric-a-brac, the place seemed much less of a temporary camp than la Galloise, or even Grands-Augustins. And as for Jacqueline, it was quickly evident that she was an accomplished and attentive mistress of the house, which in turn had its effect on Picasso.

He made no effort to conceal his appetite for work, and circumstance quickly provided opportunities to feed it. Some ink sent from the United States was able to penetrate paper without dribbling. This in turn enabled Picasso and Henri-Georges Clouzot to realize an old project: capturing the act of pictorial creation without the felt intrusion of a camera. After working out the structures of his composition in preliminary drawings, Picasso then set them directly onto whatever material he was using while the film recorded directly these acts of inscription and execution—the gestures and functioning of his painter's "hand" and the exchange between line and the thought which directed, considered, corrected, and revised.

Picasso made no changes in his methods of work except for bearing in

mind the necessity of coordinating the time needed to make a colored drawing with time available to the camera—a problem which in itself was a challenge to his virtuosity. He rose to that challenge for hours at a time in the stifling heat of the la Victorine studios in Nice, working to the point of near collapse from exhaustion.

The last part of the film catches "live" a failure by Picasso with composition in cinemascopic format of the beach at la Garoupe. Inks, after all, are used for drawing and cannot achieve the superpositions and transformations accessible to painting. The film cheated with actual time as well by omitting all the preliminaries and any recognition of rest periods, time devoted to restoring mental energy—the *cosa mentale*. Picasso could not be his own director, and Clouzot quite evidently had an inadequate sense of how creativity in painting actually functions. *Le Mystère Picasso* not only fails to capture that functioning, it also confuses and falsifies the issues. It is a dazzling documentary and intellectually a demagogic void, overlooking the modernity of Picasso's pictorial language at the very moment when the Cubist grid was gaining recognition among artists as an essential part of painting's basic grammar.

Abstract painters like Mondrian or Malevich, Arshile Gorky or Pollock passed through it, while Vieira da Silva, Hartung, Soulages, and de Staël (who killed himself in Antibes on 16 March) still looked to it for support. Dubuffet, Fautrier, Clavé, and Tapiés used the effects of *matière* from *papiers collés* and Synthetic Cubism; while Pop art—then in the process of birth—gave a second launching to assemblages and the use of scraps. "They've managed to grasp what Braque and I invented," Picasso told me with a jubilant grin as we looked through an American catalogue.

In the beginning of August, for *Lettres françaises,* he did one of his most brilliant drawings—*Don Quichotte et Sancho Pança*—to celebrate the four-hundredth anniversary of Cervantes' birth. While he was finishing the drawing, I waited in the park with Clouzot, who seemed quite impressed by his own importance. Picasso had decided that morning to show Clouzot that he (Picasso) was no actor, at Clouzot's beck and call. "My painting will go further than your film," he told Clouzot, in a somewhat irritated tone, showing the director that he could cool his heels a little longer while Picasso finished his business with me.

In due course I gathered the full flavor of this exchange when I found some canvases in cinematographic format: a collage still life and two canvases of *la Garoupe,* derivations from film which had become real paintings.[5]

Léger's sudden death at the end of August scarcely affected Picasso. They had been on bad terms. In painting and in the Communist party, Léger had felt blocked by Picasso and could not contain his outrage at what he felt to be an injustice. At the time of Léger's death, Picasso was doing—in cinematographic format—three handsome reclining nudes in luminous interiors[6] and two corridas, in which the bull dominates the space around

him. The drawings, in a specially constituted ink, were made into lithographs. He also began a portrait of Helena Rubinstein—one of his contemporaries—returning to the portrait in November.[7]

The summer had been agitated. The film and settling into la Californie had both produced numbers of visitors. Therefore, to whatever degree possible, Picasso was anxious to get back to work. He began in mid-September with six joyous etchings;[8] and on 4 October, a drawing of Jacqueline as *Lola de Valence*.[9] Taking over the new house was a major preoccupation. His exchange with Matisse, which included *les Femmes d'Alger*, was far from exhausted. The new studio included long windows whose rounded tops and divider strips suggested Moorish design, and Jacqueline was given a Turkish costume. Between late October 1955 and April 1956, Picasso was involved with *paysages intérieurs* (interior landscapes), as he called them.[10] He began by considering patches of shadow against the light, moving on to nuances of white marked by a minimum of indications, of lines and shapes of lightly applied color. Picasso had never before made such a deliberate effort to master the space, symbols, and compositional technique of Matisse, producing repeated confrontations between canvases of limpid color, which are virtually empty, with maximally abbreviated symbols—and their negatives, overflowing with baroque surcharge.

Jacqueline *au costume turc*, once again in the rocking chair, and finally as a simple presence in the studio test the powers of this style, which irradiates surrounding space with minimalist information.[11] Picasso said to me one day, "I thought so much about *Femmes d'Alger* that I found la Californie; that's always how it is with painting. And Delacroix had already met Jacqueline." Two large postscripts to *Femmes d'Alger*—*Femmes à la toilette* of 4 January and *Deux Femmes à la plage* of 16 February—join the geometrized Françoise of three years earlier.[12] In April Picasso abstracted a *Femme assise* and an *Homme couché*. And then, with even fewer *signes,* he did Jacqueline again: *Torse nu, pantalon bleu*—further geometrizations in a rocking chair beside a window.[13] At this point it was June. The summer would bring landscapes, children, and a *Femme nue dans le jardin*.[14] In March 1957 Picasso would show fifty canvases from this series at Kahnweiler's, an inaugural exhibition for the new gallery, rue de Monceau, a near neighbor to the rue la Boétie.

Le Centaure,[15] a large painted construction, had been a by-product of work on the Clouzot film. In September 1956 Picasso began a new sculpture project—*Les Baigneurs*[16]—which derives from paintings of the *Plage de la Garoupe*. Preliminary drawings and a painting were done with extreme simplification. Constructions made with odds and ends of wood from the studio produced nearly flat versions of shapes invented during the film and its immediate aftermath. Although each sculpture can be considered as an autonomous entity, *les Baigneurs* form a group, or, to use current terminology, a single "occupation of space."

And at this point, although work on these *Baigneurs* had just begun, Picasso's seventy-fifth birthday imposed a break. The occasion, celebrated at Vallauris, involved the PCF. The opening months of 1956 had been shaken by what was beginning to be known as de-Stalinization. Khrushchev had denounced Stalin's crimes at the twentieth Party Congress in February, but the PCF feigned ignorance of his speech, which they described as "attributed to Khrushchev" when it was made public by *le Monde* in June. Picasso had always found lies particularly difficult to stomach; now any question of substance to Thorez or to Casanova was invariably met by an evasion. Picasso told me of this with some irritation. "Whenever I say anything to either of them that is at all political, they just fob me off: 'Run along outside, now, and play with your nice hoop!' "

The French Party Congress in August ducked the brutal issues raised by the Hungarian revolution, unrest in Poland. In November there was the bloody Soviet intervention in Budapest. To the amazement of Thorez, Casanova, and Aragon, Picasso signed a letter—together with Edouard Pignon, Hélène Parmelin, and seven other intellectuals—to the Central Committee of the party. The letter stated that the tragedy then occurring in Budapest "poses for Communists burning issues that neither the Central Committee nor *Humanité* has helped to resolve." It requested the convocation of a special session.

There never was a special session, of course. Picasso's name gave the other signatories a measure of protection against party repression, but that was all. "Another case of 'run along and play,' " he told me, "while they concerned themselves with serious matters." But he didn't quit the party. "After all," he said, "there's no way of quitting one's family." Then, after a pause, he added, "You remember, I once told you: they might make mistakes about painting. That's not their specialty. But at the time I was hoping they were right about politics . . ."

He didn't finish this remark, but he didn't need to. He knew by then that in politics they were just as wrong as in painting. And that he, perhaps, had been wrong to think that the two could be separated. Painting for him had always provided revelation.

For Picasso membership in the Communist party was a "family affair" in the sense that one does not discuss family problems with the outside world—an attitude which sometimes produced considerable misunderstanding. Visitors from "outside" were often subjected to inexplicable bursts of anger. To the extent that Picasso felt uncomfortable or uneasy, these outbursts were all the more ferocious (or unjust) and would have a consequence which no one anticipated. Picasso and Aragon did not meet between 1956 and September 1972, when I organized a reunion. Picasso said to me, "We [he and Aragon] haven't seen each other since 1953." This was not a slip of his memory. He meant by that extra three years that they had not met since Aragon's self-criticism at the time of the *Portrait de Staline*.

La Californie continued to burst with life and visitors. Simone Signoret

and Yves Montand came and talked of Hungary and their visit to the USSR. The bullfighter Luis-Miguel Dominguín came with his beautiful wife, the actress Lucia Bose. Cocteau came and Prévert and Gary Cooper, with his family, bringing Picasso a cowboy hat. Vidal Ventosa, an old friend from Barcelona, had introduced Pablo the year before to the Gaspars, young Catalan dealers. And they in turn had just mounted in Barcelona the first exhibition of recent Picasso paintings since the civil war. The exhibition was given official sanction. Before this, publication of Picasso's name had been strictly forbidden.

A page had truly been turned.

34

AGAIN INTO THE UNKNOWN

1957–1958

S ince his major period of ceramics, Picasso's sculptural inventiveness had been flourishing. Between 1951 and 1953 he produced a large number of small plaster models. These convey an extraordinary spontaneity, seeming in some instances almost like play or perhaps an escape from private difficulties. Which is certainly the case with a dazzling set of dolls for Paloma, painted onto scraps of wood whose accidental shapes are preserved. There are also some masterpieces, like the graceful assemblage *la Liseuse* (Woman Reading), of plaster, wood, nails, and screws. The painted bronze version, although cast in May 1952, seems curiously anticipatory of Jacqueline.[1] *La Taulière* (The Madam) bridges the years between 1954, when the work was conceived, and 1957, when it was cast. The preliminary drawings still exist, as well as Edward Quinn's photographs of its various stages of construction, during May 1954, when Picasso's working period with Sylvette was at its height. At the beginning the various constituent elements were laid separately on the ground. The sculpture, which achieves a quality of extraordinary monumentality, preserves from these constituents a sense of rhythm, of gaps—even chasms—between the parts, a *gueule* (gaping hole) which produced the work's studio nickname: "A real bordello madam," Picasso explained, laughing.[2]

As for Sylvette, she had been the precipitating element for an unprecedented breakthrough. Inspired by her profile, Picasso cut a piece of sheet metal, which he then folded and painted. The result was a sculpture which although any breadth or cubic substance was a contrivance of folds in space,[3] nonetheless gave a viewer two profiles to consider as he walked around the piece, offering a different perspective at every angle.

On one occasion, some fifteen years later, in the inner studio at Notre-Dame-de-Vie, where paintings were stacked, Picasso tried to hold upright so that I could photograph it a little seascape of 1900. He had just rediscovered the picture, painted on a piece of pasteboard, one of whose corners was crumbling. When we were done, Picasso contemplated the profile of Jacqueline *découpée* on a piece of sheet metal which he had been using as a prop. Or, more precisely, he contemplated the profiles, projected as

perpendiculars so that from some angles they could be seen as a multiple entity, from others, individually, while still others emphasize the rippled rhythms—*découpés*—of wavy hair. What had been with Sylvette a matter of folding and continuity was here sharply dissociated by projections, as was done with the painted profiles of Fanny Tellier in 1910. In the more recent work, however, the parts can all be linked, and the re-created face, if one observes the work in the round, is arrived at differently. There are four of these pieces, done at la Californie in the middle of 1957. All are painted: three in metal, one in wood.[4]

Picasso pointed out the vertical axes of the most abstract pieces—or perhaps one should say, the most simplified.

> In the studio at la Californie, I lit these *découpé* heads very brightly and tried to catch them in my painting. I did the same thing with *Les Baigneurs*. First I painted them, then I sculpted them; and finally I put the sculptures onto canvas. Between painting and sculpture, the subject was pretty thoroughly discussed.

The discussion began, in fact, at Vallauris with *Crâne de chèvre, Bouteille, et Bougie* (Goat Skull, Bottle, and Candle);[5] but the novelty at la Californie lay in Picasso's use of these new sculptures—whose construction precluded further reduction—as a point of departure for painting. It seems fitting that having derived from painting, these sculptures in turn translate painting into three dimensions—a move which was also a challenge unlike anything Picasso had ever attempted. Once again he was using a subject taken from art, but no longer, as in his recent borrowings from Delacroix and Matisse, a subject launched by predecessors. This time he was looking into his own work in order to tap its store of hidden or unsuspected possibilities.

Because for Picasso exploration of the unknown remained the gist of the problem. He had mastered techniques enabling him to rediscover Poussin's ideal, to liberate Ingres' bathers from the harem, to reach beyond Cézanne. So why should he not undertake to reach beyond himself? To surpass his own previous limits? He could do this only by using as point of departure the extreme limit of his own achievement in art. Pierre de Champris reports that one day someone remarked in the presence of Braque: "There is nothing Picasso refuses to do; he speaks every language. What talent! What vice!" "But he's troubled by it," Braque retorted. "And that's what saves him." Braque himself, of course, had refused to "do Picassos," with all the implications of vassalage that would inevitably have implied. He was closed to those things which constituted the dazzling aspects of Picasso's life as a painter: the special power of his painting.

Between the war in Spain, and what it meant for him, and the end of the war with Hitler, it was probably necessary for Picasso to measure his painting against the tragedy engulfing the world. As an artist, between 1945

and *la Guerre et la Paix* he can be seen to hesitate between fresh inventive-
ness and recapitulations of what he had already mastered so that his art
could be placed at the service of his political ideals. In the middle years of
the 1950s, France finally emerged from the postwar period; and one might
say that Picasso did, too. This meant that painting no longer needed an
external model, as it had at the time of *Guernica*. Picasso had made his own
tour of inner being and had done it again during his season in hell after
Françoise left. It seemed time for painting to be its own subject. Most of his
sculptures, after all, had been engendered by his paintings.

As far back as the *Demoiselles* his primitivist sculptures had provided
models; but at that time questions at hand had been more about methods
of controlling the powers of painting and testing figurative leaps forward
into the unknown. This had also been the case with Fernande's broken head
in 1909, the dialogues with the free-form *Guitare,* and the development of
papiers collés in 1912, and again with the Grebo-Wobé mask. This time the
objective was different. When he lined up his sculptures at night in the
studio at la Californie to receive the beamed light of projectors (sometimes
these were intersecting beams), he had preconceived notions of what that
light would help him find. He felt that he could appeal to the light, as it
were, to reveal things he had put into his sculpture *without conscious intent
or knowledge.* And he relied on the power of his painting to extract them.
But it is clear that from this moment on, Picasso could no longer engage in
dialogue with his predecessors as he had previously done. He was far less
assured of his powers now than he had been when he brought the *Bain turc*
out onto the beach at Biarritz or even when he jolted *les Femmes d'Alger*.
In confrontation with Velasquez or Manet, he would no longer attempt to
stress those things about the future of painting which they could not have
known. He would focus instead on those things about their art which he
himself did not fully understand. His object was to penetrate their mystery,
and in so doing, to penetrate his own.

For Picasso to think, however, that by turning to the masters he would
find some sort of safety or shelter was clearly an absurdity. On the contrary,
he was exposing himself to a real possibility of failure, a consideration
which did not in the least deflect his purpose. A portrait of Jacqueline in
colored chalks of 25 January combines profiles which have been dissociated
and *découpés*. And on 18 February he used colored wrapping paper to
produce a head and shoulders which is a masterpiece of tenderness.[6]

There was a gap of nearly three years between the metal cutouts of
Jacqueline and their arrival in Picasso's painting, a process which was not
fully completed until Mougins and the creation of new sculptures. *Les
Baigneurs* produced a similar pattern, requiring two years of reflection after
the film with Clouzot before reappearing as a vertical canvas in the summer
of 1957. And this is not the last example of the kind but rather another
instance of Picasso's need for reflection on his own work. It also illustrates
the intensity of intellectual effort which preceded (and authorized) his

rapidity of execution. Jacqueline understood these needs. She also had a firm grasp of the best conditions for their fulfillment and the best way to realize those conditions.

The summer produced lithographs: *Jacqueline de profil* and a full face of Kahnweiler.[7] This was a period of anticipation, which quite suddenly resulted in one of the most exhaustive explorations of painting by painting: Picasso's dialogue with Velasquez's masterpiece *The Maids of Honor (Las Meninas)*.[8] He launched the project at a moment of acute awareness of the tension between painting and sculpture, a factor which is surely far from insignificant. To work it out he abandoned his studio in the drawing room (where he kept his profiles and the painting of *les Baigneurs*), establishing a new workplace in the attics, previously left to the pigeons. Here he would grapple in solitude with Velasquez for over four months—from 17 August to 30 December—without interruption except for a sequence of exterior views around his new domicile: the sea and the isles de Lérins, which fits his usual pattern of attempting to master a new environment. There was also an isolated painting—*Joueuse de piano* (Woman Playing the Piano). But the breaks for these required only two days in September and one in October.

Picasso gave Roland Penrose an analysis of *Las Meninas*.

> Look at them and try to see where each of these characters is actually located in relation to the others. Velasquez is in the picture, although he shouldn't be; he's got his back turned to the Infanta, who at first glance one might think was the subject. He is facing the big canvas on which he seems to be working; but we can only see the back of it; we have no idea what he's painting. The only solution to this is that he's painting the King and Queen, of whom we can see a reflection on the big mirror at the back of the room. Therefore, Velasquez cannot actually be painting the Meninas, who are gathered around the artist not to pose but to look at the portrait of the King and Queen. And—like the King and Queen—we are behind them.

There could be no better way of illustrating Picasso's ability actually to inhabit the room in which Velasquez was working or the degree to which he immersed himself in his predecessor's project. With *les Femmes d'Alger* he had not been able in the same way to put himself in Delacroix's position. He had understood that he lacked the emotion which must have constricted the throat of that romantic and timid young man as he penetrated the harem, as he virtually, in fact, broke into it. Therefore, he had rendered that picture in the present. But with *las Meninas* Picasso was in the court of Philip IV, in the golden age of his country. Therefore, initially, he used humor to establish a certain distance.

In the canvas of 17 August—the first of the series—Velasquez is so big that he reaches the ceiling. The ridiculous silhouette of the king in the

mirror, the grotesque stylization of the two duennas beside the open windows to the right, the caricature of the dwarf, and the noble dog, who is turned into Lump, la Californie's resident basset—all of these emphasize the artist's derision. If Velasquez treated the king's apartments in a somewhat free and easy manner, Picasso displays downright irreverence.

His examination quickly centers on the Infanta Margarita and her relationship to the two maids of honor, as if to give a nudge to Velasquez by focusing on the subject he had avoided. Then parody suddenly vanishes. Although later—between 24 October and resumption of work on 8 November—there will be a return to ironic distance, the subject of the Infanta leads to painting which is serious and sometimes even tragic. In the final canvases of the series, the Infanta and her maids of honor, all jumbled together, seem to suggest one final flourish before quitting the stage forever, like the poor actor in Shakespeare.

The spontaneity of this journal in fifty-eight canvases is striking. It contains the entire range of recent figurations but without any premeditated recapitulation. On the contrary, these appear to be products of impulse, with digressions in which at times Velasquez vanishes—but never for long. Picasso had truly appropriated for himself *las Meninas,* which in his view was one of the highest summits of painting, and one on which he had trained his sights ever since the age of fourteen or thereabouts. He had also proved that however far his own painting might be from that of Velasquez, he could nonetheless re-create the complex relationships his great predecessor had maintained with his subject, with his world, and with his canvas as it developed. He began by being against Velasquez, a counter-Velasquez. Then, in a maximally Picassolike fashion, he identified with him, by painting pictures which hold their own when compared to *las Meninas.* This, perhaps, explains the secrecy in which he kept the enterprise (except with Jacqueline). He didn't show any of it to Pignon or Michel Leiris until the whole set was done.

During the closing years of the 1950s, when Abstract Expressionism was beginning to be contested in the United States (where, in 1953, Rauschenberg erased a de Kooning drawing) and when breaking with the art of the past was emphasized everywhere as desirable and even essential, Picasso's attitude was most unusual. One cannot claim that he was swimming against the current, because there was nothing as definite as a current, but his attitude certainly reflected his total independence of spirit. As he had done between 1914 and 1923 and again more sporadically after 1944, he was reaffirming his links to great Classic works. He no longer presented himself as a rival, as he had done with Ingres or Matisse or Delacroix. Instead he invited himself onto Velasquez's terrain and invited Velasquez to his. One can measure the audacity of this undertaking now, when so many young painters (an entire section of the 1984 Biennale in Venice, for example) have reverted for shelter to painting of the past, even to paintings by Picasso. He undoubtedly considered the proceedings then in train against all figuration

(which would be enlarged to become a trial of paintings in general and then of the actual process of painting) as signs of an approaching reaction, of a new return to order, whose academism he hoped to destroy in advance.

In the course of work on *les Ménines,* Picasso received the first official commission of his life: the decoration of UNESCO's headquarters, then being built in Paris. His acceptance of this commission was reflected by a return to the *Baigneurs* sequence, which clearly continued to haunt him. A gouache from 6 December gives a view of the studio with a canvas on the right—the initial version of the *Baigneurs*—occupying about half the space. On the left a female nude seems to be leaving a canvas propped on the easel to stretch out in the armchair.[9]

Picasso clearly wishes to push as far as it can go the dialogue between painting and sculpture on which he has been working since Sylvette. With this in mind, he proceeds next to a consideration of Courbet's *l'Atelier* (The Studio). The model, to be sure, has vanished. But Picasso assigns to the canvas of *les Baigneurs* the function of opening a window onto the outer world, onto a beach—the same role Courbet gives in *l'Atelier* to the landscape on the easel. In the first two sketchbooks Picasso abstracts the nude, then returns it to organic form before removing it from the easel while bestowing sensuality and presence. Suddenly, on the right, an immense painter appears, reaching all the way to the ceiling, like Velasquez, on his arrival at Picasso's. The nude fills the space around her with voluptuous abandon, but the canvas of *les Baigneurs* disputes her supremacy. On 7 January the painter is replaced by a pot of flowers, and then, from behind, fills the empty canvas with his shadow.

Work was interrupted until 18 January. In the next phase the studio has vanished. The game is now between the nude woman, who has left the easel to become a bather taking the sun, and the various transformations in the group of bathers. The bather with outstretched arms has acquired a certain degree of roundness. And the child's round head is fused with the painter, the vertical witness of the scene, who also looks at us as we stand beside Picasso. (Another link with the explorations of *las Meninas*. But the heart of the spectacle is occupied by a figure plunging from the heavens: Icarus into the Garoupe!)

None of the others, absorbed by a sense of bodily well-being, have noticed. Only the painter is aware of what is happening. And painting is the only witness. Picasso has turned a commission to celebrate an institution into a ringing declaration of painting's true mission and of his sense that this mission is all that counts.

Picasso was confronted with a trapezoidal space, which, the architects noted, should be "decorated." (On the evidence, it looks as if these gentlemen hadn't resolved the problem of suitable treatment or perhaps couldn't.) In addition, Picasso had to work with maquettes which were too small. A record survives of this project in its early stages, its developing organization as Picasso pinned precut shapes onto a maquette of the whole to establish

their spatial relationships. He had eliminated all accessory material in order to focus the composition entirely on the single contrast between the kinetic quality of the falling figure and the immobility of the bathers. The figuration which he retained is also aimed at a maximum of simplification, hence of abstraction. The abbreviation of ideograms is done, like the reconstructions, with the greatest possible audacity. Picasso stakes everything on these oppositions and on the geometry of the whole and of an Icarus whose aleatory shapes, highly distended by his fall, suggest a free version of the "automatic" drawings of bathers and acrobats of 1928–33.

Picasso surely did not seek out, for this first public commission, those qualities in his work which had been least understood, were the least assimilable. I think he was moved by the thought of putting into the work all that he could; everything he was capable of; all that he had taught himself about his art. The supreme lesson and fundamental subject (perhaps unconscious) derive squarely from the Icarus myth: a father's experience cannot be transmitted. Or if something of that experience is passed on, that will happen in a future which the painter—then in his seventy-seventh year—will probably never see.

If one compares la Chute d'Icare (The Fall of Icarus) with the panels of la Guerre et la paix, one can appreciate the extent to which in four years Picasso shook off a certain ideological intoxication. Certainly, as he explained to the American art critic Carlton Lake (who in 1964 collaborated with Françoise Gilot on her memoirs), Communism still represented for him an ideal in which he believed. But la Chute d'Icare marked a stage in the remastery of self, which was also the case with those other trial works— the Casagemas suicide cycle, the Demoiselles, the Arlequin of 1915, la Danse, and la Crucifixion. This person plunging without nets into a void is far more of a metaphor for Picasso than the straightforward Icarus who is generally perceived. And this perhaps explains his completion—almost immediately after Icarus—of the semicircular panel with which to close off the chapel of la Guerre et la Paix. It is a proof of political fidelity, soon to be highlighted by events themselves.

For the moment, however, Picasso unwound with some grotesque heads, which he pretended were based on Max Jacob or on the young Spanish painter Ortega (who had just come to see him on behalf of the clandestine Communist party of Spain). For the trapezoidal space of the commission, he had done a monumental Nu cueillant des fleurs (Nude Gathering Flowers). He now began a large landscape, la Baie de Cannes (Cannes Bay).[10]

At just this point, the army revolt, which resulted in the assumption of power by General de Gaulle, broke out in Algeria. Public order seemed to be crumbling, and the Left—including the PCF—denounced the possibility of a Fascist regime. Picasso expressed his anxiety by a return of the bull's head, with brutal reds and patches of impasto violating the texture of the paint. He worked on the picture between 28 and 31 May and then again

from 7 to 9 June—both periods of intense political tension.[11] On the same 9 June he completed *la Baie de Cannes.*

Citing the dubious character of the chapel's claims to recognition, the prefect of the new government forbade any inaugural ceremony, a move which smacked of political persecution. In another piece of bad news, the hill overlooking la Californie was bought by developers of high-rise apartments: the villa could soon be surrounded by towers. Picasso said good-bye to the place, returning through painting to *paysages interieurs:* night scenes of baroque rhythm and hot landscapes under a summer sun. He produced another *Arlésienne,* as in 1912; but this time, which should surprise no one, it has Jacqueline's face. He then worked out a second version—a month and a half of daily labor to refine and perfect detail.[12]

Picasso was not in a good mood. There had been too much talk about him that summer; when he went to the beach, people stared. "I'm one of the public monuments of the Côte d'Azur," he shouted to me on the telephone. He felt anxious and undoubtedly displeased with what he had done for UNESCO. And they were not allowing him to supervise its execution. He also told me that he refused to invite Elsa Triolet and Aragon, who were accompanied by Elsa's elder sister, Lili Brik, and her husband. They must have made him feel like a Communist monument. He hoped that I would smooth things over somehow when they all got back to Paris. But he could not forgive "the Aragons" for having taken Françoise's part, and pretty vociferously at that. As already noted, he didn't see Aragon again until the summer of 1972.

In September 1958 *la Chute d'Icare* was installed in the great hall leading into the UNESCO conference chamber. A badly placed gangplank and insufficient room to draw back far enough made it impossible to see the whole work. There was also an official title: *les Forces de la vie et de l'esprit triomphant du mal* (The Powers of Life and Spirit Triumphing over Evil), of exactly the same idiotic character as the title I had refused for the *Portrait de Staline*—only worse. In spite of this academization and damage from poor architectural treatment, the spectator finds an Icarus-Picasso dissolving literally on top of him. A better understanding of the work can be obtained from the book on the subject published by Gaëtan Picon in 1971.

Picasso refused any birthday celebrations for 1958. After *l'Arlésienne* he stopped painting and vanished abruptly with Jacqueline. When he reappeared, he informed Kahnweiler that he had "bought the Sainte-Victoire." "Which one?" Kahnweiler asked, unaware of any Cézanne on the market. "The real one!" Picasso was crowing with pleasure. He had, in fact, just bought the Château de Vauvenargues, whose grounds include the famous mountain. While waiting to move in, he did some engravings, with new and handsome portraits of Jacqueline: *Jacqueline lisant, Jacqueline de profil à droite; Femme au corsage à fleurs* (Jacqueline Reading; Jacqueline, Right Profile; Woman with Flowered Blouse). On 12 January 1959 she appears with a black handkerchief and a Cretan rigor of profile; on 10 March, as

a horsewoman with a plume, after the fashion of Velasquez. Picasso felt happy with Jacqueline. He had never before enjoyed such a long cloudless period with any woman sharing his life.[13]

That autumn, *les Baigneurs,* cast in bronze, were exhibited at the Louise Leiris gallery. Picasso was delighted by this transmutation of the most ordinary materials—wood from a packing case, scraps of automobile chassis, and the like—into noble sculpture. No one saw the connection with *la Chute d'Icare.* And it wasn't until early 1959, when they were shown in New York, that *les Baigneurs* began to be understood in all their originality and novelty.

A full progeny of assemblages was not revealed until much later—like the *Grand Taureau* given by Jacqueline to the Museum of Modern Art in 1983. The most cruel and terroristic of these were done on 8, 9, and 10 June: *Homme au javelot,* a character whose hands end in forks; and, above all, a *Tête* made of a packing case, three fragments of wood, some plaster, and two trouser buttons.[14] These assemblages of rejects can create the impression of shrieking or howling by the work itself and by the materials from which it is made. Picasso put this capacity to good use, but the resulting works remained unknown until after his death and the 1979 exhibition of "Oeuvres reçues en paiement des droits de succession" (Works Received in Payment of Inheritance Taxes).

FROM VAUVENARGUES TO MOUGINS
BY WAY OF MANET

1959–1962

The fact that Mourlot lived in Paris—a considerable and inconvenient distance—had posed one of the principal obstacles to making lithographs in the Cote d'Azur. Then a young printer in Vallauris was found—Arnera—who used linogravure for posters. Picasso was delighted and made some posters especially for Arnera to print: an announcement of the annual pottery show and then the corrida of 1956. During the winter of 1958, he did his first linocut in the strict sense of the word, *Buste de femme d'après Cranach le Jeune,* an exercise of extreme technical virtuosity with six states, each of a different color. Picasso multiplied the possibilities of the process so that he could study the unexpected effects of these combinations of color.[1]

Picasso first stayed at Vauvenargues in midwinter 1959, replying to Kahnweiler's warnings about the dreariness of the place at that time of year with a simple declaration: "I'm Spanish." (There is, in fact, something of the Escorial about the place.) On 12 February Picasso began to paint the seat and back of a chair. In canvases from the new estate two months later, "one still finds some elements of that chair," Jardot notes, "the yellow, and red, and bottle-green; and the free and forthright brushwork, . . . an evocation of [his] internal Spain: ardent, grave, simple, and frank."[2]

No trace of Cézanne here. On 18 February, back at la Californie, Picasso painted the château's enormous buffet and Perro, his Dalmatian dog.[3] Jacqueline became the queen of Vauvenargues, so much so that Picasso would call a portrait of 20 April *Jacqueline de Vauvenargues.* Still at la Californie, he began another château buffet, even more monumental than the first, with a child and a bust.[4] On his next stay at Vauvenargues, he gave the picture a profound reworking with Ripolin, allowing the paint to run and dribble freely, producing the unforeseeable effects of hazard.

He could scarcely be unaware of the extension given to effects of substance and texture by younger artists like Dubuffet and Soulages. He himself, after all, in the beginning of 1912 had been the first to use Ripolin to create contrasts of color, which because they were lacquered were all the more dazzling against the earthy tonalities of Analytical Cubism. During

the Surrealist period, he had used impasto and incisions to demonstrate the resistance of substance and texture to the will of the artist and to create effects of chance which could not be anticipated—automatic drawing, in search of an unconscious expression. But his present efforts were another matter. What he wished to establish with the drippings and dribblings of paint—as he had already tried to do with ceramics and the accidents of engraving—was the independent, autonomous essence of substance, of texture. And in this case, with color, to let the painting "make itself." In this effort he integrated Pollock's "dripping," the splashings and spatterings of the Abstract Expressionists, and the "whiplash" brushwork of the gestural painters. Unlike most of these, however, he yielded only to reassert tighter control. In short, he studied the aims and techniques of his successors just long enough to show that he understood what they were up to rather better than they understood it themselves. He was also making the statement, as he approached his eightieth year, that he conceded nothing to age, that there would be no slackening of pace.[5]

At Vauvenargues he was once again caught up in Spain. As Jardot stresses: "The tone, timbre, and thrust of voice in Picasso's work are without equal. There is nothing, anywhere else, quite like this profound chant, this *cante jondo,* which is inspired but tempered, ample, and vigorous." Between 10 and 30 April he began twenty-one canvases, of which sixteen were eventually completed. In *Femme attablée* (Woman at Table) "puddles" of Ripolin obscure all traces of the brush, giving the female profile a brisk, trenchant line, and the jug, a sharp, almost brutal edge.

Mandoline, cruche, et Flacon (Mandoline, Jug, and Flask), done on the 13th, has firm, decisive, brushwork and thick paint. Braque's nail—from the still lifes of 1909—is brought back in giant size. (One of the 1909 paintings had already put jug and violin in a state of confrontation.) *Mandoline, Cruche, et Verre* effects a complete change of style, irradiating shapes and objects with parallel waves, which are sometimes scored with a chisel. The effects of Ripolin are very subtle here—a shimmering in suggestions of blue, a softness in the whites.

At this point—after a breathtaking *el Bobo* (derived from Murillo), a piece of stentorian hilarity—there is a sequence of paintings of Jacqueline. These combine rapidity and agility with the discreet simplifications of swiftly covered canvases, with large white surfaces and contrasts between sharp delineation and blurred fluidity. The four portraits of 17 April, Jacqueline in profile between the 16th and 20th, and on the 20th *Jacqueline à la mantille sur fond rouge* (Jacqueline with Mantilla against Red Background) are all successful. The sequence culminates in *Jacqueline de Vauvenargues,* with hair marked by parallel grooves scratched in the impasto by the handle of a brush.[6]

The final days of this April visit produced three landscapes of the village against its mountain. These Picassos from Vauvenargues are done with a constructivism entirely his own, which has no flavor of Cézanne. A

stay in June produced a *Nature morte à la dame-jeanne* (Still Life with Demijohn) and a monumental *Nu accroupi* (Crouching Nude), whose reduction to essentials has unsurpassed power.

The monument to Apollinaire, at Saint-Germain-des-Prés, was finally installed: It was one of the two bronze castings by Valsuani of the 1941 monumental head of Dora. As usual, the assiduous purveyors of gossip misunderstood the complexity of Picasso's motives. Saint-Germain-des-Prés had been par excellence the setting of his affair with Dora. Therefore, he thought, why not use the site and the opportunity it offered to honor his friend Apollinaire by honoring Dora as well? He felt that he owed her a great deal; any retrospective jealousy on the part of subsequent lovers seemed to him equally incomprehensible and revolting. And he was certainly not prepared to censor entire segments of his work.

During an August visit to Vauvenargues, Picasso launched an exploration of Manet, using as points of departure both the *Déjeuner sur l'herbe* and the *Vieux Musicien*. As we have already noted, the exhibition of this latter work at the Salon d'Automne of 1905 had influenced the reworking of *Famille de saltimbanques*. It is quite correct, therefore, to regard this new investigation of Manet as part of a broad consideration of that artist.[7] Divided between some ten periods of work—from August 1959 through December 1961—and the three studios of Vauvenargues, la Californie, and a new house (the *mas* de Mougins), Picasso's reflections on Manet were nourished and enriched by the various experiences of his life during that time.

At the outset Picasso invited Manet to join him. The bather at the back of *Déjeuner* became as well a derivation of the nude leaning forward to wash her feet in Picasso drawings of summer 1944. Manet's mistress, Victorine Meurend, plays a double role of model and intrusively anomalous woman; while the painter-figure suggests Picasso, about to replace the bather with 1961 figures cut in metal plate. From the first colored drawings of August 1959, and even more emphatically, the first oil paintings of August 1960, the strong presence of green is striking. Life at Vauvenargues seems to have restored this range of color to a palette attuned to dry, Mediterranean landscapes. (The greens of *Déjeuner* also, perhaps, contributed to the process. As far back as 1907–8—before Picasso's stay at la Rue-des-Bois—the foliage of his imaginary forests with bathers was reminiscent of Manet's.)

Over a period of two years one can observe a continuity of concern with Manet, works which either derive from or return to objectives and achievements of that painter. The situation of the four figures in *Déjeuner* is in its way as ambiguous as that of the *Ménines*. Picasso used painting here for clear declarations of things which Manet deliberately blurred, and he broached the grand question of relationships between figures and background. The most important of these paintings—in both dimension and complexity—was begun on 3 March 1960 and completed in July. The

figures are immersed in the overall texture of the painting; the signs which localize them are scarcely discernible in the intermingled festoonings of rhythms, arcs, and curves.

Picasso returned to this subject in 1961 with drawings in colored chalk, which, like negatives, set the signs against white backgrounds. Foliage is reduced to two green strokes and overflowings of green onto the nude woman and the man who is speaking. Water becomes a simple spot. By the end of the series, Picasso has eliminated virtually every constituent of his subject.

In the interval he can be observed in pursuit of associated ideas. The woman washing her feet leads to a revival of Bathsheba, who will reappear once again in 1960 in a piece of remodeling reminiscent of Henry Moore. The resemblance becomes even stronger in *Baigneuse et pelle à sable* (Bather with Shovel), a beach scene done at Vauvenargues, in which simplifications of *Nu accroupi*[8] produce discontinuous forms, each isolated from the next.

Immediately following his rudely shattered Bathsheba, Picasso returned to the subject of Jacqueline, observing her first with a view to profiles cut in metal plate and then as derived from them. This process can be inferred in the portraits of 13 and 14 February 1961, while the two profiles of 19 January loudly proclaim it. In March and April and again in July he returned to these concerns, allowing the process of painting itself full liberty. In November the profiles began to oppose each other, as it were, and then—language becomes inadequate here—to collide, to crash. By December he was using elisions and suppressions suggested by projectors, achieving in the three paintings of the 21st separations and syntheses never before realized.[9]

Picasso returned at this point to découpages and foldings of sheet metal, working at almost demented speed. Production of his *femmes de fer* (iron women), as he called them, not without pride, proceeded at its own pace, with monumental stylizations of unprecedented boldness, which employ patternless perforations to create an effect of latticework, with holes, incisions, and transparencies.

The three versions of the *Femme au chapeau* (Woman in a Hat)—at first simply a variety of foldings, to be painted later at Mougins—project in space the remodelings of Bathsheba and canvases which derive from the first profiles. The first painting was done on New Year's day, to be followed by two more on 27 January, and six variations between 28 January and 11 February. Picasso brought this set of experiments to an end in May 1962 with the discovery that profile cutouts, simplified and displaced by projection, might suggest (for instance) a molded chair leg. This not only recreates a central axis but permits a return to the transmutations he practiced in his assemblages of 1913–15.[10]

As he advanced in age and artistry, Picasso seems to have prolonged these periods of exploration, sometimes combining them with others (as,

for example, in his discussion with Manet) but never forgetting what was still in the studio or being shifted to Mougins. Picasso was now dedicating himself to his work as never before; the depth of these series and their sheer number prove it. There are, for example, some fifty découpages between the end of 1960 and 1962—at first in paper, then in metal. These include a Spanish woman in profile; birds; a chair; football players; a man with a sheep; a woman and infant; a Pierrot; masks; and a *Terrine: pigeon aux petits pois* (Baking Dish: Pigeon with Peas) dated 8 March 1961.[11]

During this period Picasso also resumed linocuts with a Mediterranean effusion of bacchanalias, centaurs, and fauns, dances of the possessed, and corridas without mercy. A witty sequence of drypoints begins with *Sabartès, Trois Femmes nues et Oiseaux.* This is followed by *Sabartès en toréador et Femme espagnole.* He engraved the series *Après la pique (After the Stab).* "One must kill one's self a little every day," Picasso told me, pointing his chisel at his guts, like a sword.[12]

He turned next to linocuts via painting, using the large painting *Sous la lampe* (Under the Lamp) as his source. In this work, as intimate as a La Tour, gentle and free, there is a sense of tenderness for the illuminated woman, although large areas of paint are laid down at breakneck speed. At eighty, despite his strength and health, Picasso felt increasingly pressed in his effort to say everything. Beneath this free and sweeping attack, however, closer observation reveals a fine architecture of white on white. When Picasso saw that I had caught the point, he brought out a small painting of *Colombe,* done two months earlier, in which he had obtained the same effect with grays. These, like the whites of the bird, melt into surrounding space. Trickles of paint mark the white support which signifies the ground at the bottom of the picture. "You see," Picasso said, "it's not the subject—it's the white that interests me."[13]

On 25 October 1961—because it was his eightieth birthday and because on some occasions celebrations are inescapable—he submitted to ceremonies at Vallauris which included a speech by the Communist leader Jacques Duclos. He had married Jacqueline in March, at the same town-hall; and in June, when Jacqueline convinced him he should not spend the whole year at Vauvenargues, he set up house at Mougins.[14] All of these transitions were accomplished smoothly, as Jacqueline in such matters was deft and organized. Picasso painted a celebratory portrait—*dans un fauteuil* (in an armchair)—beginning on 13 December and finishing in January 1962. A second portrait, known as *assise dans un fauteuil* (seated in an armchair) to distinguish it from the first, was started on 20 January and finished in July. The first of these is sumptuously decorative: fragments of painting in a splendid ensemble. Picasso has returned here to his Vauvenargues experiments with Ripolin, giving a rhythmic quality to the long white hairs of Kaboul, the Afghan hound, or carving a hollow space under a tree, like Manet in *Déjeuner.*[15]

Picasso had just embellished two nudes with Jacqueline's expression

and Kaboul's long-muzzled face. He followed these by his most tender portrait of Jacqueline—a portrait of serious youth. This is impregnation with a look, and resistance to impregnation—the only moments that count being the moments of painting themselves. Another serious young girl— *Jacqueline au chapeau rose*—appears on 20 January. Picasso signed it "Pour Jacqueline, son mari" (For Jacqueline, [from] her husband).[16]

There are roughly seventy portraits of Jacqueline from 1962. Some, looking like Fayoum portraits, are on paper; others, on ceramic tiles. In some—*au chapeau jaun et vert,* for instance—colors are pale; in others— like the contrasting profiles done between 13 May and 16 June—there is virtually no color, with the canvas restricted to black, brown-black, and white. The two bodies are disarticulated and their elements displaced so that they can be seen in their totality.[17]

Because he wanted to state all his ideas, Picasso was steadily and constantly at work. But at this time in his life, he seems to have had ample opportunity every day for reflection and for painting. Unlike Dora Maar, Jacqueline did not have to contend with the terrible pressures of historic events. At the end of October 1962, the Cuban missile crisis threatened not only the Castro regime but the peace of the world. Like a good Spaniard, Picasso had never forgiven the U.S. for the war of 1898. The aggressive crustaceans of Royan, 1940, returned to his painting at this point, and a cat as ferocious as the hunting feline of 1939 pulverizing the bird. These were followed by a battle scene deriving from David's *l'Enlèvement des Sabines* (Rape of the Sabine Women) and Poussin's *Massacre des Innocents.* The day after his eightieth birthday Picasso painted a drama of daily life, *l'Accident de vélo* (Bicycle Accident). On 2 November a mounted warrior, brandishing a spear, tramples some female bystanders; on 3 November the warrior and his horse prance beside a woman who has fallen from her bicycle; while the 4th produced that great canvas filled with murderous sound and fury: Picasso's *l'Enlèvement des Sabines.*[18]

On the final day of 1962 Picasso did a peaceful player of pipes. However on 9 January 1963 tragedy returned with two warriors confronting each other: one is nude and on foot; the other, on horseback. The picture, which also includes a trampled woman and a screaming girl, was finished in February.[19] The precipitating ingredient had been external, but the painting is moved by its own violence. These canvases were not exhibited until 1964—a signal that they were not immediate reflections of contemporary reality. When they were eventually shown, they were mixed with portraits of Jacqueline painted before they existed and work of the new period which followed them.

There is also a hinge work: the winter landscape which Picasso saw from his new studio. When I found it I wrote: "the same and unique blue, depending on how it is applied—concentrated or diluted, splashed or dripped—suffices to create distances, the sky, mountains, the far-off sea, and even the winter light, without sparkle and the coldness of the air."[20]

Hélène Parmelin in that period noted the following:

Picasso said that today people don't want painting; what they want is art. And he added that one had to know how to be vulgar. With Braque we used to say, "There is the Louvre and there is Dufayel." We judged all painting by those standards. We would look at each other and say, "Well, this one's the Louvre, but that one over there—it's got a touch of Dufayel."

"Dufayel"—furniture of standard industrial design—was utilitarian and without pretension and therefore more honest than the tastelessness of academic eclecticism.

In this winter landscape there is a strong "Dufayel" aspect. Picasso has deliberately "painted badly" not simply by making a point of dribbles and trickles but also scraping with the handle of the brush and running blue paint into dirty grays, which one might take for rinse water. He has deliberately created a sense of mucking and daubing, of leaving it to the paint to arrange itself as best it can—in short, a kind of abandonment. But with a second look, this apparent "hands off" can be seen to be highly sophisticated, controlled, in fact, by exceedingly subtle assertions of both hand and spirit.

As always, since his first collages and experiments with *matière* in 1912, Picasso here is extending knowledge gained from his experiments in the aleatory effects of Ripolin to painting itself. These experiments were pursued to an extreme limit beyond which the painting might be ruined. Or might, on the other hand, offer possibilities never before explored, possibilities which because they were new would surely be of passionate interest.

Picasso kept this winter landscape close at hand, in his sitting room, as a work on which to meditate. Two months later he moved into a new phase, a new period which recognizes his great age and stature as responsibilities conferred by mastery.

THE MASTER OF MOUGINS

1963–1965

U nlike la Californie, and even more unlike Vauvenargues, the *mas* of Notre-Dame-de-Vie, where Picasso spent the last years of his life, was a neutral place. The view was its single resource, but one of abundant presence. The sitting room where Picasso received visitors, read his mail, and watched television, and the three studios—two facing east, the third, west—all looked down, over olive trees, at Cannes bay. Picasso had at hand work and materials for every aspect of his artistry. A full range of his sculptures and materials for making them were kept in one of the big downstairs rooms; ceramics, tapestries, and items from his own collection were stored or on display throughout the house, with paintings and smaller sculptures in a studio at the back. In short, every inch of space was put to use.

During this last move Picasso's feelings about his own past had undergone something of a change. As a first step, he unrolled and framed a series of pictures leading up to *les Demoiselles d'Avignon,* some of them previously unknown to the public. And he renewed his acquaintance—resumed possession, so to speak—of pictures he had kept or bought back. Although previously he had refused to concern himself with his own past, remarking that "un artiste ne doit rien se vendre" (by which he meant that an artist should not lean on his own successes), he now gave Zervos free access to all of his notebooks, so that he could photograph them. In 1963 I was astonished by his response when I told him that an editor had commissioned me to write his biography. He said that there were many points which still needed to be made, that a great many others which had been made were wrong, and that he would help me. He showed me the Casagemas suicide paintings, which at that point no outsider had seen, and some of the "blue" paintings hanging in the sitting room, which we would photograph in 1965 for the catalogue of his early work.

These revelations did not imply any censorship of the kind suspected in the case of *les Demoiselles d'Avignon* drawings published by Zervos after Picasso's death. The point was simply that at the time Pablo hadn't wanted any of his new and current work disturbed or slowed down by inevitable

questions. Now he saw things differently—for two reasons. Firstly, he felt that as he had nothing more to prove, he had at his disposal more freedom than ever before. And secondly, that using this freedom obliged him to say everything, an "everything" which included reactions to paintings from his own past as well as to the entire heritage of art.

From 1963 on, I think, Picasso accepted his status as part of that heritage, a status attained during his lifetime with all that such a position and such acceptance implies. This is not the only meaning (but is a powerful one) of his written comment of 27 March 1963: "Painting is stronger than I am. It makes me do what it wants." This could be put another way: Picasso no longer had any accounts to render except to painting itself. He would be judged by painting alone.

The *mas* at Mougins was—more often than la Californie—closed to visitors. Contrary to many accounts, it wasn't Jacqueline but Picasso himself who sometimes kept old friends at arm's length. He felt that he couldn't afford the distraction or even the risk of it. I myself, on the telephone, often supplied the voice of refusal. Sometimes I tried to entice Picasso the other way, sensed that he was close to yielding, and then watched him reassert his original position, fully aware of the distress he was causing. Of someone toward whom he felt truly fond he simply said, "he'll understand." Jacqueline had freely accepted this form of imprisonment by a lover obsessed with painting, who required her presence so that he could devote himself fully to his work. Once, after an evening at which we had lingered longer than usual, my wife said to him as we were leaving, "Pablo, I'm sure that by the time we've reached the gate [a distance of some three hundred meters] you'll be back at work." Although he answered immediately, he had already turned away and was heading for the studio, "Even before you're in your car!"

Picasso had also assumed a certain distance toward the work of the rising generation. Not that he was uninterested. He eagerly checked through all the exhibition catalogues I brought him and often, having read a review in *Lettres françaises* (in which reproductions were only black and white), asked me to bring him a print in color. That curiosity was a product of his thirst for information, his taste for novelty and for life. But clearly the source of his creativity was elsewhere. Not in another period but in another actuality—which was all his own. Very gradually, after initial underestimation, even rejection (perhaps because the critics felt overpowered by the astonishing mass of drawings, engravings, and paintings Picasso was either showing or publishing in books), this period has come to be seen as something different in kind from anything that preceded it.

"Das Spätwerk" (Late Works), the exhibition put together by Christian Gelhaar for the Basel Kunstmuseum in 1981, was the pioneer show for this period.[1] It was rounded out and in part corrected by "The Last Years" at the Guggenheim in 1984.[2] The director of that second show, Gert Schiff, selected 1963–73 as the years to be covered—a more satisfactory and satis-

fying span of time than the period chosen for Basel, which began in 1964. The Guggenheim show was in effect a sequel to the *Peintre et son modèle*[3] and marked a new approach by Picasso to his art. He no longer invited Velasquez or Manet to visit his territory but proceeded to a straightforward examination of Picasso by and as Picasso. In the future, encounters with other artists who crossed his path—like Rembrandt (often) and Degas (deliberate encounters, and at a bordello)—would be just that: encounters. Or they might be surprises, like a drawing of 3 February 1971. After it was done, Picasso noticed and pointed out that it was "un peu Matisse" (that it had a touch of Matisse).

Why should Picasso decide to study and reexamine himself? The answer is, I think, to make his painting declare itself, make it tell him, finally, what it expects from him. I will instance as proof the observation Pablo made to Michel Leiris, quoted above, as he began the paintings for the *Peintre et son modèle* series (some five weeks after the first preliminary drawings of 10 February 1963): "Painting is stronger than I am." Previously it had been his habit to drive hard at an objective as he pushed a creative inquiry to its limit: Iberian expressivity; primitivist violence; Cézanne; African plastic purity; the mysterious properties of collage; the marriage of Cubism to perspective; the *modèle intérieur* of Surrealism; the language of war; whatever it was that drove Matisse; the erotism of the *Femmes d'Alger;* the secret essence of *las Meninas* and of *Déjeuner*. And now, having passed his eighty-first birthday, he chose to call himself to account as an artist.

The first of these drawings seem simultaneously to refer to the series of 1954 and to the image of the studio in which elaborations on *la Chute d'Icare* were launched in 1957–58. The model evolves from sumptuous nudity to ideogram, while the canvas on the easel remains empty or abstract. Painting began on 22 February, with an artist looking at a sculpted head. The head, which sits on a dresser, strongly resembles the painter and stares at him. For most of the sequence, the head stays in the same spot. However, it changes: grows old, for example. And in due course a nude is interposed between painter and sculpture. Hélène Parmelin notes:

> On 2 March Picasso did four paintings: the painter and his model, and a green nude. On the 4th, a white nude plus two canvases with the painter's head. And on the 10th, a canvas of the painter alone in front of his painting. On the 13th, the nude holds a glass at arm's length, while the painter goes on working. On the 14th, the nude has left the scene, is sleeping perhaps. In any case, the solitary painter is working at his easel in the studio. On the 25th, the painter is still alone.

The frenzy seemingly has no end. On 25 March the painter is given Picasso's head. On the 26th the size of the painting doubles. Picasso was, in fact, renewing his possession of the studio with *paysages intérieurs*

(interior landscapes) of la Californie, which summarize the ideograms, driving them even further into abstraction. The process would reach its limit in 1965 with an ideogram of the painter, an easel, and an ideogram of the model. At that point, Picasso was allowing whites to speak with an ever-increasing authority: the white along the edge of the canvas, or white paint. And it is color, directly applied in heavy, decisive brush strokes, which expresses all form.

What symbols can express the act of painting or permit one to distinguish between the external world and the creative act? The presence of the model and the space of the studio?

On 27 April the series halts briefly to celebrate the landscape through the window: this time in the colors of spring. Beneath the apparently casual manner, light touches of green and pink are treated with the most refined and delicate attentions of which painting is capable. Michel Leiris asks if

> an artistic mastery so complete that however a painting is done—in whatever style—it succeeds . . . does not, in some sort, reduce the painter? If his options are limited to success, and he is bound to win every time, does he not become simply the instrument of a guaranteed result?

In this series Picasso did everything he could to ensure that painting would fall on its face, that the painter would stop painting, and the model vanish. All of it, the better to catch himself at the last minute. There seems to be no help for it: painting carries the day.

On 1 May the painter sets out through the green foliage of *Déjeuner*: a tangled, shapeless smearing of green within which white gaps suggest the sensuality of a nude. Between 11 and 16 May there are even fewer signs against a virgin white. But the essentials are there: work and a waiting nude. By the 17th, when all available space is occupied by the forest, the painter is reduced to his head, and the nude, to sexual attributes.

The exhibition at Louise Leiris's, "Peintures 1962–1963," in January 1964 stopped at that point; but these paintings should be seen as part of a powerful outpouring which ended in November 1965, only because of illness. Since November 1963 Picasso had been working on engraving in collaboration with Aldo and Piero Crommelynck, who had just opened a studio in Mougins. His subjects move in dazzling fashion from one medium to another, with the engravings more "figurative" than the paintings. Picasso rediscovered the joys of technical audacity: a mixture of processes and mediums—aquatints, drypoint, burin—contesting for pride of place.

Picasso began with *les Étreintes* (Embraces),[4] the most sensual treatment of this subject since 1904. The novelty here is that the ten engravings grasp simultaneously the relationship between the lovers and the modalities by which the figures and the highly effective signs are formed. And it is probably this double objective—the passionate subject, the hazardous, virtuosic technique—which gives these engravings the particular detachment

which Stendhal, in a similar situation, would consider sublime.

Painters and sculptors constitute the next subject to fill the studios. The engraving of 8 November[5] can be read as the tale of a painter who puts aside an adorable nude for a man's profile, turned to the left. Fundamentally, however, it is a study of four areas or spaces: those created, respectively, by the model, the painter, the canvas on which the painter had been working, and his new canvas with the male portrait. Each of these spaces, through the interplay of aquatint and *eau-forte*, gives different values to the relationship of figure to background.

This is engraving of truly regal authority. Picasso used none of the effects obtained in recent paintings and drawings, turning instead to color washes and white chalk against a dark ground, transcriptions in black of the whites in the series *Peintre et son modèle,* and true black on white to achieve pure line drawing of extreme refinement. This series was interrupted on 8 February[6] and resumed in August with soft, colored glazes in pursuit of the same kinds of challenge, using male heads done in the interval with colored chalks or paint.[7]

A third period of engravings—from the spring of 1965—is a synthesis of technical virtuosity and flawless accomplishment. Painting and engraving here proceed in tandem. But all the large, simple profiles and delectable nudes which Picasso painted at the turn of 1964 and 1965 were necessary preliminaries for the masterpieces of 26–27 February—*Profile de femme* and *le Sculpteur,* which in effect summarize and recapitulate those antecedents. This is true as well of new sequences of nudes and studios, which began in March.[8]

The forty painted variations on a portrait of the painter from the 1963 sequence *Peintre et son modèle*[9] give some idea of Picasso's extraordinary fecundity during these years.

The work described above was punctuated by portraits of Jacqueline, including an astonishing series at the beginning of 1964 in which she is seated or stretched out with a little cat.[10] Between November 1962 and April 1963 this sequence of portraits—experiments in contrasting and combining profiles—gave way to confrontations with ideograms of the armchair which derive from *Peintre et son modèle.* In early 1964, with these reclining nudes as his point of departure, Picasso proceeded to a sequence on the *Femme au chat* (Woman with Cat): seventeen paintings, some of them quite large, between February and May.[11]

Also during this time a projected giant sculpture (some twenty meters high) for the Civic Center of Chicago progressed from the first drawings of February 1962—restating the notion of a face in which a fusion of profiles results in a molded chair leg—to a realization in three dimensions, which serves as maquette for the sculpture, eventually erected in 1967.[12]

From mid-May on, the *Femme au chat* sequence is frequently punctuated by large drawings of a man's head in colored chalks. In these, tangled combinations of plastic signs—often arbitrary—create a portrait. It is not a question of ideograms here but rather of free forms in colors which are

also quite free, as if once again, in the opening stages of a work, Picasso's hand had moved more swiftly than his thinking to permit the discovery of possibilities yet to be explored.[13] After 19 May he turned back to *Peintre et son modèle* with the same breathtaking freedom, despite the irrevocable character of colored chalks, which rules out or exposes the slightest hesitation.[14] Finally portraits became the primary concern, producing during the autumn forty variations on the artist's face—paintings of a reproduction of a painting.

These exchanges between the painter and his model, on one hand, and portraits, on the other, were effected as painting; and in that medium at the end of October 1964, Picasso took a further step in the liberty of plastic signs. At the same time he reduced the painter-model relationship to a confrontation of faces: the painter, generally full face, the elongated model, in profile. And here at the year's end he reached the boundary between figurative and abstract, the minimum of signs necessary for the perception of faces and bodies—a realization attained in a joyous intensity of color.[15]

In March 1965, when Pignon came to the studio to remind him of the Salon de mai, they proceeded from that point, and

> taking hours to do it, [they] set about composing a painting of a large number of canvases arranged in two rows. They tried inserting nudes and painters at intervals between the heads, easily including themselves. So easily and so well, in fact, that when this puzzle of chance was finished, it seemed that any change of any detail might destroy the whole thing. . . . Hung together, this group of the elect would join the Salon de mai as *Douze toiles en une, une toile en douze* (Twelve Paintings in One, One in Twelve).

Without in the least seeming to do so, Picasso in this painting reveals the secret of his work. General criticism, however, missed the point, classifying the picture as a simple divertissement. Picasso is demonstrating here his reinvention of the series, as Monet and Cézanne—or Matisse in his drawings—had needed to do: part of the effort to master the unformulated quantities of plastic representation. He had just reached his series exploring problems of painting in the 1960s, paintings that contest the claims of abstract art, as well as those of the tabula-rasa approach by young French painters of *Support-Surface*, for example, and those of brutal, summary expressionism. Through these efforts he integrated into his work a return to the elementary, like that in which Dubuffet, for example, had elaborated figurations to succeed abstraction. He demonstrates here that he is closely attuned with the times, in which the explosive spread of television, occurring in France at just that moment, was habituating the eye to images in formation. Picasso at that time never missed TV sports.

In sum, after a half century and some twenty thousand drawings, paintings, engravings, and sculptures, Picasso was turning once again to the dynamics of Synthetic Cubism's opening stages: the resumption of sensual-

ity which had followed the abstractions of Cadaquès. But he was all alone. Death had taken Braque on 31 August 1963; and even though for a long time now the two artists had not been working on the same set of problems, Picasso still felt that Braque understood better than anyone else what he was trying to do.[16] Then, on 11 October, Cocteau, too, had died. With him Picasso lost a witness to his fresh turn after Éva's death, his opening effort with *Parade,* his trip to Italy. Picasso had found Cocteau so amusing that he forgave him for joining the Académie Française. And in 1959, wanting to be helpful, he had agreed to participate with Jacqueline in the shooting of Cocteau's *Testament d'Orphée.*

Some of the most dazzling portraits of Jacqueline were painted in the spring of 1964,[17] during the personal crisis provoked by the publication of Françoise Gilot's book written in collaboration with Carlton Lake, art critic at the *Christian Science Monitor* and the *New Yorker.* For two years preceding Gilot's book, Picasso had been annoyed by the renewed diffusion—more or less worldwide—of Giovanni Papini's imaginary interview, presented as Picasso's "confession" as an artist. He sent me all the press clippings on this subject that came his way so that I could denounce them in *Lettres françaises.* I discovered later that the ideological services of the Kremlin were behind this diffusion: Khrushchev's way at the time of taking revenge on PCF criticisms of his anti-religious and anti-intellectual campaigns, a typical piece of underhanded, bureaucratic maneuvering.

Françoise Gilot's book *Life with Picasso* is a compilation of recollections and portraits of Picasso's visitors and friends, some of them quite cruel. (In the English edition the portraits of Aragon and Elsa Triolet are notable examples of this trait.) Gilot's book also reflects her bitter sense that her career as a painter suffered because of her separation from Picasso. And she is clearly unjust to Jacqueline.

Picasso felt profoundly outraged. Throughout his life he was at pains to see that difficulties arising, as Sabartès put it, from "sexual contacts" should not "complicate his existence." In this case, Françoise's "complicating" of things occurred at precisely the moment when he was assuaging his hunger for painting as never before. She stirred up all over again and even intensified feelings Fernande had first provoked thirty years earlier. Picasso reacted exactly as he did the first time. He tried to prevent publication in France, an effort as futile as it was absurd. In the course of these attempts, he was able to test the solidarity of various intellectuals and painters: protests published by *Lettres françaises* include letters from Marcelle Braque, Alice Derain, Miró, Hartung, Soulages, Clavé, Vieira da Silva, René Char, André Salmon, even Fernande Olivier. But these interventions only added fuel to the fires of success; the book became a best-seller. Jacqueline fell ill, and Françoise's children saw the doors of Notre-Dame-de-Vie closed in their faces.

The crisis undoubtedly contributed to Picasso's ulcer, which required an operation in the autumn of 1965.

BEARING THE WEIGHT OF ART

1966–1969

I n conditions of the greatest secrecy, Picasso had an operation at the American hospital in Paris. The shock to his system was severe, and his convalescence lengthy. As soon as he was back on his feet, he wanted to know whether his creative powers had been affected. The *Mousquetaires* series of 1966, with its evocation of an entire world, is part of this rediscovery and recovery of self, a return to the golden age of painting, the age of Velasquez and Rembrandt. A reconsideration of Rembrandt's work is one of the series' constituent elements, a probing of greater depth than previous efforts of the kind. When I asked him why he had chosen the *Mousquetaires,* he replied with a joke: "It's all the fault of your old pal Shakespeare." For the fourth centennial of that poet's birth, in 1964, he had done a series of drawings for *Lettres françaises:* heads with collars and ruffs. But the first direct signal of a confrontation with Rembrandt is *la Pisseuse* (Pissing Woman), an extraordinary canvas of 1965, which Picasso signed on 16 April. The painting is a vehement and caustic combination of *la Baigneuse* of 1655 and an engraving of 1631 of a woman urinating.[1]

This is the Rembrandt with whom he had always felt on thoroughly familiar terms, the Rembrandt of whom he had remarked to Kahnweiler in 1955, "Look at Rembrandt: he thought he wanted to do Bathsheba, but then he found that the servant was really far more interesting—so he did her portrait instead." Picasso called on Rembrandt for his joyous humor and for a sense almost of complicity between them, as if he were taking Rembrandt by the arm and making a confidential assertion, "You and I, old fellow, are the only ones who can paint everything." On occasion he did the same thing with Raphael or Ingres or Degas.

In 1966, with convalescence, a returning sense of well-being, and rediscovery of his own capacities, he struck a similar tone of gaiety and humor. And it is by engraving, in particular, that he put himself to the test. But the sixty plates done between August 1966 and the spring of 1967, which constitute the essential body of this testing process, were never given a general release by the artist, who only authorized reproduction by Georges Bloch in 1970.[2] Some of these, to be sure, contain white or gray "reserves"

in the shape of a phallus; but this indiscreet erotism was surely not a reason for secrecy. Picasso needed to demonstrate to himself that neither his hand nor his brain had lost any capacity for invention. He took every risk but probably wanted these works to have a period of discreet repose in which to consider them. Drawing and engraving have the advantage over painting in this regard: every lapse, great or small, is on record for inspection.

Picasso demonstrates in this series an undiminished capacity for diabolical virtuosity, which in the burins and drypoints can be breathtaking. His progress toward erotism is deliberate and restrained; and at a time when attitudes were becoming far more permissive than any he had previously encountered, he maintains distance and irony. From these he derives the extreme liberty of this reconquest of self: the first spurt of an almost breathtaking perfection and the source of certain aleatory effects, like *craquelures* (12 November IV or 22 November IV) or an astonishing delicacy of line (23 and 30 November).

He uses innovation to break through barriers of tradition in a set of extraordinary scenes. On 16 November muskateer art lovers contemplate a canvas depicting three nudes: a scene created by aquatint applied with an effect of spattering which contrasts with the limpid strokes of *aqua fortis*. On 12 April 1967 a female nude is painting; while June produces a stable and then an orgy. In 1969 the most successful of these were included in an edition of Picasso's play *el Entierro del Conde de Orgaz*.

As he approached his eighty-fifth birthday, two incidents took Picasso back to his past. First, on 28 September 1966, Breton died. A year earlier, with the title *Surrealism and Painting*, Breton had published all his writing on that subject. The collection included his last piece about Picasso, *80 Carats . . . but a shadow* (from 1961), a recollection of deference and political rupture. "And for me," Breton concludes, "that is the missing tread in the staircase, when I dream of climbing—as I used to do—up to Picasso's, with pounding heart." At the time of writing, their break had already lasted for twenty years. Picasso spoke to me with deep emotion of the farewell to the friend of their youth which Aragon had just published in *Lettres françaises*. Why, he wondered, were men unable to rise above their differences while they were alive? Picasso couldn't bring himself to accept as a fact that life was like that.

The other event was the retrospective which Jean Leymaric was preparing for Paris, a show intended to be as complete and inclusive as possible. Since 1955 there had been three shows of this kind: the first, organized by Alfred Barr in New York, in 1957; the second, at the Tate Gallery, in 1960, organized by Roland Penrose; and the third, in Toronto, in 1964, by Jean Sutherland Boggs. This last show went on to Tokyo, enriched by the fifty-seven *Ménines* canvases Picasso had not wanted to lend to Spain because of Franco. After this his entire trajectory would be shown, with emphasis increasingly placed on his more difficult periods, on landmark works of the avant-garde—some 280 of these, bringing together for the first

time since they were made *les Demoiselles d'Avignon* and *le Nu à la draperie*. Only *les Trois Femmes* and *Guernica* were missing. Picasso did not make the trip to Paris but took instead the unprecedented step of showing some five hundred pieces from his own collection, which today constitutes the core of the Musée Picasso. The group includes drawings, assemblages, and sculptures, exhibited together for the first time. Unfortunately this part of the exhibition was shown at the Petit Palais, separated from the main body of the retrospective at the Grand Palais, a division which prevented the public and most of the critics from appreciating the continuity of dialogue maintained between painting and constructions. And—a more serious matter—this separation conferred on the constructions a tone of "divertissement," a classification used as a code word to dismiss a disturbing and challenging show. As *Time* magazine pointed out fairly enough, "some critics have the impression that during recent decades Picasso has been painting above all to amuse himself." Which is to equate agility with a lack of seriousness.

This misapprehension played a part in reducing the shock value of the Petit Palais exhibition, which in fact mandated a complete reconstruction of the history of modern sculpture. Even for those who had the good fortune of seeing these pieces in the studios, the overview given by the show of the whole range of work was staggering. Picasso was as great a sculptor as he was a painter—even perhaps more innovative when he was working in three dimensions.

At this point Picasso was faced with an extremely trying experience. He would probably not have taken his sculptures back to Mougins if anyone had requested them for a museum. Instead of which, the administrative services were making no effort to prevent his expulsion from the Grands-Augustins studio right in the middle of the retrospective—another example of the contradictions in Picasso's relations with the French state. Malraux, although minister of culture at the time, could do nothing. This upheaval was just as painful to Picasso as his expulsion from the rue la Boétie had been, with the aggravating circumstance that this time the studio he was being forced to leave was the studio of *Guernica*. The new, heavily laden move was a nightmare.

On the occasion of his ninetieth birthday, in 1971, in some attempt at reparation, works by Picasso would be exhibited in the Grande Galerie of the Louvre. But these did not include any of his pioneering three-dimensional triumphs. Meanwhile, the Museum of Modern Art in New York, which already had the best collection of Picasso sculptures, undertook to fill in the gaps. After consulting with Ernst Beyeler, William Rubin offered Picasso an exchange: the *Guitare* assemblage of 1912 for a Cézanne Rubin had brought with him. Picasso felt more flattered by this proposal than he let on at the time, while the museum received as a gift not only the canvas of *Guitare* but its original sketch—previously unknown—on cardboard.

This period also saw the first enlargements of various pieces of sculp-

ture. The giant head for the Civic Center of Chicago was put into position; photographs showed how well it suited its framework of skyscrapers. Picasso had conceived this project of monumental sculptures in 1957: profiles cut into sheets of folded, painted metal. However, no one gave him a commission at this time. Subsequently, he was visited by Carl Nesjar, a young Norwegian sculptor, who had discovered a process for making enormous flat planes in concrete. These could be easily adapted, to enlarging Picasso's sheets of cut and folded metal to a monumental scale: a project made all the more possible by Nesjar's ability to engrave the concrete, reproducing Picasso's drawings. Picasso accepted the young man's proposal. A head of Jacqueline appeared in Sweden; some Sylvettes in Amsterdam and New York; a *Femme aux bras ecartés* (Woman with Outstretched Arms) on Kahnweiler's property south of Paris. In 1962 Picasso created, again for monumental sculpture, another version of the characters in [Manet's] *le Déjeuner sur l'herbe,* by cutting, folding, and drawing on cardboard. In 1965 the group was cast in concrete and installed in the garden of the Moderna Museet in Stockholm. The great bather of the group was built separately for an American university only after Picasso's death. It is now back in France, at la Mormaire castle, near Montfort l'Amaury.[3]

In the spring of 1967, the smell of paint once again filling the *mas* declared that Picasso, at eighty-six, had regained his creative confidence and was enjoying his work. *Homme et femme nue* (Man and Naked Woman), done between 22 February and 1 March,[4] has symbolic value with the evident metamorphosis of the painter into an old musketeer.

Because Jacqueline told Malraux that the musketeers "arrived on the scene when Pablo returned to his studies of Rembrandt," the long history of their intimacy has often been overlooked. During the 1963 series of the *Peintre et son modèle,* the painter suddenly catches a "cavalier" aspect of the seventeenth century, with an almost naked model holding a glass and looking at us, while pointing to the canvas on which the artist is struggling. As he finished this tableau, Picasso suddenly exclaimed, "It's Rembrandt and Saskia!"[5] His brain functioned in precisely that sequence: doing a picture first, then analyzing it. Which is how a portrait of Braque came into being in 1909. The face of a man in a hat began to look like Braque, wearing Cézanne's hat.

That the resemblance here has nothing accidental about it is indicated by the glass of red wine and the other, green glass as in Rembrandt. It reflects the registering by Picasso's memory of the unusual in the Rembrandt scene, which shows the artist holding his legitimate wife, Saskia, on his knees and assuming the hilarious attitude of a bordello client. In 1963 we come very close to that astonishing sequence of ceramic tiles in which Picasso shows a man at every phase of excitement as he pursues a nude woman. Hélène Parmelin assembled the sequence with the title *Peintre et son modèle.* Rembrandt is the father of the musketeers, a father with high coloring, who enjoys a broad joke with Saskia. This identity produces *le*

Couple of 10 June 1967,[6] in which Saskia extends a cup to a musketeer who is smoking a pipe. The painting was later offered to the Basel Kunstmuseum, with a group of earlier works, when a cantonal subscription was raised enabling the museum to keep the pictures from the Staechlin Foundation. Picasso is a musketeer from the golden age; and he is Rembrandt when the latter, as a musketeer, paints a piece of trifling swagger. With Jacqueline, Picasso is even more strongly Rembrandt with Saskia. Painting evokes such reincarnations.

On 9 June a *Vénus et l'Amour*[7] gives each of these a summary treatment of joyous humor, which recalls the *Nu couché et Musicien* of 24 March.[8] In the latter picture everything is said once again with a minimum of signs, but not one of the curves of the recumbent woman or of the guitarist-musketeer is lost. The *Aubade* (Dawn Chorus) of 18 June,[9] with a winged flutist hovering over a reclining nude, is marked by the same easy freedom and is equally successful. In contrast, the *Buste de mousquetaire* of 28 May is carefully detailed.[10] Picasso was making an inventory of his hallucinations and fantasies and of the aims and methods of his painting. Since everything was possible, since his reorganizations were maintaining their strength and integrity, he made the limits of these explorations as expansive as possible. From May to October he focused his attention on nudes, with some more self-portraits as well.

In January 1968 naked bathers in a pool recapitulate a subject which had obsessed Picasso since 1918. On the 28th of that month, the *Bain turc* returned, with a modern swimming pool.[11] Drawings at this point seem to be reviewing the range of styles from which engraving would receive a fresh infusion of vigor between 16 March and 5 October. The opening sequence considers a naked woman, a musketeer, and a female go-between in every conceivable combination; then bareback riders are added to the scene. There were ultimately 347 engravings in this broadly ranging series, which comprises autobiographical recapitulation, revision, and invention; virtuosity, lyricism, and surrender to hidden desires. An outpouring of aquatint produced a duel and the sale of a woman, before yielding to long games of solitaire in a black mode. The erotism is glorious, obscene, or amused; the venal embraces, invariably serious. We are transported to the Spain of the *Célestine*, of *pícaros*, and traveling players. But there are also some antique scenes and others in a harem from *A Thousand and One Nights*—a human comedy of unmatched breadth.

Artists appear as well. Between 19 and 26 June a painter-musketeer paints directly on an ample model, doing without the conspicuously absent canvas and easel. Above all, there is the young Raphael, stepping right out of Ingres' *Raphaël et la Fornarina*. From the first it is clear that this Raphael will not be content with simply holding this Fornarina on his knees, and is preparing to make love. Picasso details all of the preliminaries and brings a voyeur into the studio, who turns out to be the pope. The painter gets a grip on himself, picks up his palette, but even though the painter hangs onto

palette and brushes, sexual desire is the ruling passion. In one scene Piero Crommelynck assumes the pope's place as the voyeur holding the curtains. The painter becomes an ordinary man only during the ultimate embraces.

At the end of 1968, when all of these engravings were exhibited at the Louise Leiris gallery, this saga in twenty-five episodes—one of the summits of erotic art—could be seen only in a separate room. Since then some of the more inflammatory engravings have been publicly shown—in Paris, for example, in 1983 as part of the five-hundredth anniversary celebrations of Raphael's birth. On that occasion, I arranged for one of them to appear in a program on the arts which I did for Antenne 2 (Channel 2 television). French television has since revived the series—a development which would surely have delighted Picasso.

Brigitte Baer, in the catalogue of the exhibition "Le Dernier Picasso" (The Last Picasso), Paris 1988, stresses that

> more than drawing, and far more than painting, engraving is talkative, gossipy, and seems to reveal *the man himself,* as if he were giving speech—as much through image as through technique—if not to his unconscious, to something disguised as dream, which plumbs the depths of his deep self. In some sort, Picasso turns engraving into writing. Engraving henceforth replaces the texts in Surrealist mode which occupied his attention between 1935 and 1942. Engraving, in short, is a medium by which he obtains relief, but a form of relief which has been mastered, transformed into a work of art.[12]

If those who have stressed the senility of Picasso's last creative period had known how to look at what he did in these five hundred engravings, they would have seen that he was here at the height of his intellectual form and physical ability, without any suggestion of the weaknesses he sometimes allowed himself in the bitter testimony of some of his last drawings. But that would have required these critics to surmount the Victorian horror of sexuality in old age, combined with fantasies of impotence. Fortunately for him as well as for us, Picasso knew how to live his ninth decade as a man of the twentieth century.

None of the events which shook France in May 1968—the student revolt, the general strike, the dissolution of the Assemblée Nationale, and the consequent crisis of government—are reflected in Picasso's work. The Prague spring and the invasion of Czechoslovakia by troops of the Warsaw Pact are equally absent. Nonetheless, Picasso followed these developments with passionate interest, siding with the students and the Czechoslovakians. It may well be that the primary part played by imagination in these engravings was a response to that youthful spirit protesting the "dullness" of France and proclaiming the need for imagination to "take power." At the end of the autumn, with great pomp, the political office of the PCF visited

the exhibition of engravings at the Louise Leiris gallery, asking me to show them around. General Secretary Waldeck Rochet, however, declined my offer to take the group through the erotic section of the show. "That sort of thing always scares them," Picasso joked when I told him of the incident. "They don't like to be upset."

On 21 and 22 August—the days of the Prague invasion—Picasso engraved an entire harem, or *Bain turc*. The saga of Raphael and la Fornarina was launched one week later, with a copperplate engraved recto and verso. The final engraving of 5 October depicts a romantic couple—a guitar player and a naked woman in a forest. The aquatint seems to have captured each leaf, filtered each ray of sunlight. This is the only work on this subject and perhaps the only work in the Picasso canon which expresses nostalgia. Is it a kind of testament? "I've already started in [to work] again," Picasso said to me a few days after assigning the rights to print this engraving. "And yes, I've engraved my engraver, and all his family."

He began painting again even before the engravings were finished: large canvases of heads which are larger than life and which at first, as with *Homme et femme* of 14 September,[13] seem to be projections of subjects treated with acids or burin. However, painting quickly recovers its autonomy with a strong density of colors and effects of brushwork which recall modulations possible with aquatint, and superpositions of rhythms which create not only volume but movement. This technical transposition is particularly sharp in a very beautiful *Nu couché* of 8 October.[14] Thus, as he approached his eighty-seventh year, Picasso experienced the special excitement of accumulating several innovations in the art of engraving and discovering that they also applied to painting: for him, the royal language capable of containing all the others. A *Mousquetaire à la pipe* (Musketeer with Pipe) appears on 13 October,[15] quickly followed by another on the 16th,[16] in which painting plays a witty solo part, with humorous reinvention of forms surpassing the joyous skill of the Avignon period and the *Homme à la serviette* of summer 1914. There is a succession of canvases. Beginning on 10 November, smokers find themselves confronting a naked woman or wreathed in flowers. An exuberant still life celebrates *Fleurs et buste d'homme au parapluie* (Flowers and Man's Head, with Umbrella).

At about this time Picasso began to conceive of realizing in painting an equivalent of what he had done with his engravings. An exhibition of these which opened on 18 December astonished experts and public alike for the breadth and the creative power of their invention. He was presenting himself with the strongest possible challenge, with full confidence in his own abilities. He was probably hoping as well that painting would keep him at the height of his powers, and therefore alive.

He was reminded of death in February 1968 when Sabartès vanished forever. In memory of Sabartès Pablo bequeathed the *Meninas* to the Barcelona museum. He clung to the thought that Pallarès—their elder—

was still alive and in proving that despite a work schedule that anyone else would have found exhausting, he began each day ready for fresh effort. Life was to grant him not one more exhibition but two: a recapitulation of his painting and another suite of engravings, even more dazzling than set 347. And I am certain that had he been told these lay in store, he would not have been surprised.

38

A PICASSO FINALE

1969–1973

A list of works which follow 167 oil paintings and 45 drawings done between January 1969 and the end of January 1970 for the May 1970 exhibition at the Palais des Papes in Avignon includes 194 drawings between 15 December 1969 and 12 January 1971; 156 engravings between 1970 and March 1972; 172 further drawings between 21 November 1971 and 18 August 1972; and 201 paintings between 25 September 1970 and 1 June 1972. There were also 57 drawings given to the Arles museum, as well as work which was shown or published separately. Over a period of less than four years, Picasso added to his previous achievement a quantity of work large enough to constitute the lifetime oeuvre of a productive artist. In sheer numbers, as well as in the high proportion of major works (some of the engravings are certainly Picasso at the height of his form), this finale is a sumptuous bequest.

The 347 engravings derive for the most part from Picasso's private, internal Spain, with Celestines and women being sold or pursued by gentlemen who might very well be Velásquez. His paintings assume a greater distance. Since 1905 and the Harlequin series and the first engravings, Picasso's drawing always provided a means by which he could be a spectator, especially of showmen, harlequins, and circus people. The period of the *Suite Vollard* added the story of the sculptor. And the Minotaur—as a projection of the artist—took the place of Harlequin. The rupture with Françoise produced the painter, who made his appearance in the drawings for *Verve*.

During the period of the first Avignon exhibition, painting continued to explore the subjects first considered by engravings in the autumn of 1968. As Picasso moved from one engraving to the next, like a novelist following his characters' adventures and imagining what will happen to them, he probably found that each new painting posed independent problems, arousing his thirst for new solutions. Most of this work, however, rests squarely in the world of these 347 engravings. And of course, since the subject is painting, there are evocations or colloquies with Velásquez and Rembrandt, which are usually quite emphatic, as in the transpositions of the seated

dwarf, Sebastian de Morra, in *Adolescent* and in *Homme a l'épée avec des fleurs* (Man Wearing Sword, with Flowers); and that of Rembrandt's *Portrait of Jan Pellicorne with His Son Caspar* in *Personnage rembranesque et Amour* (Figure in the Style of Rembrandt, and Love).[1]

These transpositions and transfers from the Classic age in Picasso's painting are entirely "fin du XXè siècle" in their rapidity of execution, their summary signs based on rhythms of the whole composition, and the audacity of their abbreviations and plastic substitutions. And in the emphatic use of black marks, black brush strokes to give structure, as, for example, in the monumental *Vase des fleurs sur table*[2] and in the fusion of figures by whites and colors in *Homme et fillette* of 11 October 1969.[3] Picasso employs every figurative style. Sometimes he uses declamatory color; sometimes he restricts himself to black and white. Sometimes he turns to radical geometrization, as in the *Nu couché* of 2 November 1969;[4] and sometimes, to voluptuously enlaced curves, as in the *Baisers* (Kisses) sequence.[5] The only constant is size: the larger-than-life dimensions which afforded Picasso some relief of tension through the physical demands of the work—the vehement, sweeping gestures—as well as a test of strength and precision. There was also the pleasure of satisfying his basic and constant taste for the baroque. Gert Schiff notes: "Picasso has practiced an antinatural historicism. With pictorial means which are light-years from those of the Baroque, he has created a reconstitution of the Baroque more exuberant and more authentic than any of the laborious nineteenth-century reconstructions."[6]

In fact this anti-Classical dimension—very Spanish in its taste for provocation, excess, and astonishment—was always a part of Picasso. He had fought against it because he was horrified by all of its implicit suggestions of Catholic counter-reformation and also because, conversely, he felt that he himself needed rigor, abstraction, geometry, and understatement—qualities from the opposite pole of possibility. In the same way the rococo *Ma Jolie* series at the time of Éva and the absolute fantasy of Avignon had followed a Cubism which was positively Jansenist in its austerity.

Fifty-six years later, in what would be a return to Avignon—at least in painting—Picasso could reach his own limits of self; could be transported by painting to his deepest, most hidden reserves. But he couldn't undertake that project (with Yvonne Zervos) until the main body of paintings was done. And he had not dared to draw on these—the last of the Éva *Ma Jolie* series, the enchanting body of Marie-Thérèse, a dreamed-of blouse for Dora or Françoise, the more glorious renditions of Jacqueline—except from some pinnacle of happiness. But now there was nothing to hinder him. He had absolutely nothing to lose or to hide. It was time to permit himself the intellectual immunity of old age and, with cunning and skill, to employ this immunity for maximum results. "I am painting my centenary," he said to me one day, as I and my wife carried the paintings of the Notre-Dame-de-Vie series into the room with a wide opening instead of a window so that it received the direct light of the sun. Picasso wanted to choose some of

these as a private showing for Rosengart and his daughter. I made an enthusiastic remark about the great freedom of his work. He smiled. "If I'm painting better, it's because I've had some success in liberating myself." He gave that extraordinary ensemble of cavaliers and matadors—the successors in late 1970 to the first Avignon show—a long, considering look. Then added, as if to himself, "And every so often, there is just that little something extra."

This was one of his favorite expressions. That "little something extra" was a constant presence during his years of most complete accomplishment.

Yvonne Zervos was carried off by cancer before the Avignon Festival's exhibition at the Palais des Papes. Christian Zervos, himself very ill, supervised the hanging of the show. (He died the following September.) Picasso, in this instance, was counting on the public, a public largely composed of young people. It was the critics who were most disconcerted, seeing the show as a compilation of summary painting, improvisations done in febrile haste, and the erotism of an old man. Whereas in fact Picasso had given them an extraordinary demonstration of arrival at the start of a new visual era and of a growing sexual revolution which reached entirely beyond the limitations of resemblance, of artistic tradition, and convention. He was expected to rest on his laurels, his past successes. Instead of which he painted as the adolescents of the 1970s were going to paint in the 1980s.

As my catalogue of Cubism was nearing completion, I saw a great deal of him at that time. The substance of these meetings naturally carried him back to his past, to the elaboration of *les Demoiselles d'Avignon,* the more complicated problems of *papiers collés,* or of Synthetic Cubism. I was struck most of all by the degree to which his happiness in reliving former discoveries was based on a certainty that with his brushes and chalks and in his engravings he was continuing to make as many unforeseen and unforeseeable discoveries as he had during the great revolutionary periods of his youth. In short, he was a living demonstration of the fact that painting is a young art, still at its beginnings.

He went back to engraving as soon as his paintings left for Avignon—a new sequence beside which the earlier 347 look like swift thrusts. Almost every picture in the new set groups a considerable number of persons; many of them required several states and fundamental reworkings. Aquatint-drypoint contrasts are often completed with *grattages.* There are circus scenes, groups of nude women, suggestions of the *Bain turc,* the theatre, pictures within pictures. Rising to the most extreme technical challenges, Picasso convoked his entire world. There is also a strong sense of desire—each woman more delectable, more shamelessly and aggressively offered than the last.

We have, without doubt, come right into the bordello, with nothing of the Primitivist aggression of the *Demoiselles.* Often, after walking down one of the "hot" streets of Cannes, in which seductive girls had attempted to gain our custom, I saw Picasso glow with pleasure. On those occasions

he would use words almost identical to a remark of his quoted by Kahn-
weiler in 1952: "I went down the rue Saint-Denis the other day. It was
marvelous!" And in these engravings it is indeed marvelous. There are the
clients and, of course, the pimps. Instead of the surfeited sailor of 1907 or
the student with a death's head, there is Degas in person—a voyeur and
hence an element of disturbance and competition for the ladies, strutting to
meet him. When William Rubin came to negotiate the exchange of *Guitare,*
Picasso showed him his Degas monotypes done to illustrate Maupassant's
la Maison Tellier and Pierre Loüys' *Mimes des courtisanes,* acquisitions of
which he was very proud. Now, although fully clothed, Degas will stay in
the "house," either as artist or as voyeur.

"Do you think he came just to take notes? No one really knows what
he did with women," Picasso commented as we looked at the engraving of
16 March 1971 in which Degas holds a piece of paper in front of three naked
and variously interesting girls, while the madam, in the background, sizes
us up. "He would have given me a boot in the arse, old Degas, if he had
seen himself like this!" Picasso then enlarged on a whole range of possibili-
ties about Degas' sexuality: a pederast perhaps, but unaware of the fact?
And of the vices he might have hoped to satisfy. But now Degas stays in the
bordello. Girls attempt to arouse him, vying to outdo each other in provoc-
ative suggestion, or they discuss him or leave the room with a client,
gossiping among themselves. Degas appears as a fleeting profile in a mirror
or sitting in a chair. He leans back, supervises, chooses, and is surprised by
nothing—not even by the arrival of a strange chariot or the presence of a
faun. He even finds that he is a portrait bust on the wall. "Impossible to get
rid of him," Pablo concluded.

He had covered the floor with scenes of Degas at the bordello. I
remarked that this time he had engraved the adventures of a voyeur as he
had done with the sculptor in the *Suite Vollard.* The idea seemed to please
him; but he replied almost immediately, "But the real voyeur is engraving.
. . . Anyone with a copperplate *is* a voyeur. That's why I've engraved so
many clinches." He then referred—as we often did—to the *Faune dévoilant
une femme* of 1936.

> You say that I'm the Faun. . . . But I'm also the voyeur who sees the
> Faun as a voyeur. . . . That's what engraving is. Whereas painting is
> really making love. . . . The pictures you saw hung very high at Avignon,
> . . . they were hung like that because [the people running the show] were
> afraid my characters might step out of their frames and go right on doing
> what they are doing in the paintings.

One would have to be entirely ignorant of Picasso and of his art to
imagine that the erotism of his old age was a product of senility. He was
proving to himself that he could engrave women even more infused with
passionate sensuality than all the others he had already imagined and that

therefore his hand and his brain were functioning as well as ever—or better. His accumulated knowledge and skill gave him the ability to paint couples who might very well leave the canvas and make love with real bodies. As he said to Braque in 1913, looking at *Femme en chemise dans un fauteuil,* "Is this a woman or a painting? Do her armpits stink?" He was able to give the women and girls of his old age sexual attributes as recognizable as any in his drawings and paintings after 1925; but they were precisely descendants of that summer's *Baiser:* paintings made of entirely abstract plastic signs. Like *Couple*[7]—for example—despite an extreme simplicity, long and carefully worked and reworked between 23 December 1970 and 25 June 1971. Like his conceptual guitarist of 1913, this couple is capable of holding a real guitar or making real love. And they have a complete set of bodily odors.

In 1970, at the age of ninety, Picasso took the greatest pleasure in scandalizing the Avignon public. When I overheard the startled comments at the opening of his posthumous show in 1973, I thought that if there is such a thing as a paradise for painters, Picasso must be feeling jubilant.

In the autumn of 1970 he began painting the groups of *la Famille:* a musketeer with a child and sometimes with a woman, or the musketeer alone. These are all direct and strong, with highly expressive color applied with a minimum of brushwork. One picture contains only the man's head, the woman's torso, and the child. This is followed by a *Nu couché à la couronne de fleurs* (Recumbent Nude with Crown of Flowers) and the large, sumptuously decorated matadors which my wife and I assembled for the visit of Rosengart and his daughter. Then there is the *Homme au chapeau,* emerging from a mauve night and staring at us.[8] He provides a prelude to the pathetic or dangerous characters of Picasso's final phase.

Busts or simple heads, fascinating and summary or—when anguish is translated directly into painting—intricately reworked, mark a steady procession of successful but highly risky compositions. Among these is *Femme couchée de dos* (Recumbent Woman Seen from the Back) and the *Enfant à la pelle* (Child with Shovel)—both of July 1971—as well as the astonishing *Maternité à la pomme* of August. The *Étreinte* (Embrace) of 19 July is so powerful that the organizers of a show in Montreal in 1985 thought to hang it beside the *Amitié* of 1908. The *Buste de femme* of 12 August gives us a haughty duenna of the golden age, her breasts bared above her corset. The *Tête d'homme au chapeau de paille* (Man's Head with Straw Hat) of 26 July,[9] in the colors of van Gogh, stares at us with enlarged eyes, like the Iberian heads and the *Autoportrait* of 1907.

This look of grave, obsessive insistence is paramount in the *Buste d'homme* of 3 August, a painting reworked to the point of seeming to extract its subject from the night.[10] A *Tête* of 19 July is at an opposite pole: summarily painted, deliberately badly—a thick mess of paint scraped and dug by the handle of the brush and the fingers, after the fashion of Dubuffet.[11] On the 24th, the head is an indecipherable scribble on a blank canvas.

Picasso wished to ridicule not only his virtuosity but painting itself. This, however, has nothing to do with excessive age seeking an irreparably lost innocence or turning to anticulture, to brute art. This thrust into awkwardness breaks through his own painting—and all painting—to find the painting that lies beyond. He resumed an attack already led to successful conclusion in 1906 and 1908 and again after 1924. Now, however, he was aiming at his own artistic skills and abilities, as he had demonstrated them throughout his life—like a young painter trying to evict "art" from painting. He was thinking of the painting that would follow him, that would exist when he was no longer present.

He knew better than anyone that he was challenging the assumptions of those who expected him to produce work from the peak of his experience and success; and that people would readily conclude that he no longer knew what he was doing. As far as Picasso was concerned, they could think what they pleased. And so he oscillated between the *Couple assis sur un banc* (Couple Sitting on a Bench) of 28 July—a Renoirlike miracle of felicitous expression[12]—and the *Baigneur debout* (Standing Bather),[13] so rudimentary that many people fail to perceive its monumental quality, drawn from precisely that unexampled roughness.

This is followed by expression of an even more diabolic truth, prompted by the fact that a painter's creativity dies with him. How—short of painting death itself, short of exposing one's self to its ultimate terms—can one wrest from death either the painter or his artistic capacity? Is it necessary to confront the monsters lying in wait, as Goya did, in order to observe this final sleep of painting? How can one best seize that ultimate truth of truths? Will it assume the form of a man smoking a pipe? Or of a musketeer, as terrible as the fellow who put in an appearance on 26 May 1972, playing the guitar? Or might it be caught by a wink at the peerless Rembrandt, who knew right to the end how to paint himself? On 13 January 1972 Pablo moved from close-ups taken from Rembrandt's *Saint Paul in Prison* to a musketeer who has left hell for reincarnation as *le Fauconnier*.[14]

On 14 April—just a year before Picasso's death—a *Jeune Peintre*, moving, intimidated, as if all of life lay before him, lightly caresses the canvas.[15] But in his eyes one can see his plans for the conquest of art. On 30 June 1972, at the end of a cycle of portraits, Picasso attempted the absolute, drawing himself as he stares death in the face. The portrait, which fills the paper, returns to the violent strokes and huge eyes of the period which launched *les Demoiselles d'Avignon,* this time to express the fear and sadness of having to leave before there has been time to say everything. The drawing is in the same range of colors as the *Nature morte au crâne de taureau* done thirty years earlier for the death of Gonzalez.[16]

A vacation timetable brought me to his house the next day, a house full of friends. I had organized a series of related questions, and at first I thought that he would put them off for another time. Instead he took me aside,

evidently wanting to assess the matter immediately. I also had with me photographs of work from early 1913, highly complex, using stencils to re-create effects of collage. He examined them one by one, and I was struck by his evident desire to pursue points even beyond the scope of my questions, to be confidential. He lingered over the photographs I had brought, fixing them with his penetrating stare. He grouped together the *Violon bleu,* the *Nature morte à la guitare,* and the *Violon au café:* "This, perhaps, is where we went furthest, Braque and I."

He took me to the studios. As we were crossing the studio beside the sitting room, left as usual in semidarkness, with the shutters closed, he said to me in passing, "I did a drawing yesterday; and I think maybe I touched on something. It's not like anything I've done before." When he had unfolded it and opened the shutters, I saw that look emerge which resembled nothing I had ever seen. He held the drawing beside his face to establish that the fear on the portrait's face was an invention. Then he rolled the drawing up again, without another word.

Three months later, when I came to tell him that *Lettres françaises* was going to close, I saw the drawing spread out on one of the sitting-room armchairs. Picasso had deepened the sepia lines and the garnet-mauve hatchings at the top of the green-blue skull. "You see, I really did catch something with this one." His voice was easy, neutral, as if we were talking about something impersonal.

For the first time in all the years he'd been asking me to come at five o'clock, he wasn't ready. I had to wait while he finished his siesta, and when he appeared, he seemed tired and worn. He gradually recovered his vivacity and quick spirit. He told me about a visit from Aragon a few weeks before—the first in over twenty-five years. Then he looked for the photograph of himself beside the great Soviet cellist Rostropovitch, who was being persecuted at the time for having helped Solzhenitsyn, and signed it for readers of *Lettres françaises*. As we were preparing to say good-bye, he took me back to the self-portrait. I realized that he wanted me to say what I really thought, without any faking. I said that the colors were the same as those he used in his painting after the death of Gonzalez. He didn't blink; and I suddenly felt that, like a good Spaniard, he was looking his own death in the face.

This was not a case of simple courage but of intellectual courage. He had always painted self-portraits at critical junctures of his life: at the time of Apollinaire's death or of the disaster in 1940. With his habit of linking work and daily experience, it was normal that death should now take its place. And once again at a juncture of crisis, what he painted was for himself alone.

He meant, nonetheless, to exhibit the set of pictures he had just been working on, probably because he considered them a form of testament. And certainly because they constituted his truth. He never allowed the risk of incomprehension to stop him. The drawings, including the *Autoportrait* of

death, would go to Louise Leiris in December. The paintings would be part of a new exhibition in Avignon. Picasso was also thinking of some sort of homage to his friends the Zervoses.

The *Autoportrait*'s expression, with less fear and more horror, appeared in a drawing of 4 November—*Mousquetaire et Guitare*—with the head in profile.[17] He had once again reworked the musketeer and bird, reminiscent of Rembrandt's *Falconer*. He then fell ill. He told me over the telephone that he was back at work, but that it "wasn't going very well." One day he said, "All this is difficult for me." He kept putting off the moment for me to come see him. I understood. As I was part of the métier, journalist colleagues kept asking me, "Is he really dying?" I refused to participate in all the necrologies of the kind that must be prepared well in advance but felt harassed by the unhealthy drive for a scoop. And I knew that they would have no compunctions about telephoning Jacqueline or Miguel (Picasso's secretary) and harassing them as well.

Picasso kept putting off our appointment. Finally a day was set in March 1973. I had given Miguel my telephone number in Antibes so that we could fix the time. But when the phone rang and I picked up the receiver, it was Picasso himself. I knew right away that he was departing from his usual practice in order to cancel our appointment. His voice was unusually gentle. Finally he said, "You'll have to let me set my own pace." When I put down the telephone, I had a sense that I'd spoken to him for the last time.

News of his death interrupted television programs during the afternoon of 8 April, a Sunday. The plane on which I'd been able to find a seat landed at Nice during a violent storm. Midday darkness made it impossible to distinguish sea from sky. The great god Pan was dead. There was no question of proceeding up the hill of Notre-Dame-de-Vie by car. I left on foot to try to get through the muddy streams pouring down the road. On the way I ran into various old friends, simple people who felt disconcerted and lost in the throng of journalists, photographers, and television crews tramping through the storm. The police seemed overwhelmed and stunned. I managed to telephone and got Paulo on the line. "We're surrounded," he said. Only the closest relatives had been able to get in. His father would be buried at Vauvenargues.

I didn't want to do battle in order to join the cortege. To leave matters as they were was closer to reality. After all, I had been a friend of the living Picasso. He hadn't wanted me to see him in his diminished state. I didn't know, as I assured Paulo (who was just my age) of my affection, that two years later I would attend his funeral service at Saint-Sulpice.

39

ABOVE AND BEYOND

The exhibition of his last paintings opened at the Palais des Papes in Avignon late in the spring the year of his death. The astonishment of the critics—and even of some specialists, like Douglas Cooper, to whom for years Mougins had been closed—was an almost unbearable reminder that Picasso was still a living force. He had once again made a violent escape from everything which had been expected of him, from everything which people had come to consider his art. Were these works examples of decay, degeneration, and senility? At the time I was one of the few critics—in my review for *Artnews*[1]—to show that these works, considered by some to be "incoherent scribbling," in fact made sense. The reproductions which I chose then—from *Nu accroupi* (Huddled Nude) to *Enfant à la pelle* (Child with Shovel)—from among the strongest works, were retained for the final Picasso exhibitions and prove that although Picasso sometimes painted those things within himself which were in the process of being extinguished, his hand and his eye were still at the service of his capacity for structural expressivity when he wanted them to be.

The mad charm of *Femme au chapeau assise* (Seated Woman in Hat, 28 July 1971)[2] was included in the Basel "Spätwerk" show, one of the most "painted" canvases of the period and the most accomplished in its rhythms and in the vivacity of its color contrasts—a refutation par excellence of the notion that these expeditious works are a product of haste induced by the approach of death. Hélène Parmelin, one of the last to see Picasso alive, noted that for him at the time, the "perfections" of his youth seemed "horrible." Avignon 1973 was from every point of view the end of the road, the object of the journey, a diametric opposition to any notion of surrender to fatigue or old age. He had mastered the miniaturist's skills when it had suited him to do so. Now he was painting otherwise, quite deliberately; recording the de-composition of painting, an analogue to the research of 1911–14—the period of Cubist analysis and synthesis. These phenomena, erroneously categorized as a "return to figuration" at the Paris Biennale of 1985, for example, were quite properly considered by Picasso's juniors a matter of passionate concern.

One can perceive with increasing clarity the error committed by critics like Clement Greenberg, who wrote in 1966 that "Picasso's art has ceased to be indispensable." These critics identify the end of the twentieth century with tendencies in the direction of surrender or even complete abandonment of artistic tradition. Picasso, with and by his work, consigns the tabulae rasae of minimalist art and the "conceptuals," the escapisms of "op art" or hyperrealism, and the proliferation of "performances" to an academism of the avant-garde. He incarnates memory which defines these manifestations as reruns of Duchamp or Dada, symptoms of fatigue, and fear of art, of inadequate strength to transcend the pressures which reduce art to sensory reception and thereby enslave it.

What we now know of Picasso's work and what until now has been ignored establishes more clearly the degree to which the addition of modernity to the history of art is his legacy to us. His personal collection of work by other artists was not shown in Paris until 1978 (with Degas's scandalous monotypes isolated and *sous vitrine*). That show revealed his close attention to Matisse as well as his choice of Cézannes; an excellent early Vuillard, undoubtedly bought in memory of the shock of pure color used by the Nabis, which he had noted in 1901; a Van Dongen *Vigne* of 1905; and some Derains, souvenirs of friendship. The importance of his Douanier Rousseau canvases was also made clear, while Braque was represented by an audaciously Cubist *Nature morte à la bouteille* of which Malraux, when he first saw it in 1974, remarked that it could be "an extremely seductive Picasso."

The show afforded a first glimpse of an entirely private Picasso, unknown to all but his intimates: Picasso the collector. It was followed by another—infinitely more important, troubling, and revealing: the October 1979 show "Oeuvres reçues en paiement des droits de succession" (Works Received in Payment of Inheritance Taxes). This was an epilogue to a long sequence of juridical battles over his estate. These struggles led first to the participation of his illegitimate children Maya, Claude, and Paloma, and then—after the death of Paulo—to inclusion of the children of Paulo's first marriage, of whom only Marina survived (her brother, Pablito, having died, a suicide), and Bernard, the son of Paulo's second wife. Inventories proliferated. The studios produced 1,876 paintings, 7,089 separate drawings, and 4,659 drawings in 149 notebooks. There were also 1,335 pieces of sculpture, 2,880 ceramics, and 18,000 prints and woodcuts. There were vast numbers of illustrated books, copperplates, zincs. As Dominique Bozo observed, "What is striking is the absence—or very small amount—of work which is unfinished or was abandoned in midstream: usually a normal element in what one might call the depths of a studio."

The contents of the studios included all the pioneer works, the turning points, which Picasso kept so that he could go on living with them and continue to look for what his painting or sculpture had achieved on this or that occasion, and which he knew he wouldn't fully understand until later, in the light of other works still to come. And he kept all his "censored" work as well, things which had been rejected by dealers and critics, even by

friends. For example, his *Portrait de Staline* should have been there. That drawing and a sketch on wood of the *Demoiselles* have not yet been found. "His private collection" (I again quote Dominique Bozo) "is a retrospective in itself." I would add, the retrospective of a second Picasso which certainly equals what was publicly seen of the first.

The intellectual labor of connecting these two Picassos has made great strides since 1979, in particular because of the retrospective organized in 1980 by William Rubin and Dominique Bozo at the Museum of Modern Art in New York City. There has also been a considerable amount of published work and exhibitions of Jacqueline's collection[3] and Maya's; and in 1981 work from the collection of Marina Picasso. But our attempts to assess Picasso's impact on painters, scholars, and the public are still at a very early stage. It is difficult to accept as a fact that we have lived for years—even decades—with such a partial and therefore distorted view of the greatest contemporary artist. And it is the history of modern art itself which must be revised and reconstituted.

That this view is correct has already been proved by two shows: the exhibition of the *Demoiselles d'Avignon* in 1988 at the Musée Picasso in Paris; and "Picasso and Braque: Pioneering Cubism" at the Museum of Modern Art in New York in 1989. In both cases, exhuming archives and sifting through facts which had not been examined for eight decades made it clear that the entire history of Cubism had been profoundly transformed. And that—in a ricochet effect—the history of the modern revolution in Paris between 1906 and 1914 and the respective roles not only of Picasso but of Braque, Matisse, and Derain would have to be radically reassessed. When the day comes for a scientific exhibition of Picasso and Surrealism, there will undoubtedly be fresh surprises of the same magnitude.

Even for those who knew his studios, the exhibition of 1979 altered one of his artistic dimensions. This bringing together for the first time of a large number of very small works, his little three-dimensional pieces, for example, emphasized his extraordinary dexterity and ingenuity, his gift for *bricolage,* for tinkering; and gave fresh value to the "artisanal" aspect of his creativity. Of course, he always discussed his work (which he used to write in half-Spanish: *trabail*) in his letters to Kahnweiler. But the manual aspect of the work itself has a capital—indeed overwhelming—impact.

This should help to dispel a misunderstanding which arose from an apocryphal piece published in the USSR in 1926 in the magazine *Ogoniok:* "I do not seek; I find." The remark seemed quite plausible, and Jakulov, who put together the piece, may actually have heard Picasso say it. In any case, he needed to free himself from those who saw him only as a seeker, not as an artist. In 1923 he explained himself to Marius de Zayas: "It's hard for me to understand the word *recherche*—research, search—when the subject is modern painting. As I see it, 'searching' makes no sense in painting. The point is 'finding.' . . . When I paint, my aim is to show what I've found, not what I'm looking for."

This is a fundamental definition of Picasso's art, specifically in its

modernism, and it reveals the extent of his intellectual reflection on what he had made. Painting only exists in its achieved materiality. An artist's brain can see and discover his art in what has come from—been made with—his brush (or pencil or pen or burin). His mental preparation has value only after it assumes material form. It is in the subsequent return to the brain that creation works itself out, in the discoveries which constitute the difference between what is inscribed on the paper (or canvas or copperplate) and what has been conceived. It is in this exchange, too, that accident plays its part, the surprises and the various difficulties which arise; all the interventions, in short, of the materials at hand, modifying the processes of art. At this point, as well, the impossibility of undoing the effects of these accidents is established, the impossibility of returning to some kind of classical order. Instead it is clear that fortuitous discovery must be used as a point of departure for fresh intervention.

Art no longer resides in "search" and can no longer be sought in what went before. It must now be found in its actual, surging presence—"the point is to find." In 1923 Picasso's increasingly close examination of his intellectual equipment was probably influenced by what he knew of the Surrealists but also clearly derived from Apollinaire:

> Lose,
> But lose truly,
> To make room for discovery.

This is part of the Picasso-Apollinaire intellectual partnership, a partnership too often overlooked because Kahnweiler didn't like Apollinaire and didn't understand him. As a good Kantian, he needed to rationalize Picasso's work, to invent an Analytic Cubism. He dismissed as "literature" Apollinaire's enthusiasm for "surprise which laughs savagely" when "numbers and block letters appear as picturesque elements, new to art, and for a long time already, impregnated by humanity."

Apollinaire remarked that Picasso had metamorphosed from an artist to whom the Muse dictates his work to one of those

> who must draw everything from himself, who is inspired by no demon or Muse. [These artists] live in solitude and express only what they have managed to stammer by and from themselves, and have stammered so often that they sometimes manage—through continuous attempt and effort—to give expression to what they had hoped to formulate. Men created in the image of God, they will rest one day, and admire what they've made. But with what exhaustion, imperfection, and coarseness.

Picasso didn't rest until his death, and these lines written in Avignon in 1912 apply perfectly to Avignon in 1972. Apollinaire is irreplaceable here because he is the only witness to Picasso's metamorphosis who tried to formulate it—something Max Jacob never did. But Jacob lived the differ-

ence, the anxiety of knowing what Picasso said about his intentions and not knowing where in fact his friend's painting might lead. Finally, to make a start at understanding Apollinaire's *Peintres cubistes,* at least in its references to Picasso, it was necessary in the 1970s to recast the chronology of the revolution in *papiers collés* and therefore of all Synthetic Cubism.

Picasso's work was now divided between five museums. The principal repository, of course, is the Hôtel Salé in Paris. The collection here—with the best of what Picasso kept—gives intimate access to some of his boldest pioneering work. It should not, however, be dissociated from the main body of "public" masterpieces, carefully selected to make a historic ensemble by the Museum of Modern Art in New York, until now the summit of scientific Picasso analysis. The Picasso Museum in Barcelona contains work of the artist's youth and some of his more Spanish painting, through the *Meninas.* In addition to these three, the Musée national d'Art moderne at the Centre Pompidou locates Picasso, Paul Éluard, and Georges Salles, among others, within the context of modern art; while the Musée Picasso, Antibes, offers work from the summer of 1946. Smaller groups in the Jean Walter–Paul Guillaume collection at the Orangerie, and the Masurel donation to the Musée d'Art Moderne du Nord, Villeneuve d'Ascq, and the Basel Kunstmuseum make Picasso by far the most accessible of the great pioneers of modern art. Especially if one adds to them the Tchukhin and Morozov collections in the Soviet Union, which are just emerging from decades of ideological ostracism.

But do these collections, rich and various as they are, in fact correspond to Picasso's creative output? Until now the French have treated the modernity—essentially developed in Paris between 1863 and 1939—with too much disdain for this to be so. The museum in the Hôtel Salé should include in its exhibits Max Jacob, Apollinaire, Reverdy, Breton, the Surrealists—even Cocteau—for the intellectual setting, the fantasy and poetry without which Picasso becomes etiolated. The refusal of the Musée national d'Art moderne in Paris to participate in "Picasso and Braque: Pioneering Cubism" suggests that French backwardness on these subjects is still very far from exhausted.

Without meaning to, Picasso added confusion to any map of his artistic career by joining the Communist party. Hélène Parmelin, Édouard Pignon, and I were perhaps the only three with whom he could speak of his "belonging" (which implied the PCF as well as Communism in general). Hélène Parmelin quotes his remark that "if instead of joining the Communists in 1944, I had done it earlier, I would never have been Picasso." And that is an exact truth. It should be joined by the complementary truth that he also would "never have been Picasso" if he had "done it" any later. He joined at the precise historic moment when such adherence had nothing to do with Marxism or any other doctrine but was simply political, in the truest sense of the word. Joining the party for Picasso was a way of joining the citizenry, joining society.

His anarchist adolescence and his passage to maturity in an extension

of van Gogh's and Gauguin's Primitivist revolt against the Belle Époque had led him to be the first—with Braque—to include industrial materials in works of art. But for him (not for Braque) an absolute proof of validity, through the component of surprise in art, was that the new painting kept pace with the destruction of the old world. In 1964 Picasso told me "We— our collages and montages—the first ones, before '14, we knew very well it was revolution. And when they did make the Revolution in '17, the Russians understood very well what we wanted to say. At first, anyway. And after that . . . ?"

This is one of my transcriptions of his exact words, which he approved after reading it in print, and I believe it truly reflects an important aspect of his general attitude. Like members of my generation—and like those of 1968—he hoped that art of the avant-garde would develop in dialogue with a political counterpart. There was, for Pablo, no calculation in this or cunning and still less any desire to give orders or insist on ideological support. He needed to communicate. He, like the rest of the Left in the Western world, believed that liberating people from exploitation by their fellows would give them access to new realms of artistic taste and sensibility. Our century assumed the task of cruelly disabusing him. Nonetheless, he proceeded with innovations never attempted before, except perhaps by the republican Manet in his struggles with the narrow spirit of the Third Republic. And he called on Manet for help in freeing himself from the same problems.

More than any other artist, therefore, he found himself confronting the totalitarianisms of the twentieth century on the exposed terrain of image, which they hoped to use for their own purposes. As those circumstances grow more distant, one may hope for perspective with which to unite as part of the same revolt against the inhumanity of the period work which can still seem disparate and unconnected. The paintings of Casagemas' suicide, and *les Demoiselles d'Avignon*, the *Composition à la tête de mort*, the great *Arlequin* of 1915, *la Danse*, *le Baiser*, *la Crucifixion*, *Pêche de nuit à Antibes*, *le Charnier*, *l'Enlèvement des Sabines*, and the last *Autoportrait* strike the same note of protest against any stifling or crushing of the human spirit, whose apotheosis is *Guernica*. Contrary to the "art-for-art's-sake" posture which has been ascribed to the modern revolution in painting and sculpture (and which too readily disregards the message of Gauguin or van Gogh), no artist has been more consistent than Picasso in putting his gifts at the service of a better life for humanity. And by disregarding this objective, one loses the unity of the man and his work.

Very probably he owed his need for a large view of ideas and of art to an early awareness of belonging to a backward country, on the sidelines in relation to the huge upheavals of the modern age. And perhaps he felt a certain anxiety in the knowledge that he could (if he relaxed his guard) yield to an easy isolation within the parameters of his established achievements, and satisfy himself with a talent which left others breathless. Which is

probably how and why he carried to its highest point his drive to make painting a process of constant challenge and conquest of the poetry of the unknown, allowing himself only the briefest halts for celebration.

In this perhaps he has found the least forgiveness. He is surely the most Faustian artist of a modernity which is itself Faustian; but the infinity he was trying to reach excluded any reconciliation with God. Picasso seems never to have read Goethe's poem, but if like Goethe's hero he could have said, "Wie es auch sei, das Leben, es ist gut" (Whatever else it might be, life is good), this would have implied no prayer of gratitude toward a Creator but its negation, the acceptance of the real. Because this acceptance will never be completed; because the present—which we see, perforce, in light of the past—is directed only by what will come. In this Picasso was a quintessential anti-classicist—anti-Mondrian, anti-Kandinsky. Art must surpass and exceed itself and accept the duty of wresting meaning from life. Here, too, Picasso was like Faust: "Nur der verdient sich Freiheit wie das Leben / Der täglich sie erobern muss" (He alone merits liberty, like life, / Who daily struggles to conquer them).

Picasso expressed this by saying that art is truth. A truth of depths so private that it remains an enigma, seems incommunicable, is never simply *given* to us. Art must produce this truth, must teach itself to produce it. Art is not the truth. It is only "the lie which permits us to approach the truth." And in that approach, the artist must transform it. From this springs the frenzied search of a very long life, tracking down the various evasions of illusion and then forcing painting, collage, engraving to admit what they are. From that moment, that gesture, they cease to be inert matter and become the carriers, the bearers of art. Every drawing, assemblage, brush stroke embodied for Picasso a supreme test of truth, analogous to that between matador and bull, between man and woman—a truth which cannot be grasped in advance.

Nothing is ever pre-established, given beforehand. Traditional painting thought that beauty was an inherent fact and performed prodigies to prove it. "Art has no past, or future. Art which is not in the present will never exist." Picasso was clearly expressing a moral lesson here, in the course of reconsidering the direction and meaning of his life during the dramatic crisis of 1935. For Zervos he added, "It isn't what the artist does which counts, it's what he is."

Picasso, to the last day of his life, *was* his art. Therein lies his greatness.

ABBREVIATIONS
USED IN SOURCE NOTES

Catalogues raisonnés of collections and museums

Z Christian Zervos, *Pablo Picasso, Oeuvres*, Paris, 1932ff.
D-B Pierre Daix and Georges Boudaille, *Picasso: The Blue and
 Pink Period*, New York, 1967.
D-B 1989 Revised edition, Pierre Daix, Neuchâtel, 1989.
CP Pierre Daix and Joan Rosselet, *Le Cubisme de Picasso*,
 Neuchâtel, 1979.
CS *Musée Picasso, catalogue sommaire des collections*, Paris,
 1978.
CS2 *Musée Picasso, catalogue des collections, 2 Dessins,
 aquarelles, gouaches, pastels,* by Michele Richet,
 Paris, 1987.
MPB *Museu Picasso, cataleg de pintura i dibuix*, Barcelona,
 1984.
A1 *L'Oeuvre de Picasso à Antibes, catalogue raisonné du
 Musée*, Antibes, 1981.
Bloch Georges Bloch, *Catalogue de l'oeuvre gravé et
 lithographié*, Bern, 1968ff.
MOMA William Rubin, *Picasso in the Collection of the Museum
 of Modern Art*, New York, 1972.
Mourlot Fernand Mourlot, *Picasso lithographe*, Paris, 1970.
SMP Werner Spies, ed., *Pablo Picasso: Eine Ausstellung zum
 hundertsten Geburtstag, Werke aus der Sammlung
 Marina Picasso*, Munich, 1981.
Spies Werner Spies and Christine Piot, *Picasso, das plastische
 Werk*, Berlin, 1983.
WR Nicole Worms de Romilly and Jean Laude, *Braque, le
 Cubisme*, Paris, 1982.

Exhibition catalogues and reference works

AAT Gertrude Stein, *Autobiographie d'Alice B. Toklas*, Paris,
 1934.

Anth.	Marilyn McCully, *A Picasso Anthology*, London, 1981.
B-L	Jeanine Warnod, *Le Bateau-Lavoir*, Paris, 1975.
Bern 1984	Jürgen Glaesemer, *Der Junge Picasso, Frühwerk und blaue Period*, Kunstmuseum Bern, 1984.
Cooper	Douglas Cooper, *Picasso-Théâtre*, Paris, 1967.
Cubism	John Golding, *Cubism: A History and an Analysis 1907–1914*, 2d ed., London, 1968.
Baer	Brigitte Baer, *Picasso, peintre-graveur*, 3, Bern, 1968.
DHK	*Daniel-Henry Kahnweiler, Marchand, Éditeur, Écrivain*, Paris, 1984.
Don.	*Donation Louise et Michel Leiris, collection Kahnweiler-Leiris*, Paris, 1984.
Duncan	David Douglas Duncan, *Les Picassos de Picasso*, Lausanne, 1961.
FY	Alfred H. Barr, Jr., *Picasso: Fifty Years of His Art*, New York, 1946.
FA	*Four Americans in Paris*, Museum of Modern Art, catalogue by Margaret Potter, New York, 1970.
Fry	Edward Fry, *Le Cubisme*, Cologne, 1966.
Jardot	*Picasso, 1955*, Musée des Arts décoratifs, catalogue by Maurice Jardot, Paris, 1955.
Palau	Josep Palau i Fabre, *Picasso vivent*, Barcelona, 1981.
RM	*Recontre à Montréal* (Jacqueline Picasso collection), Montreal, 1985.
Rubin, 1980	*Pablo Picasso, A Retrospective*, Museum of Modern Art, catalogue by William Rubin, New York, 1980.
The Last Years	*Picasso, The Last Years, 1963–1973*, Solomon R. Guggenheim Museum, catalogue by Gert Schiff, New York, 1983.
Das Spätwerk:	*Pablo Picasso, Das Spätwerk*, Kunstmuseum, catalogue by Christian Geelhaar, Basel, 1981.
SDI	Sabartès, *Documents iconographiques*, Geneva, 1954.
Chro.	*Eléments pour une chronologie de l'histoire des "Demoiselles d'Avignon,"* by Hélène Seckel and Judith Cousins, *D.A.2.*
D.A.	*Les Demoiselles d'Avignon*, Musée Picasso, Paris, 1988, vol. 1. *D.A.2.*, vol. 2.
Daix 1988	*Les Trois periodes de travail sur "les Trois Femmes" de Picasso*, Gazette des Beaux-Arts, Paris, February 1988.
Daix	"The Chronology of Proto-Cubism. New Data on the Opening of a Picasso-Braque Dialogue," in *Picasso-Braque, a Symposium*, New York, 1992.
Docu.	*Documentary Chronology*, by Judith Cousins with the collaboration of Pierre Daix, in Rubin, 1989.
Gen.	*La Genèse des "Demoiselles d'Avignon,"* by William Rubin, *D.A.2.*

Hist.	*L'Historique des "Demoiselles d'Avignon" revisé à l'aide des Carnets de Picasso*, by Pierre Daix, *D.A.2.*
Klass.	*Picassos klassizismus*, Bielefeld, 1988.
P.A.	Fernande Olivier, *Picasso et ses amis*, Paris, 1933.
P.L.	Patricia Leighton, *Re-ordering the Universe: Picasso and Anarchism, 1897–1914*, Princeton, 1989.
Richardson	*A Life of Picasso*, vol. 1, 1881–1906, by John Richardson, New York, 1991.
Rubin, 1976	"Cézannism and the Beginnings of Cubism," in *The Late Cézanne*, Museum of Modern Art, New York, 1976.
Rubin, 1984	*"Primitivism" in Twentieth Century Art*, 2 vols., Museum of Modern Art, New York, 1984.
Rubin, 1989	*Picasso and Braque: Pioneering Cubism*, Museum of Modern Art, New York, 1989.
S.I.	Fernande Olivier, *Souvenirs intimes*, Paris, 1988.

SOURCE NOTES

Introduction

1. Princeton University Press, 1989. An extremely interesting work of deciphering, which sometimes suffers from a lack of points of comparison within the European reality of the period. This history of anarchy at the turn of the century has not received much attention at the university level. Cited hereinafter as P.L.

2. Gertrude Stein, *Picasso* (Boston, 1985), p. 52.

3. See Rubin's summary of the question in *Gen,* pp. 419 and 420. When I was working on D-B, I spoke to Picasso about his *Blindman's Feast (Repas de l'Aveugle)* owned by the Metropolitan Museum. I told him that John Berger, in his *Success and Failure of Picasso* (just out in English and not yet translated into French), claimed that he had painted blind men because he "feared blindness as a result of his [venereal] disease. He imagined this disease destroying his very center." This information produced a vehement burst of laughter, a series of offensive remarks about English sexuality, and outraged anger at such incomprehension by a writer on art who would invoke the clap to explain a painter's fascinated interest in a blindman's face. A short time later we found ourselves discussing this subject again because a former Surrealist had just died of the clap (prudishly alluded to as a "degenerative nervous malady"). Picasso told me, citing examples among friends common to both of us, that the Surrealists had been irresponsible in matters of this kind, "flaunting [as he put it] their hot piss and their cankers like so many decorations won at the front." And he recounted his own bordello adventures—notably in the company of Apollinaire—in a tone of relaxed amusement, free of the anguish that has been detected in some of his erotic drawings.

I would add that one would have to be entirely ignorant of the atmosphere within Picasso's *bande* or at the Bateau-Lavoir to think that anyone could have kept a mishap of this kind secret or would have wanted to. Everyone was aware of the private affairs of everyone else; and, unlike the generation immediately preceding—that of Baudelaire, Flaubert, Manet, and Gauguin—none of Picasso's companions are known to have suffered from syphilis.

Chapter 1

1. I have used family data from *SDI;* from Sabartès, "Pensées sur Picasso," in *Picasso* (Paris, 1955); and from Palau. For an understanding of the Mediterranean family and to escape certain misapprehensions which derive from an Anglo-Saxon or Nordic approach to these realities, Germaine Tillion's ethnological study *la République des*

Cousins (Paris, 1976) is indispensable. I am guided also by my own conversations with Picasso, based as they were on my experience of my father's Occitan family and of the Aragonese family of my wife. Although Picasso felt a strong sense of attachment to Catalonia, his attitudes and behavior were typically Andalusian.

On the question of Don José's depression, Picasso entirely corroborates Sabartès. Don José's few surviving pictures indicate that painting was an exercise to which he gave very little of himself, an approach diametrically opposed to that of his son. The latter must have regarded his father's renunciation with incomprehension and astonishment. This was written before I read Richardson's biography. Richardson discusses Don José's "renunciation" (p. 51) as if it were a fact, or—referring to reports by Sabartès and Penrose—a dramatic decision. What I understood from Picasso was that Don José, on seeing his son's first achievements, felt more depressed than ever. Picasso told me: *"Il n'y croyait plus."* The best translation of this vulgar French is: He lost faith in his painting.

2. Z, VI, 3. The eyes were pierced with holes by Pablo's little sister, Lola.

3. At the Barcelona museum (*MPB*, 110 010, p. 291).

4. Z, XXI, 10–13, supplement published in 1969.

5. At the Musée Picasso of the hôtel Salé, *CS*, 2 (*Man in a Cap* being no. 1). *Girl* is signed P. Ruiz, the son substituting himself for his father. *Aunt Pepa*, like *First Communion*, is the first use of the painter's "own" name: P. Ruiz Picasso. In a 1914 photograph of the rue Schoelcher studio, taken from the Picasso archives, *Girl* is prominently displayed, propped in a chair—proof, if proof be needed, of the importance Picasso attached to this picture even at the height of his Cubist period.

6. For the *Portrait of Ramón Perez-Costales, MPB*, p. 37, and 110 194; for *Science and Charity*, ibid., 110 046, and pp. 134, 135, 317–19.

7. Z, XXI, 35.

8. Duncan, pp. 41, 43.

9. *MPB*, 110 001, and p. 134.

10. A sketch (Palau, no. 202) shows the father holding a little girl, who is blond, like Don José. Palau i Fabre sees Conchita's death as particularly hard for Don José because she was the child who looked most like him.

11. *Picasso, Art as Autobiography* (Chicago, 1980). This book revived the psychoanalytic approach to Picasso. Its research, however, is often inadequate, and it fails to give sufficient weight to social and cultural realities particular to Spain at the turn of the nineteenth century.

12. These are all in Palau: nos. 143, 139, 148, 149, 158, 154.

13. Ibid., no. 153.

Chapter 2

1. *Homage to Barcelona, The City and Its Art, 1888–1936* (Arts Council, 1985) contains the most recent studies of the city. For the young Picasso's artistic environment one should add the catalogue of the exhibition of 1981 *Picasso i Barcelona*, directed by Joan Ainaud de Lasarte, and that of the exhibition of Casas portraits, *Ramón Casas, Retrats al carbo* (Barcelona, 1982). The most recent works of biographical updating were published in Bern in 1984: Jürgen Glaesemer, *Don José Ruiz Blasco und Pablo Picasso, der Vater als Lehrer und Model;* Pierre Daix, *Picasso und Paris;* Marilyn McCully, *Picasso und Casagemas: Eine Frage von Leben und Tod.*

Compare also the catalogue of *Picasso Todesthemen* (Kunsthalle Bielefeld, 1984), specifically Douglas Cooper, "Picasso und der Tod," and Pierre Daix, "Der Tod und Picasso."

For the importance of the renewal of 1898, see Antonio Bonnet Correa, " 'l'Age d'argent' de l'art espagnol," in the catalogue for the exhibition *Cinquante ans d'art espagnol, 1880–1936,* Galerie des Beaux-Arts de Bordeaux, 1984.

Ramón Pichot (born 1871; died in Paris 1925) participated after 1890 in modernist festivals at Sitges, organized by Santiago Rusiñol (1861–1931). Picasso probably first became aware of him on these occasions. Pichot became a close friend of Picasso in Paris between 1900 and 1912. He married—probably in 1906—Germaine, for whom Casagemas killed himself. He participated in the 1905 "Cage aux Fauves," but his painting and his palette were in fact classical.

Isidro Nonell, born in 1873, was somewhat younger. However, he died in 1911. From 1893 on he exhibited in Barcelona, where his talent developed and where Picasso took instant notice of him. In 1899 Vollard exhibited in Paris Nonell's paintings of gypsies. In 1900 Picasso took over Nonell's studio in Montmartre. Cf. *les Noces catalanes, Paris-Barcelona* (Paris, 1985).

2. Palau, p. 162, finds a Málaga exhibition of 1899, which probably included a portrait of Aunt Pepa.

3. Carolus-Duran (born 1838) was clearly influenced by his elder Manet at the time of *Déjeuner sur l'herbe,* before turning to a more academic style of painting, closer to that of Fantin-Latour. During the 1880s, however, his work comprised something of an opening toward modernism.

4. Palau, p. 162, adds that Picasso very quickly had his own table at Els 4 Gats, surrounded by admirers.

5. See Palau, no. 301, but in fact the entire theme of the *Patio andaluz,* pp. 158, 159.

6. For the father as subject, Palau, pp. 160 and 161, and 311. For Lola, nos. 321, 322, and 354. For tendencies "à la Greco," pp. 167–69, 178.

Santiago Rusiñol and the Basque painter Ignacio Zuloága are both at the root of the Spanish rediscovery of Greco. In 1894 Rusiñol bought *Saint Peter* and *The Magdalene,* showing them first in Paris (where Barrès was a fervent admirer) before moving them to Sitgès. There the enthusiasm of Catalan modernists led to the erection of a statue. For the young Picasso, to paint "à la Greco" was to be "in the swim."

7. Palau, pp. 164 and 165, and 361.

8. Palau, no. 319.

9. Palau, no. 320.

10. Palau, nos. 336 and 370, and pp. 171–73, for *Last Moments.* Palau i Fabre has found the date of admission—20 October 1899—and the publication of prize winners on 24 February. His book includes all drawings and sketches with death as a subject. At the end of 1899 works on this theme were in plentiful supply.

11. Palau has reconstituted the exhibition of portraits, pp. 183–91. No. 427 is the "modernist" *Autoportrait.*

12. Carlos Casagemas was exactly Picasso's age. He belonged to a family in comfortable circumstances. His drawings and paintings indicate that he had some talent but was influenced more by Casas than by Picasso.

13. See Palau, nos. 383, 438, and 448.

14. Palau, no. 386.

15. Palau, no. 455; D-B, A, 2. But at least two of these have not been indexed.

Chapter 3

1. The most recent developments on this point can be found in my contribution at Berne in 1984 as well as in Palau and D-B. The reconstituted Vollard exhibition (pp. 437–39) should also be noted.

I have consulted Sophie Monneret, *l'Impressionisme et son époque, dictionnaire international illustré* (vol. 3, p. 159ff.), for information regarding recent French painting at the Universal Exposition of 1900. At the show there were Manets as important as *le Déjeuner sur l'herbe, le Déjeuner dans l'atelier,* and *Un bar aux Folies-Bergère,* and a very good choice of Monet, Renoir, and Pissarro. Durand-Ruel was personally involved with the show, which explains its demonstrative character in the eyes of a champion of Academism like Gérome.

2. "To my love, Odette" (in very bad French). The picture, which belongs to the Barnes Foundation, was published by Marilyn McCully in Berne 1984, p. 192.

According to Françoise Gilot (*Vivre avec Picasso* [Paris, 1964], p. 74), Germaine had worked in a laundry, which is not incompatible with posing as a model. This creates a complicated allusion, very much in the style of Sabartès: "What harm does it do—since we know almost nothing about it—to suppose that Picasso was involved with a girl who did the ironing?" (*Picasso*, 1955, p. 38). Sabartès refers here to the *Repasseuse* (Woman Ironing) of 1904, today at the Guggenheim Museum. One may still, however, wonder if there is some confusion with Odette. First because none of the ironers looks like Germaine; and second because when I asked Picasso the identities of these ironers, my curiosity having been roused by Sabartès, he evaded a direct reply, remarking instead that it was an occupation which drove people to drink. Casagemas, in his letter to Reventos of 11 November 1900, wrote that Odette got drunk every evening. It is possible that Odette is the tipsy drinker of drawing D, IV, 3 in my catalogue, especially as the other feminine figure wears her hair in a chignon, as Germaine does in the photograph published by Palau i Fabre (no. 487a); a chignon kept by Casagemas in his portrait (no. 487b). She appears in two other drawings: once again drunk (no. 485) and with bare breasts in the company of Germaine with a carafe and a glass (no. 484). There is no reason not to assume that Picasso joined Odette when he returned to Paris in 1902 and again in 1904.

3. The letter of 11 November came to light only in 1973, on publication of *Picasso i els Reventos,* by Reventos i Conti (Barcelona, 1973).

4. This refers to D-B, II, 12–14, and Supplement A3.

5. D-B, II, 16. Phoebe Pool was the first to make the comparison with Lautrec (cf. Blunt and Pool, *Picasso, The Formative Years* [London, 1962]).

6. D-B, II, 19; II, 21; V, 63 (by a mistaken date); and II, 11.

7. P.L., pp. 21, 22

8. Palau, pp. 220 and 221. The *Lady in Blue* is no. 539.

9. In his book of 1955, Sabartès formulates Picasso's situation: he "had managed to surmount three disappointments: one, at Málaga, through a fault in his friend Casagemas and in the family situation; another, in Madrid, as he came to realize that struggle in that city would not be worth the effort; and the third—perhaps—in the Barcelona series. It would indeed be astonishing if, as the imagination trembled in the throes of a storm, joy, in fact, were waiting at the station. For Picasso—particularly after that time—Barcelona was only a station, a terminal through which he needed to pass."

10. D-B, D, IV, 12. The drawing D-B, D, IV, 23 shows him in front of the Moulin-Rouge, with his easel under his arm.

11. D-B, V, 4.

12. Particularly D-B, V, 14; V, 46, 44, 45.

13. D-B, V, 12 and 11.

14. For "Le Roi Soleil," see Palau, p. 251; for Coquiot's *Portraits,* see D-B.VI, 16 and V, 64; for *Au Moulin Rouge* and *le Divan japonais,* see Appendix.

15. Anatoly Podoksik, studying Picasso's paintings in Russian museums, published in 1989 an X-ray photograph of *l'Acrobate à la boule* revealing that it was painted over the portrait of a man. Comparing it to a photograph of Picasso's studio, boulevard de

Clinchy, John Richardson proved (p. 195) that it was the *Portrait of Iturrino,* until now considered lost.

16. D-B, V, 2 and 3. Compare my *Journal du cubisme,* pp. 12–19, and my article "Picasso und Paris," Bern 1984, p. 57.

17. D-B, V, 52, and V, 76.

18. The letter to Utrillo had been published by Palau, nos. 650 and 651. In this last drawing, Odette is identified by a flat, round hat, which enables one to identify her in a letter of 25 October to Ramón Reventos and to infer that the drinking women and the woman with bare breasts (nos. 486, 485, 484) are based on her. See n. 2 above.

These drawings sent to Utrillo make it difficult to understand why Palau i Fabre seems to doubt that the little painting dedicated to Germaine (no. 641 of his book) is a portrait of her.

19. In his *Souvenirs d'un marchand de tableaux* (Paris, 1937), Ambroise Vollard tends to minimize the Picasso of 1901, whom he exhibited and of whom he kept nothing (he was to disregard the blue period), in order to associate himself more distinctly with subsequent success. Berthe Weill, who was to preserve canvases of 1901, sold them very well. "Non mais il n'y en a que pour Picasso," she cries in her memoirs. Picasso already had collectors: M. Virenque, Spanish consul in Paris; Olivier Sainsère, counselor of state, who would help him to get residence permits; Arthur Huc, the first buyer of the *Moulin de la Galette* (for 250 francs), who was none other than the powerful director of the *Dépêche de Toulouse* (see Pierre Cabanne, *le Siècle de Picasso* [Paris, 1975], vol. 1, p. 110); and Maurice Fabre, in Narbonne, whom Vollard knew well and who had bought *le Roi-Soleil.*

Chapter 4

1. Picasso had shown *le Mort,* bought by Vollard sometime before 1914, in which Casagemas is recognizable. *L'Enterrement,* when it was shown at Berthe Weill's in 1904, was known by that name alone. The three works he showed to no one were the only ones which alluded to the suicide and therefore permitted some comprehension of the link with his friend's death. If Picasso's paintings were his diary, he nonetheless took the greatest care to cover his tracks. Why wait until 1965? I think that these works simply reappeared during the move to Mougins, and Picasso, with his recently achieved new attitude toward his own past, felt that there was a certain logic in making these pictures public on the occasion of my catalogue. I am referring to D-B, VI, 5 and 6, and D-B, A, 6.

2. Picasso could not have seen the first van Gogh retrospective, held at Bernheim-jeune's from 15 to 31 March 1901. But he already knew some of that painter's work. Casagemas' suicide by shooting could be linked readily enough to van Gogh's own suicide. I am inclined to think that this painting on a wooden lid—today at the Musée Picasso—dates to August 1901, the period immediately following the final postscripts to the exhibition at Vollard's (D-B, VI, 5).

3. Published in D-B, p. 338, in 1966.

4. Françoise Gilot describes Germaine as "a little old woman stretched out on her bed, thin, ill, and toothless" (*Vivre avec Picasso,* p. 74). This encounter took place in or close to 1945, at the beginning of Gilot's shared life with Picasso. Germaine was exactly the same age as Picasso and Casagemas—sixty-four at the time of her meeting with Françoise. She died in December 1948.

5. From the bravura quality of the workmanship and composition, I think today (in opposition to the opinion of D-B) that this self-portrait (D-B, V, 1) must be contemporary with the beginning of the Casagemas cycle, with the first of the "blue" paintings.

6. See my article in Bern 1984, p. 60. In 1948, when Georges Salles, then director

of French museums, suggested to Picasso that he hang some of his paintings beside Old Masters in the Louvre, this work was Picasso's first choice (see chap. 30 above).

7. *L'Hétaïre* is listed as D-B, VI, 17, and corresponds to D-B, V, 48. The others are, successively, D-B, VI, 24, 25, 26, and 20. *La Femme au chignon* is D-B, VI, 23. Painted on the back of *Petite Fille au chapeau* (D-B, V, 69), this painting did not leave the studio until it was bought by Quinn sometime after 1920.

8. Successively, D-B, VI, 19, 15, and 13. "You see, quite a lot goes on in my studio," Picasso said to me jokingly as we photographed D-B, VI, 13, at that time published only in black and white. The blond here is evidently neither Germaine nor Louise-Odette.

9. D-B, VI, 27, 28, 29, and 30 grouped to demonstrate, in each case, the same curving of the body.

10. I am thinking of D-B, VI, 31, and VI, 11, and of the astonishing maternity in a landscape, X, 9, whose rhythms so misled us that Georges Boudaille and I dated it for the catalog as 1904—a mistake Picasso corrected. It is done in the colors of the Vollard exhibition.

11. D-B, VI, 14. This return to the little sister who died assumes its full meaning after the Casagemas cycle and D-B, VI, 32.

12. D-B, VI, 10; their auction at Sotheby's in May 1984 provided an opportunity to study them. Also D-B, VI, 9.

13. D-B, VI, 12, which was kept by the artist. When the X-rays of the blue portrait of Sabartès (see n. 16 below) were published by F. Manchon and A. Molodell in *Miscellanea Barcinonensia* in July 1968, Picasso explained the significance of the Saint-Lazare bonnets and told me of his prison visits. *La Gommeuse* is classified as D-B, VI, 17.

14. D-B, VII, 2, 6, and 7. In 1966 we were mistaken; the series is in fact Parisian. (Cf. Sabartès, *Portraits et Souvenirs* [Paris, 1946], p. 79.) See D-B 1989, Introduction, 2.

15. Picasso gave Penrose Dr. Jullien's name in confidence. I found details on the role played by this practitioner in Alain Corbin's thesis "Les Filles de noce, misère sexuelle et prostitution" (Paris, 1978), the first scientific study on the history of this phenomenon in France in the nineteenth and early twentieth centuries.

In Berne in 1984 a Soviet researcher, Anatoly Podoksik, returned to this problem: "Die Entstehung der blauen Period Picassos und das pariser Gefängnis von St Lazare" (The Origins of Picasso's Blue Period and the Prison of Saint-Lazare). He tends to overestimate the social causes of Picasso's evolution, relying for his information on a book by Yves Guyot. Alain Corbin characterizes the book as "polemical," recalling that the book's sinister descriptions derive from a visit to the prison which took place as far back as 1877, at the height of the *ordre moral*. It is a fact that many things had changed by 1901. In fact it is because he was contemplating the phenomenon of death—on the backs of his spectacle paintings—that Picasso went to see the degradation of the girls at Saint-Lazare and to consider their unhappiness and despair. It was not, over the long run, the reverse process, which Anatoly Podoksik imagines: the shock of the discovery of Saint-Lazare affecting Picasso's painting.

The quotation from Sabartès is telling in this regard. It is enough to note the undoubtedly Wagnerian connotation of "sincerity," a Barcelonese connotation which with Picasso would be strengthened by Gauguin's credo, deriving from the same source: "I believe in the sincerity of the spirit and in the truth in art."

16. The "blue" portraits are, successively, D-B, VI, 34, which X-rays have shown to be later than the girls at Saint-Lazare, D-B, VI, 33 and 35. The drawing at Els 4 Gats is Palau, no. 716, situated in Barcelona, while stressing the imaginary presence of Sabartès. We shall see that in contemplating any physical move, Picasso almost always indulged his anticipations with paintings or drawings.

17. See Ron Johnson, "Picasso und der 98er Generation—*Arte Joven*," in Berne, 1984.

18. D-B, VII, 8, which makes it possible to identify the portrait D-B, V, 78 as another version of Germaine. Gertrude Stein (*AAT*, p. 31) speaks of Germaine in October 1907 as Pichot's wife and surmises that she is Spanish, "peaceable and serious, with square shoulders."

19. Sabartès, *SDI*, commits the error of reading "sister" in the place of "mother," a mistake which has produced rivers of ink and distorted interpretations of the painting.

20. See the grouping of studies in Palau, p. 295, and passage from the pregnant woman, no. 737, to the mother, in the final state, no. 739. The study, no. 740, emphasizes the Gothic Primitivism—more deliberate than that of no. 739—in the profile of the mother's face.

21. See Palau, pp. 296 and 297.

22. Palau, pp. 298 and 299, and no. 754.

23. Palau, no. 722.

24. Palau, no. 756.

25. Successively, Palau, nos. 757 and 758, 761, 762, 765.

26. Palau, nos. 763—disclosed in 1966, D-B, A, 12—and 766.

27. D-B, D, IV, 7, erroneously dated 1901.

28. The publication and study of these erotics was resumed by Jürgen Glaesemer, Berne, 1984, pp. 258–68.

29. See Palau, pp. 314 and 315.

30. D-B, IV, 7. Also antedated to 1901.

31. Palau i Fabre dates the encounter with Louise to this visit. In fact, at the hôtel du Maroc, Picasso drew a Spanish woman: Palau, nos. 824 and 825.

32. Palau, no. 937.

33. Palau, pp. 322 and 323; D-B, VII, 11 for *La Soupe*, IX, 4–6 for *les Pauvres*.

34. Palau, pp. 342 and 343, for a return to the subject of a couple at a bistro. The woman, who at first is consoling, gradually immures herself in the isolation of unhappiness.

35. Palau, pp. 340 and 341.

36. I have made this point on the problem in "Der Tod und Picasso" in *Picasso Todesthemen* (see n. 1, chap. 2 above). My reflections use as a point of departure Theodore Reff's article "Themes of Love and Death in Picasso's Early Work" in *Picasso 1881–1973* (London, 1973) and the X-rays done by the Cleveland Museum of Art in 1978. (See "New Light on Picasso's *La Vie*," *Bulletin of the Cleveland Museum of Art*, February 1978, pp. 66–72.)

37. Knowing Picasso, one can confidently assume that his encounter with Charles Morice led him to see (or see again) the Gauguins then at Vollard's. Among these, "D'où venons-nous, que sommes-nous, où allons-nous?" would surely have caught his eye. Charles Morice, knowing that Gauguin had attempted suicide and considering this work a testament, wished to organize a subscription to buy the picture for 1,000 francs and offer it to the Musée du Luxembourg. But Vollard exerted himself to discourage prospective subscribers, offering the picture to Paco Durrio for 1,200 francs and raising the price to 2,000 when Durrio decided to buy. In 1898, following these maneuvers, he exhibited the work, which only augmented the somewhat scandalous publicity. Everything about the picture, in short, conspired to attract Picasso's close attention. See *Tout l'Oeuvre peint de Gauguin* (Paris, 1981), p. 110.

François Cachin, in his *Gauguin* (Paris, 1968), p. 328, emphasizes the resemblance between the huddled old woman on the left of the Gauguin work and the figure at the bottom of *la Vie*. Picasso here also returned to the posture of the seated man on the right

side of the painting at the top of *la Vie*. These are indirect references, typical of Picasso, which he also dramatizes.

38. Successively, D-B, IX, 11 and 12; then Palau, p. 339.

39. Palau, p. 342.

40. D-B, IX, 14–19, with their traces of a woman named Genoveva, identified by Picasso for Richardson as "Max Jacob's one and only mistress." Richardson, p. 260.

41. Palau, p. 350.

42. Spies, 2. This is the first of Picasso's sculpture-painting dialogue.

43. Successively, D-B, IX, 32, 33, 34, 30, and 26.

44. Spies, 3, and D-B, X, 6, and IX, 1–3. Picasso had surely seen Rodin's *l'Homme au nez cassé* at the retrospective organized by the latter at the Place de l'Alma during the Universal Exposition of 1900.

45. Palau, nos. 960, 959, and 961. Junyent, for his part, had done a portrait of Picasso with *la Vie* in the background (cf. Palau, p. 342). Palau, no. 911, for Angel F. de Soto, and no. 898, for Junyer-Vidal. A red flower in his companion's hair appears for the first time within the range of blues, a red which can also be found in the period's single still life: *le Vase bleu* (Palau, no. 899).

46. Compare *SDI*, nos. 77–80, which erroneously dates them 1902.

Chapter 5

1. The map published in B-L, p. 11, and directions given to Penrose by Picasso (*Picasso* [Paris, 1961], p. 115) give the respective situations of Picasso's studio—looking into the court—and the studio occupied by Fernande (Mme de la Baume), a half story below and facing the rue Ravignan. "Bateau-Lavoir" was derived from the wooden building's resemblance to the laundry boats on the Seine. Its entrance was in the single-story facade on the rue Ravignan. The building burned in 1970.

For the attempt to suppress publication of *Picasso et ses amis,* see chap. 23. Fernande's death (1966) probably explains Picasso's waiting until 1968 to "recover" the Madeleine.

2. Successively, Palau, no. 986 and p. 381; nos. 999, 1019, and 1020 for *Madeleine* and the *Maternité rose;* nos. 988 and 989 for the prefatory drawings; no. 987 for the standing embrace, and no. 1000 for *les Deux Amies.* These are drawings with touches of blue and pink, like those of the autumn of 1904.

3. See the portrait of Vasquez Diaz in my *Vie de peintre,* no. 11.

4. Fernande's *Souvenirs intimes* (Paris, 1988) was published by Gilbert Krill, her godson and testamentary executor. Toward the end of the 1950s, Fernande, who was living in poverty, decided to publish these souvenirs, noting that, in *Picasso et ses amis,* she had "voluntarily neglected to appear." This message was transmitted to Picasso by Mme Braque; he then sent Fernande a million francs (in the currency of the time; they would be worth some thousand dollars today). "Whereupon," writes Gilbert Krill, "the manuscript returned to the little wicker trunk from which I extracted it myself, some thirty years later." On the date of the encounter with Fernande, cf. Palau, p. 381.

5. I have published the most affecting of the portraits of Alice in my *Vie de peintre,* no. 53. I gathered my information about it in conversations with Picasso. Alice has given it to the Musée national d'Art moderne in Paris.

The first quotation from Gertrude Stein comes from *AAT,* p. 122; the second, ibid., p. 29.

6. D-B, XI, 6 and 5; and for the old man, Palau, no. 973, dated Paris, 6 May, which confirms the date of Picasso's arrival, on that day. For the *Repas frugal,* cf. Roger Passeron, *Picasso* (Paris, 1985), pp. 10 and 11.

7. D-B, XI, 8, for *les Deux Amies;* not to be confused with the drawing D-B, XI, 9; D-B, XI, 10, and A, 7, for the *Femme à la corneille.* Cf. D-B, XII, 1 and 2.

8. D-B, XII, 1 and 2, for *l'Acteur;* for the two blue drawings of Fernande: D-B, D, XI, 7 and 8.

9. Respectively, D-B, XI, 11 and 12.

10. Geiser 8. It is to be noted that Fernande here wears her hair and is drawn in the same way as in *l'Acteur.* Cf. n. 8, above, which confirms a date at the beginning of 1905.

11. Reff, "Themes of Love and Death," p. 42, and the discussion by Rubin, *Gen,* pp. 416 and 418.

12. D-B, XII, 4; D-B, D, XI, 26.

13. D-B, XII, 6 and 11.

14. D-B, XII, 7. The subject is developed in a number of drawings with color wash. In 1966 we made the mistake of dissociating these from the gouaches, thus interrupting the theme. D-B, D, XII, 4, which was dedicated to Apollinaire, shows Harlequin wearing a fool's cap, alone, in adoration of his child. In D-B, XII, 8, Harlequin, in the same cap, plays his accordion in a poor but tidy lodging, while the mother swaddles the child. The drawing is dedicated "Pour Fernande, Pablo." At the time of *Demoiselles d'Avignon,* we shall see the consequences of this direct incitement to start a family. See chapter 7, nn. 18 and 19.

The account of Fernande's adoption of a young girl told by Salmon in his *Souvenirs sans fin* (Paris, 1955), p. 374 and, according to Crespelle, broadly retold in *les Saltimbanques* (see n. 16, below), is not consistent with what we know of her life or with the four months of absence at Gosol. Picasso told me that the little girl in *Saltimbanques* was a child from the *quartier.* See Ron Johnson, "Picasso's Parisian Family and the *Saltimbanques,*" *Arts* magazine, October 1980.

15. See *Picasso, The Saltimbanques,* National Gallery of Art, Washington, D.C., 1980. Catalogue edited by E. A. Carmean, Jr., D-B, XII, 18, for *la Famille d'acrobates.*

16. *Picasso, The Saltimbanques,* nos. 36 and 37; cf. also p. 35. Cf. chap. 2, note 15.

17. These versions have been published only in Z, XXII, 211 or 221. The resemblance noted by Roland Penrose between the fat clown and Apollinaire is refuted by Z, XXII, 217, which provides the name, El Tio Pepe Don José, and his age, "circa 40 años." On the other hand, Apollinaire at twenty-four had no belly; cf. Z, XXII, 287. Not only is the clown strongly individualized, with a broken nose, but his story extends beyond the *Famille de saltimbanques.* This is made clear by Z, XXII, 212, which launches the theme of the *coiffure,* taken from the *Bain turc,* and revives the circus theme during the autumn.

18. See *Je suis le cahier* (New York, 1982), p. 12.

19. Ibid., p. 42.

20. The purchase of the painting at this date, suggested by E. A. Carmean because of the notation "61 fr" on the same page of the notebook, seems to me incompatible with what the X-rays tell us about earlier versions, which relate to paintings of the beginning of the year. This does not resemble what we know of Picasso's creative methods, his habit of continuous correction, especially when embarking on a *chef-d'oeuvre,* in the sense of a salon painting. These successive corrections, furthermore, are an indication of his desire to fill his major picture with the latest discoveries made during the course of his work.

21. Jean-François Rodríguez, "Picasso à la Biennale de Venise (1905–1948)" (Estratto dagli Atti dell'Instituto Veneto di Scienze, Lettere et Arti), vol. 143 (1984–85).

22. Cf. Christie's, London, *Picasso's "Acrobate et jeune arlequin"* in which the back of the gouache is reproduced and its itinerary reconstituted; sale of 28 Novem-

ber 1988. I owe my initial information on the Venice Biennale label to James Roundell.

23. D-B, XII, 25. We know (cf. *D.A.2.*, p. 544) that this picture was bought by Eugene Rouart in the spring of 1907.

24. Cf. Pierre-Marcel Adéma, *Apollinaire* (Paris, 1968), chap. 7, and Alfred Jarry, *Oeuvres completes*, vol. 1 (Paris, 1972). Jarry, who had been a brilliant student, was remarkable for his precocity as a writer. In his own setting—that of the Symbolists and of the *Mercure de France*—he was not the "fringe" figure generally envisaged today, and his rhetorical anarchism was more or less required of antiacademic writers. Picasso was certainly aware of the shots Jarry fired at Manolo in April 1905 following a dinner at Raynal's, as Apollinaire made a great issue of that episode. However, one has only to read the chronology of Jarry's life until his death from tubercular meningitis on 29 October 1907, and to calculate the duration of his various visits to Brittany, to understand that he and Picasso could not have met very often. Neither Picasso nor Apollinaire is recorded as having been present at his burial, an occasion attended by Vallette, director of the *Mercure de France,* Rachilde, Octave Mirabeau, Descaves, Jules Renard, Paul Valéry, Charles Louis-Philippe, Paul Léautaud, Fagus, and Thadée Natanson. See Ron Johnson, "Picasso's *Demoiselles d'Avignon* and the Theatre of the Absurd," *Arts* magazine, October 1980, and P.L., chaps. 2 and 3. Many commentators have missed the humorous element in Max Jacob's references to Jarry; especially Mme A. Stassinopoulos Huffington, in *Picasso: Creator and Destroyer* (New York, 1988).

25. Palau, pp. 417–19.

26. D-B, XII, 33.

27. D-B, XII, 34.

28. D-B, XII, 23.

29. John Richardson, *Picasso: An American Tribute,* no. 16 (New York, 1962). Erroneously dated 1904.

30. See Notebook MP 1857 of the Musée Picasso.

31. D-B, 1989, XI, 22 (before the painting reappeared).

32. D-B, XII, 27. Offered at Christie's, New York, November 1987.

Chapter 6

1. At the beginning of the nineteenth century, at the starting point of the Avenue de l'Observatoire, on the edge of Montmartre, there was a public dance hall. In 1847 the spot was turned into a *closerie*—a garden planted with a thousand feet of lilac. The name—Closerie des Lilas—was assumed by a fashionable café, at which the poet Paul Fort received friends on Tuesday evenings. The guests usually included Jean Moréas, Francis Carco, Jarry, André Salmon, Apollinaire, and Max Jacob. See the caricatures of Moréas and of a corpulent Paul Fort in Palau, nos. 1013 and 1014. Mark Roskill's date—1907—in *The Interpretation of Cubism* (London, 1985) is clearly on the late side.

2. D-B, XII, 10, and XII, 7, for the two gouaches. The last of these is the largest of the series, and the most tender.

3. Bloch (2) assigns the *Tête de Femme,* based on Germaine and Madeleine, to January, and the drypoint *Deux Saltimbanques* (5) to March. But to list *l'Abreuvoir* as no. 8, immediately following the *eau-forte* of the *Famille des saltimbanques,* and before the other *Saltimbanques* engravings, makes no sense. It—like no. 9, *Au cirque*—can date only from the autumn of 1905, or even more likely, from the beginning of winter 1906. *La Danse,* close to caricature, is surely later, as evidenced by the drawings D-B, D, XIV, 1–3, which constitute perhaps the first parody of *Bonheur de vivre.* In any case, this is a parody of *Salomé* (Bloch, 14), in which the fat clown (Bloch, 10) reappears as Herod.

For Ingres and Picasso, cf. my text "Ingres, Matisse, et Picasso," in *The Presence of Ingres* (New York, Jan Krugier Gallery, 1988).

4. At the outset this group included a massive woman (Palau, p. 421), linked through the drawing (Palau, no. 1146) to the hairdressing motif derived from Ingres. The subject reappears in a scene which returns to circus subjects and the private lives of performers (Z, XXII, 212) and is developed in the Palau drawings, 1201 and 1203. A gouache of a nude arranging her hair, bought by Gertrude Stein, was perhaps inspired by Fernande's ample form (D-B, XIII, 5). The posture of this figure, in the movement of the thigh and the raised arm, suggests some analogy with the drooping woman in the right foreground of the *Bain turc*. But the definitive canvas (D-B, XIV, 20) derives from a different set of problems, in the drawing D-B, XIV, 17, which indicates how it relates to the Gosol *la Toilette*.

5. D-B, XIII, 14.

6. D-B, XIII, 19; XIII, 13.

7. D-B, XIII, 15–18, 20, 21, and the watercolor D-B, XIV, 3.

8. *AAT*, p. 49. "Gertrude Stein did not like the picture, she found something appalling in the drawing of the legs and feet, something that repelled and shocked her." Geneviève Laporte, in *Si tard le soir* (Paris, 1973), p. 169, reports that Picasso had made a girl who sold flowers pose "dressed for Communion, to represent her, in the end, nude." She adds that this girl "posed regularly for Modigliani"—something which could have happened only later, as Modigliani came to Paris in 1906. Richardson presents her (p. 340) as "a teenage flower seller from the Place du Tertre, who sold her body as well as her roses outside the Moulin Rouge." Cf. *FA*, "More Adventures," by Leo Stein; James R. Mellow, *Charmed Circle: Gertrude Stein and Company* (New York, 1974). The private story has been refreshed and retold in Linda Simon's *Alice B. Toklas* (New York, 1977).

9. The letter to Mabel Foote Weeks is dated 29 November 1905. I quote it from Irene Gordon, "A World beyond the World: The Discovery of Leo Stein," in *FA*, n. 54, p. 33. Henri-Pierre Roché, born in 1879, was then writing art criticism. He originated the tale of *Jules et Jim*, from which François Truffaut made his well-known film.

10. Gertrude in the pose of *Mr. Bertin*, which Picasso could see in the Louvre.

11. See Françoise Cachin, *Gauguin*, pp. 326–29. For the portraits of Leo Stein and his nephew, Allan, D-B, XIV, 1 and 2. The quote from James Mellow is drawn from *Charmed Circle*, pp. 117 and 118.

12. D-B, XIV, 3–16.

13. D-B, XV, 29–36.

14. *FA*, pp. 88 and 90.

15. Gertrude Stein explained herself best on this subject in her little book *Matisse, Picasso, and Gertrude Stein with Two Shorter Stories* (Paris, 1933). Gertrude Stein's note is taken from *Gertrude Stein, Picasso, The Complete Writings*, ed. Leon Katz and Edward Burns (Boston, 1985), p. 109. The quotation is taken from *AAT*, p. 60.

16. Spies, 4, 5, and 6. He says (p. 24) that Picasso told him he made Fernande's head before leaving for Gosol.

17. Especially the works reproduced by Barr in *Matisse, His Art and His Public* (New York, 1951), pp. 81, 82, 99, 100, 322, and 324.

18. For the beginnings of the relationship between Apollinaire and Derain, see P-M. Adéma, *Apollinaire*, p. 105. Le Vésinet and Chatou are in the western suburbs of Paris, near Saint-Germain en Laye, on the loop of the Seine known as the *boucle* d'Argenteuil. Derain's role in the genesis of Cubism—well known to Fernande, Kahnweiler, and Apollinaire—was obscured by what followed. First by the fact that in the 1920s Derain became a steadily successful painter; and then because after 1944, during the Occupation, Derain compromised himself with the Nazis.

19. This was particularly evident in the exhibition "The 'Wild Beasts': Fauvism and Its Affinities," New York, 1976.

20. The first study is by James Johnson Sweeney, "Picasso and Iberian Sculpture," *Art Bulletin,* 1941, pp. 191–98. Osuña is in Andalusia.

21. D-B, XV, 1–11.

22. Successively, D-B, XV, 19, 25, and 28, for *le Nu;* XV, 29–34, and 35, for *la Toilette.*

23. S-B, XV, 26 and 27.

24. D-B, XV, 39 and 40. Compare the attitude of the colossus and that of XIII, 5. The gouache *Trois Nus* is D-B, XV, 18.

25. Published by Douglas Cooper (Paris, 1958).

26. D-B, XV, 59–62. D, XV, 32–38, for the faces wrapped in scarves.

27. *CS,* 277 and 278, preceded at Gosol by two sculpted box-trees, of a head and shoulders, and of a nude with raised arms based on Fernande—nos. 275 and 276; the latter prepared by drawing no. 53 of the *Carnet Catalan.* Compare D-B, D, XV, 22. For the first, cf. D-B, D, XV, 23.

The woman arranging her hair (D-B, XV, 5–9) dates perhaps from Gosol but would not have been finished until Paris. At least, that is my conjecture at present.

28. See the discussion of these purchases in Jean Laude, *La Peinture française (1905–1914) et "l'Art nègre"* (Paris, 1968), pp. 161ff. The question is discussed in Rubin, 1984, vol. 1, in articles by Jean-Louis Paudrat, pp. 125ff., and Jack D. Flam, pp. 211ff. The quotation from Kahnweiler was taken from *Juan Gris* (Paris, 1946, 1968), n. 104, p. 211.

29. Quotations from Gertrude Stein are taken from *AAT,* pp. 64 and 61. For Gauguin, see William Rubin, "Modernist Primitivism," and Kirk Varnedoe, "Gauguin," in Rubin, 1984, vol. 1.

I have been seduced by William Rubin's hypothesis (ibid., pp. 244, 245) that the gouache of *Deux Femmes assises,* which for lack of any more precise idea, I had dated 1909 in *CP,* 304, because of its colors and the stylization of its flowers, is in fact Picasso's reaction to the discovery of Primitivist Gauguins in 1906. However, I still feel that it was done somewhat later and is probably linked to a return to Primitivism at the end of 1907 and the beginning of 1908.

30. The two notebooks cited are notebooks 1 and 2 in *Hist.*

31. D-B, XVI, 11–18, and 20.

32. D-B, XVI, 26–30, and the contemporary radicalization of the figuration of female heads, particularly D-B, XVI, 22–25.

33. See my *Vie de peintre,* p. 87, and p. 90, no. 20.

34. D-B, XVI, 30.

35. Because French scholars have paid insufficient attention to the history of Primitivism, we know very little about the transmission of these ideas among artists at the end of the nineteenth century. The best study of this subject is still that of Françoise Cachin, in her *Gauguin,* pp. 159ff. One must also mention Charles Morice, whose writings Picasso knew and with whom he had many conversations. Through him he had access to Gauguin's texts and also to Rodin, and—in a general way—to the entire passage of Symbolism into post-Impressionism.

It would be extremely interesting, for example, to know if—when Picasso spoke of "synthetic drawing"—he knew, one way or another, of Baudelaire's use of this term, which was then more or less taken over by Gauguin. Did Kahnweiler know it? He does not seem to have had Baudelaire in mind.

Charles Morice has been more or less ignored by Anglo-Saxon writers. Golding does not mention him; neither does Mark Roskill. Fry knew only his article on the

Braque exhibition of 1908. Yet he assumes his proper position in the L. C. Breunig and J.-C. Chevalier edition of Apollinaire's *Peintres cubistes* (Paris, 1965). Born in 1861, a member of the previous generation, he seems to me to have been a victim of his age and of his connections with the *Mercure de France*. He was too much identified with Symbolism, and with a mysticism which resulted in his conversion to Catholicism, to be given much credence by the avant-garde.

36. For an analysis of this first drawing and its setting, see *Hist*, in which it is numbered 32R.

Chapter 7

1. In 1912 Salmon published *l'Histoire anecdotique de cubisme*, with the first account of the creation of the *Demoiselles* (still, at that time, without a title). See Fry, p. 82. And it was he who dramatized the enterprise:

> Picasso felt extremely anxious. He turned his canvases on their heads, threw down his brushes. During long days and nights, he drew, making the abstract concrete and reducing the concrete to essentials. Work was never so unrewarded by joy. Picasso undertook a large painting, as an application of his researches. . . . The regulars at the curious studio in the rue Ravignan were disappointed, on the whole, when the young master allowed them to pass judgment on the first state of his new work.

In fact, at the time of the true first state, there was hardly anybody in Paris except for Salmon himself, of whom Picasso thought to make a portrait and a sculpture (cf. Rubin, "Picasso," in Rubin, 1984, vol. 1, pp. 284 and 285), Apollinaire, and Max Jacob. On the drawings for Apollinaire, see *SDI*, nos. 117 and 111.

2. Kahnweiler himself sent me back to his text published in *le Point* (Souillac-Mulhouse), vol. 42, October 1952, commenting that it was the most accurate. See *Hist*, p. 523ff.

3. See Daix 1988 and 1990 on Rubin's discovery of this version and attempts at reconstitution of these transformations and their probable dates.

4. Cf. *Chro*, p. 585ff.

5. See my article "There Is No 'Negro Art' in the *Demoiselles d'Avignon*" ("Il n'y a pas 'd' art nègre' dans les *Demoiselles d'Avignon*"), *Gazette des Beaux-Arts*, October 1970. On identifying various influences, *CP*, p. 11ff.; *Hist*, p. 493ff.

6. See my article "Dread, Desire, and the Demoiselles," *ArtNews*, June 1988, the reproduction (p. 127) of the presentation of the girls at the brothel in the rue de Londres which Picasso had visited in 1900; and Rubin, *Gen*, ill. 95, the salon of the rue des Moulins, ca. 1880.

7. See Rubin's discussion, *Gen*, p. 414ff. It should also be noted that in the Latin tradition, a recall from death carries with it an incentive to rejoice in life—a fundamental ambiguity not fully grasped by the Protestant tradition.

8. Alain Corbin's thesis, "les Filles de noce, misère sexuelle et prostitution" (Paris, 1978), is the first scientific study of the period in France from the point of view of sexuality and its evolution. In fact, the "venereal" arguments regarding the *Demoiselles* turn on the presence of the sailor. Beliefs like that of Mary Matthews Gedo (op. cit., p. 76), that the sailor "assumed a central role in the drama," or of Leo Steinberg ("The Philosophical Brothel, I," *ArtNews*, September 1972, p. 26), who concludes from a single sketch that the man is "effeminate," that he "represented a timid candidate for sexual initiation," reflect the fantasies of their originators. And so does the notion that Picasso deliberately withheld sketchbooks containing work on the *Demoiselles* (Gedo,

p. 77). The delay in access to these books for Zervos was due entirely to the problems of moving when Picasso was expelled from the Grands-Augustins studio in 1966.

9. Sabartès: "Pensées sur Picasso," in *Picasso,* by Jaime Sabartès and Wilhelm Boeck (Paris, 1955). It is absurd to theorize on the joke of identifying the *Demoiselles* with Max's mother or grandmother; with Fernande; with Marie Laurencin. This was a studio joke, a hoax, which made Picasso laugh some sixty years later as he recounted the embarrassment of Marie Laurencin, who had a somewhat pinched character. Contrary to the suggestion of Mary Matthews Gedo, "Art as Exorcism: Picasso's Demoiselles d'Avignon," *Arts* magazine 55, October 1980, nothing suggests that Fernande was ever a prostitute. She had worked as a model, which is not the same thing. The Bateau-Lavoir was a "glass house" in which no one had any secrets from anyone else. Picasso had a pretty good idea of his mistress's adventures, but retrospective jealousy was not his style. Yet once Fernande had entered his life, she had to belong to him, day and night. We know now that she found this confinement hard to bear—difficulties which led to a serious crisis as work on the *Demoiselles* was being completed.

10. *P.A.,* p. 60.

11. D-B, XVI, 30.

12. The drawing from the Cooper collection is at the Kunstmuseum, Basel. The X-rays of *Buste de femme à la grande oreille* are in *D.A. 1,* pp. 310–13. For the question as a whole, cf. *Hist,* pp. 507ff. Hélène Seckel, curator at the Musée Picasso in Paris, organized an exhibition at the end of 1990 to show the results of the infrared analysis of the still life *Bowl, Pitcher and Lemon.* It revealed a painting of the first version of *les Demoiselles* with seven figures. At the end of 1991, another little painting of the same first version was found in Maurice Raynal's estate (Paris, Drouot-Montaigne, 28 November, 1991). It has been bought by MOMA.

13. *Matisse,* p. 150.

14. *AAT,* p. 23: "Fernande will give you french lessons . . . because she and Pablo have decided to separate forever."

15. D-B, XV, 28.

16. It is extremely difficult to date Van Dongen's works. At the exhibition of 13 October–26 November 1967, organized by the Musée national d'Art moderne de Paris and the Museum Van Beuningen, the nude portrait of Fernande (no. 29) was dated ca. 1905–7. I am inclined to place it at the latter date for reasons of workmanship which are even more evident in *La Belle Fernande,* and because Van Dongen did not settle into Bateau-Lavoir until the end of 1905. Also I cannot imagine Picasso giving Fernande free rein at the very beginning of their union, before leaving for Gosol. Picasso was a possessor of the painted images of his mistresses. I provoked a Homeric rage more than sixty years after the event, when I put a few questions about these portraits, exactly as happened when I put in front of him the reproduction of the portrait of Madeleine, painted in 1907 (after their rupture) by Vásquez Díaz (chap. 5, n. 3). This comment of Gertrude Stein's will be remembered: "Van Dongen broke into notoriety by a portrait he did of Fernande. It was in that way that he created the type of almond eyes that were later so much in vogue. . . . Of course, Van Dongen did not admit that this picture was a portrait of Fernande, although she had sat for it and there was in consequence much bitterness."

17. See chap. 5, n. 12, above.

18. *Hist,* p. 507ff.

19. Salmon, *Souvenirs sans fin,* p. 329. "Fernande . . . really tries not to swing from endearments to slaps over every trifling detail." Pablo called Raymonde Léontine. Here is the text of a letter of 8 August, quoted in *Hist,* n. 41 (and, like all the Stein correspondence, now at the Beinecke Library at Yale): "I haven't yet seen Raymonde,

but I think I will go to see her next month. She is in a church orphanage, near us, in the rue Caulaincourt, and I can visit her there on the first Sunday of each month. It seems they are back in touch with her mother."

20. The letter of 24 August is quoted in *Chro,* p. 557, together with subsequent letters which make it possible to reconstitute the story.

21. We must remember that Fernande never once makes any public mention of this. Gertrude, who made frequent observations of the Fernande-Picasso pairing, remarks to Alice: "There was no doubt that Fernande Picasso was a *femme decorative.* . . . Fernande was always beautiful, but heavy in the hand." Gertrude felt that Picasso's sexuality was dirty, but that Fernande's maternal devotion in his regard indicated that as a woman she was unimportant to him; that the vital essence of his sexual energy was directed toward his painting. Alice's opinion of the apartment in which Fernande lived alone is severe: the place, she says, evidences a "lamentably bad taste," and Fernande herself is a person of no real interest, whose "jealousy flares up at every opportunity, over nothing."

22. None of his companions—with the exception of Éva—escaped comparable pictorial violence, comprising not only private anger but his anguish at public events and circumstances, like the war.

23. *Hist,* pp. 511, 512.

24. Ibid., pp. 512–18.

25. See *Hist,* p. 528.

26. Notebook 14 remained unedited until *D.A.* See the analysis in *Hist,* p. 526ff.

27. *Hist,* p. 531.

28. For this borrowing from Gauguin, see Rubin, 1984, vol. 1, p. 264.

29. "The Philosophical Brothel."

30. Claudine Brécourt-Villars, *Écrire d'amour* (Paris, 1985), p. 3.

31. In some respects, the period just before 1914 was more tolerant of erotic literature than the 1920s and 1930s or the Vichy period and the years immediately following the Liberation of France. The law of 29 July 1881, in the early days of the Third Republic, abrogating the sanctions which condemned "outrage to public and religious morals" produced a flowering not only of books but of systematic studies of this literature "in brown paper covers"; notably, those of Louis Perceau and Louis Fleuret, with whom Apollinaire explored the "hell" of the Bibliothèque Nationale. This degree and intensity of activity was not matched again until the 1960s, and the work of Jean-Jacques Perceau, Regine Desforges, and Pascal Pia, among others. I will simply recall that although Aragon did not deny the attributions for erotic literature in my biography of 1975, he also never "acknowledged" these writings. The first scientific edition of *Onze Mille Verges* (Eleven Thousand Cocks) by Michel Décaudin, to which I refer, also dates to 1984 in *Oeuvres d'Apollinaire,* 5 vols. (Paris).

Claudine Brécourt-Villars has assembled the significant titles of this particular marginalia. Woman is, pell-mell, *Eve nouvelle, Mephistophela, l'Animale, la Reine des Sabbats, le Monstre, gouffre d'amour, l'Idole aux sept verges* (Idol with Seven Cocks) from the *Jardin des supplices* (Garden of Torments), regulating, in a luxurious setting of *orchidées impures* (orchids of impurity), the ceremonies and rituals of *possessions démoniaques.*

The author draws from titles of novels of the period: *la Volupté féroce, la Chair qui tue* (The Flesh That Kills), *De la volupté au tombeau* (From Sensuality to the Grave), *Amante cruelle* (Cruel Mistress), *l'Invincible, Une inassouvie* (An Unslaked Woman), *Idylle mortelle, Mortelle Etreinte* (Mortal Embrace), *Scènes d'amour morbide.* "Sexuality," she writes, "is exercised here in images of cruelty, of castration and death; consummation means, above all, to kill—or be killed!"

32. *Hist,* p. 520. In his study of Picasso in *"Primitivism" in Twentieth Century Art,* William Rubin—with good reason—assigns himself the task of investigating the connotations of the word *African* at the time Picasso was painting the *Demoiselles.* He concludes with the view that the *Demoiselles* is far closer to Conrad's *Heart of Darkness* than to *Noa-Noa.* The difficulty here is that *Heart of Darkness,* which became in translation *Au Coeur des ténèbres,* was not available in French until 1926.

One can find these connotations of mode, I think, far more surely in Rimbaud, whose image at that time was associated with Gauguin. Each had fled the decadence of civilization. And if Gauguin died in the Marquesas, Rimbaud did not survive his return to France. He disappeared at the age of thirty-seven, the age of van Gogh, and figured in the pantheon of the "accursed," in which he was the incarnation of the poet. Wrapped in silence, he had run through the entire trajectory of poetry before he was twenty. His legend comprised many other elements which for Picasso were highly sympathetic, linking the genial adolescent to the Commune.

But because of the years (then considered mysterious) spent in Harar, Rimbaud was a quintessential "African." This colored the reading not only of *Une Saison en enfer* but of the poem which symbolized the work, *le Bateau ivre,* even if the savages in this case are American. Further, to a certain extent, the theme coincides with that of Kurtz's initiatory voyage in Conrad.

> Comme je descendais des Fleuves impassibles,
> Je ne me sentis plus guidé par les haleurs
> Des Peaux-Rouges criards les avaient pris pour cibles
> Les ayant cloués nus aux poteaux de couleurs.

Rimbaud provided an example not only for Max Jacob and Apollinaire. (In 1912, when *Alcools* was published, Georges Duhamel recognized "Rimbaud, whose profound and terrible voice M. Guillaume Apollinaire seems unable to forget.") He was also, preeminently, André Salmon's poet of choice. At the beginning of his *Souvenirs sans fin,* Salmon enumerates all the participants of "Rimbaudian gesture" whom he had known: Isabelle Rimbaud; Paterne Berrichon; Ernest Delahaye, a fellow disciple; Izambard, the former professor, etc. And more significantly, in his *Histoire anecdotique du cubisme* (Fry, p. 84), he defends the *Demoiselles:* "The hideousness of their faces freezes the semiconverted with horror. Deprived of Smiling, we recognize only Grimace. The Gioconda's smile was, perhaps for too long, the Sun of Art. The adoration it receives corresponds to certain decadent versions of Christianity which are particularly depressing, supremely demoralizing. One might say—to paraphrase Arthur Rimbaud—that the eternal Gioconda was a thieving devourer of energy."

33. *Picasso,* pp. 39–40. One cannot separate this work from the interest in sculpture which since Gosol was accompanied by a parallel interest in masks. These were strengthened, for Picasso, by the illuminating discovery of Gauguin's sculptures in the autumn of 1906 and by the pieces of Iberian sculpture he kept in the studio.

These are the Spies sculptures, 11; CP, 281, 280, 282, 283, and 279. Nos. 282 and 283 were unknown before Picasso's death.

Already, at Gosol, he had sculpted and carved Fernande's face in wood, works (*CS,* 275 and 276) which, like those mentioned above, remained unknown. These, however, are simple experiments in volume without the Primitivist, rough-hewn effect of the raw figures of 1907. The question was broached in a prefatory note (pp. 15–17) to Margit Rowell's catalogue at the exhibition "Qu'est-ce que la sculpture moderne?" (What Is Modern Sculpture?) at the Pompidou Center, Paris, 1986. But the author's separation of the *esthétique de la culture* from the *esthétique de la nature* leads her to dissociate

Matisse and Picasso from Derain, and—indirectly—*les Demoiselles d'Avignon* from Primitivism.

On Gauguin, cf. Kirk Varnedoe, "Gauguin," in Rubin, 1984, vol. 1; and for the presence of his sculptures in the retrospective of 1906, Anne Roquebert, "Primitivisme," in the exhibition catalogue of *la Sculpture française au XIX^e siècle* (Paris, 1986). It should also be noted that Picasso might very well have been aware of the link between Matisse's sculpture *Nu couché*, 1, and the *Nu bleu, souvenir de Biskra*. (See Jack D. Flam, "Matisse and the Fauves," in Rubin, 1984, vol. 1), and of Derain's contemporary sculptures.

34. Françoise Gilot, *Life with Picasso* (New York, 1964), p. 258.

35. Zervos, *Cahiers d'Art*, 1935, p. 174.

36. Antonina Vallentin, *Picasso* (1955), p. 236.

37. *Gazette des Beaux-Arts*, October 1970, in which, without attribution, I accepted Picasso's remarks. It contains many errors of detail which derive from the fact that I was just beginning the task of editing my *Catalogue raisonné*. These I subsequently corrected, particularly in *CP*.

38. See the discussion in "Picasso," by William Rubin, in Rubin, 1984, vol. 1. Notebook MP1863 suggests that the boxwood figure (*CS*, 280), indicating that Picasso had already seen the Guinea "nimbas," should be backdated to the spring of 1908.

39. "Picasso," in Rubin, 1984, vol. 1, with special attention to pp. 254–64.

40. Dorival, in *Encyclopédie de la Pléiade* (Paris, 1969), *Histoire de l'Art*, vol. 4, p. 650 invokes *Jesus Expelling the Money-Changers from the Temple*. For discussion of comparisons with *Fifth Seal of the Apocalypse* and the comments of Santiago Amon, Gustav Rene Hocke, Rolf Laessoe, and John Richardson, see *Gen*, p. 464 ff., and nn. 16–25.

41. One should not forget that everything in the painting that suggests a rapprochement with Greco was done *after* the Philadelphia sketch, during work on the painting itself. See *Hist*, p. 528.

42. *Gen*, p. 368.

43. *Le Point*, 1952.

44. See *Hist*, pp. 529–32, 542, 543.

45. Ibid., pp. 542, 543.

46. Today at the Hermitage Museum.

47. Z, XXVI, 194. Exhibited for the first time at the retrospective of 1980 at the Museum of Modern Art.

48. *AAT*, p. 29, see chap. 8 of the present work.

Chapter 8

1. *D.A.2.*, p. 687.

2. Ibid., p. 658.

3. Fry, p. 85. However, the tradition propagated by Salmon—that Picasso, disgusted by the poor reception accorded the *Demoiselles*, turned the painting to the wall—is contradicted by the accounts of other visitors, by Gertrude as well as by Burgess.

4. *Chro*, p. 557.

5. Leo's reaction is taken from Mellow, *Charmed Circle*, p. 143, and from Barr, "Matisse, Picasso, and the Crisis of 1907," *Magazine of Art*, May 1951. Gertrude's is from *Picasso*, p. 42.

6. *Picasso*, p. 35.

7. *Fernande et ses amis* (Paris, 1933), p. 108. She adds, it is true, "which did not

prevent him from wanting to find some kinship between their artistic conceptions, a few months later, when this new development in the work of the Spanish painter had become clear. Great artists feel a need for mutual support." In the first place, there never was any break between Matisse and Picasso. And then no discernible rapprochement occurred before 1912. Fernande, who published her memoirs a good quarter-century after this period, was not very meticulous about dates. We should add that the only precise markers of her participation in Picasso's life derive from Apollinaire's move, in April 1907, and Wiegels' suicide in June 1908. We know that Tchukhin's visit—he was brought by Matisse—could not have taken place earlier, because of the purchase of *Femme à l'éventail.*

8. The splendid *Cruche, Bol, et Citron* is the strongest still life of the period, as could be seen at the New York exhibition in 1989, which contradicts Gertrude Stein. *AAT*, p. 72.

9. I discussed the whole matter in my contribution, *"The Chronology of Proto-Cubism. New Data on the Opening of a Picasso-Braque Dialogue,"* in *Picasso-Braque, a Symposium,* New York, 1992.

10. For a discussion of different texts by Kahnweiler, cf. *Gen,* p. 384 ff.

11. *AAT*, p. 27, to fix the date of this visit. Before publication, Gertrude read Picasso the passages which concerned him. See chap. 22 of this book.

12. At the end of 1907 a contrast between Matisse and an "extremist experiment" must be aimed at Picasso. One can see that Picasso, so captious with models or companions, tolerated the contradiction of friends very well. In fact, he felt he needed it far more than he needed flattery, which he distrusted thoroughly. If, during this period, he had been someone else, he might have hanged himself behind his big painting, as Derain feared he would.

13. *Docu,* pp. 345–48.

14. Daix, 1988, p. 149.

15. *Docu,* pp. 349–50.

16. *P.A.,* p. 120.

17. *AAT,* p. 72.

18. We are still without a truly exhaustive study of Derain's youth. The most complete is Susan Ball's "The Early Figurative Paintings of André Derain, 1905–1910: A Re-evaluation." The piece has since been published in *Zeitschrift für Kunstgeschichte* 43, 1 (1980): 79–96. The author, who is clearly not taking *Trois Femmes* into account, sees in *La Toilette* the influence of the Iberian *Deux Femmes nues* from the autumn of 1906 and looks for substantiation in Gauguin's work, which is less persuasive. However, she notes that the drawing of Braque's *Trois Femmes* "seems almost a missing link between *les Baigneuses* (of Derain, 1907) and *la Toilette.*" This corresponds precisely with my hypothesis on the role of the Primitivist version of Picasso's *Trois Femmes.* This version undoubtedly played its part in the asexual Primitivism of Derain's mask-faces in 1908.

According to Susan Ball, Derain exhibited these lost *Baigneuses* at the Salon d'Automne of 1908. One cannot be certain, however, that these are the figures Burgess describes seeing during his visit to Derain's studio: "A group of contorted bathers, some green, some as pink as flamingos, penetrate a vague and smoky background."

We must not forget that *la Toilette* went to Kahnweiler's after the Indépendants of 1908, where it remained until July 1922, when it was sold for thirty-eight hundred francs (a good price) in the third sequestration-sale, before disappearing again. This entire set of paintings, therefore, has been excluded from the history of art. *La Toilette* was a canvas of 172 × 120 cm.

Since the discovery in Picasso's studio of a previously unknown sketch for the lost

painting (*CS*, T, 31), it is even more difficult to rule out the possibility that these Derain *Baigneuses*, together with *la Toilette*, influenced the final version of *Trois Femmes*. Note that in the autumn of 1908, Vauxcelles's review of the Braque exhibition considers the effect of the "bewildering example of Picasso and Derain" to be self-evident. The description of Inez Haynes Irwin is taken from *Docu*, p. 350.

19. *Docu*, p. 352. For the *analyse* of these objects, Rubin, 1984, vol. 1, pp. 298, 299.

20. This notebook had been partially published in *D.A.*, vol. 1, pp. 302–7, and discussed in *Hist*, pp. 538–42. *Femme* is CP 75, still dated in 1979 as from the summer of 1907.

21. *CP*, 168. This applies as well to the two most Expressionist figures, *Seated Nude* and *Repose*, CP, 169, 170.

22. *Confessions esthétiques* (Paris, 1963) p. 22.

23. *Docu*, p. 353. Concerning Wiegels, see Richardson, pp. 322–23.

24. *CP*, 167.

25. *CP*, 172.

26. *CP*, 173–77, for still lifes; 178–83, for landscapes.

27. Georges Duthuit, *Les Fauves* (Paris, 1949), p. 47.

28. *Docu*, p. 353, for the quotation from Burgess; p. 354, for the letter from Leo Stein.

29. *CP*, 194. On Primitivism, see Rubin, 1984, vol. 1, pp. 284, 295.

30. *Confessions esthétiques*, p. 23.

31. See *CP*, 189: *House in the Garden*, the most typical of the Rue-des-Bois landscapes. Golding, *Cubism*, p. 79, had already noted that Braque's Cézannism was more "painterly" than the Cézannism of Picasso.

32. *Docu*, p. 353.

33. See *CP*, 198, and the *compotiers* series, *CP*, 209–11.

34. Fry, p. 83. I have pointed out (Daix, 1988, p. 151) why this text can apply only to the summer of 1908, and to the *Trois Femmes*. Cf. note 9, above.

35. Rubin, 1984, vol. 1, p. 187.

36. Rubin, 1989, p. 95; corrected date.

37. Ibid., p. 109.

38. Ibid., p. 100.

39. Ibid., p. 108.

40. This is the generally accepted date. See Dora Vallier, *Tout l'oeuvre peint d'Henri Rousseau* (Paris, 1970), pp. 85 and 86. On 19 December Rousseau organized, at his house, an evening in honor of Max Weber, who had returned from the United States; and on 9 January 1909 he was found guilty of swindling. He died on 2 September 1910. His account book indicates that at the time, Vollard was making some major purchases from him; more, then, from him than from Uhde, the "discoverer" of Rousseau.

41. Rubin, 1989, p. 105. Date corrected to spring/summer 1908.

42. *CP*, 239. This canvas is linked to a complete sequence of *découpé* figures like the *Femme à la mandoline* (*CP*, 235, 236). Zervos saw in it the proclamation of "an event of such a character that it will prove to be one of the most important esthetic revolutions ever to occur." Which corresponds to Picasso's idea that this was the point of departure for the fragmentation of forms, so that their volumes and rhythms could be precisely geometrized.

43. Cf. Rubin, 1989, pp. 116 and 117.

44. Rousseau was not a customs agent but an employee of the *octroi*, the agency which administered the internal tolls or duties of Paris until it was closed in 1948. For the most recent study of the relationship between Rousseau and Picasso, see Carolyn

Lanchner and William Rubin, "Henri Rousseau et le modernisme," in the catalogue for the exhibition "le Douanier Rousseau," Paris and New York, 1984–85. William Rubin's study on *le Carnaval au bistrot* is part of his article "From Narrative to 'Iconic' " in *Picasso*, art. cit. CP, 215–20. The passages from Gertrude Stein are taken from *AAT*, pp. 113–18. Her account was later challenged by Salmon, *Testimony against Gertrude Stein* (Paris, 1935).

45. CP, 198–215, for Picasso's still lifes; WR, 27–29, and 35, for those of Braque. Although each of them paints pears in his own way, the resemblance between the *compotier* WR 35, and the series CP 199–201 (especially 201) cannot be thought accidental. Further, it is evidence of the same experimentation, focused on the same fruit bowl.

46. Vauxcelles's review in *Gil Blas,* is, as always, highly schematic.

> M. Braque is an extremely audacious young man. The perplexing examples of Picasso and Derain have emboldened him. Perhaps, too, his interest in Cézanne's style and in recollections of the static art of the Egyptians is overly obsessive. He constructs deformed, metallic figures, *bonshommes* of a truly terrible simplification. He seems to disregard the shape at hand, reducing everything—situations, figures, houses—to geometric schemas, to cubes.

It should be noted that here *bonshommes* refers to the *Grand Nu.*

Charles Morice wrote an intelligent review for the *Mercure de France* of 16 December:

> M. Van Dongen maintains a taste for, even a superstitious belief in, the general plausibility of forms. From this last trammel, this final restraint, M. Braque has liberated himself. . . . He sets out to translate all of nature by combinations of a small number of absolute shapes. . . . No one is less concerned with psychology than he; a stone and a human face—I imagine—would move him to roughly the same degree. He has created a personal alphabet, in which each character has a universal meaning.

47. *Le Chapeau de Cézanne, CP*, 215, is explained by the fact that Braque had just bought a Cronstadt. The picture is a gesture to the Cézannism of his friend. *La Reine Isabeau, CP*, 222, is a studio joke which turns on the resemblance between this decorative figure taken from *Carnaval au bistrot* and the silhouette of the wife of King Charles VI at the end of the fourteenth century.

48. CP, 236.

49. CP, 229 and 230.

50. Fernande (*P.A.*, p. 143) says that it was Matisse who brought to the Bateau-Lavoir "M. Tchoukhine [*sic*], a Russian Jew, very rich; an enthusiast for modern painting." He began his collection with the Nabis, shortly after 1890, moving on to Monet, Gauguin and Cézanne. "He was," Fernande writes, "a small, pale man, with a big head and a rather porcine mask [as can be seen in one of Picasso's caricatures]. He was afflicted with a terrible stutter and managed to express himself only with the greatest difficulty." Fernande adds that he bought "two canvases—at very high prices for the time. One of these, the *Femme à l'éventail*, is particularly fine." This fixes the visit at some point after the summer of 1908 and indicates that the relationship between Matisse and Picasso was not at the time quite so bad as Fernande says.

The Swiss collector Hermann Rupf bought some imaginary landscapes at Kahnweiler's, also from the summer of 1908. The young industrialist André Dutilleul began his purchases with works from the end of 1908.

The Steins bought the *Trois Femmes*—probably at the beginning of 1909—then sold the picture to Tchukhin when Gertrude and Leo divided their household in 1913. The consequences for the *Trois Femmes* were identical to those affecting the *Nu à la draperie*, which had a similar fate. As Leo Steinberg and William Rubin have noted,

these pictures were thereby eliminated from the history of Cubism until their brief reappearance at the Maison de la pensée française in Paris in 1954. I therefore became the first—in my biography of 1964—to reintroduce the *Trois Femmes* as well as the *Nu à la draperie.* In short, the birth of Cubism, in Picasso's case, has been described for more than half a century without the two major works which make it possible to situate accurately *les Demoiselles d'Avignon.* Kahnweiler does seem to bear some responsibility for this. Either his visits to Picasso's studio in 1907–8 were very infrequent or he removed from his list works which escaped him because of the Steins. This meant that the first posterity of the *Trois Femmes* was American, as Leo Steinberg *(Resisting Cézanne)* has shown.

Chapter 9

1. In fact Morice establishes two points for us. First, that the term *Cubism* was already, at that date, a current piece of studio terminology, used by critics; and that it was linked to Braque's "cubes." And then that Gertrude Stein was very much aware of the problems confronting Matisse, even if—after the Kahnweiler show—she did not make a connection between these and Braque's new situation within the avant-garde. She did not much like Braque, a factor which tended to reduce appreciation of his true role.

2. The postcard is reproduced in *Docu,* p. 359. The two paintings are, respectively, *CP,* 269 and 222.

3. The workmanship of the rhythms is particularly sharp and clear in *Les Pains* (*CP,* 225), *La Reine Isabeau* (*CP,* 222), and a series of studies (*CP,* 230–32) for a group of bathers which was never done. *La Femme au châle* is *CP,* 249; *Arlequin accoudé, CP,* 261.

4. *Femme à l'éventail* (*CP,* 263) should not be confused with the picture of 1908 on the same subject. See John Richardson, "Picasso," *New York Review of Books,* 17 July 1980, p. 19 n. *Clovis Sagot* is *CP,* 270; *Femme au vase,* inaccurately identified as from Horta, is *CP,* 282.

5. See my *Vie de peintre,* p. 103, and no. 20, *CP,* pp. 66 and 67. The drawings in question are Z, VI, 1083, 1085, 1087, 1091–93.

6. The *Portrait de Pallarès* (*CP,* 274) was painted in his friend's studio in Barcelona.

7. *Docu,* p. 361.

8. *CP,* 275 and 276.

9. For the first portraits of Fernande, *CP,* 297 and 283–86.

10. *CP,* 299.

11. See *CP,* 286–89 and 291.

12. *Docu,* p. 361.

13. Ibid. The letter was published in its entirety in *S.I.,* p. 233ff.

14. P.L. p. 109.

15. Quoted in P.L., p. 110.

16. *CP,* 258, 280, and 279. Although Palau i Fabre was unable to find any trace of the factory of *l'Usine* in 1966, Picasso's comments to me left me in no doubt as to the existence of such a building, but probably not in Horta itself. Patricia Leighton's finding (*P.L.,* p. 111) that "such images of Barcelona, anomalous in the idyllic rural setting, may record Picasso's concern with the workers' uprising in that city" seems to me a product of wishful thinking. Firstly, Horta is an active rural town, with no particularly idyllic qualities. Secondly, nothing suggests that *l'Usine* was painted after the insurrection in Barcelona. And thirdly, there are no industrial workers or enterprises in the painting, only pure geometry.

17. *CP,* 300–302.

18. *Docu,* pp. 362 and 363.

19. *Docu,* p. 363.

20. *AAT,* p. 73. Gertrude adds that she "enjoyed all these complications immensely."

21. Ibid., p. 106. Quotations of Fernande are taken from *P.A.,* pp. 163ff.

22. See *CP,* sec. 11.

23. Manolo, Germaine's jealous lover in 1901, settled down and married Totote, of whom—in 1912—he did an admirable sculpted head inspired by the Sumerian *Goudéa* at the Louvre. In 1909, after several visits to Spain, he moved back to Paris, and Picasso used his studio to resume sculpture. This does not imply any kind of artistic accord between Picasso and Manolo. Kahnweiler reports (*Entretiens avec Francis Crémieux* [Paris, 1961], p. 62) "a celebrated remark which he really did make to Picasso in front of *les Demoiselles d'Avignon.* 'What would you say if your parents were waiting for you at the Barcelona station with faces like that?' "

24. For the sculpted head of Fernande, see Spies, pp. 47–52, and *Der Zerbrochene Kopf* (The Broken Head), Hamburg Kunsthalle, 1981, by Helmut Leppien.

25. The volume of WR devoted to Cubism appeared in 1983, with an important preface by Jean Laude. He groups together for the first time all the important works of the period. But he does not discuss their chronology or their relation in time to Picasso's output. The conversations with Dora Vallier were published in "Braque, la peinture et nous," *Cahiers d'Art,* Paris, 1954.

26. See in particular *Femme au pot de moutarde* and *Femme en vert* (*CP,* 324 and 326). *Portrait de Braque* is *CP,* 330.

27. Ibid., 335.

28. Although Fernande may have been the model for *La Couseuse* (*CP,* 331), it is difficult to imagine that she is the *Dame au chapeau noir* (329). She was certainly not the model for *Femme nue assise dans un fauteuil* (332), which is done with a certain tenderness. Nor for *Mademoiselle Léonie* (340) or the *Femme à la mandoline* (341).

29. The two seated nudes (*CP,* 342 and 343) are of a slender, delicate woman—the model perhaps for 332; or for *Jeune Fille à la mandoline.* In all of these instances, the model may also have been Fanny Tellier.

30. Although Picasso told Penrose the model's name, he did not say that she had posed nude, a circumstance which would have given rise to gossip. Picasso took great care to conceal his adventures with women, first because he respected his companions' privacy, and then because of retrospective jealousy on the parts of both Fernande and Olga. He waited until Fernande's death (ten years after Olga's) before unburdening himself—perhaps deliberately, perhaps from a sense of relief—of anything that might have irritated either woman. On the painting itself, see *MOMA,* pp. 66 and 205.

31. Fernande's letter of 17 June 1910 to Gertrude Stein was published by Marilyn McCully, *Anth.,* as was a summary of Pablo's letter to Leo.

32. Rubin, 1989, p. 175.

33. The article by Burgess (who translated it for Picasso?) said, among other things,

Picasso is a demon. I use this term in its most eulogistic sense, because he is young and lively, with olive skin, black eyes, black hair: a Spanish type, with exuberant blood. . . . If I add further that he is the only one of all those people to have a sense of humor, you may grasp something of the striking and forceful thunderclap quality, as I did.

In addition, his paintings were "an affront to decency." This is probably the shock of a visitor confronted with the "ogresses," a reaction Picasso found hilarious. One should recall that Burgess reproduced *les Demoiselles (Study)* and the *Trois Femmes* with the title *la Femme, by Picasso!*

34. See *CP,* sec. 12, and pp. 81–84. Although Kahnweiler—unique confidant of the Cadaquès adventure—described it with precision (*Confessions esthétiques,* pp. 31–35), he tends to use Kantian terms:

> The colored surfaces can supply the formal schema without organizing themselves in closed bodies. Instead of an analytical description, the painter can also achieve in this way—if he wishes—a synthesis of the object, which is to say, as Kant would have it, *"to add one to another the various representations* (of the object) *and grasp their multiplicity as a single recognition."* See my "Conjectures," n. 2, following the notes to chap. 18.

35. Rubin, 1989, Appendix, p. 63ff.

36. Bloch, 19–22. It is possible that *le Couvent* was derived from arcades seen at Cadaquès.

37. *CP,* 368.

38. I have arranged these inquiries in *CP,* sec. 13. One can observe a simultaneous return to the object, with the square apple, and the height of structural abstraction with the landscape *la Pointe de la Cité* (400). For the significance of the scandal created by the Indépendants, see the *Journal du cubisme* (Geneva, 1982), pp. 74 and 75.

39. See *CP,* sec. 14.

40. Photographed in *P.A.,* pp. 207 and 208.

41. See *Docu,* pp. 375 ff., for the order of Braque and Picasso works of the period.

42. Braque, on his return from Céret, spoke of "my guitarist." In the second Kahnweiler sale, the picture was still known as *Le Joueur de Guitare.* The title *Le Portuguais* did not appear until later. In fact, that autumn Braque spoke of the figure to Kahnweiler as an "Italian emigrant on the bridge of a ship, with the harbor as a background," which illustrates the important changes that can occur along the way.

43. It was clear in my conversations with Picasso that he was afraid only of expulsion. He did not feel that involvement with the police or the courts was a matter of shame; his anarchist background precluded such a reaction. But his scenes with Fernande were another matter. Whenever our talk touched on these, he still grew angry.

Chapter 10

1. Kahnweiler Archives, partially published in *DHK* and *Don.*

2. *CP,* 462. That the painting was not completed until 1912 is no longer—for me—a hypothesis, as in 1979. The inscription CORT certainly comes after Picasso's discovery of Braque's *Portuguais.* See below, n. 4.

3. *CP,* 425 and 426. Breton declared it to have "une élégance fabuleuse."

4. Unpublished Kahnweiler Archives. A photograph taken in Braque's studio at Céret (*Journal du cubisme* [Geneva, 1982], p. 62) shows him at work on the *Portuguais,* which is still without its stencils. The *Homme à la mandoline* is beside it, and *le Violon* (WR, 93) is on the wall. I was unable to identify the other still lifes.

5. *CP,* 423 and 430. We know from the letter to Kahnweiler of 5 June 1912 (*Don.,* p. 167) that *Femme à la cithare* is the title given by Picasso himself.

6. *CP,* 457 and 458. Picasso uses a stenciled number in a small still life *la Glace.* In *le Bouillon Kub* (*CP,* 455), however, he imitates the stencil in painting. Severini's text is taken from *la Vita di un pittore,* rev. ed. (Rome, 1983), p. 107. See another version in *Anth.,* pp. 73 and 74. Picasso's words are in French.

Here are Gertrude's exact words (*AAT,* p. 154): "Just the other day he was talking a long time about the ripolin paints. They are he said gravely, la santé des couleurs, that is they are the basis of good health for paints. In those days, he painted pictures and everything with ripolin paint as he still does."

Severini was not the only one to stress the importance of this change. A discussion between Max Raphael and Max Pechstein in the review *Pan*—between 25 April and 9

May—is extremely significant. Pechstein wrote that "a logical cubist like Picasso must have been attracted by the idea of completely *dispensing* with hues." And Raphael replied:

> A picture by Picasso is a vision. . . . What will you say if I tell you that Picasso has shown me recent pictures in which he uses pure blue and red as the pure substance of painting—not the colour of Matisse, of course, but pure substance in its full force? . . . He does not only seek the cubic element but builds a whole world. . . . It is my firm conviction that Picasso's art must have as its consequence a new aesthetics and a new attitude to life.

Quoted from *Anth.*, pp. 92 and 93.

These texts make it very clear that to visitors Picasso himself emphasized his discovery. This must have disturbed Braque, but their friendship remained unaffected, as was proven during the crisis with Fernande.

7. *CP*, 476, mistakenly dated as from Céret.

8. *CP*, 463–65.

9. WR, 124.

10. See my article "Braque et Picasso au temps des papiers collés," p. 14, and *CP*, 451. Picasso used a real letter sent to him at 11 boulevard de Clichy and reglued the Italian stamp, which had been canceled in Florence. (Soffici was there at the time.)

11. *CP*, 466. At the Musée Picasso.

12. *AAT*, p. 122. *CP*, 456. It was the exhibition "Four Americans in Paris" in 1970 produced the present title.

13. For the arrival of the Futurists in Paris and their relations with Picasso, see my *Journal du cubisme*, p. 78, and Severini, *la Vita di un pittore*, pp. 103–6. According to Severini, Picasso, during a group discussion, shouted out, "One can make a modern subject out of Greek warriors." This anticipates his work after 1917 and establishes its continuity. One can detect Picasso's pictorial influence on Severini, Carra, and Boccioni. He gave them discontinuity of form, essential to their expression of rhythm and movement. Yet nothing indicates that the use of industrial techniques and collage by Braque and Picasso owed something—as has sometimes been claimed—to the *Manifeste technique de la sculpture futuriste* published by Boccioni on 11 April 1912.

According to Severini, Fernande developed a passion for Ubaldo Oppi; but he is wrong to think that Picasso courted Éva in order to console himself for this infidelity.

Picasso was very attached to the dog, Frika. She was the only animal he had sent to Céret. The others, including the monkey, were taken in by Germaine Pichot. See the letter to Kahnweiler, 20 May.

14. *SDI*, p. 315.

15. On 15 June Picasso wrote a long letter to Kahnweiler, of extreme interest for the details it gives of his output before leaving for Céret: "Now here are the pictures I can let you have, with their prices: *La Femme dans un fauteuil avec une mandoline* with yellow and blue [probably *CP*, 236] 300 Fr., and *la Glace* [*CP*, 455] 200 Fr; *la Cotelette* [*CP*, 452] 200 Fr.; and the still life *Bouteille, couteau, fourchette* [*CP*, 477], you know I wanted to keep it, but I'll let you have it for, say, 500 Fr. I'm very attached to it. All of that, at the Blvd. de Clichy, is now for you. At 13 de la rue Ravignan, there are:

1. *Femme dans un fauteuil avec une cithare et un papier à musique écrit Ma Jolie* [*CP*, 430, which establishes that Picasso had taken a studio in the Bateau-Lavoir before Éva arrived in his life] 500 Fr.
2. *Souvenir du Havre*—with writing on the painting [*CP*, 468]; 300 Fr.
3. *Tête de boxeur* [*CP*, 469], 300 Fr
4. *Tête avec un chapeau et des moustaches*, with yellow and ripolin in the background. [*CP*, 468] 300 Fr.

5. *La Nature morte espagnole* [CP, 476].
6. Small panel, 150 Fr.
7. Another small panel with *le Bouillon Kub* [CP, 454], 150 Fr.
8. Small oval painting with oil cloth [CP, 466].
9. The large oval poet in a gold frame [this could only be CP, 422, known as *Homme à la pipe* but actually of a man writing].
10. The *Violon d'Ingres*, to you, with Ripolin [probably CP, 457].
11. *Notre avenir est dans l'air*, with scallops [CP, 464].
12. Violin in *faux bois* [CP, 481; in fact, the only violin in *faux bois*. It can be distinguished from CP, 480, and CP, 483. The last of these is dated Céret/Sorgues].
13. Small still life of *Notre avenir est dans l'air*, with a pipe, and *le Matin* [CP, 463] 150 Fr.
14. *Notre avenir est dans l'air* with a rope. The picture was lost, and refound [CP, 465, which is how Picasso always referred to it later on].
15. The large *Mandoliniste*, extended [probably CP, 425].
16. *Le Soldat et la femme* [CP, 394].
17. Charcoal drawing, *le violon et la bouteille* [CP, 479?].
 [Followed by two unidentifiable works.]
20. Oval drawing of violin, with white on violin [CP, 477].
21. Small oval seascape of a view from the rue d'Orchampt, which had hung in the *salon* [CP, 444] 200 Fr.
 [The list ends with:]
23. The large panel for America. [For the Library of Hamilton Easter Field. Rubin 1989, Appendix.]

". . . I've put several days into writing you this business letter, but we really had to get it all settled." Partial facsimile in *Don,* p. 167.

On the 7th Picasso wrote to Kahnweiler: "My studio is already acquiring character. It is already becoming my studio."

16. A letter from Fernande to Kahnweiler—which he kept—speaks of "violation of domicile," because Kahnweiler had looked for paintings and equipment in the apartment and in the studio. She signs the letter simply Fernande Picasso. For his part, Picasso wrote on 12 June: "And if you see Fernande, you can tell her she has nothing to expect from me, and that I would be very pleased never to see her again."

17. Successively, CP, 482 (signed on the back, Céret-Sorgues), 475, and 460.

18. Successively, CP, 496, 497, 501, and 483. I mistakenly assigned them to the end of the stay at Sorgues. A letter to Kahnweiler of 29 June, published in *Don.,* indicates that they were begun at once. A letter of 11 July tells us that "Picasso is now making white violin holes," which locates *Violon et bouteille de Bass* (CP, 481) at Sorgues and *Violon et raisons* (CP, 482) as well. *Violon* (CP, 483) is traditionally dated to Sorgues (cf. Zervos). The inclusion of a line of plaster in relief seems to me to justify this, although the air holes are still (or are freshly) black.

19. At the exhibition "Picasso, la Provence et Jacqueline" (Arles 1991), I was able to show together for the first time the big gouache *l'Arlésienne* (CP, 496) and its preparatory drawing (Z, XXVIII, 74). Seeing them juxaposed in this way made it clear that during this summer of 1912, Picasso began thinking about a Cubist portrait of Éva, which he painted six months later as the female nude "J'aime Éva." Cf. Pierre Daix: *Picasso, la Provence et Jacqueline: Quatre voyages dans les secrets de la peinture,* Armes, 1991, pp. 24–28.

20. As stated in Rubin, 1989, p. 372, Braque and Marcelle Lapré "began living together sometime during 1911." Although Picasso met Marcelle Lapré before Braque did, there is not the slightest proof that they had an affair as Mrs. Stassinopoulos Huffington asserts. She theorizes about this possibility (p. 108 in her *Picasso*), stating in reference to Picasso's affair with Alice Princet before she met Derain: ["Sharing a

woman—even at different times—was for Picasso always a special bond with his men friends."] This is entirely notional; moreover, the two relationships were highly dissimilar. Alice, who was a very smart young person, did not ask Picasso's permission to fall in love with Derain. (See p. 39, above.) Fernande shared holidays in Cadaquès in 1910 with Alice and Germaine, knowing of their affairs with her lover, Picasso. But Picasso gave Éva her real first name to publicize her position as the first woman in his life (SDI no. 100, p. 314). He would never have placed her in a tricky situation like Fernande's in Cadaquès. Affairs in the Bateau-Lavoir were now things of his past. The arrival of Braque and Marcelle must have been during the last days of July—at the earliest. A letter of 11 August indicates that they did not really settle into Sorgues until they returned on 8 August from a trip to Marseilles.

Once again it was Picasso who awaited the arrival of Braque. On 10 July Picasso wrote to him, "I am already waiting for you," and on 26 July, "You are satisfied with your work and that makes me happy. It's so rare that one is a little sure of oneself. . . . I'm counting on your coming soon to visit." And again, on the 29th, "I am waiting for your visit" (*Docu,* p. 401). This was, in fact, a matter of a visit, as Braque at the outset "wanted to look for a house in l'Estaque, or in another place near Marseilles, but he came back to Sorgues and rented a house" (Picasso to Kahnweiler, 11 August, ibid.).

21. WR, 136 and 121 for the first; 143 and 144, for the other.

22. WR, 148.

23. In the absence of Kahnweiler's letters, we have no knowledge of what messages were sent during Picasso's trip to Paris, which makes details difficult to follow. There is also someone called Louise—perhaps Louise Lenoir ("Odette") of 1900–1901—who seems to be a friend of both Picasso's and Fernande's. In any case, when he came back to Sorgues on 17 September, Picasso had caught a cold because of the *mistral,* and he wrote asking Kahnweiler to "check with the concierge, so that everything will be ready for me to move right away [from the boulevard de Clichy]. Then I'll come to Paris and look for something else." It was, therefore, only at that point that Kahnweiler found the place on the boulevard Raspail.

24. Dora Vallier, "Braque, la peinture et nous."

The question of the birth of *papier collé* has been thoroughly reviewed by William Rubin in his introduction in Rubin, 1989, p. 30ff.: "The Transition of 1912, Paper Sculpture, Collage, and *Papier Collé.*" He stresses in particular the importance of differentiating between the collage of *la Nature morte à la chaise cannée* and *papiers collés* and the role of Braque's paper sculptures in the transition to *papiers collés.*

It is certainly true that the part played by the relief *Guitare* in the development of *papiers collés* at the boulevard Raspail studio (a part stressed by Picasso himself) supports Rubin's interpretation. However, when Braque emphasizes the dissociation of color and form, he is including the Ripolin as used by Picasso in his paintings. In my view, one can no longer dissociate Braque's invention of *papier collé* from his reaction to the return of color with Ripolin in April–May 1912, a change which directly challenges the series *Notre avenir est dans l'air* (Picasso's way of saying to his friend "Wilbur": "our future is in Ripolin").

25. Respectively, *CP,* 499 and 500.

26. In my catalogue of Cubism, I accepted Picasso's statement (reported by William Rubin) that *Guitare* was done before *Nature morte à la chaise cannée.* As I didn't know the pasteboard original, I called the work *Guitare en tôle.* Since then, Edward Fry has shown that it must be contemporary with the photograph in which it can be seen hanging on the wall of the boulevard Raspail studio. In his introduction to *"Primitivism" in Twentieth-Century Art,* n. 57, William Rubin states the current views on this question and associates himself with Fry's thesis, which seems to be a logical gloss on the subject. The metal version is now dated 1913, perhaps even to the period of constructions at the end of the summer.

In light of all the changes of date due to the Kahnweiler Archives, I am inclined to believe, now, that the pasteboard construction must—like the constructions of 1913— coincide with the move from the rue Schoelcher; that is, with the moment when material conditions kept Picasso from painting but not from tinkering, from *bricolage*. The end of the stay in Sorgues must have been devoted to finishing *l'Aficionado*, as Picasso told me it was. And probably to linked paintings like *Homme à la guitare* and perhaps *le Modèle*. These appear side by side, beneath *le Poète* and two guitars in a new, slender figuration, in oval canvases, in the photograph which seems to be a farewell to Sorgues. A telegram sent on the evening of 23 September, discovered by Judith Cousins at Kahnweiler's, gives us the date of Picasso's return to Paris. This means that upon his return to Sorgues with a cold, Picasso had very little time in which to embark on a new creative adventure.

27. Cf. Mark Roskill, *The Interpretation of Cubism*, Philadelphia, 1985, p. 57.

28. Ibid. pp. 52, 53.

Chapter 11

1. For changes in the chronology of travels by Braque and Picasso recognized at the present time, see *Docu*, pp. 410–12.

A letter to Gertrude Stein of 18 September (*Docu*, p. 403) states that Picasso met Tchukhin during his trip to Paris and that the picture bought was "much like the large red-style painting at your place," which is to say, the *Trois Femmes*. This, in my view, strengthens the identification which I and Isabelle Fontaine have both made. See *Docu*, note Picasso 150, p. 443.

DHK, pp. 110 and 112. The vastness of this sum was not at all grasped in Paris. In 1913 Kahnweiler would sell *l'Acrobate à la boule* of 1905 to Morozov for thirteen thousand francs. But a wider understanding of the true dimensions of these prices began with the sale of the *Famille des saltimbanques* in 1914. See chap. 12 of the present work.

2. See my *Journal du cubisme*, pp. 69–98.

3. *CP*, 492–94, for *les Pigeons*; 496, 497 and 500 for *l'Arlésienne* and *l'Aficionado*; 488–90 for the geometrized paintings; *CP*, 499, for *le Poète*.

4. *CP*, 541. This reconstruction of a face is to be compared with the portrait in a study for *la Femme en chemise dans un fauteuil* done at the end of 1913 (*CP*, p. 143), and *le Peintre et son modèle*, Avignon, 1914 (*CP*, p. 165). This is the Éva theme.

5. *CP*, 509, for the canvas. At the time of writing, I was unaware of the letter of 9 October and through stylistic analysis alone arrived at the conclusion that the picture was done before the advent of *papiers collés*.

CP, 507 for the oil painting; 508 for the *papier collé*; 506 for the assemblage; 510 for the second oil painting. Cf. Rubin, 1989, pp. 255–57.

6. *CP*, 513. The difference of approach with Braque's *papiers collés* is obvious. Picasso applied experimental results achieved with lacquer to Ripolin and to collage.

7. Respectively, *CP*, 514–16. I am certain that these three violins follow the invention of *papier collé*, like so many proofs of its power.

8. See the fine study by Françoise Will-Levaillant, *La Lettre dans la peinture cubiste*, Université de Saint-Etienne, Works 4, *le Cubisme*, 1973.

9. *PL*, p. 124ff. Patricia Leighton has discovered in *Bouteille de Suze* a newspaper clipping in which one reads that

> the speakers listened to with the greatest attention were at first the foreigners: among them M. Schneidemann [a leading German socialist], who affirmed that the German proletarians will not fire on their French brothers. . . . M. Sembat [the socialist who had just defended Cubism in the Chamber of Deputies] ended his speech affirming that the workers ought not to seek death "for the capitalists and the manufacturers of arms and munitions."

The ideas defended here are socialist rather than anarchist. Picasso adhered to them faithfully and did not join up in 1914 when so many other French and German socialists—as many French as German—rallied in each country to the "sacred union" of patriotism. See chap. 13.

10. *CP*, 551 and 552. The newspapers are from December 1912.

11. As Isabelle Monod-Fontaine points out (*Don.*, p. 170), this contract, in which Picasso engaged himself for three years "to sell nothing to anyone except you," makes an exception for five canvases a year and drawings "which I may consider necessary for my work." Picasso also reserved for himself the right to decide when a picture was finished. She emphasizes "the almost obsessive concern with keeping for himself such works he may require for the pursuit of his career, a concern confirmed as part of a convention which binds him in a very precise and detailed manner."

A comparison with the contract signed by Braque on 30 November (which can be made by referring to *Docu*, pp. 411 and 412) shows that Kahnweiler was offering Picasso roughly four times as much money as he offered Braque for work of the same dimensions. And at this date Picasso, unlike Braque, had not organized his *papiers collés* as a separate group for the sale.

12. Cf. Rubin, 1989, pp. 270 and 279.

13. Picasso glued canvas onto canvas in *Violon guitare* (*CP*, 574). See Rubin, 1989, p. 272.

14. See *Cubism*, p. 118, and n. 136 of my introduction to *CP*. Respectively *CP*, 570, 573, 571.

15. *CP*, 579. Probably the most successful of the "portraits" of the *papiers collés* period.

16. See Rubin, 1989, pp. 273, 274, and 277.

17. *CP*, 578, and Rubin, 1989, p. 280.

18. See Robert Rosenblum's decisive article, "Picasso and the Coronation of Alexandre III. A Note on the Dating of Some Papiers Collés," *The Burlington Magazine*, October 1971, and the section in *CP* devoted to "the second generation of papiers collés," pp. 300–306.

19. These are the only cases in which *papier collé* and painting recopy each other; cf. *CP*, 589 and 590, for the *Tête de jeune fille*; 617 and 618, for *l'Arlequin*. *L'Homme à la guitare* is *CP*, 616.

20. Picasso had written to Braque in October, at the publication of Salmon's book: "He is revoltingly unjust to you" (*Docu*, p. 410). It is to be noted that in the middle of this new agitation, Picasso used the occasion of St. George's Day to write to Braque on 23 April, excusing himself for not writing more often—a lapse due to anxiety at the ill health of his father. "It's really too bad the phone in your place doesn't reach Céret. Such good conversations about art . . ." (*Docu*, p. 416).

21. *Docu*, p. 417.

22. See *papiers collés*, *CP*, 611 and 612.

23. It was certainly in August 1913 that Picasso came to blows with someone in his group of friends at Céret and not in 1912, as he told me.

Chapter 12

1. See Barr, *Matisse, His Art and His Public*, p. 146.

2. Ibid., p. 147. This competition had been freely stressed by disciples and faithful camp followers on either side. Picasso, on the whole, probably countenanced rather than engaged in such talk; but every so often permitted himself a malicious witticism which was instantly repeated. However, he had no intention of exposing his private relations with Matisse—artist to artist—to public scrutiny. These were his professional secrets,

secrets of fabrication, and it is difficult to see who in 1913 would have had access to them, other than Éva. Apollinaire at that time was feeling the unsettling effects of an insolent Futurist manifesto which he published on 29 June and simultaneously the difficulties of an attempt (which failed) to repair relations with Marie Laurencin. He and Picasso would meet again on 20 September and saw each other frequently thereafter. On Matisse and Picasso's Cubism, see Pierre Schneider, *Matisse* (Paris, 1984), esp. p. 413.

3. *CP,* 630.

4. *CP,* 631–633. Rubin, 1989, thinks this last assemblage precedes the departure for Céret; but I see no reason to separate it from the others.

5. *CP,* 634.

6. *CP,* 619–21, for *l'Étudiant;* 635–42, for *la Femme en chemise;* 637 and 638, recto and verso, for the appearance of the face.

After Éluard's comment about breasts "nailed" to the chest, a somewhat sadistic interpretation of *la Femme en chemise dans un fauteuil* prevailed. Studies of this picture leave no doubt that Picasso began with the idea of doubling the breasts—a perpendicular orientation of their "European" to their "African" version. He transformed European nipples into pegs or plugs, one of several elements in the conceptual depiction of this woman. The hand holding the newspaper and the legs are similarly—to coin a phrase—"woodified."

This, too, is a process which prefigures Surrealism, particularly Picasso's in *Une Anatomie,* a sequence of drawings published in *Minotaure* in 1933. This *chosification* (thingification), particularly of women, although certainly far from innocent, has a rather playful quality, which is confirmed by other paintings, especially the *Ma Jolie* series. See chap. 21, p. 221.

7. See chap. 11, n. 3.

8. Respectively, *CP,* 650, 649, 648.

9. *Docu,* pp. 423, 424.

10. *CP,* 746. This is the designation given by Picasso, in conversation, when he learned that Penrose (who bought the work from Paul Éluard) had been burgled.

11. The Kahnweiler Archives date these glasses very precisely to before leaving for Avignon. See Spies, p. 71ff.

12. I have studied in detail communications between Picasso and Juan Gris in reference to the latter's 1985 retrospective in Madrid. See the catalogue *Juan Gris* (Madrid, 1985). With Boccioni, Severini never missed an occasion of the *Soirées de Paris.* He knew Picasso—from 1910, at least—through Apollinaire. It was he who brought Boccioni to Picasso's in 1912. His *papier collé,* using the review *Lacerba,* was done at the same time as Picasso's.

13. See *CP,* 737–42, with the single exception of *Guitare, crâne et journal,* 739, a disquieting canvas because of the skull and the tonality of mourning. I particularly remember from talking to Picasso about it that the skull here is indeed a death's head, not a mask. As the skull has female tresses attached to it, I have wondered whether the painting might not reflect an early stage of anxiety over Éva's health. There is a related drypoint for Max Jacob's *le Siège de Jérusalem,* published by Kahnweiler in early 1914.

14. See *L'Ordre et l'aventure* (Paris, 1984), part 2: "la Guerre comme Apocalypse."

15. *Entretiens avec Francis Crémieux,* pp. 73 and 74.

16. This is made particularly clear in Zervos, vol. XXIX, published in 1975, after Picasso's death, a case of delayed publication, not self-censorship. See Z, XXIX, 77; and probably Z, XXIX, 154–60.

17. *CP,* sec. 17, esp. 778 and 782.

18. *FY,* p. 89, and *CP,* pp. 161 and 162: "Anticipation of Surrealism."

19. *CP,* pp. 164 and 165, which first showed the unfinished canvas, and Z, XXIX, 160.

The drawing for *Femme couchée,* first shown in *SMP,* 101, dated November 1915, refers to Éva's illness, as noted by Reinhold Hohl. But the facial mask links Éva—or her memory—to the whole sequence of watercolors of seated women, more or less transformed, which seemed to me (*CP,* 857–69) to belong to the winter of 1915–16. In the same way, the remodelings of the body confirm what one might call another approach to Éva (or to her memory) in the drypoint *Femme nue* for Max Jacob's *Siège de Jérusalem.* Consequently the *Femme au corset lisant un livre* (*Z,* III, 105), begun at Avignon and reworked on and off during the winter of 1917–18, together with the large portraits of Olga (see chap. 15), can be attached to what might be justly termed an Éva cycle. Which only reemphasizes the fact that this painting never left Picasso's studios. Given what we know of Olga's retrospective jealousy, Picasso had no desire to reveal the extent to which Éva haunted his painting and had been a factor in his return to portraits. We now are the first since Picasso's death who can truly perceive Éva's role in the associations between figurative reworkings of Cubism and a feminine image.

20. *CP,* 766.

Chapter 13

1. Kahnweiler's text is taken from a 1919 letter to Derain quoted in *DHK,* p. 123.

Picasso always eluded my questions about this period, which must have been—at least in August and September—one of profound discouragement. My classification in section 21 of *CP* is strictly stylistic, and is complicated by his habit of starting several canvases at the same time and finishing them as he went along, which sometimes meant years later. The change of light between Avignon and Paris in the fog and cold of autumn explains the "coldness" of *Guitare, As de trèfle, Verre et journal* (807). (Guitar, Ace of Clubs, Glass, and Newspaper.)

Gris's letter appears in *Docu,* p. 432. Kahnweiler remarks (*Entretiens avec Francis Crémieux,* p. 73), "Picasso still tells me quite often that everything achieved between 1907 and 1914 could only have been done by a group effort. To be isolated, alone: that must have been highly disturbing for him, and that is when he shifted [toward a form of classicism]." But Picasso himself says that this change took place in the spring of 1914 (cf. n. 15, chap. 12, above). In fact Kahnweiler did not understand that Picasso's isolation vis-à-vis Braque began earlier, and that it was not a cause but a consequence of change. All of which demonstrates, once again, that even before the war imposed a definitive parting of the ways, the profound intimacy of 1912 between Braque and Picasso had already been broken.

2. *CP,* 801. Compare *CP,* 800.

3. Ibid., 646. After studying the picture at the Museum of Modern Art in New York, I was convinced that even though the work must have been started in the spring of 1914, the "surrealist" quality of the arm, the easy casualness of the face, and, above all, the "cold" colors suggested completion in the autumn. William Rubin recalls (*MOMA,* p. 91) that, according to Kahnweiler, it was the Russian packing, when some of his work was sent back to Paris, which gave Picasso the idea of using Cyrillic letters. Hélène d'Oettingen, the young widow of a Baltic baron, a painter and a writer, had a colorful and generous personality and a marked taste for artists. Gertrude Stein writes of this period that Éva and Picasso

> had no distraction other than letters from Guillaume Apollinaire, who was falling off his horse and trying to become an artillery soldier. They had no close friends except for a Russian to whom they gave the name G. Apostroff (for Jastrebzoff), and his sister, the baronne. These two Russians, when Rousseau died, had bought all the pictures in the studio.

4. Gertrude Stein tells of a dinner at the Rue Fleurus, at the end of 1914, which was interrupted by a Zeppelin raid. "Éva was not feeling very well just then, and was

frightened" (*AAT*, p. 171). The two quotations which follow are from *AAT*, pp. 119 and 99, successively.

5. *Picasso et la tradition française* (Paris, 1928), p. 28.

6. See above, n. 3. Drawing reproduced in the catalogue *De Chirico* (New York, Museum of Modern Art, 1982), p. 66. Picasso is seated between the baroness and Leopold Survage (1879–1968, a Cubist painter of Russian origin). For relations between Picasso and De Chirico, see William Rubin's article in this catalogue, "De Chirico and Modernism." Also Marie-Laure Bernadac's publication of the *Carnet de De Chirico du Musée Picasso, Cahiers du musée national d'Art moderne*, Paris, 84/13. Picasso bought it from Éluard, probably between 1936 and 1940.

Max Jacob's *Portrait* is Z, VI, 1284.

7. Vehicles for hire were called *fiacres* because an image of Saint Fiacre (a hermit who became a popular saint in France as a patron of gardeners) was put up in Paris near a hiring booth in the seventeenth century. Picasso did not push the joke through to the end, and Max was baptized Cyprien.

8. This portrait was shown as no. 10 in the review *Élan*, in December 1916, which brought down on Picasso's head the attacks of *Bonnet Rouge* and of *391*, Picabia's review. See Étienne-Alain Hubert, "Pierre Reverdy et le cubisme en mars 1917," in *la Revue de l'art*, no. 43, 1979. This last piece argues with my interpretation of Reverdy's condemnation of the portrait because I observed that he was unaware at the time of Picasso's position (see my text "Le retour de Picasso au portrait," in *le Retour à l'ordre, 1919–1925*, works 7 (Université de Saint-Etienne, 1975) and the revised version: Pierre Daix: *Die "Rückkehr" Picassos zum Portrait (1912–1923)* in *Picassos Klassizismus* (Bielefeld, 1988). "What is condemned here," Reverdy wrote, "is portraiture done with Cubist methods." But in vol. III of Zervos, at the beginning of 1917, one finds—beside real portraits of *Nu dans un fauteuil* (III, 2 and 3)—the entire range of methods for cubifying a portrait (III, 5–8). For Picasso the problem of returning to Ingresque portraits was not resolved until Olga—first in Barcelona, then at Montrouge. Three years, that is, after Avignon, and two and a half years after Max Jacob.

9. *CP*, p. 170. See my text "Die *'Rückkehr'* Picassos zum Portrait," pp. 137–44.

10. *CP*, 612, 613.

11. I noted in my article "Gris et Picasso" that the neutral tones of what I call *le cubisme froid*—Picasso's "cold Cubism" at the beginning of the war—were quite close to Gris's palette. Gris's still life is dated June 1915. It seems to me impossible that this conjuncture should have been fortuitous. *CP*, 814.

12. *CP*, 842.

13. Ibid., 844.

14. Ibid., 846–50.

15. Ibid., 857–69.

16. Ibid., 878–84.

17. Ibid., 886 and 889.

18. Z, VI, 1277–79. For Gaby's face, see Z, VI, 1280 and 1282.

19. Z, XXIX, 163. Picasso himself told me what he had drawn. According to him, he was still living a stone's throw away, in the Rue Schoelcher, which he left at the end of spring 1916. And he dated the scene "autumn," which implies the autumn of 1915. His affair with Gaby seems to have lasted for several months.

20. See John Richardson, "Picasso's Secret Love," *House and Garden*, September 1987, pp. 174–83; and a summary of the affair in the album of Billy Klüver and Julie Martin, *Kiki et Montparnasse* (New York, Paris, 1989), p. 72. The adventure had two sequels.

The first took place in or around 1968. Gaby Lespinasse, who was then a widow, arranged to meet Picasso at one of the large cafés in Saint-Tropez, where she was still

living. Picasso, who arrived with Jacqueline, found that Gaby had come with two friends, both of whom were more or less her age. All three waved at him. Somewhat dismayed, Picasso whispered to Jacqueline, "But which one is she?" Jacqueline laughed. "Pick the one who's staring at me with the most disagreeable expression."

"Jacqueline was right," Picasso told me. "That was the one."

The second incident occurred after Gaby's death, in the 1970s. A dealer appraising her collection showed me—with considerable distrust—a picture signed Picasso which, he said, he had unearthed from among the cobwebs. This was a splendid *Pivoine* (Peony) of 1901. (See Appendix, no. 28). Picasso had evidently been extremely taken by her.

21. See note 18, above.

Chapter 14

1. The definitive work on the period is still Douglas Cooper's *Picasso-Théâtre* (Paris, 1967). Giovanni Carandente's "Picassos italienische Reise," published in *SMP*, provides precisely detailed information about the Italian journey.

2. The move took place in July 1916. Diaghilev's visit, at the end of May, was to the rue Schoelcher. It seems, however, that Picasso kept a pied-à-terre in Paris, at least during the first part of his stay at Montrouge. At the time, of course, he was still a single man.

3. The exhibition at the Salon d'Antin took place in 1916. See my *Journal du cubisme*, p. 138.

4. These can be found at the end of Zervos, vol. II, and the beginning of vol. III.

5. Paquerette was in fact a model at Poiret's. There is a photograph of her and Picasso with Ortiz de Zarate, Kisling, and Max Jacob at Montparnasse. See *Album Cocteau* (Paris, 1970), p. 26.

Billy Klüver and Julie Martin's album, *Kiki et Montparnasse,* op. cit., pp. 2–3 and 73–75, includes the photographic record of 12 August 1916, made by Cocteau and Picasso. Before the arrival of Salmon and Modigliani, Paquerette figures prominently with Max Jacob, Ortiz de Zarate, and Kisling.

6. It is unlikely that Picasso saw the drawings Ingres did of the Villa Médicis; they were not exhibited until 1925.

7. Giovanni Carandente, in *SMP*, revived the question of sources not only for *l'Italienne* but for later works as well, indicating works in the genre Picasso could have seen in Roman museums, especially Alberto Collina and Bartolomeo Pinelli.

8. For the complete range of the relationship with Stravinsky—an extremely rich one—see *Strawinsky, sein Nachglass, sein Bild* (Kunstmuseum, Basel, 1984). Giovanni Carandente has established that the trip to Pompeii took place at the end of March; and to Naples, between 15 and 27 April. Picasso also spent 30 April in Florence, where he saw the Medici chapel, with tombs by Michelangelo.

9. As Douglas Cooper has shown—and contrary to what Picasso's statements might lead one to suppose—the photograph of Picasso with his assistants, including the Italian painter Carlo Socrate (1889–1967), was taken at a studio in Montparnasse.

10. In addition to Cocteau—in works like *Le Coq et l'Arlequin* and *Picasso*— Patrick O'Brian's biography *Pablo Ruiz Picasso* (London, New York, 1976) is very well informed on this period.

11. For the return to Barcelona, see Palau i Fabre, *Picasso en Catalunya*, rev. ed. (Barcelona, 1978); *Picasso i Barcelona,* and, above all, *Homage to Barcelona*, pp. 183–209.

12. See preface and commentaries by Douglas Cooper in *Pablo Picasso: Pour Eugénia* (Paris, 1976).

If Gertrude Stein is not making a chronological error, Picasso met Eugénia earlier, just after his return to Paris during the summer of 1917. See *AAT,* p. 183:

> Picasso was now living in a little house in Montrouge. We went out to see him. He had a marvellous rose pink silk counterpane on his bed. Where did that come from, Pablo, asked Gertrude Stein. Ah ça, said Picasso with much satisfaction, that is a lady. It was a well-known Chilean society woman who had given it to him.

13. See *MPB*, pp. 677–83 for the Barcelona period. See Z, III, 32–38, for the changes in Olga's hair; 38–40 for adjustment and finishing of the mantilla; 42, for Olga on her balcony in front of the Paseo de Colón; Olga in an armchair, prepared by Z, III, 39, is *SMP,* 112.

14. Z, III, 26–28.

15. Z, III, 50–65.

16. Z, III, 102.

17. O'Brian, *Pablo Ruiz Picasso,* p. 289.

18. *SMP,* 105. I don't feel it is necessary to put the unpublished portrait of Olga reading (Jacqueline Picasso collection) back to 1920, as Louise d'Harnoncourt does in *RM,* 7, specifically because *Éva au corset lisant un livre* had been finished. Opposing a classical Olga to a Cubist Éva was more in line with Picasso's character.

19. Respectively, Z, VI, 1335, and Z, III, 83.

Chapter 15

1. Through Jeanine Warnod I was able to find the catalogue for this exhibition, which I analyzed in my *Journal du cubisme.* Jean Bouret and Mme Domenica Walter assured me that the archives of Paul Guillaume no longer contained anything connected with this event.

2. Apollinaire's letter is quoted in the catalogue *Oeuvres reçues en paiement des droits du succession* (Paris, 1979), pp. 95 and 96. *Picasso Ombre et Soleil,* by Pierre de Champris, was published in Paris in 1960.

3. In this regard, see text by Jean Laude in *le Retour à l'ordre;* cf. note 8, p. 402, above, and my book *l'Ordre et l'Aventure,* Paris, 1984, part 2.

4. Z, III, 242. *Mme Wildenstein* is not in Zervos. Cf. Pierre de Champris, *Picasso Ombre et Soleil,* p. 27.

5. Z, III, 242, at the Fogg Art Museum.

6. Z, III, 237, at the Musée Picasso.

7. Cooper, *Pour Eugénia.*

8. *Cahiers d'Art,* 1947, pp. 142, 143.

9. Salmon was trying to court fashion. As for Cendrars, he launched *"le cube s'éffrite";* on his account Max Jacob refused to collaborate on *La Rose rouge.* "I cannot appear beside the enemies of Cubism" (see Jean Laude, *Le Retour à l'ordre*).

10. The quotation from Apollinaire is taken from the *Jolie Rousse* of early 1918. The Lutétia, at the time, was a prestigious and brand-new hotel.

11. Sabartès, *SDI,* p. 122.

12. In Z, XXIX, 338–43, and 345, one can see what amounts to a "taking possession" of the place: two views of Olga's floor, with the left-hand corner done in enlarged detail with a small, round table, a bird cage, and Picasso in sports clothes.

13. Z, III, 262.

14. *Pierrot,* Z, III, 137, at the Museum of Modern Art. Picasso kept *Arlequin jouant de la guitare,* first revealed by Rubin, 1980, p. 207; *Si tu veux,* Z, III, 160, Cleveland Museum of Art; *Nature morte sur la commode,* Z, III, 443; *Nature morte au pichet et aux pommes,* first disclosed at the exhibition of "Oeuvres reçues," *CS,* 59. The striped

space in *Table, guitare, et bouteille* (Z, III, 437) is particularly striking and remarkable. *Les Amoureux,* which were not shown until 1979, are Z, III, 438.

15. Bissière (1888–1964) became an appreciated abstract painter at the end of his life. For the Braque affair, cf. Jean Laude, *Retour à l'ordre.*

16. See Rubin, 1980, and *MOMA.*

17. Z, III, 165. Bought by Paul Rosenberg and then moved to the Heinz Berggruen collection.

18. Z, III, 371.

19. In addition to Laude's *Retour à l'ordre,* I have relied on the analyses of André Fermigier, in particular those in his *Jean Cocteau, entre Picasso et Radiguet* (Paris, 1967) and his *Picasso* (Paris, 1969). See also, n. 9, above. The watercolors from *Balcon* are scattered through Zervos between vols. III, VI, and the end of XXIX. The two lithographs are Mourlot, 1 and 2.

20. Sometime after 16 December 1918, in Delluc's magazine *Film,* Aragon wrote an article, "Du decor," in which he is the first to stress the importance of *papiers collés.* The piece also suggests the close attention paid at this time to Picasso's work by the group which considered itself the precursor to the Surrealists. See my book *Aragon, une vie à changer* (Paris, 1975). *Le Salon d'Olga* is Z, III, 427. Sabartès accompanies it with a drawing of the dining room "at a formative stage" and stresses its "desolation." "The room," he says, "is decorated in a way which is foreign to Picasso, because he had only been married a short while and had not yet had time to impose his own style." See n. 12, above.

Chapter 16

1. See Michel Sanouillet, *Dada à Paris* (Paris, 1965).

2. There are some ten gouaches in all, with no difference in quality between Paris and Juan-les-Pins. See my *Vie de peintre,* chap. 21, n. 11.

3. *DHK,* p. 129. Contrary to Jean Lescure's account in *Album Malraux* (Paris, 1968), p. 68, Malraux did not become "director of publications" of the Kahnweiler Gallery. He and Kahnweiler were simply friends.

4. Z, XXX, 88, 89, 91, 92, 98; and Z, IV, 97.

5. Perhaps the project of decor, Z, XXX, 47.

6. Cf. Z, XXX, 85, 86, 90; Z, IV, 107, today at the Musée Picasso.

7. Z, XXX, 88, 89, 91, 92, 98, and Z, IV, 97.

8. Z, IV, 161, 163, 165, 169, 172, and 173. The date corrected by Zervos, but after 1949.

9. *Le Rapt* is Z, IV, 109. See *MOMA,* pp. 110, 111, and 217. Also, the gouache, Z, XXX, 104, and Carandente, "Picassos italienische Reise," p. 77. The *Femme assise (CS,* 61) is dated November 1920, from the drawing Z, XXX, 122. This figure seems to have been the origin of the *Géantes,* with its highly exaggerated feet and hands and the brutal modeling of the peignoir.

10. Z, IV, 202, for the pastel, published, strangely, as *Adam et Ève* in *le Révolution surréaliste,* no. 5, October 1925; Z, IV, 217 for the painting from the Chrysler collection. The series was begun in April 1920, with Z, VI, 1404. Compare Z, IV, 55, 56, 58, 201, 224. And pointillist variations in Z, XXX, 62.

Walter Chrysler also owned the monumental *Deux Femmes assises* (195 x 165 cm.), which Barr places reasonably enough at the beginning of the *Géantes.* These, dated 1920, developed from the previous series. For the *cheminées* theme, see Z, XXX, 163 and 164; Z, IV, 209, at the Musée national d'Art moderne.

11. For the *Femme au tablier* Z, IV, 14, and *SMP,* 122.

12. *CS,* 60. Compare notebook Z, XXX, pp. 194–214.

13. The sanguine is Z, XXX, 265. Compare the portraits Z, XXX, 140, 145, and 150; but also, Olga threading a needle, Z, XXX, 127; probably Z, XXX, 134 and 126 as well.

14. Z, XXX, 158, in March; Z, XXX, 215, 240, and 241, in April; and 243, on 14 May. A later version, Z, XXX, 255 and 256, suggests that Picasso thought to give them the modern aspect one sees in *la Femme au chapeau tenant un livre.* See below, n. 17.

15. Compare Cooper, pp. 49 and 50, refuting the version that has Picasso collaring the job—to Gris's loss.

16. "Picasso's Three Musicians, Maskers, Artists and Friends," by Theodore Reff, was published by *Art in America, Picasso, Special Issue,* October 1980. For background, see *MOMA,* pp. 112–17, 218–20.

17. Dominique Bozo's observation is taken from his preface to the catalogue *Oeuvres reçues,* p. 16. *La Lecture de la lettre* is *CS,* 67; *La Danse villageoise, CS,* 73. Only the *Femme au chapeau,* also kept by Picasso (and sometimes known as *Femme au missel*) figured in Z, IV, 365. It is striking that Picasso should have kept practically all the significant works of his return to Classicism, not simply for their beauty but for their visible representation of audacity. The *Trois Femmes à la fontaines* of the Musée Picasso (*CS,* 74)—like the *Lecture de la lettre*—was not seen publicly until the inventory of studios after Picasso's death.

18. Respectively, Z, IV, 329, 309, 382. *Le Chien et le coq,* is Z, IV, 335.

19. As early as 1920, John Quinn bought the violinist *Si tu veux* at Paul Rosenberg's for forty-five thousand francs. See Sarah McFadden and Jeffrey Deitch, "The Midas Brush," in *Art in America, Picasso,* which gives a chronology of prices paid.

20. One need only compare *Femme et enfant* of 1921 (*SMP,* 128) with the *Maternité* of Dinard (Z, IV, 391 at the Baltimore Museum, and Z, XXX, 265). See n. 12, above.

21. Z, IV, 448, completed in Paris, 1923.

22. *CS,* 74.

Chapter 17

1. Jardot, notice 40.

2. Z, V, 15 and 14.

3. Z, V, 17, 23, 37, 135.

4. For information about Gerald Murphy I relied on Calvin Tompkins, *Living Well Is the Best Revenge* (New York, 1962), with additional details from confidential conversations with Picasso. Quoted remarks are taken from these.

5. Z, V, 141; *CS,* 76.

6. *Femme assise en bleu et rose,* Z, V, 2, and *Portrait de femme,* which is not in Zervos. Jacqueline Picasso collection, shown in Aix-en-Provence, July 1984.

7. For Surrealism in 1923, see my biography *Aragon, une vie à changer,* pp. 140–55; and Sarane Alexandrian, *Le Surréalism et le Rêve* (Paris, 1974). For Breton's role in the purchase of the *Demoiselles,* see François Chapon, *Mystère et splendeurs de Jacques Doucet* (Paris, 1984), esp. pp. 292–99, which display the documents I quote.

8. Z, V, 90 and 89. Barr emphasized that Cubism depends fundamentally not on the character of forms—whether they have straight lines or curved—but on the combination of other factors like the flattening of volumes and spaces, the overlapping and interpenetration of planes, the simultaneity of viewpoints, disintegrations and recombinations, and, more generally, independence in regard to the nature of color, form, space, and texture—all of these without entirely abandoning references to nature (*FY,* p. 132).

9. I made an inventory of these in my *Vie de peintre,* pp. 190–91.

10. Chapon, *Mystère et splendeurs de Jacques Doucet,* p. 292ff.

11. Z, V, 187 and 188. The second of these is at the Musée Picasso.

12. Z, V, 185; dated 16 May. See *MOMA,* pp. 119 and 121.

13. Z, V, 220.

14. Z, V, 268.

15. Z, V, 462. See notice 63 in Jardot, which makes the first accurate assessment of this crucial period. Today, *CS,* 78, dated spring 1924.

Henceforth, the *Nature morte à la guitare et au compotier* must be included. The painting, which was not previously catalogued, was first shown in *RM,* 9. The treatment of the impasto produces charcoal-like effects, combined with a purity of linear drawing—another instance of Picasso's experimentation, which was of far greater scope and was far more systematically approached than is generally held to be the case.

16. For the problems posed by the *Three Graces,* see my *Vie de peintre,* p. 194, n. 26.

Chapter 18

1. François Chapon, *Mystère et splendeurs de Jacques Doucet,* pp. 299–300.

2. Ibid.

3. Ibid.

4. Z, V, 364.

5. Z, V, 372 and 380, for the palette; 377 and 375, for the musical score; this second time, with the marble arm.

6. Z, V, 375; see above.

7. Z, V, 445. See *MOMA,* pp. 121 and 221, which quite correctly compares the bust in this still life to De Chirico's *Promenade de philosophe,* and the plaster limb to his *Autoportrait, 1913.*

8. Pierre Naville launched this debate by writing, "There is no Surrealist *painting.* Neither lines traced at random with a pencil nor images recapturing the content of dreams nor imaginative fantasy can be so qualified." On De Chirico, see also Max Morise's article in the July issue of *la Révolution surréaliste.*

9. Z, V, 84, and Z, V, 320.

10. Cooper, pp. 68ff. For *la Danse,* since its arrival at the Tate Gallery in 1965, there has been a considerable flowering of studies by English authors. First, Lawrence Gowing in the *Tate Gallery Report, 1964–65;* and R. Alley, *The Three Dancers,* Charlton Lectures on Art, 1967. Then, John Golding, *Picasso and Surrealism;* and Françoise Will-Levaillant, *"la Danse* de Picasso et le surréalisme en 1925," in *"l'Information de l'Histoire de l'art,"* no. 5.

11. We should note, however, that it was published as *Jeunes Filles dansant devant une fenêtre.* Picasso can't verify such a title.

12. *Le Baiser* is *CS,* 81. The other works are, respectively, Z, V, 415 and 451.

13. Z, VII, 2, given by the artist to the Musée national d'Art moderne in 1947.

14. Z, VII, 30 (*CS,* 82).

15. In fact, reworkings of this young face can be found in the painter of *Peintre et son modèle* as well as in certain Harlequins of the time. This contributes greatly to the interest of the drawing first shown in the exhibition "Picasso at Work at Home, Selections from the Marina Picasso Collection," organized by Gert Schiff and held in Miami from 19 November 1985 to 9 March 1986. This drawing—no. 51 in the catalogue—is a bridge between the dissociated profiles of *La Leçon de dessin* and those of 1926. The other *Portrait de jeune garçon*—this one, a painting—is no. 52 of the catalogue. Gert Schiff rightly links it to Paulo but emphasizes as well the violence in the strictly pictorial working of color, and of the impasto, which suggests a derivation from the *Autoportrait* of 1907.

16. These constructions were first shown in 1979, in the exhibition "Oeuvres reçues." They are catalogued as *CS,* 249–58. One should add to these *SMP,* 142.

17. Publication which was clearly by way of provocation toward Olga. The Surrealists' radicalization made them odious to her.

18. Among the paintings dated Juan-les-Pins, 1926, the *Femme à la collerette (CS,* 83), pure recomposition, with one side of the face creased by a vulva. The Harlequins are from Z, VII, 69, 70, 73—which I describe—and 74; to Z, VII, 80.

19. See my article "On a Hidden Portrait of Marie-Thérèse," *Art in America,* September 1983. This large still life was shown in Basel in 1976.

Conjectures on Picasso's Philosophy at This Critical Juncture

1. I am bearing in mind his remark to Zervos during the crisis of 1935: "One cannot oppose Nature; she is stronger than the strongest man. We all have a stake in being on good terms with her. We can permit ourselves an occasional liberty, but only about details."

For Picasso the material reality of painting—pigments, support, collages, etc. was part of Nature. He was also well aware that, as he put it to Marius de Zayas in the winter of 1924–25,

> work often expresses more than its author had intended, and he finds himself astonished by results he had not foreseen. The birth of a work of art is sometimes a form of spontaneous generation: the drawing may penetrate the object, or the colors may suggest forms which, in turn, will determine the subject.

2. I am schematizing a thought more completely expressed in the article "Forme et Vision," published in Germany in 1919 and translated by Denise Naville in *Confessions esthétiques* in 1963:

> What, then, is this external empirical world, the world of bodies which preoccupies us? It is a product of our imagination [underlined by Kahnweiler]. Whether one conceives of the external world as the contents of many individual awarenesses or as a *thing in itself,* whose outer appearance is all that can be grasped; or of physical objects as having *primary* qualities to which *secondary* qualities are added by consciousness—everyone will agree that, in the forms with which we perceive it, that external world is a product of our imagination. And, this product . . . is composed of successive *experiences* which are the images retained by memory; they present themselves in response to fresh *stimulants* to conjugate with these a fresh creation. For our vision of the external world is always a re-creation; we re-create with every glance.

One can appreciate the intellectual support Picasso was able to find in such theories, validating his need to invent the forms his painting provoked. And we should bear in mind that when they were both in Paris, he and Kahnweiler saw each other on an almost daily basis. Kahnweiler had disapproved of the confrontations with Classicism. Picasso's change of course in 1924–25 renewed and strengthened their relationship. The intellectual content of this connection must also be taken into account.

As John Golding and Fry both observed in the pages of their *Cubism* (p. 33 for Golding; pp. 74–75 for Fry), Olivier-Hourcade, a young critic from Bordeaux (born in 1892 and killed in the 1914 war) played an important part in the formulation of Cubist theory. In February 1912, with an article—"La tendance de la peinture contemporaine"—for the *Revue de France et des pays français,* he was the first to turn to Kant for an illumination of Cubism. Although the article was in fact about Gleizes and Lhote, it is an indication that these ideas were in the air, and one can be confident that Kahnweiler was aware of them.

One should also recall the propagation in French of the term *synthèse* as a surpassing of realism. This begins with Baudelaire and Gauguin (see chap. 6, n. 35) and, after

the spring of 1912, reappears in the observation by Maurice Raynal (Fry, pp. 90–92) that the Cubists "have called to support their case that law of synthesis for which they have often been condemned, but which nonetheless does govern all present speculation in good faith."

For Kahnweiler's Kantism, see chap. 9, n. 34.

3. The centerpiece of the 1889 Universal Exposition was the reconstitution of the temple at Angkor. Before that show, Khmer art was virtually unknown; but, in the decorative eclecticism of the 1900 Exposition, its impact is clearly evident. It is difficult to appreciate today the effects on Picasso's generation of such a profound challenge to a cultural heritage which since the Renaissance had been considered complete. And in that regard as well, Kahnweiler's role should not be neglected. His essay "les Limites de l'histoire de l'art," which appeared in 1920, challenged Worringer's thesis—propounded in *Abstraktion und Einfühlung*—excluding from art the "so-called art of primitive peoples" on the grounds that these works had not been created with "an artistic intention."

Similar reevaluations, occurring as part of the history of religions, led to the opening of the Musée Guimet in 1888, which first showed the art of Indian temples and of Borobudur, with profound effects for the art of both Gauguin and Derain. There were also the ethnological exhibitions of the Trocadéro.

Chapter 19

1. See the catalogue of exhibition at the Sheibu Museum of Art, p. 119.

2. Ibid., for Marie-Thérèse portraits 1–4, and my article "On a Hidden Portrait of Marie-Thérèse."

John Richardson, in "Picasso and *l'Amour Fou*" (*New York Review of Books*, 19 December 1985), considers Picasso's chance meeting with Marie-Thérèse in the light of the *Amour fou* theory dear to André Breton and Aragon; namely, the magical role played by such encounters in the streets of Paris. But, as I remarked in my 1975 biography *Aragon, une vie à changer:*

> If Surrealism today is inseparable from *l'Amour fou*, one should remember that Breton published this book in 1937, at the age of forty-one; and that his first great love poem, *l'Union libre*, dates from 1931. The [Surrealist] movement took no declared positions on love and sexuality until late in 1927; it needed to wait for the psychological maturation of a generation which, although it had lost its innocence in the war, nonetheless remained in a state of prolonged adolescence.

I will add that although Breton's encounter in the street with Nadja occurred on 26 October 1926, it had little in common with the first meeting of Picasso and Marie-Thérèse and was not a matter of public knowledge until 1928. Picasso, the elder of the two men, with a long amorous career behind him, was, perhaps, excited by Breton's adventure, but he certainly had no need for a role model.

Lydia Gasman, in "Art as a Form of Magic in Picasso" (Ph.D. diss., Yale University, 1986), and "Picasso's 'Caseta,' His Memories and His Poems," *Poetry-East*, Spring/Summer 1984, attempts to compare Picasso's behavior and various Surrealist texts.

It should be noted that neither Lydia Gasman nor John Richardson knew the paintings and letters later published by Maya or my article.

3. Z, VII, 54–56, and 58.

4. Z, VII, 16.

5. See *MOMA*, pp. 128 and 223.

6. The quotation from Gertrude Stein is taken from *AAT*, p. 229. Breton, "The

Genesis and Historical Perspectives of Surrealism," in *le Surréalisme et la peinture* (Paris, 1965), p. 70.

7. *Picasso and Surrealism*, p. 91.

8. Z, VII, 79, 98, and 137. Golding, *Picasso and Surrealism*, p. 94. Miró's *Personnage* was done in 1926. All of these can be compared to Breton's formulas in *le Surréalisme et la peinture*, especially the thrust of his passage "the eye exists in the savage state," supported by "No work of art can withstand our complete Primitivism" (underlined by Breton). And

> To apply the magic powers of figuration (a gift enjoyed by some) to the conservation and reinforcement of what would exist in any case, is to make paltry use of those powers. Is, in fact, an inexcusable abdication. . . . A plastic work, in order to respond to the absolute revision of real values which all agree is necessary, will, therefore, relate to a purely internal model [underlined by Breton], or will not continue to exist.

See also Z, VIII, 90–109.

9. *CS*, 85, 88, and, for the paintings, *SMP*, 145. For the drawings: Z, VIII, 90–109.

10. *CS*, 302.

11. Z, VII, 76 and 142; *MOMA*, pp. 130 and 224. In *Picasso and Surrealism* Golding suggests Oceanic sucker-fish as a possible source here, but this is not very convincing. Picasso invented a new geometric remodeling for the painter's head. One sees him moving, simultaneously, into a painting of a woman seated in an armchair (Z, VII, 14) and a sculpture project. See the following note.

12. Z, VII, 59, for *Artiste et modèle;* Z, VII, 143, for *le Peintre et son modèle*, 1928. *MOMA*, pp. 130, 131, and 224.

13. Spies, pp. 105 and 106, and *SMP*, 143, for the transition to sculpture. Z, VII, 135, and *CS*, 91, for the Minotaurs.

14. See, in *Julio Gonzalez 1876–1942* (New York, Frankfurt, Berlin, 1983), a study by Margit Rowell; p. 16ff.

15. Series collated from Z, VII, 209. To be completed by *CS*, 106.

16. For *Visage*, see Passeron, *Picasso*, p. 44.

Although the presence of Marie-Thérèse during this Dinard holiday had been known, its modalities were not understood until Lydia Gasman (see n. 2, above) published confidential information given her by Marie-Thérèse. The young girl came to a holiday camp at Dinard, a perfectly normal arrangement for a resident of the Paris suburbs. It was she, therefore, who had to go to Dinard. Whereupon Pablo readily acceded to Olga's wishes—Olga preferred Dinard to the Mediterranean—so that he could be near his young mistress. However, one must assume that the strict surveillance then customary for girls at summer camp made any amorous rendezvous out of the question. Also, the laws of the period were deadly serious about "the corruption of minors," consigning adult offenders to long prison terms or, at the very least, to difficult negotiations with the police.

17. *SMP*, 141ff.

18. The dates were specified by Alan Bowness in his essay "Picasso's Sculpture" in *Picasso, 1881–1973*, and by Spies. The first metal sculptures, including the *Tête*, after the painter's head in *Le Peintre et son modèle*, 1928, had been published in *Cahiers d'Art* of January 1929, which means that Picasso showed them as soon as they were finished. See the "modification of dates" in *CS*, 147–49.

19. As Alan Bowness shows ("Picasso's Sculpture"), the abstract drawings from Juan-les-Pins, 1924, are "materialized," given material form. But Picasso's pictorial work preceding these is truly remarkable. The Picasso *dation*, for example, revealed a *Femme à la palette et au chevalet* (*CS*, 90) which fits this category precisely. It is

absolutely essential that Picasso's work be considered as a whole, and now that we have access to his notebooks, we can ascertain the degree to which purely graphic imagination anticipated realizations which were as often pictorial as sculptural. Without denying the part played by private imagination, it is clear that Picasso drew on Surrealism for its formal, plastic liberation rather than as an outlet for impulse. The latter, however, is also most certainly a presence in these remodelings and transfigurations.

The three constructions in iron wire are today at the Musée Picasso (CS, 305–7). La Figure is Z, VII, 141. For the ensemble, see MOMA, pp. 130, 131, 223, and 224.

20. Documents, no. 15. Documents was a magazine in opposition to André Breton, whose moving spirit was Georges Bataille. Michel Leiris was its editorial secretary. Bataille and Breton were not reconciled until the winter of 1935–36, with the review Contre-Attaque, an ephemeral attempt at communal resistance to the rise of Fascism. Dora Maar, among others, appeared in its pages. Documents' subtitle should also be noted: Anthologie—Beaux Arts, Ethnographie, Variétés, as well as the fact that the Bataille-Breton polemics did not veer away from cloacal or sexual innuendo: "the unnamable brush which Jarry speaks of, having fallen into his plate . . ." (Breton); "le lion châtré" (the castrated lion), and "the ox Breton" (Bataille).

Chapter 20

1. An essay by Michel Leiris, for a special edition of Documents devoted to Picasso, gives a sense of the thinking in the small group which surrounded the artist—despite publication in the 1930s. Critics and dealers in this set ranged from Christian Zervos and Tériade to Vollard and Kahnweiler. There were also artists from the young Surrealist generation like André Masson, Miró, and Giacometti. Leiris writes:

> The beings he [Picasso] invents are oblivious and impenetrable, breathing the air of their own world. That world is, perhaps, closed to us; but it is closed by our own inadequacies. The structures of these creatures may have little in common with ours, but they are neither phantoms nor monsters. They are different from ourselves; or perhaps the same, but with a different form, a structure which is more striking, and which, above all, has a marvelous clarity. . . . All imagination here is leading to the invention of new forms, neither higher nor lower than the normal forms of daily experience, and just as true.

2. For corrections of the sculptures' dates, see CS, 140ff. The bricolée Tête is in the Musée Picasso (CS, 304). The painting of 24 April is Z, VII, 259. The date given to the Femme au jardin at the time of the 1932 exhibition at George Petit's—who first showed it—is 1929/30. Zervos, in his introduction to vol. VII, says that Picasso conceived this Femme as a memorial to Apollinaire. Michael Cowan supports this with factual detail in his dissertation "Pablo Picasso's Monument to Guillaume Apollinaire: Surrealism and Monumental Sculpture in France, 1918–1959" (Columbia University, 1985).

3. For Brassai's photograph, see Spies, 74.

4. Z, VII, 248.

5. At the Musée Picasso (CS, 304). L'Atelier was first photographed by Duncan in 1961. Comparison with an earlier work, Figure et profil (CS, 89)—also kept by the artist—is interesting. Here the figure confronting the artist's profile, like those in l'Atelier of 1928, is simply a remodeling. In the interval, the dramatic quality of the confrontation has been strikingly heightened.

6. CS, 88 and 89, of 5 May 1929.

7. Respectively, Z, VII, 260, for la Femme couchée; Z, VII, 259, for the canvas of 24 April; CS, 100, for 19 May, and 101 for 26 May.

8. Z, VII, 289 and 290.

9. Duncan, 213 and 214; CS, 103.

10. Z, VII, 288; cf. Reinhold Hohl's essay in *Picasso, aus den Museum of Modern Art New York und Schweitzer Sammlungen* (Basel, 1976), no. 55.

11. The two henceforth at the Musée Picasso (*CS*, 105 and 106). Jacqueline Picasso had another, generally unknown, version of *l'Acrobate: RM*, 17. See also Z, VII, 307–9.

12. Spies, 80 and 81. Gonzalez's text is from Goldwater, *What Is Modern Sculpture?* (pp. 369–72).

13. *CS*, 108.

14. *Picasso and Surrealism*, p. 117, and n. 41. *L'Apocalypse de Saint Sever* had been published by *Documents* in 1929.

15. *L'Art Dada et surréaliste* (Paris, 1975), p. 292.

16. The studies are from Z, VII, 290–305. The canvas, Z, VII, 306.

17. *CS*, 259–67. Each of these *tableaux-reliefs*—except the first—dates from the second half of August 1930.

18. For the reproduction of Etruscan bronzes, see Spies, 86–101, and 124.

19. The importance of this commission from Vollard cannot be exaggerated. It led to Picasso's resumption of engraving and the creation, between 1927 and 1939, of some of the major series done with these techniques. I refer to Bloch, 83 and 77 (not retained in the book). It is no less evident that the nude model in Bloch, 89, watching Picasso work, is inspired by Marie-Thérèse.

20. Bloch, 99–126.

Chapter 21

1. Z, VII, 317. Compare *Nature morte, pichet, bol, et fruit*, which constitutes a transition of sorts.

2. Successively, Z, VII, 328, 329, 321, and 320. The first two were kept by the artist, as well as a particularly brutal *Baiser* of 12 January: Z, VII, 325.

3. Z, VII, 347.

4. Z, VII, 333.

5. See *l'Atelier du sculpteur* (Musée d'Antibes, 1984). The engravings are Bloch, 138, 140, and 141.

6. Spies, 136–45. The dialogue with Matisse is as evident in the *Femme assise* (Spies, 105) as in the *Baigneuse allongée*. Among the sculptures which we know figured in the Exposition of 1930 was the *Grand Nu assis, bras levés,* a particularly strong work marking Matisse's return to sculpture. Certainly the attitudes of the two women are different, but the movement of the legs is so similar it must represent some reaction or reflection on Picasso's part. Moreover, Picasso regarded Matisse's return to sculpture as a matter of importance. The absence of any recorded encounter between them at this time does not mean they never met.

7. *CS*, 113, and Spies, 144, which suggests a continuity of inspiration deriving from the *Baigneuse allongée*.

8. Successively, Z, VII, 334, 362, 363, 364; *CS*, 115–17. These do not include the splendid charcoal drawings on canvas of a recumbent nude, which orchestrate the curved forms of a sleeping Marie-Thérèse. This sequence—the second drawing dated 13 March 1932—was first shown in *RM*, 19 and 20. This period constitutes one of the summits of Picasso's art.

9. *CS*, 114, whose posterity includes *la Mort de Marat* in 1934. See chap. 22, n. 9.

10. Successively, *CS*, 118; Z, VII, 377, 378, and 379. See *MOMA*, pp. 138–40; 226, 227. The *Nu au miroir* was sold at Sotheby's, New York, at the end of 1989 for $26 million.

11. *Don*, 173.

12. *Picasso,* p. 126ff. Jung's article was immediately translated—and denounced—by Zervos in *Cahiers d'Art.*

13. Spies, 120 and 218. Also, 108 and 109. And surely others as well.

14. Z, VIII, 147. The best-known painting in this series is *Femme et enfants au bord de la mer* (Z, VIII, 63). Z, VIII, 66 is its enlargement. Compare also, *Trois Femmes jouant au ballon* (Z, VIII, 231). And the engravings Bloch, 240–54.

15. Compare the relation between a drawing like *Femmes jouant au bord de la mer* (Z, VIII, 58) and the sequence Z, VII, 307, 310, 318, of 1931.

16. Z, VIII, 49–56. For those not in Zervos—particularly the drawing with the safety pin—see Rubin, 1980, pp. 300–302.

17. For the still life, Z, VIII, 84. Bloch, 240–49, 251, 254 for the subject of beach and rescue, which begins on 21 November with a *Viol* (Bloch, 239) and continues through March 1933. The sculpted heads begin in February, with a drypoint (Bloch, 250), and continue until 23 March (Bloch, 252, 253, 255–58) and the height of the *Repos du sculpteur.* The twenty states of Bloch, 250, derive from the reflection of the *Tête de femme de profil* (CS, 336) and the three-quarter view, CS, 337.

18. *Repos* and the *Atelier du sculpteur* begin on 14 March 1933 and account for forty-eight of the one hundred engravings of the *Suite Vollard.* The *Repos du sculpteur* is Bloch, 171–74, 3 and 4 April 1933. See n. 20, below.

19. *Conversations avec Picasso* (Paris, 1964). *Minotaure* was initially conceived by André Masson and his brother-in-law, Georges Bataille, as a dissident Surrealist review, an alternative to *Documents.* Breton then revived the project.

20. The *Suite Vollard* is the name given—after Vollard's death—to one hundred engravings done by Picasso between 13 September 1930 and March 1937. At the outset, between September 1930 and July 1932, Vollard bought eleven copperplates (*Flûtiste* and *Trois Femmes nues,* this last, three versions of a nude Marie-Thérèse). These prelude the young woman's grand entry as a subject for gravure. The *Suite,* strictly speaking, is Bloch, 144–233. The separate engravings are Bloch, 259–62.

Chapter 22

1. The Minotaur's embraces are Z, VIII, 112, and no. 526 of the "Oeuvres reçues." The watercolor drawings are Z, VIII, 116–21 and 124. And there are others which have not been codified. *La Danse de Silène* is p. 313 of Rubin, 1980.

2. In 1930, Picasso's mother was the victim of a swindler who had persuaded her to sell Picassso's childhood drawings for next to nothing. Picasso was quite frantic when he heard about this maneuver. In the end, after a court trial, Picasso won his case and recovered his drawings. See Palau i Fabre, *Picasso en Catalunya,* pp. 195–97. From Picasso's point of view, Fernande was also selling his youth.

3. On the story of Raymonde, for example, already told with transparent obviousness by Max Jacob and by Salmon, in 1920, in *La Négresse du Sacré Coeur,* which only intensified Olga's anger.

4. Z, VIII, 138 and 214. CS, 122 and 123.

5. Bloch, 267–78. We know the story of Rembrandt's arrival from Kahnweiler, who made a note of it on 6 February 1934. See *Huit Entretiens avec Picasso,* p. 24. The *Minotaure au javelot* is CS, 124. According to his notes, Kahnweiler went back to see Picasso on 13 February, and again on the 16th, an indication of their close relationship during this dramatic period, even though Kahnweiler only records matters connected to painting.

6. Z, VIII, 197 for the *Nature morte.* Compare *FY,* pp. 188 and 189. The *Nu au bouquet d'iris* (Z, VIII, 210) is CS, 125; and the *Nu dans un jardin* (not in Zervos), CS,

126. The wash drawing is in Zervos, *Dessins de Picasso* (Paris, 1949), no. 117, and is now part of the Marina Picasso collection.

7. Bloch, 280–84. Bloch, 275, for the *Femme nue* of 31 January.

8. *SMP,* 169. For the constructions, Z, VIII, 173 and 175.

9. Successively, for the corridas, Z, VIII, 228–30 and 232; for the unlisted oil painting done the same day—2 August 1934—*RM,* 21. For *la Mort de Marat,* Z, VII, 216, and Bloch, 282. Compare the *Femme au stylet* of Christmas 1931 (chap. 21, n. 9, above). And for the *Femme de trois quarts gauche,* Z, VIII, 243.

10. Zervos did not catalogue any of the blind Minotaur drawings. The drawing of 22 September is no. 527 of the *"Oeuvres reçues"* exhibition of 1979. The sketch with highlights and the charcoal drawing are *SMP,* 170 and 171. But there is a *postscriptum* of 30 December from the Maya Picasso collection (Sheibu Museum of Art, no. 19), which offers some important variations, with the guide/man wearing a Minotaur mask. Brigitte Baer's essay tells us in this regard that Marie-Thérèse had announced her pregnancy on Christmas Eve. This *postscriptum,* therefore, is Picasso's first piece of work since receiving that information. For the two aquatints, see Passeron, *Picasso,* pp. 64–68.

11. The trial proof, dedicated to Sabartès, is dated 3 May 1935. But Brigitte Baer (Baer, p. 25) correctly points out that Sabartès did not reach Paris until 12 November. Picasso was clearly anticipating this arrival, using Goya's *Tres de Mayo* as a coded signal, a device he and his friend frequently employed. This gives us no indication as to the completion of the states analyzed in detail by Brigitte Baer, who only confirms 23 March as the date on which the whole enterprise began. She suggests references to Velásquez's *Hilanderas,* to the *Dos de Mayo,* and to Delacroix's *Chasse au tigre* for the position of the rearing horse.

12. Z, VIII, 215, at the Musée Picasso.

13. Z, VIII, 260, 234, 246, 261–64.

14. Z, VIII, 247, for the *Femme au chapeau.* The *Monument pour Arlequin* is noted in *FY,* p. 191. It is dated 10 March 1935.

15. Jean Leymarie, *Picasso, métamorphoses et unité* (Geneva, 1971), p. 95.

16. Rubin, 1980, p. 330. Kept by Picasso.

17. Rubin, 1984, vol. 1, pp. 326–28.

18. Spies, 134–59.

19. See chap. 21, n. 17.

20. Spics, 135.

21. Spies, 136, 152, 157.

22. Spies, 163 and 165.

Chapter 23

1. The first catalogue is the concise version, for the exhibition "Picasso Intime" at the Musée de l'Athénée, Geneva, 4 July–6 September 1981. The complete catalogue, which I have used here, was published by the Sheibu Museum of Art, also in 1981. The drawings are numbered 21 (15 November 1935: Marie-Thérèse nursing Maya), 22 (Maya at three months), 23 (Maya at three and a half months), 25 (Marie-Thérèse and Maya, 13 January 1936), 26 (Marie-Thérèse nursing Maya, 22 January), 27 (Maya at ten months, 5 June). A note from Picasso was also shown at that exhibition: "Moi Picasso je suis venu et je vois que tu dors. A toi, chaque jour plus à toi. Le père de Conchita" ("I Picasso came and I see that you are sleeping. Yours, more each day. The father of Conchita").

2. Paul Éluard, *Lettres à Gala* (Paris, 1984).

3. John Richardson, *Picasso, aquarelles et gouaches* (Basel, 1964), no. 24.

4. *Paul Éluard et la Peinture surréaliste* (Geneva, 1982). And, above all, *Éluard, Picasso et la Peinture* (Geneva, 1988), p. 21. The photograph is reproduced in Penrose, *Picasso,* p. 283. In 1945 Wolfgang Paalen's wife, Alice, would boast to Anaïs Nin (*Journal* [Paris, 1972], Fr. trans., p. 78) of having been Picasso's mistress. She confided that "depriving women of their sexual pleasure had been one of his delights," a statement which has produced considerable comment, as well as speculations on Alice's psychology. Should one perhaps infer her disappointment at having been so quickly replaced by Dora?

5. This period remained unknown until Duncan's book *Picasso's Picassos* (1961), pp. 79ff. It was not the private confidence which troubled Picasso, as was the case with the drawings he kept because they belonged to the Marie-Thérèse/Maya cycle (see n. 6, below). I feel certain that he kept this group of paintings secret in order to get some perspective on this period of pictorial convalescence.

6. Z, VIII, 278, 279, 281.

7. Sheibu Museum of Art, no. 27; *SMP,* 185, for the portrait of 28 July; Sheibu Museum of Art, for the letter of 10 October.

8. Wolfgang Paalen, born in Vienna in 1905, had just left the group Abstraction-Creation. Of his entry into Surrealism he remarked, "It seemed to me that I was leaving a group of deaf-mutes in order to find myself—at last—among whole men." Because of Alice's adventure with Picasso, this pompous phrase assumes, in French, an unintended comic quality. "Entiers" (whole) also means "uncastrated" in French.

9. Z, VIII, 285–88; but also *Minotaure et Jument morte devant une grotte,* not in Zervos; at the Musée Picasso, no. 531 of the exhibition *"Oeuvres reçues."* This is a resumption of the subject which would be elaborated upon until 1937.

10. Bloch, 289–95. And, above all, Baer, 575–606, for the plates of *l'Histoire naturelle;* 607, for the plate of figures of the *Barre d'appui;* 608, for the *Grand Air;* cf. Baer, p. 92, n. 3, for the account of the plate—allegedly refused—which contains Picasso's poem. Brigitte Baer explains here the process used by Lacourière. He employed a process which was invented by Kodak in 1932 and which had just been commercialized, making the reproduction of writing possible. This was Kodatrace, with triacetate of cellulose. His invention combined this procedure and the bite of acid into copper.

Chapter 24

1. Michel Surya (*Georges Bataille, la Mort à l'oeuvre,* p. 224) presents her as "his lovely mistress in late 1933, early 1934, whom he met in the Masses group, to which she belonged." Z, VIII, 287.

2. Baer, 609, with—for the first time—the complete analysis of the six states. Brigitte Baer compares this engraving to Rembrandt's *Jupiter and Antiope,* above all to the engraving of 1659. One might say that Picasso appropriated this subject; he surely knew the three masterpieces at the Louvre which treat it: Titian's *Jupiter and Antiope,* Correggio's *The Sleep of Antiope,* and Watteau's *Antiope.* Three months after Picasso began with the subject, we find him as Jupiter waiting for Dora (see n. 4, below).

3. First shown at the 1966 Petit Palais exhibition, no. 94.

4. Z, VIII, 295.

5. See Jean-Charles Gateau, *Éluard, Picasso et la Peinture* (Geneva, 1988).

6. Z, VIII, 289 (done from memory) to 294; 297–301.

7. *Cahiers d'Art,* vol. 12, 1937. One of these proofs was reproduced by Barr, *FY,* p. 195 and p. 263 n. In 1912 Man Ray rediscovered the photogram technique, which he called rayogram.

8. Z, VIII, 310.

9. Z, VIII, 325–30; 332, 333.

10. See Spies, 170 (photographed, with commentary, by Duncan, p. 167), p. 168.

11. Z, VIII, 324, 327; but, above all, Duncan, pp. 119–23, 219–22.

12. Successively, Z, VIII, 351 and 345, 344; and Z, IX, 217. The *Femme assise* has become the Musée Picasso's *Grande Baigneuse au livre*.

13. Z, IX, 94 and 95.

14. Z, IX, 96 and 97.

15. Z, VIII, 360. The title *Sculpture nègre* is an error of perception. For a bust, Picasso used the head of a bald faun, in which the fusion of two profiles creates a kind of nostril, emphasizing ambiguity. The portraits of Dora and of Marie-Thérèse done that year should be systematically studied for the experiments with new, contrasting dissociations and new shifts of profile to become apparent.

Chapter 25

1. Jean Cassou, in the special issue of *Cahiers d'Art* devoted to *Guernica*. He added that this painting "at this hour, overflows with fullness, presence, signs, and cries. It expresses our most private tragedy."

In 1986 Ludwig Ullman's thesis for the University of Osnabrück, *Der Krieg im Werk Picassos* (pp. 47ff.), produced some interesting elaboration. Particularly a table of all the earlier analyses of *Guernica*, from Read in 1938 to Fisch in 1983.

For my part, with my essay "Picasso und der Krieg," in *Picasso im zweiten Weltkrieg* (Museum Ludwig, 1988), I tried to show the continuity between the plastic language of his work after 1936 and his expressions of violence since *les Demoiselles d'Avignon*.

2. Picasso told me this. *Ce Soir* remained his favorite paper, which I noticed myself when I ran it between May 1950 and its disappearance in 1953. For the basic sources of this chapter, see the bibliography of *la vie de peintre*. The most recent updating and correction was done by Jean-Louis Ferrier, *De Picasso à Guernica, généalogie d'un tableau* (Paris, 1985).

3. Bloch, 302. The engraving was not done until 1961 and was not generally available until 1981. See Passeron, *Picasso,* p. 86.

4. In this regard, see the catalogue for the exhibition "*Paris-Paris,*" 28 May–2 November 1981 at the Centre Pompidou; particularly the articles by Patrick Weiser and Christian Derouet.

5. Quoted by Patrick Weiser (n. 4, above). The same René Gillouin brought back with him the response of the Soviet guide at the presentation in Moscow of modern paintings at the Museum of Western Art. "This art is typical of capitalist disarray. It gives final expression to the disintegration of the bourgeoisie." The campaign led to the destruction of Jacques Lipchitz's sculpture *Prométhée et son Vautour,* exhibited on the Champs-Élysées.

6. All kept by Picasso. See Duncan, pp. 222, 223. Note the engraved portrait of Dora of 16 August (Bloch, 299).

7. Successively, Z, VIII, 382; Z, VIII, 370–72. Compare Duncan, p. 224.

Lee Miller (1907–1978) had posed at the age of twenty for Edward Steichen before becoming the Paris assistant of Man Ray. In 1930 she accidentally discovered the effect of solarization when she exposed to light a film in the process of development. Her nudes by Man Ray and her participation in Cocteau's film *le Sang d'un poète* made her famous; but the film led to a falling out with Man Ray. She returned to New York, made a grand marriage to an Egyptian, and went to live in Cairo. By 1937, however, she was back in

France, where she met Penrose. During those ragged days, did Picasso, perhaps, find her beauty too perfect? He deconstructed her, as if by torture, efforts reflecting aspects of his own inner being which can only be surmised. She was hired as a photographer by *Vogue,* reappearing later as a war correspondent.

8. Kept by the artist. Duncan, pp. 224, 225.

9. Z, VIII, 331, and Duncan, p. 217.

10. Z, IX, 73, after the version of 18 October, *CS,* 143.

11. Duncan, p. 138; today *CS,* 146.

12. The Musée Picasso has acquired the portraits of Dora done between 23 November and 18 December and the portrait of Marie-Thérèse of 4 December (*CS,* 144, 147, and 145).

13. Duncan, p. 228.

14. *Maya à la poupée, CS,* 148, and Duncan, pp. 229, 230, and 146.

15. Z, IX, 109. Compare *FY,* p. 214.

16. Duncan, p. 228.

17. *FY,* 214.

18. Duncan, pp. 152, 153.

19. Zervos recorded nine of these: Z, IX, 187–91, 203–6. Picasso hid five. See Duncan, pp. 235 and 236. The *Femme assise* of 29 August is Z, IX, 211.

20. Duncan, p. 235.

21. Duncan, p. 236.

22. Duncan, p. 232; *CS,* 150 and 149; the self-portrait never having been catalogued.

23. *Confidences* (Z, VIII, 268) is at the Musée nationale d'Art moderne. The *Femmes à leur toilette* are *CS,* 219.

24. An analysis of the five states is in Baer, pp. 156–60. The engraving has traditionally been dated 1938, which is supported by a recumbent nude done at Mougins on 10 September 1938, offering a reasonably similar remodeling of the limbs (*MOMA,* pp. 155 and 232). Brigitte Baer, however, produces convincing arguments in favor of moving the date forward to February–March 1939, just before the complex engravings in color inspired by Dora Maar. Nos. 647, 648, 650, and 651 in her catalogue.

Chapter 26

1. See Jean-Charles Gateau, *Éluard, Picasso et la Peinture,* op. cit., pp. 60–64.

2. Z, IX, 237–40.

3. Z, IX, 232, manifested, from 13 May 1938, by a sequence of paintings: Z, IX, 152, and the unpublished *RM,* 25, of 31 May.

4. Duncan, p. 238.

5. Z, IX, 250–53.

6. Duncan, pp. 238 and 241. Z, IX, 296, for the cat of 22 April; *CS,* 155, and Z, IX, 297 for another version in the Victor Ganz collection, New York, in which Picasso shifts from forty to sixty *figure* (from 39½ × 32″ to roughly 51″ × 33″).

7. All in Duncan, which is to say, kept by Picasso. The canvas of 17 June is *RM,* 26. Compare, in the same situation, with the same hat, *CS,* 156, a portrait of Marie-Thérèse.

8. Duncan, p. 177.

9. Ibid., pp. 178 and 241. Bloch, 325. But in the interval, there are engravings in which Dora's face is treated with tenderness (Bloch, 318, 322–24).

10. See *MOMA,* p. 156ff. and 232, esp. for discussion of the sexual interpretation proposed in 1970 by Albert Boime.

11. The letter was photographed at the Sheibu Museum of Art, op. cit., p. 119.

12. Z, IX, 320, 321, 323, 326–28, 15 September.

13. Z, IX, 322, of 19 September, and Z, IX, 334.

14. Z, IX, 348–51, of 1–4 October.

15. Z, IX, 366.

16. Z, IX, 367.

17. Z, IX, 359, of 3 October, and the face subjected to the greatest destruction, Z, IX, 357, of 4 October; *CS,* 158–60.

18. Z, IX, 380–83.

19. Especially Z, IX, 375, and the assemblages of oil, string, and fragments of stitched cardboard, of 1 and 2 February 1940; not in Zervos; *CS,* 268–70.

20. Z, X, 1.

21. All three dated the end of March, which implies that they were painted in Paris by a Picasso who was dreaming of Royan.

22. Not catalogued by Zervos, this large canvas remained with the artist until 1957. See *MOMA,* pp. 158, 234, 235.

23. See Z, X, 196.

24. The notebook of drawings was published by Zervos in 1948.

25. Ibid.

26. Z, XI, 81 and 82. Once again, an instance of Picasso establishing—and fixing—a face at each difficult period of his life.

27. *CS,* 161.

Chapter 27

1. The piece was published in *Messages,* no. 2, Paris, 1944, with four drawings.

2. Z, XI, 95.

3. Spies, 193.

4. Peter Whitney, quoted in *FY,* 223.

5. Z, XI, 111 and 112.

6. Z, XI, 113–20, 123–42.

7. See Z, XI, 106, 144, 145.

8. Z, XII, 154.

9. Éluard, *À Pablo Picasso* (Geneva, 1944), p. 162.

10. Compare drawings 158 and 159 of 24 and 25 December 1941, published by Zervos in 1948; and the watercolor *Nu assis* published by Richardson, *Picasso, Aquarelles et Gouaches,* no. 28, dated 28 November.

11. Spies, 197. He had previously engraved a wounded Minotaur on plaster (Spies, 194). The original is in the Musée Picasso (*CS,* 368).

12. Richardson, *Picasso, Aquarelles et Gouaches,* p. 66; commentary on a highly classic (and respectfully admiring) drawing of Dora's face, dated as a product of spring 1944, a period which also witnessed the most violent deformations of her features.

13. I have discussed their chronology in *la Vie de peintre,* p. 305, n. 10. The preparation of *l'Aubade* is in Z, XI, 290–413. See on this subject, Ludwig Ullmann, "Weibliche Akte als Metaphern für Freudlosigkeit," p. 238ff. in *Der Krieg im Werk Picassos.*

14. The best known from 5 April is at the Kunstsammlung Nord-Rhein Westfalen (and not in Zervos); another version is Z, XII, 35. This work sees the return of the ox skull brought back from Mougins. The skull had appeared in still lifes of late 1938.

15. Successively, Z, XI, 200; Z, XII, 38.

16. Z, XII, 86.

17. Z, XII, 1 and Z, XII.

18. Z, XII, 115 and 116.

19. Spies, 193–236 and 238.

20. Picasso made studies beginning on 16 July 1942, until completion in February 1943, when he was helped by Éluard. Then several postscripts, running through to March, many of them never listed by Zervos. The Barcelona museum owns an academic drawing (MPB, 110 598) shown by Werner Spies, Picasso, Pastelle, Zeichnungen, Aquarelle (Tübingen, Düsseldorf, 1986), no. 2. The drawing was done from a sculpture of a man carrying a sheep on his shoulder, a subject which, for Picasso, dates back to work done in Picasso's early adolescence. See Albert Elsen, "Picasso's Man with a Sheep," Art International, March–April 1977. This is the most penetrating and thorough study of the artist's sources and intentions.

21. Successively, Spies, 240, 234, 235, 238, 201. For la Conquête du monde and its date, see la Planète affolée, Surréalisme, Dispersion et Influences, 1938–1947 (Marseilles, 1986), pp. 66 and 68.

22. Z, XIII, 36. FY, p. 233.

23. Z, XIII, 59–64. This one is CS, no. 164.

24. Z, XIII, 68; Z, XIII, 74; Z, XIII, 51–58, for the sequence of still lifes with cherries. Z, XIII, 123, for la Chaise aux glaïeuls.

25. Spies, 219, and Z, XIII, 88–91.

26. Z, XIII, 109. Compare the Femme en vert, Z, XIII.

27. Z, XIII, 209–14; Z, XIII, 251 and 252, for Françoise. Her silhouette can be recognized in Z, XIII, 107, dated—without any further detail—1943. Beginning in November, Picasso did many drawings of enlaced lovers, renewing his attention (3 and 5 December) to the subject of heads welded together by a kiss (Z, XIII, 219–22).

28. Patrick O'Brian (Pablo Ruiz Picasso, p. 462) recalls that when the news of Max Jacob's arrest became known,

> Cocteau undertook to organize a petition, while other friends exerted all their influence and connections in an effort to get him freed.
>
> Some twenty years later, Pierre Andreu confirmed that Picasso—when he was approached—refused to help. "There's really no point in doing anything," he said. "Max is a will-o'-the-wisp. He can fly from his prison without any help from us."

Edmonde Charles-Roux repeats these words in L'Irrégulière (1974). I don't believe that they are true. Not only are they in direct contradiction to Picasso's general comportment at the time, but the emissary is supposed to have been Pierre Colle, the picture dealer who was also Jacob's testamentary executor, and Pierre Colle remained on good terms with Picasso, as did Cocteau.

I—like O'Brian—think it entirely possible that Picasso "refused to compromise himself with Cocteau in such circumstances." O'Brian recalls that Arno Brecker's bust of Cocteau is at the Musée Dali in Figueras, which reminds us of Cocteau's dubious acquaintances during the Nazi occupation. Picasso told me that he refused to associate with Cocteau at the time. He forgave him years later, as he would have forgiven Gertrude Stein's approval of Maréchal Pétain, had she not died in 1946.

I heard this story only after Picasso's death. And I myself am persuaded of two things. First, that if these were indeed Picasso's words, they were his way of getting rid of someone in whom he had no confidence, whose own relations with the Germans he very possibly found suspect. Second, he must have felt that an intervention with the Nazis by the painter of Guernica could only do Max harm and certainly would not help him. Therefore, in my view, whoever approached him on this occasion was acting either as an agent provocateur or an idiot. In any case, the fact that Picasso attended the burial of a Jew in 1944 loudly proclaims his true sentiments.

Finally—and this is probably the decisive factor in judging what happened—

Picasso never spoke of the things he had done to help threatened friends. Only after his death did we learn, for example, that in 1942 he helped Gonzalez's widow collect the forty thousand francs then necessary to pay clandestine passage across the Spanish frontier for Hans Hartung, an anti-Nazi refugee (and her then son-in-law) endangered by the arrival of German troops in the free zone.

29. Z, XIII, 296–300; Z, XIII, 320–22 (4 July), for Françoise.

30. See Alfred H. Barr, Jr., *75th Anniversary* (New York, 1957), p. 93.

31. Z, XIV, 13–16; 21–29.

32. Z, XIV, 38.

33. Z, XIII, 273.

34. Z, XIV, 30–33, 36, and 37.

35. Z, XIV, 34 and 35. See Richardson, *Picasso, Aquarelles et Gouaches,* no. 29.

Chapter 28

1. In his declaration on *Guernica* of May–June 1937, Picasso had told the Americans:

> No one can deny the vitality and youth which the struggle will bring to Spanish art. Something new and strong, which awareness of this magnificent epic will plant in the soul of Spanish artists and which will undoubtedly express itself in their works. The contribution of the purest humane values to an art in the process of rebirth will be one of the greatest triumphs of the Spanish people!

It is highly probable that in September 1944 Picasso still held to these ideas and that they in turn represented the sum of his investment in the Communist party, an investment seemingly validated by the victorious Paris insurrection. They also provide a clue as to why he remained in the party even when, in 1953–56, he had a clearer grasp of its true nature. He continued to think that whatever its faults and mistakes, only the party held out any possibility of providing that "something new and strong" for which he hoped.

2. Jean-Charles Gateau, *Éluard, Picasso et la Peinture,* p. 152.

3. *FY,* pp. 242, 243.

4. Z, XIV, 67–71.

5. Z, XIV, 87, 88, 93–100. The leeks are a plastic equivalent of the bones beside the skull. They are also, at this moment near the end of the war, a reminder of the daily presence of death in ordinary life.

6. The portraits are Z, XIV, 110–12. Roger Garaudy's speech to the French Party Congress touches on them, perhaps, with his complaint that "painters still persist in painting for snobs and decadents." Garaudy then adds that painters are certainly "not obliged to do portraits of Maurice Thorez or ascend the barricades. They should, however, learn to express the passions of the people."

The landscapes are Z, XIV, 1C1–1C8.

7. *Le Charnier* is analyzed by Rubin, *MOMA,* pp. 166–69; 236–41. See Z, XIV, 72–76. The quotation from Barr is taken from *FY,* p. 250.

In Lee Miller, Picasso had a witness to the end of the war, to the discoveries of the camps at Dachau and Buchenwald, as well as to the capture of Hitler's retreat at Berchtesgaden, from which she brought back unforgettable photographs. But by mid-June, when those events occurred, *Le Charnier* had already been conceived, and Picasso had already transmuted history into painting.

8. In Mourlot, nos. 1–5 and 7–9 are devoted to Françoise, the last of these including ten states done between 7 November and 19 February.

9. Ibid., no. 16, eighteen states between 10 November and 12 February. In his article

"Sleep Watchers" (*Life, Picasso,* 27 December 1968) Leo Steinberg shows that the seated girl in the second state is Dora and that subsequently she becomes Françoise. However, in the final states, Françoise's *signes* are evident in both women. The quotation is from Françoise Gilot and Carlton Lake, *Vivre avec Picasso,* Paris, 1964, p. 84.

10. The canvas is dated on the *chassis* 31 January 1947. This could be a mistake; or the date of the most recent touch-up. Not catalogued by Zervos, the painting remained in the artist's possession and then in Jacqueline's. After her death, in 1990, it was given to Spain by the French government.

Chapter 29

1. Z, XIV, 157 and 158, dated 21 February 1946.
2. Z, XIV, 159, 160, 167, for the *Femme-fleur.*
3. Mourlot, 38–48.
4. In particular, Z, XIV, 183 and 187. The *Femme allongée* is not in Zervos (Grand Palais, 1966, no. 211). Neither is *Françoise assise dans un fauteuil* (*CS,* 171) or the portraits first shown at "Hommage à Picasso pour le centenaire de sa naissance" (*A1,* 2). These are a series of portrait drawings in pencil (nos. 14–22), done between 21 April and 20 May 1946, and three paintings: *Nu gris—Femme-fleur, Femme au collier jaune,* and *Femme aux cheveux bouclés,* all done in 1946 and now in the collection of Claude and Sidney Picasso (nos. 28, 30, and 31).
5. Once again Picasso anticipated his rediscoveries of the Midi. On 20 October 1977, some fifty years after her first encounter with Pablo, Marie-Thérèse killed herself at cap d'Antibes, where she had been living in seclusion. She had always kept abreast of her former lover's peripatetic life. John Richardson (*"Picasso and l'Amour fou"*) writes that following Pablito's suicide attempt—four days after his grandfather's death—Marie-Thérèse was of considerable assistance materially and otherwise to the children of Paulo's first marriage. Pablito died three months after his initial attempt.
6. See *l'Oeuvre de Picasso à Antibes,* vol. 1, 1981, and vol. 4, 1982, Musée d'Antibes. Volume 1 takes up Dor de la Souchère's catalogue raisonné, completed by Danièle Giraudy; 4, *A travers Picasso* is the scientific study, with X-rays, done in collaboration with the research laboratory of the Musées de France; the complete work realized by Danièle Giraudy.

The quotations of remarks and observations by Françoise are from *Vivre avec Picasso,* pp. 92, 74, 108–9, 110, 114, 131, and 126.

Chapter 30

1. Z, XV, 19, 22, 34–36, 43, 10 January to 24 March 1947 for still lifes. Z, XV, 13, 38–40, 49, 50, for Françoise. One has the impression that she remained a visitor to Picasso's painting. The lithographs of Françoise are Mourlot, 67–69.
2. Mourlot, 109. The 30th of March 1947 launched an adventure which was not completed until 29 May 1949. At the sixth stage on zinc, Picasso had a transfer made on stone. The first version on zinc was done on 17 April 1949. See Passeron, *Picasso.*
3. See my book *Aragon, une vie à changer,* and Aragon, *Ecrits sur l'art moderne* (Paris, 1981), pp. 67–72.
4. *Picasso,* published by Hyperion, 1940.
5. *Vivre avec Picasso* (Paris, 1964), p. 192.
6. See Georges Ramié, *Les Céramiques de Picasso,* catalogue (Paris, 1975).
7. Z, XV, 103, 104. For Claude, Z, XV, 101. Mourlot, 131–38 and 109.
8. Z, XV, 106.

9. *Vivre avec Picasso,* op. cit., p. 209.

10. For the *Colombe,* Mourlot, 141. For the crustaceans, ibid., 139, 141–44.

11. Z, XV, 129; cf. Z, XV, 128, 130–37, 140, 141.

12. Mourlot, 182–84; cf. 180 and 176.

13. Spies, 350 and 351, 409, 408, 407, and 463, dated October 1951.

14. Spies, 410, and Z, XV, 201, finished at the Rue Gay-Lussac, 25 March 1952; CS, 392 and 180; *post scriptum,* Z, XV, 198, of 16 April at the Tate Gallery.

15. Z, XV, 165 and 164.

16. Z, XV, 157 and 163, 158; Duncan, 245; Z, V, 166, and Z, XV, 214 and 215.

Chapter 31

1. Z, XV, 174 and 173.

2. Mourlot, 198–201; Z, XV, 183 and 184.

3. Geneviève Laporte (whom Picasso at the time called Saint-Tropez) has published her memoirs: *"Si tard le soir le soleil brille." Pablo Picasso* (Paris, 1973). Except for my personal recollections, information about her and quotations are drawn from the second edition of her book: *Geneviève Laporte: Un amour secret de Picasso,* Monaco, 1989. Further details are provided by Patrick O'Brian *(Pablo Ruiz Picasso),* who is very knowledgeable on these subjects.

4. Z, XV, 166.

5. See publication of the notebooks *la Guerre et la Paix,* text by Claude Roy (Paris, 1952).

6. Mourlot, 214 and 215; Bloch, 712.

7. Mourlot, 195.

8. Mourlot, 238.

9. Z, XV, 245 and 246.

10. The portrait has not been found in Picasso's studios, although he always told me he had kept it.

11. Aragon, *Écrits sur l'art moderne,* pp. 110–13.

12. Spies, 464–80; Z, XV, 266–71; to which one should add a series of landscapes from Vallauris (Z, XV, 272–85), which perhaps constitute a farewell.

13. On this subject, see Patrick O'Brian, *Pablo Ruiz Picasso,* pp. 517ff. The author, who lived in Collioure, was particularly well informed about what happened there at the time.

Chapter 32

1. Z, XVI, 96. The *Femme assise* of 9 July is Z, XV, 292, St. Louis Museum of Art.

2. Z, XVI, 97 and 98.

3. Z, XVI, 54, 55, 58, 59.

4. Z, XVI, 99 and 100.

5. Tériade devoted no. 29/30 of *Verve* to these drawings. This issue of the magazine was not in fact published until September 1954, a delay which in addition to various events inside the Communist party reduced the impact of Picasso's break with the PCF's demands for socially conscious art. See nn. 12 and 14, below.

6. Mourlot, 243, 244, 247, 248, 253, 255ff.

7. Ibid., 249–51, 254, 258–60, 264.

8. Z, XVI, 258–62.

9. Z, XVI, 272 and 273; Mourlot, 263; Duncan, 245 and 246.

10. The portraits of Sylvette run from Z, XVI, 274 to 315. This work, begun on 19

April and resumed on 22 May, was not finished until 4 October. Aragon's text, "la Verve de Picasso," had been published in nos. 543–47 of *Lettres françaises*. Aragon used these drawings by Picasso as proofs of the validity of "realism" as opposed to abstract art.

11. Z, XVI, 324–26.

12. "All the Colors of Autumn," *Lettres françaises* of 12 November 1953, and "The Art of the Party in France," extract of the intervention at the thirteenth congress of the PCF, 3–7 June 1954. Both of these reappear in *Écrits sur l'art moderne*. In the last of these pieces, Aragon smuggles in a resumption of the lethal attack on Fougeron he began in the first one.

13. *Picasso, Oeuvres des musées de Leningrad et de Moscou, 1900–1914*, with an introduction by Maurice Raynal.

14. *Picasso, deux périodes, 1900–1914 et 1950–1954*, with a preface by Aragon. Reprinted in *Écrits sur l'art moderne*, op. cit.

15. To state emphatically—as Mme Gedo does (*Picasso: Art as Autobiography*, p. 224): "Between the end of June and the beginning of October 1954, Picasso finished only a single work, a drawing," and to conclude, "In the transition from Gilot to Roque, Picasso had been quite paralyzed" is to overlook the fact that Zervos was not aware of everything Picasso was doing at that time. And to overlook as well the extremely fine painting (for example) *Portrait de Paule de Lazerme*. It is true that during that summer Picasso was somewhat distracted by a need to catch his breath: a need, however, which—after 180 drawings, 40 Sylvettes, and a few Jacquelines—bore very little resemblance to intellectual paralysis, even of a temporary character. The turbulent rush of production once he had returned to Paris and settled down speaks for itself.

I may, perhaps, make this point more clearly by suggesting that Picasso was not so much subjected to the emotional complications of that summer as he was, in fact, provoking them. He enjoyed such confrontations. And, although Jacqueline did indeed stake her entire life on Pablo, one must never deduce from their intimacy—as Mme Gedo does—that

> he became . . . also the instrument through which she exacted a fanatical control; like the artist's mother, who had once possessed the most beautiful child in the neighborhood, Jacqueline could claim the world's most famous artist—albeit he was now a geriatric prodigy rather than the wunderkind he had once been.

Right to the end, it was Picasso who kept under his control both the use of his time and all decisions regarding his art. One day, when he had used Jacqueline—in front of me—to keep at a distance a visitor who was a friend of mine, I said to him, "He's going to be angry at Jacqueline." "If he thinks that this was Jacqueline's decision because she answered the phone," he replied, laughing, "then he's *really* not worth seeing."

As for "geriatric prodigy," the formula indicates that Mme Gedo had no idea either of Picasso's physical state in 1954 or of the body of work created during the nineteen years he lived with Jacqueline.

Chapter 33

1. Mourlot, 216–27, done on 25 November 1952.

2. Z, XVI, 327–31.

3. Z, XVI, 342–61 (drawings included), and Mourlot, 265 and 266.

4. Mourlot, 769–71.

5. Published in Hélène Parmelin's book *Notre-Dame-de-Vie* (Paris, 1966); not in Zervos.

6. Ibid.

7. For the August sequence, Z, XVI, 405–16; and for November, 504–22.

8. Bloch, 772–77.

9. Z, XVI, 479. This fresh return to Manet through Jacqueline marks the permanent presence henceforth of dialogue with great precursors.

10. In March 1957 Picasso was to show at the Louise Leiris Gallery fifty paintings done between 23 October 1955 and September 1956. Beginning in April, *l'Atelier* and *Femme dans l'atelier* were to alternate.

11. Z, XVI, 527, 530, 533–35, for *Jacqueline en costume turc*. However, one of the finest in the series, painted on 20 November 1955, is not in Zervos. Today the picture is in the Jacqueline Picasso collection. See Rubin, 1980, p. 425.

12. Duncan, 247, and Z, XVII, 36, transferred from the collection of Mme Cuttoli to the Musée national d'Art moderne.

13. See Z, XVII, 4–19, 22–32.

14. See Z, XVII, 151ff.

15. Spies, 500.

16. Spies, 503–8.

Chapter 34

1. Spies, 481–87, for the dolls; 462, for *La Liseuse*.

2. Spies, 237.

3. Spies, 488–91.

4. Spies, 492–95.

5. See above, chap. 30, n. 12.

6. Hélène Parmelin, *Les Dames de Mougins* (Paris, 1964), nos. 65 and 67. The latter is reproduced on the jacket.

7. Mourlot, 294–97.

8. See Jaume Sabartès, *Les Ménines et la Vie* (Paris, 1958).

9. See the history of the work in Gaëtan Picon, *La Chute d'Icare de Pablo Picasso* (Geneva, 1971).

10. Z, XVIII, 1, and Z, XVIII, 83, at the Musée Picasso.

11. Z, XVIII, 237, at the Musée Picasso.

12. Z, XVIII, 237–40, 262–68; Duncan, 256, for la Californie and landscapes. *L'Arlésienne,* painted in Ripolin, was begun on 8 July and reworked almost daily until 15 August. Z, XVIII, 269ff.

13. For *Jacqueline au mouchoir noir,* see Mourlot, 306–11 and 316.

14. Spies, 545, 543, 544, 539.

Chapter 35

1. Bloch, 859. See *Picasso, Linogravures,* with an introduction by Wilhelm Boeck (Paris, 1962); includes *lacunae*.

2. Preface to the catalogue *Peintures (Vauvenargues 1959–1961)* (Paris, 1962).

3. Not shown during the Vauvenargues period.

4. For the buffet, Z, XVIII, 452 and 453.

5. All of the Vauvenargues canvases were done with oil and Ripolin, except for one on laminated plywood.

6. Which confirms a return to the experiments with aleatory effects of 1923–24, following those with contrasting textures, as during the invention of collages in 1912.

7. All of the work on Manet was assembled by Douglas Cooper in *Les Déjeuners* (Paris, 1962), on which I rely.

8. See Z, XIX, 147–54, 160–68. The painting of Bathsheba is Z, XIX, 157; the beach scenes, Z, XIX, 235 and 236.

9. Hélène Parmelin kept a diary of these transformations in *les Dames de Mougins*.

10. Ibid., and Spies, 626. The head—as with almost all of the *femmes en fer*—was first worked out by a découpage in folded paper.

11. Spies, 578–611. The *Terrine* is no. 577a.

12. See Bloch, 901–4, 927, 929–39, all done in December 1959. The drypoints come from Bloch, 579–986. *La Pique* begins with lithographs (Bloch, 898–99) then turns to linocuts (Bloch, 907–11, 941–46).

13. Hélène Parmelin, *Le Peintre et son modèle* (Paris, 1965), pp. 31 and 26. See Bloch, 1101–3.

14. Jardot has pointed out:

> Work at Vauvenargues stopped on 20 April, 1961. The generals' putsch [in Algeria] broke out on the 22d. Since that date a canvas which has barely been started waits on the easel for fresh attention from the artist. Between Picasso and Vauvenargues, as between Spain and his own fatherland, there will be, hereinafter, the possibility of violence.

In general, there has been something of a tendency to underestimate Picasso's political will. Since May 1958 he had felt profoundly disturbed by what the Left and the Communists considered a tilt toward Fascism by many paratroop units and generals in Algeria.

15. Z, XX, 160; cf. *MOMA*, pp. 182, 183, and 246; and Z, XX, 150 and 151.

16. Parmelin, *Les Dames de Mougins*, p. 30.

17. Ibid.

18. See Parmelin, *Le Peintre et son modèle*, pp. 54–63; and, for the linked drawings, Z, XXIII, 8, 11, 12, 16–20.

19. Parmelin, *Le Peintre et son modèle*, pp. 41 and 65.

20. See my *Picasso* of 1964, pp. 251 and 252. Picasso attached particular importance to this landscape, which he kept for many years in the sitting room at Mougins.

Chapter 36

1. Basel, September–November 1981. For a first evaluation of this final work, I have referred to my article "L'Arrière saison de Picasso, ou l'art de rester à l'avant-garde," *XXe siècle*, no. 41, December 1973.

2. *The Last Years* (see Abbreviations).

3. The references are drawn from the exhibition catalogue of the Louise Leiris Gallery, *Peintures 1962–1963*, with a preface by Michel Leiris (Paris, 1964), and from Hélène Parmelin's book, *Le Peintre et son modèle*.

4. Bloch, 1110–16, 1135, 1150, and 1151; the main portion between 14 and 20 October 1963.

5. Bloch, 1123.

6. Bloch, 1117–34 and 1136–44, between 31 October and 7 December 1963; 1154–63, in early 1964.

7. Bloch, 1164–76.

8. Bloch, 1195 and 1196. The nudes and studios run from 1198 to 1229, between 1 and 18 March, interspersed with the sequence of paintings Z, XXIV, 329–40 and 352–58, in preparation for the sequence Z, XXV, 53–84, between 22 March and the beginning of April.

9. Collected in Parmelin, *Notre-Dame-de-Vie*, pp. 128–37. "I could make thou-

sands of these," Picasso said. "It's marvelous to work like that, on a painting that's already there. The most terrible thing for a painter is a blank canvas."

10. Ibid., pp. 74 and 75.

11. Ibid., pp. 89–107.

12. Spies, 309–15.

13. Parmelin, *Notre-Dame-de-Vie,* pp. 112–15, 120–27.

14. Ibid., pp. 116–19.

15. Ibid., pp. 138–70.

16. On the litho for the homage to Braque published by *Derrière le Miroir:*

Braque, one day, long ago, now, when you met me walking with a beautiful girl of the type known as classic, whom I thought was very pretty, you said to me "In love, you are not yet sufficiently detached from the masters."
Anyway, I can tell you now that I love you more than ever. You see, I still can't get away from them.

This was done on 3 February 1964, with a recumbent nude whom one can see from the front and the back, filled with Picassoesque signs.

17. I think of those done on 26 February, 21 March, and paintings ɪ and ɪɪ of 2 May 1964.

Chapter 37

1. For the Shakespeare, cf. my *la Vie de peintre,* p. 395, n. 17. *La Pisseuse* (Z, XXV, 108) went to the Musée Picasso via the donation of Louise and Michel Leiris.

2. Bloch, 1400–1457, from 27 August to 30 June 1967.

3. See Spies, 310–19.

4. Z, XXV, 92; cf. *Das Spätwerk,* p. 30ff.

5. Canvas of 13 March 1963, Parmelin, *le Peintre et son modèle,* p. 145.

6. *Das Spätwerk,* no. 25.

7. Ibid., no. 24.

8. Ibid., no. 21.

9. Ibid., no. 26.

10. *The Last Years,* no. 17.

11. Z, XXVII, 199–206—the closest to the *Bain turc,* today at the Museum of Modern Art (cf. *MOMA,* p. 185); 227–32, modernized.

12. Brigitte Baer, "Sept Années de gravures, le théâtre et ses limites," in *le Dernier Picasso 1953–1973* (Paris, 1988).

13. *The Last Years,* no. 45.

14. Z, XXVII, 331.

15. Z, XXVII, 340, 341ff.

16. *Das Spätwerk,* no. 34.

Chapter 38

1. See the analyses of Gert Schiff in *The Last Years,* p. 38ff.

2. Z, XXXI, 85; *Das Spätwerk,* no. 43.

3. Z, XXXI, 463.

4. *Das Spätwerk,* no. 45.

5. In particular Z, XXXI, 485, of 24 October, and *CS,* 194, of the 26th; Z, 534 etc.

6. *The Last Years,* p. 31.

7. I have returned to the subject of Degas thanks to the drawings brought together

at Jan Krugier in Geneva (9 June–25 July 1989), with my text, *44 Dessins du 90ème printemps*. Some of the drawings were done between 12 and 27 April during a break in work on engraving; others, at the end of December 1971. *Le Couple* is Z, XXXI, 73. We now know many unpublished drawings on the same subject were done by Picasso until the end of 1972.

8. In particular *CS*, 195; and Z, XXXII, 272; Z, XXXII, 298; the *Nu couché*, Z, XXXII, 295; *L'Homme au chapeau*, Z, XXXII, 310; cf. *The Last Years*, no. 47.

9. These are the works I had chosen to illustrate my *ArtNews* article ["For Picasso Truth Was Art, and Falsity, the Death of Art"] 72, 6 (Summer 1973). Successively, Z, XXXIII, 118, 229; *CS*, 200; *RM*, 73; *RM*, 72.

10. Z, XXXIII, 130; *Das Spätwerk*, no. 93.

11. See my *la Vie de Peintre*, p. 399.

12. Z, XXXIII, 120; *Das Spätwerk*, p. 92.

13. Z, XXXIII, 144.

14. *The Last Years*, p. 37, and Z, XXXIII, 274.

15. Z, XXXIII, 350.

16. Z, XXXIII, 435.

17. Z, XXXIII, 529.

Chapter 39

1. "For Picasso Truth Was Art" (see n. 9, chap. 38). Also, my "L'Arrière saison de Picasso," partly translated in *Anth.*, p. 274ff. The best account of Picasso's last moments is in Hélène Parmelin, *Voyage en Picasso* (Paris, 1980), from which I have taken the quotations used in this chapter.

2. *Das Spätwerk*, no. 60; Z, XXXIII, 122. There is an interesting study on the significance of this final period, "Picasso après-coup" by Guy Scarpetta, in *le Dernier Picasso*.

> The present demonstrations of "bad painting" can be perceived as the most recent avatar of a nihilism, an ideology, of the death of art. A nihilism which no longer takes Duchamp as its model, as in the '60s and '70s, but rather, Picabia: as a method of destroying art by its own deliberate internal corruption. Picasso, on the other hand, even in his most ironic and destructive moments, aims at extending the field of art toward new, previously unrecognized territories. . . . During a period [the '70s] in which the "values" of art are in a state of crisis more or less everywhere, he doesn't hesitate to affirm them—the primacy of invention, of originality, of style, of visual pleasure. And continues, always, to enlarge their scope. Further, he has taken great care to keep himself clear of the ideology of the death of art—to mistrust and even fear it.

At this point he quotes the comments I reported in 1977 in my *Vie de peintre de Pablo Picasso:* "People who shout that they're anti-art: they do it so that they won't be believed. . . . But what if they are right? What if they are *really* preparing the death of art?"

3. Jacqueline died on 15 October 1986. She was in the process of preparing an exhibition of her collection at the Museo Nacional de Arte Moderno de Madrid, which was to open on 25 October, Picasso's 105th birthday. She is now buried beside him in the park of the château de Vauvenargues.

APPENDIX:
THE EXHIBITION AT VOLLARD'S
AND ITS CONSEQUENCES

The catalogue of the Picasso exhibition at Vollard's comprises sixty-four titles, or headings, without including drawings. One heading—no. 62, *Portraits,* for example—implies several paintings. Further, the spirit of these headings and titles, reasonably *boulevardier,* seems to be due to Gustave Coquiot, who organized the show. Now that the inventories of Picasso's studios are complete, and various works of the period have been sold at public auctions, we can supply precise details to the reconstitution of D-B resumed and corrected by Josep Palau i Fabre in *Picasso vivent.*

1. *Portrait de l'artiste:* D-B, V, 2.
2. *Portrait de Monsieur Iturrino:* painted over in 1905 as *L'Acrobate à la boule,* see above.
3. *Portrait de Monsieur Mañach:* D-B, V, 4.
4. *Toledo:* probably—as Palau i Fabre surmises—the pastel D-B, V, 51, linked to the trip to Toledo.
5. *Femme nue:* Probably the *Femme nue assise* (D-B, V, 6).
6. *Iris: Les Iris jaunes* (D-B, V, 25).
8. *La Mère:* The title which remains, D-B, V, 9.
9. *Morphinomane: La Pierreuse la main sur l'épaule* (D-B, V, 11).
10. *L'Absinthe: Buveuse accoudée* (D-B, V, 12).
11. *Moulin-Rouge: Au Moulin-Rouge* (D-B, V, 13).
12. *La Buveuse: Femme assise à la terasse d'un café* (D-B, V, 14).
13. *La fille du roi d'Egypte:* In popular French, this means a gypsy. Which explains the uncomprehending protests of the Catalan critic Pere Coll (cf. *Picasso vivent,* appendix 11). Perhaps the *Jeune Fille à la fleur rouge* (D-B, V, 60) is in question; or the *Danseuse naine* (D-B, IV, 2), which does not correspond to any other title.
14. *Le Soir:* Since this evidently concerns "the evening of life" (and one hardly sees Picasso in 1901 painting an evening landscape), this might be the *Femme aux bijoux* (D-B, IV, 4).*
15. *Une fille:* i.e., a prostitute. The most typical, as she presents herself, is the *Nu aux bas bleus* (D-B, V, 5).
16. *Les Blondes Chevelures: La Ronde des fillettes* (D-B, V, 15).

*The picture suggested by Palau i Fabre, no. 624 (Z, XXXI, 279) does not seem entirely appropriate. Firstly, it is a nocturnal scene. And secondly, it is not signed. At that time, Picasso signed everything he exhibited: sometimes, with oversized letters.

17. *La Folle aux chats: Nu aux chats* (D-B, V, 16).

18. *Le Jardin enchanté: Femme dans un jardin* (D-B, V, 17); cf. no. 21.

19. *Germaine:* Portrait dedicated to Germaine (Z, XXI, 153).

21. *Jardin de rêve:* This might be a derivation of *Jardin public,* D-B, V, 19, filled with children, cf. no. 18.

22. *Le Square:* Either the other *Jardin public* (D-B, V, 18) or the *Marchande de fleurs* (D-B, V, 65), who is walking toward a small public garden.

23. *Les Toits: Les Toits bleus* (D-B, V, 21).

24. *Le Roi-Soleil:* Agrees with Palau i Fabre's proposed identification with a portrait of a beplumed child. Not in D-B. *Picasso vivent,* no. 584.

26. *La Cruche verte:* By process of elimination, the painting at the Tate Gallery is surely later. This must be D-B, V, 23.

27. *Fleurs.*

28. *Fleurs:* Among the collected bouquets of D-B, only nos. 24, 26, and 28 were done in 1901. To these must be added the *Pivoine,* a painting of a single flower, which Picasso at one time gave to Mme Lespinasse (Drouot Rive gauche, sale of 8 March 1976, no. 114).*

29. *Le Pot blanc:* either D-B, V, 24, or D-B, V, 26; cf. nos. 27, 28.

30. *Boulevard de Clichy: Boulevard de Clichy* (D-B, V, 30).

31. *Les Gosses: Les Enfants aux jouets,* not in D-B, oil on pasteboard, 52 x 66 cm., signed Picasso in lower right. (Sold at Palais Galliera, 3 December 1973.)

32. *Les Courses:* One must exclude D-B, V, 31, bought by M. Virenque directly from the artist. This leaves D-B, V, 32–34, and is probably a question of 33 or 34, which are general views.

33. *Le Matador.*

34. *Les Victimes.*

35. *L'Arène:* Paradoxically there are no oil paintings and no pastels which depict a matador—unless Picasso allowed himself to be affected by the vague French use of the term or the general view, D-B, IV, 5, was given that title without his permission. However, because of the gutted horse, it might apply to *Victimes,* as could D-B, IV, 6. *L'Arène,* on the other hand, might very well be the large pastel D-B, II, 8, bought by M. Virenque, which would prove that it had been taken to Paris.

36. *Café-concert:* The only work which might fit here is the *Café-concert du Paralelo.* See *Picasso vivent,* no. 558. Painted in 1899, according to Zervos (Z, I, 11) and put forward to spring 1901 by Palau i Fabre.

37. *Brasserie:* Probably a previously unknown painting shown to me in 1985, now at Galerie Salemit, Paris.

38. *La Femme jaune:* Perhaps the *Femme au théâtre* (D-B, V, 71), but it has not been signed, which really excludes that possibility. D-B, V, 47, and V, 59, might also be appropriate choices.

39. *Le Divan japonais:* Identified with the other *Femme au théâtre* (D-B, V, 77) by Palau i Fabre.

40. *El Tango:* In the spirit of hanging titles, this might be the *Danseuse espagnole* (D-B, IV, 3).

41. *La Bête:* This might designate—as Palau i Fabre thinks—the violent embrace (D-B, supplement A 3).

42. *Monjuich:* Among the identifications suggested by Palau i Fabre, the pastel *la Bohémienne* (D-B, II, 9) seems a possibility, as it was taken to Paris.

*The picture actually belonged to Mme Besnard, as the Vollard catalogue indicates. Ownership is recorded on the back of the picture.

43. *Courses de village: Corrida de village* (D-B, p. 340).

44. *Église d'Espagne: Devant l'église* (D-B, V, 49).

45. *Village d'Espagne:* Unidentified. A pastel?

46. *Buveurs:* Probably the watercolor with this title (D-B, V, 44).

47. *L'Enfant blanc: Le Gourmand* (D-B, V, 43).

48. *Jeanneton:* Jeanne, *le Nu Couché* (D-B, V, 52).

49. *La Méditerranée:* Not in D-B. Oil on pasteboard, in the Picasso estate, *Picasso vivent,* no. 565.

50. *Les Rochers:* Not in D-B. Z, XXI, 150.

51. *Les Buveuses:* Pastel of *Femmes au café* (D-B, V, 46).

52. *Danseuses: Le Cancan* (D-B, V, 55).

53. *Madrilena:* Why not *la Madrilène* (D-B, V, 57)?

54. *Chanteuse:* Probably the pastel D-B, V, 35.

55. *L'Amoureuse:* Perhaps, ironically, the eager young woman beside the old gentleman of the *Soupeurs* (D-B, V, 66).

56. *Au Bord de l'eau: Mère et enfants sur la plage* (D-B, V, 54).

57. *Femme de nuit:* One of many courtesans like D-B, V, 47, 48, 58, or 59.

58. *Vieille Fille:* A title of some wit: one is meant to assume that this is a *vieille fille de joie.* And the origin of the *Femme aux bas bleus* (D-B, V, 62).

59. *La Foire:* Surely *la Baraque de foire* (D-B, V, 63).

60. *Les Roses:* This can correspond only to D-B, V, 28.

61. *Carmen:* Unless she is the *Fille du roi d'Egypte,* this is probably one of the heads of young Spanish-looking women as in V, 60, or the large watercolor V, 36.

63. *Don Tancredo:* Like Palau i Fabre, we are giving our tongues to the cat.

64. *La Mère et l'Enfant:* the bravura piece *Mère et Enfant aux fleurs* is one among several possible identifications (D-B, V, 7).

There are still two numbers listed for *Portrait* and one for *Portraits,* in the plural, which implies at least one—if not both—of the portraits of Coquiot (D-B, V, 64, and VI, 16), and without question the portraits of Lola, the artist's sister (D-B, V, 56); of Jeanne, clothed, the *Femme à la cape* (D-B, V, 76), and probably, *Bibi la purée* (D-B, V, 74). Perhaps the two little girls—D-B, V, 9 and 10—should be included as well.

This now makes a coherent whole, with too many paintings of *Courses.* However, the plural perhaps authorizes showing several of them. We also have one *Mère et Enfant* too many (D-B, V, 9 and 10). Perhaps both of them were shown.

A *Mère allongée tenant un bébé au bord de la Méditerranée* (52 x 67 cm.) should be added to the list of uncatalogued works. The picture—no. 212—signed Picasso in the lower right, was sold at Sotheby's on 5 November 1981 and was perhaps earlier known as no. 56, *Au bord de l'eau,* and a *Femme souriante en blanc,* which appeared at Christie's, New York, 16 May 1977 (cf. my *Vie de peintre,* no. 118), which might correspond with no. 57.

It is clear that Picasso continued his pursuit of particular subjects and techniques, probably right through the show. Among the new subjects to appear at this time are *Sur l'impériale* (D-B, V, 61), a most audacious work in its use of squaring and space; *Le Quatorze juillet,* a height of impassioned color (D-B, V, 70); the *Café de la Rotonde* (D-B, V, 45), a close-up—unthinkable before photography, even stronger than Degas— of the place in which Casagemas killed himself; and a bravura still life (D-B, V, 72), which seems to be a tip of the hat to Manet, with its oysters and its crosswise fork; and perhaps also to Cézanne, with its *compotier* and at least one apple. The picture is one of a kind, with, already, a great deal of blue. Perhaps it should be read as a farewell to the impetuous virtuosity of the exhibition at Vollard's.

INDEX OF NAMES

INDEX OF WORKS